P9-CSS-614

The Art of Art History:
A Critical Anthology

Oxford History of Art

Donald Preziosi is Professor of Art History at the University of California, Los Angeles, where he developed and directs the art history critical theory programme.
He was educated in art history, classics, and linguistics at Harvard, and has taught at Yale, Cornell, SUNY, and MIT. He has lectured and conducted seminars for many years on the history of art history and museology in the United States, Europe, and Australia. Among his books are *Rethinking Art History: Meditations on a Coy Science*; *Minoan Architectural Design*; and a forthcoming critical study of museums and museology, *Brain of the Earth's Body*. He is also the co-author with Louise Hitchcock of the Oxford University Press volume *Ancient Aegean Art*.

Oxford History of Art

The Art of Art History: A Critical Anthology

Edited by Donald Preziosi

OXFORD
UNIVERSITY PRESS

OXFORD

UNIVERSITY PRESS

Great Clarendon Street, Oxford OX2 6DP

Oxford New York
Auckland Bangkok Buenos Aires Cape Town
Chennai Dar es Salaam Delhi Hong Kong Istanbul Karachi
Kolkata Kuala Lumpur Madrid Melbourne Mexico City Mumbai
Nairobi São Paulo Shanghai Taipei Tokyo Toronto
Oxford is a registered trade mark of Oxford University Press
in the UK and in certain other countries

© Donald Preziosi 1998
First published 1998 by Oxford University Press

All rights reserved. No part of this publication may be reproduced,
stored in a retrieval system. or transmitted, in any form or by any means,
without the proper permission in writing of Oxford University Press.
Within the UK, exceptions are allowed in respect of any fair dealing for
the purpose of research or private study, or criticism or review, as permitted
under the Copyright, Design and Patents Act, 1988, or in the case of
reprographic reproduction in accordance with the terms of the licences issued by
the Copyright Licensing Agency. Enquiries concerning reproduction outside
these terms and in other countries should be sent to the Rights Department,
Oxford University Press, at the address above.

This book is sold subject to the condition that it shall not, by way of trade
or otherwise, be lent, re-sold, hired out or otherwise circulated without
the publisher's prior consent in any form of binding or cover other than
that in which it is published and without a similar condition including
this condition being imposed on the subsequent purchaser

British Library Cataloguing in Publication Data
Data available

Library of Congress Cataloguing in Publication Data
Data available

ISBN 978-0-19-284242-8

10 9

Picture Research by Elisabeth Agate
Design by Esterson Lackersteen
Printed in China
on acid-free paper by
C&C Offset Printing Co. Ltd

Contents

Introduction

The Art of Art History is a collection of resources for constructing a critical history of art history. It is not organized as a conventional 'history of art history' in its own right, nor is it a historical novel with a beginning, middle, and end. It is rather more of an assemblage, or a cabinet of provocative things to think with, each of which has multiple connections to others, both within this anthology and elsewhere. It is also an 'anthology' in the older sense of the word—an accounting of things which in their variety and allure might resemble a garden of flowers; a collection of texts that, in some cases, have been appreciated as fine works of art in their own right.

The volume is made up of essays and excerpts from books written on a number of interrelated themes over the past two centuries. Each of these in its own time (and differently at other times) has either sparked, engaged with, or been used by other writers for their own engagements with a wide variety of intensive and in many cases ongoing debates. The arguments of some directly address those of essays juxtaposed with them. There are several alternate perspectives on the same issue or artwork. All of them deal with the nature and fate of the phenomenon of 'art' in modern times, with differing articulations of artistic 'histories', with different visions on the social roles of art history and criticism, and with the enterprises of modernity more broadly.

The collected texts are treated not as isolated monuments, however persistently influential some of them have been—in some cases seeming to have lives of their own. Nor are they arranged to simulate a single mainstream evolutionary path. They are not assembled here disingenuously to 'speak for themselves', as if they were paintings hung on the bare walls of a modernist art gallery. There are few blank walls in *The Art of Art History*. Its walls are covered with writing, signposts, an occasional bit of graffiti, and punctuated by openings onto other spaces, with invitations and provocations guiding the visitor towards more specimens, different resources, and other possible worlds.

All of the texts in this collection were originally produced within often highly charged environments of controversy and debate in various places around the world over the past two hundred years, having

themselves often sparked such controversies. They are deployed here within a series of discussions, commentaries, and critiques whose aim is to foster an understanding of important aspects of their critical and historical situations, and to allow the reader to engage with them in a dialogic and interrogative manner. The texts, in short, are embedded in a dense series of overwritings or palimpsests. The collection may thus be walked through from a variety of directions, and along several intersecting paths, and issues or themes elicited through and around one text will often re-emerge elsewhere in a similar or transformed manner. The accompanying commentaries both link and mark differences between texts, and serve as catalysts and workpoints for discussion. They also indicate alternative paths through this thicket of texts and overwritings.

Organization

In format, *The Art of Art History* is organized around groups of major debates and themes that have characterized the literature of the discipline since the eighteenth century's articulation of the 'aesthetic' as a distinct object of study connected with the production of knowledge about human nature and cognition. The volume attends to the diverse ways in which art history may be seen as constituting a *social and epistemological technology* which has been essential to the conception, fabrication, and maintenance of (originally European, subsequently all) modern nation-states, and of the individual and collective identities that are staged as the supports and justifications for these political entities.

The readings deal with many familiar subjects of art, aesthetics, history, style, meaning, protocols of explanation, perception, identity, gender, and ethnicity. The selections are organized according to these themes, and the texts included follow a roughly chronological order from the late eighteenth to late twentieth centuries. Included in each chapter is a bibliography of related readings recommended for further study. In each section, the texts presented as well as those recommended are pertinent to an understanding of the history of art history *and* to the complementary development of museums and museological practice. Their aim is to foreground some of the fundamental issues that lie deeper than recent academic debates over competing theories and methodologies.

As already noted, the selections and the trajectory of readings are not meant to chart an imaginary singular narrative history of art history. It will become clear that any such narrative is not a little problematical given the diversity of the field, its disparate missions and motivations, as well as the often contrary social, political, or ideological uses to which such singular genealogies and narrative stories have been put in the past and at present. *The Art of Art History* has an

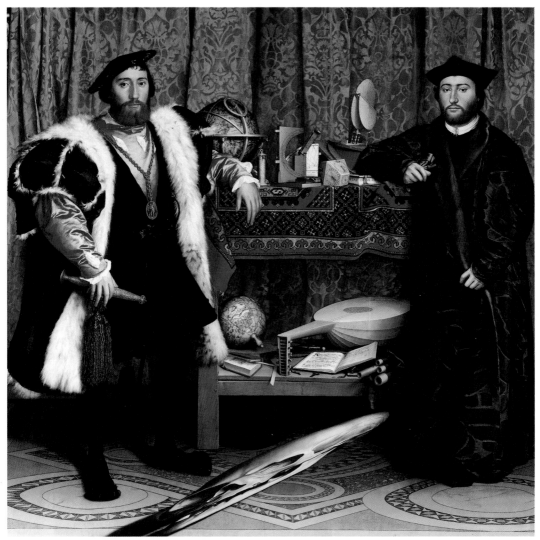

1 Hans Holbein the Younger
The Ambassadors, 1533

explicitly different aim: to provide the reader with what in the writer's experience have proven to be productive and useful resources and points of departure in the continuing debates about the state—and possible fate—of the art of art history, in both senses of the phrase.

Two essays specially written for this collection are placed so as to frame it (if this Introduction was a curtain covering the entrance, then the first essay is the threshold or vestibule, and the second frames an exit). The first essay, 'Art History: Making the Visible Legible', is intended as a general overview of the subject—and objectives—of art history, and may be imagined as a small *belvedere*, or perhaps an introductory gallery, providing an overview or synopsis of the issues taken up throughout the rest of the collection (as with any overview, of course, it is neither neutral nor innocent). The final essay ('The Art of Art History') is a hindsight meditation on the preceding texts and

discussions, including the first essay itself: a palimpsest on the whole, and a crossroads leading to other journeys and other worlds.

Both essays might function as *anamorphic* patches in the overall collection, like the odd shape in Hans Holbein's *The Ambassadors* (1533), the slantwise focus upon which reveals otherwise hidden perspectives on, and different readings of, a larger assemblage [1]. In this case, the two texts 'read' the overall collection *otherwise*. Relative to each other, and seen in the same frame, the first and last essays comprise the alternating co-present faces or fronts of an 'optical illusion'; an oscillating and enigmatic double image—a simulation (as it may become clear) of the *artifice* that historically set art history in play, and of the tensions that have kept it in motion.

Art History: Making the Visible Legible

Art history is one of a network of interrelated institutions and professions whose overall function has been to fabricate a historical past that could be placed under systematic observation for use in the present. As with its allied fields—art criticism, aesthetic philosophy, art practice, connoisseurship, the art market, museology, tourism, commodity fashion systems, and the heritage industry—the art historical discipline incorporated an amalgam of analytic methods, theoretical perspectives, rhetorical or discursive protocols, and epistemological technologies, of diverse ages and origins.

Although the formal incorporation of art history into university curricula began in Germany in the 1840s,[1] by the end of the nineteenth century the greatest number of academic programmes, professorships, students, and advanced degrees conferred were in the United States rather than in Europe, a situation even more marked a century later. There were differing circumstances and justifications for its academic institutionalization in Europe and its former colonies, and the early profession was variously allied with or patterned after the methods of philosophy, philology, literature, archaeology, various physical sciences, connoisseurship, or art criticism.[2]

Nevertheless, wherever art history was professionalized, it took the problem of *causality* as its general area of concern, construing its objects of study—individual works of art, however defined—as *evidential* in nature. It was routinely guided by the hypothesis that an artwork is reflective, emblematic, or generally *representative* of its original time, place, and circumstances of production. Art objects of all kinds came to have the status of historical documents in the dual sense that (1) each was presumed to provide significant, often unique and, on occasion, profoundly revealing evidence for the character of an age, nation, person, or people; and that (2) their appearance was the resultant *product of* a historical milieu, however narrowly or broadly framed.

The latter sense has regularly included the various social, cultural, political, economic, philosophical, or religious forces arguably in play at a particular time and place. Characteristically, disciplinary practice was devoted to reconstructing the elusive 'realities' of such ambient forces—from the intentions that might be ascribed to an individual

maker, to more general historical forces or circumstances. In short, the principal aim of all art historical study has been to make artworks more fully *legible* in and to the present.

Since the institutional beginnings of art history there has been only loose and transitory consensus about the efficacy of various paradigms or analytic methods for rendering artworks adequately legible, the key issue being the quantity and quality of historical or background information sufficient to a convincing interpretation of a given object. As criteria of explanatory adequacy have changed over time, and the purposes to which any such understandings might be put in the present have varied widely over the past two centuries, there has been considerable disagreement regarding the extent to which an art object can be taken, legitimately, as indicative or symptomatic of its historical milieu.

For some, art historical interpretation was complete and sufficient with the explication of a work's relationship to an evolving stylistic system manifested either by an individual artist (a particular corpus of work or *œuvre*) or by a broader aesthetic school or movement. For others, interpretation involved the articulation of interrelationships between stylistic development and the unfolding of an artist's biography, or (as in the case of the sixteenth-century artist and historian Giorgio Vasari) a regional and national style culminating in the synthetic work of a great artist (like Michelangelo) in the present.[3] For some, explication approached adequacy only with the articulation of an object's larger historical 'contexts', foregrounding the work's documentary or representational status and its circumstances of production and reception.[4]

There has also been no abiding consensus about the limits or boundaries of art history's object-domain. For some, that domain was properly the corpus of traditional luxury items comprising the 'fine arts' of painting and sculpture, and the architecture of ruling classes or hegemonic institutions. Such a domain of attention was normally justified by reference either to shared criteria of demonstrable skill in execution or to what was documented (or postulated) as self-conscious aesthetic intent. Characteristically, this excluded the greater mass of images, objects, and buildings produced by human societies. For others, the purview of disciplinary attention ideally incorporated the latter, the conventional fine arts occasionally forming a distinguishable subset or idealized *canon* of historical artefacts. The situation is further compounded by the modern museological attention given to virtually any item of material culture, conflating current exhibitionary value (its originality or poignancy within the formal logic of an unfolding system of stylistic or intellectual fashion) with social, cultural, or historical importance.

The fuller network of associated discourses and professions of

which art history is an integral and co-constructed facet has only begun to be examined by art historians and others, often under the discursive umbrella of cultural history or visual culture studies. Critical historiographic accounts of the discipline of art history are continually beset by (1) unresolved questions about the field's proper purview or object-domain of study; (2) the fragmentation and dispersion of professional attention to art historical objects across different fields of study with conflicting aims and theoretical assumptions; and (3) markedly different criteria of adequacy in paradigms of explanation and interpretation within each profession or institution.

Existing histories of art history have either been biographical and genealogical accounts of influential professionals, narrative accounts charting the evolution of theories of art (either in a vacuum or as unproblematic reflections of some broader spirit of an age, people, or place), or accounts of the development of various interpretative methodologies. Nevertheless, the following observations may be applicable to a broad spectrum of this network of practices.

In addition to a shared concern with questions of causality and evidence, the most fundamental principle underlying all these interrelated fields has been the assumption that changes in artistic *form* signal changes in individual or collective *mentality* or *intention*. Most commonly, the artefact or object is taken as a specific inflection of some personal or shared perspective on certain ideas, themes, or values—whether the object is construed as reflective or constructive (or both) of such ideas.

A corollary of this set of assumptions is that changes in form (and attitude) are themselves indicative of a *trajectory* of development; an *evolution* or overall direction in mentality which might be materially charted in stylistic changes over time and space. Such a figure (or 'shape') in time has often been interpreted as evidence for a shape *of* time itself; a 'spiritual' teleology or evolution. For some, artistic phenomena have been construed as providing key documentary evidence for such spiritual or social evolutions.

The most pervasive theory of the art object in art history as well as in conventional aesthetic philosophies was its conception as a *medium* of communication or expression. The object was construed within this communicational or linguistic paradigm as a 'vehicle' by means of which the intentions, values, attitudes, ideas, political or other messages, or the emotional state(s) of the maker—or by extension the maker's social and historical contexts—were conveyed, by design or chance, to targeted (or circumstantial) beholders.

This was linked to the widespread presumption in art history and elsewhere that formal changes exist *in order to* effect changes in an audience's understanding of what was formerly conveyed before the in(ter)vention of the new object. For some art historians, artworks

were seen as catalysts for social and cultural change; for others they were the products of such changes. In either case, the analytical object was commonly sited within a predicative or propositional framework so as to be pertinent to a particular family of questions, the most basic of which was: in what way is this object a representation, expression, reflection, or embodiment of its particular time and place—that is, a trace or effect of the peculiar mentality of the person, people, or society that produced it?

In the history of art history, there were elaborated a variety of criteria for classifying objects of study according to their ability to convey such information. For some, the presumptive semantic 'carrying capacity' of certain kinds of objects was a function of traditional hierarchical distinctions between 'fine' and 'applied' arts, although notions regarding the semantic densities of all kinds of objects have varied widely among historians over time.

Common to these hypotheses was a facet of art historical practice shared with its allied discources and institutions—namely, a fundamental concern with siting its objects of study within a discursive field, rhetorical framework, or analytic stage such that the work's specifiable relationship to pertinent aspects of its original environment may be construed *causally* in some sense. Art history was closely allied with (indeed has been ancillary to) museology in this fixing-in-place of individual objects within the ideal horizons of a (potentially universal) history of artistic form—with the assignment, in short, of a locus or 'address' to the work within a finely calibrated system of chronological or geographic relationships of causality or influence.

From the sequential juxtaposition of objects in museum space to the formatting of photo or slide collections (material or virtual) to the curricular composition of university departments, disciplinary practice has been characteristically motivated by a desire to construe the significance of works as a function of their *relative position* in an unfolding historical or genealogical scheme of development, evolution, progress, or accountable change. Such schemata have framed objects within broad sectors of social and intellectual history, and within the evolving careers of single artists, in essentially similar ways. In this regard, the given object is a marker of difference, in a massive differential and relational system, from other objects—a situation clearly reflected in the very language of description, evaluation, and criticism of art.

Crucial to the articulation of art history as a systematic or even 'scientific' historical discipline in the nineteenth century was the construction of a centralized *data mass* to which the work of generations of scholars have contributed. This consisted of a universally extendable archive (potentially coterminous, by the late twentieth century, with the material culture of all human societies) within which

every possible object of study might find its unique and proper place relative to all others. Every item might thereby be sited (and cited) as referencing or indexing another or others. A principal motivation for this massive labour over the past two centuries has been the assembly of material evidence for the construction of historical narratives of social, cultural, or cognitive development.

Grounded upon the associations of similarity or contiguity (or metaphor and metonymy) among its incorporated specimens or examples, this disciplinary archive became a critical artefact in its own right; itself a systematic, panoptic *instrument* for the calibrating and accounting for variation in continuity, and for continuity in variation and difference. Such an epistemological technology was clearly central to, and a paradigmatic instance of, the social and political formation of the modern nation-state and its various legitimizing paradigms of ethnic uniqueness and autochthony, or evolutionary progress or decline in ethics, aesthetics, hegemony, or technology.

Art history shared with its allied fields, and especially with museums, the fabrication of elaborate typological orders of 'specimens' of artistic activity linked by multiple chains of causality and influence over time and space and across the kaleidoscope of cultures (which could thereby be interlinked in evolutionary and diffusionist ways). This immense labour on the part of generations of historians, critics, and connoisseurs was in the service of assigning to objects a distinct place and moment in the historical 'evolution' of what thereby became validated as the pan-human phenomenon of *art* as a natural and legitimate subject in its own right; as cultural matter of deep significance because of what it arguably *revealed* about individuals, nations, or races.

From the beginning, the principal concern of historians and critics of the visual arts was the linkage of objects to patterns of causality assumed to exist between objects and makers, objects and objects, and between all of them and their various contemporary contexts. Underlying this was a family of organic metaphors linked to certain common theories of race in the early modern period: in particular, the presumption of a certain demonstrable kinship, sameness, or homogeneity among objects produced or appearing at a given time and in a particular place. It was claimed that the products of an individual, studio, nation, ethnic group, class, gender, or race could—if read carefully and deeply enough—be shown to share certain common, consistent, and unique properties or principles of formation. Corresponding to this was a temporal notion of the art historical 'period' marked by similar homogeneities of style, thematic preoccupation, or technical approach to formal construction or composition.

Art history and museology traditionally fabricated histories of form as surrogates for or parallels to histories of persons or peoples: narrative

stagings which served (on the model of forensic laboratory science) to illustrate, demonstrate, and delineate significant aspects of the character, level of civilization, or degree of social or cognitive advancement or decline of an individual or nation. Art objects were of documentary importance in so far as they might have evidential value relative to the past's causal relations to the present, and thus the relationship of ourselves to others. The academic discourse of art history thereby served as a powerful modern *concordance* for systematically linking together aesthetics, ethics, and social history, providing essential validating instruments for the modern heritage industry and associated modes of the public consumption of objects and images.

From its beginnings, and in concert with its allied professions, art history worked to make the past synoptically visible so that it might function in and upon the present; so that the present might be seen as the demonstrable *product* of a particular past; and so that the past so staged might be framed as an *object of historical desire*: figured as that from which a modern citizen might desire descent.

The broad amalgam of complementary fields in which the modern discipline of art history is positioned never achieved fixed or uniform institutional integration. Nevertheless, in the long run its looseness, and the opportunistic adaptability of its component institutions and professions, proved particularly effective in naturalizing and validating the very *idea* of art as a 'universal' human phenomenon. Thus framed as an *object* of study, the art of art history simultaneously became a powerful *instrument* for imagining and scripting the social, cognitive, and ethical histories of all peoples.

As a keystone enterprise in making the visible legible, art history made of its legibilities a uniquely powerful medium for fabricating, sustaining, and transforming the identity and history of individuals and nations.

The principal product of art history has thus been modernity itself.

1

Art as History

Introduction

Do works of art provide us with knowledge that is significantly different from that offered elsewhere?

The modern discipline of art history is founded upon a series of assumptions regarding the meaning or significance of objects of human manufacture. Of these, two principal hypotheses have informed the field from its beginnings, constituting its conceptual core. The *first* is that not all objects are equal in the amount of information they might reveal about their sources or maker, some conveying more information about their sources than others. The *second* is that all such objects are time-factored: that is, they contain legible marks of the artefact's historical genealogy, either of a formal or thematic nature. A corollary of this is that any such marks exist within the genealogical time-frame of a particular people or culture. The first assumption lies behind varying justifications for delimiting art history's field of enquiry, while the second links that defined subject-domain to particular visions of individual and collective history and development.

The history of art historical practice may be understood as the development of many variations, transformations, and consequences of these fundamental assumptions. Linking all forms of practice over the past several centuries has been a virtually universal agreement that its objects of study—works of 'art'—are uniquely privileged in the degree to which they are able to communicate, symbolize, express, or embody certain deep or fundamental truths about their makers or sources, whether that be a single person or an entire culture or people.

The two individuals whom later art historians commonly regarded as the intellectual founders of the discipline—the Arezzo-born artist-historiographer of Renaissance Florence, Giorgio Vasari (1511–74), and the Prussian antiquarian-aesthete and resident of Rome, Johann Joachim Winckelmann (1717–68)—were motivated in their writing by a need to resolve dilemmas which had arisen in their time as a result of following out the consequences of contemporary perspectives on the aforementioned assumptions about works of 'art'. In each case, the problems they addressed were in no small measure the product of their

own positions on the nature of historical causality and on what objects of art could actually mean, and how they might signify.

These two extraordinary figures, however, occupied very different positions in relation to their historical contexts. Vasari worked to establish what was to become the dominant art historical and critical tradition in which the heritage of Florentine art was seen as paradigmatic of a revived antique glory. The progressive evolution of Florentine art was depicted as recapitulating the artistic processes that led to the glories of antique art because, as he saw it, Florentine and ancient artists were grappling with similar *artistic problems* concerning representation and the imitation of nature. The paradigm of artistic progress was articulated through metaphors of biological growth, the art of his time corresponding to a period of full maturity.

> Up to the present, I have discoursed upon the origin of sculpture and painting … because I wish to be of service to the artists of our own day, by showing them how a small beginning leads to the highest elevation, and how from so noble a situation it is possible to fall to the utterest ruin, and consequently, how these arts resemble nature as shown in our human bodies; and have their birth, growth, age and death, and I hope by this means they will be enabled more easily to recognise the progress of the renaissance of the arts, and the perfection to which they have attained in our own time.[1]

Winckelmann was working exactly two centuries later, when the history of art that Vasari argued had reached its plateau of perfection in Michelangelo and his generation seemed to some to have been buried beneath two centuries of uncreative imitation and 'baroque' excess. One of Winckelmann's pragmatic motivations for re-establishing the *history* of art on a sound historical footing was the transformation and elevation of contemporary *art*. Rather than imitating the glories of the art of Michelangelo and Raphael, Winckelmann's contemporaries were exhorted to reach back to a 'true antiquity'—that of classical Greece—to thoroughly rebuild and transform the art of modern times; to create a *new* (or Neo-) classicism appropriate to the modern world.

At the same time, Winckelmann was working in reaction to two centuries of post-Vasarian imitators whose writings he characterized (not without some hyperbole) as 'mere narrative[s] of the chronology and alterations of art'; fragmented imitations of Vasarian art history applied to increasingly diverse and alien contexts. He envisioned and attempted to delineate a 'systematic' history of art in his remarkable 1764 book *The History of the Art of Antiquity*.[2] Like Vasari, he was concerned with articulating what he perceived to be the *historicity* of artworks: the idea that an object bore within its very form certain identifiable traces of its temporal position in a unilinear and developmental historical *system* (his word)—a coherent evolutionary sequence of artistic styles modelled (as all histories of art had been for some

time) upon an organic metaphor of birth, maturity, and decline. His work was a progenitor of what came to be formalized in mid-nineteenth-century Europe as the academic discipline of art history. It instituted categories and paradigms which today remain deeply embedded in the structural framework and the pragmatic working assumptions of both classical archaeology (which also took Winckelmann as its chief progenitor) and modern art historical practice.

Winckelmann's *History* grappled with two principal problems. First, he aimed to highlight the specific, concrete historical *causes*—the climatic, biological, political, and social conditions—responsible for the appearance and evolution of a given artistic style. Understanding such conditions would be a way of comprehending the nature of style as such. Secondly, his work sought to articulate a viable analytic, explanatory position or role for the historian of art as a viewer of works. He was concerned here with elucidating the relations between the historian as subject and the historian's object of study in such a way as to be productive of knowledge about the individual object, and about the nature of art itself more universally (art as uniquely revelatory about individuals and peoples). He was equally concerned with understanding what the encounter between subject and object might reveal about the nature of the viewing subject.

In point of fact, Winckelmann invented a new *version* of artistic history that was already present (both in general scope and in some of its particulars) in the work of Vasari two centuries earlier. The importance of Winckelmann's revolutionary contributions to the development of the modern discipline of art history cannot be fully appreciated without an understanding of the Vasarian tradition within which he was working, and against whose corruptions (as he saw it) he was working. Nevertheless, his writings were at the same time the principal catalyst of what may reasonably be understood as a revolution in art historical thinking which made possible the professional discipline as we know it today.

The differences in Vasari's and Winckelmann's projects and motivations are notable. Vasari's 1550 work (and its much-enlarged 1568 edition) *The Lives of the Most Eminent Italian Architects, Painters, and Sculptors from Cimabue to Our Times* was written from the perspective of a practising artist actively engaged in the artistic and political life of his time. He was deeply concerned with understanding the history of art both internally and externally: as an account of the technical progress made by individual artists in successive generations towards an ideal representation of nature, and as documentary evidence of the superiority of Florentine art as itself emblematic of more general contrasts between the Florentine city-state and other cities and peoples. But much of this process was past for Vasari; it was already, in his view, at its apex and fulfilment, as embodied most closely in the work of his

own artistic mentor, Michelangelo.

More broadly, his writing constituted a systematic attempt to account for the apparent contradictions in the *relativity* of artistic reputation—the fact that artists could be considered *justly* great at a particular time and place even though their accomplishments might be seen by later generations, and with equal justification, as less great or as artistically incomplete. His solution to the problem of reconciling sharply divergent historical perceptions was to reduce all such differences to episodes of a single, progressive, linear narrative wherein the accomplishments of any artist responded to and built upon what by hindsight could be seen as the foundations laid down by predecessors involved with a similar *mission*—in this case, with the commonly shared problem of representing nature. In Vasari's words:

As the men of the age were not accustomed to see any excellence or greater perfection than the things thus produced, they greatly admired them, and considered them to be the type of perfection, barbarous as they were. Yet some rising spirits, aided by some quality in the air of certain places, so far purged themselves of this crude style that in 1250 Heaven took compassion on the fine minds that the Tuscan soil was producing every day, and directed them to the original forms.[3]

Vasari's history of art, then, was above all a *history of precedents* in the progressive approximation to a norm or ideal manifested in its fulfilment by the work of his own time. That present moment of artistic perfection was articulated as the implicit goal of all previous practice *and* as the norm or standard with which to assess all such practice. It was framed, very specifically, as the conclusion of an upward movement from the Gothic barbarisms of what subsequently came to be characterized as the 'Middle' Ages and the contemporary reconstitution (or Renaissance) of the artistic ideals of a once-lost Graeco-Roman antiquity being doubly reborn in uncovered Roman ruins and in the (Florentine) art inspired both by those ruins and by contemporary readings of various ancient texts on art by Cicero and Pliny. For Vasari, what had been lost was now regained by artists following the *example* of ancient works' imitation of nature's inner truths.

Winckelmann had generally similar motivations in composing his systematic history of art. The art of ancient Greece (which he and his generation knew only indirectly in what we now know to be mostly later Roman copies) represented for him an ideal perfection of style that in certain respects was lost for ever in its full particularities—that is, in its specific expressions of a(n equally idealized) social, political, and erotic world—but which none the less might find echoes in other times and places. It might even serve as an inspiration for a new classicism to rise phoenix-like from the ashes of the past. It is important to note that Vasari's *history of artistic precedent* was grounded in an

understanding of a still-living tradition of artistic practice in which he himself was a very active participant; Winckelmann's *history of art* was founded upon the articulation of patterns of growth and change revealed to antiquarian eyes and taste in fragmentary relics and copies of the art of a culture dead for two millennia. Vasari was part of the (Renaissance) tradition he elucidated, while Winckelmann was alienated from his own (Baroque) times.

For both Vasari and Winckelmann, there existed unresolvable tensions and contradictions in their attempts to deal with the relativities of historical thinking as such. For Vasari, this entailed the seemingly simultaneous completeness *and* incompleteness of a given work of art at a particular historical moment. In other words, a work may be incomplete in its approximation to an ideal norm of representation, yet complete or true in terms of its mission within a specific historical milieu. This was in large part an artefact of the vision of history as a linked series of solutions to what was characterized by hindsight as a common problem (in this case the imitation of nature). The difficulty was that the norm or ideal was itself historical and already incorporated into the momentum of history, changing over time and with each redefinition of artistic 'problems' of representation. The norm, in short, was *both* historical *and* outside history; both part of the historical process and its goal or fulfilment.

Vasari's most famous work—his *Lives*—was but an initial synthesis in a broader and ongoing project of monumentalizing and institutionalizing his aesthetic doctrines, and documenting the canonical examples of the rise to full realization of these doctrines. The encyclopaedic nature of his life's work itself became more pronounced with the second, more fully illustrated 1568 edition of the *Lives* (which also included new portrait images of the artists discussed), and with a series of related works such as an album of drawings of the artists studied, his *Libro del disegno*.[4] In 1563, Vasari was instrumental in founding the first artists' Academy in Florence, which, under the patronage of Cosimo de' Medici, and with Michelangelo as its head, became the paradigm of artistic academies throughout Europe and its colonial extensions for several centuries. As a virtual temple-museum of Vasari's aesthetic doctrines, the Academy combined the functions of an archive or *libreria* for the study of the designs, models, and plans of the artists of the *Lives* and *Libro*, a hall of exhibition, and a collection of portraits of members and old master artists. The Florentine Academy was the *cumulative* expression of (and monument to) Vasari's own professional engagement with modelling the history of artistic practice in a comprehensive and systematic fashion.

Winckelmann's notion of historical change was also based upon the idea of artistic history as a linked series of solutions to common artistic problems. The scale and ambition of his work, however, was broader

than that of Vasari in a number of respects.

For one thing, he attempted to depict an entire national artistic tradition—that of ancient Greece—from its birth through to its historical decline and demise. He sought to fully account historically (as well as formally or technically) for how and why that tradition developed the way it did when and where it did. Winckelmann's interest in the visual arts also extended beyond what was then customary in that he envisioned the history of a people's art as providing a deeper and more lucid understanding of a people and its general historical development than any other history, or any merely political account. Art, in other words, was made to bear the burden of being an emblem of the *totality* of a people's culture: its quintessential expression. To understand a people's art was thus to understand that people in the deepest possible way.

Winckelmann's systematic history also extended and refined the general organic model common to histories of all kinds during his time in that it postulated a sequence of more clearly delineated steps or periods in the development of ancient art. These stages—still today implicitly canonical in most art historical practice—went from an early stylized ('archaic') origin to a phase characterized by an ideal mastery of naturalistic representation (coinciding with the period of Athenian democracy from the early fifth to the late fourth century BC) to a time of long decline, characterized by excessive decoration and the stale imitation of earlier precedents (the 'Hellenistic' period). In this regard, Winckelmann not only transformed the idea of the history of art into a notion that art is the emblem of the spirit of an entire culture, but he also argued that it achieves an ideal moment—what later came to be referred to as 'classical'—in which the *essential* qualities of a people are most fully and truly revealed: in this case, with the nude male *kouros* statue. In his eyes, the history of Greek art not only mirrored the rise, maturity, and decline of the free Greek city-state, but it was also its allegory; its classical moments constituted the epitome of all that culture had striven towards. His historical paradigm also permitted a patent analogy between the time of ancient 'decline'—the 'Hellenistic' period—and the later Baroque period in which he himself lived.

His genealogical system of Greek art was elaborated as an allegory of *all* artistic history at all times: the norm or standard against which the art of any people might be measured. This allowed him to compose the history of antiquity as a grand transcultural narrative with a mainstream and marginal side-tracks. He could thus evaluate Etruscan or Egyptian art as stunted in growth or side-tracked before a full 'classical' maturity could be achieved. It also enabled him *not* see Roman art at all—except as a late, 'derivative' phase of the art of Greece. Such views ran contrary to the reigning sentiment of the time, in which the vision of ancient Rome dominated the historical imagination (and whose

monumental grandeur, decorum, and *gravitas* were being praised in the engravings of Winckelmann's contemporary, Giovanni Battista Piranesi, as being not at all 'dependent' upon Greek influence). The motivations for Winckelmann's unorthodox preferences remain obscure, although it seems likely that they were tied to contemporary political attitudes in which what was seen as one latter-day manifestation of Roman imperial art and architecture—the Baroque style—was inferentially linked to large and in some cases despotic states and institutions to which his own views on personal freedom were antipathetic.

While Winckelmann was instrumental in furthering excavations at Pompeii and Herculaneum in southern Italy, within a generation the empirical supports for his theory of the history of art began to dissolve as a result of an exponential increase in knowledge due to discovery and excavation not only in Italy, but in Greece and the eastern Mediterranean, which Winckelmann never saw. Nevertheless, the paradigmatic structure or conceptual system of Winckelmann's art history remained largely in place—both in its particulars and as one or another version of organicist metaphors for historical change—in the subsequent development of the modern discipline in the nineteenth century, both as its implicit ideal and as a historiographic straitjacket of unresolvable dilemmas.

Central to his notion of the ideal ('classical') moment of Greek art was a fantasy of a free, desiring self, both reflecting and reflected in Athenian approximations of democratic self-rule. Such a moment in art would paradoxically also be style*less*; having to be a pure unadorned mirror or expression of individual free agency. Herein lay one of the contradictions of Winckelmann's systematic history. In trying to comprehend the Greek ideal in a more fully historical manner he effectively *relativized* it, thereby making it a rather problematic model for the contemporary practice which he simultaneously wished to inspire. In his work, then, there is an oscillation between two senses of the ideal in art: as that which was the organic, historical expression of one particular society and culture—Greece (i.e. Athens) in the ('classical') fifth century BC, after the 'Archaic' age and before the 'Hellenistic' period, *and* as that which transcended style *per se*: as a (n ahistorical) quality of 'the best' in all free artistic expression.

Despite many refinements and transformations, a not inconsiderable amount of the conceptual structure of Winckelmann's art history has remained in play through most of the two hundred years since his death. Many of the deeper (and less visible) assumptions about art and its history common to our own contemporary practices echo and refract the questions, problems, and theses that Winckelmann so eloquently articulated in the eighteenth century in his own transformation and reinvention of the Vasarian tradition. Many of these remain unresolved, and may in fact be unresolvable in the terms

habitually used to grapple with them.

Although Winckelmann's *History* provided the master blueprint for much of the stage machinery with which the discipline of art history was to operate in the nineteenth and twentieth centuries, there is an important sense in which his work differs significantly from its progeny. This has to do with the *second* of the major problems that his work sought to address: his conception of the relationship between the historian as subject and the historian's object of study. It is here that we may begin to appreciate not only what may have been at stake for him in the late eighteenth century, but also, and equally importantly, how art history may have changed, during its nineteenth-century professionalization and academic institutionalization, in articulating the relationships between viewing subjects and the objects of their attention.

As Whitney Davis demonstrates quite lucidly in the second reading in this chapter, for Winckelmann, such a relationship was not simple and straightforward, and not at all an unproblematic or directly revelatory confrontation of a viewer and an object. His particular involvement in attempting to articulate this position—or these positions, since they are multiple and shifting—brought to the surface (a surface more visible after Freud) a set of dilemmas which remains central to the problem of what it means to conceive of being a 'historian' of art, and what it means to conceive of something called art history, in the most general sense.

If Vasari saw himself as a witness who was part of an unfolding tradition that successfully reconstituted the achievements of ancient art, Winckelmann saw himself as a witness to something that had *doubly* departed—both the ancient tradition, and its Renaissance or rebirth, now itself over and gone: the latter demise being part of his own history. In what position would the art historian find him- or herself with respect to all these losses? Particularly if it were the case that the process of restoring the object of the historian's desire in the fullness of its *own* history is to result in its alienation from the historian's own place and time: its irrevocable *loss*. The art historical act of investigating the nature of the interesting or desirable object, the attempt to understand and to come ever closer to it, would inevitably result in a recognition of its real *otherness*; its being of and for another (lost) time: its speaking to others in terms they would have always already understood more fully than the contemporary historian. At the same time, this loss would seem to undercut the possibility of restoring or reviving those ideals as a model for artistic practice in the present.

In no small measure, as Davis's essay suggests, these dilemmas and contradictions underlay Winckelmann's attempt to reconcile his own homoerotic fetishization of the beauty represented doubly by the youthful Greek male nude statue, and by the (present) living objects of

his own personal desires, with his scholarly historical investigations in which the former objects were staged as the (departed) classical epitome of the totality of Greek culture. The problem of the position of the historian-observer is cast in his writings in such a way as to foreground the ambiguities and ambivalences both of gender-relations and, more generally, of distinctions between 'subjects' and 'objects' *per se*. Such ambiguities are those upon the repression of which modern society depends for its boundaries, laws, and social organisation.[5]

In the systematic project of understanding the circumstances that made Greek art possible, the *History* historicized the Greek ideal, relativizing its accomplishments, and placing it irrevocably beyond his own grasp. What is in the historian's possession are copies (even if they be 'originals') which serve as catalysts for an unquenchable desire for the elusive realities of the beauty they represent. The pursuit of such a desire is unending; the dead objects can never be brought to life; the beauty possessed (either in objects of art or in living subjects) always leaves something more to be desired.

There is another aspect of this problem which is pertinent to our understanding of the subsequent evolution of art history. It is important to appreciate that Winckelmann lived before the great nineteenth-century efflorescence of European public museums and the massive civic staging of works of art composed in museological space as continuous narrative histories or genealogies of individuals, regions, nations, and peoples. Within such new, intensely art-saturated environments, many of the complexities and ambiguities of viewing and understanding historical objects to which Winckelmann was sensitive came to be buried beneath the stage machinery of more dichotomous subject–object relations, which institutionalized art objects by the thousands as commodities to be vicariously consumed or unproblematically 'read' (in novelistic fashion) as relics not only of their makers but of national patrimony (see Chapter 9).

None the less, the underlying structure or system of many such stagings was (and still is) Winckelmannian in origin, if not in ostensible motivation. The nature of subject–object relations formatted by the nineteenth-century civic museum was integral to the larger enterprise of the modern nation-state and the fashioning of disciplined populations, an enterprise into which the nineteenth-century discipline of art history was integrated, albeit at times uneasily and ambivalently, as both handmaid and guiding light.

As many of the texts later in this book will reveal, the dilemmas and paradoxes that were central to the European project of constructing histories of art in the sixteenth or eighteenth centuries are no less powerful or poignant at the end of the twentieth century—and for reasons which, as we shall see, may be complementary to those with which Vasari and Winckelmann contended.

The readings making up this chapter include selections from Winckelmann's 1755 book *Reflections on the Imitation of Greek Works in Painting and Sculpture*,[6] and two contemporary texts: a 1994 essay on Winckelmann by Whitney Davis, and an excerpt from Michael Baxandall's 1985 book *Patterns of Intention*. The first includes sections dealing with beauty and the notion of 'noble simplicity and quiet grandeur'—for Winckelmann, the quintessential quality of Greek art. The next two readings are important elucidations of the essential problems of art historical practice. The Baxandall selection is one of the most lucid discussions in recent literature on art historical description and explanation, and in its broad implications addresses fundamental problems faced by Winckelmann himself.

The essay by Davis, a provocative discussion both of Winckelmann's position in the history of the discipline and of the problems facing art historical practice in the most general sense, is one of the most interesting analyses on both subjects to have appeared in recent years; it is also a good illustration of the ways in which contemporary research on questions of gender-construction and of subject–object relations may usefully elucidate aspects of the life and work of a historical figure. (For a penetrating view of the subject of death and 'loss' for the historian more generally, see also Michel de Certeau, *The Writing of History*.)[7]

The bibliography of work pertaining to Winckelmann is extensive, and only a few pertinent titles are given here; additional references may be found in the cited works, as well as in the notes to the Davis essay below. The most comprehensive and insightful studies of Winckelmann may be found in the writings of Alex Potts, whose volume *Flesh and the Ideal: Winckelmann and the Origins of Art History* (New Haven and London, 1994) is the most important study of Winckelmann's work to date, and an excellent source of references to the Winckelmann literature in various languages.

In addition to the primary and secondary works on Winckelmann and Vasari listed in the Notes, the following texts are recommended: Svetlana Alpers, 'Ekphrasis and Aesthetic Attitude in Vasari's *Lives*', *Journal of the Warburg and Courtauld Institutes*, 23 (1960), 190–215; Hans Belting, 'Vasari and his Legacy: The History of Art as a Process?', in Belting, *The End of the History of Art?* (Chicago, 1987), 67–94; Ernst Gombrich, 'The Renaissance Conception of Artistic Progress and its Consequences', in id., *Norm and Form: The Stylistic Categories of Art History and their Origins in the Renaissance* (London, 1978), 1–10; and Francis Haskell and Nicholas Penny, *Taste and the Antique* (New Haven and London, 1981).

Reflections on the Imitation of Greek Works in Painting and Sculpture

I. Natural Beauty

Good taste, which is becoming more prevalent throughout the world, had its origins under the skies of Greece. Every invention of foreign nations which was brought to Greece was, as it were, only a first seed that assumed new form and character here. We are told[1] that Minerva chose this land, with its mild seasons, above all others for the Greeks in the knowledge that it would be productive of genius.

The taste which the Greeks exhibited in their works of art was unique and has seldom been taken far from its source without loss. Under more distant skies it found tardy recognition and without a doubt was completely unknown in the northern zones during a time when painting and sculpture, of which the Greeks are the greatest teachers, found few admirers. This was a time when the most valuable works of Correggio were used to cover the windows of the royal stables in Stockholm.[2]

One has to admit that the reign of the great August[3] was the happy period during which the arts were introduced into Saxony as a foreign element. Under his successor, the German Titus, they became firmly established in this country, and with their help good taste is now becoming common.

An eternal monument to the greatness of this monarch is that he furthered good taste by collecting and publicly displaying the greatest treasures from Italy and the very best paintings that other countries have produced. His eagerness to perpetuate the arts did not diminish until authentic works of Greek masters and indeed those of the highest quality were available for artists to imitate. The purest sources of art have been opened, and fortunate is the person who discovers and partakes of them. This search means going to Athens; and Dresden will from now on be an Athens for artists.

The only way for us to become great or, if this be possible, inimitable, is to imitate the ancients. What someone once said of Homer— that to understand him well means to admire him—is also true for the art works of the ancients, especially the Greeks. One must become as familiar with them as with a friend in order to find their statue of Laocoon[4] just as inimitable as Homer. In such close acquaintance one

learns to judge as Nicomachus judged Zeuxis' Helena: 'Behold her with my eyes', he said to an ignorant person who found fault with this work of art, 'and she will appear a goddess to you.'

With such eyes did Michelangelo, Raphael, and Poussin see the works of the ancients. They partook of good taste at its source, and Raphael did this in the very land where it had begun. We know that he sent young artists to Greece in order to sketch for him the relics of antiquity.

The relationship between an ancient Roman statue and a Greek original will generally be similar to that seen in Virgil's imitation of Homer's Nausicaa, in which he compares Dido and her followers to Diana in the midst of her Oreads.[5]

Laocoon was for the artist of old Rome just what he is for us—the demonstration of Polyclitus' rules, the perfect rules of art.[6]

I need not remind the reader that certain negligences can be discovered in even the most famous works of Greek artists. Examples are the dolphin which was added to the Medicean Venus[7] together with the playing children; and the work of Dioscorides, except the main figure, in his cameo of Diomedes[8] with the Palladium. It is well known that the workmanship on the reverse of the finest coins of the kings of Syria and Egypt rarely equals that of the heads of these kings portrayed on the obverse. But great artists are wise even in their faults. They cannot err without teaching. One should observe their works as Lucian would have us observe the Jupiter of Phidias: as Jupiter himself, not his footstool.

In the masterpieces of Greek art, connoisseurs and imitators find not only nature at its most beautiful but also something beyond nature, namely certain ideal forms of its beauty, which, as an ancient interpreter of Plato[9] teaches us, come from images created by the mind alone.

The most beautiful body of one of us would probably no more resemble the most beautiful Greek body than Iphicles resembled his brother, Hercules.[10] The first development of the Greeks was influenced by a mild and clear sky; but the practice of physical exercises from an early age gave this development its noble forms. Consider, for example, a young Spartan conceived by a hero and heroine and never confined in swaddling clothes, sleeping on the ground from the seventh year on and trained from infancy in wrestling and swimming. Compare this Spartan with a young Sybarite[11] of our time and then decide which of the two would be chosen by the artist as a model for young Theseus, Achilles, or even Bacchus. Modelled from the latter it would be a Theseus fed on roses, while from the former would come a Theseus fed on flesh, to borrow the terms used by a Greek painter to characterize two different conceptions of this hero[2].

The grand games gave every Greek youth a strong incentive for

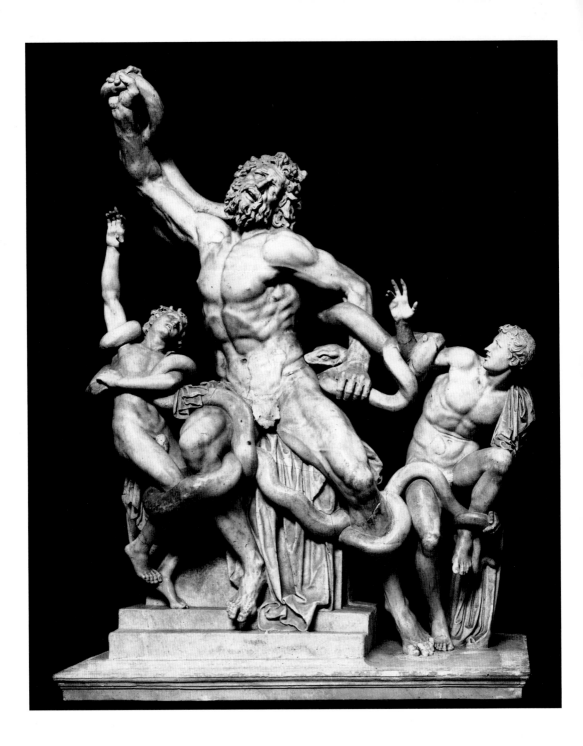

physical exercise, and the laws demanded a ten month preparation period for the Olympic Games, in Elis,[12] at the very place where they were held. The highest prizes were not always won by adults but often by youths, as told in Pindar's odes. To resemble the god-like Diagoras was the fondest wish of every young man.[13]

Behold the swift Indian who pursues a deer on foot—how briskly his juices must flow, how flexible and quick his nerves and muscles must be, how light the whole structure of his body! Thus did Homer portray his heroes, and his Achilles he chiefly noted as being 'swift of foot'.

These exercises gave the bodies of the Greeks the strong and manly contours which the masters then imparted to their statues without any exaggeration or excess. [...]

IV. Noble Simplicity and Quiet Grandeur

The general and most distinctive characteristics of the Greek master-pieces are, finally, a noble simplicity and quiet grandeur, both in posture and expression. Just as the depths of the sea always remain calm how-ever much the surface may rage, so does the expression of the figures of the Greeks reveal a great and composed soul even in the midst of pas-sion.

Such a soul is reflected in the face of Laocoon[14]—and not in the face alone—despite his violent suffering [3]. The pain is revealed in all the muscles and sinews of his body, and we ourselves can almost feel it as we observe the painful contraction of the abdomen alone without regarding the face and other parts of the body. This pain, however, ex-presses itself with no sign of rage in his face or in his entire bearing. He emits no terrible screams such as Virgil's Laocoon, for the opening of his mouth does not permit it; it is rather an anxious and troubled sigh-ing as described by Sadoleto.[15] The physical pain and the nobility of soul are distributed with equal strength over the entire body and are, as it were, held in balance with one another. Laocoon suffers, but he suffers like Sophocles' Philoctetes;[16] his pain touches our very souls, but we wish that we could bear misery like this great man.

The expression of such nobility of soul goes far beyond the depiction of beautiful nature. The artist had to feel the strength of this spirit in himself and then impart it to his marble. Greece had artists who were at once philosophers, and there was more than one Metrodorus.[17] Wisdom extended its hand to art and imbued its figures with more than common souls.

If the artist had clothed him, as would indeed befit his station as a priest, Laocoon's pain would have lost half its expression. Bernini even claimed to detect in the rigidity of one of Laocoon's thighs the first effects of the snake's venom.

All movements and poses of Greek figures not marked by such traits of wisdom, but instead by passion and violence, were the result of an

error of conception which the ancient artists called *parenthyrsos*.[18]

The more tranquil the state of the body the more capable it is of portraying the true character of the soul. In all positions too removed from this tranquillity, the soul is not in its most essential condition, but in one that is agitated and forced. A soul is more apparent and distinctive when seen in violent passion, but it is great and noble when seen in a state of unity and calm. The portrayal of suffering alone in Laocoon would have been *parenthyrsos*; therefore the artist, in order to unite the distinctive and the noble qualities of soul, showed him in an action that was closest to a state of tranquillity for one in such pain. But in this tranquillity the soul must be distinguished by traits that are uniquely its own and give it a form that is calm and active at the same time, quiet but not indifferent or sluggish.

The common taste of artists of today, especially the younger ones, is in complete opposition to this. Nothing gains their approbation but contorted postures and actions in which bold passion prevails. This they call art executed with spirit, or *franchezza*.[19] Their favorite term is *contrapposto*,[20] which represents for them the essence of a perfect work of art. In their figures they demand a soul which shoots like a comet out of their midst; they would like every figure to be an Ajax or a Capaneus.[21]

The arts themselves have their infancy as do human beings, and they begin as do youthful artists with a preference for amazement and bombast. Such was the tragic muse of Aeschylus; his hyperbole[22] makes his Agamemnon in part far more obscure than anything that Heraclitus wrote. Perhaps the first Greek painters painted in the same manner that their first good tragedian wrote.

Rashness and volatility lead the way in all human actions; steadiness and composure follow last. The latter, however, take time to be discovered and are found only in great matters; strong passions can be of advantage to their students. The wise artist knows how difficult these qualities are to imitate.

> ut sibi quivis
> Speret idem, sudet multum frustraque laboret
> Ausus idem.
>
> (Horace)[23]

La Fage, the great draughtsman, was unable to match the taste of the ancients. His works are so full of movement that the observer's attention is at the same time attracted and distracted, as at a social gathering where everyone tries to talk at once.

The noble simplicity and quiet grandeur of the Greek statues is also the true hallmark of Greek writings from their best period, the writings of the Socratian school. And these are the best characteristics of Raphael's greatness, which he attained through imitation of the Greeks.

So great a soul in so handsome a body as Raphael's was needed to first feel and to discover in modern times the true character of the ancients. He had, furthermore, the great good fortune to achieve this at an age when ordinary and undeveloped souls are still insensitive to true greatness.

We must approach his works with the true taste of antiquity and with eyes that have learned to sense these beauties. Then the calm serenity of the main figures in Raphael's 'Attila', which seem lifeless to many, will be for us most significant and noble. The Roman bishop here,[24] who dissuaded the king of the Huns from attacking Rome, does not make the gestures and movements of an orator but is shown rather as a man of dignity whose mere presence calms a violent spirit, as in Virgil's description:

> Tum pietate gravem ac meritis si forte virum quem
> Conspexere, silent arrectisque auribus adstant.
>
> (Aen. I)[25]

Full of confidence he faces the raging tyrant, while the two apostles hovering in the clouds are not like avenging angels but, if I may compare the sacred with the profane, like Homer's Jupiter, who makes Mount Olympus quiver with a blink of his eyes.

Algardi, in his famous representation of this same story in bas-relief on an altar of St Peter's in Rome, did not give or know how to give the figures of his two apostles the active tranquillity of his great predecessor. There they appeared like messengers of the lord of hosts, but here they are like mortal warriors with human weapons.

How few experts have been able to understand the grandeur of expression which Guido Reni gave his beautiful painting of Archangel Michael in the Church of the Capuchins in Rome. Concha's St Michael[26] is preferred because his face shows anger and revenge, whereas Guido's archangel, after casting down the enemy of God and man, hovers over him without bitterness, his expression calm and serene.

Just as calm and serene is the avenging hovering angel with whom the English poet compares the victorious commander at Blenheim as protector of Britannia.[27]

The Royal Gallery of Paintings in Dresden now contains among its treasurers one of Raphael's best works, as Vasari and others have noted. It is a Madonna and Child with St Sixtus and St Barbara kneeling on each side, and two angels in the foreground.[28] This picture was the central altar-piece at the monastery of St Sixtus in Piacenza. Art lovers and connoisseurs went to see this Raphael just as people traveled to Thespiae[29] solely to see Praxiteles' beautiful statue of Cupid.

Behold this Madonna, her face filled with innocence and extraordinary greatness, in a posture of blissful serenity! It is the same

serenity with which the ancients imbued the depictions of their deities. How awesome and noble is her entire contour! The child in her arms is a child elevated above ordinary children; in its face a divine radiance illuminates the innocence of childhood. St Barbara kneels in worshipful stillness at her side, but far beneath the majesty of the main figure—in a humility for which the great master found compensation in the gentle charm of her expression. St Sixtus, kneeling opposite her, is a venerable old man whose features bear witness to his youth devoted to God.

St Barbara's reverence for the Madonna, which is made more vivid and moving by the manner in which she presses her beautiful hands to her breast, helps to support the gesture which St Sixtus makes with his hand. This gesture of ecstasy was chosen by the artist to add variety to his composition and is more appropriate to masculine strength than to feminine modesty.

Time has, to be sure, robbed this painting of much of its glory, and its color has partially faded, but the soul which the artist breathed into the work of his hands still makes it live.

All those who approach this and other works of Raphael in the hope of finding there the trifling beauties that make the works of Dutch painters so popular: the painstaking diligence of a Netscher or a Dou, the ivory flesh tones of a van der Werff, or the tidy manner of some of Raphael's countrymen in our times—those, I say, will never find in Raphael the great Raphael. [...]

VI. Painting

Everything that can be said in praise of Greek sculpture should in all likelihood also hold true for Greek painting. But time and human barbarity have robbed us of the means to make sure judgments.

It is conceded only that Greek painters had knowledge of contour and expression; they are given no credit for perspective, composition, or coloring. This judgment is based partly on bas-reliefs, partly on the paintings of antiquity (one cannot say that they are Greek) discovered in and near Rome, in subterranean vaults of the palaces of Maecenas, of Titus, Trajan, and the Antonini. Of these, barely thirty have been preserved intact, and some only in the form of mosaics.

Turnbull included in his work on ancient paintings[30] a collection of the best-known items, drawn by Camillo Paderni and engraved by Mynde, which give the magnificent but misused paper of his book its only value. Among them are two copies from originals in the collection of the famous physician Richard Mead of London.

Others have already noted that Poussin made studies of the so-called 'Aldobrandini Marriage',[31] that there are drawings by Annibale Carracci of a presumed 'Marcius Coriolanus', and that there is a great similarity between the heads of Guido Reni's figures and those of the

well-known mosaic 'The Abduction of Europa'.

If such remnants of frescos provided the only basis for judging the ancient paintings, one might be inclined even to deny that their artists knew contour and expression. We are informed that the paintings with life-sized figures taken, together with the walls, from the theater in Herculaneum give a poor impression of their skills: Theseus as the conqueror of the Minotaur,[32] with the young Athenians embracing his knees and kissing his hands; Flora with Hercules and a faun; an alleged 'Judgment of the Decemvir Appius Claudius'—all are, according to the testimony of an artist, either mediocre or poor. Not only do most of the faces lack expression but those in the 'Appius Claudius' lack even character. But this very fact proves that they are paintings by very mediocre artists; for the knowledge of beautiful proportion, of bodily contour, and expression found in Greek sculptors must also have been possessed by their good painters.

Although the ancient painters deserve recognition of their accomplishments, much credit is also due the moderns. In the science of perspective modern painters are clearly superior despite all learned defense of the ancients. The laws of composition and arrangement were imperfectly known to antiquity as evidenced by bas-reliefs dating from the times when Greek art flourished in Rome. As for the use of color, both the accounts of ancient writers and the remains of ancient paintings testify in favor of the moderns.

Various other objects of painting have likewise been raised to a higher degree of perfection in more modern times, for example, landscapes and animal species. The ancient painters seem not to have been acquainted with more handsome species of animals in other regions, if one may judge from individual cases such as the horse of Marcus Aurelius, the two horses in Monte Cavallo, the horses above the portal of San Marco's Church in Venice, presumably by Lysippus, or the Farnesian Bull and the other animals of this group.

It should be mentioned in passing that in the portrayal of horses the ancients did not observe the diametrical movements of the legs as seen in the Venetian horses and those depicted on old coins. Some modern artists have, in their ignorance, followed their example and have even been defended for doing so.

Our landscapes, especially those of the Dutch, owe their beauty mainly to the fact that they are painted in oil; their colors are stronger, more lively and vivid. Nature itself, under a thicker and moister atmosphere, has contributed not a little to the growth of this type of art. These and other advantages of modern painters over the ancients deserve to be better demonstrated, with more thorough proof than heretofore. [...]

Winckelmann Divided: Mourning the Death of Art History

J. J. Winckelmann's *History of Ancient Art*, first published in Dresden in 1764, is often taken to be the first true 'history of art.'[1] Winckelmann raised art history from the chronicle of artists' lives and commissions to a higher level: he attempted systematic stylistic analysis, historical contextualization, and even iconographical analysis, especially if we include his publications of gems and other antiquities and his treatise on visual allegory.[2] Of course, Winckelmann also helped to forge one of the essential tools of general criticism: in his 1759 essays on the Belvedere *Torso* and *Apollo* and on the *Laocoon* [see **2, 3**], included in the *History*, he produced what were for his time lengthy focused de-scriptions of the individual artwork as it appears to us, an apparition that can be turned either to aesthetic-ethical-evaluation or to historical-critical analysis. Winckelmann's enormous—undeniably formative—contribution to the establishment of art history as an intellectual enterprise and a scholarly discipline has been considered at length from a number of points of view.[3] Put most succinctly, Winckelmann's *History* inaugurally integrated the twin methods of what later became the professional discipline of art history—namely, 'formalism' and 'historicism'. Winckelmann explored the forms of Greco-Roman art and all the facts, going back to the role of climate, that he took to be relevant to explaining form historically.

It is well known, however, that major aspects of the content of Classical art—its inherence in the social practices of ancient Greek homoeroticism—were not usually acknowledged by Winckelmann. He employed an elaborate euphemism: for him, Greek art is formally about and historically depends on 'freedom'—although the 'freedom' to be or to do exactly what is left vague. It would be a misreading of German Enlightenment discourse to suppose that Winckelmann's *Freiheit* means political freedom alone; freedom is a cognitive condi-tion.[4] Some recent commentators, chiefly Alex Potts, have explored Winckelmann's own republicanism and anticlericalism and the later critical and political reception of his 'historicist' determination of the form of Greek art in the civic freedom of the Greek *polis*.[5] But this aspect of Winckelmann's account hardly exhausts the matter. It is precisely the manifest formal-historical analysis Winckelmann

offers—determining artistic production, somewhat uneasily, in the political structures of civil society—that we should now attempt to go beyond.

The history of art history, from the 1760s to the 1990s, has produced an approach in which art history is often reductively equated with the objective historicist explanation of artistic form. As is often said, this paradigm constitutes a discipline. But what it disciplines are not the 'facts' of the history of art, or only secondarily the facts of the history of art. What it primarily and inaugurally disciplines is itself—by means of its supposed 'realism,' a standard cultural determinism with an underlying appeal to supposed universals of social process, grasped 'scientifically'; its cleaving of 'aesthetics' or 'criticism' from 'history' itself; its suppression of the subjective reality of the historian's own place and taste; and its claim to comprehend history through chronological and causal analysis without simultaneously and by the same terms acknowledging its own status as narrative. I want, here, to look at this defensive splitting—this *Ichspaltung im Abwehrvorgang*—in Winckelmann's *History*.[6]

At points in the text of the *History* and other writings, Winckelmann's understanding of the 'freedom' of Greek art does shine forth—but always in code. For example, the naturalistic beauty of Greek statues derived, he says, from the Greek sculptors' close observation of inherently beautiful boys naked in the gymnasium. But why the boys are beautiful is not represented as an hallucination of the historian-observer himself, who cannot actually see them. Instead it is said to result from the 'favorable' Greek climate (another hallucination) and practice of training men for war—facts which must somehow determine particular forms of natural beauty and of art. In general, throughout Winckelmann's account of ancient art such objective 'historicist' explanation overrides the 'subjective' aesthetic, political-sexual response that motivated it in the first place.

Many contradictions derive from this systematic transposition of subjective erotics—the idea or memory of what is subjectively beautiful and desirable in sexual, ethical, and political terms—into objectivizing formalist and historicist analysis. For example, according to the explicit standards of Winckelmann's analysis, the Hellenistic hermaphrodites, let alone works like the portraits of Hadrian's young lover Antinous, were contemporary with the total decline of political 'freedom' in Greece (that is, with the Roman conquest)—and thus could not embody the essence of Greek art. But none the less they are cited as great Classical works—indicating that the real denotation of 'freedom,' for Winckelmann, is not (or not only) in civic politics at all but rather in species of social-sexual organization possible in both democratic and authoritarian society.

Indeed, the *History* exhibits a general disjunction, as Potts has

acutely observed, between the eras of specifically political freedom in the Greco-Roman world and the period of its great or Classical art.[7] We should add that Winckelmann defines classicism itself in relation to formal and historical precursors—Egyptian, archaic Greek, Etruscan, and late Roman (Byzantine) arts—which he cannot quite disentangle from classicism itself, supposedly the autonomous formal expression of historical factors peculiar to the fifth- and late fourth-century Greek city-states. For example, because Greece in the sixth century possessed the same climate and roughly the same militarized competitiveness of Greece in the fifth century, according to Winckelmann's historicism its art should be classically beautiful. What archaic Greece supposedly lacked, of course, was political freedom. But if Winckelmann is willing to admit the unfree, if Hellenized, art of Hadrianic Rome or Justinian's Ravenna as producing great classicism, on what grounds can he exclude the sixth- and late fifth-century archaic or severe phases of Greek classicism?[8] Obviously the real point of distinction must lie in other aesthetic or ethical responses to the non- or prenaturalistic and the naturalistic works respectively, but Winckelmann does not directly produce his criteria. Instead the objective formal-historical chronology—with its statement of causes and sequences—is supposed in itself to render the distinction intelligible to us *ex post facto*. Despite their unfreedom, Rome or Ravenna preserve enough of a memory of Greek classicism to engender a Classical art, while preclassical Greece, although causally and chronologically closer to the zenith, did not. As Winckelmann's reasoning implies, identifying the Classical evidently turns on the play of memory and retrospective allusion—a condition foreclosed for all forerunners of the classical Greeks, who cannot remember and allude to what has not yet happened. Thus Egyptian art remains aesthetically inert. Significantly, however, Etruscan art gives Winckelmann trouble: it is neither really a forerunner nor quite an inheritor of fifth-century Greek art but rather a parallel cultural development. A reader of Winckelmann's book can be forgiven for not being able completely to work out these tangles, even though they might interest historians today: the general point is that the *History of Ancient Art* manages the erotic almost entirely off stage, a transference (*Übertragung*) or 'carrying over' in the strict sense.[9]

'Off stage,' that is, from the point of view of the reader. From the point of view of Winckelmann himself, however, it is possible that he was having things both ways. Exploring his sexual and ethical attractions—actively filling them out with images, information, and a social and historical reality, both through and in the very doing of his research—he finally transposes them all into another narrative for others.

Winckelmann is an enigmatic figure; and here I am not claiming

fully to link my reading of his writings with historical analysis of his own life and work in their social-sexual and social-political context, although such a link could ultimately be made.[10] I will presume, however, that Winckelmann, both socially and personally defined as a sodomite (a role that he took little pains to disguise), participated in the male-male sodomitical subculture of his day—a subculture that revolved, like some modern urban homosexual subcultures, around certain cafes, theaters, and drinking establishments as well as open-air strolling in various quarters of the city and suburbs.[11] Thus it is entirely relevant to remember that one of Winckelmann's chief employments as papal antiquarian was to guide British, German, and other northern gentlemen on their tour through the ruins of Rome—an activity that by the late eighteenth century already clearly signified, at least for many participants, the availability of sex with local working boys, liaisons that tended to be frustrated or proscribed in the northern nations. That Winckelmann's apartment in Rome was graced with a bust of a beautiful young faun, which he published and described in the *History* and elsewhere, was not, then, merely a manifestation of his antiquarian scholarship in the questions of Greco-Roman art history.[12] It also was fully consistent with, and probably functioned partly as, his self-definition and representation in the contemporary culture to which he belonged.

Winckelmann's active same-sex erotics were recognized by Goethe, his acutest commentator, to motivate much of his conceptual labor.[13] But what those erotics actually involved still remains uncertain. Because of the *History*'s emphasis on androgyny and hermaphroditism, it is useful to have Casanova's report of surprising Winckelmann relaxing with one of the young Roman castrati he favored,[14] as well as Winckelmann's own testimonies to his infatuations with noble German boys, especially a young nobleman, Friedrich von Berg, to whom he dedicated his 1763 essay 'On the Ability to Perceive the Beautiful in Art.' Before his murder in 1768, Winckelmann was a valued member of the Papal Court, the personal librarian to the great collector Cardinal Alessandro Albani. But he had been born to a poor family in Prussia, studying and finding his first secretarial jobs in a state with some of the most repressive laws against sodomy, harshly and somewhat hypocritically enforced for the lower classes by Frederick the Great.[15] Although he seems to have had a long affair in the 1740s with his first private student, a modern psychologist might say that through early middle age he ferociously sublimated both his sexual appetite and his political views. But his self-censorship was not only in the interest of personal security. As he moved up in the world, and especially after he moved to Italy in 1755, he was freer to move in the sexually permissive world of the upper classes. He also behaved opportunistically: recognizing that nominal Catholicism was a paper creden-

tial for employment in Rome, he converted. Again, the threads are tangled: he converted in order to get to Rome, for Rome was where he could best pursue classical studies—but for many worldly Europeans 'Rome,' as well as 'Greek art,' already signified sexual freedom and available boys.[16]

Without attempting to realize—some would say to literalize or reduce—a textual reading in terms of Winckelmann's own personal and professional history, it is striking to see how division between subject and object, and between subjective and objective, figures in Winckelmann's writing about the art-historical endeavor he himself invents. This division is not just a transposition of the subjective into the objective, or of the erotic-ethical into the formal-historical, as I have so far described it, for this might imply that the one can be replaced by the other without any loss—the treatise on beautiful Greek statues perfectly translating its author's desiring of naked Italian boys. Because Winckelmann imagines an interminable oscillation between the two positions, art history is not invented *through* division; it is invented *as* division and what we might call an endless acknowledgement of loss, an interminable mourning.

In a famous passage at the very end of the *History*, Winckelmann meditates on what he calls the 'downfall' of Greek art in the late Roman empire. In the final paragraph but one, he briefly describes the last work of art to be cited in his enormous work—an illuminated manuscript page thought to date from the reign of Justinian depicting 'in front of the throne of King David two female dancers with tucked-up dresses, who hold over their heads with both hands a floating drapery.' The two dancers are 'so beautiful,' Winckelmann writes, 'that we are compelled to believe that they have been copied from an ancient picture'—that is, from a lost Classical Greek painting. Thus, he says, to the end of art history—that is, to the end of Greek art—'may be applied the remark made by Longinus of the *Odyssey*, that in it we see Homer as the setting sun; its greatness is there, but not its force.' Examining these beautiful figures—the copy of a more 'forceful' original, they are the trace of its loss—Winckelmann says, in the last paragraph of his history, that he feels 'almost like the historian who, in narrating the history of his native land, is compelled to allude to its destruction, of which he was a witness.'

But Winckelmann does not actually indicate any specific work that the manuscript has 'copied,' although he has earlier given many examples of the relation between prototype and copy. We are, he says, just 'compelled to believe' that the page is a 'copy', and thus the trace of a loss, only because it is itself so 'beautiful'. Its 'beauty', for us, is what compels us to see a loss in it. But why should the beautiful dancers' being a 'copy' imply that something has been lost or destroyed, when Winckelmann recommends the imitation of Classical art precisely as a

finding or *restoration* of the beautiful? Of course, the late Roman copy may lose something because it merely copies rather than 'imitates' in more synthetic fashion. Although Winckelmann does not directly say so, perhaps he thinks the dancers do not attain the *Nachahmung* recommended in 'Reflections on the Imitation of Greek Works of Art in Painting and Sculpture' (1755).[17] But then how could they be 'beautiful', and how could he see them as the trace of a loss, when beauty is precisely the 'imitation' and thus the finding, not the 'copying' and thus the losing, of Classical art?

Furthermore, in meditating upon the loss that explains the beauty before him, in what sense can Winckelmann be a 'witness' to the destruction of Greek art? Its 'downfall' occurred between the age of Pericles and the age of Justinian—that is, between the time of the unspecified lost prototype and the manuscript. It did not actually occur in his own time. By the same token, in what sense could Greek art—from the age of Pericles to the age of Justinian—be Winckelmann's 'native land', the 'destruction' of which he witnesses? He was born in Prussia and came no closer to Greece than the collection of antiquities in Dresden—which were badly housed in a shed constructed for the king, who had purchased many of them from Italy in the first half of the century—or the Villa Albani, with its large but eclectic assemblage of ancient sculptures of varying quality, and the temple sites of southern Italy, which he described in an essay of 1759.

Indeed, in the terms of his own metaphor what Winckelmann witnesses does not obviously amount to a loss, a 'downfall', at all. Although the sun may set, it always rises again. And although 'Odysseus'—Greek art in the age of Justinian—may have wandered far from his native land, he *does* return home: it was other heroes of the *Iliad*, in all their 'force', who left their native land of Greece to perish at Troy. It must be, then, that the late Roman manuscript is like a sun endlessly setting, without going down and without rising, or like Odysseus endlessly returning home without getting there. But what kind of a 'downfall' is it that is always such a down-falling without full presence or complete absence—as Longinus says, a 'greatness' without 'force'?

Now it would be easy to say that Winckelmann witnesses the 'downfall' of Greek art in writing his *History of Ancient Art*. As an historian, we could say, he witnesses the historical loss of the 'force' of Greek art in the stylistic transformations that he chronicles—the setting of its sun from Pericles to Justinian. And it would be easy to conclude, in parallel, that it must be in his aesthetic imagination and especially in his personal (homo)erotics that Winckelmann takes Classical Greece as his 'native land'. Thus we could say that Winckelmann, as historian, witnesses the 'downfall' of the object with which he imaginatively identifies—'my native land'—by chronicling

it, by producing an historical narrative of its transformation from Pericles to Justinian. If he were not the *historian* of Greek art, then he could not witness its destruction—seeing Classical Greek art as something that art has historically lost.

But the matter is not so simple. In his self-conscious, supremely nuanced German, Winckelmann carefully says that as an historian he is 'compelled to allude' to a destruction he has *already* witnessed—just as he has been 'compelled to believe' that the beauty before his eyes is a copy of something that has already been lost. Therefore it is not as an historian of art that he witnesses the destruction of Greek art: rather, it is as an historian that he writes about a loss he has already witnessed. Thus it may be his witnessing of the downfall of Greek art that constitutes him as its historian, rather than the other way around. The difference is between living through the loss to become its historian, and becoming the historian of the loss to live through it. In the former case, the loss is already part of one's own history, a loss for oneself— although as an historian one writes about the loss as having taken place in history outside and before oneself, a loss for art; the subjective loss of the object becomes the objective loss of the object. In the latter case, however, the loss is *not* part of one's own history, for it is only a loss for art, although as an historian one makes it so, a loss for oneself: objective loss becomes subjective. If Winckelmann acknowledges two losses— a loss within art history and a loss for oneself—as well as their complementary histories, the history one witnesses and the history within which one is witnessing history, the task is to relate the two—to separate, conjoin, reduce, or transcend them.

Most modern art history can be seen as an 'objective' account of the history of art using Winckelmann's instruments of periodization, stylistic criticism, iconography, historicism, and ethical valuation. This practice is founded on radically distinguishing the two fields I have identified. Within the discipline, or, more accurately, with discipline, the loss—of the sexually, ethically, and politically beautiful or desirable—is always *outside* the art historian in the history of art as such; the art historian only 'alludes' to what takes place in a 'native land' in which he does not now and probably never did reside. None the less, as Winckelmann's nuance implies, we must identify a necessary reflexive moment in which the loss must be *within* the art historian and his history in order for him to witness the history of art as any kind of loss—for if the loss were absolute, utterly unwitnessed by the art historian in his own history, then there would be nothing of the history of art to which he could possibly 'allude' in the first place.

Again Winckelmann puts it carefully. In concluding his own *History* with an example of the 'downfall' of Greek art, he is, he says, 'almost like' an historian writing about a destruction he has also witnessed. Yet in assuming this position, he has, as he notes, 'already over-

stepped the boundaries of the history of art'. Strictly speaking, the history of art is the history of what has been lost in, and to, history. But one does not begin an art history unless what has been lost was once not unredeemably lost in an irreducibly past history one precisely did not witness. Rather, to begin an art history the loss must be in one's own history to be 'witnessed' there. It is only there that it is *being seen to be being lost*. Something happens just outside the boundary of art history, at a horizon or place of sunsetting, where the object, the history of art, is witnessed as being lost—as being evacuated of its force despite its greatness, as departing or being destroyed; and the historian, writing his art history, alludes to his witnessing of this departing of the history of art.

Winckelmann depicts this condition in the final lines of the *History* in what I take to be the founding image of the discipline—or, more precisely, what founds the 'objective' need for (a) discipline. 'Compelled to believe' that what is before him, however beautiful, is just a 'copy' of what has been lost, precisely because he takes it as beautiful, and 'compelled to allude' to his 'native land' being destroyed, finally he 'cannot refrain from searching into the fate of works of art as far as my eye could reach'—and he adds, 'just as a maiden, standing on the shore of the ocean, follows with tearful eyes her departing lover with no hope of ever seeing him again, and fancies that in the distant sail she sees the image of her beloved'. The metaphor is intricate, but Winckelmann glosses himself: 'Like that loving maiden we too have, as it were, nothing but a shadowy outline left of the object of our wishes, but that very indistinctness awakens only a more earnest longing for what we have lost, and we study the copies of the originals more attentively than we should have done the originals themselves if we had been in full possession of them.'

According to the logic I examined a moment ago, the 'maiden' is not the art historian *as* art historian, the one who has just presented a history of the development of Greek art and just ended it with this metaphor about the loss he has chronicled. Rather, she is that art historian *before* beginning an art history—witnessing the loss the history of which he will then chronicle. We should notice the shift here: before beginning the art history, witnessing the loss 'she' is female; after writing the art history, 'he' is a male 'alluding' to the loss 'she' witnessed. Although it is not my main topic here, one begins to see why androgyny, hermaphroditism, and the amalgamation of gender might play an absolutely central role in Winckelmann's objective chronicle of the history of art:[18] they animate Winckelmann's own history—as a 'she' witnessing the downfall and loss of Classical Greek art, the sailing of 'her' lover, the departing to which 'he' will allude—in the very suspension of decision between them. Indeed, the dynamic of subjective, feminized 'witness' and objective, masculinized 'allusion' is

the very mode of Winckelmann's homosexuality (or homotextuality)—to be specific, a delayed activation and partial transposition of loss from one register to the other, a fault-line across which the observing, objective subject, male for the moment, never quite refinds the object that subjectively she never wholly lost.

If 'she' is Penelope, then her 'native land' will be destroyed because Odysseus has left it. She will be beset with false suitors like the modern arts Winckelmann deplored. But in weeping at the shore she cannot know this yet. She mourns not the destruction of her native land, which she will only be able to see as the *historian* of the loss she also witnesses, but rather the departure of her lover, whom she has 'no hope of ever seeing again.' The art historian—and what she desires, of course, is a man—weeps not because he is an historian but because she is a lover; indeed, he becomes an historian because she was such a lover.

As a lover, she has lost the 'object of desire.' The loss occurred, however, not without having seen the beloved depart and not without him seeming to appear to her, if only as an 'image' in the 'distant sail.' That is to say, the loss preserves the possibility of writing its history as he 'searches … as far as my eye could reach,' looking out to rediscover what she saw departing. But once become an historian, the maiden finds that the beloved has been destroyed. The image of the departing beloved—returned by the 'distant sail' to the lover-historian standing on the shore of his native land—must be the image of the death of the beautiful beloved, the black sail of the ships announcing the deaths of the Athenian boys and girls. Thus the 'maiden' on the shore is not only a Penelope mourning her loss, being constituted as the one who will write the history of her native land as it is destroyed. He is *also* the lover Theseus, who cannot accept the loss and sails off into history itself to save his native land from being destroyed. The historian begins his history in order to *prevent* the loss she has already witnessed: 'he' is Theseus, sailing off from his native land in heroic rescue, because 'she' is already Penelope, expecting never again to see Odysseus, who kept her native land alive. But if he sails off, Theseus must become just like the Odysseus mourned by Penelope—one who leaves his native land and who is only endlessly returning to it without getting there. Another maiden, of course, will guide Theseus out of his labyrinth and back to love: there is the barest hint that the widening circle of division might close, although even Ariadne must finally watch her Theseus depart.

In sum, the historian, to become a historian, remains partly behind himself, standing on the shore in his 'native land,' precisely in order to witness the departing that sets him off in the first place—at the same time as he goes partly ahead of himself, sailing away to his 'native land' from destruction, the loss she himself (if I can put it this way) will witness. What is the loss, then, but a loss of part of the self, a part that

once was (and still might be) real? She witnesses his departing and thus experiences the destruction of her native land; he alludes to her witnessing, and by chronicling the destruction thus partly prevents it. But although he sails off into the chronicle to prevent the destruction, he never actually returns to her except as an image or copy, and the loss is never fully made up: her subjective 'witness' always exceeds his objective 'allusion' coming behind, too late and merely as allusion.

This might be the place to identify the 'object of desire,' as such, that Winckelmann loses. Here we would need to situate Winckelmann's 'beautiful young men'—the Classical Greek athletes naked in the Gymnasium whose loss 'she' witnesses while relaxing with Italian boys but to whom 'he' can allude in the *History* of Classical art chronicling what she has lost. The resulting divisions would require us to trace Winckelmann's inability to reconcile the time of the 'beautiful' with the time of 'freedom'; or to admit the place of 'imitation' within the unfolding of Classical art itself; or to conceive a Greece outside its afterimaging Rome, or its forerunning Egypt and sidetracking Etruria; or to conceive Classical art outside an imprint, copy, or fragment in the first place. In each context, the object of desire is the lost historical object toward which the historian moves in his allusions and the subjective object from which his very witness of loss proceeds—in this case, neither Classical Greek art as such, merely a cold and lifeless fossil, nor beautiful Italian boys as such, merely available embraces, but the image of their identity, an object in consciousness which neither real sculpture nor real boy can do anything but copy because they are always found only in the move away from or back to it.[19] (Of course, this object-in-consciousness or subjective object is, itself, a repetition. But I will not pursue any particular model for this relation; it is sufficient to remind ourselves that the constitution of the object is defensive and occurs in 'defensive process' [*Abwehrvorgang*].) To excavate Winckelmann's object of desire, whatever it might be, would also be to recognize his *History* as a great and exemplary work, for it comes close, I think, to finding an objective subject that almost satisfies its subjective object—the bust of a faun gracing his apartment in the Villa Albani, an object which, I believe, integrates his subjective erotic and objective scholarly inquiries. But this identification, although it deserves further exploration, takes me in directions too particular, and perhaps too literal, for the final observations I want to make.

Instead I want to generalize beyond the identification of any particular historian's particular loss. Such losses constitute the discipline of art history just because they are the objects for its subjectivity—not the artefacts in themselves, fossils with no intrinsic status, but rather the ways of their departings from art historians. Thus T. J. Clark, for example, mourns his loss—the 'rendezvous between artistic practice and ... alternative meanings to those of capital,'[20] here and

there or once upon a time, he imagines, actually realized—like the tradition, community, democratic society, undiluted *jouissance*, truth, or gender equality: in any case, a particular subjective loss made out to be the objective reality of history. It is not the substance of such lost objects I want to discover; they are plainly the result, as Winckelmann engagingly put it, of an 'interview with spirits.' But they all share a status as the motivating objects of any art history which is, itself, interesting or *interested*, in the strict sense: troubled, 'searching ... as far as the eyes can reach,' the 'tearful' witnessing of loss, that which 'compels' the historian's 'allusion'—or, as Freud put it, what establishes the historian's 'conviction' (*Überzeugung*) about his history-to-be-written, that is, his 'carrying-over' or 'transference' (*Übertragung*) or what I have been calling his subjective-objective 'trans-position', not the transformation of one's practice but rather the placing of it 'across' the division of positions.[21]

As Winckelmann's practice implies, the life of art history is the mourning of the loss of the history of art. Therefore the *death* of art history would be the loss of its life-in-mourning. But art history could not be due to loss alone. Art history requires not only the loss of its objects but also, and much more important, its witnessing of that loss—that is, our witnessing not of the loss itself, since it took place long ago, but of the fact that what has been lost is, in fact, being-lost for us. The history of art is lost, but art history is still with us; and although art history often attempts to bring the object back to life, finally it is our means of laying it to rest, of putting it in its history and taking it out of our own, where we have witnessed its departure. To have the history of art as *history*—acknowledging the irreparable loss of the objects—we must give up art history as a bringing-to-life, as denial of departure. If it is not to be pathological, art history must take its leave of its objects, for they have already departed anyway.

For many there is a dilemma here. To the extent that we acknowledge the loss of the objects, we can only have art history as a pathological not-letting-go; but to the extent that we admit our desire to mourn, we can only have the history of art as a pathological walking-of-the-dead. Do we want a pageant of corpses revivified by the historian, dead things reanimated with their supposed original ideas and passions, a ghastly puppet show—like that 'social history of art' on such clairvoyant terms with the agencies and intentions, politics and subjectivities of the departed? Or an echoing mausoleum of the vanished, crypts within crypts endlessly swept out by the historian forever coming across the bones—like that 'deconstruction' so devoted to the vacated? Ethics, treating the objects as subjects, or forensics, treating the subjects as objects?[22]

But the supposed dilemma is a false one. Just as the departure is not an original, irreducible one—not a departure existing before our

witnessing but always a departing for us—neither is the leave-taking completely outside the departure. It is always a taking-leave of what we witness departing. Put another way, although the departing, the history of art, and the leave-taking, art history, take place at different times and in different places, they are not two different histories—the histories of art and of the art historian—but inextricably *one* history. Art history is produced under 'the shadow of the object,' no matter how long ago or far away, by she who witnesses its retreat within him—an on-going taking-leave of a departing.[23] It will not be pathological precisely so long as it does not entirely divide into two different histories, subject and object, subjective and objective. The 'shadow of the object' is not only the field of death for and in the subject; the object 'also offers the ego the inducement to live'[24]—if I can put it paradoxically but accurately, to live *as* death.

Winckelmann could have had two different histories held utterly apart from one another—antiquarian and sodomite, let us say. But his division is reconciled—although not, of course, effaced—in the witness and allusion of his work, its on-going mourning. Indeed, he invents art history precisely because his two histories—she 'witnessing' and he 'alluding'—are conjoined in him without closure, without a full restoration, through 'his' activity of alluding to what 'she' witnesses being lost. If this mourning were to cease either through the absolute subjective departure of the object or its total objective restoration, then art history could not begin or would come to an end—but art history lived in Winckelmann because in division he and she mourn unceasingly, because as division *they* are a whole.

Michael Baxandall 1985
Patterns of Intention

Introduction: Language and Explanation
I. The objects of explanation: pictures considered under descriptions

We do not explain pictures: we explain remarks about pictures—or rather, we explain pictures only in so far as we have considered them under some verbal description or specification. For instance, if I think or say about Piero della Francesca's *Baptism of Christ* [**4**] something quite primitive like 'The firm design of this picture is partly due to Piero della Francesca's recent training in Florence', I am first proposing 'firm design' as a description of one aspect of the *Baptism of Christ*'s interest. Then, secondly, I am proposing a Florentine training as a cause of that kind of interest. The first phase can hardly be avoided. If I simply applied 'Florentine training' to the picture it would be unclear what I was proposing to explain; it might be attached to angels in high-waisted gowns or to tactile values or whatever you wished.

Every evolved explanation of a picture includes or implies an elaborate description of that picture. The explanation of the picture then in its turn becomes part of the larger description of the picture, a way of describing things about it that would be difficult to describe in another way. But though 'description' and 'explanation' interpenetrate each other, this should not distract us from the fact that description is the mediating object of explanation. The description consists of words and concepts in a relation with the picture, and this relation is complex and sometimes problematic. I shall limit myself to pointing—with a quite shaky finger, since this is intricate ground beyond my competence—to three kinds of problem explanatory art criticism seems to meet.

2. Descriptions of pictures as representations of thought about having seen pictures

There is a problem about quite what the description is of. 'Description' covers various kinds of verbal account of a thing, and while 'firm design' is a description in one sense—as, for that matter, is 'picture'—it may be considered untypically analytical and abstract. A more straightforward and very different sort of description of a picture might seem to be this:

4 Piero della Francesca
Baptism of Christ, c.1440–50

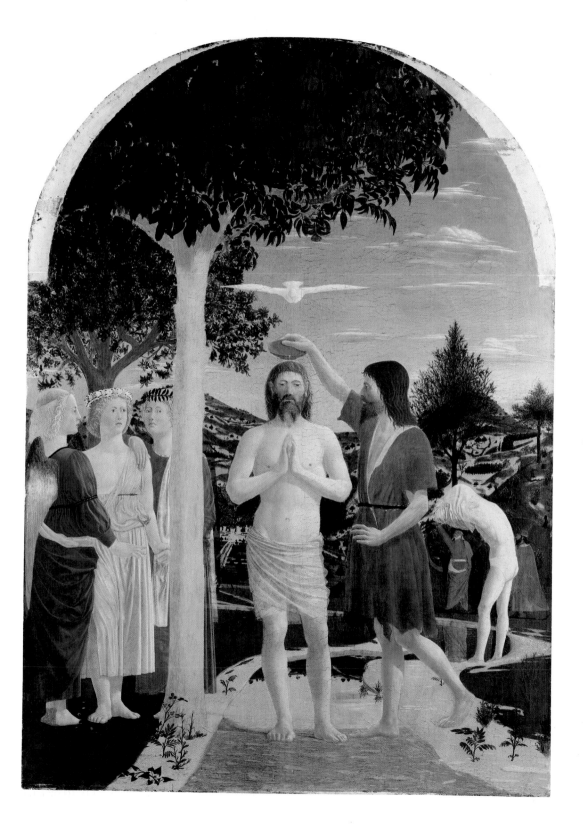

There was a countryside and houses of a kind appropriate to peasant country-people—some larger, some smaller. Near the cottages were straight-standing cypress trees. It was not possible to see the whole of these trees, for the houses got in the way, but their tops could be seen rising above the roofs. These trees, I dare say, offered the peasant a resting-place, with the shade of their boughs and the voices of the birds joyfully perched in them. Four men were running out of the houses, one of them calling to a lad standing near—for his right hand showed this, as if giving some instructions. Another man was turned towards the first one, as if listening to the voice of a chief. A fourth, coming a little forward from the door, holding his right hand out and carrying a stick in the other, appeared to shout something to other men toiling about a wagon. For just at that moment a wagon, fully-loaded, I cannot say whether with straw or some other burden, had left the field and was in the middle of a lane. It seemed the load had not been properly tied down. But two men were trying rather carelessly to keep it in place—one on this side, one on the other: the first was naked except for a cloth round his loins and was propping up the load with a staff; of the second one saw only the head and part of his chest, but it looked from his face as if he was holding on to the load with his hands, even though the rest of him was hidden by the cart. And as for the cart, it was not a four-wheeled one of the kind Homer spoke of, but had only two wheels: and for that reason the load was jolting about and the two dark red oxen, well-nourished and thick-necked, were much in need of helpers. A belt girded the drover's tunic to the knee and he grasped the reins in his right hand, pulling at them, and in his left hand he held a switch or stick. But he had no need to use it to make the oxen willing. He raised his voice, though, saying something encouraging to the oxen, something of a kind an ox would understand. The drover had a dog too, so as to be able to sleep himself and yet still have a sentinel. And there the dog was, running beside the oxen. This approaching wagon was near a temple: for columns indicated this, peeping over the trees …

This—the greater part of a description written by the fourth-century Greek Libanius of a picture in the Council House at Antioch—works by retailing the subject-matter of the picture's representation as if it were real. It is a natural and unstrained way of describing a representational picture, apparently less analytical and abstract than 'firm design', and one we still use. It seems calculated to enable us to visualize the picture clearly and vividly: that was the function of the literary genre of description, *ekphrasis*, in which it is a virtuoso essay. But what really is the description to be considered as representing?

It would not enable us to reproduce the picture. In spite of the lucidity with which Libanius progressively lays out its narrative elements, we could not reconstruct the picture from his description. Colour sequences, spatial relations, proportions, often left and right, and other things are lacking. What happens as we read it is surely that out of our memories, our past experience of nature and of pictures, we

construct something—it is hard to say what—in our minds, and this something he stimulates us to produce feels a little like having seen a picture consistent with his description. If we all now drew our visualizations—if that is what they are—of what Libanius has described, they would differ according to our different prior experience, particularly according to which painters it made us think of, and according to our individual constructive dispositions. In fact, language is not very well equipped to offer a notation of a particular picture. It is a generalizing tool. Again, the repertory of concepts it offers for describing a plane surface bearing an array of subtly differentiated and ordered shapes and colours is rather crude and remote. Again, there is an awkwardness, at least, about dealing with a simultaneously available field—which is what a picture is—in a medium as temporally linear as language: for instance, it is difficult to avoid tendentious reordering of the picture simply by mentioning one thing before another.

But if a picture is simultaneously available in its entirety, *looking* at a picture is as temporally linear as language. Does or might a description of a picture reproduce the act of looking at a picture? The lack of fit here is formally obvious in an incompatibility between the gait of scanning a picture and the gait of ordered words and concepts. (It may help to be clear about how our optical act is paced. When addressing a picture we get a first general sense of a whole very quickly, but this is imprecise; and, since vision is clearest and sharpest on the foveal axis of vision, we move the eye over the picture, scanning it with a succession of rapid fixations. The gait of the eye, in fact, changes in the course of inspecting an object. At first, while we are getting our bearings, it moves not only more quickly but more widely; presently it settles down to movements at a rate of something like four or five a second and shifts of something like three to five degrees—this offering the overlap of effective vision that enables coherence of registration.) Suppose the picture in Antioch were present to us as Libanius delivered his *ekphrasis*, how would the description and our optical act get along together? The description would surely be an elephantine nuisance, lumbering along at a rate of something less than a syllable an eye-movement, coming first, sometimes after half a minute, to things we had roughly registered in the first couple of seconds and made a number of more attentive visits to since. Obviously the optical act of scanning is not all there is to looking: we use our minds and our minds use concepts. But the fact remains that the progression involved in perceiving a picture is not like the progression involved in Libanius's verbal description. Within the first second or so of looking we have a sort of impression of the whole field of a picture. What follows is sharpening of detail, noting of relations, perception of orders, and so on, the sequence of optical scanning being influenced both by general scanning habits and by particular cues in the picture acting on our attention.

It would be tedious to go on in this fussy way to the other things the description cannot primarily be about, because it will be clear by now what I am trying to suggest this is best considered as representing. In fact, there are two peculiarities in Libanius's *ekphrasis* which sensitively register what I have in mind. The first is that it is written in the past tense—an acute critical move that has unfortunately fallen out of use. The second is that Libanius is freely and openly using his mind: 'These trees, *I dare say*, offered … '; '*It seemed* the load had not been properly tied down …'; 'only two wheels: and *for that reason* …'; 'one saw only the head and part of the chest, but *it looked* from his face *as if* he was …'; 'columns *indicated* this, peeping over the trees.…' Past tense and cerebration: what a description will tend to represent best is thought after seeing a picture.

In fact, Libanius's description of subject-matter is not the sort of description one is typically involved with when explaining pictures: I used it partly to avoid a charge of taking 'description' in a tendentiously technical sense, partly to let a point or two emerge. The sort of description I shall be concerned with is much more like 'The design is firm', and it too can be linearly quite long. Here is an excellent passage from Kenneth Clark's account of Piero della Francesca's *Baptism of Christ*, in which he develops an analysis of a quality which might be one constituent of 'firm design':

… we are at once conscious of a geometric framework; and a few seconds' analysis shows us that it is divided into thirds horizontally, and into quarters vertically. The horizontal divisions come, of course, on the line of the Dove's wings and the line of angels' hands, Christ's loin-cloth and the Baptist's left hand; the vertical divisions are the pink angel's columnar drapery, the central line of the Christ and the back of St. John. These divisions form a central square, which is again divided into thirds and quarters, and a triangle drawn within this square, having its apex at the Dove and its base at the lower horizontal, gives the central motive of the design.

Here it is clearer than with Libanius's description that the words are representing less the picture than thought after seeing the picture.

There is much to be said, if one wants to match words and concepts with the visual interest of pictures, for both being and making clear—as Libanius and Kenneth Clark make clear—that what one offers in a description is a representation of thinking about a picture more than a representation of a picture. And to say we 'explain a picture as covered by a description' can conveniently be seen as another way of saying that we explain, first, thoughts we have had about the picture, and only secondarily the picture.

3. Three kinds of descriptive word
'… *about* the picture' is the proper way to put it. The second area of

problem is that so many of the thoughts we will want to explain are indirect, in the sense that they are not pointed quite directly at the picture—considered, at least, as a physical object (which is not how, in the end, we will consider it). Most of the better things we can think or say about pictures stand in a slightly peripheral relation to the picture itself. This can be illustrated by taking and sorting a few words from Kenneth Clark's pages on Piero's *Baptism of Christ*:

One type of term, those on the right, refers to the effect of the picture on the beholder: *poignant* and so on. And indeed it is usually precisely the effect of the picture we are really concerned with: it has to be. But terms of this type tend to be a little soft and we sometimes frame our sense of the effect in secondarily indirect ways. One way is by making a comparison, often by metaphor, as in the type at the top: *resonance* of colour and so on. (One especially bulky sort of comparison, which we tend to work very hard with representational paintings, is to refer to the colours and patterns on the picture surface as if they were the things they are representing, as in Libanius.) And then there is a third type, that on the left. Here we describe the effect of the picture on us by telling of inferences we have made about the action or process that might have led to the picture being as it is: assured *handling*, of a frugal *palette*, *excited* blots and scribbles. Awareness that the picture's having an effect on us is the product of human action seems to lie deep in our thinking and talking about pictures—so the arrows in the diagram—and what we are doing when we attempt a historical explanation of a picture is to try developing this kind of thought.

We have to use concepts of these indirect or peripheral kinds. If we confined ourselves to terms that referred directly or centrally to the physical object we would be confined to concepts like *large*, *flat*, *pigments on a panel*, *red and yellow and blue* (though there are complications about these), perhaps *image*. We would find it hard to locate the sort of interest the picture really has for us. We talk and think 'off' the object rather as an astronomer looks 'off' a star, because acuity or sharpness are greater away from the centre. And the three principal indirect moods of our language—speaking directly of the effect on us, making comparisons with things whose effect on us is of a similar quality, making inferences about the process which would produce an object having such an effect on us—seem to correspond to three modes of thinking about a picture, which we treat as something more than a

physical object. Implicitly we treat it as something with a history of making by a painter and a reality of reception by beholders.

Of course, as soon as such concepts become part of a larger pattern, sustained thinking or sustained discourse—over a couple of pages in a book in this case—things become more complicated and less crisp. One type of thinking is subordinated to another in the hierarchy of syntax. Ambiguities or conflations of type develop, between the inferential and the comparative, in particular. There are shifts in the actual reference of terms. . . . But an indirectness of mood and thought remains in a complex weave. And when I applied the thought 'firm design' to the *Baptism of Christ* it was a thought that involved an inference about cause. It described the picture by speculating about the quality of the process that led to it being an object of a kind to make that impression on me that it does. 'Firm design' would go on the left-hand side of the diagram. In fact, I was deriving one cause of the picture, 'firm design', from another less proximate cause, 'Florentine training'.

But it may be objected that to say that a concept like 'design' involves an element of inference about cause begs various questions about the actual operation of words. In particular, is one perhaps confusing the sense of the word, the range of its possible meanings, with its reference or denotation in the particular case? 'Design' has a rich gamut of sense:

Mental plan; scheme of attack; purpose; end in view; adaptation of means to ends; preliminary sketch for picture etc.; delineation, pattern; artistic or literary groundwork, general idea, construction, plot, faculty of evolving these, invention.

If I use the concept 'design' I do not normally use it in all these senses at once. If I used it of a picture in a more unqualified way—as in 'I do like the design of this picture'—surely I would be shedding for the moment that part of its sense that lies in the process of making the picture and referring to a quality more intrinsic to the marks on the panel— 'pattern' rather than 'drawing' or 'purposing' or 'planning'? In its finished reference this may be so: I would be entitled to expect you to take it, for the purpose of criticism, in that more limited sense. But in arriving at it, I and you and the word would have been coming from the left of the field, so to speak: there are leftist and centrist uses of 'design' in current and frequent use, but if we pick on the centrist denotation we have been active on the left at least to the extent of shelving its meanings. In semantics the colouring of a word used in one sense by other current senses is sometimes called 'reflected' meaning; in normal language it is not powerful. A better term for what happens with words and concepts matched with pictures—not at all a normal use of language—might be 'rejected' meaning, and one reason for its importance brings us to the third area of problem.

4. The ostensivity of critical description

Absolutely 'design' and indeed 'firm' are very broad concepts. I could plausibly say either of Piero della Francesca's *Baptism of Christ* [**4**] or of Picasso's *Portrait of Kahnweiler*—'The design is firm'. The terms are general enough to embrace a quality in two very different objects; and, supposing you had no idea what the pictures looked like, they would tell you little that would enable you to visualize the pictures. 'Design' is not a geometrical entity like 'cube' or a precise chemical entity like 'water', and 'firm' is not a quantity expressible numerically. But in an art-critical description one is using the terms not absolutely; one is using them in tandem with the object, the instance. Moreover one is using them not informatively but demonstratively. In fact, the words and concepts one may wish to handle as a mediating 'description' of the picture are not in any normal sense descriptive. What is determining for them is that, in art criticism or art history, the object is present or available—really, or in reproduction, or in memory, or (more remotely) as a rough visualization derived from knowledge of other objects of the same class.

This has not always been so to the degree it now is so: the history of art criticism in the last five hundred years has seen an accelerating shift from discourse designed to work with the object unavailable, to discourse assuming at least a reproduced presence of the object. In the sixteenth century Vasari assumes no more than a generic acquaintance with most of the pictures he deals with; in particular, his celebrated and strange descriptions are often calculated to evoke the character of works not known to the reader. By the eighteenth century an almost disabling ambivalence had developed on this point. Lessing cannily worked with an object, the Laocoon group, that most of his readers would have known, as he only did himself, from engravings or replicas. Diderot, on the other hand, nominally writing for someone not in Paris, actually seems never to be clear whether or not his reader has been to the Salon he is discussing, and this is one reason for the difficulty of his criticism. By 1800 the great Fiorillo was adding foot-notes to his books specifying the makers of the best engravings after the pictures he is discussing and he tends to concentrate on what can be seen in them. In the nineteenth century books were increasingly illustrated with engravings and eventually half-tones, and with Wölfflin, notoriously, art-critical discourse begins to be directed at a pair of black-and-white diapositive projections. We now assume the presence or availability of the object, and this has great consequences for the workings of our language.

In everyday life if I offer a remark like 'The dog is big', the intention and effect will depend a great deal on whether or not that dog is present or known to my hearers. If it is not, the 'big'—which, in the context of dogs, has a limited range of meaning—is likely to be primarily a matter

of information about the dog; it is big, they learn, rather than small or middle-sized. But if it is present—if it is standing before us as I talk—then 'big' is more a matter of my proposing a kind of interest to be found in the dog: it is *interestingly* big, I am suggesting. I have used 'dog' to point verbally to an object and 'big' to characterize the interest I find in it.

If I say of a picture, present or reproduced or remembered, 'The design is firm', the remark's force is rather specialized. What I am doing is not to inform, but to point to an aspect of its interest, as I see it. The act is one of demonstration: with 'design' I direct attention to one element in the picture and with 'firm' I propose a characterization of it. I am suggesting that the concept 'firm design' be matched with the interest of the picture. You may follow my prompting or not; and if you do follow my prompting you may agree or disagree.

So I am making two points here. As a verbalized proxy for the quality in Piero's *Baptism of Christ*, 'firm design' would mean little; but by its reference to the instance it takes on more precise meaning. Since my remark about Piero's picture is an act not of information but of demonstration in its presence, its meaning is largely ostensive: that is, it depends on both myself and my hearers supplying precision to it by reciprocal reference between the word and the object. And this is the texture of the verbal 'description' that is the mediating object of any explanation we may attempt. It is an alarmingly mobile and fragile object of explanation.

However it is also excitingly flexible and alive, and our disposition to move around in the space offered by the words is an energetic and muscular one. Suppose I use of the *Baptism of Christ* this sentence: 'The design is firm because the design is firm.' This is circular nonsense, in a way, but to a surprising extent we have the will to get meaning out of people's statements. In fact, if you leave people for a minute with this sentence *and the picture*, some of them will begin to find a meaning in it—working from an assumption that if someone says something he intends a meaning, from the space within the words, and from the structural cue offered by the word 'because'. And what some of them move towards is a meaning that could be caricatured as: 'The [pattern] is firm because the [planning/drawing] is firm.' Within the gamut of senses of 'design' they find references differentiated enough to set against each other: and, working from 'because', they derive the less causally suggestive from the more causally suggestive—the more centred from the more left. At the same time they must have shaded the two appearances of 'firm' differently too.

But the present point is that the ostensive working of our terms is going to make the object of explanation odd. We explain the picture as pointed up by a selective verbal description which is primarily a representation of our thoughts about it. This description is made up of

words, generalizing instruments, that are not only often indirect—inferring causes, characterizing effects, making various kinds of comparison—but take on the meaning we shall actually use only in their reciprocal relation with the picture itself, a particular. And behind this lies a will to remark on an interest in the picture.

5. Summary

If we wish to explain pictures, in the sense of expounding them in terms of their historical causes, what we actually explain seems likely to be not the unmediated picture but the picture as considered under a partially interpretative description. This description is an untidy and lively affair.

Firstly, the nature of language or serial conceptualization means that the description is less a representation of the picture, or even a representation of seeing the picture, than a representation of thinking about having seen the picture. To put it in another way, we address a relationship between picture and concepts.

Secondly, many of the more powerful terms in the description will be a little indirect, in that they refer first not to the physical picture itself but to the effect the picture has on us, or to other things that would have a comparable effect on us, or to inferred causes of an object that would have such an effect on us as the picture does. The last of these is particularly to the point. On the one hand, that such a process penetrates our language so deeply does suggest that causal explanation cannot be avoided and so bears thinking about. On the other, one may want to be alert to the fact that the description which, seen schematically, will be part of the object of explanation already embodies preemptively explanatory elements—such as the concept of 'design'.

Thirdly, the description has only the most general independent meaning and depends for such precision as it has on the presence of the picture. It works demonstratively—we are pointing to interest—and ostensively, taking its meaning from reciprocal reference, a sharpening to-and-fro, between itself and the particular.

These are general facts of language that become prominent in art criticism, a heroically exposed use of language, and they have (it seems to me) radical implications for how one can explain pictures—or, rather, for what it is we are doing when we follow our instinct to attempt to explain pictures.

2

Aesthetics

Introduction

What kind of knowledge do works of art provide? Is this knowledge different from other forms of thought? What kind of knowledge could be provided by constructing a 'history' of such phenomena? What would a history of such objects consist of? What significance would it have?

Although the notion of sensory knowledge as inferior to rational thinking had a long tradition in European theology, philosophy, and psychology (a tradition which is still alive), in the middle of the eighteenth century the argument began to be made that such knowledge had a perfection of its own, which in its way was analogous to that of logic or reason. It came to be argued that there were in fact *two* distinct but *analogous* kinds of knowing, and that in consequence there should be two kinds of theory or 'science' of knowledge corresponding to each: logic and *aesthetics*.

The first notable appearance of the term *aesthetics* in its modern sense was as the title of a 600-page book written in Latin and published in 1750 by Alexander Gottlieb Baumgarten, the *Aesthetica*.[1] It was coined to denote a special cognitive domain, that of sensual thinking, which he argued was distinct from rational or logical thought. Baumgarten's new 'science of sensible knowledge' would deal as fully with truth as did logic, but truth in so far as it is known through the senses. For Baumgarten, sensible knowledge was a faculty of the mind that he termed an *analogon rationis*—an *analogue* of reason: in short, a unique mode of reasoning in its own right.

His views departed from those of the philosophers of the previous generation such as Gottfried Wilhelm Leibniz (1646–1716) or his disciple, Christian Wolff (1679–1754), who held that the difference between sensation and thought is that the latter is lucid whilst the former is confused, and that sense perception cannot be made lucid without transforming it into thought (and, by implication, into systematic discourse). In other words, as a 'lower' form of cognition, sensation was taken to be but a primitive or *preliminary* stage of the same knowledge that was imagined to be represented most clearly in rational or logical thought. Baumgarten argued against this hierarchy of modes of

thought, and went on to consider what the nature of beauty and of fine art might be within the framework of a *non*-hierarchized cognition.

Several things were at stake here, not least of which was the canonical idea of art's function being that of 'imitating nature'—a paradigm that underlay attitudes toward art down to and including Baumgarten's contemporary, Winckelmann. To perceive beauty, in Baumgarten's terms, was to perceive perfection both in things and in people (the latter constituting moral perfection). We conceive of this beauty not rationally but by *taste*—by which was meant *extremely clear sense perception*. In these terms, the fine arts were analogous to fine sciences: their aim was not to 'imitate' nature (even its most perfect examples) but rather to create perfect wholes out of indistinct images made extremely clear; in short, to create sensory knowledge.

One of the results of these innovations was the idea that sense perception could be perfected without turning it into logical or rational thought. The idea that sensual knowledge could have its own perfection—and further, that an aesthetic judgement about beauty or beautiful objects could have a validity for persons other than the individual making it—became the cornerstone of aesthetic philosophy as it was to develop in the latter half of the eighteenth century, and provided the foundation and immediate background for the *Critique of Judgement* by Immanuel Kant (1724–1804), published in 1790.[2]

Kant's *Critique of Judgement* ('critique' in the sense of analytic discernment rather than of criticism, and 'judgement' as the *ability* to judge) is divided into two interrelated sections. The first dealt with 'Aesthetic Judgement', and was devoted to the ability to make individual judgements about the beautiful in art and nature—that is, judgements of taste (a second part of this dealt with judgements about the sublime). The second section was devoted to 'Teleological Judgement', or the discernment of final causes or the purposiveness in things.

In the 'Aesthetic Judgement', Kant addressed the following problem. In using the term 'beautiful' in speaking of natural or human objects, it is commonly assumed that beauty is a property or characteristic of the thing itself—and that, by extension, others should be able to confirm our judgement. What, then, is the nature of the perception of such properties of things? Are such aesthetic pleasures purely subjective or are they intersubjective, or even universal?

Kant argued that the judgement of taste—that is, the ability to make judgements of taste—was universal, in contrast to judgements about what was merely agreed upon by individuals: 'gathering votes and asking other people what kind of sensation they are having', he argued, cannot account for the fact that judgements of taste are universal.

In trying to understand why judgements of taste should be universal, Kant argued roughly as follows. The feelings involved in all judgements of taste are connected to two things: *theoretical knowledge*,

knowledge of how things are, and *morality*, knowledge of how things ought to be. Nature had a final cause or purposiveness which can be discerned through the faculty of aesthetic thinking, which goes beyond all (rational) concepts by creating intuitions about nature that transcend what is immediately perceptible. As with nature, so with art: judging works of art, Kant argued, is *equivalent* to judging the purposiveness of nature; in both cases, we judge in terms of beauty, whether natural or artistic.

Closely tied to aesthetic judgement is Kant's concept of *genius*, which was a measure of the quality of an artwork, and a sign of the degree of its purposiveness: genius as a great capacity for aesthetic thinking. Works of fine art are judged on the basis of *how much* genius they manifest. Nature is judged, as a whole, as a system of purposes; on the basis of how its purposiveness is manifested in its appearances. Kant's interest in the aesthetic and in understanding what is at stake in judgements of taste in the beauty of works of art is thus essentially an interest in understanding how the knowledge and appreciation of art reflects, or is an analogue of, our appreciation of the purposiveness of nature. In this he may be as much allied with the Romantic movement of the early nineteenth century as he was with the classical rationalists of the Enlightenment, for the *Critique of Judgement* suggested analogies between the genius-artist and the source of the purposiveness of the universe (the world being the artefact of a divine Artificer).

At the same time, Kant was interested in understanding the sublime, and in understanding the Baroque as a great project of the imagination—the project that Winckelmann earlier shunned in his writings in favour of an idealist classicism. What distinguished Kant from Winckelmann with regard to notions of taste and beauty was his willingness to explore beyond the boundaries and canons of classical good taste. He argued (against classical rationalism) that what is beautiful is not merely the material image of some singular inner truth or rational essence in nature, but is related to a freedom of the imagination that constitutes the defining characteristic of humanity as a finite creature capable of thinking the infinite. For Kant, an aesthetics of the well-wrought would always be far removed from true genius.

Kant's *Critique of Judgement* appeared over two decades after Winckelmann's death. Although an earlier perspective on these issues[3] was published by Kant in the same year as Winckelmann's *History* (1764), it is unclear whether Winckelmann was aware of Kant's work. From the later perspective of the *Critique*, a Winckelmannian classical rationalism would have certainly seemed very much out of step with the new philosophy of aesthetics that had already been pioneered by Baumgarten at the time that Winckelmann's own writing was beginning, in the middle of the century. It would have seemed to hark back to the old hierarchized notions of sensate knowledge as inferior to the

ideals of rationality—ideas that could only have been compatible with an ideology grounded in a *singular* ideal of beauty.

In effect, the work of Kant's aesthetic philosophy relativized notions of beauty, opening up the possibility of multiple coexisting aesthetic systems, united by the pan-human power or ability to make aesthetic judgements. Such a notion would have been foreign to Winckelmann (despite his own ultimate relativization or historicization of his beloved Greek ideal) but Kant appears to have accepted this as a challenge to understanding the problem of the universality of the human capacity for aesthetic judgement. What distinguished Kant from Winckelmann was in the former's understanding of Enlightenment (see p. 71), which he linked to his 'aesthetic conception of the public sphere as an intersubjective space of free discussion not mediated by a concept or a rule'.[4]

At the same time that Kant's philosophy opened up the possibility of multiple aesthetic tastes, he also closely tied aesthetics to morality, of which he held that beauty was the *symbol* or analogue. Beautiful objects, he argued, arouse in us sensations that are analogous to the awareness we have in the mental state produced by moral judgements. In linking together aesthetics and ethics, Kant made it possible to imagine linking together degrees of genius and taste with the moral character of an artist or a viewer.

For Georg Wilhelm Friedrich Hegel (1770–1831), the notion of the symbol played a central role in his philosophy of art, which is known particularly from his *Aesthetics: Lectures on Fine Arts* of 1835–38, originally delivered four times between 1820 and 1830 at the University of Berlin.[5] Hegel's history of philosophy was constructed by analogy with his ideas regarding the historical development of art.

His notion of art, however, was strikingly less complex or subtle than those which had developed in the aesthetic philosophy of the latter half of the eighteenth century. He regarded art as basically a secondary or surface phenomenon, the presentation of common (inner) ideas in diverse (outer) sensual forms—thus harking back to a pre-Baumgarten and pre-Kantian ideology which privileged the Ideal or Thought by *devalourizing* visual knowledge, and by relegating it once again to the realm of confused intelligibility or primitive rationality. Art, in Hegel's system, became merely the vehicle or dependent medium of thought; its external form or shape; or, in more recent terminology, the signifier-form of a signified-content.

In contrast to Baumgarten and Kant, Hegel's interest in the aesthetic was confined to works of art, and not to the perception of art or of the beautiful as such, which might be manifest in artefacts as well as in nature. For him, the aesthetic sphere—art—was a form of symbolism, whose principal historical function was to represent and articulate the Divine in material form. As the handmaid of religion, art shares

with it the same subject-matter. For Kant, the aesthetic and the rational were distinct modes of knowing and producing knowledge; for Hegel, the aesthetic was but a debased reflection of the intelligible.

Hegel's philosophical counter-revolution was a challenge to Kant's attempt to break free of classicism, and was an explicit attempt to return to a pre-Kantian concern (as expressed in the earlier work of Leibniz) with re-establishing a Divine point of view in relationship to the works of Man. This 'theodicy', as Hegel termed his meditations, was an attempt to understand the entirety of history as both a system and a *process*—a process of the unfolding of the Divine Idea in the (sensory, and hence illusory) temporality of artistic change. The Divine Idea is unchanging and immutable; its changing representations over time are but the confused ways in which mortal beings attempt to grasp the unchanging and singular Divine perfection.

Hegel's conceptions of art and of the relationships among various arts are given in summary form (see p. 98) from the Introduction to his *Aesthetics*. To a certain extent, his ideas resonate with those of Winckelmann, and represent a broadening of the system of Winckelmann's classicism: for Hegel, the visual arts were the means by which a culture's essential ideas were expressed and communicated. But in contrast to Winckelmann, for Hegel those essential ideas concerned divinity as such rather than the nature of what a people might have been in their historical totality and diversity.

It may be readily imagined how a Hegelian perspective on art as the expression or representation of some deeper ideal would have proved remarkably suitable to the formation of a systematic discipline of art history in the decade following Hegel's death. Such an interpretative field of knowledge-production would of course find ready service in contributing to and imagining the histories of both European nation-states and other cultures and peoples—which is precisely what Hegel himself undertook to accomplish in his characterization of the relationships between European Christian cultures and their antecedents both in ancient Greece and Rome, as well as in the Near and Far East.

It would also provide a persuasive model and a powerful catalyst for organizing systematic art historical enquiry as a universal domain of historical knowledge-production, applicable to all times, places, and cultures. Art history could be fashioned as a more or less secularized version of Hegel's theodicy, in which the Idea of art itself (or of the Divine, or of Humanity, or of an ethnicity, race, culture, or nationality) could be understood as an evolutionary, historical pageant from antiquity to the present. Hegel's theodicy—or historicized classicism—renders the visible *legible* as episodes in a historical novel. But art is historical for Hegel not necessarily because of some intrinsic formal aesthetic evolution—as, for example, in Vasari's history of artistic precedents—but principally because it is the sensible presentation

of the history of truth's unfolding.

This history of truth—the unfolding of Spirit—is not formless or wandering; it is an evolution, or rather a hierarchized teleology, moving from primitive states to a modern (civilized, Christian, post-Antique, post-Oriental) state. For Hegel, the various arts reflect this chronological hierarchy in three great moments of what he termed the symbolic, the classical, and the romantic, as outlined in the reading below. This third stage of art's history was for Hegel in a very real sense the *end* of art: the dissolution and absorption of art into religion, into a spirituality (epitomized for Hegel by the Protestant Reformation of Christianity) in no need of material representations.

There are some questions to consider: is the modern discipline of art history, then, but a secularized version of a history of Spirit? Could such a discipline have existed which was *not* grounded in a vision of human history in which everything is poured into a single mould signifying the evolutionary triumph of Christianity over primitive versions of the Divine? Or, by extension, a history signifying the evolutionary triumph of European art, culture, and civilization over all others, which are thereby framed as Europe's anterior and prologue? These and related issues will be taken up in the readings and commentaries below.

The readings here—two by Kant, one by Hegel—provide a good overview both of what was at stake in their two very distinct philosophical and historical projects: the Kantian revolution of aesthetic philosophy, and the Hegelian counter-revolutionary attempt to put aesthetics back in its (pre-Kantian, theologically contingent) place.

The primary sources and their best translations are cited in the Notes. The literature on both figures is truly enormous, and summarizing it here would serve little practical purpose. Instead, I have listed a few texts which may be especially useful in understanding the background of eighteenth-century aesthetic philosophy, and its Hegelian aftermath.

Ernst Cassirer's *The Philosophy of the Enlightenment*, translated by F. C. A. Koelln and J. P. Pettigrew (Princeton; 1951, originally published as *Die Philosophie der Aufklärung*, Tübingen, 1932), is a widely influential early twentieth-century reinterpretation of the period. Donald W. Crawford, *Kant's Aesthetic Theory* (Madison, 1974) is a detailed and methodical analysis of Kant's *Critique of Judgement*. Moshe Barasch's *Modern Theories of Art*, 1. *From Winckelmann to Baudelaire* (New York, 1990) is a useful historical synopsis of the work of many philosophers, historians, and critics of the eighteenth and nineteenth centuries, and its passages on Winckelmann, Baumgarten, Kant, and Hegel are well written.

In addition to the excellent introductory sections of Werner

Pluhar's 1987 translation of Kant's *Critique of Judgement*, cited in n. 2, another book, also cited, by Luc Ferry (*Homo Aestheticus: The Invention of Taste in the Democratic Age*) is perhaps the most important and lucid discussion of both Kant and Hegel in recent years, especially chapters 3 ('The Kantian Moment: The Subject of Reflection'), 77–113, and 4 ('The Hegelian Moment: The Absolute Subject or the Death of Art'), 114–47. An important earlier overview of Kant's *Critiques* is Gilles Deleuze, *La Philosophie critique de Kant* (Paris, 1963), in translation as Gilles Deleuze, *Kant's Critical Philosophy: The Doctrine of the Faculties*, translated by Hugh Tomlinson and Barbara Habberjam (Minneapolis, 1984).

What is Enlightenment?

Enlightenment is man's release from his self-incurred tutelage. Tutelage is man's inability to make use of his understanding without direction from another. Self-incurred is this tutelage when its cause lies not in lack of reason but in lack of resolution and courage to use it without direction from another. *Sapere aude!*[n] 'Have courage to use your own reason!'—that is the motto of enlightenment.

Laziness and cowardice are the reasons why so great a portion of mankind, after nature has long since discharged them from external direction (*naturaliter maiorennes*), nevertheless remains under lifelong tutelage, and why it is so easy for others to set themselves up as their guardians. It is so easy not to be of age. If I have a book which understands for me, a pastor who has a conscience for me, a physician who decides my diet, and so forth, I need not trouble myself. I need not think, if I can only pay—others will readily undertake the irksome work for me.

That the step to competence is held to be very dangerous by the far greater portion of mankind (and by the entire fair sex)—quite apart from its being arduous—is seen to by those guardians who have so kindly assumed superintendence over them. After the guardians have first made their domestic cattle dumb and have made sure that these placid creatures will not dare take a single step without the harness of the cart by which they are confined, the guardians then show them the danger which threatens if they try to go alone. Actually, however, this danger is not so great, for by falling a few times they would finally learn to walk alone. But an example of this failure makes them timid and ordinarily frightens them away from all further trials.

For any single individual to work himself out of the life under tutelage which has become almost his nature is very difficult. He has come to be fond of this state, and he is for the present really incapable of making use of his reason, for no one has ever let him try it out. Statutes and formulas, those mechanical tools of the rational employment, or rather misemployment, of his natural gifts, are the fetters of an everlasting tutelage. Whoever throws them off makes only an uncertain leap over the narrowest ditch because he is not accustomed to that sort of free motion. Therefore there are only few who have succeeded by

their own exercise of mind both in freeing themselves from incompetence and in achieving a steady pace.

But that the public should enlighten itself is more possible; indeed, if only freedom is granted, enlightenment is almost sure to follow, for there will always be some independent thinkers, even among the established guardians of the great masses, who, after throwing off the yoke of tutelage from their own shoulders, will disseminate the spirit of the rational appreciation of both their own worth and every man's vocation of thinking for himself. But be it noted that the public, which has first been brought under this yoke by their guardians, forces the guardians themselves to remain bound when it is incited to do so by some of the guardians who are themselves incapable of any enlightenment—so harmful is it to implant prejudices, for they later take vengeance on their cultivators (or at least on those whose ancestors had cultivated them). Thus the public can only slowly attain enlightenment. Perhaps a fall of personal despotism or of avaricious or tyrannical oppression may be accomplished by revolution, but never a true reform in ways of thinking. Rather, new prejudices will serve as well as old ones to harness the great unthinking masses.

For this enlightenment, however, nothing is required but freedom, and indeed the most harmless among all the things to which that term can properly be applied. It is the freedom to make public use of one's reason at every point. But I hear on all sides, 'Do not argue!' The officer says: 'Do not argue, but drill!' The tax-collector: 'Do not argue, but pay!' The cleric: 'Do not argue, but believe!' Only one prince in the world says: 'Argue as much as you will and about what you will, but obey!'

Everywhere there is restriction on freedom. But what sort of restriction is an obstacle to enlightenment, and what sort is not an obstacle but a promoter of it? I answer: The public use of one's reason must always be free, and it alone can bring about enlightenment among men. The private use of reason, on the other hand, may often be very narrowly restricted without particularly hindering the progress of enlightenment. By the public use of one's reason I understand the use which a person makes of it as a scholar before the reading public. Private use I call that which one may make of it in a particular civil post or office which is entrusted to him. Many affairs which are conducted in the interest of the community require a certain mechanism through which some members of the community must passively conduct themselves with an artificial unanimity, so that the government may direct them to public ends, or at least prevent them from frustrating those ends. Here argument is certainly not allowed—one must obey. But so far as a part of the mechanism regards himself at the same time as a member of the whole community or of a society of world-citizens, and thus in the role of a scholar who addresses the public (in the proper

sense of the word) through his writings, he certainly can argue without hurting the affairs for which he is in part responsible as a passive member. While it would be ruinous for an officer in service to quibble about the suitability or utility of a command given to him by his superior, he must obey; but the right to make remarks on errors in the military service and to lay them before the public for judgment cannot equitably be refused him as a scholar. The citizen cannot refuse to pay the taxes imposed to him; indeed, an impudent complaint at those levied on him can be punished as a scandal (as it could occasion general refractoriness). But the same person nevertheless does not act contrary to his duty as a citizen when, as a scholar, he publicly expresses his thoughts on the inappropriateness or even the injustice of these levies. Similarly a clergyman is obligated to make his sermon to his pupils in catechism and his congregation conform to the symbol of the church which he serves, for he has been accepted on this condition. But as a scholar he has complete freedom, even the calling, to communicate to the public all his carefully tested and well-meaning thoughts on that which is erroneous in the symbol and to make suggestions for the better organization of the religious body and church. In doing this, there is nothing that could be laid as a burden on his conscience. For what he teaches as a consequence of his office as a representative of the church, this he considers something about which he has no freedom to teach according to his own lights; it is something which he is appointed to propound at the dictation of and in the name of another. He will say, 'Our church teaches this or that; those are the proofs which it adduces.' He thus extracts all practical uses for his congregation from statutes to which he himself would not subscribe with full conviction, but to the enunciation of which he can very well pledge himself because it is not impossible that truth lies hidden in them, and, in any case, there is at least nothing in them contradictory to inner religion. For if he believed he had found such in them, he could not conscientiously discharge the duties of his office; he would have to give it up. The use, therefore, which an appointed teacher makes of his reason before his congregation is merely private, because this congregation is only a domestic one (even if it be a large gathering); with respect to it, as a priest, he is not free, nor can he be free, because he carries out the orders of another. But as a scholar, whose writings speak to his public, the world, the clergyman in the public use of his reason enjoys an unlimited freedom to use his own reason and to speak in his own person. That the guardians of the people (in spiritual things) should themselves be incompetent is an absurdity which amounts to the eternalization of absurdities.

But would not a society of clergymen, perhaps a church conference or a venerable classis (as they call themselves among the Dutch), be justified in obligating itself by oath to a certain unchangeable symbol in

order to enjoy an unceasing guardianship over each of its members and thereby over the people as a whole, and even to make it eternal? I answer that this is altogether impossible. Such a contract, made to shut off all further enlightenment from the human race, is absolutely null and void even if confirmed by the supreme power, by parliaments, and by the most ceremonious of peace treaties. An age cannot bind itself and ordain to put the succeeding one into such a condition that it cannot extend its (at best very occasional) knowledge, purify itself of errors, and progress in general enlightenment. That would be a crime against human nature, the proper destination of which lies precisely in this progress; and the descendants would be fully justified in rejecting those decrees as having been made in an unwarranted and malevolent manner.

The touchstone of everything that can be concluded as a law for a people lies is the question whether the people could have imposed such a law on itself. Now such a religious compact might be possible for a short and definitely limited time, as it were, in expectation of a better. One might let every citizen, and especially the clergyman, in the role of scholar, make his comments freely and publicly (i.e., through writing) on the erroneous aspects of the present institution. The newly introduced order might last until insight into the nature of these things had become so general and widely approved that through uniting their voices (even if not unanimously) they could bring a proposal to the throne to take those congregations under protection which had united into a changed religious organization according to their better ideas, without, however, hindering others who wish to remain in the order. But to unite in a permanent religious institution which is not to be subject to doubt before the public even in the lifetime of one man, and thereby to make a period of time fruitless in the progress of mankind toward improvement, thus working to the disadvantage of posterity—that is absolutely forbidden. For himself (and only for a short time) a man can postpone enlightenment in what he ought to know, but to renounce it for himself and even more to renounce it for posterity is to injure and trample on the rights of mankind.

And what a people may not decree for itself can even less be decreed for them by a monarch, for his lawgiving authority rests on his uniting the general public will in his own. If he only sees to it that all true or alleged improvement stands together with civil order, he can leave it to his subjects to do what they find necessary for their spiritual welfare. This is not his concern, though it is incumbent on him to prevent, to the best of his ability, one of them from violently hindering another in determining and promoting this welfare. To meddle in these matters lowers his own majesty, since by the writings in which his subjects seek to present their views he may evaluate his own governance. He can do this when, with deepest understanding, he lays upon himself the

reproach, *Caesar non est supra grammaticos*. Far more does he injure his own majesty when he degrades his supreme power by supporting the ecclesiastical despotism of some tyrants in his state over his other subjects.

If we are asked, 'Do we now live in an *enlightened age?*' the answer is, 'No,' but we do live in an *age of enlightenment*. As things now stand, much is lacking which prevents men from being, or easily becoming, capable of using their own reason in religious matters correctly, with assurance and free from outside direction. But, on the other hand, we have clear indications that the field has now been opened wherein men may freely deal with these things and that the obstacles to general enlightenment or the release from self-imposed tutelage are gradually being reduced. In this respect, this is the age of enlightenment, or the century of Frederick.

A prince who does not find it unworthy of himself to say that he holds it to be his duty to prescribe nothing to men in religious matters but to give them complete freedom while renouncing the haughty name of *tolerance*, is himself enlightened and deserves to be esteemed by the grateful world and posterity as the first, at least from the side of government, who divested the human race of its tutelage and left each man free to make use of his reason in matters of conscience. Under him venerable ecclesiastics are allowed, in the role of scholars, and without infringing on their official duties, freely to submit for public testing their judgements and views which here and there diverge from the established symbol. And an even greater freedom is enjoyed by those who are restricted by no official duties. This spirit of freedom spreads beyond this land, even to those in which it must struggle with external obstacles erected by a government which misunderstands its own interest. For an example gives evidence to such a government that in freedom there is not the least cause for concern about public peace and the stability of the community. Men work themselves gradually out of barbarity if only intentional artifices are not made to hold them in it.

I have placed the main point of enlightenment—the escape of men from their self-incurred tutelage—chiefly in matters of religion because our rulers have no interest in playing the guardian with respect to the arts and sciences and also because religious incompetence is not only the most harmful but also the most degrading of all. But the manner of thinking of the head of a state who favours religious enlightenment goes farther, and he sees that there is no danger to his sovereignty in allowing his subjects to make public use of their reason and to publish their thoughts on a better formulation of his legislation and even their open-minded criticisms of the laws already made. Of this we have a shining example wherein no monarch is superior to him whom we honor.

But only one who is himself enlightened, is not afraid of shadows,

and has a numerous and well-disciplined army to assure public peace can say: 'Argue as much as you will, and about what you will, only obey!' A republic could not dare say such a thing. Here is shown a strange and unexpected trend in human affairs in which almost everything, looked at in the large, is paradoxical. A greater degree of civil freedom appears advantageous to the freedom of mind of the people, and yet it places inescapable limitations upon it; a lower degree of civil freedom, on the contrary, provides the mind with room for each man to extend himself to his full capacity. As nature has uncovered from under this hard shell the seed for which she most tenderly cares—the propensity and vocation to free thinking—this gradually works back upon the character of the people, who thereby gradually become capable of managing freedom; finally, it affects the principles of government, which finds it to its advantage to treat men, who are now more than machines, in accordance with their dignity.*

* Today I read in the *Büschingsche Wöchentliche Nachrichten* for September 13 an announcement of the *Berlinische Monatsschrift* for this month, which cites the answer to the same question by Herr Mendelssohn. But this issue has not yet come to me; if it had, I would have held back the present essay, which is now put forth only in order to see how much agreement in thought can be brought about by chance.

The Critique of Judgement

III The Critique of Judgement as a means of connecting the two parts of Philosophy in a whole

The Critique which deals with what our cognitive faculties are capable of yielding *a priori* has properly speaking no realm in respect of Objects; for it is not a doctrine, its sole business being to investigate whether, having regard to the general bearings of our faculties, a doctrine is possible by their means, and if so, how. Its field extends to all their pretensions, with a view to confining them within their legitimate bounds. But what is shut out of the division of Philosophy may still be admitted as a principal part into the general Critique of our faculty of pure cognition, in the event, namely, of its containing principles which are not in themselves available either for theoretical or practical employment.

Concepts of nature contain the ground of all theoretical cognition *a priori* and rest, as we saw, upon the legislative authority of understanding.—The concept of freedom contains the ground of all sensuously unconditioned practical precepts *a priori*, and rests upon that of reason. Both faculties, therefore, besides their application in point of logical form to principles of whatever origin, have, in addition, their own peculiar jurisdiction in the matter of their content, and so, there being no further (*a priori*) jurisdiction above them, the division of Philosophy into theoretical and practical is justified.

But there is still further in the family of our higher cognitive faculties a middle term between understanding and reason. This is *judgement*, of which we may reasonably presume by analogy that it may likewise contain, if not a special authority to prescribe laws, still a principle peculiar to itself upon which laws are sought, although one merely subjective *a priori*. This principle, even if it has no field of objects appropriate to it as its realm, may still have some territory or other with a certain character, for which just this very principle alone may be valid.

But in addition to the above considerations there is yet (to judge by analogy) a further ground, upon which judgement may be brought into line with another arrangement of our powers of representation, and one that appears to be of even greater importance than that of its kinship with the family of cognitive faculties. For all faculties of the soul,

or capacities, are reducible to three, which do not admit of any further derivation from a common ground: the *faculty of knowledge*, the *feeling of pleasure or displeasure*, and the *faculty of desire*.[1] For the faculty of cognition understanding alone is legislative, if (as must be the case where it is considered on its own account free of confusion with the faculty of desire) this faculty, as that of *theoretical cognition*, is referred to nature, in respect of which alone (as phenomenon) it is possible for us to prescribe laws by means of *a priori* concepts of nature, which are properly pure concepts of understanding.—For the faculty of desire, as a higher faculty operating under the concept of freedom, only reason (in which alone this concept has a place) prescribes laws *a priori*.— Now between the faculties of knowledge and desire stands the feeling of pleasure, just as judgement is intermediate between understanding and reason. Hence we may, provisionally at least, assume that judgement likewise contains an *a priori* principle of its own, and that, since pleasure or displeasure is necessarily combined with the faculty of desire (be it antecedent to its principle, as with the lower desires, or, as with the higher, only supervening upon its determination by the moral law), it will effect a transition from the faculty of pure knowledge, i.e. from the realm of concepts of nature, to that of the concept of freedom, just as in its logical employment it makes possible the transition from understanding to reason.

Hence, despite the fact of Philosophy being only divisible into two principal parts, the theoretical and the practical, and despite the fact of all that we may have to say of the special principles of judgement having to be assigned to its theoretical part, i.e. to rational cognition according to concepts of nature: still the Critique of pure reason, which must settle this whole question before the above system is taken in hand, so as to substantiate its possibility, consists of three parts: the Critique of pure understanding, of pure judgement, and of pure reason, which faculties are called pure on the ground of their being legislative *a priori*.

IV Judgement as a Faculty by which Laws are prescribed *a priori*

Judgement in general is the faculty of thinking the particular as contained under the universal. If the universal (the rule, principle, or law) is given, then the judgement which subsumes the particular under it *is determinant*. This is so even where such a judgement is transcendental and, as such, provides the conditions *a priori* in conformity with which alone subsumption under that universal can be effected. If, however, only the particular is given and the universal has to be found for it, then the judgement is simply *reflective*.

The determinant judgement determines under universal transcendental laws furnished by understanding and is subsumptive only; the law is marked out for it *a priori*, and it has no need to devise a law for its own guidance to enable it to subordinate the particular in nature to the

universal.—But there are such manifold forms of nature, so many modifications, as it were, of the universal transcendental concepts of nature, left undetermined by the laws furnished by pure understanding *a priori* as above mentioned, and for the reason that these laws only touch the general possibility of a nature, (as an object of sense), that there must needs also be laws in this behalf. These laws, being empirical, may be contingent as far as the light of *our* understanding goes, but still, if they are to be called laws, (as the concept of a nature requires), they must be regarded as necessary on a principle, unknown though it be to us, of the unity of the manifold.—The reflective judgement which is compelled to ascend from the particular in nature to the universal, stands, therefore, in need of a principle. This principle it cannot borrow from experience, because what it has to do is to establish just the unity of all empirical principles under higher, though likewise empirical, principles, and thence the possibility of the systematic subordination of higher and lower. Such a transcendental principle, therefore, the reflective judgement can only give as a law from and to itself. It cannot derive it from any other quarter (as it would then be a determinant judgement). Nor can it prescribe it to nature, for reflection on the laws of nature adjusts itself to nature, and not nature to the conditions according to which we strive to obtain a concept of it,—a concept that is quite contingent in respect of these conditions.

Now the principle sought can only be this: as universal laws of nature have their ground in our understanding, which prescribes them to nature (though only according to the universal concept of it as nature), particular empirical laws must be regarded, in respect of that which is left undetermined in them by these universal laws, according to a unity such as they would have if an understanding (though it be not ours) had supplied them for the benefit of our cognitive faculties, so as to render possible a system of experience according to particular natural laws. This is not to be taken as implying that such an understanding must be actually assumed, (for it is only the reflective judgement which avails itself of this idea as a principle for the purpose of reflection and not for determining anything); but this faculty rather gives by this means a law to itself alone and not to nature.

Now the concept of an Object, so far as it contains at the same time the ground of the actuality of this Object, is called its *end*, and the agreement of a thing with that constitution of things which is only possible according to ends, is called the *finality* of its form. Accordingly the principle of judgement, in respect of the form of the things of nature under empirical laws generally, is the *finality of nature* in its multiplicity. In other words, by this concept nature is represented as if an understanding contained the ground of the unity of the manifold of its empirical laws.

The finality of nature is, therefore, a particular *a priori* concept, which has its origin solely in the reflective judgement. For we cannot

ascribe to the products of nature anything like a reference of nature in them to ends, but we can only make use of this concept to reflect upon them in respect of the nexus of phenomena in nature—a nexus given according to empirical laws. Furthermore, this concept is entirely different from practical finality (in human art or even morals), though it is doubtless thought after this analogy. […]

PART I Critique of Aesthetic Judgement
First Section Analytic of Aesthetic Judgement
First Book Analytic of the Beautiful
First Moment of the Judgement of Taste[2]: Moment of Quality
§ 1 The judgement of taste is aesthetic.

If we wish to discern whether anything is beautiful or not, we do not refer the representation of it to the Object by means of understanding with a view to cognition, but by means of the imagination (acting perhaps in conjunction with understanding) we refer the representation to the Subject and its feeling of pleasure or displeasure. The judgement of taste, therefore, is not a cognitive judgement, and so not logical, but is aesthetic—which means that it is one whose determining ground *cannot be other than subjective*. Every reference of representations is capable of being objective, even that of sensations (in which case it signifies the real in an empirical representation). The one exception to this is the feeling of pleasure or displeasure. This denotes nothing in the object, but is a feeling which the Subject has of itself and of the manner in which it is affected by the representation.

To apprehend a regular and appropriate building with one's cognitive faculties, be the mode of representation clear or confused, is quite a different thing from being conscious of this representation with an accompanying sensation of delight. Here the representation is referred wholly to the Subject, and what is more to its feeling of life—under the name of the feeling of pleasure or displeasure—and this forms the basis of a quite separate faculty of discriminating and estimating, that contributes nothing to knowledge. All it does is to compare the given representation in the Subject with the entire faculty of representations of which the mind is conscious in the feeling of its state. Given representations in a judgement may be empirical, and so aesthetic; but the judgement which is pronounced by their means is logical, provided it refers them to the Object. Conversely, be the given representations even rational, but referred in a judgement solely to the Subject (to its feeling), they are always to that extent aesthetic.

§ 2 The delight which determines the judgement of taste is independent of all interest.

The delight which we connect with the representation of the real existence of an object is called interest. Such a delight, therefore, always in-

volves a reference to the faculty of desire, either as its determining ground, or else as necessarily implicated with its determining ground. Now, where the question is whether something is beautiful, we do not want to know, whether we, or any one else, are, or even could be, concerned in the real existence of the thing, but rather what estimate we form of it on mere contemplation (intuition or reflection). If any one asks me whether I consider that the palace I see before me is beautiful, I may, perhaps, reply that I do not care for things of that sort that are merely made to be gaped at. Or I may reply in the same strain as that Iroquois *sachem* who said that nothing in Paris pleased him better than the eating-houses. I may even go a step further and inveigh with the vigour of a *Rousseau* against the vanity of the great who spend the sweat of the people on such superfluous things. Or, in fine, I may quite easily persuade myself that if I found myself on an uninhabited island, without hope of ever again coming among men, and could conjure such a palace into existence by a mere wish, I should still not trouble to do so, so long as I had a hut there that was comfortable enough for me. All this may be admitted and approved; only it is not the point now at issue. All one wants to know is whether the mere representation of the object is to my liking, no matter how indifferent I may be to the real existence of the object of this representation. It is quite plain that in order to say that the object *is beautiful*, and to show that I have taste, everything turns on the meaning which I can give to this representation, and not on any factor which makes me dependent on the real existence of the object. Every one must allow that a judgement on the beautiful which is tinged with the slightest interest, is very partial and not a pure judgement of taste. One must not be in the least prepossessed in favour of the real existence of the thing, but must preserve complete indifference in this respect, in order to play the part of judge in matters of taste.

This proposition, which is of the utmost importance, cannot be better explained than by contrasting the pure disinterested[3] delight which appears in the judgement of taste with that allied to an interest—especially if we can also assure ourselves that there are no other kinds of interest beyond those presently to be mentioned.

§ 3 Delight in the agreeable is coupled with interest.

That is AGREEABLE *which the senses find pleasing in sensation*. This at once affords a convenient opportunity for condemning and directing particular attention to a prevalent confusion of the double meaning of which the word 'sensation' is capable. All delight (as is said or thought) is itself sensation (of a pleasure). Consequently everything that pleases, and for the very reason that it pleases, is agreeable—and according to its different degrees, or its relations to other agreeable sensations, is attractive, charming, delicious, enjoyable, &c. But if this is conceded,

then impressions of sense, which determine inclination, or principles of reason, which determine the will, or mere contemplated forms of intuition, which determine judgement, are all on a par in everything relevant to their effect upon the feeling of pleasure, for this would be agreeableness in the sensation of one's state; and since, in the last resort, all the elaborate work of our faculties must issue in and unite in the practical as its goal, we could credit our faculties with no other appreciation of things and the worth of things, than that consisting in the gratification which they promise. How this is attained is in the end immaterial; and, as the choice of the means is here the only thing that can make a difference, men might indeed blame one another for folly or imprudence, but never for baseness or wickedness; for they are all, each according to his own way of looking at things, pursuing one goal, which for each is the gratification in question.

When a modification of the feeling of pleasure or displeasure is termed sensation, this expression is given quite a different meaning to that which it bears when I call the representation of a thing (through sense as a receptivity pertaining to the faculty of knowledge) sensation. For in the latter case the representation is referred to the Object, but in the former it is referred solely to the Subject and is not available for any cognition, not even for that by which the Subject *cognizes* itself.

Now in the above definition the word sensation is used to denote an objective representation of sense; and, to avoid continually running the risk of misinterpretation, we shall call that which must always remain purely subjective, and is absolutely incapable of forming a representation of an object, by the familiar name of feeling. The green colour of the meadows belongs to *objective* sensation, as the perception of an object of sense; but its agreeableness to *subjective* sensation, by which no object is represented: i.e. to feeling, through which the object is regarded as an Object of delight (which involves no cognition of the object).

Now, that a judgement on an object by which its agreeableness is affirmed, expresses an interest in it, is evident from the fact that through sensation it provokes a desire for similar objects, consequently the delight presupposes, not the simple judgement about it, but the bearing its real existence has upon my state so far as affected by such an Object. Hence we do not merely say of the agreeable that it *pleases*, but that it *gratifies*. I do not accord it a simple approval, but inclination is aroused by it, and where agreeableness is of the liveliest type a judgement on the character of the Object is so entirely out of place, that those who are always intent only on enjoyment (for that is the word used to denote intensity of gratification) would fain dispense with all judgement.

§ 4 Delight in the good is coupled with interest.

That is *good* which by means of reason commends itself by its mere

concept. We call that *good for something* (useful) which only pleases as a means; but that which pleases on its own account we call *good in itself*. In both cases the concept of an end is implied, and consequently the relation of reason to (at least possible) willing, and thus a delight in the *existence* of an Object or action, i.e. some interest or other.

To deem something good, I must always know what sort of a thing the object is intended to be, i.e. I must have a concept of it. That is not necessary to enable me to see beauty in a thing. Flowers, free patterns, lines aimlessly intertwining—technically termed foliage—have no signification, depend upon no definite concept, and yet please. Delight in the beautiful must depend upon the reflection on an object precursory to some (not definitely determined) concept. It is thus also differentiated from the agreeable, which rests entirely upon sensation.

In many cases, no doubt, the agreeable and the good seem convertible terms. Thus it is commonly said that all (especially lasting) gratification is of itself good; which is almost equivalent to saying that to be permanently agreeable and to be good are identical. But it is readily apparent that this is merely a vicious confusion of words, for the concepts appropriate to these expressions are far from interchangeable. The agreeable, which, as such, represents the object solely in relation to sense, must in the first instance be brought under principles of reason through the concept of an end, to be, as an object of will, called good. But that the reference to delight is wholly different where what gratifies is at the same time called *good*, is evident from the fact that with the good the question always is whether it is mediately or immediately good, i.e. useful or good in itself; whereas with the agreeable this point can never arise, since the word always means what pleases immediately—and it is just the same with what I call beautiful.

Even in everyday parlance a distinction is drawn between the agreeable and the good. We do not scruple to say of a dish that stimulates the palate with spices and other condiments that it is agreeable—owning all the while that it is not good: because, while it immediately *satisfies* the senses, it is mediately displeasing, i.e. in the eye of reason that looks ahead to the consequences. Even in our estimate of health this same distinction may be traced. To all that possess it, it is immediately agreeable—at least negatively, i.e. as remoteness of all bodily pains. But, if we are to say that it is good, we must further apply to reason to direct it to ends, that is, we must regard it as a state that puts us in a congenial mood for all we have to do. Finally, in respect of happiness every one believes that the greatest aggregate of the pleasures of life, taking duration as well as number into account, merits the name of a true, nay even of the highest, good. But reason sets its face against this too. Agreeableness is enjoyment. But if this is all that we are bent on, it would be foolish to be scrupulous about the

means that procure it for us—whether it be obtained passively by the bounty of nature or actively and by the work of our own hands. But that there is any intrinsic worth in the real existence of a man who merely lives for *enjoyment*, however busy he may be in this respect, even when in so doing he serves others—all equally with himself intent only on enjoyment—as an excellent means to that one end, and does so, moreover, because through sympathy he shares all their gratifications,—this is a view to which reason will never let itself be brought round. Only by what a man does heedless of enjoyment, in complete freedom and independently of what he can procure passively from the hand of nature, does he give to his existence, as the real existence of a person, an absolute worth. Happiness, with all its plethora of pleasures, is far from being an unconditioned good.[4]

But, despite all this difference between the agreeable and the good, they both agree in being invariably coupled with an interest in their object. This is true, not alone of the agreeable, § 3, and of the mediately good, i.e. the useful, which pleases as a means to some pleasure, but also of that which is good absolutely and from every point of view, namely the moral good which carries with it the highest interest. For the good is the Object of will, i.e. of a rationally determined faculty of desire. But to will something, and to take a delight in its existence, i.e. to take an interest in it, are identical.

§ 5 Comparison of the three specifically different kinds of delight.

Both the Agreeable and the Good involve a reference to the faculty of desire, and are thus attended, the former with a delight pathologically conditioned (by stimuli), the latter with a pure practical delight. Such delight is determined not merely by the representation of the object, but also by the represented bond of connexion between the Subject and the real existence of the object. It is not merely the object, but also its real existence, that pleases. On the other hand the judgement of taste is simply *contemplative*, i.e. it is a judgement which is indifferent as to the existence of an object, and only decides how its character stands with the feeling of pleasure and displeasure. But not even is this contemplation itself directed to concepts; for the judgement of taste is not a cognitive judgement (neither a theoretical one nor a practical), and hence, also, is not *grounded* on concepts, nor yet *intentionally directed* to them.

The agreeable, the beautiful, and the good thus denote three different relations of representations to the feeling of pleasure and displeasure, as a feeling in respect of which we distinguish different objects or modes of representation. Also, the corresponding expressions which indicate our satisfaction in them are different. The *agreeable* is what GRATIFIES a man; the *beautiful* what simply PLEASES him; the *good* what is ESTEEMED (*approved*), i.e. that on which he sets an objective worth. Agreeableness is a significant factor even with irrational

animals; beauty has purport and significance only for human beings, i.e. for beings at once animal and rational (but not merely for them as rational—intelligent beings—but only for them as at once animal and rational); whereas the good is good for every rational being in general; —a proposition which can only receive its complete justification and explanation in the sequel. Of all these three kinds of delight, that of taste in the beautiful may be said to be the one and only disinterested and *free* delight; for, with it, no interest, whether of sense or reason, extorts approval. And so we may say that delight, in the three cases mentioned, is related to *inclination*, to *favour*, or to *respect*. For FAVOUR is the only free liking. An object of inclination, and one which a law of reason imposes upon our desire, leaves us no freedom to turn anything into an object of pleasure. All interest presupposes a want, or calls one forth; and, being a ground determining approval, deprives the judgement on the object of its freedom.

So far as the interest of inclination in the case of the agreeable goes, every one says: Hunger is the best sauce; and people with a healthy appetite relish everything, so long as it is something they can eat. Such delight, consequently, gives no indication of taste having anything to say to the choice. Only when men have got all they want can we tell who among the crowd has taste or not. Similarly there may be correct habits (conduct) without virtue, politeness without good-will, propriety without honour, &c. For where the moral law dictates, there is, objectively, no room left for free choice as to what one has to do; and to show taste in the way one carries out these dictates, or in estimating the way others do so, is a totally different matter from displaying the moral frame of one's mind. For the latter involves a command and produces a need of something, whereas moral taste only plays with the objects of delight without devoting itself sincerely to any.

Definition of the beautiful derived from the first moment.
Taste is the faculty of estimating an object or a mode of representation by means of a delight or aversion *apart from any interest*. The object of such a delight is called *beautiful*.

Second Moment of the Judgement of Taste: Moment of Quantity
§6 The beautiful is that which, apart from concepts, is represented as the Object of a universal delight.
This definition of the beautiful is deducible from the foregoing definition of it as an object of delight apart from any interest. For where any one is conscious that his delight in an object is with him independent of interest, it is inevitable that he should look on the object as one containing a ground of delight for all men. For, since the delight is not based on any inclination of the Subject (or on any other deliberate

interest), but the Subject feels himself completely *free* in respect of the liking which he accords to the object, he can find as reason for his delight no personal conditions to which his own subjective self might alone be party. Hence he must regard it as resting on what he may also presuppose in every other person; and therefore he must believe that he has reason for demanding a similar delight from every one. Accordingly he will speak of the beautiful as if beauty were a quality of the object and the judgement logical (forming a cognition of the Object by concepts of it); although it is only aesthetic, and contains merely a reference of the representation of the object to the Subject;—because it still bears this resemblance to the logical judgement, that it may be presupposed to be valid for all men. But this universality cannot spring from concepts. For from concepts there is no transition to the feeling of pleasure or displeasure (save in the case of pure practical laws, which, however, carry an interest with them; and such an interest does not attach to the pure judgement of taste). The result is that the judgement of taste, with its attendant consciousness of detachment from all interest, must involve a claim to validity for all men, and must do so apart from universality attached to Objects, i.e. there must be coupled with it a claim to subjective universality.

§ 7 Comparison of the beautiful with the agreeable and the good by means of the above characteristic.

As regards the *agreeable* every one concedes that his judgement, which he bases on a private feeling, and in which he declares that an object pleases him, is restricted merely to himself personally. Thus he does not take it amiss if, when he says that Canary-wine is agreeable, another corrects the expression and reminds him that he ought to say: It is agreeable *to me*. This applies not only to the taste of the tongue, the palate, and the throat, but to what may with any one be agreeable to eye or ear. A violet colour is to one soft and lovely: to another dull and faded. One man likes the tone of wind instruments, another prefers that of string instruments. To quarrel over such points with the idea of condemning another's judgement as incorrect when it differs from our own, as if the opposition between the two judgements were logical, would be folly. With the agreeable, therefore, the axiom holds good: *Every one has his own taste* (that of sense).

The beautiful stands on quite a different footing. It would, on the contrary, be ridiculous if any one who plumed himself on his taste were to think of justifying himself by saying: This object (the building we see, the dress that person has on, the concert we hear, the poem submitted to our criticism) is beautiful *for me*. For if it merely pleases *him*, he must not call it *beautiful*. Many things may for him possess charm and agreeableness—no one cares about that; but when he puts a thing on a pedestal and calls it beautiful, he demands the same delight from

others. He judges not merely for himself, but for all men, and then speaks of beauty as if it were a property of things. Thus he says the *thing* is beautiful; and it is not as if he counted on others agreeing in his judgement of liking owing to his having found them in such agreement on a number of occasions, but he *demands* this agreement of them. He blames them if they judge differently, and denies them taste, which he still requires of them as something they ought to have; and to this extent it is not open to men to say: Every one has his own taste. This would be equivalent to saying that there is no such thing at all as taste, i.e. no aesthetic judgement capable of making a rightful claim upon the assent of all men.

Yet even in the case of the agreeable we find that the estimates men form do betray a prevalent agreement among them, which leads to our crediting some with taste and denying it to others, and that, too, not as an organic sense but as a critical faculty in respect of the agreeable generally. So of one who knows how to entertain his guests with pleasures (of enjoyment through all the senses) in such a way that one and all are pleased, we say that he has taste. But the universality here is only understood in a comparative sense; and the rules that apply are, like all empirical rules, *general* only, not *universal*,—the latter being what the judgement of taste. upon the beautiful deals or claims to deal in. It is a judgement in respect of sociability so far as resting on empirical rules. In respect of the good it is true that judgements also rightly assert a claim to validity for every one; but the good is only represented as an Object of universal delight *by means of a concept*, which is the case neither with the agreeable nor the beautiful.

§ 8 In a judgement of taste the universality of delight is only represented as subjective.

This particular form of the universality of an aesthetic judgement, which is to be met with in a judgement of taste, is a significant feature, not for the logician certainly, but for the transcendental philosopher. It calls for no small effort on his part to discover its origin, but in return it brings to light a property of our cognitive faculty which, without this analysis, would have remained unknown.

First, one must get firmly into one's mind that by the judgement of taste (upon the beautiful) the delight in an object is imputed to *every one*, yet without being founded on a concept (for then it would be the good), and that this claim to universality is such an essential factor of a judgement by which we describe anything as *beautiful*, that were it not for its being present to the mind it would never enter into any one's head to use this expression, but everything that pleased without a concept would be ranked as agreeable. For in respect of the agreeable every one is allowed to have his own opinion, and no one insists upon others agreeing with his judgement of taste, which is what is invariably done

in the judgement of taste about beauty. The first of these I may call the taste of sense, the second, the taste of reflection: the first laying down judgements merely private, the second, on the other hand, judgements ostensibly of general validity (public), but both alike being aesthetic (not practical) judgements about an object merely in respect of the bearings of its representation on the feeling of pleasure or displeasure. Now it does seem strange that while with the taste of sense it is not alone experience that shows that its judgement (of pleasure or displeasure in something) is not universally valid, but every one willingly refrains from imputing this agreement to others (despite the frequent actual prevalence of a considerable consensus of general opinion even in these judgements), the taste of reflection, which, as experience teaches, has often enough to put up with a rude dismissal of its claims to universal validity of its judgement (upon the beautiful), can (as it actually does) find it possible for all that, to formulate judgements capable of demanding this agreement in its universality. Such agreement it does in fact require from every one for each of its judgements of taste,—the persons who pass these judgements not quarrelling over the possibility of such a claim, but only failing in particular cases to come to terms as to the correct application of this faculty.

First of all we have here to note that a universality which does not rest upon concepts of the Object (even though these are only empirical) is in no way logical, but aesthetic, i.e. does not involve any objective quantity of the judgement, but only one that is subjective. For this universality I use the expression *general validity*, which denotes the validity of the reference of a representation, not to the cognitive faculties, but to the feeling of pleasure or displeasure for every Subject. (The same expression, however, may also be employed for the logical quantity of the judgement, provided we add *objective* universal validity, to distinguish it from the merely subjective validity which is always aesthetic.)

Now a judgement that has *objective universal validity* has always got the subjective also, i.e. if the judgement is valid for everything which is contained under a given concept, it is valid also for all who represent an object by means of this concept. But from a *subjective universal validity*, i.e. the aesthetic, that does not rest on any concept, no conclusion can be drawn to the logical; because judgements of that kind have no bearing upon the Object. But for this very reason the aesthetic universality attributed to a judgement must also be of a special kind, seeing that it does not join the predicate of beauty to the concept of the *Object* taken in its entire logical sphere, and yet does extend this predicate over the whole sphere of *judging Subjects*.

In their logical quantity all judgements of taste are *singular* judgements. For, since I must present the object immediately to my feeling

of pleasure or displeasure, and that, too, without the aid of concepts, such judgements cannot have the quantity of judgements with objective general validity. Yet by taking the singular representation of the Object of the judgement of taste, and by comparison converting it into a concept according to the conditions determining that judgement, we can arrive at a logically universal judgement. For instance, by a judgement of taste I describe the rose at which I am looking as beautiful. The judgement, on the other hand, resulting from the comparison of a number of singular representations: Roses in general are beautiful, is no longer pronounced as a purely aesthetic judgement, but as a logical judgement founded on one that is aesthetic. Now the judgement, 'The rose is agreeable' (to smell) is also, no doubt, an aesthetic and singular judgement, but then it is not one of taste but of sense. For it has this point of difference from a judgement of taste, that the latter imports an *aesthetic quantity* of universality, i.e. of validity for every one which is not to be met with in a judgement upon the agreeable. It is only judgements upon the good which, while also determining the delight in an object, possess logical and not mere aesthetic universality; for it is as involving a cognition of the Object that they are valid of it, and on that account valid for every one.

In forming an estimate of Objects merely from concepts, all representation of beauty goes by the board. There can, therefore, be no rule according to which any one is to be compelled to recognize anything as beautiful. Whether a dress, a house, or a flower is beautiful is a matter upon which one declines to allow one's judgement to be swayed by any reasons or principles. We want to get a look at the Object with our own eyes, just as if our delight depended on sensation. And yet, if upon so doing, we call the Object beautiful, we believe ourselves to be speaking with a universal voice, and lay claim to the concurrence of every one, whereas no private sensation would be decisive except for the observer alone and *his* liking.

Here, now, we may perceive that nothing is postulated in the judgement of taste but such a *universal voice* in respect of delight that is not mediated by concepts; consequently, only the *possibility* of an aesthetic judgement capable of being at the same time deemed valid for every one. The judgement of taste itself does not *postulate* the agreement of every one (for it is only competent for a logically universal judgement to do this, in that it is able to bring forward reasons); it only *imputes* this agreement to every one, as an instance of the rule in respect of which it looks for confirmation, not from concepts, but from the concurrence of others. The universal voice is, therefore, only an idea—resting upon grounds the investigation of which is here postponed. It may be a matter of uncertainty whether a person who thinks he is laying down a judgement of taste is, in fact, judging in conformity with that idea; but that this idea is what is contemplated

in his judgement, and that, consequently, it is meant to be a judgement of taste, is proclaimed by his use of the expression 'beauty'. For himself he can be certain on the point from his mere consciousness of the separation of everything belonging to the agreeable and the good from the delight remaining to him; and this is all for which he promises himself the agreement of every one—a claim which, under these conditions, he would also be warranted in making, were it not that he frequently sinned against them, and thus passed an erroneous judgement of taste. […]

Definition of the beautiful drawn from the second moment.

The *beautiful* is that which, apart from a concept, pleases universally.

Third Moment of Judgements of Taste: Moment of the Relation of the Ends Brought under Review in such Judgements.
§10 Finality in general.

Let us define the meaning of 'an end' in transcendental terms (i.e. without presupposing anything empirical, such as the feeling of pleasure). An end is the object of a concept so far as this concept is regarded as the cause of the object (the real ground of its possibility); and the causality of a *concept* in respect of its *Object* is finality (*forma finalis*). Where, then, not the cognition of an object merely, but the object itself (its form or real existence) as an effect, is thought to be possible only through a concept of it, there we imagine an end. The representation of the effect is here the determining ground of its cause and takes the lead of it. The consciousness of the causality of a representation in respect of the state of the Subject as one tending *to preserve a continuance* of that state, may here be said to denote in a general way what is called pleasure; whereas displeasure is that representation which contains the ground for converting the state of the representations into their opposite (for hindering or removing them).

The faculty of desire, so far as determinable only through concepts, i.e. so as to act in conformity with the representation of an end, would be the will. But an Object, or state of mind, or even an action may, although its possibility does not necessarily presuppose the representation of an end, be called final simply on account of its possibility being only explicable and intelligible for us by virtue of an assumption on our part of a fundamental causality according to ends, i.e. a will that would have so ordained it according to a certain represented rule. Finality, therefore, may exist apart from an end, in so far as we do not locate the causes of this form in a will, but yet are able to render the explanation of its possibility intelligible to ourselves only by deriving it from a will. Now we are not always obliged to look with the eye of reason into what we observe (i.e. to consider it in its possibility). So we may at least observe a finality of form, and trace it in objects—though by reflection

only—without resting it on an end (as the material of the *nexus finalis*).

§ 11 The sole foundation of the judgement of taste is the form of finality of an object (or mode of representing it).

Whenever an end is regarded as a source of delight it always imports an interest as determining ground of the judgement on the object of pleasure. Hence the judgement of taste cannot rest on any subjective end as its ground. But neither can any representation of an objective end, i.e. of the possibility of the object itself on principles of final connexion, determine the judgement of taste, and, consequently, neither can any concept of the good. For the judgement of taste is an aesthetic and not a cognitive judgement, and so does not deal with any *concept* of the nature or of the internal or external possibility, by this or that cause, of the object, but simply with the relative bearing of the representative powers so far as determined by a representation.

Now this relation, present when an object is characterized as beautiful, is coupled with the feeling of pleasure. This pleasure is by the judgement of taste pronounced valid for every one; hence an agreeableness attending the representation is just as incapable of containing the determining ground of the judgement as the representation of the perfection of the object or the concept of the good. We are thus left with the subjective finality in the representation of an object, exclusive of any end (objective or subjective)—consequently the bare form of finality in the representation whereby an object is *given* to us, so far as we are conscious of it—as that which is alone capable of constituting the delight which, apart from any concept, we estimate as universally communicable, and so of forming the determining ground of the judgement of taste. [...]

§ 17 The Ideal of beauty.

There can be no objective rule of taste by which what is beautiful may be defined by means of concepts. For every judgement from that source is aesthetic, i.e. its determining ground is the feeling of the Subject, and not any concept of an Object. It is only throwing away labour to look for a principle of taste that affords a universal criterion of the beautiful by definite concepts; because what is sought is a thing impossible and inherently contradictory. But in the universal communicability of the sensation (of delight or aversion)—a communicability, too, that exists apart from any concept—in the accord, so far as possible, of all ages and nations as to this feeling in the representation of certain objects, we have the empirical criterion, weak indeed and scarce sufficient to raise a presumption, of the derivation of a taste, thus confirmed by examples, from grounds deep-seated and shared alike by all men, underlying their agreement in estimating the forms under which objects are given to them.

For this reason some products of taste are looked on as *exemplary*—not meaning thereby that by imitating others taste may be acquired. For taste must be an original faculty; whereas one who imitates a model, while showing skill commensurate with his success, only displays taste as himself a critic of this model.[5] Hence it follows that the highest model, the archetype of taste, is a mere idea, which each person must beget in his own consciousness, and according to which he must form his estimate of everything that is an Object of taste, or that is an example of critical taste, and even of universal taste itself. Properly speaking, an *idea* signifies a concept of reason, and an *ideal* the representation of an individual existence as adequate to an idea. Hence this archetype of taste—which rests, indeed, upon reason's indeterminate idea of a maximum, but is not, however, capable of being represented by means of concepts, but only in an individual presentation—may more appropriately be called the ideal of the beautiful. While not having this ideal in our possession, we still strive to beget it within us. But it is bound to be merely an ideal of the imagination, seeing that it rests, not upon concepts, but upon the presentation—the faculty of presentation being the imagination.—Now, how do we arrive at such an ideal of beauty? Is it *a priori* or empirically? Further, what species of the beautiful admits of an ideal?

First of all, we do well to observe that the beauty for which an ideal has to be sought cannot be a beauty that is *free and at large*, but must be one *fixed* by a concept of objective finality. Hence it cannot belong to the Object of an altogether pure judgement of taste, but must attach to one that is partly intellectual. In other words, where an ideal is to have place among the grounds upon which any estimate is formed, then beneath grounds of that kind there must lie some idea of reason according to determinate concepts, by which the end underlying the internal possibility of the object is determined *a priori*. An ideal of beautiful flowers, of a beautiful suite of furniture, or of a beautiful view, is unthinkable. But, it may also be impossible to represent an ideal of a beauty dependent on definite ends, e.g. a beautiful residence, a beautiful tree, a beautiful garden, &c., presumably because their ends are not sufficiently defined and fixed by their concept, with the result that their finality is nearly as free as with beauty that is quite *at large*. Only what has in itself the end of its real existence—only *man* that is able himself to determine his ends by reason, or, where he has to derive them from external perception, can still compare them with essential and universal ends, and then further pronounce aesthetically upon their accord with such ends, only he, among all objects in the world, admits, therefore, of an ideal of *beauty*, just as humanity in his person, as intelligence, alone admits of the ideal of *perfection*.

Two factors are here involved. *First*, there is the aesthetic *normal idea*, which is an individual intuition (of the imagination). This repres-

ents the norm by which we judge of a man as a member of a particular animal species. *Secondly*, there is the *rational idea*. This deals with the ends of humanity so far as capable of sensuous representation, and converts them into a principle for estimating his outward form, through which these ends are revealed in their phenomenal effect. The normal idea must draw from experience the constituents which it requires for the form of an animal of a particular kind. But the greatest finality in the construction of this form—that which would serve as a universal norm for forming an estimate of each individual of the species in question—the image that, as it were, forms an intentional basis underlying the technic of nature, to which no separate individual, but only the race as a whole, is adequate, has its seat merely in the idea of the judging Subject. Yet it is, with all its proportions, an aesthetic idea, and, as such, capable of being fully presented *in concreto* in a model image. Now, how is this effected? In order to render the process to some extent intelligible (for who can wrest nature's whole secret from her?), let us attempt a psychological explanation.

It is of note that the imagination, in a manner quite incomprehensible to us, is able on occasion, even after a long lapse of time, not alone to recall the signs for concepts, but also to reproduce the image and shape of an object out of a countless number of others of a different, or even of the very same, kind. And, further, if the mind is engaged upon comparisons, we may well suppose that it can in actual fact, though the process is unconscious, superimpose as it were one image upon another, and from the coincidence of a number of the same kind arrive at a mean contour which serves as a common standard for all. Say, for instance, a person has seen a thousand full-grown men. Now if he wishes to judge normal size determined upon a comparative estimate, then imagination (to my mind) allows a great number of these images (perhaps the whole thousand) to fall one upon the other, and, if I may be allowed to extend to the case the analogy of optical presentation, in the space where they come most together, and within the contour where the place is illuminated by the greatest concentration of colour, one gets a perception of the *average size*, which alike in height and breadth is equally removed from the extreme limits of the greatest and smallest statures; and this is the stature of a beautiful man. (The same result could be obtained in a mechanical way, by taking the measures of all the thousand, and adding together their heights, and their breadths (and thicknesses), and dividing the sum in each case by a thousand). But the power of imagination does all this by means of a dynamical effect upon the organ of internal sense, arising from the frequent apprehension of such forms. If, again, for our average man we seek on similar lines for the average head, and for this the average nose, and so on, then we get the figure that underlies the normal idea of a beautiful man in the country where the comparison is instituted. For this reason

a negro must necessarily (under these empirical conditions) have a different normal idea of the beauty of forms from what a white man has, and the Chinaman one different from the European. And the process would be just the same with the *model* of a beautiful horse or dog (of a particular breed).—This *normal idea* is not derived from proportions taken from experience *as definite rules*: rather is it according to this idea that rules for forming estimates first become possible. It is an intermediate between all singular intuitions of individuals, with their manifold variations—a floating image for the whole genus, which nature has set as an archetype underlying those of her products that belong to the same species, but which in no single case she seems to have completely attained. But the normal idea is far from giving the complete *archetype* of *beauty* in the genus. It only gives the form that constitutes the indispensable condition of all beauty, and, consequently, only *correctness* in the presentation of the genus. It is, as the famous *Doryphorus* of *Polycletus* was called, the *rule* (and *Myron's* Cow might be similarly employed for its kind). It cannot, for that very reason, contain anything specifically characteristic; for otherwise it would not be the *normal idea* for the genus. Further, it is not by beauty that its presentation pleases, but merely because it does not contradict any of the conditions under which alone a thing belonging to this genus can be beautiful. The presentation is merely academically correct.[6]

But the *ideal* of the beautiful is still something different from its *normal idea*. For reasons already stated it is only to be sought in the *human figure*. Here the ideal consists in the expression of the *moral*, apart from which the object would not please at once universally and positively (not merely negatively in a presentation academically correct). The visible expression of moral ideas that govern men inwardly can, of course, only be drawn from experience; but their combination with all that our reason connects with the morally good in the idea of the highest finality—benevolence, purity, strength, or equanimity, &c.—may be made, as it were, visible in bodily manifestation (as effect of what is internal), and this embodiment involves a union of pure ideas of reason and great imaginative power, in one who would even form an estimate of it, not to speak of being the author of its presentation. The correctness of such an ideal of beauty is evidenced by its not permitting any sensuous charm to mingle with the delight in its Object, in which it still allows us to take a great interest. This fact in turn shows that an estimate formed according to such a standard can never be purely aesthetic, and that one formed according to an ideal of beauty cannot be a simple judgement of taste.

Definition of the beautiful derived from this third moment

Beauty is the form of *finality* in an object, so far as perceived in it *apart from the representation of an end.*[7]

Fourth Moment of the Judgement of Taste: Moment of the Modality of the Delight in the Object

§ 18 Nature of the modality in a judgement of taste.

I may assert in the case of every representation that the synthesis of a pleasure with the representation (as a cognition) is at least *possible*. Of what I call *agreeable* I assert that it *actually* causes pleasure in me. But what we have in mind in the case of the *beautiful* is a *necessary* reference on its part to delight. However, this necessity is of a special kind. It is not a theoretical objective necessity—such as would let us cognize *a priori* that every one *will feel* this delight in the object that is called beautiful by me. Nor yet is it a practical necessity, in which case, thanks to concepts of a pure rational will in which free agents are supplied with a rule, this delight is the necessary consequence of an objective law, and simply means that one ought absolutely (without ulterior object) to act in a certain way. Rather, being such a necessity as is thought in an aesthetic judgement, it can only be termed *exemplary*. In other words it is a necessity of the assent of *all* to a judgement regarded as exemplifying a universal rule incapable of formulation. Since an aesthetic judgement is not an objective or cognitive judgement, this necessity is not derivable from definite concepts, and so is not apodictic. Much less is it inferable from universality of experience (of a thorough-going agreement of judgements about the beauty of a certain object). For, apart from the fact that experience would hardly furnish evidences sufficiently numerous for this purpose, empirical judgements do not afford any foundation for a concept of the necessity of these judgements.

§ 19 The subjective necessity attributed to a judgement of taste is conditioned.

The judgement of taste exacts agreement from every one; and a person who describes something as beautiful insists that every one *ought* to give the object in question his approval and follow suit in describing it as beautiful. The *ought* in aesthetic judgements, therefore, despite an accordance with all the requisite data for passing judgement, is still only pronounced conditionally. We are suitors for agreement from every one else, because we are fortified with a ground common to all. Further, we would be able to count on this agreement, provided we were always assured of the correct subsumption of the case under that ground as the rule of approval.

§ 20 The condition of the necessity advanced by a judgement of taste is the idea of a common sense.

Were judgements of taste (like cognitive judgements) in possession of a definite objective principle, then one who in his judgement followed such a principle would claim unconditioned necessity for it. Again, were they devoid of any principle, as are those of the mere taste of

sense, then no thought of any necessity on their part would enter one's head. Therefore they must have a subjective principle, and one which determines what pleases or displeases, by means of feeling only and not through concepts, but yet with universal validity. Such a principle, however, could only be regarded as a *common sense*. This differs essentially from common understanding, which is also sometimes called common sense (*sensus communis*): for the judgement of the latter is not one by feeling, but always one by concepts, though usually only in the shape of obscurely represented principles.

The judgement of taste, therefore, depends on our presupposing the existence of a common sense. (But this is not to be taken to mean some external sense, but the effect arising from the free play of our powers of cognition.) Only under the presupposition, I repeat, of such a common sense, are we able to lay down a judgement of taste. [...]

§ 22 The necessity of the universal assent that is thought in a judgement of taste, is a subjective necessity which, under the presupposition of a common sense, is represented as objective.

In all judgements by which we describe anything as beautiful we tolerate no one else being of a different opinion, and in taking up this position we do not rest our judgement upon concepts, but only on our feeling. Accordingly we introduce this fundamental feeling not as a private feeling, but as a public sense. Now, for this purpose, experience cannot be made the ground of this common sense, for the latter is invoked to justify judgements containing an 'ought'. The assertion is not that every one *will* fall in with our judgement, but rather that every one *ought* to agree with it. Here I put forward my judgement of taste as an example of the judgement of common sense, and attribute to it on that account *exemplary* validity. Hence common sense is a mere ideal norm. With this as presupposition, a judgement that accords with it, as well as the delight in an Object expressed in that judgement, is rightly converted into a rule for every one. For the principle, while it is only subjective, being yet assumed as subjectively universal (a necessary idea for every one), could, in what concerns the consensus of different judging Subjects, demand universal assent like an objective principle, provided we were assured of our subsumption under it being correct.

This indeterminate norm of a common sense is, as a matter of fact, presupposed by us; as is shown by our presuming to lay down judgements of taste. But does such a common sense in fact exist as a constitutive principle of the possibility of experience, or is it formed for us as a regulative principle by a still higher principle of reason, that for higher ends first seeks to beget in us a common sense? Is taste, in other words, a natural and original faculty, or is it only the idea of one that is artificial and to be acquired by us, so that a judgement of taste, with its demand for universal assent, is but a requirement of reason for gener-

ating such a con*sensus*, and does the 'ought', i.e. the objective necessity of the coincidence of the feeling of all with the particular feeling of each, only betoken the possibility of arriving at some sort of unanimity in these matters, and the judgement of taste only adduce an example of the application of this principle? These are questions which as yet we are neither willing nor in a position to investigate. For the present we have only to resolve the faculty of taste into its elements, and to unite these ultimately in the idea of a common sense.

Definition of the beautiful drawn from the fourth moment

The beautiful is that which, apart from a concept, is cognized as object of a *necessary* delight. [...]

Philosophy of Fine Art

Division of the Subject

After the foregoing introductory remarks it is now time to pass on to the study of our subject itself. But the introduction, where we still are, can in this respect do no more than sketch for our apprehension a conspectus of the entire course of our subsequent scientific studies. But since we have spoken of art as itself proceeding from the absolute Idea, and have even pronounced its end to be the sensuous presentation of the Absolute itself, we must proceed, even in this conspectus, by showing, at least in general, how the particular parts of the subject emerge from the conception of artistic beauty as the presentation of the Absolute. Therefore we must attempt, in the most general way, to awaken an idea of this conception.

It has already been said that the content of art is the Idea, while its form is the configuration of sensuous material. Now art has to harmonize these two sides and bring them into a free reconciled totality. The *first* point here is the demand that the content which is to come into artistic representation should be in itself qualified for such representation. For otherwise we obtain only a bad combination, because in that case a content ill-adapted to figurativeness and external presentation is made to adopt this form, or, in other words, material explicitly prosaic is expected to find a really appropriate mode of presentation in the form antagonistic to its nature.

The *second* demand, derived from the first, requires of the content of art that it be not anything abstract in itself, but concrete, though not concrete in the sense in which the sensuous is concrete when it is contrasted with everything spiritual and intellectual and these are taken to be simple and abstract. For everything genuine in spirit and nature alike is inherently concrete and, despite its universality, has nevertheless subjectivity and particularity in itself. If we say, for example, of God that he is simply *one*, the supreme being as such, we have thereby only enunciated a dead abstraction of the sub-rational Understanding. Such a God, not apprehended himself in his concrete truth, will provide no content for art, especially not for visual art. Therefore the Jews and the Turks have not been able by art to represent their God, who does not even amount to such an abstraction of the Understanding, in

the positive way that the Christians have. For in Christianity God is set forth in his truth, and therefore as thoroughly concrete in himself, as person, as subject, and, more closely defined, as spirit. What he is as spirit is made explicit for religious apprehension as a Trinity of Persons, which yet at the same time is self-aware as *one*. Here we have essentiality or universality, and particularization, together with their reconciled unity, and only such unity is the concrete. Now since a content, in order to be true at all, must be of this concrete kind, art too demands similar concreteness, because the purely abstract universal has not in itself the determinate character of advancing to particularization and phenomenal manifestation and to unity with itself in these.

Now, *thirdly*, if a sensuous form and shape is to correspond with a genuine and therefore concrete content, it must likewise be something individual, in itself completely concrete and single. The fact that the concrete accrues to both sides of art, i.e. to both content and its presentation, is precisely the point in which both can coincide and correspond with one another; just as, for instance, the natural shape of the human body is such a sensuously concrete thing, capable of displaying spirit, which is concrete in itself, and of showing itself in conformity with it. Therefore, after all, we must put out of our minds the idea that it is purely a matter of chance that to serve as such a genuine shape an actual phenomenon of the external world is selected. For art does not seize upon this form either because it just finds it there or because there is no other; on the contrary, the concrete content itself involves the factor of external, actual, and indeed even sensuous manifestation. But then in return this sensuous concrete thing, which bears the stamp of an essentially spiritual content, is also essentially *for* our inner [apprehension]; the external shape, whereby the content is made visible and imaginable, has the purpose of existing solely for our mind and spirit. For this reason alone are content and artistic form fashioned in conformity with one another. The *purely* sensuously concrete—external nature as such—does not have this purpose for the sole reason of its origin. The variegated richly coloured plumage of birds shines even when unseen, their song dies away unheard; the torch-thistle, which blooms for only one night, withers in the wilds of the southern forests without having been admired, and these forests, jungles themselves of the most beautiful and luxuriant vegetation, with the most sweet-smelling and aromatic perfumes, rot and decay equally unenjoyed. But the work of art is not so naïvely self-centred; it is essentially a question, an address to the responsive breast, a call to the mind and the spirit.

Although illustration by art is not in this respect a matter of chance, it is, on the other hand, not the highest way of apprehending the spiritually concrete. The higher way, in contrast to representation by means of the sensuously concrete, is thinking, which in a relative sense is indeed abstract, but it must be concrete, not one-sided, if it is to be

true and rational. How far a specific content has its appropriate form in sensuous artistic representation, or whether, owing to its own nature, it essentially demands a higher, more spiritual, form, is a question of the distinction which appears at once, for example, in a comparison between the Greek gods and God as conceived by Christian ideas. The Greek god is not abstract but individual, closely related to the natural [human] form. The Christian God too is indeed a concrete personality, but is *pure* spirituality and is to be known as *spirit* and in spirit. His medium of existence is therefore essentially inner knowledge and not the external natural form through which he can be represented only imperfectly and not in the whole profundity of his nature.

But since art has the task of presenting the Idea to immediate perception in a sensuous shape and not in the form of thinking and pure spirituality as such, and, since this presenting has its value and dignity in the correspondence and unity of both sides, i.e. the Idea and its outward shape, it follows that the loftiness and excellence of art in attaining a reality adequate to its Concept will depend on the degree of inwardness and unit in which Idea and shape appear fused into one.

In this point of higher truth, as the spirituality which the artistic formation has achieved in conformity with the Concept of spirit, there lies the basis for the division of the philosophy of art. For, before reaching the true Concept of its absolute essence, the spirit has to go through a course of stages, a series grounded in this Concept itself, and to this course of the content which the spirit gives to itself there corresponds a course, immediately connected therewith, of configurations of art, in the form of which the spirit, as artist, gives itself a consciousness of itself.

This course within the spirit of art has itself in turn, in accordance with its own nature, two sides. *First*, this development is itself a spiritual and universal one, since the sequence of definite conceptions of the world, as the definite but comprehensive consciousness of nature, man, and God, gives itself artistic shape. *Secondly*, this inner development of art has to give itself immediate existence and sensuous being, and the specific modes of the sensuous being of art are themselves a totality of necessary differences in art, i.e., the *particular arts*. Artistic configuration and its differences are, on the one hand, as spiritual, of a more universal kind and not bound to *one* material [e.g. stone or paint], and sensuous existence is itself differentiated in numerous ways; but since this existence, like spirit, has the Concept implicitly for its inner soul, a specific sensuous material does thereby, on the other hand, acquire a closer relation and a secret harmony with the spiritual differences and forms of artistic configuration.

However, in its completeness our science is divided into three main sections:

First, we acquire a *universal* part. This has for its content and sub-

ject both the universal Idea of artistic beauty as the Ideal, and also the nearer relation of the Ideal to nature on the one hand and to subjective artistic production on the other.

Secondly, there is developed out of the conception of artistic beauty a *particular* part, because the essential differences contained in this conception unfold into a sequence of particular forms of artistic configuration.

Thirdly, there is a *final* part which has to consider the individualization of artistic beauty, since art advances to the sensuous realization of its creations and rounds itself off in a system of single arts and their genera and species.

(i) The Idea of the Beauty of Art or the Ideal

In the first place, so far as the first and second parts are concerned, we must at once, if what follows is to be made intelligible, recall again that the Idea as the beauty of art is not the Idea as such, in the way that a metaphysical logic has to apprehend it as the Absolute, but the Idea as shaped forward into reality and as having advanced to immediate unity and correspondence with this reality. For the *Idea as such* is indeed the absolute truth itself, but the truth only in its not yet objectified universality, while the Idea as the *beauty of art* is the Idea with the nearer qualification of being both essentially individual reality and also an individual configuration of reality destined essentially to embody and reveal the Idea. Accordingly there is here expressed the demand that the Idea and its configuration as a concrete reality shall be made completely adequate to one another. Taken thus, the Idea as reality, shaped in accordance with the Concept of the Idea, is the *Ideal*.

The problem of such correspondence might in the first instance be understood quite formally in the sense that any Idea at all might serve, if only the actual shape, no matter which, represented precisely this specific Idea. But in that case the demanded *truth* of the Ideal is confused with mere *correctness* which consists in the expression of some meaning or other in an appropriate way and therefore the direct rediscovery of its sense in the shape produced. The Ideal is not to be thus understood. For any content can be represented quite adequately, judged by the standard of its own essence, without being allowed to claim the artistic beauty of the Ideal. Indeed, in comparison with ideal beauty, the representation will even appear defective. In this regard it may be remarked in advance, what can only be proved later, namely that the defectiveness of a work of art is not always to be regarded as due, as may be supposed, to the artist's lack of skill; on the contrary, defectiveness of *form* results from defectiveness of *content*. So, for example, the Chinese, Indians, and Egyptians, in their artistic shapes, images of gods, and idols, never get beyond formlessness or a bad and untrue definiteness of form. They could not master true beauty

because their mythological ideas, the content and thought of their works of art, were still indeterminate, or determined badly, and so did not consist of the content which is absolute in itself. Works of art are all the more excellent in expressing true beauty, the deeper is the inner truth of their content and thought. And in this connection we are not merely to think, as others may, of any greater or lesser skill with which natural forms as they exist in the external world are apprehended and imitated. For, in certain stages of art-consciousness and presentation, the abandonment and distortion of natural formations is not unintentional lack of technical skill or practice, but intentional alteration which proceeds from and is demanded by what is in the artist's mind. Thus, from this point of view, there is imperfect art which in technical and other respects may be quite perfect in its *specific* sphere, and yet it is clearly defective in comparison with the concept of art itself and the Ideal.

Only in the highest art are Idea and presentation truly in conformity with one another, in the sense that the shape given to the Idea is in itself the absolutely true shape, because the content of the Idea which that shape expresses is itself the true and genuine content. Associated with this, as has already been indicated, is the fact that the Idea must be determined in and through itself as a concrete totality, and therefore possess in itself the principle and measure of its particularization and determinacy in external appearance. For example, the Christian imagination will be able to represent God in human form and its expression of *spirit*, only because God himself is here completely known in himself as *spirit*. Determinacy is, as it were, the bridge to appearance. Where this determinacy is not a totality emanating from the Idea itself, where the Idea is not presented as self-determining and self-particularizing, the Idea remains abstract and has its determinacy, and therefore the principle for its particular and solely appropriate mode of appearance, not in itself, but outside itself. On this account, then, the still abstract Idea has its shape also external to itself, not settled by itself. On the other hand, the inherently concrete Idea carries within itself the principle of its mode of appearance and is therefore its own free configurator. Thus the truly concrete Idea alone produces its true configuration, and this correspondence of the two is the Ideal.

(ii) Development of the Ideal into the Particular Forms of the Beauty of Art

But because the Idea is in this way a concrete unity, this unity can enter the art-consciousness only through the unfolding and then the reconciliation of the particularizations of the Idea, and, through this development, artistic beauty acquires a *totality of particular stages and forms*. Therefore, after studying artistic beauty in itself and on its own account, we must see how beauty as a whole decomposes into its

particular determinations. This gives, as the *second* part of our study, the doctrine of the *forms of art*. These forms find their origin in the different ways of grasping the Idea as content, whereby a difference in the configuration in which the Idea appears is conditioned. Thus the forms of art are nothing but the different relations of meaning and shape, relations which proceed from the Idea itself and therefore provide the true basis for the division of this sphere. For division must always be implicit in the concept, the particularization and division of which is in question.

We have here to consider *three* relations of the Idea to its configuration.

(*a*) *First*, art begins when the Idea, still in its indeterminacy and obscurity, or in bad and untrue determinacy, is made the content of artistic shapes. Being indeterminate, it does not yet possess in itself that individuality which the Ideal demands; its abstraction and one-sidedness leave its shape externally defective and arbitrary. The first form of art is therefore rather a *mere search* for portrayal than a capacity for true presentation; the Idea has not found the form even in itself and therefore remains struggling and striving after it. We may call this form, in general terms, the *symbolic* form of art. In it the abstract Idea has its shape outside itself in the natural sensuous material from which the process of shaping starts and with which, in its appearance, this process is linked. Perceived natural objects are, on the one hand, primarily left as they are, yet at the same time the substantial Idea is imposed on them as their meaning so that they now acquire a vocation to express it and so are to be interpreted as if the Idea itself were present in them. A corollary of this is the fact that natural objects have in them an aspect according to which they are capable of representing a universal meaning. But since a complete correspondence is not yet possible, this relation can concern only an *abstract* characteristic, as when, for example, in a lion strength is meant.

On the other hand, the abstractness of this relation brings home to consciousness even so the foreignness of the Idea to natural phenomena, and the Idea, which has no other reality to express it, launches out in all these shapes, seeks itself in them in their unrest and extravagance, but yet does not find them adequate to itself. So now the Idea exaggerates natural shapes and the phenomena of reality itself into indefiniteness and extravagance; it staggers round in them, it bubbles and ferments in them, does violence to them, distorts and stretches them unnaturally, and tries to elevate their phenomenal appearance to the Idea by the diffuseness, immensity, and splendour of the formations employed. For the Idea is here still more or less indeterminate and unshapable, while the natural objects are thoroughly determinate in their shape.

In the incompatibility of the two sides to one another, the relation

of the Idea to the objective world therefore becomes a *negative* one, since the Idea, as something inward, is itself unsatisfied by such externality, and, as the inner universal substance thereof, it persists *sublime* above all this multiplicity of shapes which do not correspond with it. In the light of this sublimity, the natural phenomena and human forms and events are accepted, it is true, and left as they are, but yet they are recognized at the same time as incompatible with their meaning which is raised far above all mundane content.

These aspects constitute in general the character of the early artistic pantheism of the East, which on the one hand ascribes absolute meaning to even the most worthless objects, and, on the other, violently coerces the phenomena to express its view of the world whereby it becomes bizarre, grotesque, and tasteless, or turns the infinite but abstract freedom of the substance [i.e., the one Lord] disdainfully against all phenomena as being null and evanescent. By this means the meaning cannot be completely pictured in the expression and, despite all striving and endeavour, the incompatibility of Idea and shape still remains unconquered.—This may be taken to be the first form of art, the symbolic form with its quest, its fermentation, its mysteriousness, and its sublimity.

(*b*) In the *second* form of art which we will call the *classical*, the double defect of the symbolic form is extinguished. The symbolic shape is imperfect because, (i) in it the Idea is presented to consciousness only as indeterminate or determined *abstractly*, and, (ii) for this reason the correspondence of meaning and shape is always defective and must itself remain purely abstract. The classical art-form clears up this double defect; it is the free and adequate embodiment of the Idea in the shape peculiarly appropriate to the Idea itself in its essential nature. With this shape, therefore, the Idea is able to come into free and complete harmony. Thus the classical art-form is the first to afford the production and vision of the completed Ideal and to present it as actualized in fact.

Nevertheless, the conformity of concept and reality in classical art must not be taken in the purely *formal* sense of a correspondence between a content and its external configuration, any more than this could be the case with the Ideal itself. Otherwise every portrayal of nature, every cast of features, every neighbourhood, flower, scene, etc., which constitutes the end and content of the representation, would at once be classical on the strength of such congruity between content and form. On the contrary, in classical art the peculiarity of the content consists in its being itself the concrete Idea, and as such the concretely spiritual, for it is the spiritual alone which is the truly inner [self]. Consequently, to suit such a content we must try to find out what in nature belongs to the spiritual in and for itself. The *original* Concept itself it must be which *invented* the shape for concrete spirit, so that

now the *subjective* Concept—here the spirit of art—has merely *found* this shape and made it, as a natural shaped existent, appropriate to free individual spirituality. This shape, which the Idea as spiritual—indeed as individually determinate spirituality—assumes when it is to proceed out into a temporal manifestation, is the human form. Of course personification and anthropomorphism have often been maligned as a degradation of the spiritual, but in so far as art's task is to bring the spiritual before our eyes in a sensuous manner, it must get involved in this anthropomorphism, since spirit appears sensuously in a satisfying way only in its body. The transmigration of souls is in this respect an abstract idea and physiology should have made it one of its chief propositions that life in its development had necessarily to proceed to the human form as the one and only sensuous appearance appropriate to spirit.

But the human body in its form counts in classical art no longer as a merely sensuous existent, but only as the existence and natural shape of the spirit, and it must therefore be exempt from all the deficiency of the purely sensuous and from the contingent finitude of the phenomenal world. While in this way the shape is purified in order to express in itself a content adequate to itself, on the other hand, if the correspondence of meaning and shape is to be perfect, the spirituality, which is the content, must be of such a kind that it can express itself completely in the natural human form, without towering beyond and above this expression in sensuous and bodily terms. Therefore here the spirit is at once determined as particular and human, not as purely absolute and eternal, since in this latter sense it can proclaim and express itself only as spirituality.

This last point in its turn is the defect which brings about the dissolution of the classical art-form and demands a transition to a higher form, the *third*, namely the *romantic*.

(*c*) The romantic form of art cancels again the completed unification of the Idea and its reality, and reverts, even if in a higher way, to that difference and opposition of the two sides which in symbolic art remained unconquered. The classical form of art has attained the pinnacle of what illustration by art could achieve, and if there is something defective in it, the defect is just art itself and the restrictedness of the sphere of art. This restrictedness lies in the fact that art in general takes as its subject-matter the spirit (i.e. the *universal*, infinite and concrete in its nature) in a *sensuously* concrete form, and classical art presents the complete unification of spiritual and sensuous existence as the *correspondence* of the two. But in this blending of the two, spirit is not in fact represented in its *true nature*. For spirit is the infinite subjectivity of the Idea, which as absolute inwardness cannot freely and truly shape itself outwardly on condition of remaining moulded into a bodily existence as the one appropriate to it.

Abandoning this [classical] principle, the romantic form of art cancels the undivided unity of classical art because it has won a content which goes beyond and above the classical form of art and its mode of expression. This content—to recall familiar ideas—coincides with what Christianity asserts of God as a spirit, in distinction from the Greek religion which is the essential and most appropriate content for classical art. In classical art the concrete content is *implicitly* the unity of the divine nature with the human, a unity which, just because it is only immediate and implicit, is adequately manifested also in an immediate and sensuous way. The Greek god is the object of naïve intuition and sensuous imagination, and therefore his shape is the bodily shape of man. The range of his power and his being is individual and particular. Contrasted with the individual he is a substance and power with which the individual's inner being is only implicitly at one but without itself possessing this oneness as inward subjective knowledge. Now the higher state is the *knowledge* of that *implicit* unity which is the content of the classical art-form and is capable of perfect presentation in bodily shape. But this elevation of the implicit into self-conscious knowledge introduces a tremendous difference. It is the infinite difference which, for example, separates man from animals. Man is an animal, but even in his animal functions, he is not confined to the implicit, as the animal is; he becomes conscious of them, recognizes them, and lifts them, as, for instance, the process of digestion, into self-conscious science. In this way man breaks the barrier of his implicit and immediate character, so that precisely because he *knows* that he is an animal, he ceases to be an animal and attains knowledge of himself as spirit.

Now if in this way what was implicit at the previous stage, the unity of divine and human nature, is raised from an *immediate* to a *known* unity, the *true* element for the realization of this content is no longer the sensuous immediate existence of the spiritual in the bodily form of man, but instead the *inwardness of self-consciousness*. Now Christianity brings God before our imagination as spirit, not as an individual, particular spirit, but as absolute in spirit and in truth. For this reason it retreats from the sensuousness of imagination into spiritual inwardness and makes this, and not the body, the medium and the existence of truth's content. Thus the unity of divine and human nature is a known unity, one to be realized only by *spiritual* knowing and *in spirit*. The new content, thus won, is on this account not tied to sensuous presentation, as if that corresponded to it, but is freed from this immediate existence which must be set down as negative, overcome, and reflected into the spiritual unity. In this way romantic art is the self-transcendence of art but within its own sphere and in the form of art itself.

We may, therefore, in short, adhere to the view that at this third

stage the subject-matter of art is *free concrete spirituality*, which is to be manifested as *spirituality* to the spiritually inward. In conformity with this subject-matter, art cannot work for sensuous intuition. Instead it must, on the one hand, work for the inwardness which coalesces with its object simply as if with itself, for subjective inner depth, for reflective emotion, for feeling which, as spiritual, strives for freedom in itself and seeks and finds its reconciliation only in the inner spirit. This *inner* world constitutes the content of the romantic sphere and must therefore be represented as this inwardness and in the pure appearance of this depth of feeling. Inwardness celebrates its triumph over the external and manifests its victory in and on the external itself, whereby what is apparent to the senses alone sinks into worthlessness.

On the other hand, however, this romantic form too, like all art, needs an external medium for its expression. Now since spirituality has withdrawn into itself out of the external world and immediate unity therewith, the sensuous externality of shape is for this reason accepted and represented, as in symbolic art, as something inessential and transient; and the same is true of the subjective finite spirit and will, right down to the particularity and caprice of individuality, character, action, etc., of incident, plot, etc. The aspect of external existence is consigned to contingency and abandoned to the adventures devised by an imagination whose caprice can mirror what is present to it, *exactly as it is*, just as readily as it can jumble the shapes of the external world and distort them grotesquely. For this external medium has its essence and meaning no longer, as in classical art, in itself and its own sphere, but in the heart which finds its manifestation in itself instead of in the external world and *its* form of reality, and this reconciliation with itself it can preserve or regain in every chance, in every accident that takes independent shape, in all misfortune and grief, and indeed even in crime.

Thereby the separation of Idea and shape, their difference and inadequacy to each other, come to the fore again, as in symbolic art, but with this essential difference, that, in romantic art, the Idea, the deficiency of which in the symbol brought with it deficiency of shape, now has to appear *perfected* in itself as spirit and heart. Because of this higher perfection, it is not susceptible of an adequate union with the external, since its true reality and manifestation it can seek and achieve only within itself.

This we take to be the general character of the symbolic, classical, and romantic forms of art, as the three relations of the Idea to its shape in the sphere of art. They consist in the striving for, the attainment, and the transcendence of the Ideal as the true Idea of beauty. [...]

3

Style

Introduction

It has been observed on not a few occasions that the history of art history after Hegel has been a long playing-out of the dilemmas and contradictions set in motion by his counter-revolutionary aesthetic philosophy of the 1820s. Although such an observation may seem drastically reductive, it may not be entirely unjust. It may well be true that what Hegel's work did accomplish was the establishment of a powerfully persuasive framework for imagining a viable art historical discipline with a common goal and with an apparently clear system of procedures for the production of historical and cultural knowledge.

Yet at the same time, when understood as part of a larger historical picture, Hegel's vision was indissolubly linked to a very ancient and continuing European tradition of discussion and debate on the nature of form and meaning, dating back to Plato and Aristotle, and deeply informing Christian theology. In a very real sense, Hegel's counter-revolution consisted in reaffirming certain philosophical positions of Leibniz—with their dual roots in Platonic thought and Christian theology—that Enlightenment aesthetic philosophers such as Kant had reacted against during the latter half of the eighteenth century. There is certainly a more than faint echo of Plato in Hegel's devaluation of art.

(Briefly put, Plato observed that while individual forms (horses, humans, or tables) have a transient material existence, their *forms* always reappear, apparently eternally. What constitutes horses as horses, then, must be some eternal essence of which they partake, and without which they could not keep reappearing with such astonishing fidelity to type. Such Forms were thus in one sense more real than their physical manifestations. This led Plato to devalue art and artifice as the least real or ideal of things, for art was taken by him to be an imitation of a phenomenal world which was *itself* an imitation of a pure world of Forms or Ideas.[1] The ways in which such notions resonate with a Christian cosmology founded on the dualism of a divine realm of perfection and an imperfect mortal world are obvious.)

Hegel's perspective on art in a curious way resembles one facet of the attempt by Byzantine theologians a millennium earlier who, in

their debates with Iconoclasts who wished to destroy all religious imagery, argued that if paintings and icons were of no intrinsic value in themselves, yet they were indeed valuable as a *medium* through which the divine spirit could be apprehended, however faintly, by mortals.[2] That is to say, Hegel sought to maintain the Leibnizian perspective on art and on sensory knowledge as the realm of confused intelligibility or primitive rationality while at the same time valourizing it as a vehicle or a means through which Spirit or the Ideal might be made manifest.

His version of iconoclasm, however, derived not from Byzantium but from a more immediate source: the banishing or marginalizing of religious imagery in Protestant Christianity. It may come as no surprise that Hegel's entire aesthetico-religious world-historical system of the unfolding of divine Spirit culminated in nineteenth-century Protestant Christian Germany, where religious art had in Hegel's view been transcended by religion as such. In no small measure, Hegel's world history thus had ethnic and nationalistic pertinence as well.

His work also addressed the central dilemma of the idealist tradition, seeking to reconcile two radically contrary claims: (*A*) that art objects had timeless value in themselves, and (*B*) that they were but transient and illusory phenomena.

The Hegelian 'solution' consisted, in short, of valourizing art's role as an instrument of Spirit (or religion, of which Hegel claimed that art was the symbol) by imagining art's own internal 'history' as a secondary yet none the less valuable chronological record and index of the unfolding of that divine Spirit. The usefulness of art was as the medium through which mortals might come to an approximate understanding of that Spirit and hence of human purpose itself. Of course art's history was itself essentially *over* for Hegel—a state of affairs symbolized by the disappearance of art in (Protestant) Christian religious contexts.

In other words, art had a 'history' in so far as changes in artistic form over time could be *read* (properly) as representing or reflecting a great cosmic narrative or teleology. The unfolding of Spirit thereby provided the underlying plot and purposive trajectory of artistic chronology; its narrative shape and form. Art history was a history with a (spiritual) point, trajectory, and purpose: a teleology (its ultimate purpose being to disappear). Thus even though art had a history, not only was it a second-order reflection of some more real Spirit, but that history itself did not extend indefinitely into the future: art was a *temporary* secondary phenomenon.

The overall history of artistic practices, the meaning of groups of objects seen to share certain stylistic features, and the significance of any individual object, could thus all be united under a single umbrella of legibility: as related facets or dimensions of a common story-line—that of *evolution*. The significance of Hegel's work with regard to the history of the discipline of art history is that it afforded a system and

structure that was both loose enough to accommodate a wide variety of specific motivations and aims, and yet concrete enough to unify art historical knowledge-production as a professional enterprise with generically shared theories and methods. To practise art history could thus constitute an elevated secular religiosity, wherein the unfolding of the spirit of a time (*Zeitgeist*) or of a people, could be systematically and empirically traced in the genealogy of objects of a people's manufacture.

It constituted a powerful and seemingly cogent ideology which appeared to hold out the promise of conferring meaning upon the increasingly incomprehensible material world of the Industrial Revolution and the social upheavals attendant upon the formation of the modern nation-state and its new forms of citizenship and political representation. This was a material world which, it should be remembered, was radically different from the Europe of the eighteenth century in that it had become massively saturated with literally millions of new artefacts and commodities of all kinds, from all over the world as well as from all periods of the world's history. Hegel is writing and lecturing at the time of the great burgeoning of public collections and of the founding of scores of civic museums in large and small cities all over Europe, increasingly stuffed with all the world's natural and man-made treasures.

Seen in this fuller light, Hegel's 'theodicy' or aesthetic philosophy of history can be seen as one facet of a massive intellectual and social movement of the early nineteenth century which in many diverse ways consisted of conferring various kinds of *historicist* legibility on the experience of the world, wherein phenomena were meaningful in so far as they occupied chronological or genealogical positions in an overall developmental sequence. From individual identities to national entities, from the realm of human experience to the entire planet and its biosphere, the significance of things was being articulated as historical, evolutionary, developmental, and progressive.

What Hegel's work accomplished for European modernity, in a very pragmatic sense, was to make it possible to envision all artistic phenomena—and by extension all objects of human manufacture—as fundamentally historical in a dualistic sense: in terms of their 'forms', and in terms of their 'contents', meanings, and functions. By keeping them distinct in this hierarchized fashion, each might be cogently imagined as having its own genealogy and teleology. The result was powerfully to set in motion an entire family of debates and controversies regarding which genealogy or history was primary or secondary; which was derivative or essential; and whether or not these historical or genealogical processes (either of form or of content) had a 'shape' or logic of their own. (It also had the effect of affording a related art historical dualism: an opposition between 'historical' and 'a-historical'

(or contextualist and formalist) explanation; this was a dilemma that pervaded art historical practice through much of the twentieth century, as we shall see below).

It may not be an exaggeration to claim that the subsequent history of art history, down to the present, might be written as a historical drama based upon ongoing and, in the terms in which they have been played out, quite possibly unresolvable debates about theoretical or methodological positions on these issues. Certainly, as the readings in this anthology will make abundantly clear, many of these debates centre upon validating one or another prefabricated position—and the history of such positions from one generation to the next resembles an oscillation between the extremes of two poles—now on the side of 'form', now on the side of 'content' or 'context'. Yet by definition, no contextualization of art will ever be satisfyingly full or complete, nor will any view of form be entirely pure or satisfyingly divested of extraneous and distracting matter.

There is another and equally important dimension to the Hegelian counter-revolution, one which will be taken up later: the roles of the artist and of the viewer, user, or consumer of art. That Hegel's theodicy afforded an intensely ethical comprehension of the built environment and its components may be clear; what it also afforded was a complementary commodification of the individual—the artist and/as his or her work, and the individual citizen as his or her deeds.

Are works of art, then, but surrogate subjects, and subjects ethical objects? Is art history dependent upon an implicit superimposition of objects and subjects? Does it imply a comprehension of objects as if they were to be judged as (ethical) subjects, and subjects as if their lives and deeds constituted objects to be judged aesthetically in terms of their coherence, consistency, and composition?

The readings in Chapter 3 deal with questions of *form* and of *style*, two core concepts affecting all aspects of art historical and critical practice throughout the nineteenth and twentieth centuries. The texts chosen range in time from 1915 (Wölfflin) to 1989 (Summers), and include two discussions on the notion of style that have been very widely influential in the discipline in the second half of the twentieth century: the essays by Schapiro (1953), and Gombrich (1968).

The Swiss art historian Heinrich Wölfflin (1864–1945) is generally regarded as one of the most important and influential figures in the field of art history in the late nineteenth and early twentieth centuries. His reputation stemmed as much from his success as a vivid and innovative lecturer (in Basel, Munich, Berlin, and Zurich) as well as from his life-long project of systematizing the art historical analysis of form and of style. Wölfflin's efforts in this regard were inspired by the work of his father, a distinguished scholar of linguistics and language history, and his interests in comprehending the broad, underlying stylistic char-

acteristics of a people and a period undoubtedly reflect the enterprise of his university teacher, the great historian of the Italian Renaissance, Jacob Burckhardt (1818–97), to whose university chair he succeeded upon the latter's retirement. Wölfflin's work is perhaps most cogently pictured as an attempt to synthesize the enterprises of these two mentors.

The selection excerpted here is drawn from his 1915 *Principles of Art History: The Problem of the Development of Style in Later Art*,[3] a book which for much of the early and mid-twentieth century became an essential text: a statement of principle and methodology which several generations of art historians have been compelled to address as much by emulation as by negative reaction. It was a book that was instantly controversial, and affected discussion and debate in several different disciplines.

For many, *Principles* became a powerful and canonical statement of a certain 'formalism' in art history—an approach to art in which the genealogical development of formal changes (the physical face of the Hegelian or idealist coin) constituted an internally coherent system of differences, according to measured and in principle predictable variations in the underlying distinctive features of objects. In this respect, Wölfflin's *Principles* was an attempt to articulate visual change on the analogy of the models of linguistic evolution, which were thought in the late nineteenth century to take place according to an internal structural or systemic logic, rather than as a reflection of actual usage or social context. Wölfflin's principles were presented as being derived from a close empirical analysis of the contrasts between Renaissance and Baroque art, and in this regard his famously acute analytic powers were regarded by many as supporting his more general theoretical claims regarding the underlying mechanisms of artistic change. The excerpt below is perhaps the clearest explication of his general theory.

The following text, by Renaissance art historian David Summers, is an extensive and thoughtful discussion of the varying uses of the art historical notions of form and style from the eighteenth century to the late twentieth, and is also a good source of references to major and less well-known texts on these subjects.

The next essay, by Meyer Schapiro (1904–95), is a notable mid-twentieth-century discussion of notions of style both within various theoretical schools of the modern discipline of art history, as well as in anthropology. It was originally published in an anthropology journal. Ernst Gombrich's essay on style (originally published in a social sciences encyclopaedia) is somewhat more wide-ranging than Schapiro's, and, in contrast to the latter, has an extensive bibliography of relevant texts on style in the humanities and social sciences.

Two other widely influential books both reflect some of the central concerns of Wölfflin's project and in many ways go beyond certain of

its conclusions. The book *The Life of Forms*[4] by the French art historian Henri Focillon (1881–1943), is a lucid and elegant monograph outlining the broad implications of a 'formalist' articulation of art history. Focillon's work, arising out of a close interest in the technical possibilities of the instruments of art-making for defining and determining the development of styles (on which also see the discussion of Riegl below), substantially influenced that of the contemporary American art historian of pre-Columbian and Latin American colonial art, George Kubler, whose *The Shape of Time*[5] is a notable synthesis of the entire formalist tradition, seen from the perspective of a reaction to disciplinary emphases on content, context, and symbolism.

Principles of Art History

The Most General Representational Forms

This volume is occupied with the discussion of these universal forms
of representation. It does not analyse the beauty of Leonardo but
the element in which that beauty became manifest. It does not analyse
the representation of nature according to its imitational content, and
how, for instance, the naturalism of the sixteenth century may be dis-
tinguished from that of the seventeenth, but the mode of perception
which lies at the root of the representative arts in the various centuries.

Let us try to sift out these basic forms in the domain of more
modern art. We denote the series of periods with the names Early
Renaissance, High Renaissance, and Baroque, names which mean
little and must lead to misunderstanding in their application to south
and north, but are hardly to be ousted now. Unfortunately, the sym-
bolic analogy bud, bloom, decay, plays a secondary and misleading
part. If there is in fact a qualitative difference between the fifteenth and
sixteenth centuries, in the sense that the fifteenth had gradually to
acquire by labour the insight into effects which was at the free disposal
of the sixteenth, the (classic) art of the Cinquecento and the (baroque)
art of the Seicento are equal in point of value. The word classic here
denotes no judgment of value, for baroque has its classicism too.
Baroque (or, let us say, modern art) is neither a rise nor a decline from
classic, but a totally different art. The occidental development of mod-
ern times cannot simply be reduced to a curve with rise, height, and
decline: it has two culminating points. We can turn our sympathy to
one or to the other, but we must realise that that is an arbitrary judg-
ment, just as it is an arbitrary judgment to say that the rose-bush lives
its supreme moment in the formation of the flower, the apple-tree in
that of the fruit.

For the sake of simplicity, we must speak of the sixteenth and seven-
teenth centuries as units of style, although these periods signify no
homogeneous production, and, in particular, the features of the
Seicento had begun to take shape long before the year 1600, just as, on
the other hand, they long continued to affect the appearance of the
eighteenth century. Our object is to compare type with type, the
finished with the finished. Of course, in the strictest sense of the word,

there is nothing 'finished': all historical material is subject to continual transformation; but we must make up our minds to establish the distinctions at a fruitful point, and there to let them speak as contrasts, if we are not to let the whole development slip through our fingers. The preliminary stages of the High Renaissance are not to be ignored, but they represent an archaic form of art, an art of primitives, for whom established pictorial form does not yet exist. But to expose the individual differences which lead from the style of the sixteenth century to that of the seventeenth must be left to a detailed historical survey which will, to tell the truth, only do justice to its task when it has the determining concepts at its disposal.

If we are not mistaken, the development can be reduced, as a provisional formulation, to the following five pairs of concepts:

(1) The development from the linear to the painterly,[1] i.e. the development of line as the path of vision and guide of the eye, and the gradual depreciation of line: in more general terms, the perception of the object by its tangible character—in outline and surfaces—on the one hand, and on the other, a perception which is by way of surrendering itself to the mere visual appearance and can abandon 'tangible' design. In the former case the stress is laid on the limits of things; in the other the work tends to look limitless. Seeing by volumes and outlines isolates objects: for the painterly eye, they merge. In the one case interest lies more in the perception of individual material objects as solid, tangible bodies; in the other, in the apprehension of the world as a shifting semblance.

(2) The development from plan to recession:[2] Classic[3] art reduces the parts of a total form to a sequence of planes, the baroque emphasises depth. Plane is the element of line, extension in one plane the form of the greatest explicitness: with the discounting of the contour comes the discounting of the plane, and the eye relates objects essentially in the direction of forwards and backwards. This is no qualitative difference: with a greater power of representing spatial depths, the innovation has nothing directly to do: it signifies rather a radically different mode of representation, just as 'plane style' in our sense is not the style of primitive art, but makes its appearance only at the moment at which foreshortening and spatial illusion are completely mastered.

(3) The development from closed to open form.[4] Every work of art must be a finite whole, and it is a defect if we do not feel that it is self-contained, but the interpretation of this demand in the sixteenth and seventeenth centuries is so different that, in comparison with the loose form of the baroque, classic design may be taken as the form of closed composition. The relaxation of rules, the yielding of tectonic strength, or whatever name we may give to the process, does not merely signify an enhancement of interest, but is a new mode of representation consistently carried out, and hence this factor is to be adopted among the

basic forms of representation.

(4) The development from multiplicity to unity.[5] In the system of a classic composition, the single parts, however firmly they may be rooted in the whole, maintain a certain independence. It is not the anarchy of primitive art: the part is conditioned by the whole, and yet does not cease to have its own life. For the spectator, that presupposes an articulation, a progress from part to part, which is a very different operation from perception as a whole, such as the seventeenth century applies and demands. In both styles unity is the chief aim (in contrast to the pre-classic period which did not yet understand the idea in its true sense), but in the one case unity is achieved by a harmony of free parts, in the other, by a union of parts in a single theme, or by the subordination, to one unconditioned dominant, of all other elements.

(5) The absolute and the relative clarity of the subject.[6] This is a contrast which at first borders on the contrast between linear and painterly. The representation of things as they are, taken singly and accessible to plastic feeling, and the representation of things as they look, seen as a whole, and rather by their non-plastic qualities. But it is a special feature of the classic age that it developed an ideal of perfect clarity which the fifteenth century only vaguely suspected, and which the seventeenth voluntarily sacrificed. Not that artistic form had become confused, for that always produces an unpleasing effect, but the explicitness of the subject is no longer the sole purpose of the presentiment. Composition, light, and colour no longer merely serve to define form, but have their own life. There are cases in which absolute clarity has been partly abandoned merely to enhance effect, but 'relative' clarity, as a great all-embracing mode of representation, first entered the history of art at the moment at which reality is beheld with an eye to other effects. Even here it is not a difference of quality if the baroque departed from the ideals of the age of Dürer and Raphael, but, as we have said, a different attitude to the world.

Imitation and Decoration

The representational forms here described are of such general significance that even widely divergent natures such as Terborch and Bernini can find room within one and the same type. The community of style in these two painters rests on what, for people of the seventeenth century, was a matter of course—certain basic conditions to which the impression of living form is bound without a more special expressional value being attached to them.

They can be treated as forms of representation or forms of beholding: in these forms nature is seen, and in these forms art manifests its contents. But it is dangerous to speak only of certain 'states of the eye' by which conception is determined: every artistic conception is, of its very nature, organised according to certain notions of pleasure. Hence

our five pairs of concepts have an imitative and a decorative significance. Every kind of reproduction of nature moves within a definite decorative schema. Linear vision is permanently bound up with a certain idea of beauty and so is painterly vision. If an advanced type of art dissolves the line and replaces it by the restless mass, that happens not only in the interests of a new verisimilitude, but in the interests of a new beauty too. And in the same way we must say that representation in a plane type certainly corresponds to a certain stage of observation, but even here the schema has obviously a decorative side. The schema certainly yields nothing of itself, but it contains the possibility of developing beauties in the arrangement of planes which the recessional style no longer possesses and can no longer possess. And we can continue in the same way with the whole series.

But then, if these more general concepts also envisage a special type of beauty, do we not come back to the beginning, where style was conceived as the direct expression of temperament, be it the temperament of a time, of a people, or of an individual? And in that case, would not the only new factor be that the section was cut lower down, the phenomena, to a certain extent, reduced to a greater common denominator?

In speaking thus, we should fail to realise that the second terms of our pairs of concepts belong of their very nature to a different species, in so far as these concepts, in their transformations, obey an inward necessity. They represent a rational psychological process. The transition from tangible, plastic, to purely visual, painterly perception follows a natural logic, and could not be reversed. Nor could the transition from tectonic to a-tectonic, from the rigid to the free conformity to law.

To use a parable. The stone, rolling down the mountain side, can assume quite different motions according to the gradient of the slope, the hardness or softness of the ground, etc., but all these possibilities are subject to one and the same law of gravity. So, in human psychology, there are certain developments which can be regarded as subject to natural law in the same way as physical growth. They can undergo the most manifold variations, they can be totally or partially checked, but, once the rolling has started, the operation of certain laws may be observed throughout.

Nobody is going to maintain that the 'eye' passes through developments on its own account. Conditioned and conditioning, it always impinges on other spiritual spheres.[7] There is certainly no visual schema which, arising only from its own premises, could be imposed on the world as a stereotyped pattern. But although men have at all times seen what they wanted to see, that does not exclude the possibility that a law remains operative throughout all change. To determine this law would be a central problem, the central problem of a history of art.

Multiplicity and Unity

The principle of closed form of itself presumes the conception of the picture as a unity. Only when the sum of the forms is felt as one whole can this whole be thought as ordered by law, and it is then indifferent whether a tectonic middle is worked out or a freer order reigns.

This feeling for unity develops only gradually. There is not a definite moment in the history of art at which we could say—now it has come: here too we must reckon with purely relative values.

A head is a total form which the Florentine Quattrocentists, like the early Dutch artists, felt as such—that is, as a whole. If, however, we take as comparison a head by Raphael or Quenten Massys, we feel we are confronted by another attitude, and if we seek to comprehend the contrast, it is ultimately the contrast of seeing in detail and seeing as a whole. Not that the former could mean that sorry accumulation of details over which the reiterated corrections of the art master try to help the pupil—such qualitative comparisons do not even come into consideration here—yet the fact remains that, in comparison with the classics of the sixteenth century, these old heads always preoccupy us more in the detail and seem to possess a lesser degree of coherence, while in the other case, in any detail, we at once become aware of the whole. We cannot see the eye without realising the larger form of the socket, the way it is set between forehead, nose, and cheekbone, and to the horizontal of the pair of eyes and of the mouth the vertical of the nose at once responds: the form has a power to awaken vision and to compel us to a united perception of the manifold which must affect even a dense spectator. He wakes up and suddenly feels quite a new fellow.

And the same difference obtains between a pictorial composition of the fifteenth and sixteenth centuries. In the former, the dispersed; in the latter, the unified: in the former, now the poverty of the isolated, now the inextricable confusion of the too much; in the latter, an organized whole, in which every part speaks for itself and is comprehensible, yet makes itself felt in its coherence with the whole as a member of a total form.

In establishing these differences between the classic and the pre-classic period, we first obtain the basis for our real subject. Yet here we at once feel the painful lack of distinguishing vocabulary: at the very moment at which we name unity of composition as an essential feature of Cinquecento art, we have to say that it is precisely the epoch of Raphael which we wish to oppose as an age of multiplicity to later art and its tendency to unity. And this time we have no progress from the poorer to the richer form, but two different types which each represent an ultimate form. The sixteenth century is not discredited by the seventeenth, for it is not here a question of a qualitative difference but of something totally new.

A head by Rubens is not better, seen as a whole, than a head by Dürer or Massys, but that independent working-out of the separate parts is abolished which, in the latter case, makes the total form appear as a (relative) multiplicity. The Seicentists envisage a definite main motive, to which they subordinate everything else. No longer do the separate elements of the organism, conditioning each other and holding each other in harmony, take effect in the picture, but out of the whole, reduced to a unified stream, individual forms arise as the absolute dominants, yet in such a way that even these dominant forms signify for the eye nothing separable, nothing that could be isolated.

The relationship can be elucidated most satisfactorily in the composite sacred picture.

One of the richest motives of the biblical picture-cycle is the *Descent from the Cross*, an event which sets many hands in movement and contains powerful psychological contrasts. We have the classic version of the theme in Daniele da Volterra's picture in the Trinità dei Monti in Rome. This has always been admired for the way in which the figures are developed as absolutely independent parts, and yet so work together that each seems governed by the whole. That is precisely renaissance articulation. When later Rubens, as spokesman of the baroque, treats the same subject in an early work, the first point in which he departs from the classic type is the welding of the figures into a homogeneous mass, from which the individual figure can hardly be detached. He makes a mighty stream, reinforced by devices of lighting, pass slanting through the picture from the top. It sets in with the white cloth falling from the transverse beam; the body of Christ lies in the same course, and the movement pours into the bay of many figures which crowd round to receive the falling body. No longer, as in Daniele da Volterra, is the fainting Virgin a secondary centre of interest detached from the main event. She stands, and is completely absorbed, in the mass round the Cross. If we wish to denote the change in the other figures by a general expression, we can only say that each has abdicated part of its independence to the general interest. On principle, the baroque no longer reckons with a multiplicity of co-ordinate units, harmoniously interdependent, but with an absolute unity in which the individual part has lost its individual rights. But thereby the main motive is stressed with a hitherto unprecedented force.

It must not be objected that these are less differences of development than differences of national taste. Certainly, Italy has always had a preference for the clear component part, but the difference persists too in any comparison of the Italian Seicento with the Italian Cinquecento or in the comparison between Rembrandt and Dürer in the north. Although the northern imagination, as contrasted with Italy, aimed rather at the interweaving of the members, a *Deposition* by Dürer, compared with Rembrandt provides the absolutely pronounced

opposition of a composition with independent figures to a composition with dependent figures. Rembrandt focusses the story on the motive of two lights—a strong, steep one at the top left-hand corner, and a weak, horizontal one at the bottom right. With that, everything that matters is indicated. The corpse, only partially visible, is being let down, and is to be laid out on the winding-sheet lying on the ground. The 'down' of the deposition is reduced to its briefest expression.

Thus there stand opposed the multiple unity of the sixteenth century and the unified unity of the seventeenth: in other words, the articulated system of forms of classic art and the (endless) flow of the baroque. And, as is evident from previous examples, two elements interact in this baroque unity—the cessation of the independent functioning of the individual forms and the development of a dominating total motive. This can be achieved plastically, as in Rubens, or by means of more painterly values, as in Rembrandt. The example of the *Deposition* is only characteristic of an isolated case: unity fulfils itself in many ways. There is a unity of colour as well as of lighting, and a unity of the composition of figures as of the conception of form in a single head or body.

That is the most interesting point: the decorative schema becomes a mode of apprehension of nature. It is not only that Rembrandt's pictures are built up on a different system from Dürer's, things are seen differently. Multiplicity and unity are, so to speak, vessels in which the content of reality is caught and takes form. We must not assume that just any decorative system was clapped over the world's eyes: matter plays its part too. People not only see differently, they see *different things*. But all the so-called imitation of nature has only an artistic significance when it is inspired by decorative instincts and produces in its turn decorative works. That the concept of a multiple beauty and of a unified beauty also exists, apart from any imitative content, is borne out by architecture.

The two types stand side by side as independent values, and it does not meet the case if we conceive the later form only as an enhancement of the former. It goes without saying that baroque art was convinced that it had first found truth and that renaissance art had only been a preliminary form, but the historian judges otherwise. Nature can be interpreted in more than one way. And therefore it came about that it was just in the name of nature that, at the end of the eighteenth century, the baroque formula was ousted and again replaced by the classic.

The Principal Motives

The subject of this chapter, therefore, is the relation of the part to the whole—namely, that classic art achieves its unity by making the parts independent as free members, and that the baroque abolishes the uniform independence of the parts in favour of a more unified total

motive. In the former case, co-ordination of the accents; in the latter, subordination.

All our previous categories have led up to this unity. The painterly is the deliverance of the forms from their isolation; the principle of recession is no other than the replacement of the sequence of separate planes by a uniform recessional movement, and a-tectonic taste dissolves the rigid structure of geometric relations into flux. We cannot avoid partly repeating familiar matter: the essential viewpoint of the consideration is all the same new.

It does not happen of itself and from the outset that the parts function as free members of an organism. Among the primitives, the impression is checked because the component parts either remain too dispersed or look confused and unclear. Only where the single detail seems a necessary part of the whole do we speak of organic articulation, and only where the component part, bound up in the whole, is still felt as an independently functioning member, has the notion of freedom and independence a sense. That is the classic system of forms of the sixteenth century, and it makes no difference, as we have said, whether we understand by a whole a single head or a composite sacred picture.

Dürer's impressive woodcut of the *Virgin's Death* outstrips all previous work in that the parts form a system in which each in its place appears determined by the whole and yet looks perfectly independent. The picture is an excellent example of a tectonic composition—the whole reduced to clear geometric oppositions—but, beside that, this relationship of (relative) co-ordination of independent values should always be regarded as something new. We call it the principle of multiple unity.

The baroque would have avoided or concealed the meeting of pure horizontals and verticals. We should no longer have the impression of an *articulated* whole: the component parts, whether the bed canopy or one of the apostles, would have been fused into a total movement dominating the picture. If we recall the example of Rembrandt's etching of the *Virgin's Death*, we shall realise how very welcome to the baroque was the motive of the upward streaming clouds. The play of contrasts does not cease, but it keeps more hidden. The arrangement of obvious side-by-side and clear opposite is replaced by a single weft. Pure oppositions are broken. The finite, the isolable, disappear. From form to form, paths and bridges open over which the movement hastens on unchecked. But from such a stream, unified in the baroque sense, there arises here and there a motive so strongly stressed that it focusses the eye upon it as the lens does the light rays. Of this kind, in drawing, are those spots of most expressive form which, similarly to the culminating points of light and colour, of which we shall speak presently, fundamentally separate baroque from classic art. In classic art, even accentuation: in the baroque, one main effect. These motives

which bear the main accent are not pieces which could be broken out of the whole, but only the final surges of a general movement.

The characteristic examples of unified movement in the composite figure picture are given by Rubens. At all points, the transposition of the style of multiplicity and separation into the assembled and flowing with the suppression of independent separate values. The *Assumption* is not only a baroque work because Titian's classic system—the main figure opposed as vertical to the horizontal form of the group of the apostles—has been transformed into a general diagonal movement, but because the parts can no longer be isolated. The circle of light and angels which fills the centre of Titian's *Assunta* still re-echoes in Rubens, but it only receives an aesthetic sense in the context of the whole. However regrettable it is that copyists should offer Titian's central figure alone for sale, a certain possibility of doing so still exists: with Rubens, such an idea could present itself to nobody. In Titian's picture, the apostle motives to left and right mutually balance—the one looking up and the other with upstretched arms. In Rubens, only one side speaks, the other is, as far as content is concerned, reduced to insignificance, a suppression which makes the unilateral right-hand accent much more intense.

A second case—Rubens' *Bearing of the Cross*, which has already been compared with Raphael's *Spasimo*. An example of the transposition of plane into recession, but also an example of the transposition of articulated multiplicity into unarticulated unity. In the *Spasimo*, the soldier, Christ, and the women—three separate, equally accented motives; in Rubens, the same, as regards subject matter, but the motives kneaded together, and foreground and background carried into each other in a uniform drift of movement, without caesura. Tree and mountain work together with the figures and the lighting completes the effect. Everything is one. But out of the stream the wave rises here and there with surpassing force. Where the herculean soldier rams his shoulder under the cross, so much strength is concentrated that the balance of the picture might seem menaced—not the man as a separate motive, but the whole complex of form and light determines the effect—these are the characteristic nodal points of the new style.

To give unified movement, art need not necessarily have at its disposal plastic resources such as are contained in these compositions of Rubens. It needs no procession of moving human figures: unity can be enforced merely by lighting.

The sixteenth century also distinguishes between main and secondary light, but—we refer to the impression of a black and white plate such as Dürer's *Virgin's Death*—it is still an even weft which is created by the lights adhering to the plastic form. Pictures of the seventeenth century, on the other hand, readily cast their light on one point, or, at any rate, concentrate it in a few spots of highest light which then form

an easily apprehended configuration between them. But that is only half the matter. The highest light or the highest lights of baroque art proceed from a general unification of the light-movement. Quite otherwise than previously, the lights and darks roll on in a common stream, and where the light swells to a final height, just there it emerges from the great total movement. This focussing on individual points is only a derivative of the primary tendency to unity, in contrast to which classic lighting will always be felt as multiple and separating.

It must be a pre-eminently baroque theme if, in a closed space, the light flows from one source only. Ostade's *Studio* gives a clear example of this. Yet the baroque character is not merely a question of subject: in his *St. Jerome* engraving, Dürer, as we know, drew quite different conclusions from a similar situation. But we will leave such special cases out of the question and base our analysis on a plate with a less salient quality of lighting. Let us take Rembrandt's etching of *Christ Preaching*.

The most striking visual fact here is that a whole mass of conglomerated highest light lies on the wall at Christ's feet. This dominating light stands in the closest relation to the other lights. It cannot be isolated as an individual thing, as is possible with Dürer, nor does it coincide with a plastic form: on the contrary, the light glides over the form, it plays with the objects. All the tectonic elements thereby become less obvious and the figures on the stage are, in the strangest way, dragged apart and reassembled as if not they but the light were the element of reality in the picture. A diagonal of light passes from the left foreground over the middle through the archway into the background, yet what meaning does such a statement have beside the subtle quiver of light and dark throughout the whole space, that rhythm by means of which Rembrandt, more than any other, imparts to his scenes a compelling unity of life?

Other unifying factors are, of course, at work here too. We disregard what does not belong to the subject. An essential reason why the story is presented with such impressive emphasis lies in the fact that the style also uses distinctness and indistinctness to intensify the effect, that it does not speak with uniform clearness at all points, but makes places of most speaking form emerge from a groundwork of mute or less speaking form.

The development of colour offers an analogous spectacle. In place of the 'bright' colouring of the primitives with their juxtaposition of colour without systematic connection, there comes in the sixteenth [-century] selection and unity, that is, a harmony in which the colours mutually balance in pure oppositions. The system is perfectly obvious. Every colour plays its part with reference to the whole. We can feel how, like an indispensable pillar, it bears and holds together the building. The principle may be developed with more or less consistency, the

fact remains that the classic epoch, as an epoch of fundamentally multiple colouring, is very clearly to be distinguished from the following period with its aiming at tonal relations. Whenever we pass from the Cinquecentist room in a gallery to the baroque, the surprise we feel is that clear, obvious juxtaposition ceases and that colours seem to rest on a common ground in which they sometimes sink into almost complete monochrome, in which, however, if they stand out clearly, they remain mysteriously moored. We can, even in the sixteenth century, denote single artists as masters of tone and attribute to individual schools a generally tonal style; that does not hinder the fact that, even in such cases, the 'painterly' century introduces an enhancement which should be distinguished by a word of its own.

Tonal monochrome is only a transitional form. Artists soon learned to use tonality and colour simultaneously, and in so doing, to intensify individual colours in such a way that, similarly to the highest lights, as spots of strongest colouring they radically reshape the whole physiognomy of painting in the seventeenth century. Instead of uniformly distributed colour, we now have the single spot of colour—it can be a chord of two or three colours—which unconditionally dominates the picture. The picture is, as we say, pitched in a definite hue. With that is connected a partial negation of colouring. Just as the drawing abandons uniform clearness, so it promotes the focussing of colour effect to make the pure colour proceed from the dullness of half or no colour. It breaks out, not as a thing which happens once, or can be isolated, but as one long prepared. The colourists of the seventeenth century handled this 'becoming' of colour in various ways, but there is always this distinction from the classic system of coloured composition, that the classic age to a certain extent builds with finished units, while in the baroque the colour comes and goes and comes again, there louder, here lower, and the whole is not to be apprehended save through the idea of an all-pervading general movement. In this sense, the foreword to the great Berlin picture catalogue states that the mode of description of colour tried to adapt itself to the course of the development. 'From the detailed notation of colour, there was a gradual transition to a description envisaging the whole of the colouristic impression.'[8]

But it is a further consequence of baroque unity that a single colour can stand out as a solitary accent. The classic system does not know the possibility of casting an isolated red into the scene as Rembrandt does in his *Susanna* in Berlin. The complementary green is not absent, but works only softly, from the depths. Co-ordination and balance are no longer aimed at, the colour is meant to look solitary. We have the parallel in design: baroque art first found room for the interest of the solitary form—a tree, a tower, a human being.

And so, from the consideration of detail, we come back to the general principle. The theory of variable accents, which we have here

developed, would be inconceivable unless art could show the same differences of type as regards content. A characteristic of the multiple unity of the sixteenth century is that the separate things in the picture are felt to be relatively equal in material value. The narrative certainly distinguishes between main and secondary figures. We can see—in contrast to the narration of the primitives—from far off where the crucial point of the event lies, but for all that, what have come into being are creations of that relative unity which to the baroque looked like multiplicity. All the accessory figures still have their own existence. The spectator will not forget the whole in the details, but the detail can be seen for itself. This can be well demonstrated by Dirk Vellert's drawing (1524), showing the child Saul coming to the High Priest. The man who created this work was not one of the pioneer spirits of the sixteenth century, but he was not a backward one either. On the contrary, the representation, articulated through and through, is purely classic in style. Yet every figure has its own centre of interest. The main motive certainly stands out, yet not so that the secondary figures find no room to live their own lives. The architectonic element too is so handled that it must claim some interest for itself. It is still classic art, and not to be confused with the scattered multiplicity of the primitives: everything has its clear relation to the whole, but how ruthlessly would an artist of the seventeenth century have cut down the scene to the points of vital interest! We do not speak of qualitative differences, but even the conception of the main motive lacks, for modern taste, the character of a real event.

The sixteenth century, even where it is quite unified, renders the situation broadly, the seventeenth concentrates it on the moment. But only in this way does the historical picture really speak. We make the same experience in the portrait. For Holbein, the cloak is as valuable as the man. The psychic situation is not timeless, yet cannot be understood as the fixation of a moment of freely flowing life.

Classic art does not know the notion of the momentary, the poignant, or of the climax in the most general sense: it has a leisurely, broad quality. And though its point of departure is absolutely the whole, it does not reckon with first impressions. The baroque conception has shifted in both directions.

'Form', Nineteenth-Century Metaphysics, and the Problem of Art Historical Description

It has seemed to me for some time that a discussion should be begun concerning the descriptive language of the history of art. The transformation of works into words is of crucial importance and in a certain sense everything follows from the way it is done. Some of the language about works of art is unproblematical because agreement is fairly easily reached on certain issues. We may easily agree that a painting is a mural, or a book illumination (even if these things have to be defined), or that a person or group of persons is depicted. Iconography provides fairly definite procedures by means of which conventional subject matter may be restored and deciphered. But things become more difficult when we approach what is called 'form.' At this point the history and criticism of art clearly seem to veer off into their own realm and also into more difficult problems of description and interpretation. These difficult problems cannot simply be avoided since it is on the 'formal' level that we usually talk about both expression and style in art. The technique of formal analysis, which grew up with the discipline of art history, seemed to provide a sturdy bridge between what we see and what we say, a secure metalanguage applicable to any art whatever. Formal analysis is, however, open to very serious criticisms, as we shall see. It is also intimately related to nineteenth-century idealist metaphysics and thus to kinds of historical inference and generalization running the gamut from quaint to dangerous. It is no wonder that formal analysis, although it survives as a professional technique, is used with less and less certainty about its systematic implications, and with a greater and greater sense of its distance from central art historical problems. At the same time, formal analysis remains the way in which 'the work of art itself' is talked about, and if it is simply abandoned, then the history of art is placed in the paradoxical position of being unable to speak in significant ways about the objects of its peculiar concern, which is not even to mention the problems of fashioning histories of these objects. An art historian's art historian disavows the speculations of the 'methodologians' and prides himself or herself on going about what needs to be done in the way demanded by the matter at hand. It is

not possible to avoid methodological questions, however, when they begin to touch the most basic procedural and pedagogical matters. Moreover, it is precisely because of the specific character of its own theoretical past that the history of art now finds itself in a situation in which the discussion of works of art 'themselves' is a problem. It is that problem I will begin to address in this essay. I wish briefly to examine the notions 'form' and 'formal analysis,' to consider the relation of these notions to more general issues of idealism and materialism, and to raise the question of how kinds of description might be devised that sidestep old alternatives but still make it possible to talk about art as distinct from other human endeavors in a historically significant way. I will not, of course, in a single study succeed in completely overhauling ideas that so thoroughly permeate the conceptual and institutional structure of the history of art. Still I believe all these problems and questions must begin to be addressed before it will be possible to consider higher problems of art historical interpretation or the further, perhaps more elegant problems of the ways in which art historical interpretation relates to interpretation in fields not immediately concerned with saying what we see.

I shall begin with what Michael Podro calls 'interpretative vision'.[1] This is the art theoretical version of the broadly Kantian notion that consciousness constitutes its world. It is an idea absolutely central to the modern intellectual discipline of the history of art. According to this idea, which is now so familiar as to seem truistic (or axiomatic) in many fields in the humanities, the artist is not just a recorder of appearances but a shaper and interpreter of them. Heinrich Wölfflin begins his *Principles of Art History* with the story of four painters who set out to paint exactly the same thing just as it was and came up with four quite different pictures.[2] Two conclusions, one negative, the other positive, may be drawn from this anecdote. The negative conclusion is that objective vision is impossible; but the positive one—drawn at length by Wölfflin himself in the book that follows—is that the nonmimetic component of art, evident in the very disparity among the paintings, pointed toward another dimension of reality altogether. 'Form,' as this nonmimetic component came to be called, rather than being incidental or superfluous, is essential; it is the expression of spirit, and, as such, it is also an expression of the essential freedom of the human spirit, opposed to nature, which is a realm of resistance and necessity. By the analysis of form in art, the argument runs, it is possible to investigate the structures of the human spirit itself. It is possible not just to see the individual character of a painter even in the drawing of a mere nostril, as Wölfflin wrote, it is also possible to see and characterize *'the style of the school, the country, the race'*. Shared nonmimetic features of works of art may be explained in terms of individual or collective 'spirit,' which accounts not only for individual differences but for

differences (and similarities) among the 'styles' of periods, nations, and races. In this idealist matrix, 'form' thus took on a vastly important modern connotation; it became the essence of art, supplanting imitation once and for all. At the same time form also became essential in a new way to the artist/viewer, whose spirit it reflected or expressed. It should be evident that Wölfflin's familiar device of comparing treatments of the same theme from different periods inserted these assumptions into the technical basis of art historical teaching and writing.

The notion of interpretative vision might have been carried a step further to include the critic or historian, the analogy being that just as the painter interprets what is seen and reveals his or her own spirit in the forms in which what is seen is expressed, so the historian has a point of view in the expression of which psychology, ideology, or general culture and historical predicament are to be discerned. But the complexities of such a hermeneutic position seem to have been almost entirely ignored or avoided by art historians, who confidently and even 'scientifically' set about the task of defining the new territory of form. The scientific cast of this enterprise was very much reinforced by traditional philosophical meanings of form and by the ancient taxonomic connotations of the idea, which blended easily with the diachrony of taxonomy, that is, with the idea of evolution. Taken altogether, form came to provide access to the 'development of spirit,' and the notion of form provided the basis for historical narrative of a sublime grandeur.

An important and deeply transformative consequence of the great generality of the idea of form was the unprecedented breadth and reach it gave to the idea of art. Form came to be regarded as the universal common denominator of human things, 'fine' and 'minor' arts alike, and the idea of form thus made it possible for the history of art to become a kind of universal cultural history. It was largely under such auspices that the history of art came into existence and currency as an intellectual discipline. The new understanding of the traditional idea of form—opposed now not so much to matter as to nature—also gave new meaning and vastly greater potency to the idea of style (which had always referred to what was artificial rather than natural about imitative art), and style became basic to the history of art in a way it could not have been before. In sum, the newly grasped dimension of 'form' in art provided the basis for 'formalist' art history, a term now used somewhat imprecisely to cover all art history written as if art had a distinct and independent history, as I shall discuss below in more detail. Consistent with this general enterprise, the idea of form also fundamentally altered the description of works of art and finally stands behind current pedagogical practices of formal analysis, practices that continue even though their intellectual ancestry may have been forgotten. As Podro points out, even so discerning a critic as Goethe still

described Leonardo's *Last Supper* mostly in terms of narrative and verisimilitude. Late nineteenth- and early twentieth-century authors, however, discovered 'a way of showing non-literal order in which the depicted figures of the composition could be reconstituted'.[3] A modern author may write about the *Last Supper* in terms of the character of its symmetry, speak of the figure of Christ as a diamond or triangle, or of horizontality and axiality, and be understood to be writing not only about what is legitimately in the work of art but also about what is most important about it. According to the ideas we are considering, 'form' is the indicator of differences in the interpretation of subject matter, or nature, and it follows that form is thus not only the means by which artists (and styles) interpret the historical and natural worlds. It also follows that form must be the agent through which this interpretation is expressed. Interpretative vision thus implies a theory of expression. It also implies a theory of abstraction since form as such may be isolated. Because form is also expressive and is in a sense primary significance, subject matter in such a view tends to be superfluous. The rise of abstraction goes hand in hand with the problem of the relation of 'form' and 'content' (the latter of which came to be associated at once with the natural and the conventional) that has plagued modern criticism. How do the meanings of form square with manifest subject matter? This problem entails familiar alternatives: that form is more important than content, or vice versa, or that there is a unity of form and content, or should be one.

It will be useful to consider briefly how the ideas surrounding 'form' work in practice. Such ideas rapidly developed to a high stage of sophistication, subtlety, and complexity, but they did not, I believe, stray from the foundations I have tried to indicate for them. Let us consider the example of Wilhelm Worringer, who, like Alois Riegl, found it preferable to discuss ornament rather than images because ornament is a purer expression of form and therefore provides a less encumbered view into form's spiritual meaning. Concerning interlace ornament of the first millennium in Northern Europe, Worringer wrote that it is 'impossible to mistake the restless life contained in this tangle of lines'; it is 'the decisive formula for the whole medieval North.' The 'need for empathy of this inharmonious people' requires the 'uncanny pathos which attaches to the animation of the inorganic'; the 'inner disharmony and unclarity of these peoples … could have borne no clearer fruit'.[4] Here forms—mostly lines and edges and their relations—are compared to a natural outgrowth, a fruit, and are interpreted in such a way as to permit the characterization of all peoples among whom artifacts with such forms were made and used. The range of formal style becomes coextensive with the range of the deep principles of the worldview of races, nations, and epochs.

It is not necessary to follow the ideas of form and expression to quite

the hypertrophied consequences Worringer did, although many authors have done so and many more have done so less systematically. The important thing for my purposes is the pattern of inference from form to historical statement and conclusion.

In general, 'form' has a simple meaning, something like 'shape,' and then a higher meaning, something like 'essence.' In older philosophical language it made perfect sense to talk about 'intelligible form,' which was invisible. The idea underlying this old usage seems to be that 'form' as shape is the means by which things are distinguished and thereby begin to be understood (they are named on the basis of this prior discrimination, for example), and that because form provides access to the intelligible, it is in fact fundamentally related to that about things which is intelligible. Form in this second, higher sense is by definition more or less abstract and general, and, because it is abstract and general, it is associated with the spiritual (or mental or intellectual). This ambivalent notion of form, combining a visual metaphor with a definition of the intelligible as nonvisual, provided justification for long traditions of both allegory and idealization. 'Form,' in the post-Kantian sense in which we use it, is still 'higher' than sensation; it has also become more specifically 'visual,' rooted not in sensation but in the determinable structures by means of which 'sense' is made of visual sensation, the properly aesthetic structures of perception standing between sensation and thought. This higher meaning of 'visual' was given great authority and currency by Gestalt psychology. On such a view perception (or the higher 'vision' that unifies simple optical sensation) is a principle awaiting sensation, becoming actual along with sensation. It is very important, however, that this new visual 'form' retained its association with the higher and with the general. The general cannot be specific, and that is why when we do the formal analysis of, say, a Raphael Madonna, the painted surface becomes a plane, and in general we abstract from three dimensions to two, from centers of gravity to verticals, from horizons to horizontals, simplifying as we go; as we do that we presumably approach what is essentially 'visual' about the painting. But the particularity of the formal relationships in the work thus abstracted never comes close to the simple particularity of the work itself, many of whose obvious features have been left aside or suppressed in analysis. Space has been eliminated or reduced to relations of overlapping; light is eliminated together with all modeling, except insofar as it can be seen to make shapes. In short, we ignore at the outset many features and qualities possessed by the painting and shared with other works of art; more simply still, we ignore what we may just see before us, a faintly smiling woman seated on the ground, looking over two children, palpable but distant in a space of considered clarity, in even and peaceful light, painted in earth and primary colors. And this is not even to mention the stretched canvas on which the

image is painted, the pigments used, the preparation and sequence of execution, the facture and finish, all of which have more or less complex and significant histories, histories leading up to the making of Raphael's painting and leading away from it, to the survival and career of use of the painting. These are all things that we see, even if they are not 'visual' in a higher 'formal' sense.

The opposition between form and content strongly implies that whatever can be said in a fairly straightforward sense not to be subject matter must belong in the realm of form and, as form, must be left to the free prerogative of the individual artist (or to definition by the larger stylistic 'spirits' with which that freedom is concentric, form expressing not just the spirit of the artist but the 'spirit of the age'). Given the opposition of form and content implicit in the general idea of form, we might call a strong formalist position one governed by the assumption that form in some sense *is* itself a kind of content, and a weak formalist position one in which form is simply the vehicle of content. As might be expected, art historians tend to be strong formalists to the degree that they are not simply concerned with the chronology of events relating to works of art. Political historians (and historians who are not art historians in general) tend to be weak formalists insofar as they concern themselves with art, since they regard it as illustration of events irrespective of the significance or historicity of the ways in which these events are represented. Against the backdrop of the opposition of form and content, the ideal of the unity of form and content also provides familiar alternatives. Iconographers might argue that meaning has priority in works of art because form serves meaning, and there is a corresponding position that meaning must be given form. Sometimes efforts are made to combine these possibilities, as when generalizations about the formal styles of periods or places are worked into other kinds of history, or, more commonly, when the works of an artist are worked into his or her biography.

At this point I would like to introduce some more general questions of interpretation that will be seen to be closely related to the idea that art is *essentially* formal in nature. Rosalind Krauss has characterized what might be called usual interpretation as based on the 'notion that there is a work, x, *behind which* there stands a group of meanings, a, b, or c, which the hermeneutic task of the critic unpacks, reveals, by breaking through, peeling back the literal surface of the work'.[5] In such a view the understanding of how images mean underlying usual interpretation is very much like the traditional notion of allegory. In fact the metaphorical language of 'surfaces' and 'rinds' is the same language of *integumentum* and *involucrum* used to explain allegory in the late Middle Ages, when allegory provided a major justification for the blandishments of poetry (and painting). Poetry, as the formula went, is truth (or at least higher meaning) set out in a fair and fitting garment of

fiction. The lies of the poet lead us by an appeal to sense to meaning higher than the appeal itself. Botticelli's *Primavera* really sets forth the realm of the Natural Venus,[6] and if that is not what it sets forth, it shows something like that, some idea of a similar level of abstractness, unity, and simplicity in comparison to the complexity of the surfaces and appearances of the painting. The demonstration of such significance at the heart of works of art is never easy, and the example chosen, Botticelli's *Primavera*, has provoked a series of scholarly interpretations. These interpretations do not differ in the relation assumed to hold between the painting and its own meaning, however. This explanation of higher, unitary meaning is very deeply lodged in our expectations (and explanations) of images, and has been for a long time. A Renaissance portrait was thought to show not just someone's appearance but the soul through the appearance, and a similar opposition of higher and lower was also argued to hold for emblems, in which the image was the 'body,' the text the 'soul'.[7] Allegory, like naturalism itself, may be said to depend on a kind of transparency of means in the simple sense that, as the metaphorical language of usual interpretation implies, it is possible to 'see through' the surfaces of the work to its meaning. To be sure, there were (and are) different degrees of allegory, differing precisely in point of difficulty. Some allegories were (and are) meant to be easily penetrable, others to demand a 'sweet labor' before understanding is attained, still others to be impenetrable and therefore exclusive of most of their potential audiences, either because such concealment was (or is) thought appropriate to sacred subject matter or because the image was made for a select group.[8] But the pattern is always the same: the opposition between lower appearance and higher meaning. With modernism all this transparency, both of meaning and of pictorial means, began to change, and at the same time allegory came to be thought impossible, or comic. The 'usual' allegorical expectation lives on, however, animating both 'usual' reactions to works of art and their interpretation, or expectation of interpretability. An unsophisticated viewer might express hostility to a work that seems to block such understanding. Perhaps more frequently, however, this same viewer is intimidated by his or her own puzzlement, and the allegorical expectation is tacitly exploited to mystify and dignify work, artist, and apparent cognoscenti, at the same time that it stratifies and classifies them relative to the viewer, all because it is assumed by the viewer that there must be some higher meaning he or she is for some reason inadequate to judge. These remarks about 'usual' interpretation suggest that there are alternative but congruent assumptions about the way in which either form or content must be the essence of a work of art, that its 'meaning' must either be 'visual' in a higher sense or conceptual (usually specifically textual). These assumptions are in my view large and stubborn impediments to many kinds of art historical under-

standing and in general terms fundamentally misdirect art historical interpretation.

Having brushed in the genealogy of the notion of form and considered some of its implications for art historical analysis, I would now like to continue my argument by considering two major attacks on art historical essentialism launched by E. H. Gombrich, whose ideas will already have been glimpsed at several points in the preceding discussion. In an essay on Raphael's *Madonna della Sedia* first delivered as a lecture in 1955, Gombrich criticized the idea of formal analysis and suggested alternatives to it.[9] He had become aware, he writes, of the frequency with which he used the phrase 'organic unity' in reference to works of art he admired, and he had come to feel that Gestalt psychology had perhaps succeeded too well in its attempt to teach us to understand perception in terms of whole configurations. The criterion of such unity seems too inclusive and therefore too incapable of making distinctions. Gombrich's target in these arguments is not really Gestalt psychology but the long tradition of Aristotelian metaphysics, from which the idea of organic unity descends. Aristotle's notion of order, or organic unity, is linked to his idea of entelechy, thus to final cause. There is a higher principle, an essence that unifies both the structure and the unfolding of the structure of natural things, and so by analogy a work of art has (or should have) an essence unifying its parts.

What is the essence by which the work of art is unified and which corresponds to the entelechy of a natural thing? It is, Gombrich seems to mean, the putative formal unity of the work itself. Of course every 'composition' of 'forms' is unlike every other, but however different they may be, they must still all be unities; they must all fall under that one category. Actually, Gombrich argues, the possession of formal unity does not distinguish a great work of art from lesser or even trivial ones. Most important, if the *Madonna della Sedia* is essentially the unified composition it is, how are we to relate its formal essence to the historical context from which it arose? (This question assumes, of course, that we wish to do that.) Or how are we even to connect this aspect of the work with everything that is obvious about it?

It is form in art that expresses what is nontrivial about representation, and form entails the question of expression, as we have seen. Gombrich addresses this question in terms of what he calls the 'physiognomic fallacy,' which he has defined in a series of essays begun nearly fifty years ago.[10] The adjective 'physiognomic' refers to the ancient, now pseudoscience of physiognomy, according to which it was thought that the nature of the souls of individuals could be inferred directly from the characteristics of their appearance, that those who resemble lions are leonine and those who resemble pigs, porcine. The 'physiognomic fallacy' is the mistaken assumption that in an analogous way we may infer directly some spiritual reality—the inwardness of

artists or the 'spirits' of the ages or places in which works of art were made—from the forms of the works themselves.

The physiognomic fallacy, Gombrich argues, is rooted in a more general and neutral 'physiognomic perception.' This is the first project-ive individual encounter with things and as such occupies a central place in Gombrich's adaptation of Karl Popper's 'searchlight theory of perception'.[11] At this projective level we begin to discriminate things, and these discriminations lead to the relatively more 'objective' levels of systematic inquiry and scrutiny. At the physiognomic level, colors, say, may have an emotional reach embracing a great variety of sensory data. The sky, distant mountains, certain music, and the emotional state of depression might all be united by the color blue, for example. Physiognomic perception might be said to become the pathetic fallacy before it becomes the physiognomic one when we suppose that project-ive meanings belong to the works over which they are projected. 'Blue skies smiling on me' may be blue, but it is wrong to suppose that they are really smiling, or happy, and that the macrocosm really mirrors our microcosmic mood. If we further suppose that the *form* of works of art expresses these projected meanings, then we have crossed over from the pathetic to the physiognomic fallacy. The gist of these arguments is that the meanings we simply see in works of art, although not without their own value, are not historical, and therefore not explanatory. In order to try to gain such historical understanding we must actually do history.

Gombrich's arguments are thus part of a systematic attack on ex-pressionism. He again and again rejects the idea that the feelings of the artist and the feelings of the viewer are symmetrical on either side of the forms the artist uses. If such symmetry held for all art, then it would follow that we are simply able to see what is essential about any art. Such an idea in fact undergirds the modern notion—upon which the history of art stakes much of its claim as an intellectual discipline, and not incidentally, much of its claim to a place in university curricula—that art is a 'universal language' capable of making other cultures available to us as nothing else can. We could never learn the languages and literature necessary to understand what we seem to apprehend about the French of the twelfth century or about the Aztecs by learning to see the forms of their art. Gombrich is well aware of the attraction and apparent naturalness of such thinking. He is also aware that his own arguments threaten the foundations of the modern institutions of the study of art, and further threaten the laudable idea of art as an important agent of human community. But he nevertheless rejects the arguments supporting this view because he feels that expres-sionism implies essentialism. A line does not just 'mean'—or possess, or express—happiness or sadness, rather, he wishes to insist, it means whatever it means in relation to other lines and in general to other

forms, and to the reality of the conditions within which these forms are seen.

Gombrich's idea of the physiognomic fallacy collides head-on with another of the great critical 'fallacies' of our time, the so-called intentional fallacy, one of the cornerstones of the New Criticism. The intentional fallacy seems to me to be little more than a corollary of the kind of expressionism Gombrich wishes to call into question, and perhaps only became formulatable when the idea of expressive form had made it thinkable that the work of art (which in the classic essay of W. K. Wimsatt, Jr, and M. C. Beardsley is, of course, a work of literature) is, or should be, an adequate expression of its own meaning, or better, that its meaning is primarily what its form expresses.[12] The argument presupposes both complete confidence in the expressiveness of the form of the work and a reader sensitive (or passive) to that expressiveness. This neat symmetry is merely complicated when it is supposed that either the work or the reader/viewer or both are determined by deeper structures, psychological or broadly ideological, and such an assumption, rather than substantially changing the situation, again throws the interpreter back on the construal of 'forms.' It is still assumed that historical reconstruction of intention is irrelevant or merely ancillary to interpretation.

For Gombrich, there are even more sinister implications of the physiognomic fallacy involving an even more dangerous kind of essentialism. The forms of art may be imagined not just to express the inwardness of individual artists, but, as we have seen, the spirits of whole nations, races, and epochs. Thus baldly phrased, such inferences seem improbable and daring, but in fact they are everywhere to be found in art historical writing and teaching. Gombrich traces this habit of thought back to the beginnings of modern art history, to Johann Winckelmann, who saw in the impassivity of classical sculpture not just ' "noble simplicity and quiet grandeur," ' but the ' "noble simplicity and quiet grandeur" *of the Greek soul*'.[13] Over the centuries Winckelmann's classical ideal was eclipsed and ceased to be normative, but the principle of interpretation has remained the same, and has been incorporated into the great relativistic scheme of universal art history. Thus at the same time that the idea of form served the positive purpose of universalizing and therefore relativizing the study of art, this universalization was based on kinds of inference and on at least implicit assumptions of the existence of historical entities and forces that are very problematic.

Gombrich closely identifies the physiognomic fallacy with the idea of Weltanschauung, with 'the Romantic belief that style expresses the 'worldview' of a civilization.' This belief encouraged a conception of the history of art as the history of some metaphorical 'seeing,' a history, that is, of 'formal' vision.[14] The physiognomic fallacy and its corollary

understanding of form are thus not only Romantic, they are once again obviously idealist. The history of artistic style in such a view is ancillary to the history of culture, and looks first of all to the history of spirit for the primary motive forces behind historical change. The implications of Gombrich's argument are that, in order to avoid unproductive critical circularity *and* essentialism on the one hand, and to avoid being party to the fabrication of some of the most murderous myths of modern times on the other, we must avoid such historical inferences altogether. And if Gombrich's critique of form and expression is taken seriously, then some very basic art critical and art historical habits must be called into question. If Gombrich is right and we cannot see through form (or through all form) to some kind of meaning, then new ways must be devised for talking about works of art and for making historical inferences from them.

Gombrich's critique of form and expression is closely linked to his critique of historicism. Again following Popper, Gombrich has argued repeatedly that the sort of 'spirit of peoples' thinking that has justified racism and genocide in our time is a brand of essentialism, or pseudo-essentialism (if such a term is possible), that seems to make the ends of history visible, thus to justify the liquidation of groups seen not to have a place in the scheme of history. The programmatic ideological skepticism animating Gombrich's arguments unequivocally rejects totalizing historical schemes of all kinds and dismisses the Hegelian tradition of historical interpretation, idealist and materialist alike.

The arguments to this point might be summarized to say that art historical interpretation is often conducted as if directed toward some essence, formal or thematic or both. What has been called strong formalism pursues a visual essence, weak formalism pursues a thematic essence, and the 'unity of form and content' really means that *essential* form agrees with animating subject matter. As we have also seen, the modern notion of form has always implied development. This is to say that the history of art in being formalist is also historicist. In this essay I shall consider three meanings of the term historicism. The first, just briefly encountered in Gombrich's arguments against it, arguments he derives from Popper, is that laws of history are formulatable and that in general the outcome of history is predictable. The second, which I shall discuss in the example of Walter Benjamin, is the idea that history is a universal matrix prior to events, which are simply placed in order within that matrix by the historian. The third is the idea that a thing is meaningful insofar as it is a part of a development. The history of art is heavily involved in all of these arguments. We need only consider the teaching of history of art surveys, in which periods, styles, and, at least implicitly, whole cultures 'turn into' something else, and in which this 'turning into' is shown to be a more or less necessary development. This assumption of continuity contains the further assumption that

there is one thing that changes (art) that is always essentially the same (formal); it also makes series of events or sequences of period styles into 'developments' and makes art historians look for the ways in which one series of works, regarded either morphologically or physiognomically, changes into another one. Such radical diachronicity, of course, has the great advantage of providing a kind of transcendental thread through the complexity of history, permitting us to say what was 'really' baroque as opposed to what simply happened in the seventeenth century. The same principles are fundamental to art criticism and the art market. 'Modernism' has always meant the 'really' modern, not just what has happened in the late nineteenth and twentieth centuries, and modernist criticism consists not so much of simple judgments about contemporary works as in justifications of judgments in historicist terms, or even in the shaping of judgments to historicist arguments (which last makes problematical judgments of 'quality' unnecessary). A formalist critic explicitly or implicitly asserts not only that 'formal' art is better, but also that only such art is historically authentic and fashions a narrative to show that this is so. In the case of criticism as opposed to history, historicism provides a means by which a thin line may be selected from the vast production of artists of all kinds and defended as in some sense necessary, thus at least providing an absolute criterion for the selection of works of art, a criterion at least incidentally necessary to the optimal functioning of the art market. Postmodernism, which as a general intellectual tendency arises from currents deeply at odds with the historicist habits of thought of the last two centuries, still takes much of its authority as the unwieldy style term it is from its supposed developmental relation to modernism. Postmodernism, that is to say, takes much of its authority and vitality from the very historicist scheme it would reject in its own terms.

As an essentialist and historicist idea, form provides a link between this part of the argument and the next, in which I would like to examine formalism in relation to idealism and materialism as they bear on the history of art. Art historians are now sometimes classified as idealist in professional judgments and communications of one sort or another, and I would like to consider the question of just what this categorization means and how it affects what seems to me to be one of the simplest and most basic problems of art historical interpretation, the explanation of why works of art look the way they look.

At a recent conference a paper on the early modern theory of abstraction was introduced with an apology for its being a 'formalist' subject. The enterprise in which the writer of the paper was engaged could be justified, however, the introducer explained, because the formal motif under examination had 'ideological' import. Everyone in the room understood that the apology was necessary and desirable, or at least understood why it was made, and in fact it points to many of the

interpretative issues I have tried to raise in the first part of this paper.

In the history of art the term 'formalist' has come to refer to a number of paths of interpretation proceeding on the assumption that art is in important respects historically autonomous, and that therefore a meaningful history can be written about art without reference to other historical factors. On such a view the very term 'history of art' would seem to be formalist and therefore idealist in that it implicitly states the assumption that art itself has or is some kind of history. The opposite of formalism is 'contextualism,' a set of methods based on the idea that art is in a very real sense made by historical situations. One setting out to do formalist history will be concerned with works of art 'in themselves'; one setting out to do contextualist art history will be concerned with the circumstances in which art was made. If these options were to be carried into practice as they stand, it would mean that formalists would not be interested in circumstances and contextualists would not be interested in works of art themselves. Very few art historians really occupy either of these extremes, which are probably impracticable. The possibility of the logical purity of either extreme clearly exerts a pull over art historical writing, however, and this pull is reinforced by the relation of these ideas to other intellectual issues.

The term 'context' is of course a broad one, and art may be interpreted in relation to a number of external factors. One of the most powerful contextualist methods has been Erwin Panofsky's iconology. The context in question here is predominantly cultural and intellectual historical, however, and for that reason such investigations may be said to belong to the idealist tradition of art history. (Iconography, the technique preliminary to iconological interpretation according to Panofsky, may also be used for the purposes of political interpretation, which may point to a very different general definition of context.) Even though it is not formalist, such art history is consistent with the formalist and idealist version of art history as the history of the spirit. This leads to what I think is the real force of the category of 'idealist art history,' which is only understandable if 'idealist' means *not* materialist. 'Materialist art history' points to another definition of context, not as cultural historical but as social, political, and economic historical. And to return to the story with which I began, it is now clear why it was necessary to apologize for a 'formalist' paper topic, to justify it by indicating its ideological dimension. Although ideology is also a complex term—especially in relation to the question of historical idealism or materialism—its use has at least the rhetorical effect of transforming an apparently idealist topic into a materialist one.

In the next section I am going to examine materialist art history, argue that it also is ultimately unsatisfactory as a kind of essentialism, and close by offering some alternatives outside the bounds of these nineteenth-century metaphysical categories.

I wish to begin by examining certain arguments from Benjamin's brief 'Theses on the Philosophy of History,' which seem to me to provide a paradigmatic and influential treatment of what Benjamin himself calls 'materialistic historiography'.[15] His arguments are set in terms closely related in one or another aspect to those we have been considering. Benjamin also wrote about 'historicism,' but used the term in a special sense, as we have seen. Benjamin understood the word to refer to the presumption of a kind of Newtonian continuous time into which all events can be placed. The method of historicist history is 'additive,' which is to say that what we call 'contributions' can be assumed all to have a place in the same great but abstract narrative. The historicist historian need not worry about more than setting events in their proper order, and so, beyond the presumption of underlying time, what Benjamin calls 'universal' (that is, historicist) history 'has no theoretical armature'.[16] Benjamin opposes all of this to his 'materialistic historiography.' He considers it imperative that historicist history be rejected because historicism, by making the present seem to be the cumulative progressive consequence of what has gone before, can be seen to justify the status quo. Human history, Benjamin wants to say, is neither neutral nor is it positive progress; it is instead endless carnage and suffering, Hegel's slaughterbench. The very assumption of the absolute continuity of history is acquiescence in oppression and murder.

'Materialistic historiography,' in short, sees the terrible confluence of history with momentary victory, and Benjamin wants to eliminate the political and moral anesthesia of historicism once and for all by denying its assumption of underlying continuity. Events are not continuous with one another, they are disjunctive; and materialistic historiography embraces this disjunctiveness, making it a part of the historian's own procedure, which cannot simply be justified by what needs to be done in some subscientific sense. The past may inevitably be at hand, but if it is alive it is made alive in the present. The rejection of continuity thus implies a willfully violent hermeneutics in which the past is appropriated to the purposes of the present. The historian, Benjamin says, seizes the past with virile force in a revolutionary transformative act. I linger over these ideas because such ideas are widely diffused; but to keep to Benjamin's arguments, they are based on an extreme dichotomy corresponding to extreme circumstances. Benjamin was trying to cut away the intellectual underpinnings of fascism and to do so rejected the entire tradition of what he called universal history. To do that he juxtaposed absolute continuity and absolute discontinuity.

Both Benjamin and Gombrich formulated their arguments under the immediate pressure of the cataclysmic threat of the rise of Nazism and both rejected what they called 'historicism.' However different their understanding of this word may have been, for both writers the

rejection of historicism meant the rejection of negative principles of continuity that had to be given up not least because of their horrible moral and political consequences. The solutions to the problem of discontinuity offered by the two writers point in two quite different directions, raising an alternative that will guide much of the remainder of this essay.

If discontinuity is materialist, then continuity is (at least by implication) idealist. If Benjamin does not in fact say this, it is a tack taken by other 'materialist' writers and has a place among the issues of this discussion. Historicism as Benjamin understood it is essentialist if not idealist because it implies that time itself is a progressive principle of change. As such it misplaces the locus of significant historical transformation from class conflict to a metaphysical (or physical) principle.

Since it is based on the rejection of continuity, practitioners of materialistic historiography might be expected to favor synchronic over diachronic explanation. This again gives a more specific definition to 'context,' which is not only economic and political, but is structurally rather than causally related to whatever is to be interpreted. Art is not to be explained primarily in relation to previous art, and this position may easily be translated into terms of the earlier argument. 'Form' was said to be a principle of continuity, expressive of the culture to which it belonged. Form thus had a kind of built-in historical cogency, but at the same time it made it difficult (if not impossible) to explain anything but evolutionary change and relations to broader 'spiritual' factors. This difficulty was acknowledged in the conclusion of one of the greatest and best-known formalist essays in the literature of the history of art. At the end of his *Principles of Art History* Wölfflin acknowledged that his formal principles, which had been used to describe a development from Renaissance through baroque art, could not explain why the same development should end and begin again. He regarded this recommencement (that is, the return to a linear style in art around 1800) as 'unnatural' and attributed it to 'profound changes in the spiritual world,' to 'a revaluation of being in all spheres'. Meyer Schapiro defined a similar problem in more general terms in his essay on style, this time suggesting social rather than spiritual historical context as a solution.[17]

The principles by which are explained the broad similarities in development are of a different order from those by which the singular facts are explained. The normal motion and the motion due to supposedly perturbing factors belong to different worlds; the first is inherent in the morphology of styles, the second has a psychological or social origin. It is as if mechanics had two different sets of laws.

This paradoxical state of affairs has by no means ended; rather the pendulum has swung now to one, now to the other side. The availability

of the distinction between the synchronic and the diachronic (which Ferdinand de Saussure formulated in reaction to a developmental linguistics) has only served to harden the opposition, as we have seen; but again, this opposition is perfectly consistent with the general distinction between materialist discontinuity and idealist continuity.

To the degree that it can be called formalist at all, materialist art history might be expected to take a weak formalist posture, that is, to assume that the means of representation are vehicles of content and are historical only insofar as they are vehicles of content, which is determined by social and economic context.[…]

Why do such contradictory patterns of explanation occur? I believe it is because both 'idealism' and 'materialism' as a priori bases of historical investigation demand the suppression of one or another kind of historical evidence. Idealism and materialism are alternative principles of the highest generality. This is not to say that they are simply different ways of describing the same thing since each involves the relative deepness or priority of one or another principle, that is, the generality means that one kind of thing is *always* able to be explained in terms of the other ('mind is the highest form of matter'; 'matter is something about mind'). The whole question thus revolves around the point of which principle is explanatory relative to the other, and if we turn these distinctions to history, it means that some kinds of evidence are always explanatory relative to others. I observed above that a most basic task of the history of art is the explanation of why works of art look the way they look. This is not a trivial statement; it provides a criterion according to which both idealist and materialist art history are of limited explanatory usefulness. Either alternative must exclude kinds of evidence that bear on the explanation of the appearance and change in the appearance of series of works of art. Idealist art historians tend to be unconcerned with the patronage, use, and reception of images, which are manifestly part of their legitimate history, and materialist art historians tend to avoid any reference to cultural history or the technical history of art traditions themselves because they are assumed to bear merely a 'superstructural' relationship to a deeper, 'truer' historical principle.

How is this dilemma to be resolved? We might consider the following. When Marx inverted Hegel's scheme of history, he retained one essential thing, namely its absolute totality. This totality followed inevitably from the continued reduction of all historical process to a single metaphysical principle, but it also retained a vision of something like overarching providential purpose in history and in human action. In the terms of this argument, however, totality is based on a most general kind of essentialism, which is finally disenabling for historical interpretation. […]

Style

By style is meant the constant form—and sometimes the constant elements, qualities, and expression—in the art of an individual or a group. The term is also applied to the whole activity of an individual or society, as in speaking of a 'life-style' or the 'style of a civilization.'

For the archaeologist, style is exemplified in a motive or pattern, or in some directly grasped quality of the work of art, which helps him to localize and date the work and to establish connections between groups of works or between cultures. Style here is a symptomatic trait, like the nonaesthetic features of an artifact. It is studied more often as a diagnostic means than for its own sake as an important constituent of culture. For dealing with style, the archaeologist has relatively few aesthetic and physiognomic terms.

To the historian of art, style is an essential object of investigation. He studies its inner correspondences, its life-history, and the problems of its formation and change. He, too, uses style as a criterion of the date and place of origin of works, and as a means of tracing relationships between schools of art. But the style is, above all, a system of forms with a quality and a meaningful expression through which the personality of the artist and the broad outlook of a group are visible. It is also a vehicle of expression within the group, communicating and fixing certain values of religious, social, and moral life through the emotional suggestiveness of forms. It is, besides, a common ground against which innovations and the individuality of particular works may be measured. By considering the succession of works in time and space and by matching the variations of style with historical events and with the varying features of other fields of culture, the historian of art attempts, with the help of common-sense psychology and social theory, to account for the changes of style or specific traits. The historical study of individual and group styles also discloses typical stages and processes in the development of forms.

For the synthesizing historian of culture or the philosopher of history, the style is a manifestation of the culture as a whole, the visible sign of its unity. The style reflects or projects the 'inner form' of collective thinking and feeling. What is important here is not the style of an individual or of a single art, but forms and qualities shared by all the

arts of a culture during a significant span of time. In this sense one speaks of Classical or Medieval or Renaissance Man with respect to common traits discovered in the art styles of these epochs and documented also in religious and philosophical writings.

The critic, like the artist, tends to conceive of style as a value term; style as such is a quality and the critic can say of a painter that he has 'style' or of a writer that he is a 'stylist.' Although 'style' in this normative sense, which is applied mainly to individual artists, seems to be outside the scope of historical and ethnological studies of art, it often occurs here, too, and should be considered seriously. It is a measure of accomplishment and therefore is relevant to understanding of both art and culture as a whole. Even a period style, which for most historians is a collective taste evident in both good and poor works, may be regarded by critics as a great positive achievement. So the Greek classic style was, for Winckelmann and Goethe, not simply a convention of form but a culminating conception with valued qualities not possible in other styles and apparent even in Roman copies of lost Greek originals. Some period styles impress us by their deeply pervasive, complete character, their special adequacy to their content; the collective creation of such a style, like the conscious shaping of a norm of language, is a true achievement. Correspondingly, the presence of the same style in a wide range of arts is often considered a sign of the integration of a culture and the intensity of a high creative moment. Arts that lack a particular distinction or nobility of style are often said to be style-less, and the culture is judged to be weak or decadent. A similar view is held by philosophers of culture and history and by some historians of art.

Common to all these approaches are the assumptions that every style is peculiar to a period of a culture and that, in a given culture or epoch of culture, there is only one style or a limited range of styles. Works in the style of one time could not have been produced in another. These postulates are supported by the fact that the connection between a style and a period, inferred from a few examples, is confirmed by objects discovered later. Whenever it is possible to locate a work through nonstylistic evidence, this evidence points to the same time and place as do the formal traits, or to a culturally associated region. The unexpected appearance of the style in another region is explained by migration or trade. The style is therefore used with confidence as an independent clue to the time and place of origin of a work of art. Building upon these assumptions, scholars have constructed a systematic, although not complete, picture of the temporal and spatial distribution of styles throughout large regions of the globe. If works of art are grouped in an order corresponding to their original positions in time and space, their styles will show significant relationships which can be co-ordinated with the relationships of the works of art to still other features of the cultural points in time and space.

II

Styles are not usually defined in a strictly logical way. As with languages, the definition indicates the time and place of a style or its author, or the historical relation to other styles, rather than its peculiar features. The characteristics of styles vary continuously and resist a systematic classification into perfectly distinct groups. It is meaningless to ask exactly when ancient art ends and medieval begins. There are, of course, abrupt breaks and reactions in art, but study shows that here, too, there is often anticipation, blending, and continuity. Precise limits are sometimes fixed by convention for simplicity in dealing with historical problems or in isolating a type. In a stream of development the artificial divisions may even be designated by numbers—Styles I, II, III. But the single name given to the style of a period rarely corresponds to a clear and universally accepted characterization of a type. Yet direct acquaintance with an unanalyzed work of art will often permit us to recognize another object of the same origin, just as we recognize a face to be native or foreign. This fact points to a degree of constancy in art that is the basis of all investigation of style. Through careful description and comparison and through formation of a richer, more refined typology adapted to the continuities in development, it has been possible to reduce the areas of vagueness and to advance our knowledge of styles.

Although there is no established system of analysis and writers will stress one or another aspect according to their viewpoint or problem, in general the description of a style refers to three aspects of art: form elements or motives, form relationships, and qualities (including an all-over quality which we may call the 'expression').

This conception of style is not arbitrary but has arisen from the experience of investigation. In correlating works of art with an individual or culture, these three aspects provide the broadest, most stable, and therefore most reliable criteria. They are also the most pertinent to modern theory of art, although not in the same degree for all viewpoints. Technique, subject matter, and material may be characteristic of certain groups of works and will sometimes be included in definitions; but more often these features are not so peculiar to the art of a period as the formal and qualitative ones. It is easy to imagine a decided change in material, technique, or subject matter accompanied by little change in the basic form. Or, where these are constant, we often observe that they are less responsive to new artistic aims. A method of stone-cutting will change less rapidly than the sculptor's or architect's forms. Where a technique does coincide with the extension of a style, it is the formal traces of the technique rather than the operations as such that are important for description of the style. The materials are significant mainly for the textural quality and color, although they may affect the conception of the forms. For the subject

matter, we observe that quite different themes—portraits, still lifes, and landscapes—will appear in the same style.

It must be said, too, that form elements or motives, although very striking and essential for the expression, are not sufficient for characterizing a style. The pointed arch is common to Gothic and Islamic architecture, and the round arch to Roman, Byzantine, Romanesque, and Renaissance buildings. In order to distinguish these styles, one must also look for features of another order and, above all, for different ways of combining the elements.

Although some writers conceive of style as a kind of syntax or compositional pattern, which can be analyzed mathematically, in practice one has been unable to do without the vague language of qualities in describing styles. Certain features of light and color in painting are most conveniently specified in qualitative terms and even as tertiary (intersensory) or physiognomic qualities, like cool and warm, gay and sad. The habitual span of light and dark, the intervals between colors in a particular palette—very important for the structure of a work—are distinct relationships between elements, yet are not comprised in a compositional schema of the whole. The complexity of a work of art is such that the description of forms is often incomplete on essential points, limiting itself to a rough account of a few relationships. It is still simpler, as well as more relevant to aesthetic experience, to distinguish lines as hard and soft than to give measurements of their substance. For precision in characterizing a style, these qualities are graded with respect to intensity by comparing different examples directly or by reference to a standard work. Where quantitative measurements have been made, they tend to confirm the conclusions reached through direct qualitative description. Nevertheless, we have no doubt that, in dealing with qualities, much greater precision can be reached.

Analysis applies aesthetic concepts current in the teaching, practice, and criticism of contemporary art; the development of new viewpoints and problems in the latter directs the attention of students to unnoticed features of older styles. But the study of works of other times also influences modern concepts through discovery of aesthetic variants unknown in our own art. As in criticism, so in historical research, the problem of distinguishing or relating two styles discloses unsuspected, subtle characteristics and suggests new concepts of form. The postulate of continuity in culture—a kind of inertia in the physical sense— leads to a search for common features in successive styles that are ordinarily contrasted as opposite poles of form; the resemblances will sometimes be found not so much in obvious aspects as in fairly hidden ones—the line patterns of Renaissance compositions recall features of the older Gothic style, and in contemporary abstract art one observes form relationships like those of Impressionist painting.

The refinement of style analysis has come about in part through

problems in which small differences had to be disengaged and described precisely. Examples are the regional variations within the same culture; the process of historical development from year to year; the growth of individual artists and the discrimination of the works of master and pupil, originals and copies. In these studies the criteria for dating and attribution are often physical or external—matters of small symptomatic detail—but here, too, the general trend of research has been to look for features that can be formulated in both structural and expressive-physiognomic terms. It is assumed by many students that the expression terms are all translatable into form and quality terms, since the expression depends on particular shapes and colors and will be modified by a small change in the latter. The forms are correspondingly regarded as vehicles of a particular affect (apart from the subject matter). But the relationship here is not altogether clear. In general, the study of style tends toward an ever stronger correlation of form and expression. Some descriptions are purely morphological, as of natural objects—indeed, ornament has been characterized, like crystals, in the mathematical language of group theory. But terms like 'stylized,' 'archaistic,' 'naturalistic,' 'mannerist,' 'baroque,' are specifically human, referring to artistic processes, and imply some expressive effect. It is only by analogy that mathematical figures have been characterized as 'classic' and 'romantic.'

III

The analysis and characterization of the styles of primitive and early historical cultures have been strongly influenced by the standards of recent Western art. Nevertheless, it may be said that the values of modern art have led to a more sympathetic and objective approach to exotic arts than was possible fifty or a hundred years ago.

In the past, a great deal of primitive work, especially representation, was regarded as artless even by sensitive people; what was valued were mainly the ornamentation and the skills of primitive industry. It was believed that primitive arts were childlike attempts to represent nature—attempts distorted by ignorance and by an irrational content of the monstrous and grotesque. True art was admitted only in the high cultures, where knowledge of natural forms was combined with a rational ideal which brought beauty and decorum to the image of man. Greek art and the art of the Italian High Renaissance were the norms for judging all art, although in time the classic phase of Gothic art was accepted. Ruskin, who admired Byzantine works, could write that in Christian Europe alone 'pure and precious ancient art exists, for there is none in America, none in Asia, none in Africa.' From such a viewpoint careful discrimination of primitive styles or a penetrating study of their structure and expression was hardly possible.

With the change in Western art during the last seventy years,

naturalistic representation has lost its superior status. Basic for contemporary practice and for knowledge of past art is the theoretical view that what counts in all art are the elementary aesthetic components, the qualities and relationships of the fabricated lines, spots, colors, and surfaces. These have two characteristics: they are intrinsically expressive, and they tend to constitute a coherent whole. The same tendencies to coherent and expressive structure are found in the arts of all cultures. There is no privileged content or mode of representation (although the greatest works may, for reasons obscure to us, occur only in certain styles). Perfect art is possible in any subject matter or style. A style is like a language, with an internal order and expressiveness, admitting a varied intensity or delicacy of statement. This approach is a relativism that does not exclude absolute judgments of value; it makes these judgments possible within every framework by abandoning a fixed norm of style. Such ideas are accepted by most students of art today, although not applied with uniform conviction.

As a result of this new approach, all the arts of the world, even the drawings of children and psychotics, have become accessible on a common plane of expressive and form-creating activity. Art is now one of the strongest evidences of the basic unity of mankind.

This radical change in attitude depends partly on the development of modern styles, in which the raw material and distinctive units of operation—the plane of the canvas, the trunk of wood, toolmarks, brushstrokes, connecting forms, schemas, particles and areas of pure color—are as pronounced as the elements of representation. Even before nonrepresentative styles were created, artists had become more deeply conscious of the aesthetic-constructive components of the work apart from denoted meanings.

Much in the new styles recalls primitive art. Modern artists were, in fact, among the first to appreciate the works of natives as true art. The development of Cubism and Abstraction made the form problem exciting and helped to refine the perception of the creative in primitive work. Expressionism, with its high pathos, disposed our eyes to the simpler, more intense modes of expression, and together with Surrealism, which valued, above all, the irrational and instinctive in the imagination, gave a fresh interest to the products of primitive fantasy. But, with all the obvious resemblances, modern paintings and sculptures differ from the primitive in structure and content. What in primitive art belongs to an established world of collective beliefs and symbols arises in modern art as an individual expression, bearing the marks of a free, experimental attitude to forms. Modern artists feel, nevertheless, a spiritual kinship with the primitive, who is now closer to them than in the past because of their ideal of frankness and intensity of expression and their desire for a simpler life, with more effective participation of the artist in collective occasions than modern society allows.

One result of the modern development has been a tendency to slight the content of past art; the most realistic representations are contemplated as pure constructions of lines and colors. The observer is often indifferent to the original meanings of works, although he may enjoy through them a vague sentiment of the poetic and religious. The form and expressiveness of older works are regarded, then, in isolation, and the history of an art is written as an immanent development of forms. Parallel to this trend, other scholars have carried on fruitful research into the meanings, symbols, and iconographic types of Western art, relying on the literature of mythology and religion; through these studies the knowledge of the content of art has been considerably deepened, and analogies to the character of the styles have been discovered in the content. This has strengthened the view that the development of forms is not autonomous but is connected with changing attitudes and interests that appear more or less clearly in the subject matter of the art. [...]

Style

Style is any distinctive, and therefore recognizable, way in which an act is performed or an artifact made or ought to be performed and made. The wide range of applications implied in this definition is reflected in the variety of usages of the word in current English. (Definitions and illustrations in the *Shorter Oxford English Dictionary* take up almost three columns.) They may be conveniently grouped into descriptive and normative usages. Descriptions may classify the various ways of doing or making, according to the groups or countries or periods where these were or are habitual—for example, the gypsy style of music, the French style of cookery, or the eighteenth-century style of dress; it may take its name from a particular person, as in 'Ciceronian style,' or even denote one individual's manner of doing something ('This is not my style.'). In a similar way institutions or firms may have a distinctive way of procedure or production, publishers have a 'house style' and provide authors with a 'style sheet' indicating how to quote titles of books, etc.

Often styles are described by some characteristic quality that is experienced as expressive of psychological states—'a passionate style,' 'a humorous style'; frequently, also, these characterizations shade over into intrasensory (synesthetic) descriptions, as in a 'sparkling,' a 'drab,' or a 'smooth' style of writing or playing. Equally often, the distinctive quality to be described is derived from a particular mode of performance or production and transferred to others of similar character, as in a 'theatrical' style of behavior, a 'jazzy' style of ornament, a 'hieratic' style of painting. Finally, there are the terms now reserved for categories of style, such as the 'Romanesque' or the 'Baroque' style, which have sometimes been extended in their application from the descriptions of architectural procedures to the manner of performance in other arts and beyond to all utterances of the societies concerned during the periods covered (Baroque music, Baroque philosophy, Baroque diplomacy, etc.).[1]

As in most terms describing distinctions—including the very words 'distinction' and 'distinguished'—the term 'style' stripped of any qualifying adjective can also be used in a normative sense, as a laudatory term denoting a desirable consistency and conspicuousness that makes a performance or artifact stand out from a mass of 'undistinguished' events or objects: 'He received him in style'; 'This acrobat has style'; 'This build-

ing lacks style.' Huckleberry Finn, describing a 'monstrous raft that was as long going by as a procession' remarked, 'There was a power of style about her. It *amounts* to something being a raftsman on such a raft as that' (Mark Twain, *Huckleberry Finn*, chapter 16). To the anthropologist, perhaps, every raft has a 'style' if he chooses to use this term for the way of producing any such craft habitual in any society. But to Mark Twain's hero the term connotes a raft with a difference, one sufficiently elaborate to impress. This connotation is illustrated in Winston Churchill's reply to a barber who had asked him what 'style of haircut he desired': 'A man of my limited resources cannot presume to have a hair *style*—get on and cut it' (*News Chronicle*, London, December 19, 1958).

Intention and description. It might have saved critics and social scientists a good deal of trouble and confusion if Churchill's distinction had been applied in the usage of the term—that is, if the word 'style' had been confined to cases where there is a choice between ways of performance or procedure. Historically, this is clear. Thus, the word 'style' was adopted for the alternative forms of dating in use during the period between the introduction and acceptance of the Gregorian calendar in England. When the 'old style' gradually fell out of use, nobody continued to speak of the 'style' of dating a letter.

But usage apart, the indiscriminate application of the word 'style' to any type of performance or production which the user, rather than the performer or producer, is able to distinguish has had grave methodological consequences. It may be argued (and will be argued in this article) that only against the background of alternative choices can the distinctive way also be seen as expressive. The girl who chooses a certain style of dress will in this very act express her intention of appearing in a certain character or social role at a given occasion. The board of directors that chooses a contemporary style for a new office building may equally be concerned with the firm's image. The laborer who puts on his overalls or the builder who erects a bicycle shed is not aware of any act of choice, and although the outside observer may realize that there are alternative forms of working outfits or sheds, their characterization as 'styles' may invite psychological interpretations that can lead him astray. To quote the formulation of a linguist, 'The pivot of the whole theory of expressiveness is the concept of *choice*. There can be no question of style unless the speaker or writer has the possibility of choosing between alternative forms of expression. Synonymy, in the widest sense of the term, lies at the root of the whole problem of style'.[2]

If the term 'style' is thus used descriptively for alternative ways of doing things, the term 'fashion' can be reserved for the fluctuating preferences which carry social prestige. A hostess may set the fashion in a smaller or wider section of the community for a given style of decoration or entertainment. Yet the two terms may overlap in their

application. A fashionable preference can become so general and so lasting that it affects the style of a whole society. Moreover, since considerations of prestige sometimes carry with them the suspicion of insincerity and snobbery, the same movement may be described as a fashion by its critics and as a style by its well-wishers.

Etymology. The word 'style' derives from Latin *stilus*, the writing instrument of the Romans. It could be used to characterize an author's manner of writing (Cicero, *Brutus*, 100), although the more frequent term for literary style was *genus dicendi*, 'mode of speech'.[3] The writings of Greek and Roman teachers of rhetoric still provide the most subtle analyses ever attempted of the various potentialities and categories of style. The effect of words depends on the right choice of the noble or humble term, with all the social and psychological connotations that go with these stratifications. Equal attention should be paid to the flavor of archaic or current usages.[4] Either usage can be correct if the topic so demands it. This is the doctrine of *decorum*, of the appropriateness of style to the occasion. To use the grand manner for trivial subjects is as ridiculous as to use colloquialisms for solemn occasions (Cicero, *Orator*, 26). Oratory, in this view, is a skill that slowly developed until it could be used with assurance to sway the jury. But corruption lurks close to perfection. An overdose of effects produces a hollow and affected style that lacks virility. Only a constant study of the greatest models of style (the 'classical' authors) will preserve the style pure.[5]

These doctrines, which also have an application to music, architecture, and the visual arts, form the foundation of critical theory up to the eighteenth century. In the Renaissance, Giorgio Vasari discussed the various manners of art and their progress toward perfection in normative terms. The word 'style' came only slowly into usage as applied to the visual arts, although instances multiply in the late sixteenth century and in the seventeenth century.[6] It became established as a term of art history in the eighteenth century, largely through J. J. Winckelmann's *History of Ancient Art* (1764). His treatment of Greek style as an expression of the Greek way of life encouraged Herder and others to do the same for the medieval Gothic and, thus, paved the way for a history of art in terms of succeeding period styles. It is worth noting that the names for styles used in art history derive from normative contexts. They denote either the (desirable) dependence on a classical norm or the (condemned) deviations from it.[7] Thus, 'Gothic' originated from the idea that it was the 'barbaric' style of the destroyers of the Roman Empire.[8] 'Baroque' is a conflation of various words meaning 'bizarre' and 'absurd'.[9] 'Rococo' was coined as a term of derision about 1797 by J. L. David's pupils for the meretricious taste of the age of Pompadour.[10] Even 'Romanesque' started its career about 1819 as a term denoting 'the corruption of the Roman style,' and 'mannerism,' equally, signified the affectation that corrupted the purity of the Renaissance.[11]

Thus, the sequence of classical, postclassical, Romanesque, Gothic, Renaissance, mannerist, baroque, rococo, and neoclassical originally recorded the successive triumphs and defeats of the classical ideal of perfection.[12] While the eighteenth-century Gothic revival brought the first challenge to this view, it was only in the nineteenth century that the whole repertory of 'historical styles' was available for the architect, a state of affairs which made the century increasingly style-conscious and led to the insistent question, 'What is the style of *our* age?'.[13] Thus, the concepts of style developed by critics and historians reacted back on the artists themselves. In the course of these debates the relation between style and the progress of technology came increasingly to the fore.

Technology and fashion

The distinctive way an act is performed or an artifact made is likely to remain constant as long as it meets the needs of the social group. In static groups the forces of conservatism are, therefore, likely to be strong and the style of pottery, basketry, or warfare may not change over long periods.[14] Two main forces will make for change: technological improvements and social rivalry. Technological progress is a subject extending far beyond the scope of this article, but it must be mentioned because of its effect on choice situations. Knowledge of better methods might be expected to change the style of artifacts irresistibly, and indeed, where the technical aim is paramount—as in warfare, athletics, or transport—the demonstrably better method is likely to change the style of procedure as soon as it is known and mastered.

What is relevant here for the student of style is that the older method may yet be retained within certain limited contexts of ritual and ceremony. The queen still drives to Parliament in a coach, not in an automobile, and is guarded by men with swords and lances, not with Tommy guns. The Torah is still in scroll form, while the world has adopted the more convenient codex. It is clear that the expressive value of the archaic style will tend to increase with the distance between the normal technological usages and the methods reserved for these distinctive occasions. The more rapid technical progress becomes, the wider will be the gap between adoption and rejection. In our technological society, even the retention of the 'vintage car' is symptomatic of a 'style of life.'

We are here touching on the second factor making for change—the element of social rivalry and prestige. In the slogan 'Bigger and better,' 'better' stands for technological improvement with reference to a stable purpose, 'bigger' for the element of display that is such a driving force in competitive groups. In medieval Italian cities rival families vied with each other in building those high towers that still mark the city of San Gimignano. Sometimes civic authority asserted its symbolic rights by forbidding any of these towers to rise higher than the

tower of the town hall. Cities, in their turn, might vie with each other to have the biggest cathedral, just as princes would outdo each other in the size of their parks, the splendor of their operas, or the equipment of their stables. It is not always easy to see why competition suddenly fastens on one element rather than another, but once the possession of a high tower, a large orchestra, or a fast motorcycle has become a status symbol within a given society, competition is likely to lead to excesses far beyond the need of the technological purpose.

It might be argued that these developments belong to the realm of fashion rather than of style, just as the improvement of method belongs to technology. But an analysis of stability and change in style will always have to take into account these two influences. The pressures of fashion, like those of technology, provide an additional dimension of choice for those who refuse to go with the fashion and, thus, desire to assert their independence. Clearly, this independence is only relative. Even a refusal to join in the latest social game is a way of taking up a position toward it. Indeed, it might make those who adopt this course willy-nilly more conspicuous than the followers of fashion. If they have sufficient social prestige, they might even find themselves to be creators of a nonconformist fashion which will ultimately lead to a new style of behavior.

The above distinction between technical and social superiority is of necessity artificial, for technological progress tends to create prestige for the society in which it originated, which will carry over into other fields. Admiration for Roman power and for the ruins of Rome led to the fashion for all things Roman in the Renaissance, and the admiration of Peter the Great and Kemal Pasha for Western superiority even led to a forced change to Western dress and hairstyles in their countries. The fashions for American jazz or American slang so much deplored by conservative Europeans on both sides of the Iron Curtain are reminders of the legendary prestige of American technology and power, just as the rush to learn the Russian language can be traced back to the success of the first Sputnik. Here, as always, however, the reaction of the nonconformist provides the best gauge for the potential attractions of the style. Leaders of underdeveloped nations, such as Gandhi, have defiantly resisted Westernization in their style of dress and behavior and exalted the virtues of uncorrupted technological primitivity.

Style in art has rarely been analyzed in terms of these pressures, but such an analysis might yield worthwhile results, for the various activities which, since the eighteenth century, have gradually become grouped together under the name of art[15] once served a variety of practical purposes in addition to increasing prestige. In architecture both aspects interacted from the very beginning, the erection of the Egyptian pyramids, for example, displaying both technological and organizational skills and competitive pride. Opinions tend to differ about the relative proportions of technological and prestige elements in the suc-

cession of medieval architectural styles; the technology of stone vaulting offered a clear advantage in view of fire risks, but it is still an open question whether the introduction of the Gothic rib and the subsequent competition in light and high structures was motivated principally by technical considerations. Clearly, considerations of prestige, of outdoing a rival city or a rival prince, have always played a part in architectural display. At the same time, architectural history exhibits many reactions away from these dual pressures, toward simpler styles or more intimate effects. The rejection of ornament in neoclassical architecture, the conspicuous simplicity of Le Petit Trianon—not to speak of Marie Antoinette's *hameau* at Versailles—are cases in point. The Gothic revival drew its strength from the associations of that style with a preindustrial age. Indeed, the history of architecture provides perhaps the most interesting conflict of motives. When, in the nineteenth century, technology and engineering improved the use of iron constructions, architects adopted, for a time, the ritualistic attitude that this new material was essentially inartistic: the Eiffel Tower was a display of engineering, not of art. But ultimately, it was the prestige of technology within our industrial society that assured the embodiment of the new methods in a new technological 'functional' style.[16] Now even functionalism, the conspicuous look of technological efficiency, has become a formal element of expression in architecture and, as such, sometimes influences design at least as much as genuine adaptation to a purpose. The best example for this interaction of technology and fashion in the visual arts is the adoption of 'streamline' patterns to designs not intended to function in rapid currents.

Even the development of painting and sculpture could be seen in the light of these dual influences if it is accepted that image making usually serves a definite function within society. In tribal societies the production of ritual masks, totem poles, or ancestral figures is usually governed by the same conservative traditions of skill as is the production of other artifacts. When the existing forms serve their purpose, there is no need for change and the craftsman's apprentice can learn the procedures from his master. However, foreign contacts or playful inventions may lead to the discovery of 'better' methods of creating images—better, at least, from the point of view of naturalistic plausibility. Whether these methods are accepted, ignored, or deliberately rejected will depend largely on the function assigned to images within a given society. Where the image functions mainly in a ritualistic context, changes will be discouraged even though they cannot be entirely prevented. The conservative styles of Egypt and Byzantium are cases in point. On the other hand, when the principal function of painting and sculpture lies in their capacity to evoke a story or event before the eyes of the spectator,[17] demonstrable improvements in this capacity will tend to gain ready acceptance and displace earlier methods, which

may then only linger on in confined, sacred contexts. This prestige of improved methods can be observed at least twice in the history of art: in the development of Greek art from the sixth to the fourth century B.C. and in the succession of styles in Europe from the twelfth to the nineteenth century.

The invention of such illusionistic devices as foreshortening, in the fifth century B.C., or of perspective, in the fifteenth century A.D., gave to the arts of Greece and Florence a lead which is expressed in the prestige and the diffusion of these styles over the whole of the civilized world. It took centuries until the momentum of such spectacular superiority was spent and a reaction set in.

Even in this realm of artistic styles, however, the introduction of better illusionistic devices could and did lead to tensions where rejection was as powerful a means of expression as was acceptance. This reaction became particularly important after the method of achieving the then main purpose of art—convincing illustration—had been mastered in fourth-century Greece and sixteenth-century Italy. It was felt that technical progress was no longer needed once the means had been perfected to suit the ends, as in the (lost) paintings by Apelles or in the masterpieces by Leonardo, Raphael, and Michelangelo. Subsequent innovations in the dramatic use of light and shade (Caravaggio and Rembrandt) or in the rendering of movement (Bernini) were rejected by critics as obscuring rather than helping the essential purpose of art and were considered an illicit display of technical virtuosity at the expense of clarity. Here lie the roots of that philosophy of style that is essential to the whole development of criticism in the Western tradition. The perfect harmony between means and ends marks the classical style,[18] periods in which the means are not yet quite sufficient to realize the ends are experienced as primitive or archaic, and those in which the means are said to obtrude themselves in an empty display are considered corrupt. To evaluate this criticism, we would have to ask whether display could not and did not develop into an alternative function of art with its own conventions and code.

Evolution and disintegration of styles

It is clear that from the normative point of view there is an intrinsic destiny which artistic styles are likely to follow and that this will overtake different activities at different points in time. The classic moment in epic poetry may have been achieved in Homer; that of tragedy, in Sophocles; that of oratory, in Demosthenes; that of sculpture, in Praxiteles; and that of painting in Apelles or Raphael. Symphonic music may have reached its perfect balance between ends and means, its classic moment, in Mozart, three hundred years after Raphael's paintings.

It has indeed been argued that such phenomena as mannerism or

the baroque, however they may be valued, occur in the development of any art which has reached maturity and, perhaps, overripeness. In that 'late' phase, the increasingly hectic search for fresh complexities may lead to an 'exhaustion' of the style when all permutations have been tried.[19] Although there is a certain superficial plausibility in this interpretation, which accounts for some stretches of historical development, it must never be forgotten that terms such as 'complexity' and 'elements' do not here refer to measurable entities and that even the relationship of means to ends is open to contrasting interpretations. What may appear to one critic as the classic moment of an art may carry, for another, the seeds of corruption, and what looks like the final stage of exhaustion of a style to one interpreter may be seen from another point of view as the groping beginnings of a new style. Cézanne, the complexity of whose art is beyond doubt, saw himself as the primitive of a new age of art, and this ambiguity adheres to any great artist, who can always be described as representing the culmination of a preceding evolution, a new beginning, or (by his adversaries) an archcorruptor. Thus, the naturalism of Jan van Eyck can be seen as the climax of late Gothic tendencies in the descriptive accumulation of minute details[20] or as the primitive start of a new era. The style of J. S. Bach can be experienced as late complexity or as archaic grandeur. For the same reasons almost any style can be convincingly described as transitional.

It is evident, moreover, that the units, or styles, by which the evolution is traced will always be rather arbitrarily chosen. Aristotle gave the lead in his famous sketch of the evolution of tragedy (*Poetics* 1448b3–1449a) but to do so, he had first to set off tragedy from comedy or mime. In a similar way, we may either describe the evolution of painting or of one of its branches, and we may find, for instance, that what was a late phase for portrait painting (e.g., mannerism) was an early one for landscape painting.

If the analysis of styles in terms of the inner logic of their evolution has, nevertheless, yielded illuminating results, this must be attributed less to the validity of alleged historical laws than to the sensitivity of critics. Heinrich Wölfflin,[21] for example, used this framework in order to draw attention to the artistic means available to a given master and developed a vocabulary for a debate, which, however inconclusive it is bound to be, will increase our awareness of the traditions within which the masters concerned operated. By placing an *oeuvre* into a continuous chain of developments, we become alerted to what its creator had learned from predecessors, what he transformed, and how he was used, in his turn, by later generations. We must only guard against the temptation of hindsight to regard this outcome as inevitable. For every one of the masters concerned, the future was open, and although each may have been restricted in his choice by certain characteristics of the situation, the directions the development might have taken are still

beyond computation. Ackerman has provided a fuller criticism of this type of stylistic determinism.[22] But these strictures do not invalidate the search for a morphology of style that should underpin the intuitions of the connoisseur.

Style and period. The analysis of stylistic traditions in terms of the means peculiar to individual arts cuts across another approach, which is less interested in the 'longitudinal' study of evolution than in the synchronic characterization of all activities of a particular group, nation, or period. This approach to style as an expression of a collective spirit can be traced back to romantic philosophy, notably to Hegel's *Philosophy of History* (1837). Seeing history as the manifestation of the Absolute in its growing self-awareness, Hegel conceived of each stage of this process as a step in the dialectical process embodied in one particular nation. A nation's art, no less than its philosophy, religion, law, mores, science, and technology, will always reflect the stage in the evolution of the Spirit, and each of these facets will thus point to the one common center, the essence of the age. Thus, the historian's task is not to find out what connections there may be between aspects of a society's life, for this connection is assumed on metaphysical grounds.[23] There is no question, for instance, whether the Gothic style of architecture expresses the same essential attitude as scholastic philosophy or medieval feudalism. What is expected of the historian is only to demonstrate this unitary principle.

It matters little in this context whether the historian concerned thinks of this unitary principle as the 'Hegelian spirit' or whether he looks for some other central cause from which all the characteristics of a period can be deduced. In fact, the history of nineteenth-century historiography of art (and its twentieth-century aftermath) can largely be described as a series of attempts to get rid of the more embarrassing features of Hegel's metaphysics without sacrificing his unitary vision. It is well known that Marx and his disciples claimed to do precisely this when they turned Hegel's principle upside down and claimed that material conditions are not the manifestation of the spirit, but rather the spirit is an outflow or superstructure of the material conditions of production. It was these conditions (to remain with our previous example) which led to medieval feudalism and which are reflected in scholastic philosophy no less than in Gothic architecture.

What distinguishes all these theories from a genuinely scientific search for causal connections is their a priori character. The question is not whether, and in what form, feudalism may have influenced the conditions under which cathedrals were constructed, but how to find a verbal formula that makes the assumed interdependence of style and society immediately apparent. In this conviction the various holistic schools of historiography agreed, regardless of whether they belonged to the materialist Hegelian left-wing or to the right-wing of

Geistesgeschichte. As Wölfflin, one of the most subtle and sophisticated analysts of style, formulated his program in his youth, in 1888: 'To *explain* a style then can mean nothing other than to place it in its general historical context and to verify that it speaks in harmony with the other organs of its age'.[24] What matters in the present context is that this holistic conviction became widely accepted by historians and artists alike. As Adolf Loos, the pioneer of modern architecture in Austria, put it: 'If nothing were left of an extinct race but a single button, I would be able to infer, from the shape of that button, how these people dressed, built their houses, how they lived, what was their religion, their art, and their mentality'.[25]

It is the old classical tag *Ex ungue leonem* ('The claw shows the lion') applied to the study of culture. By and large, historians and anthropologists have preferred to display their skill for interpretation where the results were foreknown rather than risk being proved wrong by fresh evidence.

Stylistic physiognomics

Seductive as the holistic theory of style has proved to be, it is still open to criticism on methodological grounds. It is true that both individuals and groups exhibit to our mind some elusive unitary physiognomy. The way a person speaks, writes, dresses, and looks merges for us into the image of his personality. We therefore say that all these are expressions of his personality, and we can sometimes rationalize our conviction by pointing out supposed connections.[26] But the psychologist knows that it is extremely hazardous to make inferences from one such manifestation to all the others even when we know the context and conventions extremely well. Where this knowledge is lacking, nobody would venture such a diagnosis. Yet, it is this paradoxically which the diagnosticians of group styles claim to be able to do .[27] More often than not, they are simply arguing in a circle and inferring from the static or rigid style of a tribe that its mentality must also be static or rigid. The less collateral evidence there is, the more easily will this kind of diagnosis be accepted—particularly if it is part of a system of polarities in which, for instance, dynamic cultures are opposed to static ones or intuitive mentalities to rational ones.

The weaknesses of this kind of procedure in both history and anthropology are obvious. The logical claims of cultural holism have been subjected to dissection and refutation in K. R. Popper's *The Poverty of Historicism* (1957). There is no necessary connection between any one aspect of a group's activities and any other.

This does not mean, however, that style cannot sometimes provide a fruitful starting point for a hypothesis about certain habits and traditions of a group. One of these possibilities has been mentioned already. There certainly are conservative groups or societies which will tend to

resist change in all fields, and other societies (like ours) in which prestige attaches to experimentation as such.[28] It might be argued that contrasting characteristics of style may flow from these contrasting attitudes. The static societies may tend to value solid craftsmanship and the refinements of skill, while the dynamic groups may favor the untried even where it is the unskilled. But such generalizations are subject to the same qualifications as the ones criticized in the preceding section. There is no real common gauge by which to compare the skill of Picasso with that of a conservative Chinese master. Once more, therefore, the evaluation of expressiveness will largely depend on a knowledge of choice situations. In such a situation the twentieth-century art lover may indeed prefer originality to skill, while the Chinese would select the skillful, rather than the novel, painting. The same applies to such dominant values of a society as love of luxury or its rejection. What constitutes luxury may change, but it may still be true to say that at the fashionable courts of Europe, around 1400, the more precious and shiny artifact or painting would have been preferred, while a Calvinist paterfamilias would have thrown the same gaudy bauble out of the window. Such basic attitudes may, indeed, color the style of several arts at the same time.

It might even be argued that social values such as the traditional English love of understatement will influence the choice of means and styles in various fields and favor the rejection of display in architecture, of 'loud' colors in painting, and of emotionalism in music. But, although there is an intuitive truth in such connections, it is only too easy to point to opposite features in the grandiloquent vulgarity of English Victorian town halls, the shrill colors of pre-Raphaelite paintings, or the emotionalism of Carlyle's tirades.

What is true of national character as allegedly 'expressed' in art is even more conspicuously true of the spirit of the age. The baroque pomp and display of the *Roi soleil* at Versailles is contemporaneous with the classical restraint of Racine. The functionalist rationalism of twentieth-century architecture goes hand in hand with the irrationalism of Bergson's philosophy, Rilke's poetry, and Picasso's painting. Needless to say, it is always possible to reinterpret the evidence in such a way that one characteristic points to the alleged 'essence' of a period, while other manifestations are 'inessential' survivals or anticipations, but such *ad hoc* explanations invalidate rather than strengthen the unitary hypothesis.

The diagnostics of artistic choice

To escape from the physiognomic fallacy, the student of style might do worse than return to the lessons of ancient rhetoric. There, the alternative vocabularies provided by social and chronological stratifications provided the instrument of style. We are familiar with similar

stratifications in the styles of speech, dress, furnishings, and taste which allow us to size up a person's status and allegiance with reasonable confidence. Taste in art is now similarly structured between the cheap and the highbrow, the conservative and the advanced. No wonder that artistic choices offer themselves as another badge of allegiance. But what is true today need not always have been true.[29] The temptation to overrate the diagnostic value of artistic style stems partly from an illicit extension of our experience in modern society.

It is possible that this situation in art did not fully arise before the French Revolution, which polarized European political life into right-wing reactionaries and left-wing progressives. While the champions of reason clung to the neoclassical style, its opponents became medievalizers in architecture, painting, and even dress to proclaim their allegiance to the age of faith. From then on, it was not exceptional for an artistic movement to be identified with a political creed. Courbet's choice of working-class models and subjects was felt to be an act of defiance that stamped him as a socialist. In vain did some artists protest that their radicalism in painting or music did not imply radical political views.[30] The fusion and confusion of the two was strengthened by the critics' jargon, which spoke of the avant-garde[31] and revolutionaries in art, and by the artists who copied the politicians in issuing manifestoes.

But, although the divisions of our societies are possibly reflected in the range of our art, it would be rash to conclude that the allegiance can be read off the badge, as it were. There was a time, in the early 1920s, when abstract painting was practiced in revolutionary Russia and when opposition to these experiments could rally the opponents of 'cultural Bolshevism.' Now abstract art is denounced in Russia, where 'social realism' is extolled as the healthy art of the new age. This change of front, in its turn, has made it possible for abstract art to be used as a subsidiary weapon in the cold war, in which it now has come to stand for freedom of expression. The toleration of this style of painting in Poland, for instance, is indeed a social symptom of no minor importance.

There are perhaps two lessons which the student of style can learn from this example. The first concerns the 'feedback' character of social theories. Soviet Russia, having adopted the Marxist version of Hegelianism as its official creed, could not look at any artistic utterance but as a necessary expression of a social situation. Deviation and nonconformity in art were therefore bound to be interpreted as symptoms of potential disloyalty, and a monolithic style appealing to the majority became a theoretical necessity. We in the West, happily, do not suffer from the same state religion, but the Hegelian conviction is still sufficiently widespread among critics and politicians to encourage a political interpretation of stylistic changes—our newspapers prefer

to ask of every new movement in art or architecture what it stands for, rather than what its artistic potentialities may be. The second lesson suggested by this contemporary experience in East and West is that one cannot opt out of this game. Once an issue has been raised in this form, once a badge has been adopted and a flag hoisted, it becomes hard, if not impossible, to ignore this social aspect. One might pity the anticommunist Pole who would like to paint a brawny, happy tractor driver, but one would have to tell him that this subject and style has been pre-empted by his political opponents. The harmless subject has become charged with political significance, and one person alone cannot break this spell.

These two observations underline the responsibility of the social scientist in his discussion of style. Here, as always, the observer is likely to interfere with what he observes.

Morphology and connoisseurship

The distinctive character of styles clearly rests on the adoption of certain conventions which are learned and absorbed by those who carry on the tradition. These may be codified in the movements learned by the craftsman taught to carve a ritual mask, in the way a painter learns to prime his canvas and arrange his palette, or in the rules of harmony, which the composer is asked to observe. While certain of these features are easily recognizable (e.g., the Gothic pointed arch, the cubist facet, Wagnerian chromaticism), others are more elusive, since they are found to consist not in the presence of individual, specifiable elements but in the regular occurrence of certain clusters of features and in the exclusion of certain elements.

We become aware of these hidden taboos when we encounter an instance of their infringement in a bad imitation. We then say with conviction that Cicero would never have ended a sentence in that fashion, that Beethoven would never have made this modulation, or that Monet would never have used that color combination. Such apodictic statements seem to restrict severely the artist's freedom of choice. Indeed, one approach to the problem of style is to observe the limitations within which the artist or craftsman works. The style forbids certain moves and recommends others as effective, but the degree of latitude left to the individual within this system varies at least as much as it does in games. Attempts have been made to study and formulate these implicit rules of style in terms of probabilities. The listener who is familiar with the style of a piece of music will be aware at any moment of certain possible or probable moves, and the interaction between these expectations and their fulfillment or evasion is a necessary part of the musical experience. Not surprisingly, this intuition is confirmed by mathematical analysis, which shows the relative frequency of certain sequences within a given style of composition.[32]

Music, with its limited number of permutations of discrete elements, is, however, a rather isolated case, which cannot be readily generalized. Even so, the analysis of literary style in terms of word order, sentence length, and other identifiable features has also yielded promising results for statistical morphology.[33] No systematic attempt to extend this method to the analysis of style in the visual arts is known to the present writer. Certainly, methods of prediction and completion could even be applied in these cases. We would not expect the hidden corner of a brownish Rembrandt painting to be light blue, but it may well be asked if observations of this kind stand in need of statistical confirmation.

The limitations of scientific morphology are perhaps all the more galling when we realize that a style, like a language, can be learned to perfection by those who could never point to its rules.[34] This is true not only of contemporaries who grow into the use of their styles and procedures in learning the craft of building or gardening but also of the most skillful forger, mimic, or parodist, who may learn to understand a style from within, as it were, and reproduce it to perfection without bothering about its syntax. Optimists like to state that no forgery can be successful for a long time, because the style of the forger's own period is bound to tell and tell increasingly with distance, but it must be recognized that this argument is circular and that any forgeries of the past which were sufficiently successful simply have not been detected. The possibility exists, for instance, that certain busts of Roman emperors which are universally held to date from antiquity were in fact made in the Renaissance, and it is equally likely that many Tanagra figures and Tang horses in our collections are modern. Some forgeries, moreover, were unmasked only on external evidence such as the use of materials or of tools unknown in the alleged period of their origin.[35] It is true that this achievement of the successful forger also suggests that the understanding of style is not beyond the reach of the intuitively minded and that the great connoisseur who is pitted against the forger has at least as much chance as has his opponent.

Confronted with a painting, a piece of music, or a page of prose attributed to a particular author or age, the connoisseur can also say with conviction that this does not look or sound right. There is no reason to doubt the authority of such statements, though it would be incautious to consider them infallible. It has happened that an essay published under Diderot's name was deleted from the author's canon on stylistic grounds but had to be restored to it when the original draft in his hand was found. If such independent evidence came more frequently to light, the fame of the connoisseur would probably suffer, but he would still be sure to score quite an impressive number of hits. For the time being, at any rate, the intuitive grasp of underlying *Gestalten* that makes the connoisseur is still far ahead of the morphological analysis of styles in terms of enumerable features.

4

History as an Art

Introduction

Art history takes every object as a symptom of what produced it. It constructs the past by placing in a position so as to be observable the objects that are destined to be read as its relics and remainders. The history of art fabricated by art history is in this sense a function of place and plot: a stagecraft and a dramaturgy. Through the concatenation of objects in virtual and material space, in texts and in architecture, artworks (and their reproductions) themselves become the sites of transformation and metamorphosis. In the hands of the art historian, the work seems to pass from opacity to transparency; from silence to speech.

The history of art historical and critical practice throughout the nineteenth and twentieth centuries has been a history of such *evocations*: of the drawing out of what can be plausibly argued at a given time to be the historical truth of objects; or the meanings they contain within themselves: their content. This has always in some way constituted a mode of *decipherment* in the original root meaning of the term; namely, the removal of a 'cipher'—a hole or lacuna—in meaning or sense, by appearing to fill it up with meaning, so that no areas of nonsense would be seen to remain. That truth constituted the object's uniqueness and specificity; its difference and distinction from the present, and at the same time, its connectedness to us.

One of the principal functions of art historical writing, then, has been the production of the *present* as both distinct from and yet connected with the past. The past is separated out and distanced from the present so that the present can more clearly be *seen* to be tied to it as its ancestral or genealogical background. The legibility of art history's objects—their metamorphosis into object-lessons—is also a function of how and where they are deployed in this system of genealogies, in sites designed for meaningful reading, such as museums, galleries, archives. These latter are in effect *erudite machines*:[1] places whose own organization confers meaning and sense to the arrangements of things (on which see below, Chapter 9), and within which each object becomes the locus of an analytical metamorphosis or transformation—the passage of things from being opaque and resistant to reading, to a state of

transparency or legibility.

In the hands of the art historian, objects speak in the third person (the historical mode) of what they are in relationship to other objects. That relationship is presented, furthermore, as an expression or reflection of the meaning of a whole historical or evolutionary system, which itself stands as a figure or emblem of the totality of a society (or the life of an individual) in its genesis. History-writing is thus an art of fashioning time as a legible formation: a form that might be walked through, as through a gallery or a book; time as unfolding before one's eyes. History, in short, as the art of instilling a secure belief in pregiven realities.

If art objects are symptoms of what produced them, then of what exactly are they symptomatic or symbolic (apart from their being the immediate effects or products of human manufacture)? Art history in the Hegelian tradition—whether of an explicitly theological orientation, or in more secularized versions charting the progressive evolution of national, ethnic, or racial character or spirit—presumed above all that stylistic change was symptomatic of broader or deeper (and preexisting) changes in meaning or significance; in individual or collective mentality or will.

In the late nineteenth and early twentieth centuries, the majority of art historians continued to confront the contradictory implications of the Hegelian aesthetic world-system for the interpretation of individual works, styles, and schools of art. In addition to Wölfflin and Focillon, the great French historian of art, literature, and culture Hippolyte Taine (1828–93),[2] and the Viennese art historian and museum curator of decorative arts Alois Riegl (1858–1905) wrestled with the problem of relating individual and collective factors affecting the formation of objects.

In attempting to delineate what factors determined or affected the form of art objects, the work of Riegl was notable in departing from the forward-progressive aspect of the Hegelian dialectic of the unfolding world Spirit. In his *Stilfragen* of 1893[3] and then in his monumental *Late Roman Art Industry*,[4] Riegl postulated that whereas a *Geist* or Spirit could be said to inform individual art works and sequences of development (he termed this the cultural or social Will to Form, or *Kunstwollen*), changes came about primarily as a result of the unfolding logic or trajectory of the system of forms itself. Each object thus represented a step or moment in a continuum of aesthetic solutions to common cultural problems.

This was a perspective in one sense not all that dissimilar to that of Vasari (see Chapter 1) but without Vasari's progressive movement towards some ideal solution in the most recent art. The 'history' of art for Riegl was a set of linked solutions whose trajectory and direction may be predetermined and inevitable (given the inner logic of forms and

designs), but which can in principle be altered by changes in the social or cultural Will. In this regard, his work stood in opposition to histories of art organized as genealogies of great individual artists. For Riegl, the particular maker's individuality and originality are submerged in a large collective movement of stylistic change, composed of minute (and largely anonymous) developments. The artist is as much the product of the unfolding system of formal choices, options, and artistic and technical constraints as he or she is the instigator or initiator of style.[5]

Riegl's *Late Roman Art Industry*, much of which appeared after his death, caused substantial problems for the older evolutionary models of artistic change, and in particular for the cyclical and organicist models common to previous scholarship. Rather than seeing late Roman Imperial and early Christian art as facets of a late classicism in decline, Riegl argued that they represented above all moments in a logical unfolding of formal techniques, or a language of form. They were neither superior nor inferior to what preceded them, but were rather the apt expressions of a *Kunstwollen*; links in a chain or a logical trajectory of artistic practice. The first reading is from the introduction to Riegl's *Late Roman Art Industry*, and outlines his perspective and his explanation for the nature of late Roman style.

The remainder of the readings in this Chapter are devoted to the extraordinary work of Aby Warburg (1866–1929). His interdisciplinary pursuit of understanding the history and subsequent fates of the classical tradition in European art, and of non-European forms of expression in the face of their annihilation and transformation by Western cultural practices, set him apart from much of his generation, on several counts. With regard to the former, his delineation of classicism was closer to that of Nietzsche than to the classical doctrines of Winckelmann and Enlightenment rationalism, in portraying enduring and fundamentally unreconciled tensions between contradictory emotions and attitudes towards reason.[6] With respect to the latter, Warburg's perspective on the relentless march of Western culture and civilization was anti-triumphalist, and, as two of the readings below will indicate, he viewed its progress as ultimately self-destructive.

Warburg's interest in style was in one sense the obverse of Riegl's, in that he understood style in art as *continuous with* rather than as a 'reflection' of other aspects of social and cultural practice. This was at the same time a result of his resolutely interdisciplinary approach to art, and of his encouragement of diversity and heterogeneity in scholarship. It also reflected his very wide-ranging researches into cultural forms, collective memory, and symbolism across cultures, which found its greatest expression in the organization of the library he created in Hamburg, designed so as to help the user elude what he called the 'border police' of disciplinary specialization[7] and parochial and

fragmented knowledge.

In the years just before his death his unfinished *Bilderatlas* or picture-book project, entitled *Mnemosyne* (and alternatively called by him a 'Picture Book for a Critique of Pure Unreason') was a non-discursive and non-linear composition of images of diverse types and origins, continually being changed and resembling a Dadaistic performance piece. It was in fact an explication of his method and of his vision of the complex interrelatedness of things.

In addition to Warburg's 1923 lecture on images from the Pueblo Indian region which he observed in his travels to the American southwest in 1896, two texts below, by Edgar Wind and Margaret Iversen, analyse different aspects of Warburg's life and work. In the first piece, written in 1930, Wind examines Warburg's notion of *Kulturwissenschaft* and his opposition to the 'autonomous' art histories of Wölfflin and Riegl.

In the second essay, published in 1993, Margaret Iversen foregrounds the revolutionary historical and critical positions of Warburg that can best be appreciated by setting his work next to that of two later and much more conservative followers—Erwin Panofsky and Ernst Gombrich. She argues that their interpretations of Warburg's life and work essentially reduced and flattened out Warburg's complex insights into a more domestic (and, as she suggests, a more masculinist and idealist) humanism, causing him to be (mis)understood as a latter-day Enlightenment rationalist.

There are several excellent studies of Riegl and Warburg now in print. On Riegl, see Kurt Foster, 'Aby Warburg's History of Art: Collective Memory and the Social Mediation of Images', *Daedalus*, 305 (1976), 169–76; Margaret Iversen, *Alois Riegl: Art History and Theory* (Cambridge, Mass., 1993); Margaret Olin, 'Forms of Respect: Alois Riegl's Concept of Attentiveness', *Art Bulletin*, 71 (1989), 285–99; Margaret Olin, *Forms of Representation in Alois Riegl's Theory of Art* (University Park, Pa., 1992); Henri Zerner, 'Alois Riegl: Art, Value, Historicism', *Daedalus*, 305 (1976), 177–89.

In addition to Warburg's untranslated Collected Works,[8] see Ernst Gombrich's useful but ultimately reductively idealist portrait, *Aby Warburg: An Intellectual Biography, with a Memoir on the History of the Library by F. Saxl* (Chicago, 1986), first published 1970 by the Warburg Institute, University of London; and Silvia Ferretti, *Cassier, Panofsky, Warburg: Symbol, Art, and History*, trans. Richard Pierce (New Haven, 1989).

Leading Characteristics of the Late Roman 'Kunstwollen'

The late Roman *Kunstwollen* has in common with the *Kunstwollen* of all previous antiquity that it was still oriented toward the pure perception of the individual shape with its immediately evident material appearance, while modern art is less concerned with the sharp separation of the individual appearances and more than with a connection of collective appearances, or especially with a demonstration of an independence of seemingly individual elements. The essential artistic medium which late Roman art used in the same way as antiquity in order to reach this artistic goal was rhythm. With rhythm, that is the sequential repetition of the same appearances, the coalition of the parts to an individual entity became immediately obvious and convincing to the beholder; and where there were several individual elements it was rhythm again which was able to create a higher unity. Rhythm, however, as long as it appears to be evident for the beholder is necessarily bound to the plane. Rhythm exists from elements beside and above one another, but not behind one another; in the latter case, individual shapes and parts would overlap and thus withdraw themselves from the immediate visual perception of the beholder. Hence, an art which wants to present units in a rhythmic composition is forced to compose on the plane and to avoid deep space. As all ancient art, so also late Roman art strove for the representation of individual unifying shapes via a rhythmic composition on the plane.

Late Roman *Kunstwollen* differs from previous art periods in antiquity—the more the further apart it is from them, and less harsh the closer it is to them—in that it was not satisfied with looking at the individual shape in its two-dimensional expansion, but it wanted to see it in its three-dimensional, fully spatial boundaries. Consequently, connected with this was the separation of the individual shape out of the universal visual plane (ground) and its isolation from the ground level and from other individual shapes. Yet the individual shape here was not only free, but free are also the individual intervals of ground lying in between, which prior to that were bound on a common ground level (visual plane); following the complete isolation of the individual shape there was thus at the same time an emancipation of intervals, the elevation of the hitherto neutral shapeless ground to an artistic one,

that is, to an individual unity of a finished powerful shape. The medium for it remained still rhythm, which results in the fact that now the interval also had to be shaped rhythmically.

While the intervals were now like the individual shapes, separated three-dimensionally from depths, they produced also a free spatial niche of a particular depth. Even though this depth was never considerable, it would question an effect of a rhythm bound to the plane. It sufficed, however, to fill the intervals thus treated more or less with dark shadows, which, together with the projecting bright individual shapes in between, created a colorful rhythm between light and shadow, black and white. This color rhythm, which belonged especially to the middle Roman works, but also to the fourth century (sarcophagi of the City of Rome), remained particularly dominant for a long time in architecture and in the crafts, it ceased a bit on essentially late Roman figurative reliefs (sarcophagi from Ravenna), which again reveals an inclination toward the return to a tactile perception in order to attribute to the linear rhythm an even greater unlimited dominance. Besides those we find even in the advanced late Roman period figurative reliefs which in the middle Roman tradition observe color rhythm as well as linear rhythm.

The levelling of the ground and the individual shapes led in the cases where one wanted to emphasize the individual shape, still effectively to the mass composition: an even more unheard phenomenon within ancient art since it obviously constitutes also the preliminary step to the modern perception of the collective character of seemingly individual shapes.

The isolation of the individual shape has also had its influence on the expression of the rhythm in that the rhythm was now no longer concerned only with articulation and change, which always had a combining effect, but also with simplification and creation of massiveness. While classical rhythm was one of contrast (contrapposto, triangular composition), late Roman rhythm as such became the one of a series with equal shapes (quadrangular composition). As soon, however, as the individual shapes dissolved their connection with one another, they were represented in their objective appearance separated from a momentary relation to other individual shapes whenever possible. Hence, there develops the striving for objectivity of the appearance of the typical character, and the anonymity of late Roman, art, which is always inseparably connected with such an anti-individualistic artistic creation.

We know of these main leading characteristics of late Roman art from a thorough investigation of the monuments of the four types of art. Yet there exists a medium hitherto unused with which we may test the correctness of our results. This medium is the comparative use of literary sources by the late Romans concerning *Kunstwollen* in artistic creation.

I would like to bring herewith to the attention of the scholars an art historical source, which has been to date neglected to the same degree as the literary sources were, which contain external, local and time data that have been the object of greatest appreciation and diligent studies. Yet a time which liked to perceive the work of art as a mechanistic product of raw material, technique and the immediate external reason of purpose, could in the utterances of authors concerning the *Kunstwollen* of their time, see nothing else than speculative fantasies: in the eyes of the art materialists there exists no conscious *Kunstwollen* and what was said about it in earlier times could in the best case be just a worthless self-deception, not to say, intended deception. But whoever realized that mankind meant to see the visual appearances according to outlines and color on the plane or in space at different times in a different manner, will without hesitation, be familiar with the thought that the utterances of studious and learned men about what they expected from the work of art of their time deserve full attention from art historical research. This can be seen as a medium which might help us test whether ideas reached by us with our subjective observation about the leading *Kunstabsichten* of a certain period were indeed the ideas of those belonging to the period. In other words, if at that time one indeed wanted from the visual arts what we imagine it to have been based on our investigation of the monuments, then this obviously will be the true and only reliable proof for our results of research.

The material which is available for such purposes from the time between the third and the fifth centuries is extremely rich and would permit a most thorough proof. For the late pagans, we have mainly the neo-platonic philosophers and among them above all, Plotinus. It would be no less enlightening to look at the Christian authors. At this place the teaching of St Augustine about beauty and its relation to late Roman art may be sketched—not so much to describe the subject and not at all to exhaust it, but rather to offer proof that it is possible to solve this future problem of art historical research.[1]

According to Augustine, essential beauty lies only with God; yet, on the other side there is no object in nature that would not contain traces (*vestigia*) of beauty: even ugly objects are not excluded from this.[2] The visual arts have the responsibility during the imitation (*imitatio*) of natural objects to emphasize those traces of beauty one-sidedly.[3] Hence, everything points to the question of what Augustine would have understood under the generally dispersed 'traces' of beauty. These are, to say it right away, the principal goals of all ancient artistic creation: unity (isolated perception of the individual shape) and rhythm.

The individual completeness of the shape is understood also by Augustine (as by all his ancient predecessors) to be as much a precondition for all existence as it was a seat and manner of expression for beauty in all objects from nature.[4] His ideas differ from the ancient Near

Eastern and the early Greek ones through dualistic perception, according to which in each object besides the materialistic unity of shape there exists also a spiritual one, which is of higher value than the first one: a perception, which, by the way, in its very roots goes back, as is generally known, to the pre-Alexandrian Greeks.[5] Hence, Augustine concludes that the responsibility of the artist is nothing other than to produce as much as he can in his art work, all which seems to make the individual formal entity of the shape of a natural object really evident.

Even more valuable for us is the following: in individual cases Augustine explains with clear words how he sees unity as the expression of beauty in particular types of art. So, for example, during the dialogue with an architect with whom he agrees that he should not strive for anything but unity in his buildings and that he should try to reach this mainly with symmetrical and proportional composition of the individual parts of the building when compared with the entire building.[6]

Symmetry and proportion, however, are special forms of appearances of a higher universal medium in the visual arts: rhythm. The medium through which unity, that is the individual completion of the shape of the natural object within a work of art, is expressed is also according to Augustine rhythm (*numerus*).[7] Its importance is so much emphasized and placed in the foreground by Augustine that Berthaud even believed it to be the actual principle of beauty according to the ideas of Augustine; he, therefore, presented unity as a form of expression of the rhythm, while obviously the true relationship can just be the opposite one. All other characteristics of beauty in the works of the visual arts (to the symmetry and proportion already mentioned) come as a third organization and there exist special forms of expression for rhythm. There are also pertinent utterances by Augustine concerning individual remarks for certain works of art. For example, he demands that the windows of a building be either equal (rhythm of equal series) or that they, if uneven, be treated in such a manner that the window of medium size is by the same degree larger than the smaller, as it was surpassed by the largest.[8] Since such an increasing line is accompanied also by a decreasing one, to be imagined on the same plane, we have thus as a result a rhythm of contrast, as it can, for example, be observed in the windows of the semi-circular lunettes of the large middle Roman halls (such as the Baths of Diocletian and the Basilica of Maxentius).

This example warrants two additional remarks. First, it is remarkable that Augustine chooses his concrete examples of works of art from architecture; the figurative arts (sculpture and painting) are not entirely left out, but stand in the background. This reluctance of Augustine in regard to the figurative arts gains a deeper importance as soon as one recalls that the development of figurative art during the following

centuries was generally not a favorable one; the Semitic Near East had done away with it forever and the Greek Near East threatened it at least for a century with iconoclasm; and even in the West, the large pioneering achievements at least until the twelfth century belonged not to sculpture or painting but to architecture (and to the crafts).

Secondly, I would like to state most emphatically how the choice of the perforated (*perforatis*) windows in buildings reveals the change which took place in late antiquity. Aristotle would have chosen as analogous examples columns or any other material positive individual shape: Augustine, however, uses for this a de-materialized perforation. This leads now to the question how far with the doctrine of beauty Augustine, besides a general ancient basic characteristic of the visual arts of his time, also expressed the specific one for late antiquity (middle and late Roman).

This difference follows, as we showed in the monuments, the treatment of unity and rhythm. The common ancient tendency toward the perception of the individual shape is still dominant, yet, one saw through the increased spaces of the individual shape now clearer that also this needed an interval as precondition: hence, derives the emancipation of the interval, ground, and space.[9] Furthermore rhythm still dominates with its linear composition on the plane; but because now, besides the individual shapes, the intervals also are respected, rhythm is used also for those spacious intervals. Hence the role of art in late antiquity, in contrast to the one of classical antiquity, as well as in contrast to modern art, is clearly defined: space was emancipated (different from classical antiquity which tended to refuse space) but it was formed into rhythmic intervals (in opposition to modern art which emphasizes shapeless infinite deep space).

The emancipation of the intervals is now again one of the basic principles in Augustine's ethics and aesthetics, which is repeated at numerous places and helped him particularly in his fight against the Manichaeans.[10] It is here where among other things he demonstrated not just the right of existence, but even the necessity of ugliness and shapelessness. Evil is just a *privatio* of the good, the ugly is merely intervals of beauty; they are as necessary as the intervals between words in language and between tones in music. We are used to seeing evil and ugly from nearby, when it appears to us naturally evil and ugly. But when we see it all from a *Fernsicht* we will observe that beauty would not be possible without its complementary ugly shape, and that both together present a picture of perfect harmony.[11]

Among the numerous pertinent places one may be chosen here which Berthaud missed, but which is for us of special importance, because it is one of the few where Augustine uses a concrete example from the figurative arts, especially from painting: 'Sicut pictura cum colore nigro, loco suo posita, ita universitas rerum, si quis possit

intueri, etiam cum peccatoribus pulchra est, quamvis per se ipsos consideratos sua deformitas turpet'.[12]

According to this, black color is in the painted picture the same as evil is in entire mankind. Individual shapes which appear in clear materiality, that is in bright colors, are beautiful; opposite to this, black color represents shadow that is the untouchable, immaterial, the shapeless, the empty, the nonexistent element. However, if the black is put within the picture at the right place, then it has in a *fernsichtig* observation together with the brightly painted material individual shapes the effect of beauty. According to the doctrine of Augustine the function of placing it in the right place is done through the *ordo* which, according to what was said earlier, is nothing but the form of expression for the rhythm; hence, Augustine had also in painting the rhythmic distribution between black and light and shadow and light as the aim of art in mind. Augustine expects thus from painting exactly that coloristic treatment, which we have known through monuments to be an important character trait of the art of late antiquity.[13]

To obtain an understanding of the nature of late antique art (that is the art of the middle and late Roman period) we may study individual monuments or the surviving literary sources. In either case, we obtain an insight of the same basic proposition: that there was in general at that time only one direction for the *Kunstwollen* to take. This force dominated all four divisions of the visual arts equally, appropriated every purpose and material to its artistic meaning (*Kunstzweck*) and with fixed independence chose in every case the appropriate technique for the envisioned work of art. There is support for this interpretation of the nature of late antique art in the fact that the *Kunstwollen* of antiquity, especially in the final phase, is practically identical with other major forms of expression of the human *Wollen* during the same period.

All such human *Wollen* is directed towards self-satisfaction in relation to the surrounding environment (in the widest sense of the word, as it relates to the human being externally and internally). Creative *Kunstwollen* regulates the relation between man and objects as we perceive them with our sense; this is how we always give shape and color to things (just as we visualize things with the *Kunstwollen* in poetry). Yet man is not just a being perceiving exclusively with his sense (passive), but also a longing (active) being. Consequently, man wants to interpret the world as it can most easily be done in accordance with his inner drive (which may change with nation, location and time). The character of this *Wollen* is always determined by what may be termed the conception of the world at a given time [*Weltanschauung*] (again in the widest sense of the term), not only in religion, philosophy, science, but also in government and law, where one or the other form of expression mentioned above usually dominates.

Obviously, an inner relation exists between a *Wollen*, which is directed toward a pleasurable visualization of things through the visual arts, and that other *Wollen* which wants to interpret them as much as possible according to its own inner drive. In antiquity this relationship can be traced everywhere. We can only sketch it now in very general terms, but this may suffice to identify another basis for our investigation of the meaning of late Roman art within the general history of civilization.

The development of the ancients' conception of the world [*Weltanschauung*] took place in three clearly distinguishable phases, which are completely parallel to the three periods of development of ancient art as outlined in the beginning. The common factor here as well is a notion of the world as composed of tactile (plastic), self-contained, individual shapes. In the earliest period, the idea prevailed that the existence and the forms of life of these individual shapes were ruled by arbitrary forces. This conception of the world was therefore necessarily aimed at a religious frame of reference in which man undertook personal and benign propitiation of those forces by persuasion. In the second period, which runs parallel with the classical art of the Greeks, men now developed (together with a gradual change in religion toward philosophy and science) concepts of binding and logical relationships among individual phenomena. In the postulated relationship we can immediately recognize the same inclination toward establishing a relation between individual shapes shown by the art of classical antiquity.

In the surrounding world ancient man saw only individual self-contained shapes. Therefore, he conceived their interrelationship only on a mechanical level (that is the level of forces and impact). Both ancient idealistic and materialistic philosophy (atomism) are fully agreed on this point. Consequently, for these thinkers there must be a chain-like connection (leading from one individual to the next) which corresponds exactly to the rhythmic composition of the individual shapes in the contemporary plastic arts. So art was charged with selecting a few individual shapes from the infinite confusion of phenomena and connecting them in a new, clearly defined unity by arrangement in a sequence on a flat surface. In the same way, ancient science had to disentangle the knot of phenomena and to arrange them in a coherent sequence of individual shapes according to the law of causality.

The third period of antiquity deserves our special interest. Not only was the classic attempt to erect a mechanistic system of causality between individual phenomena no longer valued, but one went so far as to bring externally, individual shapes in reciprocal isolation from each other. In no way did this mean a return to a primitive disconnectedness. Instead, a mechanistic theory of connection between individual shapes no longer seemed satisfactory and was replaced with a different kind of connection—magic. The latter found expression in the entire

late-pagan, early Christian world in neoplatonism and in syncretic cults as well as in the beliefs of the early Christian church. A correspondence of this process with the isolation of individual shapes on the visual plane is obvious in contemporary art. As done before, we must now raise the question whether this change, as conceived, is progress or decline.

The answer is the same: the change in the late antique conception of the world was a necessary transition made by the human mind in order to take it from the concept of a purely mechanistic and sequential relationship of things (as if they were projected on a plane) to one of a general chemical connection, including, as it were, space in all directions.[14] Anyone who wishes to perceive the change in late antiquity as decline has the presumption to dictate today the route the human mind should have taken in order to move from the ancient to the modern concept of nature. Indeed, the late antique tendency toward magic was a detour. However, the necessity of this detour becomes clear as soon as one realizes that it was not the product of a specific scientific theory, but came from the abolition of a thousand-year-old notion which all antiquity held in common and which conceived the world composed of mechanistic self-contained and individual shapes. The necessary preconditions of this change were the erosion of faith in a purely mechanistic structure as much as the rise of a new, positive faith in the relationship of objects, which went beyond mechanics, but was still based on individual shapes and in that sense magic. Just when this new faith was bearing permanent fruits, the idea of a mechanistic connection (never completely forgotten by the inhabitants of the West) regained its rightful status (in the visual arts just as much as in the conception of the world). There was no longer a danger of falling back on the notion of an exclusively mechanistic connection and of unchangeable individual shapes. The notion of an extra-mechanistic connection among all things of creation had meanwhile become firmly rooted in the mind of the West, as had, to be the basic elements in art, the perception of mass composition (in place of the individuality of material shapes) and deep space (in place of a plane on which is disposed a sequence of individual shapes). The development of European culture, which occupies a leading place in the world, owes both concepts to the late Roman period.[15]

Images from the Region of the Pueblo Indians of North America

Es ist ein altes Buch zu blättern, Athen-Oraibi, alles Vettern.
It is a lesson from an old book: the kinship of Athens and Oraibi.

If I am to show you images, most of which I photographed myself, from a journey undertaken some twenty-seven years in the past, and to accompany them with words, then it behooves me to preface my attempt with an explanation. The few weeks I have had at my disposal have not given me the chance to revive and to work through my old memories in such a way that I might offer you a solid introduction into the psychic life of the Indians. Moreover, even at the time, I was unable to give depth to my impressions, as I had not mastered the Indian language. And here in fact is the reason why it is so difficult to work on these pueblos: Nearby as they live to each other, the Pueblo Indians speak so many and such varied languages that even American scholars have the greatest difficulty penetrating even one of them. In addition, a journey limited to several weeks could not impart truly profound impressions. If these impressions are now more blurred than they were, I can only assure you that, in sharing my distant memories, aided by the immediacy of the photographs, what I have to say will offer an impression both of a world whose culture is dying out and of a problem of decisive importance in the general writing of cultural history: In what ways can we perceive essential character traits of primitive pagan humanity?

The Pueblo Indians derive their name from their sedentary lives in villages (Spanish: *pueblos*) as opposed to the nomadic lives of the tribes who until several decades ago warred and hunted in the same areas of New Mexico and Arizona where the Pueblos now live.

What interested me as a cultural historian was that in the midst of a country that had made technological culture into an admirable precision weapon in the hands of intellectual man, an enclave of primitive pagan humanity was able to maintain itself and—an entirely sober struggle for existence notwithstanding—to engage in hunting and agriculture with an unshakable adherence to magical practices that we are accustomed to condemning as a mere symptom of a completely backward humanity. Here, however, what we would call superstition

goes hand in hand with livelihood. It consists of a religious devotion to natural phenomena, to animals and plants, to which the Indians attribute active souls, which they believe they can influence primarily through their masked dances. To us, this synchrony of fantastic magic and sober purposiveness appears as a symptom of a cleavage; for the Indian this is not schizoid but, rather, a liberating experience of the boundless communicability between man and environment.

At the same time, one aspect of the Pueblo Indians' religious psychology requires that our analysis proceed with the greatest caution. The material is contaminated: it has been layered over twice. From the end of the sixteenth century, the Native American foundation was overlaid by a stratum of Spanish Catholic Church education, which suffered a violent setback at the end of the seventeenth century, to return thereafter but never officially to reinstate itself in the Moki villages. And then came the third stratum: North American education.

Yet closer study of Pueblo pagan religious formation and practice reveals an objective geographic constant, and that is the scarcity of water. For so long as the railways remained unable to reach the settlements, drought and desire for water led to the same magical practices toward the binding of hostile natural forces as they did in primitive,

5

Interior of a house in Oraibi with dolls and broom

Laguna. Young woman
carrying a pot inscribed
with bird 'hieroglyph'

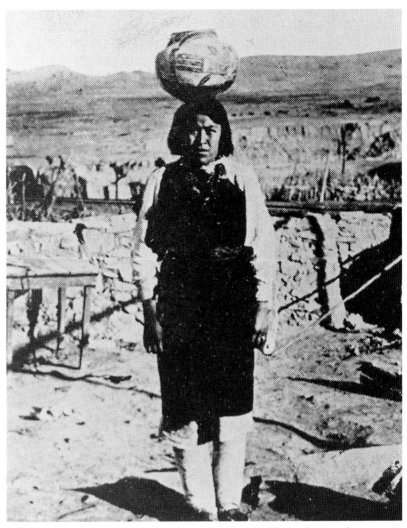

pretechnological cultures all over the world. Drought teaches magic
and prayer.

The specific issue of religious symbolism is revealed in the orna-
mentation of pottery. A drawing I obtained personally from an Indian
will show how apparently purely decorative ornaments must in fact be
interpreted symbolically and cosmologically and how alongside one
basic element in cosmologic imagery—the universe conceived in the
form of a house—an irrational animal figure appears as a mysterious
and fearsome demon: the serpent. But the most drastic form of the
animistic (i.e., nature-inspiring) Indian cult is the masked dance,
which I shall show first in the form of a pure animal dance, second in
the form of a tree-worshipping dance, and finally as a dance with live
serpents. A glance at similar phenomena in pagan Europe will bring
us, finally, to the following question: To what extent does this pagan
world view, as it persists among the Indians, give us a yardstick for

the development from primitive paganism, through the paganism of classical antiquity, to modern man?

All in all it is a piece of earth only barely equipped by nature, which the prehistoric and historic inhabitants of the region have chosen to call their home. Apart from the narrow, furrowing valley in the northeast, through which the Rio Grande del Norte flows to the Gulf of Mexico, the landscape here consists essentially of plateaus: extensive, horizontally situated masses of limestone and tertiary rock, which soon form higher plateaus with steep edges and smooth surfaces. (The term *mesa* compares them with tables.) These are often pierced by flowing waters, … by ravines and canyons sometimes a thousand feet deep and more, with walls that from their highest points plummet almost vertically, as if they had been sliced with a saw…. . For the greater part of the year the plateau landscape remains entirely without precipitation and the vast majority of the canyons are completely dried up; only at the time that snow melts and during the brief rainy periods do powerful water masses roar through the bald ravines.[1]

In this region of the Colorado plateau of the Rocky Mountains, where the states of Colorado, Utah, New Mexico, and Arizona meet, the ruined sites of prehistoric communities survive alongside the currently inhabited Indian villages. In the northwestern part of the plateau, in the state of Colorado, are the now abandoned cliff-dwellings: houses built into clefts of rock. The eastern group consists of approximately eighteen villages, all relatively accessible from Santa

7

Serpent as lightning.
Reproduction of an altar floor,
kiva ornamentation

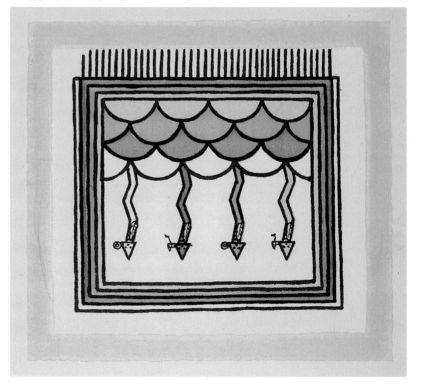

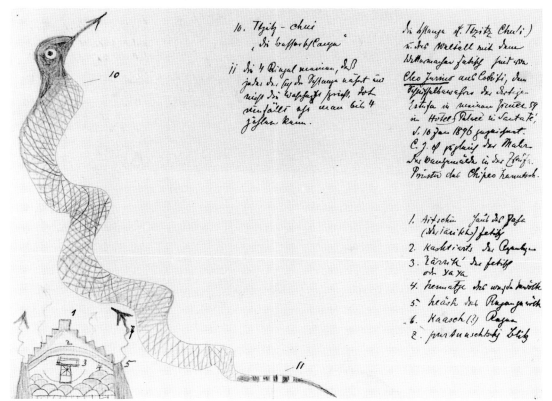

8 Cleo Jurino

Drawing of serpent and 'worldhouse' with Warburg's annotations

Fe and Albuquerque. The especially important villages of the Zuñi lie more to the southwest and can be reached in a day's journey from Fort Wingate. The hardest to reach—and therefore the most undisturbed in the preservation of ancient ways—are the villages of the Moki (Hopi), six in all, rising out of three parallel ridges of rock.

In the midst, in the plains, lies the Mexican settlement of Santa Fe, now the capital of New Mexico, having come under the dominion of the United States after a hard struggle, which lasted into the last century. From here, and from the neighboring town of Albuquerque, one can reach the majority of the eastern Pueblo villages without great difficulty.

Near Albuquerque is the village of Laguna, which, though it does not lie quite so high as the others, provides a very good example of a Pueblo settlement. The actual village lies on the far side of the Atchison–Topeka–Santa Fe railway line. The European settlement, below in the plain, abuts on the station. The indigenous village consists of two-storied houses. The entrance is from the top: one climbs up a ladder, as there is no door at the bottom. The original reason for this type of house was its superior defensibility against enemy attack. In this way the Pueblo Indians developed a cross between a house and a fortification which is characteristic of their civilization and probably reminiscent of prehistoric American times. It is a terraced structure of

houses whose ground floors sit on second houses which can sit on yet third ones and thus form a conglomeration of rectangular living quarters.

In the interior of such a house, small dolls are suspended from the ceiling—not mere toy dolls but rather like the figures of saints that hang in Catholic farmhouses [5]. They are the so-called kachina dolls: faithful representations of the masked dancers, the demoniac mediators between man and nature at the periodic festivals that accompany the annual harvest cycle and who constitute some of the most remarkable and unique expressions of this farmers' and hunters' religion. On the wall, in contradistinction to these dolls, hangs the symbol of intruding American culture: the broom.

But the most essential product of the applied arts, with both practical and religious purposes, is the earthenware pot, in which water is carried in all its urgency and scarcity. The characteristic style for the drawings on these pots is a skeletal heraldic image. A bird, for example, may be dissected into its essential component parts to form a heraldic abstraction. It becomes a hieroglyph, not simply to be looked at but, rather, to be read [6]. We have here an intermediary stage between a naturalistic image and a sign, between a realistic mirror image and writing. From the ornamental treatment of such animals, one can immediately see how this manner of seeing and thinking can lead to symbolic pictographic writing.

The bird plays an important part in Indian mythical perception, as anyone familiar with the Leatherstocking Tales knows. Apart from the devotion it receives, like every other animal, as a totem, as an imaginary ancestor, the bird commands a special devotion in the context of the burial cult. It seems even that a thieving bird-spirit belonged to the fundamental representations of the mythical fantasies of the prehistoric Sikyatki. The bird has a place in idolatrous cults for its feathers. The Indians have made a special prayer instrument out of small sticks—*bahos*; tied with feathers, they are placed on fetish altars and planted on graves. According to the authoritative explanations of the Indians, the feathers act as winged entities bearing the Indians' wishes and prayers to their demoniac essences in nature.

There is no doubt that contemporary Pueblo pottery shows the influence of medieval Spanish technique, as it was brought to the Indians by the Jesuits in the eighteenth century. The excavations of Fewkes have established incontrovertibly, however, that an older potting technique existed, autonomous from the Spanish.[2] It bears the same heraldic bird motives together with the *serpent*, which for the Mokis—as in all pagan religious practice—commands cultic devotion as the most vital symbol. This serpent still appears on the base of contemporary vessels exactly as Fewkes found it on prehistoric ones: coiled, with a feathered head. On the rims, four terrace-shaped attach-

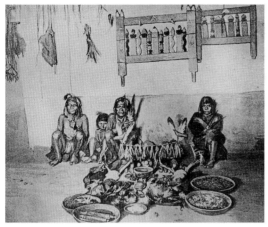

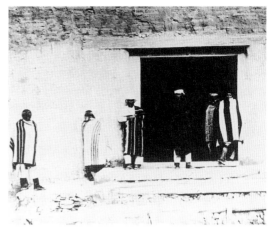

9

The kiva at Sia.

10

In front of the Acoma church door

ments carry small representations of animals. We know from work on Indian mysteries that these animals—for example, the frog and the spider—represent the points of the compass and that these vessels are placed in front of the fetishes in the subterranean prayer room known as the *kiva*. In the kiva, at the core of devotional practice, the serpent appears as the symbol of lightning [**7**].

In my hotel in Santa Fe, I received from an Indian, Cleo Jurino, and his son, Anacleto Jurino, original drawings that, after some resistance, they made before my eyes and in which they outlined their cosmologic world view with colored pencils [**8**]. The father, Cleo, was one of the priests and painter of the kiva in Cochiti. The drawing showed the serpent as a weather deity, as it happens, unfeathered but otherwise portrayed exactly as it appears in the image on the vase, with an arrow-pointed tongue. The roof of the worldhouse bears a stair-shaped gable. Above the walls spans a rainbow, and from massed clouds below flows the rain, represented by short strokes. In the middle, as the true master of the stormy worldhouse, appears the fetish (not a serpent figure): Yaya or Yerrick.

In the presence of such paintings the pious Indian invokes the storm with all its blessings through magical practices, of which to us the most astonishing is the handling of live, poisonous serpents. As we saw in Jurino's drawing, the serpent in its lightning shape is magically linked to lightning.

The stair-shaped roof of the worldhouse and the serpent-arrow-head, along with the serpent itself, are constitutive elements in the Indians' symbolic language of images. I would suggest without any doubt that the stairs contain at least a Pan-American and perhaps a worldwide symbol of the cosmos.

A photograph of the underground kiva of Sia, after Mrs. Stevenson, shows the organization of a carved lightning altar as the focal point of sacrificial ceremony, with the lightning serpent in the company of other sky-oriented symbols. It is an altar for lightning

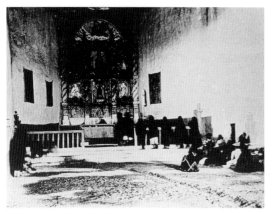

from all points of the compass. The Indians crouching before it have placed their sacrificial offerings on the altar and hold in their hand the symbol of mediating prayer: the feather [**9**].

My wish to observe the Indians directly under the influence of official Catholicism was favored by circumstance. I was able to accompany the Catholic priest Père Juillard, whom I had met on New Year's Day 1895 [*sic*] while watching a Mexican Matachina dance, on an inspection tour that took him to the romantically situated village of Acoma.

We traveled through this gorse-grown wilderness for about six hours, until we could see the village emerging from the sea of rock, like a Heligoland in a sea of sand. Before we had reached the foot of the rock, bells began to ring in honor of the priest. A squad of brightly clad redskins [*Rothäute*] came running with lightning speed down the path to carry up our luggage. The carriages remained below, a necessity that proved ill fated: the Indians stole a cask of wine the priest had received as a gift from the nuns of Bernalillo. Once on top, we were immediately received with all the trappings of honor by the Governador—Spanish names for the ruling village chiefs are still in use. He put the priest's hand to his lips with a slurping noise, inhaling, as it were, the greeted person's aura in a gesture of reverential welcome. We were housed in his large main room together with the coachmen, and on the priest's request, I promised him that I would attend mass the following morning.

Indians are standing before the church door [**10**]. They are not easily led inside. This requires a loud call by the chief from the three parallel village streets. At last they assembled in the church. They are wrapped in colorful woolen cloths, woven in the open by nomadic Navajo women but produced also by the Pueblos themselves. They are ornamented in white, red, or blue and make a most picturesque impression.

The interior of the church has a genuine little baroque altar with figures of saints [**11**]. The priest, who understood not a word of the

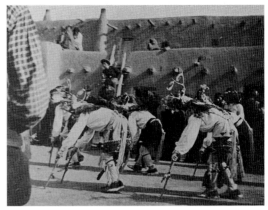

13

Stair ornament carved from a tree

14

Antelope dance at San Ildefonso

Indian language, had to employ an interpreter who translated the mass sentence by sentence and may well have said whatever he pleased.

It occurred to me during the service that the wall was covered with pagan cosmologic symbols, exactly in the style drawn for me by Cleo Jurino. The church of Laguna is also covered with such painting, symbolizing the cosmos with a stair-shaped roof [**12**]. The jagged ornament symbolizes a stair, and indeed not a perpendicular, square stair but rather a much more primitive form of a stair, carved from a tree, which still exists among the Pueblos [**13**].

In the representation of the evolution, ascents, and descents of nature, steps and ladders embody the primal experiences of humanity. They are the symbol for upward and downward struggle in space, just as the circle—the coiled serpent—is the symbol for the rhythm of time. Man, who no longer moves on four limbs but walks upright and is therefore in need of a prop in order to overcome gravity as he looks upward, invented the stair as a means to dignify what in relation to animals are his inferior gifts. Man, who learns to stand upright in his second year, perceives the felicity of the step because, as a creature that has to learn how to walk, he thereby receives the grace of holding his head aloft. Standing upright is the human act par excellence, the striving of the earthbound toward heaven, the uniquely symbolic act that gives to walking man the nobility of the erect and upward-turned head.

Contemplation of the sky is the grace and curse of humanity.

Thus the Indian creates the rational element in his cosmology through his equation of the worldhouse with his own staired house, which is entered by way of a ladder. But we must be careful not to regard this worldhouse as a simple expression of a spiritually tranquil cosmology; for the mistress of the worldhouse remains the uncanniest of creatures: the serpent.

The Pueblo Indian is a hunter as well as a tiller of the soil—if not to the same extent as the savage tribes that once lived in the region. He depends for his subsistence on meat as well as on corn. The masked dances, which at first seem to us like festive accessories to everyday life,

are in fact magical practices for the social provision of food. The masked dance, upon which we might ordinarily look as a form of play, is in its essence an earnest, indeed warlike, measure in the fight for existence. Although the exclusion of bloody and sadistic practices makes these dances fundamentally different from the war dances of the nomadic Indians, the Pueblos' worst enemies, we must not forget that these remain, in their origin and inner tendency, dances of plunder and sacrifice. When the hunter or tiller of the soil masks himself, transforms himself into an imitation of his booty—be that animal or corn— he believes that through mysterious, mimic transformation he will be able to procure in advance what he coterminously strives to achieve through his sober, vigilant work as tiller and hunter. The dances are expressions of applied magic. The social provision of food is schizoid: magic and technology work together.

The synchrony [*Nebeneinander*] of logical civilization and fantastic, magical causation shows the Pueblo Indians' peculiar condition of hybridity and transition. They are clearly no longer primitives dependent on their senses, for whom no action directed toward the future can exist; but neither are they technologically secure Europeans, for whom future events are expected to be organically or mechanically determined. They stand on middle ground between magic and logos, and their instrument of orientation is the symbol. Between a culture of touch and a culture of thought is the culture of symbolic connection. And for this stage of symbolic thought and conduct, the dances of the Pueblo Indians are exemplary.

When I first saw the antelope dance in San Ildefonso, it struck me as quite harmless and almost comical. But for the folklorist interested in a biologic understanding of the roots of human cultural expression, there is no moment more dangerous than when he is moved to laugh at popular practices that strike him as comical. To laugh at the comical element in ethnology is wrong, because it instantly shuts off insight into the tragic element.

At San Ildefonso—a pueblo near Santa Fe which has long been under American influence—the Indians assembled for the dance. The musicians gathered first, armed with a large drum. (You can see them standing, in **14**, in front of the Mexicans on horseback.) Then the dancers arranged themselves into two parallel rows and assumed the character of the antelope in mask and posture. The two rows moved in two different ways. Either they imitated the animal's way of walking, or they supported themselves on their front legs—small stilts wound with feathers—making movements with them while standing in place. At the head of each row stood a female figure and a hunter. With regard to the female figure, I was able to learn only that she was called the 'mother of all animals'.[3] To her the animal mime addresses his invocations.

The insinuation into the animal mask allows the hunting dance to simulate the actual hunt through an anticipatory capture of the animal. This measure is not to be regarded as mere play. In their bonding with the extrapersonal, the masked dances signify for primitive man the most thorough subordination to some alien being. When the Indian in his mimetic costume imitates, for instance, the expressions and movements of an animal, he insinuates himself into an animal form not out of fun but, rather, to wrest something magical from nature through the transformation of his person, something he cannot attain by means of his unextended and unchanged personality.

The simulated pantomimic animal dance is thus a cultic act of the highest devotion and self-abandon to an alien being. The masked dance of so-called primitive peoples is in its original essence a document of social piety. The Indian's inner attitude to the animal is entirely different from that of the European. He regards the animal as a higher being, as the integrity of its animal nature makes it a much more gifted creature than man, its weaker counterpart.

My initiation into the psychology of the will to animal metamorphosis came, just before my departure, from Frank Hamilton Cushing, the pioneering and veteran explorer of the Indian psyche. I found his insights personally overwhelming. This pockmarked man with sparse reddish hair and of inscrutable age, smoking a cigarette, said to me that an Indian had once told him, why should man stand taller than animals? 'Take a good look at the antelope, she is all running, and runs so much better than man—or the bear, who is all strength. Men can only *do* in part what the animal *is*, totally.' This fairy-tale way of thinking, no matter how odd it may sound, is the preliminary to our scientific, genetic explanation of the world. These Indian pagans, like pagans all over the world, form an attachment out of reverential awe—what is known as totemism—to the animal world, by believing in animals of all kinds as the mythical ancestors of their tribes. Their explanation of the world as inorganically coherent is not so far removed from Darwinism; for whereas we impute natural law to the autonomous process of evolution in nature, the pagans attempt to explain it through arbitrary identification with the animal world. It is, one might say, a Darwinism of mythical elective affinity which determines the lives of these so-called primitive people.

The formal survival of the hunting dance in San Ildefonso is obvious. But when we consider that the antelope has been extinct there for more than three generations, then it may well be that we have in the antelope dance a transition to the purely demoniac kachina dances, the chief task of which is to pray for a good crop harvest. In Oraibi, for example, there exists still today an antelope clan, whose chief task is weather magic.

Whereas the imitative animal dance must be understood in terms of

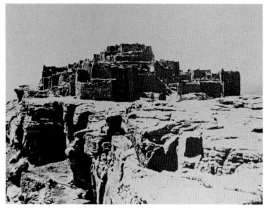

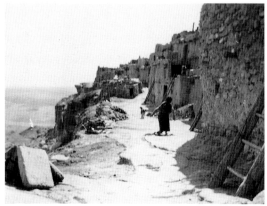

15

Walpi

16

Walpi village street

the mimic magic of hunting culture, the kachina dances, corresponding to cyclic peasant festivals, have a character entirely of their own which, however, is revealed only at sites far removed from European culture. This cultic, magical masked dance, with its entreaties focused on inanimate nature, can be observed in its more or less original form only where the railroads have yet to penetrate and where—as in the Moki villages—even the veneer of offical Catholicism no longer exists.

The children are taught to regard the kachinas with a deep religious awe. Every child takes the kachinas for supernatural, terrifying creatures, and the moment of the child's initiation into the nature of the kachinas, into the society of masked dancers itself, represents the most important turning point in the education of the Indian child.

On the market square of the rock village of Oraibi, the most remote westerly point, I was lucky enough to observe a so-called humiskachina dance. Here I saw the living originals of the masked dancers I had already seen in puppet form in a room of this same village of Oraibi.

To reach Oraibi, I had to travel for two days from the railway station of Holbrook in a small carriage. This is a so-called buggy with four light wheels, capable of advancing through desert sands where only gorse can grow. The driver throughout my stay in the region was Frank Allen, a Mormon. We experienced a very strong sandstorm, which completely obliterated the wagon tracks—the only navigational aid in this roadless steppe. We had the good luck nevertheless to arrive after our two days' journey in Keams Canyon, where we were greeted by Mr Keam, a most hospitable Irishman.

From this spot I was able to make the actual excursions to the cliff villages, which extend from north to south on three parallel rock formations. I arrived first at the remarkable village of Walpi. It is romantically perched on the rock crest, its stair-shaped houses rising in stone masses like towers from the rock. A narrow path on the high rock leads past the masses of houses. The illustration shows the desolation and severity of this rock and its houses, as they project themselves into the world [**15, 16**].

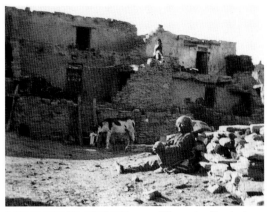

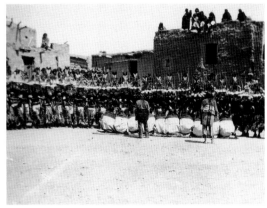

Very similar in its overall impression to Walpi is Oraibi, where I was able to observe the humiskachina dance. Up on top, on the market-place of the cliff village, where an old blind man sits with his goat, a dancing area was being prepared [17]. This humiskachina dance is the dance of the growing corn. On the evening before the actual dance, I was inside the kiva, where secret ceremonies take place. It contained no fetish altar. The Indians simply sat and smoked ceremonially. Every now and then a pair of brown legs descended from above on the ladder, followed by the whole man attached to them.

The young men were busy painting their masks for the following day. They use their big leather helmets again and again, as new ones would be too costly. The painting process involves taking water into the mouth and then spraying it onto the leather mask as the colors are rubbed in.

By the following morning, the entire audience, including two groups of children, had assembled on the wall [18]. The Indians' relationship to their children is extraordinarily appealing. Children are brought up gently but with discipline and are very obliging, once one has earned their trust. Now the children had assembled, with earnest anticipation, on the marketplace. These humiskachina figures with artificial heads move them to real terror, all the more so as they have learned from the kachina dolls of the inflexible and fearsome qualities of the masks. Who knows whether our dolls did not also originate as such demons?

The dance was performed by about twenty-to-thirty male and about ten female dancers—the latter meaning men representing female figures. Five men form the vanguard of the two-row dance configuration. Although the dance is performed on the market square, the dancers have an architectonic focus, and that is the stone structure in which a small dwarf pine has been placed, adorned with feathers. This is a small temple where the prayers and chants accompanying the masked dances are offered. Devotion flows from this little temple in the most striking manner.

The dancers' masks are green and red, traversed diagonally by a white stripe punctuated by three dots [**19**, **20**]. These, I was told, are raindrops, and the symbolic representations on the helmet also show the stair-shaped cosmos with the source of rain identified again by semicircular clouds and short strokes emanating from them. These symbols appear as well on the woven wraps the dancers wind around their bodies: red and green ornaments gracefully woven on a white background [**21**]. In one hand, each male dancer holds a rattle carved from a hollow gourd and filled with stones. And at each knee he wears a tortoise shell hung with pebbles, so that the rattle noises issue from the knees as well [**22**].

The chorus performs two different acts. Either the girls sit in front of the men and make music with a rattle and a piece of wood, while the men's dance configuration consists of one after another turning, in solitary rotation; or, alternately, the women rise and accompany the rotating movements of the men. Throughout the dance, two priests sprinkle consecrated flour on the dancers [**23**].

The women's dance costume consists of a cloth covering the entire body, so as not to show that these are, in fact, men. The mask is adorned, on either side at the top, with the curious anemonelike hairdo that is the specific hair adornment of the Pueblo girls [**24**, **25**]. Red-dyed horsehair hanging from the masks symbolizes rain, and rain ornamentation appears as well on the shawls and other wrappings.

During the dance, the dancers are sprinkled by a priest with holy flour, and all the while the dance configuration remains connected at the head of the line to the little temple. The dance lasts from morning till evening. In the intervals the Indians leave the village and go to a rocky ledge to rest for a moment [**26**]. Whoever sees a dancer without his mask, will die.

The little temple is the actual focal point of the dance configuration. It is a little tree, adorned with feathers. These are the so-called Nakwakwocis. I was struck by the fact that the tree was so small. I went to the old chief, who was sitting at the edge of the square, and asked him why the tree was so small. He answered: we once had a large tree, but now we have chosen a small one, because the soul of a child is small.

We are here in the realm of the perfect animistic and tree cult, which the work of Mannhardt has shown to belong to the universal religious patrimony of primitive peoples, and it has survived from European paganism down to the harvest customs of the present day. It is here a question of establishing a bond between natural forces and man, of creating a symbol as the connecting agent, indeed as the magical rite that achieves integration by sending out a mediator, in this case a tree, more closely bound to the earth than man, because it grows from the earth. This tree is the nature-given mediator, opening the way to the subterranean element.

The next day the feathers are carried down to a certain spring in the valley and either planted there or else hung as votive offerings. These are to put into effect the prayer for fertilization, resulting in a plentiful and healthy crop of corn.

Late in the afternoon the dancers resume their indefatigable, earnest ceremonial and continue to perform their unchanging dance movements. As the sun was about to sink, we were presented with an astonishing spectacle, one which showed with overwhelming clarity how solemn and silent composure draws its magical religious forms from the very depths of elemental humanity. In this light, our tendency to view the spiritual element alone in such ceremonies must be rejected as a one-sided and paltry mode of explanation.

Six figures appeared. Three almost completely naked men smeared with yellow clay, their hair wound into horn shapes, were dressed only in loin cloths. Then came three men in women's clothes. And while the chorus and its priests proceeded with their dance movements, undisturbed and with unbroken devotion, these figures launched into a thoroughly vulgar and disrespectful parody of the chorus movements. And no one laughed. The vulgar parody was regarded not as comic mockery but, rather, as a kind of peripheral contribution by the revellers, in the effort to ensure a fruitful corn year. Anyone familiar with ancient tragedy will see here the duality of tragic chorus and satyr play, 'grafted onto a single stem'. The ebb and flow of nature appears in anthropomorphic symbols: not in a drawing but in the dramatic magical dance, actually returned to life.

The essence of magical insinuation into the divine, into a share of its superhuman power, is revealed in the terrifyingly dramatic aspect of Mexican religious devotion. In one festival a woman is worshipped for forty days as a corn goddess and then sacrificed, and then the priest slips into the skin of the poor creature. Compared to this most elementary and frenzied attempt to approach the divinity, what we observed among the Pueblos is indeed related but infinitely more refined. Yet there is no guarantee that the sap does not still rise in secret from such blood-soaked cultic roots. After all, the same soil that bears the Pueblos has also witnessed the war dances of the wild, nomadic Indians, with their atrocities culminating in the martyrdom of the enemy.

The most extreme approximation of this magical desire for unity with nature via the animal world can be observed among the Moki Indians, in their dance with live serpents at Oraibi and Walpi. I did not myself observe this dance, but a few photographs will give an idea of this most pagan of all the ceremonies of Walpi. This dance is at once an animal dance and a religious, seasonal dance. In it, the individual animal dance of San Ildefonso and the individual fertility ritual of the Oraibi humiskachina dance converge in an intense expressive effort. For in August, when the critical moment in the tilling of the soil arrives

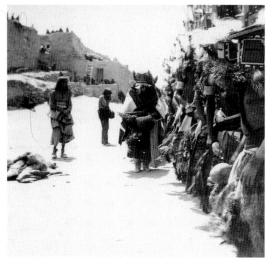

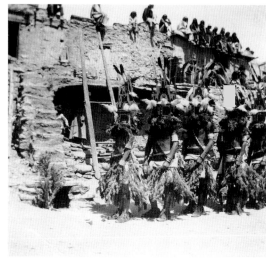

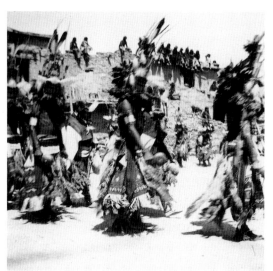

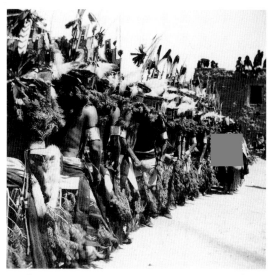

19-22

Humiskachina dancers, Oraibi

to render the entire crop harvest contingent on rainstorms, these redemptive storms are invoked through a dance with live serpents, celebrated alternately in Oraibi and Walpi. Whereas in San Ildefonso only a simulated version of antelope is visible—at least to the uninitiated—and the corn dance achieves the demoniac representation of corn demons only with masks, we find here in Walpi a far more primeval aspect of the magic dance.

Here the dancers and the live animal form a magical unity, and the surprising thing is that the Indians have found in these dance ceremonies a way of handling the most dangerous of all animals, the rattlesnake, so that it can be tamed without violence, so that the creature will participate willingly—or at least without making use of its aggressive abilities, unless provoked—in ceremonies lasting for days. This would surely lead to catastrophe in the hands of Europeans.

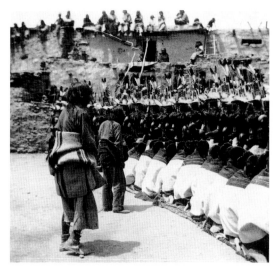

23
Humiskachina dancers, Oraibi

24-25
'Anemone' hairdos

26
Dancers at rest, Oraibi

Two Moki clans provide the participants in the serpent ceremony: the antelope and the serpent clans, both of whom are folklorically and totemistically linked with the two animals. That totemism can be taken seriously even today is proved here, as humans not only appear masked as animals but enter into cultic exchange with the most dangerous beast, the live serpent. The serpent ceremony at Walpi thus stands between simulated, mimic empathy and bloody sacrifice. It involves not the imitation of the animal but the bluntest engagement with it as a ritual participant—and that not as sacrificial victim but, like the *baho*, as fellow rainmaker.

For the snakes themselves, the serpent dance at Walpi is an enforced entreaty. They are caught live in the desert in August, when the storms are imminent, and in a sixteen-day ceremony in Walpi they are attended to in the underground kiva by the chiefs of the serpent and

antelope clans in a series of unique ceremonies, of which the most significant and the most astonishing for white observers is the washing of the snakes. The snake is treated like a novice of the mysteries, and notwithstanding its resistance, its head is dipped in consecrated, medicated water. Then it is thrown onto a sand painting done on the kiva floor and representing four lightning snakes with a quadruped in the middle. In another kiva a sand painting depicts a mass of clouds from which emerge four differently colored lightning streaks, corresponding to the points of the compass, in the form of serpents. Onto the first sand painting, each snake is hurled with great force, so that the drawing is obliterated and the serpent is absorbed into the sand. I am convinced that this magic throw is intended to force the serpent to invoke lightning or produce rain. That is clearly the significance of the entire ceremony, and the ceremonies that follow prove that these consecrated serpents join the Indians in the starkest manner as provokers and petitioners of rain. They are living rain serpent–saints in animal form.

The serpents—numbering about a hundred and including a distinct number of genuine rattlesnakes with, as has been ascertained, their poisonous fangs left intact—are guarded in the kiva, and on the festival's final day they are imprisoned in a bush with a band wound around it. The ceremony culminates as follows: approach to the bush, seizing and carrying of the live serpents, dispatching of the snakes to the plains as messengers. American researchers describe the clutching of the snake as an unbelievably exciting act. It is carried out in the following way.

A group of three approaches the serpent bush. The high priest of the serpent clan pulls a snake from the bush as another Indian with painted face and tattoos, wearing a fox skin on his back, clutches the snake and places it in his mouth. A companion, holding him by the shoulders, distracts the attention of the serpent by waving a feathered stick. The third figure is the guard and the snake catcher, in case the serpent should slip out of the second man's mouth. The dance is played out in just over half an hour on the small square at Walpi. When all the snakes have thus been carried for a while to the sound of rattles—produced by the Indians who wear rattles and stone-filled tortoise shells on their knees—they are borne by the dancers with lightning speed into the plain, where they disappear.

From what we know of Walpi mythology, this form of devotion certainly goes back to ancestral, cosmologic legend. One saga tells the story of the hero Ti-yo, who undertakes a subterranean journey to discover the source of the longed-for water. He passes the various kivas of the princes of the underworld, always accompanied by a female spider who sits invisibly on his right ear—an Indian Virgil, Dante's guide to the underworld—and eventually guides him past the two sun houses of

the West and East into the great serpent kiva, where he receives the magic *baho* that will invoke the weather. According to the saga, Ti-yo returns from the underworld with the *baho* and two serpent-maidens, who bear him serpentine children—very dangerous creatures who ultimately force the tribes to change their dwelling place. The serpents are woven into this myth both as weather deities and as totems that bring about the migration of the clans.

In this snake dance the serpent is therefore not sacrificed but rather, through consecration and suggestive dance mimicry, transformed into a messenger and dispatched, so that, returned to the souls of the dead, it may in the form of lightning produce storms from the heavens. We have here an insight into the pervasiveness of myth and magical practice among primitive humanity.

The elementary form of emotional release through Indian magical practice may strike the layman as a characteristic unique to primitive wildness, of which Europe knows nothing. And yet two thousand years ago in the very cradle of our own European culture, in Greece, cultic habits were in vogue which in crudeness and perversity far surpass what we have seen among the Indians.

In the orgiastic cult of Dionysus, for example, the Maenads danced with snakes in one hand and wore live serpents as diadems in their hair, holding in the other hand the animal that was to be ripped to pieces in the ascetic sacrificial dance in honor of the god. In contrast to the dance of the Moki Indians of today, blood sacrifice in a state of frenzy is the culmination and fundamental significance of this religious dance [**27**].

The deliverance from blood sacrifice as the innermost ideal of

purification pervades the history of religious evolution from east to west. The serpent shares in this process of religious sublimation. Its role can be considered a yardstick for the changing nature of faith from fetishism to the pure religion of redemption. In the Old Testament, as in the case of the primal serpent Tiamat in Babylon, the serpent is the spirit of evil and of temptation. In Greece, as well, it is the merciless, devouring creature of the underworld: the Erinyes are encircled by snakes, and when the gods mete out punishment they send a serpent as their executioner.

This idea of the serpent as a destroying force from the underworld has found its most powerful and tragic symbol in the myth and in the sculpted group of Laocoon. The vengeance of the gods, wrought on their priest and on his two sons by means of a strangler serpent, becomes in this renowned sculpture of antiquity the manifest incarnation of extreme human suffering. The soothsaying priest who wanted to come to the aid of his people by warning them of the wiles of the Greeks falls victim to the revenge of the partial gods. Thus the death of the father and his sons becomes a symbol of ancient suffering: death at the hands of vengeful demons, without justice and without hope of redemption. That is the hopeless, tragic pessimism of antiquity (see [3]).

The serpent as the demon in the pessimistic world view of antiquity has a counterpart in a serpent-deity in which we can at last recognize the humane, transfigured beauty of the classical age. Asclepius, the ancient god of healing, carries a serpent coiling around his healing staff as a symbol [28]. His features are the features carried by the world savior in the plastic art of antiquity. And this most exalted and serene god of departed souls has his roots in the subterranean realm, where the serpent makes its home. It is in the form of a serpent that he is accorded his earliest devotion. It is he himself who winds around his staff: namely, the departed soul of the deceased, which survives and reappears in the form of the serpent. For the snake is not only, as Cushing's Indians would say, the fatal bite in readiness or fulfillment, destroying without mercy; the snake also reveals by its own ability to cast off its slough, slipping, as it were, out of its own mortal remains, how a body can leave its skin and yet continue to live. It can slither into the earth and re-emerge. The return from within the earth, from where the dead rest, along with the capacity for bodily renewal, makes the snake the most natural symbol of immortality and of rebirth from sickness and mortal anguish.[4]

In the temple of Asclepius at Kos in Asia Minor the god stood transfigured in human form, a statue holding in his hand the staff with the serpent coiled around it. But his truest and most powerful essence was not revealed in this lifeless mask of stone but lived instead in the form of a serpent in the temple's innermost sanctum: fed, cared for, and attended in cultic devotion as only the Mokis are able to care for their

serpents.

On a Spanish calendar leaf from the thirteenth century, which I found in a Vatican manuscript, representing Asclepius as the ruler of the month in the sign of Scorpio, significant aspects of the Asclepian serpent cult are revealed in their coarseness as well as their refinement [**29**]. We can see here, hieroglyphically indicated, ritual acts from the cult of Kos in thirty sections, all identical to the crude, magical desire of the Indians to enter the realm of the serpent. We see the rite of incubation and the serpent as it is carried by human hands and worshipped as a deity of the springs.

This medieval manuscript is astrological. In other words, it shows these ritual forms not as prescriptions for devotional practices, as had previously been the case; rather, these figures have become hieroglyphs for those born under the heavenly sign of Asclepius. For Asclepius has become precisely a star-deity, undergoing a transformation through an act of cosmologic imagination which has completely deprived him of the real, the direct susceptibility to influence, the subterranean, the

lowly. As a fixed star he stands over Scorpio in the zodiac. He is surrounded by serpents and is now regarded only as a heavenly body under whose influence prophets and physicians are born. Through this elevation to the stars, the serpent-god becomes a transfigured totem. He is the cosmic father of those born in the month when his visibility is highest. In ancient astrology, mathematics and magic converge. The serpent figure in the heavens, found also in the constellation of the Great Serpent, is used as a mathematical outline; the points of luminosity are linked together by way of an earthly image, in order to render comprehensible an infinity we cannot comprehend at all without some such outline of orientation. So Asclepius is at once a mathematical border sign and a fetish bearer. The evolution of culture toward the age of reason is marked in the same measure as the tangible, coarse texture of life, fading into mathematical abstraction.

About twenty years ago in the north of Germany, on the Elbe, I found a strange example of the elementary indestructibility of the memory of the serpent cult, despite all efforts of religious enlighten-

30 Giulio Romano

Vendor of Antidote against Snake Bites

ment; an example that shows the path on which the pagan serpent wanders, linking us to the past. On an excursion to the Vierlande [near Hamburg], in a Protestant church in Lüdingworth, I discovered, adorning the so-called rood screen, Bible illustrations that clearly originated in an Italian illustrated Bible and that had found their way here through the hands of a strolling painter.

And here I suddenly spotted Laocoon with his two sons in the terrible grasp of the serpent. How did he come to be in this church? But this Laocoon found his salvation. How? Looming in front of him was the staff of Asclepius and on it a holy serpent, corresponding to what we read in the fourth book of the Pentateuch: that Moses had commanded the Israelites in the wilderness to heal snakebites by setting up a brazen serpent for devotion.

We have here a remnant of idolatry in the Old Testament. We know, however, that this can only be a subsequent insertion, intended to account retroactively for the existence of such an idol in Jerusalem. For the principal fact remains that a brazen serpent idol was destroyed by King Hezekiah under the influence of the prophet Isaiah. The prophets fought most bitterly against idolatrous cults that engaged in human sacrifice and worshipped animals, and this struggle forms the

crux of Oriental and of Christian reform movements down to the most recent times. Clearly the setting up of the serpent is in starkest contradiction to the Ten Commandments, in sharpest opposition to the hostility to images that essentially motivates the reforming prophets.

But there is another reason why every student of the Bible should consider the serpent the most provocative symbol of hostility: the serpent on the tree in Paradise dominates the biblical narrative of the order of the world as the cause of evil and of sin. In the Old and New Testaments alike, the serpent clutches the tree of Paradise as the satanic power that summons the entire tragedy of sinning humanity as well as its hope for redemption.

In the battle against pagan idolatry, early Christianity was more uncompromising in its view of the serpent cult. In the eyes of the pagans, Paul was an impervious emissary when he hurled the viper that had bitten him into the fire without dying of the bite. (The poisonous viper belongs in the fire!) So durable was the impression of Paul's invulnerability to the vipers of Malta that as late as the sixteenth century, jugglers wound snakes around themselves at festivals and fairgrounds, representing themselves as men of the house of Saint Paul and selling soil from Malta as an antidote to snakebites. Here the principle of the immunity of the strong in faith ends up again in superstitious magical practice [30].

In medieval theology we find the miracle of the brazen serpent curiously retained as a part of legitimate religious devotion. Nothing attests to the indestructibility of the animal cult as does the survival of the miracle of the brazen serpent into the medieval Christian world view. So lasting in medieval theological memory was the serpent cult and the need to overcome it that, on the basis of a completely isolated passage inconsistent with the spirit and the theology of the Old Testament, the image of serpent devotion became paradigmatic in typological representations for the Crucifixion itself [31]. The animal image and the staff of Asclepius as reverential objects for the kneeling multitude are treated and represented as a stage, albeit to be overcome, in humanity's quest for salvation. In the attempt at a tripartite scheme of evolution and of the ages—that is, of Nature, Ancient Law, and Grace—an even earlier stage in this process is the representation of the impeded sacrifice of Isaac as an analogue to the Crucifixion. This tripartite scheme is still evident in the imagery adorning the minster of Salem.

In the church of Kreuzlingen itself, this evolutionary idea has generated an astonishing parallelism, which cannot make ready sense to the theologically uninitiated. Here, on the ceiling of the famous Mount of Olives chapel, immediately above the Crucifixion, we find an adoration of this most pagan idol with a degree of pathos that does not suffer in comparison with the Laocoon group. And under the

reference to the Tables of the Law, which, as the Bible recounts, Moses destroyed because of the worship of the golden calf, we find Moses himself, forced into service as shield bearer to the serpent.

I shall be satisfied if these images from the everyday and festive lives of the Pueblo Indians have convinced you that their masked dances are not child's play, but rather the primary pagan mode of answering the largest and most pressing questions of the Why of things. In this way the Indian confronts the incomprehensibility of natural processes with his will to comprehension, transforming himself personally into a prime causal agent in the order of things. For the unexplained effect, he instinctively substitutes the cause in its most tangible and visible form. The masked dance is danced causality.

If religion signifies bonding,[5] then the symptom of evolution away from this primal state is the spiritualization of the bond between humans and alien beings, so that man no longer identifies directly with the masked symbol but, rather, generates that bond through thought alone, progressing to a systematic linguistic mythology. The will to devotional zeal is an ennobled form of the donning of a mask. In the process that we call cultural progress, the being exacting this devotion gradually loses its monstrous concreteness and, in the end, becomes a spiritualized, invisible symbol.

What does this mean? In the realm of mythology the law of the smallest unit does not hold; there is no search for the smallest agent of rationality in the course of natural phenomena; rather, a being saturated with as much demoniac power as possible is postulated for the sake of a true grasp of the causes of mysterious occurrences. What we have seen this evening of the symbolism of the serpent should give us at least a cursory indication of the passage from a symbolism whose efficacy proceeds directly from the body and the hand to one that unfolds only in thought. The Indians actually clutch their serpents and treat them as living agents that generate lightning at the same time that they represent lightning. The Indian takes the serpent in his mouth to bring about an actual union of the serpent with the masked figure, or at least with the figure painted as a serpent.

In the Bible the serpent is the cause of all evil and as such is punished with banishment from Paradise. Nevertheless, the serpent slithers back into a chapter of the Bible itself as an indestructible pagan symbol—as a god of healing.

In antiquity the serpent likewise represents the quintessence of the most profound suffering in the death of Laocoon. But antiquity is capable also of transmuting the inconceivable fertility of the serpent-deity, representing Asclepius as a savior and as the lord of the serpent, ultimately placing him—the serpent-god with the tamed serpent in his hand—as a starry divinity in the heavens.

32

Hopi schoolboy's drawing of a house in a storm with lightning

In medieval theology, the serpent draws from this passage in the Bible the ability to reappear as a symbol of fate. Its elevation—though expressly considered as an evolutionary stage that has been surpassed—posits it on par with the Crucifixion.

In the end the serpent is an international symbolic answer to the question, Whence come elementary destruction, death, and suffering into the world? We saw in Lüdingworth how christological thought makes use of pagan serpent imagery to express symbolically the quintessence of suffering and redemption. We might say that where helpless human suffering searches for redemption, the serpent as an image and explanation of causality cannot be far away. The serpent deserves its own chapter in the philosophy of 'as if'.

How does humanity free itself from this enforced bonding with a poisonous reptile to which it attributes a power of agency? Our own technological age has no need of the serpent in order to understand and control lightning. Lightning no longer terrifies the city dweller, who no longer craves a benign storm as the only source of water. He has his water supply, and the lightning serpent is diverted straight to the ground by a lightning conductor. Scientific explanation has disposed of mythological causation. We know that the serpent is an animal that

must succumb, if humanity wills it to. The replacement of mytho-
logical causation by the technological removes the fears felt by primit-
ive humanity. Whether this liberation from the mythological world
view is of genuine help in providing adequate answers to the enigmas
of existence is quite another matter.

The American government, like the Catholic Church before it, has
brought modern schooling to the Indians with remarkable energy. Its
intellectual optimism has resulted in the fact that the Indian children
go to school in comely suits and pinafores and no longer believe in
pagan demons. That also applies to the majority of educational goals.
It may well denote progress. But I would be loath to assert that it does
justice to the Indians who think in images and to their, let us say,
mythologically anchored souls.

I once invited the children of such a school to illustrate the German
fairy tale of 'Johnny-Head-in-the-Air' (*Hans-Guck-in-die-Luft*),
which they did not know, because a storm is referred to and I wanted to
see if the children would draw the lightning realistically or in the form
of the serpent. Of the fourteen drawings, all very lively but also under
the influence of the American school, twelve were drawn realistically.
But two of them depicted indeed the indestructible symbol of the
arrow-tongued serpent, as it is found in the kiva [**32**].

We, however, do not want our imagination to fall under the spell of
the serpent image, which leads to the primitive beings of the under-

world. We want to ascend to the roof of the worldhouse, our heads perched upwards in recollection of the words of Goethe:

Wär nicht das Auge sonnenhaft—
Die Sonne könnt' es nie erblicken.

If the eye were not of the sun,
It could not behold the sun.

All humanity stands in devotion to the sun. To claim it as the symbol that guides us upward from nocturnal depths is the right of the savage and the cultivated person alike. Children stand before a cave [33]. To lift them up to the light is the task not only of American schools but of humanity in general.

The relation of the seeker of redemption to the serpent develops, in the cycle of cultic devotion, from coarse, sense-based interaction to its transcendence. It is and has always been, as the cult of the Pueblo Indians has shown, a significant criterion in the evolution from instinctual, magical interaction to a spiritualized taking of distance. The poisonous reptile symbolizes the inner and outer demoniac forces that humanity must overcome. This evening I was able to show you all too cursorily an actual survival of the magical serpent cult, as an example of that primordial condition of which the refinement, transcendence, and replacement are the work of modern culture.

34
'Uncle Sam'

The conqueror of the serpent cult and of the fear of lightning, the inheritor of the indigenous peoples and of the gold seeker who ousted them, is captured in a photograph I took on a street in San Francisco. He is Uncle Sam in a stovepipe hat, strolling in his pride past a neo-classical rotunda. Above his top hat runs an electric wire. In this copper serpent of Edison's, he has wrested lightning from nature [**34**].

The American of today is no longer afraid of the rattlesnake. He kills it; in any case, he does not worship it. It now faces extermination. The lightning imprisoned in wire—captured electricity—has produced a culture with no use for paganism. What has replaced it? Natural forces are no longer seen in anthropomorphic or biomorphic guise, but rather as infinite waves obedient to the human touch. With these waves, the culture of the machine age destroys what the natural sciences, born of myth, so arduously achieved: the space for devotion, which evolved in turn into the space required for reflection.

The modern Prometheus and the modern Icarus, Franklin and the Wright brothers, who invented the dirigible airplane, are precisely those ominous destroyers of the sense of distance, who threaten to lead the planet back into chaos.

Telegram and telephone destroy the cosmos. Mythical and symbolic thinking strive to form spiritual bonds between humanity and the surrounding world, shaping distance into the space required for devotion and reflection: the distance undone by the instantaneous electric connection.

Warburg's Concept of 'Kulturwissenschaft' and its Meaning for Aesthetics

My task is to describe to this Congress on Aesthetics the problems of a library which defines its own method as that of *Kulturwissenschaft*.[1] I ought first, therefore, to explain the relationship between aesthetics and *Kulturwissenschaft* as it is understood in this library. With this purpose in mind I shall refer to the changes which the relationship between art history and the history of culture has undergone in recent decades, and explain, with reference to one or two episodes in the history of these changes, how the development of these studies has generated problems which the library seeks to cater for by providing both material and a framework of thought. In explaining this need I shall concentrate on three main points: Warburg's concept of imagery, his theory of symbols, and his psychological theory of expression by imitation and by the use of tools.[2]

The Concept of Imagery

If we consider the works of Alois Riegl and of Heinrich Wölfflin, which have exercised such a decisive influence in recent years, we see that, despite differences in detail, they are both informed by a polemical concern for the autonomy of art history, by a desire to free it from the history of civilization and thus to break with the tradition associated with the name of Jacob Burckhardt. I will try briefly to summarize the forces behind this struggle and their consequences for the methodology of the subject.

1. This separation of the scholarly methods of art history and those of cultural history was motivated by the artistic sensibility of an age which was convinced that it was of the essence of a pure consideration of a work of art to ignore the nature and meaning of its subject-matter and to confine oneself to 'pure vision'.

2. Within the history of art this tendency was given added impetus by the introduction of critical concepts which shifted the emphasis from the artistic object itself to the manner in which it was depicted, to a point where the two were fully separated. Thus Wölfflin, for example, makes use of the antithesis between subject-matter and form. Since he includes on the side of form only what he calls 'the visual layer of style',[3] everything else, which is not in this radical sense visible, belongs under

the heading of matter—not only representational or pictorial motifs, ideas of beauty, types of expression, modulations of tone, but also the differences resulting from the distinct use of tools which cause gradations in the representation of reality and different artistic genres. It was as though Wölfflin had set himself to discover, in a mathematical manner, the most general characterization of a particular style that it is possible to conceive of. But just as a mathematical logician states in formal terms a propositional function, which only becomes a meaningful proposition when the variables are replaced by words of determinate meaning and names for particular relations, so Wölfflin defines the 'painterly' way of looking at things as a general stylistic function, which can be variously instantiated according to what needs to be expressed, leading now to the style of Bernini, now to the very different style of Terborch.[4] And this general formula, whose logical force undoubtedly lies in its ability to unite such contrasting phenomena under one head, so as to distinguish them as a whole from a differently structured formula, which in turn classifies as 'linear' such contrasting phenomena as Michelangelo and Holbein the Younger—this general formula is now suddenly reified as a perceptible entity with its own history. The logical tendency towards formalization, which lends to the theory of aesthetic form a degree of precision which it cannot justify in its own right, is thus combined with a tendency towards hypostasization which turns the formula, once it has been established, into the living subject of historical development.

3. The antithesis of form and matter thus finds its logical counterpart in the theory of an autonomous[5] development of art, which views the entire developmental process exclusively in terms of form, assuming the latter to be the constant factor at every stage of history, irrespective of differences both of technical production and of expression. This has both positive and negative consequences: it involves treating the various genres of art as parallel with each other—for, as far as the development of form is concerned, no one genre should be any less important than another; it also involves levelling out the differences between them—for no one genre can tell us anything that is not already contained in the others. In this way we attain, not a history of art, which traces the origin and fate of monuments as bearers of significant form, but, as in Riegl, a history of the autonomous formal impulse (*Kunstwollen*),[6] which isolates the element of form from that of meaning, but nevertheless presents change in form in terms of a dialectical development in time—an exact counterpart of Wölfflin's history of vision.[7]

4. Finally, it is not just the various genres within art that are treated as parallel with each other; art itself is treated as evolving in exact parallel to the other achievements within a culture. This, however, only means a further step on the path to formalization; for the same antithesis of

form and content, which at its lowest level brought about the rift between the history of art and the history of culture, now serves at this higher level to re-establish the relationship between the two. But the subsequent reconciliation presents just as many problems as the original division; for the concept of form has now become, at the highest level, just as nebulous as that of content, which at the lowest level united the most heterogenous elements in itself. It has become identical with a general cultural impulse (*Kulturwollen*) which is neither artistic nor social, neither religious nor philosophical, but all of these in one.

There is no doubt that this urge towards generalization gave the art history confined within this scheme grandiose perspectives. Wölfflin brought this out graphically when he declared that one can as easily gain an impression of the specific form of the Gothic style from a pointed shoe as from a cathedral.[8] However, the more critics learnt in this way to see in a pointed shoe what they were accustomed to seeing in a cathedral, or to see in a cathedral what a shoe could perhaps have told them, the more they lost sight of the elementary fact that a shoe is something one slips on to go outside, whereas a cathedral is a place one goes into to pray. And who would deny that this, so to speak, pre-artistic functional differentiation constituting the essential difference between the two objects, arising from man's use of different tools for distinct purposes, is a factor which plays a decisive part in their artistic formation, giving rise to aesthetic differences in formal content in relation to the observer?

I mention this elementary fact not because I believe it would ever have been completely overlooked, but because by stressing it I can get to grips with the present problem. We must recognize that the refusal to adequately differentiate artistic genres, and the consequent disregard of the fact that art is made by tool-using man, are both derived from the conjunction of the formalist interpretation on the one hand and the 'parallelizing' historical view on the other. This fuses into an indissoluble triad the critical study of individual works of art, aesthetic theory, and the reconstruction of historical situations: any weakness in one of these enterprises is inevitably passed on to the others. We can therefore apply constructive criticism in three ways. First, by reflecting on the nature of history it can be shown that, if the various areas of culture are treated as parallel, we shall fail to take account of those forces which develop in the interaction between them, without which the dynamic march of history becomes unintelligible. Or, secondly, we can approach the problem from the standpoint of psychology and aesthetics, and show that the concept of 'pure vision' is an abstraction which has no counterpart in reality; for every act of seeing is conditioned by our circumstances, so that what might be postulated conceptually as the 'purely visual' can never be completely isolated from the context of

the experience in which it occurs. But, thirdly, we can also approach the problem by taking a middle course, and instead of positing *in abstracto* that inter-relationships exist, search for them where they may be grasped historically—in individual objects. In studying this concrete object, as conditioned by the nature of the techniques used to make it, we can develop and test the validity of categories which can then be of use to aesthetics and historical understanding.

This third course is the one Warburg adopted. With the intention of determining the factors conditioning the formation of style more thoroughly than had hitherto been done, he took up Burckhardt's work and extended it in the very direction that Wölfflin, also in the interests of a deeper understanding of the formation of style, had deliberately eschewed. When Wölfflin called for the separation of the study of art and the study of culture, he was able, with a certain amount of justification, to cite the example of Burckhardt.[9] However, if in Burckhardt's *Cicerone* and *Kultur der Renaissance in Italien* there was a separation of the two disciplines, this was not based on principle, but dictated by the demands of the economy of the work. 'He did nothing more', Warburg writes, 'than first of all observe Renaissance man in his most highly developed type and Renaissance art in the form of its finest creations. As he did so he was quite untroubled by whether he would himself ever be able to achieve a comprehensive treatment of the whole civilization.'[10] In Warburg's view, it was the self-abnegation of the pioneer which caused Burckhardt, 'instead of tackling the problem of the history of Renaissance civilization in all its full and fascinating artistic unity, to divide it up into a number of outwardly disconnected parts, and then with perfect equinimity to study and describe each one separately.'[11] But later scholars were not free to imitate Burckhardt's detachment. Hence what for him was simply a practical problem of presentation became for Wölfflin and Warburg a theoretical problem. The concept of pure artistic vision, which Wölfflin developed in reacting to the ideas of Burckhardt, Warburg contrasts with the concept of culture as a whole, within which artistic vision fulfils a necessary function. However, to understand this function—so the argument continues—one should not dissociate it from its connection with the functions of other elements of that culture. One should rather ask the twofold question: what do these other cultural functions (religion and poetry, myth and science, society and the state) mean for the pictorial imagination; and what does the image mean for these other functions?

Characteristically, Wölfflin and Riegl, having explicitly declined to answer the first question, involuntarily overlooked the second. 'To relate everything solely to expression', Wölfflin writes, 'is falsely to presuppose that every state of mind must have had the same means of expression at its disposal.'[12] But what does 'every state of mind' really mean here? Is it that moods have remained the same, while only the

means or expressing them have changed? Does the image only depict a state of mind? Does it not at the same time also stimulate it?

A very similar sort of observation can be found in Riegl. 'The visual arts', he says clearly, 'are not concerned with the What of appearance, but with the How. They look to poetry and religion to provide them with a readymade What.'[13] But what does 'provide readymade' mean here? Does the image have no effect on the poet's imagination, or play no part in the formation of religion?

It was one of Warburg's basic convictions that any attempt to detach the image from its relation to religion and poetry, to cult and drama, is like cutting off its lifeblood. Those who, like him, see the image as being indissolubly bound up with culture as a whole must, if they wish to make an image that is no longer directly intelligible communicate its meaning, go about it in a rather different way from those who subscribe to the notion of 'pure vision' in the abstract sense. It is not just a matter of training the eye to follow and enjoy the formal ramifications of an unfamiliar linear style, but of resurrecting the original conceptions implied in a particular mode of vision from the obscurity into which they have fallen. The method used for achieving this can only be an indirect one. By studying all kinds of documents that by methods of historical criticism can be connected with the image in question, one must prove by circumstantial evidence that a whole complex of ideas, which must be individually demonstrated, has contributed to the formation of the image. The scholar who thus brings to light such a complex of associations cannot assume the task of considering an image is simply a matter of contemplating it and of having an immediate empathic sense of it. He has to embark upon a process of recollection, guided by the conception he is trying to understand, through which he can contribute to keeping alive the experience of the past. Warburg was convinced that in his own work, when he was reflecting upon the images he analysed, he was fulfilling an analogous function to that of pictorial memory when, under the compulsive urge to expression, the mind spontaneously synthesizes images, namely the recollection, or more literally, the revival of pre-existing forms. The word ΜΝΗΜΟΣΥΝΗ, which Warburg had inscribed above the entrance to his research institute, is to be understood in this double sense: as a reminder to the scholar that in interpreting the works of the past he is acting as trustee of a repository of human experience, but at the same time as a reminder that this experience is itself an object of research, that it requires us to use historical material to investigate the way in which 'social memory' functions.

When Warburg was studying the early Florentine Renaissance he came across just such concrete evidence of the operation of 'social memory'—in the revival of imagery from antiquity in the art of later ages. Thereafter, he never ceased to inquire into the significance of the

influence of classical antiquity on the artistic culture of the early Renaissance. Because this problem always contained for him another more general one, namely what is involved in our encounter with pre-existing images transmitted by memory, and because his personal work was bound up with this more general one, the question of the continuing life of classical antiquity became by a kind of magical process his own. Each discovery regarding the object of his research was at the same time an act of self-discovery. Correspondingly, each shattering experience, which he overcame through self-reflection, became a means of enriching his historical insight. Only thus was he able, in analysing early Renaissance man, to penetrate through to that level at which the most violent contradictions are reconciled, and to develop a psychological theory concerned with the resolution of conflicts (*Ausgleichs-psychologie*), which assigns opposing psychological impulses to different psychological 'loci', and conceives of them as poles of a unifying oscillation—poles whose distance from each other is a measure of the extent of the oscillation. And only thus is it also possible to explain how the answer which he found in this theory of the polarity of psychological behaviour to his fundamental question concerning the nature of the response to the pre-existing forms of ancient art was developed into a general thesis: namely, that in the course of the history of images their pre-existing expressive values undergo a polarization which corresponds to the extent of the psychological oscillation of the creative power which refashions them. It is only by means of this theory of polarity that the role of an image within a culture as a whole is to be determined. [...]

I have tried to convey some idea of the nature of Warburg's method of inquiry; but my words must necessarily remain somewhat abstract and lifeless without concrete illustration. Indeed this lecture is intended as an introduction to the picture display which is set up here in the hall,[14] and also to the library itself which is expressly arranged to bring out the particular problems that were Warburg's concern.

You will there clearly see the great extent to which Warburg, in pursuing his theory of polarity, was obliged to forsake the traditional domains of art history and to enter into fields which even professional art historians have tended on the whole to fight shy of—the history of religious cults, the history of festivals, the history of the book and literary culture, the history of magic and astrology. However, it was just because he was interested in revealing tensions that these intermediate areas were of great importance to him. It is in the nature of festivals to lie between social life and art; astrology and magic lie half-way between religion and science. Warburg, intent on probing further, always chose to study those intermediate fields in precisely the historical periods he considered to be themselves periods of transition and conflict: for example, the early Florentine Renaissance, the Dutch

Baroque, the orientalizing phases of late classical antiquity. Furthermore, within such periods he always tended to apply himself to the study of men who, whether through their profession or their fortune, occupy ambiguous positions: for example, merchants who are at the same time lovers of art, whose aesthetic tastes mingle with their business interests; astrologers who combine religious politics with science and create a 'double truth' of their own; and philosophers whose pictorial imagination is at odds with their desire for logical order. In dealing with the individual work of art, Warburg proceeded in a way which must have seemed somewhat paradoxical to the student of art with a formalist training; his practice of gathering together pictures in groups gave his work its peculiar stamp: he interested himself just as much in the artistically bad picture as in the good, and indeed often more so, for a reason which he himself explicitly acknowledged—because it had more to teach him. In his study of the iconographic meaning of the cycle of frescoes in the Palazzo Schifanoia—a pictorial enigma which he solved brilliantly[15]—he went first to the master who seemed to him to be the weakest. And why? Because the problem posed by the task with which the artist had to wrestle was easier to see in the flaws of the undistinguished work: the complicated structure of the major work made the problem much harder to pick out, because the artist resolved it with such a display of virtuosity.

The same applies to other branches of learning. Physicists were able to analyse the nature of light by studying its refraction through an inhomogenous medium. And modern psychology owes its greatest insights into the functioning of the mind to the study of those disorders in which individual functions, instead of harmonizing, are in conflict. To proceed only from great works of art, Warburg tells us, is to fail to see that the forgotten artefact is precisely the one most likely to yield the most valuable insights. If we go straight to the great masters, to Leonardo, Raphael, and Holbein, to works in which the most violent conflicts have been most perfectly resolved, and if we enjoy them aesthetically, that is, in a mood which is itself no more than a momentary harmonious resolution of opposing forces, we shall spend happy hours, but we shall not arrive at a conceptual recognition of the nature of art, which is, after all, the real business of aesthetics.

Warburg adopted the same kind of approach in assembling his remarkable library. Compared with other specialist libraries, it must appear peculiarly fragmentary, for it covers many more areas than a specialist library normally seeks to do. At the same time, its sections on particular fields will not be found to be as complete as one would normally expect of a specialist library. Its strength, in short, lies precisely in the areas that are marginal; and since these are the areas that play a crucial part in the progress of any discipline, the library may fairly claim that its own growth is entirely in keeping with that of the

particular field of study it seeks to advance. The more work that is done in those 'marginal' areas classified by the library, the more the corresponding sections in the library will automatically fill up. This means that it depends upon collaborative effort. That is why the library welcomes the opportunity this Congress offers us to learn something of the problems with which aestheticians are concerned: for, in Warburg's own words, it is 'a library eager not only to speak, but also to listen'— *eine Bibliothek die nicht nur reden, sondern auch aufhorchen will.*

Retrieving Warburg's Tradition

There have been many re-evaluations of the golden age of German historiography in recent years, some receptive, some critical;[1] yet none as far as I know has been written from a feminist standpoint. One exception is Svetlana Alpers's essay 'Art History and its Exclusions', in which she argues that art-historical categories and judgements of value in the work of Wölfflin and Panofsky are based on the model of Italian Renaissance art which is characterized by 'a commanding attitude taken toward the possession of the world'.[2] More often feminist critiques have been directed at the tradition of the social history of art; witness, for example, Griselda Pollock's insistent objections to the work of one of the most eminent bearers of that tradition, T.J. Clark.[3] And just as Pollock intends not to denounce social history but to free it from its masculinist fetters, so too my project has positive and negative moments. The focus of my critique is on the tradition of art-historical scholarship founded in Hamburg at the beginning of this century by Aby Warburg and Erwin Panofsky. Warburg, as one of the important founding fathers of the discipline, has attracted much critical commentary from many quarters. Nor, given the centrality of his position, should he be excluded from feminist reassessments. But, rather than criticizing, we may choose to enlist him as an ally. In the difficult task of elaborating a new art-historical methodology, his work might prove valuable, usable. The nature of Warburg's contribution can be best appreciated by setting it beside Panofsky's.

One possibly valuable dimension of Warburg's work is his implicit critique of the ideal of total detachment in either aesthetics or scholarship. He maintained a dialectical grasp on the need for distanced reflection and intimate connection. I want to develop this theme of detachment/connection, later introducing some related conceptual pairs: disembodiment/embodiment and homogeneity/heterogeneity. My claim is that Warburg's approach anticipates in many ways feminist critiques of science and phallogocentric logic.[4] Although the polarities associated with that logic—mind/body, reason/sense experience, logos/pathos and so on—structure his work, they tend to lose any strict hierarchical ordering and become dynamic, dialectical polarities. In sharp contrast, the project of his illustrious 'follower' Erwin Panofsky

seems to have been to re-instate the original fixity of these oppositions. The same can be said of his biographer Ernst Gombrich, formerly director of the Warburg Institute in London. In their hands Warburg is deproblematized, becalmed, and his complex and conflicted theory of art turned into an unambiguous affirmation of Enlightenment ideals. If they can be said to carry forward Warburg's tradition, they do so in a way which perhaps reminds one that the word 'tradition' is etymologically related to the word 'traitor'. One might want to argue that there are good historical reasons for this tradition; namely, that Panofsky (1892–1968) and Gombrich (b.1909) are of younger generations and both became Jewish exiles forced out of their countries in the 1930s. Warburg died in 1929; only his library under the directorship of Fritz Saxl sought asylum in England in 1933. Yet Warburg suffered so dreadfully during the chaos of World War I that he had to be institutionalized for five years. He had reason enough to dread unreason.

Perhaps the clearest illustration of what I see as a defusing of Warburg's historiography in Panofsky and Gombrich turns on their conceptions of classical antiquity. It is well known that Warburg was deeply influenced by Nietzsche's *The Birth of Tragedy* (1872) and by his radically new re-reading of Greek culture as a creative tension between Dionysian and Apollonian forces—one side dangerous, nihilistic, emotionally unfettered and physically in motion, the other side a beautiful and calm illusion which enabled the Greeks to live.[5] Warburg thought of antiquity as best symbolized by a Janus-faced herm with the faces of Apollo and Dionysus. In Warburg's 1906 lecture 'Dürer and the Italian Antique', he directly attacks Winckelmann's 'one-sided classical doctrine' and argues that 'artists in fifteenth-century Italy sought as keenly after representations of intense pathos just as much as classically idealized calm'.[6] In Panofsky's essay 'Albrecht Dürer and Classical Antiquity' (1921–2),[7] which makes frequent reference to Warburg, a completely different gloss is put on antiquity's value. The 'pathos formulae', which for Warburg were exemplary expressions of primitive emotion and 'tragic unrest', become in Panofsky's scheme 'universals' which exemplify classes of particulars: 'Thus to have captured and ordered the multitude of phenomena is the eternal glory of classical art.'[8] Further, 'typification necessarily implies moderation' and so 'there is no place for extremes'. He continues: 'Classical aesthetics insists on harmony and the mean'[9] and affirms with Warburg: 'Nietzsche was right in stating that the Greek soul, far from being all *'edle einfalt und stille Grösse'*, noble simplicity and quiet grandeur, is dominated by a conflict between the 'Dionysian' and the 'Apollonian'.'[10] But he immediately defuses Nietzsche and Warburg by adding that in Greek art these principles are reconciled: 'In it there is neither beauty without movement nor pathos without moderation.'[11] While Panofsky continually interprets both antique and Renaissance art as an harmoni-

ous reconciliation of opposites, Warburg sees antiquity as a cultural mint which coined enduring expressions of both sides of the opposition. His view of *Laocoön* as 'a vivid embodiment of dire human suffering' suggests that for him it represented not moderation but the very superlative of pain and tragic pessimism.[12] Panofsky's aim, here as elsewhere, seems to have been to turn Warburg's dynamic, conflicted, heterogeneous antiquity into an homogeneous, harmonious whole.

One can find evidence of a similar agenda throughout Gombrich's biography of Warburg. In the Preface, for example, he claims that Warburg in no way departed from the late nineteenth-century belief 'that the art of the Italian Renaissance, the art of Leonardo, Michelangelo and Raphael, was the visible expression of a supreme moment of human civilization—bordered on the one side by the barbarism of the bigoted Middle Ages and on the other by the deplorable excesses of Baroque rhetoric'.[13] While it is true that Warburg acknowledged Raphael's achievement on more than one occasion, Gombrich's emphasis is insistently one-sided:

Though he saw the Renaissance as an area of conflict between reason and unreason he was entirely on the side of reason. For him the library he collected and wanted to hand on to his successors was to be an instrument of enlightenment, a weapon in the struggle against the powers of darkness which could so easily overwhelm the precious achievement of rationality.[14]

A fairer reading of Warburg would indicate his equal concern for the losses incurred by too much rational detachment from 'the powers of darkness', that is, myth, tragedy, emotion or what we might call the unconscious. In Panofsky, and even more so in Gombrich, the Apollonian and Dionysian appear as simple positive and negative poles, as good rational distanciation versus bad emotional abandon. On this reading, the Renaissance is understood as a triumph of distanciation from medieval superstition. Yet, in Warburg's account of the entry of classical antiquity into Quattrocento Italy, one of its heralds is the swift-footed Nympha who rushes in to disturb the staid company assembled for Ghirlandaio's *Birth of St John the Baptist*.[15] This descendant of an ecstatic maenad or winged Victory flies in the face of such reductionist readings of the Renaissance.

Before moving on to more detailed contrasts of certain aspects of Warburg's and Panofsky's work, I want to locate my own methodological standpoint. I am guided in my reading by recent feminist, poststructuralist and psychoanalytic critiques of science which now amount to so considerable a body of literature that I cannot do justice to it here.[16] Perhaps the best way to sum up the general drift of this literature is by re-telling the fable first told by a young woman in 1816, Mary Shelley's *Frankenstein*. It is clear that Dr Frankenstein is meant to represent the thoroughly enlightened scientist who has turned away

with contempt from his childhood preoccupation with magicians and alchemists. His conversion is brought about in adolescence when he witnesses the terrible destructive power of a bolt of lightning which reduces an ancient oak to ribbons. Yet even before this supernatural sign of prohibition, he is explicitly contrasted with his 'feminized' friend Clerval who concerns himself with 'the moral relations of things',[17] and who later in life studies Oriental languages and literature, 'so different', as Frankenstein remarks, 'from the manly and heroical poetry of Greece and Rome'.[18] Completely on the side of the phallic principle, young Frankenstein is encouraged by his university professor 'to penetrate into the recesses of nature and show how she works in her hiding places',[19] advice which repeats the sexually inflected discourse of science founded by Bacon and Descartes.[20] Scientific research is couched in the language of sexual transgression. So utterly demystified and secularized is the doctor's world that he is prepared to violate graves to further his study. Deferring his marriage, he creates life without the aid of woman. His creation, an unnamable Monster, returns with a vengeance like the repressed and eventually destroys him. Shelley herself made the connection between the single-minded desire for mastery of nature with overweening political ambition and colonial expansionism. Frankenstein, ruined by his own Promethean hubris, observes that if these desires had been tempered, then 'America would have been discovered more gradually, and the empires of Mexico and Peru had not been destroyed.'[21] In this tragic parable Shelley links together a castrating trauma in youth, distance from familial ties, abstraction from ethical context, and overweening desire for knowledge as a means of wielding power and winning fame.

Frankenstein anticipates by nearly two centuries recent feminist and postmodernist reflections on masculinist technology and science and, further, does so in a way which points forward to a psychoanalytical model which underpins many of them. One such critic, Julia Kristeva, observes in 'Woman's Time' that because of certain bio-familial conditions and relationships, men tend to magnify both separation from the mother and the order of language into which they are inserted and, terrified, attempt to master them.[22] Masculinity, then, is likely to have an obsessional character. This psychic propensity is mirrored in certain scientific epistemologies. In an article of 1973, Kristeva notes that theories of meaning or of representation are at a crossroads. Along one path they become increasingly technico-mathematical and, as she observes, based 'on a conception ... of meaning as the act of a *transcendental ego*, cut off from its body, its unconscious, and also its history'. Along the other path, however, they incorporate 'the theory of the speaking subject as a divided subject (conscious/unconscious) and go on to specify the types of operations characteristic of the two sides of this subject'— that is, both social constraints and pre-symbolic drives.[23] Within the

body of feminist theory to which I have referred, a 'feminine' de-centred, situated, divided, overdetermined subject is set in opposition to a 'masculine' transcendental ego, which is theorized as having an autonomous, constitutive rationality. These two conceptions of the subject are, then, linked to different methodological approaches to the products of culture. My contention is that if Warburg represents the former of these tendencies within the discipline of art history, then Panofsky represents the latter.

Kristeva's observations are cast in a post-Lacanian framework, yet Freud said something very similar in his essay 'Some Psychical Consequences of the Anatomical Distinction between the Sexes' (1925). As a man of his time, Freud tended to have a high regard for the virtues of neutrality and distance and to ascribe them to men. He connected this ideal of rationality with the Oedipal moment when the child represses his love for his mother: he exchanges the physical proximity of the mother for identification with the position of the father whose law he must internalize in the shape of a severely critical super-ego. He is, so to speak, hollowed out and normalized. Freud thought that women, as they had nothing to lose, could not be threatened with castration and so did not suffer such severe repression. 'Their super-ego is never so inexorable, so impersonal, so independent of its emotional origins as we require it to be in men.'[24] It is possible to read this last description as a positive tribute to women, especially in the light of the writings of 'New French Feminists', such as Luce Irigaray and Hélène Cixous, who stress the virtues associated with being less cut off from the maternal body—flexibility, connection with others, embodiedness.[25]

The feminist critique of the ideal of detachment helps to explain why Warburg's art history is so sympathetic and fascinating; it stays so close to the emotional origins both of the art under study and of the interest of the art historian in the objects he studies. His work suggests a sensibility which remembers proximity to the mother, that is, the lack of differentiation between self and other; remembers the pain of separation. He sees the necessity of separation and also the impoverishment of a complete loss of contact which results in a hyper-trophy of the intellect. In the notes for his lecture on Serpent Ritual (1923) [Images from the Region of the Pueblo Indians of North America], Warburg meditates on the losses and gains of separation and repression:

The primeval category of causal thought is maternity. The relation between mother and child displays the enigma of the tangible-material connection bound up with the profoundly bewildering trauma of the separation of one living being from another. The detachment of the subject from the object which establishes the zone for abstract thought originates in the experience of the cutting of the umbilical cord.[26]

In the Freudian scenario, the crucial separation is psychic and is effected by a threatened cut. Yet the ultimate consequence is the same for both: it splits the subject. Also in the notes Warburg writes: 'All mankind is eternally and at all times schizophrenic.'[27] The double need Warburg saw for connection and detachment is apparent in a passage from the lecture on Rembrandt in which he praises the artist's close contact with classical antiquity: 'May these tours through the semi-subterranean regions where the expressive contours of the mind are minted help to overcome a purely formalistic approach to aesthetics … The ascent with Helios towards the sun and the descent with Proserpine into the depths symbolize two stages which belong as inseparably to the cycle of life as do the alternations of breathing.'[28]

Warburg's tradition is understood to have been carried forward by Panofsky, yet to my mind the latter was the very model of the detached scholar, cut off from his body and unconscious. His early contact with the neo-Kantian philosopher Ernst Cassirer set the pattern. The tendency of his thought is evident in the 1920 paper 'Der Begriff des Kunstwollens', his critique of and appropriation of Alois Riegl, which sets out to find an Archimedean point, that is, a fundamental *a priori* concept outside the historical phenomena.[29] The concept would function in a way analogous to Kant's concept of causality which combines with necessity different presentations as it is part of the mind's contribution to experience. In Panofsky's 1921 'Proportion' paper, this Archimedean point comes to be associated with the achievement of a reflexive awareness of the nature of our knowledge, which combines both attention to the world and a recognition of the subjective conditions of perception—that is, experience as described by Kant.[30] For Panofsky, Renaissance art embodies this achievement; it is a synthesis of receptivity and spontaneity. A similar argument is mounted in the 'Perspective' paper (1924–25), to which I will return. In all these papers, Riegl's sliding scale between objective and subjective attitudes to the world, which was specifically elaborated so as not to privilege any period style, gets collapsed into a uniquely legitimate norm, and every other period is regarded as either approaching or falling away from it.[31] Although Panofsky did not elaborate a theory of the subject, I am suggesting that his positing of an *a priori* schema and his privileging of a single aesthetic norm are bound up with the conception of a transcendental ego.

Another repeated motif in Panofsky's work confirms what I have said about the insistence on distance in 'masculinist' scientific discourses. One could cite many examples in his work of the principle that knowledge requires separation and distance. In his methodological manifesto 'History of Art as a Humanistic Discipline' (1940), for example, Panofsky wrote: 'To grasp reality we have to detach ourselves from the present.'[32] He saw a parallel between the elaboration of

systematic perspective construction in the Renaissance and the attainment of a truly historical point of view; both imply separation and objectification. This detachment may be tinged with hostility; in 'The First Page of Giorgio Vasari's "Libro" ' (1930), Panofsky argued that it was precisely Vasari's antipathy to the gothic that enabled him to see it as a distinct style.[33] Or again, in 'Albrecht Dürer and Classical Antiquity' (1921–22), the German artist is said to have grasped more fully than the Italians the nature of classical antiquity because of his 'complete estrangement from it'. As a consequence of his remoteness, his attitude to classical art had to be that of a '*conquistador*': 'It was for him a lost 'kingdom' which had to be reconquered by a well-ordered campaign.'[34] Oddly, Panofsky uses this unblushingly Eurocentric imagery again in his tribute to Warburg, comparing the group of scholars that he gathered around his library to a 'crew for his Columbus-ship'.[35] The point is clear enough: if something is to become an object of knowledge it must be split off from the subject and, if necessary, denigrated and conquered. It is rather as though one believed that the European colonizers of the New World were in the best position to understand native American culture.

Warburg, too, certainly saw the need for detachment. The first sentence of the introduction to his last, unfinished work reads: 'The conscious creation of distance between the self and the external world may be called the fundamental act of civilization.'[36] Yet for him, it is the constant oscillation between close identification with the object or its concrete representation and the abstractions of thought which is both our fate and our salvation. Art's history oscillates between moments of fusion and dissociation. For Warburg, grisaille is an example of a poise achieved between one extremity and another, and he is especially close to Nietzsche's vision of the artist in this: 'Even the image of the angry Achilles is only an image to him whose angry expression he enjoys with the dreamer's pleasure in illusion. Thus, by this mirror of illusion, he is protected against becoming one and fused with his figures.'[37] The consequences of one-sided rationalistic detachment which is not in this way dialectically related to fusion are most clearly spelled out in the 'Serpent Ritual Lecture' to which I will return. However, some measure of Warburg's dialectical grasp of our condition is contained in the following poignant sentence from that lecture: 'Human culture evolves toward reason in the same measure as the tangible fullness of life fades into a mathematical symbol.[38]

Because Warburg's interest was in following the oscillations of culture rather than in establishing an authoritative point of view, he focused on moments that were in a heterogeneous state of transition: the early Renaissance and the period of the Reformation in northern Europe. His interpretation of them tended to increase their heterogeneous quality; their incorporation of Oriental astrological belief and

imagery, for example, and the circulation of images between northern and southern Europe. His Quattrocento Florence could accommodate business-minded merchant art lovers, perfectly pious and yet also believers in the Fate of the ancients and the astrology of the East.[39] For Warburg, this *was* the Renaissance and not the resolution of a preceding state of conflict.

The library Warburg created was designed to encourage heterogeneity in scholarship, that is, to draw the reader away from a narrow specialization. He complained bitterly about disciplinary border police.[40] In a letter of 1927 he wrote: 'Not until art history can show ... that it sees the work of art in a few more dimensions than it has done so far will our activity again attract the interest of scholars and of the general public.'[41] Yet it is doubtless his unfinished project for a *Bilderatlas* or picture book (1928–29), which has been variously called a 'pictoral symphony',[42] a mosaic, a montage and even dadaistic,[43] that best sums up Warburg's extraordinary cast of mind. Gombrich relates how he kept on changing the sequence of the reproductions which he arranged on large screens without commentary or even captions;[44] even this non-discursive, non-linear form of expression seemed to him too rigid. And the pictures themselves mix classical sculpture and early Renaissance frescoes with pages of medieval manuscripts from East and West, cheap popular prints, calendars, astrological charts, tapestries, advertisements, playing cards, stamps and newspaper clippings. Part of the introduction to the Atlas, called the *Grundbegriffe* or fundamental concepts, reads like concrete poetry. Not even the project's title *Mnemosyne* was quite fixed; other ideas included *Gespenstergeschichten für ganz Erwachsene* (*Ghost Stories for Grown-ups*), and *Bilder Atlas sur Kritik der reinen Unvernunft* (*Picture Book for a Critique of Pure Unreason*).

Warburg's heterogeneity, his play with words and contradictions, stand in sharp contrast to Panofsky's high evaluation of systematicity and homogeneity. Panofsky once tellingly quoted from Goethe: 'The highest thing would be so to grasp things that everything factual was already theory.'[45] In other words, the world must be thoroughly absorbed and rendered thought-like. The achievement of the Renaissance was for him precisely its resolution of contradictions between things and voids, subject and object. This can perhaps best be seen in 'Perspective as Symbolic Form',[46] which has the added advantage in this context of bearing on the theme of embodiment/disembodiment as well. According to Panofsky, the history of conceptions of space as they appear in works of art and in documents shows how the raw material of experience has been systematically elaborated and how space has become a mental construction: 'For the structure of an infinite, unchanging and homogenous space, in short, purely mathematical space is directly opposed to that of psycho-physiological space.'[47]

The argument is supported by reference to Cassirer's second volume of *Philosophy of Symbolic Forms*[48] on myth where he noted that perception is unacquainted with infinity and that psychologically relevant spatial relations—in front/behind, above/below, right/left—are not, like mathematical spatial relations, equivalent. Panofsky concludes, with Cassirer, that infinite, homogeneous space is not given in experience; it must be constructed and perspective construction 'abstracts fundamentally' from psycho-physiological space.[49] All this, and more, is brought in evidence against a naïve realist's view of perspective construction which might suppose that it represents the world exactly as we experience it; on the contrary, perspective is the culmination of a long history in which perceived space is systematically modified, mathematically corrected and thoroughly unified.

While one would not want to criticize Panofsky's celebration of perspective construction in the name of some romantic notion of immediate sense experience, it is still worth observing that he values it because all the coordinates of space which pertain to the body are expunged while those relating purely to thought instated. Troublesome oppositions or contradictions in earlier spatial organizations are transcended in the purely mathematical conception of space which is later theoretically elaborated by, for example, Descartes.

Panofsky concludes that systematic perspective opens up the possibility for post-Renaissance styles to take advantage of its two-sided significance. Because perspective both recognizes the distance between mind and things and overcomes that distance 'by drawing into the eye, as it were, the independently existing world of things',[50] artists can move with great flexibility between one possibility and the other.

So the history of perspective may be understood with equal right as a triumph of the distancing and objectivizing feeling for reality and as a triumph for the distance-denying human struggle for power; equally well [can it be understood] as a fixing and systematizing of the external world as an extension of the ego's sphere.[51]

Although this sounds superficially like a Warburgian 'two-sided' formulation, in fact both sides of Panofsky's polarity dominate the object—one by studied distance, the other by overwhelming force. Warburg's polarities, on the other hand, are always structured around active and passive positions: domination and submission, 'calm contemplation' and 'orgiastic surrender to the emotions', 'murderous cannibalism' and 'helpless brooding'.[52]

In the 'Perspective' paper, the intellectual ideal of distanciation is given a theory of vision in which measured distance, fixity, monocularity and mastery define the spectator who looks out on a space/object which is rectilinear, abstract and uniform. In a suggestive article called 'Scopic Regimes of Modernity', Martin Jay points out that this kind of

vision is 'conceived in the manner of a lone eye looking through a peep-hole' and goes on to say that 'the abstract coldness of the perspectival gaze meant the withdrawal of the painter's emotional entanglement with the objects depicted.'[53] The spectator becomes a disembodied point of sight, abstract identity, and the body of the other is subsumed under a generalized conception of 'extended substance'.[54] While Warburg's 'vision' can be understood as situated, shifting, tentative and partial, just like embodied perception, Panofsky's ideal is locked into a fantasy of a fixed and universalizable point of view.

Warburg also gave a socio-political dimension to the dialectic of fusion and detachment. He saw advanced technological progress as a creature of enlightened rationality which threatened to bite its own tail. This he discussed in 'A Lecture on Serpent Ritual' which was written and delivered in 1923 at the end of his stay in the institution where he was being treated for his mental illness. In it he brought his polarities to bear on the culture of the Pueblo Indians whom he had visited in 1896 and on the modern American culture which was over-whelming it. He was sharply critical of the latter.

The forces of nature are no longer seen in anthropomorphic shapes; they are conceived as an endless succession of waves, obedient to the touch of man's hand. With these waves the civilization of the mechanical age is destroying what natural science, itself emerging out of myth, had won with such effort—the sanctuary of devotion, the remoteness needed for contemplation.[55]

It is interesting to compare this with the ideas of another thinker, Walter Benjamin, who also made use of the metaphors of proximity and distance, drawn from Riegl, and who likewise observed the way in which technology abolishes distance.[56] Benjamin, however, unlike Warburg, perceived a revolutionary potential in the shock of the new media. But in the passage I have just quoted, I do not think that Warburg is only referring to new media or, as Gombrich thinks, merely expressing his distaste for the wireless.[57] Just before the passage I have quoted, he describes a snapshot he took in San Francisco of a man in a top hat, whom he calls 'Uncle Sam'—the personification of the United States. He is the conqueror of the Serpent cult and of the fear of light-ning, the heir to the original inhabitants, the gold-seeking intruder in the land of the Indians, proudly striding down the road in front of an imitation classical rotunda with an electric wire overhead.[58] It is not a flattering portrait. 'Uncle Sam' is aggressive and materialistic and his art and architecture are imitative, cut loose from their source, hollowed out. 'Electricity enslaved, the lightening held captive in the wire has produced a civilization which has no use for heathen poetry.'[59] Modern science and technology, which at first created the necessary distance for thought, 'Denkraum', ends up by destroying that 'Denkraum', the sav-ing interval between impulse and action, not to mention the very life of

another culture. Warburg comes close here to articulating the paradox of civilization so forcefully described in Adorno's and Horkheimer's *Dialectic of Enlightenment*:

Myth turns into Enlightenment, and nature into mere objectivity. Men pay for the increase of their power with alienation from that over which they exercise their power. Enlightenment behaves toward things as a dictator toward men. He knows them in so far as he can manipulate them.[60]

Warburg saw that the progressive march of modern civilization is accompanied by destruction, not only of indigenous cultures, but of the conquering culture as well. This happened, he thought, because technology, unlike the symbol, is one-sided; it so completely controls its object that distance quickly degenerates into demonically possessed domination. The essay closes, however, on a hopeful note: 'Myths and symbols, in attempting to establish spiritual bonds between man and the outside world, create space for devotion and scope for reason which are destroyed by the instantaneous electrical contact—unless a disciplined humanity re-introduce the impediment of conscience'.[61]

5

Mechanisms of Meaning: Iconography and Semiology

Introduction

While there have been many important controversies about art historical theory and methodology in the twentieth century, perhaps the two most enduring have concerned, first, the extent of information required to render works of art adequately legible, and, second, the proper extent of the domain of art historical study.

With regard to the first question, as previous discussions and readings have indicated, perspectives have varied widely. For some, an understanding of an object's formal properties, and the manner in which such properties might change over time in chronological sequences of like objects, have constituted sufficiently relevant information. The formal transformations of the properties or features seen in artworks have for some art historians and critics provided, by structural analogy, certain essential insights into the nature of a culture or a people. In such cases, the genealogy of forms comprises a representation or simulation of a genealogy of spirit, character, or mentality, either of an individual artist or of an entire society, class, ethnic group, nationality, or people.

For others, criteria of adequacy in interpretation may swing to what may appear to be an opposite extreme, whereby the formal features of objects are of secondary or ancillary importance relative to other circumstantial factors of production or reception. In which case, objects become illustrative or constitutive of the social, political, or economic contexts of their construction and construal. Consider in this context the 'social-historical' genre of anglophone art historical practice in the 1970s and 1980s,[1] an admirable attempt to move away from the spiritualism inherent in Hegelian-based historicisms but one which stalled before mounting the necessary radical critique of its cognitive system.[2]

This oscillation between formalist and contextualist views on the adequacy of information required for interpretation has characterized art historical debate in the twentieth century no less than in the eight-

eenth and nineteenth, even if the specific construals of form, content, and context have varied substantially at different times and places. Marxist (proto-structuralist) Formalism of the 1920s was radically different from the formalism of Wölfflin, itself decried by Walter Benjamin in his 1930s' defence of an Alois Riegl who today would be understood as virtually indistinguishable from Wölfflin in his 'formalism'.[3] Part of Benjamin's motivation for attacking Wölfflin was the latter's failure to escape a 'sentimentalist' vision of artistic interpretation, despite the apparent rigour of his formal methods: by contrast, Riegl's formalist methodology allowed for a vision of a larger social collective (the *Kunstwollen*) which was more congenial to Benjamin's own critical enterprise. If the aesthetic for an eighteenth-century bourgeoisie might have signalled a reaction to dogmatic religion, absolutist politics, and mechanistic rationalism, in contemporary terms it may for some constitute a radical yet impotent disturbance of the bureaucratization of culture by hegemonic institutions.[4]

Whether the continuities in the terms of the debates are more important than their immediate contextual differences is a question about which there has been much debate for generations. Riegl's 'formalism' might be more amenable to certain modes of construing subject–object interactions in contemporary critical theory than certain non-formalist perspectives associated with the latter.

Such complexities render the vision of a unilinear and progressive evolution of the discipline of art history extremely problematic, and may foreground what is often obscured in these debates—the disciplinary impulse to see as commensurate the history of artistic practice and the history of art history (or the history of art historical practice) as an historical artefact in its own right, with a comparable shape, style, or figure in chronological or evolutionary time. What is at stake here are visions of history itself, of which art history is always seen as a particular instance.

In this regard, the twentieth-century debates about the nature of signification and meaning in art and in art's historical developments—both *what* and *how* objects mean—are commonly viewed at the end of the century, and by hindsight, as falling into a series of generational differences or transformations. Such has been especially characteristic of the portrayal of relations between *iconography* as developed by a member of Aby Warburg's circle in the 1920s, Erwin Panofsky (1892–1968), and a *semiology* or semiotics of art, as a post-World War II (or for some a 1970s) phenomenon. The former is framed as a precursor of the latter, and the latter is seen as a more inclusive, interdisciplinary version of the former.

In fact, investigations into the mechanisms of meaning under the name of semiology or semiotics have a long and ancient history in Western philosophy and in theories of art, language, and communica-

tion.[5] The first two readings in this Chapter, by Hubert Damisch[6] and by Mieke Bal and Norman Bryson,[7] outline aspects of those histories, although neither is an explicit survey of the general subject of meaning or signification in art, and the latter demands very close attention to the several threads of its argumentation. They are positioned here prior to the (historically earlier) iconographical study by Panofsky, and the semiotic study by Marin, so as to familiarize the reader with some of the basic issues at stake.

The short Damisch essay addresses the question of contrasts and similarities between modern (Panofskian) iconology and semiology, published at a time (1975) when art historical interest in semiology—reflecting that in many other fields—was burgeoning, although very little art historical writing on the subject was widely available. It appeared in an anthology of writings on semiological research in different fields. The much longer essay by Bal and Bryson was published nearly twenty years later in the official journal of the US College Art Association, the *Art Bulletin*, as one of a series of commissioned essays designed to introduce its audience to 'new' perspectives that had been affecting disciplinary practice in recent years.

The contrasts between the two texts are instructive, and their juxtaposition here will highlight the differences in the authors' perceptions of semiology and of various theses treating works of art as a visual sign-system linked to other social systems of signification. They also foreground the differences in their implied audiences: for Damish, an interdisciplinary audience of semioticians; for Bal and Bryson, a professional art historical audience who might welcome a serious investigation of the potential usefulness of semiotic theories for disciplinary practice.

In the case of Bal and Bryson, this challenge was met both in general terms, as in the introductory sections excerpted here, and in specific areas of the discipline of personal interest to the authors (Rembrandt studies in the case of Bal, a Dutch literary theorist, verbal-visual interrelations in the case of Bryson, an art historian trained in literary studies). They also address the hostility of (largely American) art historians in the 1980s to various facets of contemporary 'critical theory', which had become an umbrella term for gender studies, semiology, psychoanalysis, postcolonial theory, reception theory, and deconstruction.

The authors devoted separate sections of their essay to some of these areas—titled 'Context', 'Senders' (the two reprinted here), 'Receivers', 'Charles Sanders Peirce', 'Ferdinand de Saussure', 'Psychoanalysis as a Semiotic Theory', 'Narratology', and 'History and the Status of Meaning'. The excerpted sections below may provide a good introduction to some of the ways in which the discipline has been affected both by developments in other areas and by anxieties about

what were *rumoured* to be developments elswhere which might impact upon art historical practice. To read the fuller text is to gain some familiarity with the (often abrupt and surprising) changes taking place in the academic discipline of art history in the Anglo-American world in the latter years of the twentieth century.[8]

By contrast, the Damisch essay is succinct and seems more straightforward, yet tantalizingly brief. The polemical battles mostly seem offstage, and the issues raised are articulated with a broader brush and from a deeper historical perspective. While it explicitly regrets the post-World War II provinciality and parochialism of the art historical discipline as an abdication of its former close engagement with important intellectual issues (for Damisch, that meant Panofsky, Riegl, Wölfflin, and others of their generation), its rhetorical aim was to serve as a catalyst for disciplinary change by reconnecting contemporary practice to its own intellectual history.[9]

Erwin Panofsky's essay 'Iconography and Iconology' was originally published in 1939 as the introduction to the book *Studies in Iconology: Humanistic Themes in the Art of the Renaissance*.[10] It was a revision of an essay published in German in 1932, the year before Panofsky migrated from Germany to the USA, and was first delivered as a lecture in Philadelphia.[11] Prior to his departure, Panofsky was one of a group of scholars (including his collaborator, Fritz Saxl, and Ernst Cassirer) who in the 1920s were part of the intellectual circle around Aby Warburg.

Panofsky was concerned above all with the meaning, subject-matter, or content of works of art, in reaction to what he and his associates in the early decades of the twentieth century perceived to be too great a preoccupation with the formal qualities of objects (for example, in their eyes, the 'formalist' work of Wölfflin and Riegl). He viewed the relationships between form and meaning as complex and multilayered, and the essay reprinted here is a good illustration of an art historical attempt to deal with issues of signification prior to the later and more explicit engagement by the discipline with semiological problems shared by other areas of research.

Panofsky's aim was to render less impressionistic and naturalistic, and thus also considerably more complex, the *processes* of signification; the procedures he hypothesized that we undergo in attributing meaningfulness to objects. Meaning is layered because our knowledge of the world is itself the result of processes of apprehension that unfold over time. Even if that time factor is minute or near-instantaneous, the steps to understanding correspond in Panofsky's understanding to different modes or forms of knowledge. Those forms of knowledge, he argued, presuppose historical experience: an understanding of the history of styles; the history of types (the kinds of themes or concepts commonly expressed by objects of certain styles); and the history of

cultural symbols (the kinds of underlying essential tendencies of the human mind expressed by the themes or concepts that are themselves commonly expressed by certain forms and styles).

Panofsky's tripartite system of signification thus established a nested series of meanings, each incorporating or presupposing the other, the apprehension of each calling for specific and distinct kinds of knowledge. These consist of the knowledge of objects (practical experience), knowledge of texts (familiarity with themes and concepts), and a form of knowledge he termed 'synthetic intuition', or the familiarity with the essential tendencies of the human mind as realized within the frameworks of a given culture and society at a particular time. Interpretation at the first or primary level he termed *pre-iconographical* description; the second he termed *iconography* proper; and the deepest level *iconology*.

Panofsky's system of interpretation was in one sense the antithesis of those of Riegl or Wölfflin. Here, there was no such thing as form as such that would be of direct interest to the art historian, virtually everything being assimilated into one or another aspect of subject-matter. It was developed in relationship to certain kinds of art, and was thought at the time of its greatest post-war flourishing in the 1950s and 1960s to have its most significant effect in the analysis of European figurative art, particularly medieval and Renaissance painting with religious and political subject-matter. In that respect, iconographic analysis was a method for correlating visual imagery with other (principally textual) cultural information that would be pertinent to the proper reading of traditional imagery.

It was also seen by some—because of its generality and seemingly neutral technical nature—to provide a useful methodological framework for the analysis of certain forms of non-European figurative art as well. Taken out of the specific role-related position it occupied relative to other levels of analysis, 'iconography' came after World War II to be a generic term for the study of visual subject-matter, guided by an assumption that every image contains a certain amount of hidden or 'symbolic' matter which may be elicited by a close reading of the image and some knowledge of the referential context of the work.

In its loosest and most watered-down sense, the term has come to refer to meaning or reference generally. It is also commonly used in art historical teaching in contrast to more strictly 'formal' or descriptive analysis of a work, and fuller 'contextual' analyses (including 'social-historical' analysis), both of which are also articulated as 'stages' in the analysis of an object: analysis presumably reaching a degree of closure or completion with an interlinked account of these different 'levels' of analysis.

Such usages would have been foreign to Panofsky, for whom the levels of signification were not distinct categories of meaning, but

rather organically interrelated facets of a work. The reification of different levels which became common as Panofsky's 'methodology' came to be standard academic doctrine (principally in the USA) transforms Panofsky's insights into precisely the Hegelian form-content idealism which his work sought to oppose.

It used to be said that few apart from Panofsky could employ his analytic methodology so brilliantly and to its full richness and complexity in a non-static, processual manner. It is perhaps more correct to say that generations of students and scholars influenced directly and indirectly by Panofsky and his teaching have in some cases successfully transformed his system into mechanically repeated academic dogma while in other cases they have extended both the letter and spirit of his work in new directions. In any event, among the latter has been a renewed interest in Panofsky's work and in his career on both sides of the Atlantic, and a number of studies during the 1970s and 1980s sought to explicitly link his iconographic theories with those of art historical and visual semiology both at the time of his writings in the 1930s and subsequent to his death.[12]

The two essays included here both contribute to that work, and provide references to related studies. The first of these is Panofsky's 1936 essay '*Et in Arcadia Ego*: Poussin and the Elegiac Tradition',[13] and is presented here as illustrating to brilliant effect Panofsky's own practice of iconographical analysis. It is juxtaposed with an equally brilliant virtuoso piece of semiotic analysis of the same painting by Poussin, published four decades later by the late Louis Marin (1931–92), 'Toward a Theory of Reading in the Visual Arts: Poussin's *The Arcadian Shepherds*'.[14]

If Panofsky's very close reading of the painting opens the imagery out to the textual world in relation to which this remarkable seventeenth-century painting was made and seen, the Marin essay connects the work both with that world and with fundamental problems of signification and reception: questions involving perception, representation, and the psychoanalytic and topological processes attendant upon subjects confronting themselves reading objects that engage the reader's gaze in astonishingly complex ways. The Panofsky analysis makes it clear that the meaning of the work is a complex function of its position in a field of cultural production, while Marin's makes it clear that the act of 'reading' objects in such a field is not only no simple matter of direct apprehension, but that it is something that goes to the heart of the essential construction both of subjects and object-worlds. In one sense, Marin accomplishes what Panofsky might have recognized as a form of thoroughgoing 'iconological' analysis of the work, albeit one informed by a more explicit engagement with semiological and psychoanalytic traditions of analysis and interpretation.

Taken together, the two readings highlight aspects of a major shift that took place in art historical studies between World War II and the late 1960s, and which some have associated with fundamental changes in the perception of modernity itself. This is the subject of the next chapter.

For art historians, the most useful texts on semiology in general would include: (1) Winfried Noeth, *Handbook of Semiotics* (Bloomington, Ind., 1990), the best survey of many different facets of the field, with an extensive discussion of various approaches to visual semiotics (pp. 421–80) and the most comprehensive bibliography in print; (2) Goeran Harry Sonesson, *Pictorial Concepts* (1989), published by the University of Lund Press for that university's Institute of Art History (the most complete historical survey of the semiology of the visual arts); and (3) Fernande Saint-Martin, *Semiotics of Visual Language* (Bloomington, Ind., 1990), a useful introductory survey.

Semiotics and Iconography

The title given, as a cover, to these few, too brief remarks on the scope and implications of a possible semiotic approach to artistic practices is, with its false simplicity, *suspect*, like all titles of this double-entry type ('art and revolution', 'civilization and technology', etc.) where two uncertainly defined terms are coordinated in the service of a demonstration, usually of an ideological nature. For this conjunction can, according to circumstances, denote union just as much as opposition (semiotics as allied to iconography or, conversely, as its opponent?), adjunction as much as exclusion (semiotics *and* iconography, semiotics *or* iconography), and even dependence (iconography as the servant of semiotics, or conversely as its 'blueprint', in the sense that, as for Saussure, linguistics was to be the 'blueprint' of all semiology). But this conjunction takes on a still more equivocal function, in so far as it may appear to balance the two terms against each other, while at the same time introducing an element of doubt. To question the status of iconographic studies (of iconography, in Panofsky's definition, as 'a method applicable to the history of art') in their connexion with a semiotics of the visual arts considered as possible means, in fact, to question the very validity of semiotics' attempts at analysing the products of Art (if not their application to the history of Art itself), and above all to question their novelty, and originality [35].

By the same token a first justification is found for the covering title, delineating as it does the boundaries assigned to the text and imposing its own regimen upon it. And even if it is to reset the whole stake of the semiotic and iconographical work, at least it should ensure, from the start, freedom from the imperialism as well as the dogmatism and a-priorism which all too often characterize semiotic discourse. For it might seem that in the field of the visual arts iconography has already achieved, if perhaps on too empirical a plane, a large part of the analytical work which semiotics, for its part, obstinately puts off undertaking. Does this mean that in this respect semiotics (like, according to Panofsky, iconology before it) is no more than a word, a new label for an already ancient practice?

Certainly, the moment that it recognizes the existence of a meaning, if not a denotation, in artistic images, and undertakes, for instance,

to identify figures from their attributes, or to establish the repertory of motives, symbols, themes, etc., characteristic of the art of an epoch, iconography seems to justify the introduction into art studies of a problematics of the sign, while imposing the idea that an image is not intended solely for perception and contemplation, but demands a real effort of reading, even of interpretation. When, moreover, having designated the figures (having, as the old textbooks say, 'declared' them), it then sees them as the protagonists of scenes, or, as Alberti puts it, 'Stories', which are themselves identifiable and recognizable as such, it may seem to open the way for an analysis of a semiotic kind, of the syntactic, and even the narrative structures of the image. But semiotics, in so far as its object is taken as the 'life of signs' and the functioning of signifying systems, establishes itself on another level. Whereas iconography attempts essentially to state what the images *represent*, to 'declare' their meaning (if we accept Wittgenstein's assertion of the equivalence between the meaning of an image and what it represents), semiotics, on the contrary, is intent on stripping down the mechanism of signifying, on bringing to light the mainsprings of the signifying process, of which the work of art is, at the same time, the locus and the possible outcome. In view of the almost artisanal modesty of its declared intent, could iconography, having once been the servant of the history of Art, become the servant of semiotics, providing it with part of its raw material, while semiotics in return would reinforce it with its

35

Parte Prima. Dissegno, ? sixteenth century.

own theoretical apparatus and enable it to widen its scope, to elaborate its aims?

We are in fact a long way from any such division of labour, since iconography persists in serving exclusively a history of Art which—now that the great period of Riegl, Dvorak, Wölfflin and others is past, and excepting a few prestigious but isolated enterprises (such as that of Meyer Schapiro, virtually unique of its kind nowadays)—has shown itself to be totally incapable of renovating its method, and above all of taking any account of the potential contribution from the most advanced lines of research in linguistics, psychoanalysis and, *a fortiori*, semiotics, not to mention Marxism, which has entered this field only in its most caricatural form. Nor does this resistance point merely to the epistemological abdication of an intellectual discipline which, in its day, was one of the best-attested sources of the Formalist movement, and thereby of the semiotic venture itself. Even at its best, it answers the perfectly legitimate concern to assert the specificity of artistic, and principally plastic phenomena, and to preserve their study from any contamination by verbal models, whether linguistic or psychoanalytic, since the characteristic articulation and import of the work of art are assumed to be irreducible to the order and dimension of discourse.

It is a paradox that, while making iconography a privileged weapon in its methodological arsenal, art history has never ceased in practice—and this quite innocently—to adhere to the logocentric model which it claimed to be denouncing, at the very moment when, for their part, linguistics and the philosophy of language were beginning to take notice of the image, which Saussure and Wittgenstein were about to set at the operative core of sign and proposition: Saussure, by defining the sign as a two-faced entity consisting of an 'acoustic-image' associated to a concept, itself represented by a drawing; Wittgenstein, by establishing the image, in its 'logical form', the form it has in common with reality, to the principle of language and proposition. In so far as iconography concerns itself primarily with the 'signified' in images, and reduces the plastic 'signifier' to a question of treatment, a connotation of 'style', it must necessarily be led to confuse meaning and—at any rate verbal—denotation. Of course, what the image *signifies* cannot be in any way reduced to what it gives us to *see*: on any supposedly natural meaning, corresponding to a strictly iconic level of articulation, to the image as it addresses itself to perception, there is often superposed (in accordance with the theory of levels of reading and interpretation developed by Panofsky) a conventional, if not arbitrary meaning (the figure of a naked woman with her head wreathed in clouds will be read as the sign of 'Beauty'). The important point is that on both levels, if the image lends itself to a reading, and eventually to an interpretation, it is only to the extent that the elements—figures and/or signs—of which it is made up allow themselves to be identified and indicated: the

reading necessarily proceeding according to a declarative order in which each element comes up in turn to be named.

Of course iconography, at least in its most sophisticated form, can in no way be reduced to a mere nomenclature: but even at this elementary level, it already implies a reference to pre-existing knowledge, which predates the reading, and has been elaborated externally to it. And this knowledge is not merely 'anthropological', as Roland Barthes would say, inscribed at the deepest level in each of the individuals sharing one culture, and allowing them to recognize immediately in a given configuration of lines or dots the image of a house, a tree, an apple or a horse; on the contrary, it is a knowledge which is 'cultivated', elaborated, linked, in the final analysis, to the textual order. In most cases of doubt a textual reference will carry the day by providing a 'key' which allows the image to be interpreted. But the same is true at the level of the 'subject', of the 'story', a level where iconography mostly applies Poussin's precept literally: 'Read both the story *and* the picture to know whether each thing is appropriate to the subject.' In parentheses, one could note that such a precept bears testimony that the metaphor of reading, as applied to the works of art, was introduced long before semiotics emerged as a specific discipline, implicit as it was from the beginning in the practice of iconography. To read both the story and the picture certainly does not mean envisaging the picture as a text, and even less citing painting before the jurisdiction of the text, as semiotics, in its most elaborate form, attempts to do. It means introducing into the analysis of the picture the authority of the text from which the picture is supposed to derive its arrangement through a kind of figurative and/or symbolical *application*, in which each pictorial element corresponds to a linguistic term. This is an important distinction, and one with epistemological implications. The iconographic method, iconography as a method, is theoretically founded on the postulate that the artistic image (and indeed any relevant image) achieves a signifying articulation only within and because of the textual reference which passes through and eventually imprints itself in it.

If this is the case, we must admit that any iconographic reading of the image is, as it were, appended to the verbal chain (text or discourse) which 'declares' its figures. But it is precisely this complicity between the method as such and the logocentric model—an inborn, although never explicit, never theorized, complicity—which explains why iconography can nowadays try to some extent to appear not only as part of a semiotics of art (still to be formally established), but also as a 'blueprint' for it, as the model whose pattern and articulations should be copied by any similar enterprise. The essential fact (but also the one most difficult to elaborate into a theory) is the degree to which the idealistic conception of the image implied in the iconographic approach as defined above is indissolubly bound up with a representat-

ive structure whose limits, historical as well as geographical, have now been recognized. Such a structure, from the moment it claims to base its effects demonstratively on the repetition of the experimental conditions of vision, seems indeed to imply a purely *denoted* level, referable immediately to external reality.

This claim to a truth value, if not a reality value (what Frege, precisely, means by *denotation*), which was one of the mainsprings of the 'break' that occurred in the visual arts at the beginning of the fifteenth century, is clearly illustrated in a famous painting by Rogier van der Weyden, 'St. Luke painting the Virgin' (Boston Museum of Fine Arts); whereas a Byzantine (or perhaps medieval) icon reproduced a 'prototype', a pre-existing image, which acted as its referent, the modern painter is not afraid of showing the making of the prototype itself, placing its creator, and his model as well, in the position of what is denoted. The Virgin (and, as in a mirror, the painter himself, a latter-day St. Luke) is installed in contemporary costume in front of a window framing a familiar landscape, Alberti's 'window' in fact, and the painting assimilated to an aperture in the wall, opening on to the outside; in this way it is 'reiterated' within the painting itself, according to the schema of double inscription which governs the representative system (any representation, as Peirce says, being a representation of a representation). The schema calls for a further elaboration, as soon as a more acute observation reveals that the painter ('St. Luke') is not *painting* the Virgin but *drawing* her, that he is making a sketch from nature with a pencil, the operation introducing one more relay in the representative circuit, as well as alluding to the function devoted, in such a circuit, to drawing and to the process of intra-semiotic translation.

A painting of this type requires not so much a reading as an interpretation (the one roughly outlined here, or some other). But if the process of interpretation can thus short-circuit the reading process, if the interpretation does not assume an antecedent theoretical constitution and articulation of the pictural text, this is because no trace of the creative apparatus which produced the image as such can be found in the picture; it cannot be too much emphasized that this creative apparatus, in the case of Rogier van der Weyden's painting, cannot even be hypothetically reduced to some 'perspectivist' model (that of the 'camera obscura', the principle of which the photographic camera was to reproduce), for while defining it one must equally take into account the actual process of coloured 'reproduction', and of illusionist texture linked to the 'discovery' of painting with oils (whose position in the system corresponds to the one assigned, in the circuit of photographic registration, to the sensitized plate or film).

If iconography operates from a privileged position within the system of representation, which it goes so far as to take literally, it does so

precisely to the extent that this system introduces a decisive split between a denotative plane presented as 'natural' and the network of symbolic, even stylistic connotations which can be grafted on to it. But by the same token it takes its place within the historical limits of the iconological venture as Cesare Ripa, in the 'Proemio' of his *Iconology* (1593), had already defined it. This 'iconology'—the first responding to this name—insisted on dealing solely, to the exclusion of all others, with such images as were meant to *signify* something different from what they offered to *view* (like the image of 'Beauty'), that is the very definition which Panofsky was to adopt—without referring to Ripa and without distinguishing between the different types of images—to characterize the second of the levels of meaning which he recognizes in the work of art, the strictly iconographical level where the image is invested with a conventional meaning which may be at any distance from the primary, 'natural' meaning. The fact remains that Ripa's text went much further towards an iconology, a science of images, than any of the 'iconographies' which have flourished since its time, in as much as he was the first and only one of his kind able to enunciate the programme and conditions both of a logic of images (*ragionamenti d'imagini*) and of a discourse of meaning applicable to images, while marking quite sharply, if not quite clearly, the distinction between the register of *formare* and that of *dichiarare*, as well as that between the strictly iconic constitution of the image and its logical articulation, between its description and its explanation. The 'iconological operator' puts into work a logic of concatenation which paves the way for an analysis of the image as a visual definition, articulated in metaphorical and allegorical terms.

The image conceived in the mode of definition: such a formula may sound extravagant (how can it be conceived, Peirce was to ask, that something like an iconic proposition can exist?); it nevertheless fits in, in spite of its assumed naivety, with the attempt to set up a semiotics of art totally conditioned by the category of the sign, and by the hypothesis of the axiomatic interdependence of image and concept, such as was already clear in Saussure's schema of the operation of translation, characterized by acoustic and conceptual images switching positions.

The iconographic project is thus linked in its principle to a representational structure which implies the erasing of the externality of the signifier, and, first of all, the obliteration of the actual substance of expression, as long as the signified seems to be directly attainable, before any attention is to be paid to the figurative system. It is consequently easy to see the value of all those attempts made at breaking down the naturalist prejudices which cling to images conceived in the illusionist mode. In this way, in the field opened by Panofsky's *Perspective as Symbolic Form*, the now classical study of B. A. Uspenskij on ancient Russian icons sets about demonstrating the existence of a primary level

of articulation of the painted image corresponding to the phonological level in natural language: that is the level of figuration corresponding to the most general processes (non-significant in themselves?), which allow the painter to represent relations of time and space and on which are superimposed semantic (figurative), grammatical (ideographic), even idiomatic (symbolic) levels.

Of course, such a cleavage is still modelled after the linguistic 'blueprint'. But the very idea that different systems of organization for one and the same figurative material might exist, or even coexist (one recalls that Buffon meant by 'figuration' a specific mode of the organization of matter, characteristic of minerals, as 'vegetation' is of plants and 'life' of animals), this idea cannot have any theoretical consequences until the split, constitutive of the representative system, between the (figurative) level of denotation and the (symbolic) levels of connotation has been questioned. The image is always seen, whatever its constitution as image, as the prop, the vehicle for any and every signified injected into it from outside, and research still obeys a model of signifying, of communication, which leads to a radical distinction between that aspect of the image which belongs to the order of perception, and that which has properly semiotic dimensions.

Iconography has its roots deeply entrenched in the metaphysics of the sign. But where the old Platonic theory, which assimilated the relation between the image and its signified to that between body and soul—the perceptible body of the image being supposed to awaken in the spectator a wish, a *desire* to know its soul (i.e. its meaning)—did at least pose the problem of the articulation of the visible and the legible, iconography no longer heeds the sensible body of the image. Phenomenology comes to its aid, with its notion of the 'neutralization', if not the 'neantization' of the material element of the image, as does a strictly logocentric linguistics, according to which the sound as such does not belong to the realm of *langue*, whose system takes its cue from the acoustic, the verbal *image*. Although less metaphorical than the platonic theory, Freud's notion of *regression* also registers the question of the relation between visual and verbalized thought within the dependence of desire: the (dream) image is not the mirrored double, the perceptible manifestation of thought as constituted in the element of language; it is both the locus and the product of an activity which allows impulses originating in the unconscious, and which have been refused all possibility of verbalization, to find expression through figurative means and to move at ease (in Freud's own terms) on a stage *other* than that of language.

It so happens, remarkably, that the most subtle research engendered by the iconographic method cuts across, up to a point, Freud's schemata. Panofsky has refuted a too-narrow notion of iconography, intended as an auxiliary discipline, a purely classificatory one, which

would provide the historian with a first localisation in space and time of the works he has to deal with. Moreover, at a more elaborate level, he has been led to go much beyond a strictly lexical approach. His work on symbolism in Flemish painting and on the figurative procedures used by the Van Eycks to represent, through purely visual means, abstract notions and relations (such as the opposition of 'before' and 'after', of the old and the new Law, etc., as indicated by the juxtaposition within a single painting of architectural elements of the Romanesque and Gothic styles) belongs, in a formal sense, in the line of Freud's analysis of the dream-work and the acceptance of figurability (*Darstellbarkeit*). A decisive encounter, yet insufficient to break the circle of icon and sign as it has been drawn by a centuries old tradition which has passed through great crises (fits of iconoclasm) without really being shaken. Peirce, once again, in his last writings, was to introduce, together with the distinction between icon and *hypoicon*, the idea that the icon is not necessarily a sign, that it does not necessarily follow the triadic order of representation, and that inside that order itself there is something not to be accounted for in terms of this relation. (Peirce even goes so far as to mention the 'immediate, characteristic flavour' of a tragedy such as *King Lear*: but what about a painting like Titian's 'Sacred and profane love' or Picasso's 'Demoiselles d'Avignon'?) The images of art might primarily be *hypoicons*: an idea which is hard to grasp, just as it is hard to *see* not only the visual products of alien cultures, but also those of the very few artists of our time who, from Cézanne to Mondriaan, from Matisse to Rothko and Barnett Newman, seem to carry out their work *on the near side* of the figure if not against it, *on the near side* of the sign, if not against it.

The Impressionists had already brought to the fore the question of coloured articulation instead of figurative denotation, thus forcing the spectator to read traditional works of art in this new light, in order to recognize in them everything that, in the icon itself, eludes the order of the sign in the strict sense of the word (on this point, I cannot do better than refer the reader back to Schapiro's essay on 'Field and Vehicle in Image-signs').[1] Like possibly the Byzantine or the Chinese image, the modern image imposes a different concept of 'signification', of meaning and of its 'cuisine' (Barthes' term), and consequently a different notion of *taste* in the most profound sense of that word, irreducible to the norms of communication (except in so far as it would be possible to determine what factors in the notion of information itself belong with a theory of form, or even with the formless). This, rather than the logocentric starting-point which a humanist history of Art refuses to give up, is the area in which a semiotics of art, whose very existence depends on its being comparative, might have a chance to develop.

Mieke Bal and Norman Bryson 1991

Semiotics and Art History: A Discussion of Context and Senders

The basic tenet of semiotics, the theory of sign and sign-use, is anti-realist. Human culture is made up of signs, each of which stands for something other than itself, and the people inhabiting culture busy themselves making sense of those signs. The core of semiotic theory is the definition of the factors involved in this permanent process of sign-making and interpreting and the development of conceptual tools that help us to grasp that process as it goes on in various arenas of cultural activity. Art is one such arena, and it seems obvious that semiotics has something to contribute to the study of art.[1]

From one point of view, it can be said that the semiotic perspective has long been present in art history: the work of Riegl and Panofsky can be shown to be congenial to the basic tenets of Peirce and Saussure,[2] and key texts of Meyer Schapiro deal directly with issues in visual semiotics.[3] But in the past two decades, semiotics has been engaged with a range of problems very different from those it began with, and the contemporary encounter between semiotics and art history involves new and distinct areas of debate: the polysemy of meaning; the problematics of authorship, context, and reception; the implications of the study of narrative for the study of images; the issue of sexual difference in relation to verbal and visual signs; and the claims to truth of interpretation. In all these areas, semiotics challenges the positivist view of knowledge, and it is this challenge that undoubtedly presents the most difficulties to the traditional practices of art history as a discipline.

Because of the theoretical skepticism of semiotics, the relationship between contemporary semiotics and art history is bound to be a delicate one. The debate between the critical rationalists and the members of the Frankfurt school, earlier on in this century, may have convinced most scholars of the need for a healthy dose of doubt in their claims to truth; nevertheless, much 'applied science' —in other words, scholarship that, like art history, exists as a specialized discipline—seems to be reluctant to give up the hope of reaching positive knowledge. Whereas epistemology and the philosophy of science have developed sophisticated views of knowledge and truth in which there is little if any room for unambiguous 'facts,' causality, and proof, and in which interpreta-

tion has an acknowledged central position, art history seems hard pressed to renounce its positivistic basis, as if it feared to lose its scholarly status altogether in the bargain.[4]

Although art history as a whole cannot but be affected by the skepticism that has radically changed the discipline of history itself in the wake of the 'linguistic turn,' two fields within art history are particularly tenacious in their positivistic pursuit: the authentication of œuvres—for example, those of Rembrandt, van Gogh, and Hals, to name just a few recently and hotly debated cases—and social history.[5] As for the former, the number of decisions that have an interpretive rather than a positive basis—mainly issues of style—have surprised the researchers themselves, and it is no wonder, therefore, that their conclusions remain open to debate.[6] In section 2 ('Senders') we will pursue this question further. But, one might object, this interpretive status concerns cases where positive knowledge of the circumstances of the making of an artwork is lacking, not because such knowledge is by definition unattainable. Attempts to approach the images of an age through an examination of the social and historical conditions out of which they emerged, in the endeavor of social history, are not affected by that lack.

The problem, here, lies in the term 'context' itself. Precisely because it has the root 'text' while its prefix distinguishes it from the latter, 'context' seems comfortably out of reach of the pervasive need for interpretation that affects all texts. Yet this is an illusion. As Jonathan Culler has argued,

But the notion of context frequently oversimplifies rather than enriches the discussion, since the opposition between an act and its context seems to presume that the context is given and determines the meaning of the act. We know, of course, that things are not so simple: context is not given but produced; what belongs to a context is determined by interpretive strategies; contexts are just as much in need of elucidation as events; and the meaning of a context is determined by events. Yet whenever we use the term *context* we slip back into the simple model it proposes.[7]

Context, in other words, is a text itself, and it thus consists of signs that require interpretation. What we take to be positive knowledge is the product of interpretive choices. The art historian is always present in the construction she or he produces.[8]

In order to endorse the consequences of this insight, Culler proposes to speak not of context but of 'framing': 'Since the phenomena criticism deals with are signs, forms with socially constituted meanings, one might try to think not of context but of the framing of signs: how are signs constituted (framed) by various discursive practices, institutional arrangements, systems of value, semiotic mechanisms?'[9]

This proposal does not mean to abandon the examination of 'context' altogether, but to do justice to the interpretive status of the insights thus gained. Not only is this more truthful; it also advances the search for social history itself. For by examining the social factors that frame the signs, it is possible to analyze simultaneously the practices of the past and our own interaction with them, an interaction that is otherwise in danger of passing unnoticed. What art historians are bound to examine, whether they like it or not, is the work as effect and affect, not only as a neatly remote product of an age long gone. The problem of context, central in modern art history, will be examined further from a semiotic perspective in section 1 here, and the particular problem of the reception of images, and of the original viewer, will come up in section 3 ('Receivers'), and again in section 8 ('History and the Status of Meaning').

In this article, we intend to conduct two inquiries simultaneously. On the one hand, we will examine how semiotics challenges some fundamental tenets and practices of art history. Although this is intrinsic to the article as a whole, it will receive greater emphasis in the first three sections. On the other hand and perhaps more important for many, we will demonstrate how semiotics can further the analyses that art historians pursue (this point will be central to sections 6 and 7). The parallel presentation of a critique and a useful set of tools conveys our view that art history is in need of, but also can afford, impulses from other directions. Since semiotics is fundamentally a transdisciplinary theory, it helps to avoid the bias of privileging language that so often accompanies attempts to make disciplines interact. In other words, rather than a linguistic turn, we will propose a semiotic turn for art history. Moreover, as the following sections will demonstrate, semiotics has been developed within many different fields, some of which are more relevant to art history than others. Our selection of topics is based on the expected fruitfulness for art history of particular developments, rather than on an attempt to be comprehensive, which would be futile and unpersuasive. This article does not present a survey of semiotic theory for an audience of art historians. For such an endeavor we refer the reader to Fernande Saint-Martin's recent study.[10] Some of the specialized semioticians (e.g., Greimas, Sebeok) might see an intolerable distortion in our presentation. However, some of the theorists discussed here, like Derrida or Goodman, might not identify themselves as semioticians, nor might some of the art historians whose work we will put forward as examples of semiotic questioning of art and art history. In order to make this presentation more directly and widely useful, we have opted to treat semiotics as a perspective, raising a set of questions around and within the methodological concerns of art history itself.

The first three sections deal centrally with the semiotic critique of

'context' as a term in art-historical discussion. From questions of context we move to the origins and history of semiotics, the ways in which these tools and critical perspectives have grown out of initial theoretical projects. The limits of space force us to consider just two early figures: Charles Sanders Peirce, the American philosopher (section 4), and the Swiss linguist Ferdinand de Saussure (section 5). In section 6 we present a semiotic view of psychoanalysis, demonstrating a variety of ways that psychoanalysis is bound up with semiotics and can be useful for art history, and then going on to discuss the most relevant concept, central in art history, that of the gaze. Psychoanalysis connects semiotics with an awareness of gender differentiation as pervasively relevant, indeed, as a crucial basis for the heterogeneous and polysemous nature of looking. Feminist cultural analysis has been quick to see the relevance of semiotic tools for its own goals. We wish to acknowledge that efficacy and we would have liked to demonstrate the inevitable 'feminist turn' in semiotic theory itself by presenting the intersections between feminism's theorizing of gender, semiotics, and art history. But lack of space combined with the risk of overlap with an earlier survey article on feminism and art history published in this journal forced us, regretfully, to relegate feminism to the margins.[11] Following the presentation of a psychoanalytically oriented semiotics, we go on to show the interpretive and descriptive, but also critical, value of a semiotically based narrative theory or narratology for the study of images—images that frequently have a narrative side that is not necessarily literary in background (section 7, 'Narratology'). Instead of rehearsing the view of history painting as basically illustrative of old stories, a view that privileges language over visual representation, we demonstrate the specifically visual ways of story-telling that semiotics enables one to consider. Section 8 offers a few reflections on the status of meaning in relation to the historical considerations so important for art history.

One further question concerns the relation between the disciplines. Interdisciplinary research poses specific problems of methodology, which have to do with the status of the objects and the applicability of concepts designed to account for objects with a different status. Thus a concept mainly discussed in literary theory—for example, metaphor—is relevant to the analysis of visual art, and refusing to use it amounts to an unwarranted decision to take all images as literal expressions. But such use requires a thinking-through of the status of signs and meaning in visual art—for example, of the delimitation of discrete signs in a medium that is supposed to be given over to density.[12] Rather than borrowing the concept of metaphor from literary theory, then, an art historian will take it out of its unwarranted confinement within that specific discipline and first examine the extent to which metaphor, as a phenomenon of transfer of meaning from one sign onto another,

should be generalized. This is the case here, but not all concepts from literature lend themselves to such generalization. Rhythm and rhyme, for example, although often used apropos visual images, are more medium-specific and their use for images is therefore more obviously metaphorical.

Semiotics offers a theory and a set of analytic tools that are not bound to a particular object domain. Thus it liberates the analyst from the problem that transferring concepts from one discipline into another entails. Recent attempts to connect verbal and visual arts, for example, tend to suffer from unreflected transfers, or they painstakingly translate the concepts of the one discipline into the other, inevitably importing a hierarchy between them. Semiotics, by virtue of its supradisciplinary status, can be brought to bear on objects pertaining to any sign-system. That semiotics has been primarily developed in conjunction with literary texts is perhaps largely a historical accident, whose consequences, while not unimportant, can be bracketed.[13] As a supradisciplinary theory, semiotics lends itself to interdisciplinary analyses, for example, of word and image relations, which seek to avoid both the erection of hierarchies and the eclectic transferring of concepts.[14] But the use of semiotics is not limited to interdisciplinarity. Its multidisciplinary reach—as journals like *Semiotica* demonstrate, it can be used in a variety of disciplines—has made semiotics an appropriate tool for monodisciplinary analysis as well. Considering images as signs, semiotics sheds a particular light on them, focusing on the production of meaning in society, but it is by no means necessary to semiotic analysis to exceed the domain of visual images.

1. Context

One area in which the semiotic perspective may be of particular service to art history is in the discussion of 'context'[15]—as in the phrase 'art in context.' Since semiotics, following the structuralist phase of its evolution, has examined the conceptual relations between 'text' and 'context' in detail, in order to ascertain the fundamental dynamics of socially operated signs, it is a field in which analysis of 'context' as an idea may be particularly acute. Many aspects of that discussion have a direct bearing on 'context' as a key term in art-historical discourse and method.[16]

When a particular work of art is placed 'in context,' it is usually the case that a body of material is assembled and juxtaposed with the work in question in the hope that such contextual material will reveal the determinants that make the work of art what it is. Perhaps the first observation on this procedure, from a semiotic point of view, is a cautionary one: that it cannot be taken for granted that the evidence that makes up 'context' is going to be any simpler or more legible than the visual text upon which such evidence is to operate. Our observation

is directed in the first place against any assumption of opposition, or asymmetry, between 'context' and 'text', against the notion that here lies the work of art (the text), and over there is the context, ready to act upon the text to order its uncertainties, to transfer to the text its own certainties and determination. For it cannot be assumed that 'context' has the status of a given or of a simple or natural ground upon which to base interpretation. The idea of 'context,' posited as platform or foundation, invites us to step back from the uncertainties of text. But once this step is taken, it is by no means clear why it may not be taken again; that is, 'context' implies from its first moment a potential regression 'without brakes.'

Semiotics, at a particular moment in its evolution, was obliged to confront this problem head-on, and how it did so has in important ways shaped the history of its own development. We will discuss later the different conceptions of semiosis in Saussure and in the work of post-Saussureans such as Derrida and Lacan. Suffice it to say, for now, that in its 'structuralist' era semiotics frequently operated on the assumption that the meanings of signs were determined by sets of internal oppositions and differences mapped out within a static system. In order to discover the meanings of the words in a particular language, for example, the interpreter turned to the global set of rules (the *langue*) simultaneously governing the language as whole, outside and away from actual utterances (*parole*). The crucial move was to invoke and isolate the synchronic system, putting its diachronic aspects to one side. What was sought, in a word, was structure. The critique launched against this theoretical immobility of sign systems pointed out that a fundamental component of sign systems had been deleted from the structuralist approach, namely the system's aspects of ongoing semiosis, of dynamism. The changeover from theorizing semiosis as the product of static and immobile systems, to thinking of semiosis as unfolding in time is indeed one of the points at which structuralist semiotics gave way to post-structuralism. Derrida, in particular, insisted that the meaning of any particular sign could not be located in a signified fixed by the internal operations of a synchronic system; rather, meaning arose exactly from the movement from one sign or signifier to the next, in a *perpetuum mobile* where there could be found neither a starting point for semiosis, nor a concluding moment in which semiosis terminated and the meanings of signs fully 'arrived.'[17]

From this perspective, 'context' appears to have strong resemblances to the Saussurean signified, at least in those forms of contextual analysis that posit context as the firm ground upon which to anchor commentaries on works of art. Against such a notion, post-structuralist semiotics argues that 'context' is in fact unable to arrest the fundamental mobility of semiosis for the reason that it harbors exactly the same principle of interminability within itself. Culler provides a

readily understood example of such nonterminability in his discussion of evidence in the courtroom.[18] The context in a legal dispute is not a given of the case, but something that lawyers make, and thereby make their case; and the nature of evidence is such that there is always more of it, subject only to the external limits of the lawyers' own stamina, the court's patience, and the client's means. Art historians, too, confront this problem on a daily basis. Suppose that, in attempting to describe the contextual determinants that made a particular work of art the way it is, the art historian proposes a certain number of factors that together constitute its context. Yet it is always conceivable that this number could be added to, that the context can be augmented. Certainly there will be a cut-off point, determined by such factors as the reader's patience, the conventions followed by the community of art-historical interpreters, the constraints of publishing budgets, the cost of paper, etc. But these constraints will operate from an essentially external position with regard to the enumeration of contextual aspects. Each new factor that is added will, it may be hoped, help to bolster the description of context, making it more rounded and complete. But what is also revealed by such supplementation is exactly the uncurtailability of the list, the impossibility of its closure. 'Context' can always be extended; it is subject to the same process of mobility that is at work in the semiosis of the text or artwork that 'context' is supposed to delimit and control.

To avoid misunderstanding, one should remark that while the consideration that contexts may be indefinitely extended makes it impossible to establish 'context' in the form of a totality—a compendium of all the circumstances that constitute a 'given' context—semiotics does not in fact follow what may appear to be a consequence of this, that the concept of determination should somehow be given up. On the contrary, it is only the goal of totalizing contexts that is being questioned here, together with the accompanying tendency toward making a necessarily partial and incomplete formulation of context stand for the totality of contexts, by synecdoche. Certainly the aim of identifying the total context has at times featured prominently in linguistics (among other places). Austin's remark concerning speech act theory is a case in point: 'The total speech act in the total speech situation is the *only actual* phenomenon which, in the last resort, we are engaged in elucidating.'[19] Semiotics' objection to such an enterprise focuses primarily on the idea of mastering a totality that is implicit here, together with the notion that such a totality is 'actual,' that is, that it can be known as a present experience. However, this by no means entails an abandoning of 'context' and 'determination' as working concepts of analysis. Rather, semiotics would argue that two principles must operate here simultaneously: 'No meaning can be determined out of context, but no context permits saturation.'[20] Though the two principles may not sit easily together or interact in a classical or topologically

familiar fashion, context as determinant is very much to the fore in semiotic analyses, and particularly those that are *post*structuralist.

As semioticians have tried to work through the complexities of the text/context distinction, they have developed a further caveat, concerning the stroke or bar (/) between the terms 'text' and 'context.' That mark of separation presupposes that one can, in fact, separate the two, that they are truly *independent* terms. Yet there are many situations within art-historical discourse that, if we consider them in detail, may make it difficult to be sure that such independence can easily be assumed. The relation between 'context' and 'text' (or 'artwork') that these terms often take for granted is that history stands prior to artifact; that context generates, produces, gives rise to text, in the same way that a cause gives rise to an effect. But it is sometimes the case that the sequence (from context to text) is actually inferred from its endpoint, leading to the kind of metalepsis that Nietzsche called 'chronological reversal.'[21] 'Suppose one feels a pain. This causes one to look for a cause and spying, perhaps, a pin, one links and reverses the perceptual or phenomenal order, *pain ... pin*, to produce a causal sequence, *pin ... pain*.'[22] In this case, the pin as cause is located after the effect it has on us has been produced. Does one find comparable instances of such metalepsis or 'chronological reversal' in art-historical analysis?

The answer may well be yes. Imagine a contemporary account of, say, mid-Victorian painting, one that aims to reconstruct the context for the paintings in terms of social and cultural history. The works themselves depict such social sites as racetracks, pubs, railway stations and train compartments, street scenes where well-to-do ladies pass by workmen digging the road, interiors in which domestic melodramas are played out, the stock exchange, the veterans' hospital, the church, the asylum. It would not be thought unusual for the art historian to work from the paintings out toward the history of these sites and milieux, in order to discover their historical specificity and determination, their detailed archival texture. Just this sort of inquiry is what, perhaps, the word 'context' asks for; such reconstruction would be fitting and, one might say, *indicated* by the nature of the visual materials to hand.

But there are senses in which the procedure is still strange, despite its aura of familiarity. A primary difficulty is that those features of mid-Victorian Britain missing from mid-Victorian painting are rarely featured as part of the context that accounts for the works of art. A social history that set out, unassisted by pictures, to discover the social and historical conditions of mid-Victorian Britain might well attend to quite other milieux, different social sites, and indeed many other kinds of historical objects that do not readily lend themselves to pictorial representation. A harder social analysis might treat the pictures incidentally, in passing, as one sort of evidence among many. If one is going to study social history, why privilege works of art in such a way

that the findings of historiography must be bound to the *mise-en-scène* of painting?

There are a number of observations that might be made at this point: for example, concerning the relations between art history and social history as disciplines both intertwined and impelled by different kinds of momentum, or concerning the role played by synecdoche in the rhetoric of art-historical discourses.[23] The point that concerns us here, though, is that in the example chosen, the pictures have in some sense *predicted* the form of the historian's portrayal, that the work of art history is 'anticipated by the structure of the objects it labors to illuminate.'[24] If that is so, then the 'context' in which the work of art is placed is in fact being generated out of the work itself, by means of a rhetorical operation, a reversal, a metalepsis, that nonetheless purports to regard the work as having been produced by its context and not as producing it. Moreover, in a further rhetorical maneuver, the work of art is now able to act as evidence that the context that is produced for it is the right one; the reversal can be made to produce a 'verification effect' (the contextual account must be true: the paintings prove it).

In cases of this kind, elements of visual text migrate from text to context and back, but recognition of such circulation is prevented by the primary cut of text-stroke-context. The operation of the stroke consists in the creation of what, for semiotics, is a fantasmatic cleavage between text and context, followed by an equally uncanny drawing together of the two sides that had been separated. The stroke dividing 'text' from 'context' is the fundamental move here, which semiotic analysis would criticize as a rhetorical operation.[25] From one point of view, as Derrida has argued, this cut is precisely the operation that establishes the aesthetic as a specific order of discourse. From another point of view, the cut (text/context) is what creates a discourse of art-historical explanation; it is because the blade can so cleanly separate the two edges, of text and context, that one seems to be dealing with an order of explanation at all, with explanation on one side and *explanandum* on the other. To set up this separation of text from context, then, is a fundamental rhetorical move of self-construction in art history.

Semiotic inquiry has a further reservation about procedures of this kind; since it is concerned with the functioning of signs, it is particularly sensitive to the fact that in our example (a contextual account of mid-Victorian painting) the status of the paintings as works of the sign has in fact largely been effaced. This need not happen with all contextualizing accounts—and our example is, of course, only an imaginary case. What the example depends on is the idea of a number of contextual factors converging on the work (or works) of art. The factors proposed may be many; they may belong to all sorts of domains; but they all finally arrive *at* the artwork, conceived as singular and as the terminus of all the various causal lines or chains. The question to be

answered was, 'what factors made the work of art what it is?' And in order to answer such a question, it is appropriate and inevitable that some narrative of convergence will be produced. The question casts itself in just this convergent form: n number of factors, all leading toward and into their final point of destination, the work of art in question.

What semiotics would query here is the idea, the shape, of convergence. Certainly the model is appropriate if the object of the inquiry is assumed to be singular, complete in itself, autotelic. All the clues point toward the one outcome, as in a work of detection. But the problem that is overlooked here is that insofar as works of art are works of the sign, their structure is not in fact singular, but iterative.[26] Singular events occur at only one point in space and time: the guest at the country house party was murdered in the library; the Magna Carta was written in 1215; the painting was autographed and framed. But signs are by definition repeatable. They enter into a plurality of contexts; works of art are constituted by different viewers in different ways at different times and places. The production of signs entails a fundamental split between the enunciation and the enunciated: not only between the person, the subject of enunciation, and what is enunciated; but between the circumstances of enunciation and what is enunciated, which can never coincide.[27] Once launched into the world, the work of art is subject to all of the vicissitudes of reception; as a work involving the sign, it encounters from the beginning the ineradicable fact of semiotic play. The idea of convergence, of causal chains moving toward the work of art should, in the perspective of semiotics, be supplemented by another shape: that of lines of signification opening out from the work of art, in the permanent diffraction of reception.

It may be that scholars in certain other disciplines are more at ease than art historians with the possibility of a work of art that constitutively changes with different conditions of reception, as different viewers and generations of viewers bring to bear upon the artwork the discourses, visual and verbal, that construct their spectatorship. Admittedly, the openness of such a text or work of art can and has been appropriated and used in the name of a number of ideological exercises: the rehabilitation of the concept of the canon in literary criticism is one (the open text turning out to coincide with the shelf of master-works, the rest remaining ephemeral and merely *lisible*); the cult of the reader as hedonistic consumer is another (a consumer who never reflects on the preconditions of consumption). But obviously the plurality attributed so selectively to the 'classic' text (whether visual or verbal) is not excessive because it is a masterpiece. Rather the opposite: the openness of the classic is the result of that fundamental lack it shares with all texts, master-works or not. It is the consequence of the fact that the text or artwork cannot exist outside the circumstances in

which the reader reads the text or the viewer views the image, and that the work of art cannot fix in advance the outcome of any of its encounters with contextual plurality. The idea of 'context' as that which will, in a legislative sense, determine the contours of the work in question is therefore different from the idea of 'context' that semiotics proposes: what the latter points to is, on the one hand, the unarrestable mobility of the signifier, and on the other, the construction of the work of art within always specific contexts of viewing.

When 'context' is located in a clearly demarcated moment in the past, it becomes possible to overlook 'context' as the contextuality of the present, the current functioning of art-historical discourses. Such an outcome is something that semiotics is particularly concerned to question. It hardly needs remarking that the referent of 'context' is (at least) dual: the context of the production of works of art and the context of their commentary. Semiotics, despite frequent misunderstandings of precisely this point (and especially of semiotic 'play'), is averse neither to the idea of history nor to the idea of historical determination. It argues that meanings are always determined in specific sites in a historical and material world. Even though factors of determination necessarily elude the logic of totality, 'determination' is recognized and indeed insisted upon. Similarly, in recommending that the present context be included within the analysis of 'context,' semiotics does not work to avoid the concept of historicity; rather, its reservations concern forms of historiography that would present themselves in an exclusively aoristic or constative mode, eliding the determinations of historiography as a performative discourse active in the present. The same historiographic scruple that requires us to draw a distinguishing line between 'us' and the historical 'them'—in order to see how they are different from us—should, in the semiotic view, by the same token urge us to see how 'we' are different from 'them' and to use 'context' not as a legislative idea but as a means that helps 'us' to locate ourselves instead of bracketing out our own positionalities from the accounts we make.

2. Senders

'Context,' then, turns out to be something very different from a given of art-historical analysis. But no less problematic is the status of the concept of 'artist'—painter, photographer, sculptor, and so forth. (To avoid some of the connotational baggage that comes with the label 'artist,' we use here the more neutral word 'author.')[28] It might seem at first that the idea of the author of a work of art is, again, a natural term in the order of explanation, and one that is now much more substantial and tangible than 'context.' As the idea of context is probed and tested, various disturbing vistas open up—regressions, *mises-en-abyme*,[29] multiple or folded temporalities—but 'author' seems much more stable. We may not be able in the end to point to a context, since in so many

ways the context-idea involves lability and shifting grounds; but the author of a work of art is surely someone we can indeed point to, a living (or once living), flesh-and-blood personage with a palpable presence in the world, as solid and undeniable as any individual bearing a proper name, as reliably there as you or me.

Yet, as Foucault points out,[30] the relation between an individual and his or her proper name is quite different from the relation that obtains between a proper name and the function of authorship. The name of an individual (as they say in Britain, J. Bloggs)[31] is a designation, not a description; it is arbitrary in the sense that it does not assign any particular characteristics to its bearer. But the name of an author (a painter, a sculptor, a photographer, etc.) oscillates between designation and description: when we speak of Homer, we do not designate a particular individual; we refer to the author of the *Iliad* or the *Odyssey*, of the body of texts performed by the rhapsodes at the Panathenaic Festivals, or we intend a whole range of qualities, 'Homeric' qualities that can be applied to any number of cases (epics, epithets, heroes, types of diction, of poetic rhythm—the list is open-ended). 'J. Bloggs' is in the world, but an 'author' is in the works, in a body of artifacts and in the complex operations performed on them. Like 'context,' 'authorship' is an elaborate work of framing, something we elaborately produce rather than something we simply find.

Some of the processes of this enframement can be seen at work in the strategies of attribution.[32] Perhaps the first procedure in attribution is to secure clear evidence of the material traces of the author in the work, metonymic contiguities that move in a series from the author in the world, the flesh-and-blood J. Bloggs, into the artifact in question. The traces may be directly autographic—evidence of a particular hand at work in the artifact's shaping. Or they may be more indirect— perhaps documents pertaining to the work, or the physical traces of a milieu (as when an artifact is assigned to the category 'Athenian, circa 700 B.C.'). At this level, the most 'scientific' stage of attribution, all sorts of technologies may provide assistance: X-rays, spectroscopic analysis, cryptography. What is assumed is that the category of authorship will be decided on the basis of material evidence, and what 'author' names here is the work's physical origin. The techniques employed are essentially the same as those that would be used by a detective[33] to establish whether J. Bloggs is guilty or innocent (whether the artwork is authentic or fake); and to this extent there is nothing as yet peculiar to art-historical discourse about the construction of authorship: the techniques are part of a general science of forensics. But attribution in art history involves further operations that lead away from science and technology into subtler, and more ideologically motivated, considerations concerning quality and stylistic standardization. Before, the 'author' referred to a physical agent in the world, but now it refers to

the putative creative subject. In the drastic changeover from scientific procedures built on measurement and experimental knowledge to the highly subjective and volatile appraisals of quality and stylistic uniformity, one already sees how multifarious are the principles that 'authorship' brings into play. Not only are the principles diverse, which would make 'authorship' an aggregated or multilayered concept, but they are also contradictory—though the essentially unificatory drive of the concept of authorship as a whole will work to mask this, and to conceal the joins between conflicting elements from view.

If a certain measure of arbitrariness is already evident in the principles of quality and of stylistic standardization, a further and quite different range of the arbitrary is found in the procedures for 'setting limits' to what counts within authorship. J. Bloggs, under the forensic principle, is the origin of all the physical traces that point to Bloggs's presence in the world, every one of them, however minute; forensics can consider all possible evidence, even the most unpromising. But 'authorship' is an exclusionary concept. On one side, it works to circumscribe the artistic corpus, and on the other it works to circumscribe the archive. If the author were the physical agent J. Bloggs, we should have to count among Bloggs's authorized works every doodle, every jotted diagram, that Bloggs left in the world. Similarly, in defining the archive for Bloggs, we would have to admit into it the traces of every circumstance that Bloggs encountered in his life. As a concept, 'authorship' turns out after all to entail the same regressions and *mises-en-abyme* involved in 'context.' And as it operates in practice, 'authorship' manages these receding vistas through many variations on the theme of nonadmission.

Excluded from 'authorship' are whole genres, and the decisions regarding such genres are historically variable to a degree. In our own time, graphic art occupies a mysteriously fluctuating zone between authorship (many graphics in magazines bear signatures) and anonymity (many others do not). Photography is similarly divided, with sometimes an expectation of authorship (for example, when photographs appear in museums, where authorship operations are essential), and sometimes not (many photographs in daily newspapers). Among the forces that patrol these borders are those deriving from the economic matrix, since 'authorship' in the modern sense has historically developed *pari passu* with the institution of property. Here the concept becomes a legal and monetary operation, closely bound up with the history of copyright law. And the forces must also include the protocols of writing and the rules governing what is to count as a correct mode of narration. For instance, a catalogue raisonné would be breaking those rules if it wandered into the realm of an author's doodles and napkin sketches, just as a biography of the author would be breaking them if it widened the aperture of relevance to the proportions of a *Tristram*

Shandy. That such deviant narratives are rarely encountered is proof of the efficiency of the 'authorship' operation, which is designed to prevent such aberrations. By a rule of correct narration or 'emplotment,' only those aspects of an author's innumerable wanderings through the world that may be harmonized with the corpus of works will count as relevant, and only a certain number of an author's traces will count as elements of the authorized corpus. The exclusionary moves are mutually supportive, and 'correct' narration will set up further conventions, which vary from period to period, from Vasari to the present,[34] concerning exactly how much latitude may be permitted in describing the perimeters.

Authorship, then, is no more a natural ground of explanation than is context. To paraphrase Jonathan Culler, authorship is not given but produced; what counts as authorship is determined by interpretive strategies;[35] and in the disparities among the plural forces that determine authorship are seen lines of fissure that put in question the very unity that the concept seeks, contradictions that the concept must (and does) work hard to overcome. Consider the following:

(B) physical agency

(A) property 'author' (C) creative subject

(D) narration

Interdependent, these are various pressures that take different forms in different sites: in museums and auction houses, for example, (A) and (B) assume more centrality, and are subject to more exacting differentiation, than in departments of art history, where (C) and (D) may be more pressing than questions of monetary value or of forensics. In art history, modes of narration are of capital importance. And according to the view of many writers, from Barthes to Preziosi, the whole purpose of art-historical narration is to merge the authorized corpus and its producer into a single entity, the totalized narrative of the-man-and-his-work, in which the rhetorical figure *author=corpus* governs the narration down to its finest details.

What these writers find unacceptable is that such narratives are saturated with a romantic mythology of the full creative subject. Barthes writes: 'The author is never more than the instance writing, just as *I* is nothing other than the instance saying *I*... We know now that a text is not a line of words releasing a single "theological" meaning (the "message" of the Author-God) but a multidimensional space in which a variety of writings, none of them original, blend and clash.'[36] Preziosi writes:

The disciplinary apparatus works to validate a metaphysical recuperation of Being and a unity of intention or Voice. At base, this is a theophanic regime,

manufactured in the same workshops that once crafted paradigms of the world as Artifact of a divine Artificer, all of whose Works reveal ... a set of traces oriented upon a(n immaterial) center. In an equivalent fashion, all the works of the artist canonized in this regime reveal traces of (that is, are signifiers with respect to) a homogeneous Selfhood that are proper(ty) to him.[37]

The concept of 'author' brings together a series of related unities that, though assumed as given, are precisely the products and goals of its discursive operations. First is the unity of the Work. Second is the unity of the Life. Third, out of the myriad of accidents and contingent circumstances, and the plurality of roles and subject positions that an individual occupies, the discourse of authorship constructs a coherent and unitary Subject. Fourth is the doubly reinforced unity that comes from the superimposition of Work upon Life upon Subject in the narrative genre of the life-and-work; for in that genre, everything the Subject experiences or makes will be found to signify his or her subjecthood. The mythology of this Subject is not only theophanic, it is also—as Griselda Pollock and others have shown—sexist: In a male-dominated art history 'Women were not historically significant artists ... because they did not have the innate nugget of genius (the phallus) which is the natural property of men.'[38]

There can be little doubt that the discursive operations of authorship have been appropriated by ideologies with a heavy investment in the kind of Subject described here. In art history, and particularly through the formula of the monograph, the narrative genre of the man-and-his-work has exercised a hold over writing that is perhaps unparalleled in the humanities. To the extent that this has been the case, the author-function has enjoyed a hegemonic influence within the discipline, naturalizing a whole series of ideological constructs (among them, genius, genius as masculine, the subject as unitary, masculinity as unitary, the artwork as expressive, the authentic work as most valuable). But however much one may recognize the forcefulness of the critique of the author/Subject, it may now be just as critical to realize the strategic limitations operating upon it. […]

'Et in Arcadia Ego': Poussin and the Elegiac Tradition

[…] Poussin had come to Rome in 1624 or 1625, one or two years after Guercino had left it. And a few years later (presumably about 1630) he produced the earlier of his two *Et in Arcadia ego* compositions, now in the Devonshire Collection at Chatsworth. Being a Classicist (though in a very special sense), and probably conversant with Virgil, Poussin revised Guercino's composition by adding the Arcadian river god Alpheus and by transforming the decaying masonry into a classical sarcophagus inscribed with the *Et in Arcadia ego*; moreover, he emphasized the amorous implications of the Arcadian milieu by the addition of a shepherdess to Guercino's two shepherds. But in spite of these improvements, Poussin's picture does not conceal its derivation from Guercino's. In the first place, it retains to some extent the element of drama and surprise: the shepherds approach as a group from the left and are unexpectedly stopped by the tomb. In the second place, there is still the actual skull, placed upon the sarcophagus above the word *Arcadia*, though it has become quite small and inconspicuous and fails to attract the attention of the shepherds who—a telling symptom of Poussin's intellectualistic inclinations—seem to be more intensely fascinated by the inscription than they are shocked by the death's-head. In the third place, the picture still conveys, though far less obtrusively than Guercino's, a moral or admonitory message. It formed, originally, the counterpart of a *Midas Washing His Face in the River Pactolus* (now in the Metropolitan Museum at New York), the iconographically essential figure of the river god Pactolus accounting for the inclusion of its counterpart, the less necessary river god Alpheus, in the Arcadia picture.[1]

In conjunction, the two compositions thus teach a twofold lesson, one warning against a mad desire for riches at the expense of the more real values of life, the other against a thoughtless enjoyment of pleasures soon to be ended. The phrase *Et in Arcadia ego* can still be understood to be voiced by Death personified, and can still be translated as 'Even in Arcady I, Death, hold sway,' without being out of harmony with what is visible in the painting itself.

After another five or six years, however, Poussin produced a second and final version of the *Et in Arcadia ego* theme, the famous picture in

the Louvre. And in this painting—no longer a *memento mori* in classical garb paired with a *cave avaritiam* in classical garb, but standing by itself—we can observe a radical break with the mediaeval, moralizing tradition. The element of drama and surprise has disappeared. Instead of two or three Arcadians approaching from the left in a group, we have four, symmetrically arranged on either side of a sepulchral monument. Instead of being checked in their progress by an unexpected and terrifying phenomenon, they are absorbed in calm discussion and pensive contemplation. One of the shepherds kneels on the ground as though rereading the inscription for himself. The second seems to discuss it with a lovely girl who thinks about it in a quiet, thoughtful attitude. The third seems trajected into a sympathetic, brooding melancholy. The form of the tomb is simplified into a plain rectangular block, no longer foreshortened but placed parallel to the picture plane, and the death's-head is eliminated altogether.

Here, then, we have a basic change in interpretation. The Arcadians are not so much warned of an implacable future as they are immersed in mellow meditation on a beautiful past. They seem to think less of themselves than of the human being buried in the tomb—a human being that once enjoyed the pleasures which they now enjoy, and whose monument 'bids them remember their end' only in so far as it evokes the memory of one who had been what they are. In short, Poussin's Louvre picture no longer shows a dramatic encounter with Death but a contemplative absorption in the idea of mortality. We are confronted with a change from thinly veiled moralism to undisguised elegiac sentiment.

This general change in content—brought about by all those individual changes in form and motifs that have been mentioned, and too basic to be accounted for by Poussin's normal habit of stabilizing and in some measure tranquillizing the second version of an earlier picture dealing with the same subject[2]—can be explained by a variety of reasons. It is consistent with the more relaxed and less fearful spirit of a period that had triumphantly emerged from the spasms of the Counter-Reformation. It is in harmony with the principles of Classicist art theory, which rejected 'les objets bizarres,' especially such gruesome objects as a death's-head.[3] And it was facilitated, if not caused, by Poussin's familiarity with Arcadian literature, already evident in the Chatsworth picture, where the substitution of a classical sarcophagus for Guercino's shapeless piece of masonry may well have been suggested by the tomb of Daphnis in Virgil's Fifth *Eclogue*. But the reverent and melancholy mood of the Louvre picture, and even a detail such as the simple, rectangular shape of the tomb, would seem to reveal a fresh contact with Sannazaro. His description of the 'Tomb in Arcadia'—characteristically no longer enclosing the reluctant shepherd Daphnis but a no less reluctant shepherdess named Phyllis—

actually foreshadows the situation visualized in Poussin's later composition:

> farò fra questi rustici
> La sepoltura tua famosa e celebre.
> Et da monti Thoscani et da' Ligustici
> Verran pastori ad venerar questo angulo
> Sol per cagion che alcuna volta fustici.
> Et leggeran nel bel sasso quadrangulo
> Il titol che ad tutt'hore il cor m'infrigida,
> Per cui tanto dolor nel petto strangulo:
> 'Quella che ad Meliseo si altera et rigida
> Si mostrò sempre, hor mansueta et humile
> Si sta sepolta in questa pietra frigida.'[4]

I will make thy tomb famous and renowned among these rustic folk. Shepherds shall come from the hills of Tuscany and Liguria to worship this corner of the world solely because thou hast dwelt here once. And they shall read on the beautiful square monument the inscription that chills my heart at all hours, that makes me strangle so much sorrow in my breast: 'She who always showed herself so haughty and rigid to Meliseo now lies entombed, meek and humble, in this cold stone.'

These verses not only anticipate the simple, rectangular shape of the tomb in Poussin's Louvre picture which strikes us as a direct illustration of Sannazaro's *bel sasso quadrangulo*; they also conform in an amazing degree to the picture's strange, ambiguous mood—to that hushed brooding over the silent message of a former fellow being: 'I, too, lived in Arcady where you now live; I, too, enjoyed the pleasures which you now enjoy; I, too, was hardhearted where I should have been compassionate. And now I am dead and buried.' In thus paraphrasing, according to Sannazaro, the meaning of the *Et in Arcadia ego* as it appears in Poussin's Louvre painting, I have done what nearly all the Continental interpreters did: I have distorted the original meaning of the inscription in order to adapt it to the new appearance and content of the picture. For there is no doubt that this inscription, translated correctly, no longer harmonizes with what we see with our eyes.

When read according to the rules of Latin grammar ('Even in Arcady, there am I'), the phrase had been consistent and easily intelligible as long as the words could be attributed to a death's-head and as long as the shepherds were suddenly and frighteningly interrupted in their walk. This is manifestly true of Guercino's painting, where the death's-head is the most prominent feature of the composition and where its psychological impact is not as yet weakened by the competition of a beautiful sarcophagus or tomb. But it is also true, if in a considerably lesser degree, of Poussin's earlier picture, where the skull, though smaller and already subordinated to the newly introduced sarcophagus, is still in evidence, and where the idea of sudden inter-

ruption is retained.

When facing the Louvre painting, however, the beholder finds it difficult to accept the inscription in its literal, grammatically correct, significance. In the absence of a death's-head, the *ego* in the phrase *Et in Arcadia ego* must now be taken to refer to the tomb itself. And though a 'speaking tomb' was not unheard of in the funerary poetry of the time, this conceit was so unusual that Michelangelo, who used it in three of his fifty epitaphs on a handsome boy, thought it necessary to enlighten the reader by an explanatory remark to the effect that here it is, exceptionally, 'the tomb which addresses him who reads these verses.'[5] It is infinitely more natural to ascribe the words, not to the tomb but to the person buried therein. Such is the case with ninety-nine per cent of all epitaphs, including the inscriptions of the tomb of Daphnis in Virgil and the tomb of Phyllis in Sannazaro; and Poussin's Louvre picture suggests this familiar interpretation—which, as it were, projects the message of the Latin phrase from the present into the past—all the more forcibly as the behavior of the figures no longer expresses surprise and dismay but quiet, reminiscent meditation.

Thus Poussin himself, while making no verbal change in the inscription, invites, almost compels, the beholder to mistranslate it by relating the *ego* to a dead person instead of to the tomb, by connecting the *et* with *ego* instead of with *Arcadia*, and by supplying the missing verb in the form of a *vixi* or *fui* instead of a *sum*. The development of his pictorial vision had outgrown the significance of the literary formula, and we may say that those who, under the impact of the Louvre picture, decided to render the phrase *Et in Arcadia ego* as 'I, too, lived in Arcady,' rather than as 'Even in Arcady, there am I,' did violence to Latin grammar but justice to the new meaning of Poussin's composition.

This *felix culpa* can, in fact, be shown to have been committed in Poussin's own circle. His friend and first biographer, Giovanni Pietro Bellori, had given, in 1672, a perfectly correct and exact interpretation of the inscription when he wrote: '*Et in Arcadia ego*, cioè, che *il sepolcro si trova ancora* in Arcadia, e la Morte a luogo in mezzo le felicità'[6] ('*Et in Arcadia ego*, which means that the *grave is to be found* [present tense!] *even* in Arcady and that death occurs in the very midst of delight'). But only a few years later (1685) Poussin's second biographer, André Félibien, also acquainted with him, took the first and decisive step on the road to bad Latinity and good artistic analysis: 'Par cette inscription,' he says, 'on a voulu marquer que *celui qui est dans cette sépoulture a vécu* en Arcadie et que la mort se rencontre parmi les plus grandes félicitez'[7] ('This inscription emphasizes the fact that the *person buried in this tomb has lived* [past tense!] in Arcady'). Here, then, we have the occupant of the tomb substituted for the tomb itself, and the whole phrase projected into the past: what had been a menace has become a

remembrance. From then on the development proceeded to its logical conclusion. Félibien had not bothered about the *et*; he had simply left it out, and this abbreviated version, quaintly retranslated into Latin, survives in the inscription of a picture by Richard Wilson, painted at Rome in 1755: 'Ego fui in Arcadia.' Some thirty years after Félibien (1719), the Abbé du Bos rendered the *et* by an adverbial 'cependant': 'Je vivais cependant en Arcadie,'[8] which is in English: 'And yet I lived in Arcady.' The final touch, it seems, was put by the great Diderot, who, in 1758, firmly attached the *et* to the *ego* and rendered it by *aussi:* 'Je vivais aussi dans la délicieuse Arcadie,'[9] 'I, too, lived in delightful Arcady.' His translation must thus be considered as the literary source of all the later variations now in use, down to Jacques Delille, Johann Georg Jacobi, Goethe, Schiller, and Mrs. Felicia Hemans.[10]

Thus, while—as we have seen—the original meaning of *Et in Arcadia ego* precariously survived in the British Isles, the general development outside England resulted in the nearly universal acceptance of what may be called the elegiac interpretation ushered in by Poussin's Louvre picture. And in Poussin's own homeland, France, the humanistic tradition had so much decayed in the nineteenth century that Gustave Flaubert, the great contemporary of the early Impressionists, no longer understood the famous phrase at all. In his beautiful description of the Bois de la Garenne—'parc très beau malgré ces beautés factices'—he mentions, together with a Temple of Vesta, a Temple of Friendship, and a great number of artificial ruins: 'sur une pierre taillée en forme de tombe, *In Arcardia ego*, non-sens dont je n'ai pu découvrir l'intention,'[11] 'on a stone cut in the shape of a tomb one reads *In Arcadia ego*, a piece of nonsense the meaning of which I have been unable to discover.'

We can easily see that the new conception of the Tomb in Arcady initiated by Poussin's Louvre picture, and sanctioned by the mistranslation of its inscription, could lead to reflections of almost opposite nature, depressing and melancholy on the one hand, comforting and assuaging on the other; and, more often than not, to a truly 'Romantic' fusion of both. In Richard Wilson's painting, just mentioned, the shepherds and the funerary monument—here a slightly mutilated *stele*—are reduced to a *staffage* accentuating the muted serenity of the Roman Campagna at sundown. In Johann Georg Jacobi's *Winterreise* of 1769—containing what seems to be the earliest 'Tomb in Arcady' in German literature—we read: 'Whenever, in a beautiful landscape, I encounter a tomb with the inscription *Auch ich war in Arkadien*, I point it out to my friends; we stop a moment, press each other's hands, and proceed.'[12] And in a strangely attractive engraving by a German Romanticist named Carl Wilhelm Kolbe, who had a trick of constructing wondrous jungles and forests by magnifying grass, herbs or cabbage leaves to the size of bushes and trees, the tomb

and its inscription (here, correctly, *Et in Arcadia ego* although the legend of the engraving consists of the erroneous 'Auch ich war in Arkadien') serve only to emphasize the gentle absorption of two lovers in one another. In Goethe's use of the phrase *Et in Arcadia ego*, finally, the idea of death has been entirely eliminated.[13] He uses it, in an abbreviated version ('Auch ich in Arkadien') as a motto for his famous account of his blissful journey to Italy, so that it merely means: 'I, too, was in the land of joy and beauty.'

Fragonard, on the other hand, retained the idea of death; but he reversed the original moral. He depicted two cupids, probably spirits of departed lovers, clasped in an embrace within a broken sarcophagus while other, smaller cupids flutter about and a friendly genius illumines the scene with the light of a nuptial torch. Here the development has run full cycle. To Guercino's 'Even in Arcady, there is death' Fragonard's drawing replies: 'Even in death, there may be Arcady.'

Toward a Theory of Reading in the Visual Arts: Poussin's 'The Arcadian Shepherds'

The Reading Process: *Deixis* and Representation

The first problem we are able to raise about historical painting in general is one that we may articulate as the 'negation-structure' of enunciation in pictorial representations.[1] The problem is of the utmost importance, for it defines, by its very terms, the viewer-reader's position in front of the painting, the process of reading or the reception of the visual message emitted by the painter.

A possible approach to the problem resulting from the transference of the linguistic model of communication to painting is the study of the deictic structure of painting. Every linguistic utterance occurs in a determined spatio-temporal situation. It is produced by a person, the speaker (or sender) and addressed to another person (the hearer) who receives it. The *deixis* of an utterance is constituted by the orientational traits of language, traits related to the time and the situation where the utterance takes place. In language, these traits are personal pronouns, whose meaning is defined by reference to the deictic coordinates of the typical situation where the utterance is emitted, as well as adverbs of time and place. Moreover, we must notice that the typical situation of emission is egocentric, every linguistic exchange implying automatically the shift of the center of the deictic system when emission passes from one interlocutor to the other. Finally, we may add that the deictic system expands to include demonstrative pronouns, verb tenses, and ultimately frames the whole linguistic process. This should hardly be surprising, since a situation of communication implies that the linguistic system is actualized in a specific place and time, a place and a time that deictics refer to and whose structure is inscribed in the utterance.

Now, if the characteristic of the 'historical' enunciative modality is that events narrate themselves in the story as if nobody were speaking, this means that the whole deictic network has to be erased in the narrative message. Is it possible to point out in Poussin's *Arcadian Shepherds* [36], say in its narrative content, the 'negation' of iconic deictics? Does such a question make sense in the iconic domain? My

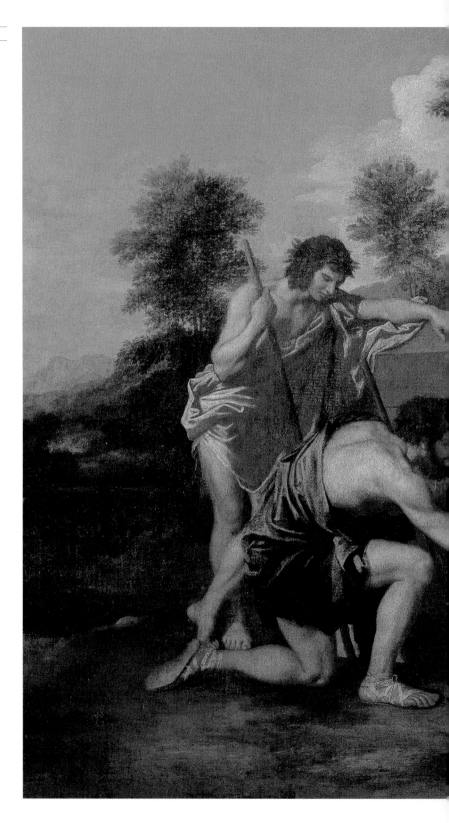

36 Nicolas Poussin
The Arcadian Shepherds, oil
on canvas, 1638–9

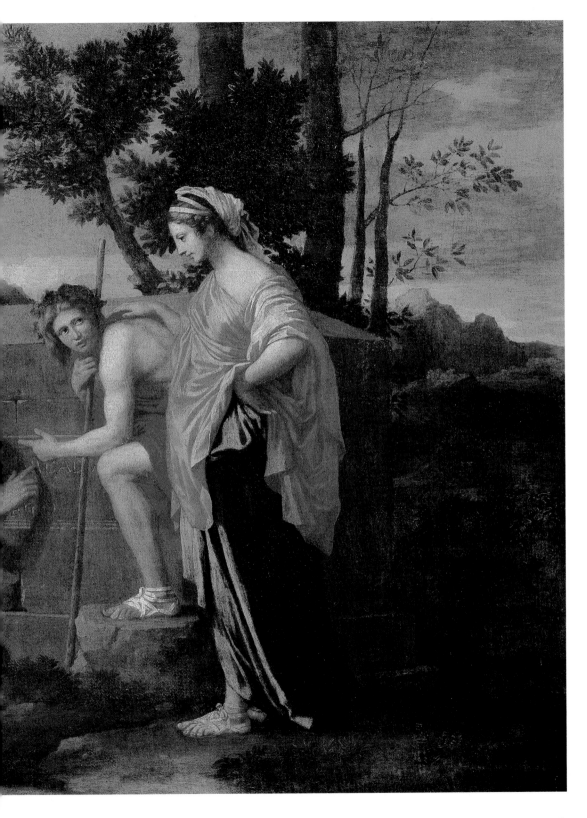

hypothesis is the following: except for the very existence of the painting and the fact that we are looking at it, nothing in the iconic message marks its situation of emission and reception; that is to say, no figure is looking at us as viewers, nobody addresses us as a representative of the sender of the message. As viewers-readers we just catch the figures performing their narrative functions. Apparently they do not need us in order to narrate themselves. We are only the distant spectators of a story, separated from it by a 'spectacular' distance that is the insuperable distance of the painter-narrator from the story he narrates. A comparison with portrait painting may illuminate the point. It has been observed that a full-face portrait functions like the 'I–You' relation which characterizes the discursive enunciation, but with an interesting difference that I shall only mention here: the sitter of the portrait appears only to be the *represented* enunciative 'ego,' who nonetheless defines the viewer's position as a 'Tu' he addresses. The sitter portrayed in the painting is the representative of enunciation in the utterance, its inscription on the canvas screen, as if the sitter here and now were speaking by looking at the viewer: 'Looking at me, you look at me looking at you. Here and now, from the painting locus, I posit you as the viewer of the painting.' In a word, the typical situation of reception is equivalent to the typical situation of emission, through the 'representation-representative' who plays the role of a shifting operator of the center of the deictic system.

What is remarkable is that we find in Alberti's *Della Pittura* a clear articulation of the problem we have just raised, in the figure he called the 'commentator.' Sometimes, Alberti explains, it would make a historical painting more emotionally effective to introduce in the 'istoria' a character who, by his gestures and emotional expression, points out the important part of the story to the viewer at whom he looks, and thus establishes a link between the scene represented and the viewer.[2] The fact that in Poussin's painting nobody is looking at us allows us to state, according to our hypothesis, that the represented scene operates in its propositional content the 'negation' of all marks of emission and reception of the narrative message.

The Reading Process: The Syntax of Visibility and Its Self-Representation

I would like to go a little further and rephrase in a more formal way, on a syntactic level one might say, the problem of iconic *deixis* (its system, properly speaking) as it works in classical representation. What corresponds here to the equivalence between painter and viewer that we find in the particular example of the full-face portrait? As in the case of the historical locus for the shifting operator in Alberti's 'commentator,' the equivalence between painter and viewer, eye and vision (to use Lacan's terms)[3] was structurally established, within the representational sys-

tem historically determined as the optico-geometrical network of the Renaissance, by a kind of experimental device built by Brunelleschi; this device, an optical box whose description is given by Brunelleschi's biographer Manetti, may be used in our analysis as a paradigmatic model pointing out the elements of the problem we have just raised. Brunelleschi pictured the church of San Giovanni and its surroundings directly in front of him on a small panel about half a *braccio* square.

He assumed that it had to be seen from a single point which is fixed in reference to the height and the width of the picture, and that it had to be seen from the right distance. Seen from any other point, the effect of the perspective would be destroyed. Thus, to prevent the spectator from falling into error in choosing his viewpoint, Filippo (Brunelleschi) made a hole in the picture at that point in the view of the church of San Giovanni which is directly opposite to the eye of the spectator who might be standing in the central portal of S. Maria dei Fiori in order to paint the scene. This hole was as small as a lentil on the painted side, and on the back of the panel it opened out in a conical form to the size of a ducat or a little more, like the crown of a woman's straw hat. Filippo had the beholder put his eye against the reverse side where the hole was large and while he shaded his eye with his one hand, with the other he was told to hold a flat mirror on the far side in such a way that the painting was reflected in it. The distance from the mirror to the hand near the eye had to be in a given proportion to the distance between the point where Filippo stood in painting his picture and the church of San Giovanni. When one looked at it thus, the perspective of the piazza and the fixing of that point of vision made the scene absolutely real.[4]

Brunelleschi's optical box established the equivalence between the eye of the spectator and the vision of the painter—the reception point and the emission point—through the identification of the viewpoint and the vanishing point actually operating in the panel, and its reflection in the mirror the spectator holds in front of it. In other words, the mirror in which the viewer's eye looks at the reflection of the scene represented on the panel acts as if to endow the painting itself with vision: the painting looks at the viewer-painter like an eye. Brunelleschi's device provides a model or an experimental metaphor of the theory itself. I emphasize the fact that it is only a metaphor: it refers to a specific representational structure among others equally possible. The viewer is posited in the system as a spectator; he is immobilized, caught in the apparatus as a peeping Tom. It is as if what the viewer looked at through the small hole in the panel was the painting's vision, the mirror being the operator of that 'as if.' But this function does not appear as such in Brunelleschi's device, since what the spectator looks at is a scene represented on the panel. He forgets the very fact that he is looking at a picture, he is fascinated by his own 'scopic' desire (or drive).

We may provisionally conclude that the apparatus of iconic repres-

entation constituted by the perspective network is a formal apparatus that integrates the propositional represented contents, the 'discourse' of the painting, according to a theoretically reversible process which constitutes the space represented by the painting. In a less abstract way, we may theoretically consider that in the vanishing point, in its hole, the things represented gradually disappear (reception-process) or that from the viewpoint they gradually appear to be distributed in the represented space (emission-process). And the reversibility which constitutes that space theoretically neutralizes the temporal and successive scanning of the painting by the viewer's eye in a kind of permanent present of representation.

Before coming back once more to Poussin's *Arcadian Shepherds*, I would like to emphasize the paradigm of the specular image in the pictorial representational model since the Renaissance. In this paradigm the painting, a window opened onto the world, functions—in its theoretical and even technical constitution—as a mirror duplicating the world. The actual referent of the picture is present on the canvas as an absence, that is to say as its image, its reflection, its shadow, scientifically built in its perceptual reality (an assumption whose universality can be questioned, as Panofsky has shown in his essay on perspective as a symbolic form).[5] More generally speaking, these are the contradictory axioms of the representational system: (1) the representation screen is a transparent window through which the spectator, Man, contemplates the scene represented on the canvas as if he saw the real scene in the world; (2) but at the same time, that screen—actually a surface and a material support—is also a reflecting device on which the real objects are pictured.

In other words, the canvas as a support and as a surface does not exist. For the first time in painting, Man encounters the real world. But the canvas as a support and as a surface does exist to operate the duplication of reality: the canvas as such is simultaneously posited and neutralized; it has to be technically and ideologically assumed transparent. Invisible and at the same time a necessary condition of visibility, reflecting transparence theoretically defines the representational screen. We find here, in the iconic field, the *same* process we encountered in the Port-Royal reductive analysis of judgment.

A Reading of *The Arcadian Shepherds*
The Three Levels of Analysis
Now we can come back to Poussin's painting, equipped with the models we have just built on various levels of generality, to observe that the relationships which do not appear on the plane of representation—I mean those we analyzed between the painter, the viewer-reader, and the representational screen—are precisely the 'subject' or the '*istoria*' told by the painting: Three figures, one on the left, the two others on

the right, are 'exchanging' gestures and gazes, an exchange that concerns a fourth figure, a man who is kneeling in front of a tomb. Such a dialogue is entirely iconic, since its manifestations (gestures, gazes) are visible either directly (gestures) or indirectly (gazes that are recognizable through the positions of heads and the orientation of eyes). Three figures exchange a message whose referent is what the fourth figure is doing. We may observe, in particular, that the shepherd on the extreme left has nothing in common with the two figures on the right except the fact that he is looking at his kneeling companion. Iconically, he emits the kneeling man as a visual object while the shepherd on the right points to that same man and the woman beside him 'receives' that object by looking at him. At the same time, by his gaze directed at her, the shepherd on the right obviously asks her a question concerning the kneeling man he is pointing to.

We may sum up the scene represented according to the various functions of a communicational exchange as defined by Jakobson: emission—message—reception—reference—code.[6] The shepherd on the left visually emits a message, which the woman on the right receives, while the man on the right refers to the kneeling shepherd, and by his interrogative gaze toward the 'shepherdess,' designates the code: What does it mean? What is he doing?—the kneeling man being the message whose 'code' or meaning is in question. We may represent schematically the iconic dialogue in this way (straight arrows are gestures, dotted arrows, gazes):

A=shepherd on left C=shepherd on right
B=kneeling shepherd D=shepherdess

A few remarks about this analysis, which transposes the Jakobsonian model of communication to the painting not as an explanatory sketch, but as the very subject matter of the story the painting tells us: First, in a sense, the painting is the pictorial representation of that model. Second, the painter and/or the beholder occupy the metaiconic/linguistic position of the linguist who constructs a model about a communication process. Third, the scheme is oriented from A to D for pictorial reasons (the balance and composition of the painting) and nonpictorial ones, following precisely the reading orientation of a written text in our culture, which implies a starting point on the left, an observation that is particularly relevant to our painting since a legible text is carved on the tomb. Four, when D is looking at B, we may interpret her gaze simultaneously as a way of closing the model and as an

enigmatic answer in the dialogue that the figures are involved in. Five, a single figure—C—condenses two functions: C is overdetermined.

The third level of our analysis concerns the 'message.' What is in question on this level is B, the kneeling figure: That shepherd is looking at a written line, pointing at it with his forefinger, reading it or rather trying to read or to decipher it. Moreover he is visually saying the written sentence since the three first words, 'Et in Arcadia,' are inscribed just out of his open mouth in a modern version of the medieval phylactery. So B sees, points at, reads, says a written message whose signification he attempts to grasp. In other words, the figure B clusters all the semantic functions we already recognized represented by the other figures, but now related to the text at the very center of the painting, a text about which we as readers-beholders of the painting may ask, exactly like the kneeling shepherd, Who has written it? What is its meaning? What is the name of 'ego'?

Unfortunately we cannot enter any further into the painting: our vision is stopped by the wall of the tomb. The only thing we can say is this: somebody has carved its opaque and continuous surface, has written a few words on the stone, somebody whose name is *ego*.

Now if we relate the three levels of our analysis to each other, we ascertain two missing terms at the extreme poles of the descriptive sketch: on the first level, the fact that nothing indicates the painter and/or the viewer; on the third one, the fact that nothing in the inscription gives the name of its writer. Two missing terms that, once related to each other, reveal a relationship between the painter-viewer and the writer, the indication of the viewpoint of the whole painting and the name, the signifier of the vanishing point at its center.

However, at the same time, the question concerning a missing term at the 'origin' of the painting and another one at its end allows us to acknowledge another function of the kneeling figure B: for, exactly like us who behold, read, 'speak' the painting, the shepherd beholds, reads, 'speaks' the written text on the tomb.

The Syntax of Legibility: Displacement

What is in question in this painting is finally what is in question in all paintings: What does it mean 'to represent'? How is such a representational process articulated in and by its product, a painting that is a surface and a material support, geometrically defined, limited, and framed, in which the depth of another world is made visible? Here it would be useful to recall the results of our previous analyses:

1. The distinction between semiotics and semantics.
2. The distinction between discourse and story (narrative).
3. The transference of the first distinction to iconic representations:
 a. the legitimate perspective as a metaphor of the formal apparatus of enunciation;

b. the contradictory postulates regarding (the mimetic representation displayed by) the representational screen as a transparent window open onto the world *and* as a mirror reflecting it.

Now my working hypothesis concerning the transference of the distinction between discourse and story to historical or narrative iconic representation is the following: The denial (in the Freudian sense) of the representational apparatus consists in the displacement of the vanishing point to the central movement of the story represented, and in the 'lateralization' of the depth dimension from the level of *enunciation* (representation) to the level of what is *enounced* (the story represented).

I would like to emphasize this last point in our example: The whole critical literature devoted to *The Arcadian Shepherds* has underscored the contrast between an earlier version called the Chatsworth version[7] and the Louvre version. The change consists precisely in the lateralization of the depth structure of representation by situating the figures represented, the *istoria*, in a frieze parallel to the representational screen. The change has always been interpreted historically as a move from a baroque organization to a classical one.[8]

But it seems important to analyze the operations implied by such a move. They consist in: (1) displacing the vanishing point from the deep visible structure of perspective (i.e., the horizon of the represented space) to the central point of the legible foreground of the story represented (i.e., a lateral structure); (2) operating a ninety-degree rotation of the network of optical rays (whose poles are the viewpoint and the vanishing point) in order to locate them in a plane parallel to the representational screen, a plane which is scanned by the frieze disposition of the figures in two symmetrical groups where the equivalence of the viewpoint and the vanishing point appears simply reversed.

The viewpoint of the formal representational network becomes the starting point and the final point of the represented story, and the vanishing point becomes the central event, the moment of representation that is the focus of the story.

As J. Klein observed in his 1937 article,[9] the starting point of the story, the fact that A is looking at B, is reflected symmetrically by D looking at B and this is the end of the story, while the vanishing point is displaced to the central part of the scene, the two hands, the two forefingers pointing out the locus of the event, the reading of an inscription—and even more precisely, the place of a cleft in the wall of the tomb and the place of a letter in the epitaph.

What is at stake in the 'transformation' is to make representation escape its own process of constitution, which it nevertheless requires; to posit representation in its 'objective' autonomy and independence, which it gets only from a subject who constitutes it in constituting himself through it.

But the story set on the stage by Poussin in this painting—the

'event'—is not a historical event. The event here is the story of enunci-ation, or of representation. What is represented is the very process of representation. It is the enunciative *Aufhebung*, the negation-position of discourse, its self-referentiality, which is set on the stage by Poussin, who reverses the reference to the world into a reference to the subject-*ego*. [...]

Et in Arcadia ego: A Semantic Problem

Once more our reading is led to that central locus, a syncope or break between the two groups of figures, a locus and a moment of the narrat-ive transformation which is filled up by the inscription 'Et in Arcadia ego.' We have now come to its grammatical and semantic analysis, which was the subject of Panofsky's remarkable study. How are we to translate the inscription: 'Even in Arcady, I am' or 'I too was born or lived in Arcady'? In the first case, it is Death itself that writes the inscription on the tomb; in the second, it is a dead shepherd who has written his epitaph. Panofsky builds his essay on a cross-argumenta-tion: If we choose the first translation, we do not take into account the elegiac meditation that gives the Louvre version (as compared to the Chatsworth one) its specific atmosphere. With the second translation, we are faithful to the nostalgic mood of the painting but we make a grammatical mistake, since 'the adverbial *et* invariably refers to the noun or the pronoun directly following it and this means that it belongs, in our case, not to *ego* but to *Arcadia*.'[10] The way in which Panofsky poses the problem is perfectly consistent with his philosophy of art history as a constant displacement of motives and themes, forms and legends, vision and iconography—connections and displacements that point out the iconological level of cultural symbols. For some years, a very fruitful controversy has taken place between Panofsky, Weisback, Blunt, and Klein, a discussion that was initiated, as Panofsky observed, in the seventeenth century with the diverging interpretations of Bellori and Félibien.[11]

However, the question of the translation and meaning of 'Et in Arcadia ego' does not seem to me correctly raised by Panofsky in his apparently rigorous philological analysis: 'The phrase *Et in Arcadia ego* is one of those elliptical sentences like *Summum jus, summa injuria, E pluribus unum, Nequid Mimis*, or *Sic Semper tyrannis*, in which the verb has to be supplied by the reader. This unexpressed verb must therefore be unequivocally suggested by the words given, and this means that it can never be a preterit. . . . it is also possible though fairly unusual to suggest a future as in Neptune's famous *quos ego* ('These I shall deal with'); but it is not possible to suggest a past tense.'[12] It seems to me that the key question lies in the difference between a phrase like *Summum jus, summa injuria* and Neptune's *quos ego*. Do we have a nominal sentence (*Summum jus* ...) or an *oratio imperfecta*, an in-

complete sentence? If it is a nominal sentence, then, according to Benveniste's study,[13] its basic characteristics would be the following: (1) it is a sentence that cannot be reduced to a complete sentence whose verb 'to be' would be absent; (2) it is a nontemporal, nonpersonal, nonmodal sentence, since it bears upon terms that are reduced to their basic semantic content; (3) such a sentence cannot relate the time of an event to the time of discourse about the event, since it asserts a quality appropriate to the subject of the utterance without any relationships to the speaker (the subject of enunciation); (4) the inventory of its uses in Greek and Latin texts shows that it is always employed to state permanent truths, and it assumes an absolute and nontemporal relation expressed as an authoritative proof in direct speech. What seems to me to make difficult the interpretation of *Et in Arcadia ego* as a nominal sentence is the presence of *ego* in the phrase, *ego* which designates the speaker. In *ego*, a present is here and now implied and not a nontemporal present of a general assertion: 'I (who speak here and now to you) lived in Arcadia.' The past is referred to as past, but in relation to the present moment when I articulate the sentence.

So I am inclined to interpret the sentence as an incomplete one, *oratio imperfecta*, some parts of which have been erased. It lacks its verb, but also the proper name corresponding to *ego*. We may compare it, for instance, with one of the iconographical referents of the painting, Virgil's *Fifth Eclogue*, in which we find this epitaph of the shepherd Daphnis:

Daphnis ego in silvis hinc usque ad sidera notus
Formosi pecoris custos, formosior ipse.

'Daphnis ego in silvis … notus (sum)': *ego* is twice determined by the proper name, Daphnis, and by a verb in a past tense 'notus sum.' And we know that the identifying presence of the proper name is a permanent feature of funerary poetry.[14]

These last observations do not, however, solve all the questions raised by a statement written in the past tense and including an 'enunciative' *I* and a proper name. In memoirs or autobiographical narratives, the *written I* is at one and the same time 'I' and 'he-she,' 'I—as he (or she),' I as another whose identity is nevertheless assumed by the writer beyond the temporal gap marked by the past tense. In this case, 'I' possesses, through writing, the status of a permanently divided *ego*, but one whose scission is constantly reinscribed and neutralized by the writing process. With an epitaph, the paradox of the writing 'I' and the written 'I' is insuperable, since the writer inscribes here and now—that is, *after* his death—his ego as a dead man.

My hypothesis would be to leave the inscription to its indiscernible meaning, an indeterminability which may be the sense of Poussin's painting: I mean a self-reflexive writing of history. The fact that *ego*'s

name has disappeared makes *ego* a kind of 'floating signifier' waiting for its fulfilment by our reading. The absence of a conjugated verbal form locates the sentence between present and past, identity and alterity, at their limits which are the very limits of representation. In other words, a certain representation of death refers to the process of representation as death, which writing (and painting as a writing process) tames and neutralizes among the living people who read and contemplate it.

The obliteration of the name and the verb in the inscription points out the operation enacted by the representational-narrative process and represents it as the concealment of the 'enunciative' structure itself, thanks to which the past, death, loss, can come back here and now by our reading—but come back as representation, set up on its stage, the object of a serene contemplation exorcising all anxiety.

Text and Icon: The Representational 'Negation' Represented

It seems to me that Poussin's *Arcadian Shepherds* bears some traces of the functioning of the historiographical process. But I do not offer this next stage of my reading as a conclusive explanation; it will be only a step further into the indeterminable area which is ultimately the contemplative reading of a painting—that area between proving and dreaming, vision and fantasy, analysis and projection, that Poussin calls delectation.

I would like to come back to the central space between the two groups of figures, and precisely to the part of the painting imperatively pointed out by the two shepherds' forefingers. The index finger of the shepherd on the left is located on the letter *r* of the word *Arcadia*, that is the central letter of the inscription and also the central point of the painting resulting from the displacement of the vanishing point from the horizon of the representational stage to the wall of the tomb. That *r* is the initial of the name of Cardinal Rospigliosi, who invented the phrase 'Et in Arcadia ego' and commissioned the painting we have been studying. This letter *r*, a pure signifier which takes the place of the vanishing point and viewpoint on the tomb, the place of death, is a kind of 'hypogrammatic' signature of a name, that of the author of the motto and of the painting as well. It is the signifier of the name of the Father of the painting in the place of the painter-beholder: Rospigliosi, who commissioned two other paintings by Poussin whose allegories might signify the symbols that *The Arcadian Shepherds* reveal: *Time Saving Truth from Envy and Discord*, and *A Dance of the Ages of Life to the Music of Time*.[15]

The other shepherd's forefinger is located on a vertical cleft in the tomb wall, a crack situated straight up the break which divides the stage ground and isolates the 'shepherdess' on the right. That cleft splits the inscription, the legible syntagm written in the painting. Moreover, while it runs *between* the two words of the first line, *in* and

Arcadia, it *divides e/go*. That 'pun,' right in the center of the painting, indicates what is at stake in it: a gap between two gestures, between the initial of the name of the Father (of the motto and the painting) and the splitting of the writing-painting Ego, the *ego* of the representation of Death in Arcadia; a scission of the absent name of the painter, who nevertheless has made the painting and who signifies that he too is in Arcadia, but as one absent from that blissful place which is nothing else than the painting itself.

A last word: We observe that the light of the sunset projects the shadow of the shepherd who attempts to decipher the inscription onto the tomb wall, as an unexpected version of the Platonic myth of the cave: his shadow, his vanishing double, his image, is inscribed in that other painting within the painting which is the opaque wall of the tomb. So, the tomb is somehow the painting, a surface reflecting only shadows, reflections, appearances where the actual happiness, Arcady, is lost and found again but only as its double, or rather as its representation. If the shadow of the shepherd's arm and hand points out the letter *r* of the Father's name, it traces too on the wall of the tomb, not an arm and a hand, but a scythe, the attribute of Saturn, who reigns over the Arcadian Golden Age, the attribute of Cronos too, the castrating God and Chronos, Time, who makes everything pass away; the scythe which we also find as an allegorical sign in the two other paintings commissioned by Rospigliosi and which would be in *The Arcadian Shepherds* a kind of 'hypogrammatic icon.'

Demonstration or fantasy, I leave my reading indeterminate: self-conscious intentions of Poussin, who modestly said: 'Je n'ai rien négligé,' or enigmatic operations of the painting always in excess of its reading. This may be the 'Golden Bough' Poussin alludes to,[16] Virgil's Golden Bough that opens the gates of horn and ivory through which the actual shadows and dreamed recollections come to light: my reading of *The Arcadian Shepherds* has no other justification than my 'delectation' in a painting of Poussin, who was said by Bernini to be a great myth maker.[17]

Et in Arcadia ego could be read as a message sent by Poussin in order to signify that from the representation of death—that is, the writing of history—to representation *as* death and as delight, history in the history painting is our contemporary myth.

6

Modernity and its Discontents

Introduction

Is the undoing of modernity the end of art history as we know it? If modernity is the having of the past as a problem, as something to be explained so that it might itself be employed, in turn, to explain the present, then the modern profession of art history has surely been at the dramatic heart of staging and articulating that problem. It takes a position or a stand relative to the past, making of it a picture and a world—a world which seems somehow to be designed to meet and address the art historical eye—which is, in the end, the eye of the camera, itself generalized into a world-scanning and thus world-building machinery.

Does postmodernism offer an alternative vision? Consider the following words of Stephen Melville, taken from his extract in Chapter 8:

It may be tempting to say here something familiar like 'postmodernism offers us a new perspective on the past', but what needs to be said is something more like 'postmodernism compels a rethinking of the way in which we imagine "perspective" to offer us an access to the past'. It is perhaps worth noting that it follows from this that whatever 'postmodernism' is, it is not quite a period term and it is not quite within the existing terms of art history, an art historical object; it is more nearly a way in which attention can be drawn to certain 'grammatical'—a term I prefer to 'methodological'—difficulties in our talk of periodization and objectivity. What defines the postmodern within an art history curriculum is a certain slippage between it and the received terms of that curriculum.

What would it mean to go 'beyond' that? Not simply to put Hegel at arm's length—postmodernism as yet another art historical period-style, always already superseded by the dream (the 'myth', as Rosalind Krauss put it[1] of yet another avant-garde, yet another 'post')—but to cultivate perhaps a tactical indifference (however *ad hoc* and transitory) to a Hegelian historicism of the spirit?

It will have become clear in the readings and commentaries in this volume that art history has been at the same time (1) a *place* for reading (a virtual and material space where the truth or significance of what may be read is most clearly visible); (2) an *archive*, encyclopaedia, and

thesaurus (an infinitely expandable resource of 'material' for creating texts; for narratives of filiation and genealogy, influence and reaction); and (3) a scanning device or instrument; the *optical machine* that does the 'reading'.

While this may in itself be quite remarkable, it also gives rise to dilemmas that multiply like echoes in a cave (Platonic or otherwise). How can one separate oneself from this Hegelian contraption and still *see* what this (art) historical machinery is doing; see it as if its surface, which in the daily operational life of the machine is opaque, is transparent, with all the innards visible? All this may have begun to sound like one of those conundrums of particle physics, which we can memorize readily like a mantra but which continues to elude practical reasoning.

Art historical practice constitutes the becoming-visible of the historicality of art. Historicality is an artefact of perspective. Perspective is an artefact of privileging. And the privileging of objects is at once the birth and death of art. How can this be? Perhaps the answer can be explained as follows:

It is the *birth* because it is in the double evacuation of the heterogeneity of all that is present that an opposition is erected between a dead past and a living present, and a second opposition is erected between those things that are in the present that are like those things of the past that have been separated out and thereby linked with the dead and put aside from all the rest, which constitutes the living. It is the *death* because once separated out from other things, that which is art exists in opposition to the place of non-art where we now appear to be living once the cut is made, or else art would be invisible to us, and part of the (living) place where we are.

You may have noticed that this is resonating with issues that emerged in the discussion of Winckelmann's art history in the introduction to Chapter 1. If art history is the becoming-visible of art's historicity, art history is then intimately concerned with the fabrication and maintenance of modernity—it is what art history is *for* and what in its historical foundations in the Enlightenment and in its Hegelian spiritualization (I mean its dematerialization), and up to the present, it has been all *about*.

Now, if this is so, then any talk of 'postmodernity' is very important indeed. In fact, it is essential to any consideration of the very possibility of something calling itself 'the history of art' at present, for it returns us to art history's historical beginnings—which, as now seems unavoidable, are always beginning, even at the present moment (as Lyotard will have said more generically, as quoted below (p. 282)).

Three essays in this chapter directly address the question of the postmodern. These include a widely read 1980 text by the late art critic Craig Owens in the journal *October*, which is a fine articulation of the allegorical bases of all modes of art historical practice, and an essay

from 1984 by Andreas Huyssen, published in *New German Critique*, which opened up broader perspectives on these debates.

The earliest essay is the second, Michel Foucault's justly famous 'What is an Author', published in 1969. It problematized the notion of authorship as fixed and constant, and discussed the varying senses of authorship over the centuries in the West. Foucault argued that much of the inherited importance of what he termed the author-function has its roots in early Christian religious discourse, and specifically in biblical exegesis. Originally a very controversial lecture delivered in 1969 at the Collège de France, when Foucault's 'structuralist tendencies' were being hotly debated (and contested by Foucault himself), the essay revitalized the debate surrounding the nature of the individual subject by arguing that it too was neither universal nor constant. The argument has important implications for notions of art, artist, and artistry.

The first essay, 'Sculpture in the Expanded Field', published by New York art historian Rosalind Krauss in 1979, successfully achieved an effect complementary to that of Foucault's by demonstrating the non-universality and historical boundedness of 'sculpture' as an art historical category—thereby astutely troubling certain basic conventional disciplinary assumptions. This was pursued through the framework of a rigorously logico-formalist explication of stylistic change as the playing-out of a series of possible chessboard-like moves made up of artistic options at particular moments, namely those from New York school art.

She described the transformation from modernist sculpture (with its links to traditional notions of space, viewing subject, and monumentality) to a postmodernist 'expanded field' by adapting mathematical (topological) models and the paradigmatic logic of contraries and contradictions taken from linguistic semiology. It was a poignant early attempt to apply rigorous structural semiotic methods to traditional problems of stylistic evolution, with results that unsurprisingly harked back, for some, to the art historical formalisms of the early twentieth century.[2]

The bibliography on postmodernism, postmodernity, and modernity's discontents is enormous even without explicit references to structuralist or poststructuralist semiology, feminism, gender studies, deconstruction, critical theory, and so on, to name just a few of the usual critical rubrics commonly brought under the postmodern umbrella, and even then just limiting our purview to visual art practices exclusive of architecture and urbanism, where these debates also took place, and in some cases slightly earlier than in art history. Brave attempts were made in various countries during the 1980s to publish useful reading lists, but at the end of the millennium (and with the revival of various

millennialisms about which not a few poststructuralists have warned) such ambitions have waned. The following list is brief and idiosyncratic, but generally useful as a kind of browser-device for accessing this literature.

There were two key short texts that for many set the terms of the early debates on postmodernism. The first is Jean-François Lyotard's *La Condition postmoderne: Rapport sur le savoir* (Paris, 1979), translated by Geoff Bennington and Brian Massumi as *The Postmodern Condition: A Report on Knowledge* (Minneapolis, 1983), with a foreword by Frederic Jameson. The translated volume included Lyotard's 1983 essay, 'Answering the Question: What is Postmodernism?' in which Lyotard says (p. 79): 'Postmodernism ... is not modernism at its end but in the nascent state, and this state is constant.'

The second essay is by the German critical historian Jürgen Habermas (whom Lyotard cast as a neoconservative). His 'Modernity versus Postmodernity', first presented as a lecture in Frankfurt in 1980 and again in 1981 in New York, has (like Lyotard's essay) been republished many times. It may be most readily found in English (and under the altered title 'Modernity—An Incomplete Project') in an anthology which itself was an important and influential early collection of essays on postmodernism, H. Foster (ed.), *The Anti-Aesthetic: Essays on Postmodern Culture* (Seattle, 1983), 3–15. The unresolved (and unresolvable) 'Lyotard–Habermas debate' was played out for many years; the readings in this chapter (and especially the Huyssen essay) touch on some of what has been most crucially at stake. On postmodernist architecture as symptomatic of latter-day capitalisms, see Frederic Jameson, 'Postmodernism, or the Cultural Logic of Late Capitalism', *New Left Review*, 146, (1984), 53–92.[3]

Several other useful anthologies are: Jonathan Arac (ed.), *Postmodernism and Politics* (Minneapolis, 1986); E. Ann Kaplan (ed.), *Postmodernism and its Discontents: Theories, Practices* (London, 1988); Howard Risatti (ed.), *Postmodern Perspectives: Issues in Contemporary Art* (Englewood Cliffs, NJ, 1990); and Brian Wallis (ed.), *Art After Modernism: Essays on Rethinking Representation* (New York, 1984).

The most useful general collection of texts which over the years have become part of the 'critical theory' tradition is the 800-page paperback anthology *Critical Theory Since 1965*, edited by Hazard Adams and Leroy Searle (Tallahassee, Fla., 1986). It includes influential texts and excerpts by some fifty twentieth-century authors.

Sculpture in the Expanded Field

Toward the center of the field there is a slight mound, a swelling in the earth, which is the only warning given for the presence of the work. Closer to it, the large square face of the pit can be seen, as can the ends of the ladder that is needed to descend into the excavation. The work itself is thus entirely below grade: half atrium, half tunnel, the boundary between outside and in, a delicate structure of wooden posts and beams. The work, *Perimeters/Pavilions/Decoys*, 1978, by Mary Miss, is of course a sculpture or, more precisely, an earthwork [**37**], [**38**].

Over the last ten years rather surprising things have come to be called sculpture: narrow corridors with TV monitors at the ends; large photographs documenting country hikes; mirrors placed at strange angles in ordinary rooms; temporary lines cut into the floor of the desert. Nothing, it would seem, could possibly give to such a motley of effort the right to lay claim to whatever one might mean by the category of sculpture. Unless, that is, the category can be made to become almost infinitely malleable.

The critical operations that have accompanied postwar American art have largely worked in the service of this manipulation. In the hands of this criticism categories like sculpture and painting have been kneaded and stretched and twisted in an extraordinary demonstration of elasticity, a display of the way a cultural term can be extended to include just about anything. And though this pulling and stretching of a term such as sculpture is overtly performed in the name of vanguard aesthetics—the ideology of the new—its covert message is that of historicism. The new is made comfortable by being made familiar, since it is seen as having gradually evolved from the forms of the past. Historicism works on the new and different to diminish newness and mitigate difference. It makes a place for change in our experience by evoking the model of evolution, so that the man who now is can be accepted as being different from the child he once was, by simultaneously being seen—through the unseeable action of the telos—as the same. And we are comforted by this perception of sameness, this strategy for reducing anything foreign in either time or space, to what we already know and are.

No sooner had minimal sculpture appeared on the horizon of the

aesthetic experience of the 1960s, than criticism began to construct a paternity for this work, a set of constructivist fathers who could legitimize and thereby authenticate the strangeness of these objects. Plastic? inert geometries? factory production?—none of this was *really* strange, as the ghosts of Gabo and Tatlin and Lissitzky could be called in to testify. Never mind that the content of the one had nothing to do with, was in fact the exact opposite of, the content of the other. Never mind that Gabo's celluloid was the sign of lucidity and intellection, while Judd's plastic-tinged-with-dayglo spoke the hip patois of California. It did not matter that constructivist forms were intended as visual proof of the immutable logic and coherence of universal geometries, while their seeming counterparts in minimalism were demonstrably contingent—denoting a universe held together not by Mind but by guy wires, or glue, or the accidents of gravity. The rage to historicize simply swept these differences aside.

Of course, with the passing of time these sweeping operations got a little harder to perform. As the 1960s began to lengthen into the 1970s and 'sculpture' began to be piles of thread waste on the floor, or sawed redwood timbers rolled into the gallery, or tons of earth excavated from the desert, or stockades of logs surrounded by firepits, the word *sculpture* became harder to pronounce—but not really that much harder. The historian/critic simply performed a more extended sleight-of-hand and began to construct his genealogies out of the data of millennia rather than decades. Stonehenge, the Nazca lines, the Toltec ballcourts, Indian burial mounds—anything at all could be

hauled into court to bear witness to this work's connection to history and thereby to legitimize its status as sculpture. Of course Stonehenge and the Toltec ballcourts were just exactly *not* sculpture, and so their role as historicist precedent becomes somewhat suspect in this particular demonstration. But never mind. The trick can still be done by calling upon a variety of primitivizing work from the earlier part of the century—Brancusi's *Endless Column* will do—to mediate between extreme past and present.

But in doing all of this, the very term we had thought we were saving—*sculpture*—has begun to be somewhat obscured. We had thought to use a universal category to authenticate a group of particulars, but the category has now been forced to cover such a heterogeneity that it is, itself, in danger of collapsing. And so we stare at the

41 Robert Morris

Green Gallery Installation,
1964

pit in the earth and think we both do and don't know what sculpture is.

Yet I would submit that we know very well what sculpture is. And one of the things we know is that it is a historically bounded category and not a universal one. As is true of any other convention, sculpture has its own internal logic, its own set of rules, which, though they can be applied to a variety of situations, are not themselves open to very much change. The logic of sculpture, it would seem, is inseparable from the logic of the monument. By virtue of this logic a sculpture is a commemorative representation. It sits in a particular place and speaks in a symbolical tongue about the meaning or use of that place. The equestrian statue of Marcus Aurelius is such a monument, set in the center of the Campidoglio to represent by its symbolical presence the relationship between ancient, Imperial Rome and the seat of government of modern, Renaissance Rome. Bernini's statue of the *Conversion of Constantine*, placed at the foot of the Vatican stairway connecting the Basilica of St. Peter to the heart of the papacy is another such monument, a marker at a particular place for a specific meaning event. Because they thus function in relation to the logic of representation and marking, sculptures are normally figurative and vertical, their pedestals an important part of the structure since they mediate between actual site and representational sign. There is nothing very mysterious about this logic; understood and inhabited, it was the source of

a tremendous production of sculpture during centuries of Western art.

But the convention is not immutable and there came a time when the logic began to fail. Late in the nineteenth century we witnessed the fading of the logic of monument. It happened rather gradually. But two cases come to mind, both bearing the marks of their own transitional status. Rodin's *Gates of Hell* and his statue of *Balzac* were both conceived as monuments [**39**]. The first were commissioned in 1880 as the doors to a projected museum of decorative arts; the second was commissioned in 1891 as a memorial to literary genius to be set up at a specific site in Paris. The failure of these two works as monuments is signaled not only by the fact that multiple versions can be found in a variety of museums in various countries, while no version exists on the original sites—both commissions having eventually collapsed. Their failure is also encoded onto the very surfaces of these works: the doors having been gouged away and anti-structurally encrusted to the point where they bear their inoperative condition on their face; the *Balzac* executed with such a degree of subjectivity that not even Rodin believed (as letters by him attest) that the work would ever be accepted.

With these two sculptural projects, I would say, one crosses the threshold of the logic of the monument, entering the space of what could be called its negative condition—a kind of sitelessness, or homelessness, an absolute loss of place. Which is to say one enters modernism, since it is the modernist period of sculptural production that

42 Alice Aycock
Maze, 1972

43 Richard Serra
5:30, 1969

operates in relation to this loss of site, producing the monument as abstraction, the monument as pure marker or base, functionally placeless and largely self-referential.

It is these two characteristics of modernist sculpture that declare its status, and therefore its meaning and function, as essentially nomadic. Through its fetishization of the base, the sculpture reaches downward to absorb the pedestal into itself and away from actual place; and through the representation of its own materials or the process of its construction, the sculpture depicts its own autonomy. Brancusi's art is an extraordinary instance of the way this happens [**40**]. The base becomes, in a work like the *Cock*, the morphological generator of the figurative part of the object; in the *Caryatids* and *Endless Column*, the sculpture is all base; while in *Adam and Eve*, the sculpture is in a reciprocal relation to its base. The base is thus defined as essentially transportable, the marker of the work's homelessness integrated into the very fiber of the sculpture. And Brancusi's interest in expressing parts of the body as fragments that tend toward radical abstractness also testifies to a loss of site, in this case the site of the rest of the body, the skeletal support that would give to one of the bronze or marble heads a home.

In being the negative condition of the monument, modernist sculpture had a kind of idealist space to explore, a domain cut off from the project of temporal and spatial representation, a vein that was rich and new and could for a while be profitably mined. But it was a limited vein and, having been opened in the early part of the century, it began by about 1950 to be exhausted. It began, that is, to be experienced more and more as pure negativity. At this point modernist sculpture appeared as a kind of black hole in the space of consciousness, something whose positive content was increasingly difficult to define, something that was possible to locate only in terms of what it was not. 'Sculpture is what you bump into when you back up to see a painting,' Barnett Newman said in the fifties. But it would probably be more accurate to say of the work that one found in the early sixties that sculpture had entered a categorical no-man's-land: it was what was on or in front of a building that was not the building, or what was in the landscape that was not the landscape.

The purest examples that come to mind from the early 1960s are both by Robert Morris. One is the work exhibited in 1964 in the Green Gallery [41]—quasi-architectural integers whose status as sculpture reduces almost completely to the simple determination that it is what is in the room that is not really the room; the other is the outdoor exhibition of the mirrored boxes—forms which are distinct from the setting only because, though visually continuous with grass and trees, they are not in fact part of the landscape.

In this sense sculpture had entered the full condition of its inverse

44 Robert Morris
Observatory, 1971

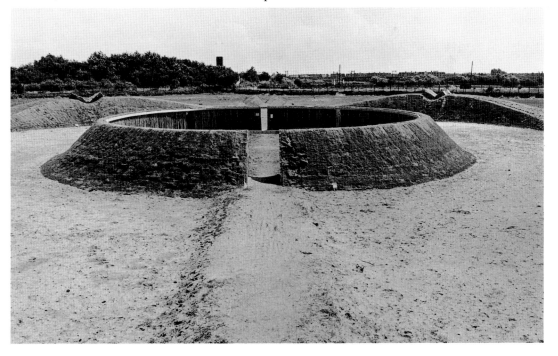

logic and had become pure negativity: the combination of exclusions. Sculpture, it could be said, had ceased being a positivity, and was now the category that resulted from the addition of the *not-landscape* to the *not-architecture*. Diagrammatically expressed, the limit of modernist sculpture, the addition of the neither/nor, looks like this:

Now, if sculpture itself had become a kind of ontological absence, the combination of exclusions, the sum of the neither/nor, that does not mean that the terms themselves from which it was built—the *not-landscape* and the *not-architecture*—did not have a certain interest. This is because these terms express a strict opposition between the built and the not-built, the cultural and the natural, between which the production of sculptural art appeared to be suspended. and what began to happen in the career of one sculptor after another, beginning at the end of the 1960s, is that attention began to focus on the outer limits of those terms of exclusion. For, if those terms are the expression of a logical opposition stated as a pair of negatives, they can be transformed by a simple inversion into the same polar opposites but expressed positively.

45 Robert Smithson
Spiral Jetty, 1969–70

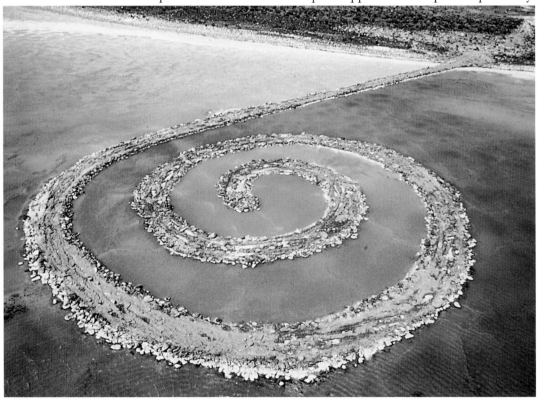

That is, the *not–architecture* is, according to the logic of a certain kind of expansion, just another way of expressing the term *landscape*, and the *not–landscape* is, simply, *architecture*. The expansion to which I am referring is called a Klein group when employed mathematically and has various other designations, among them the Piaget group, when used by structuralists involved in mapping operations within the human sciences.[1] By means of this logical expansion a set of binaries is transformed into a quaternary field which both mirrors the original opposition and at the same time opens it. It becomes a logically expanded field which looks like this:

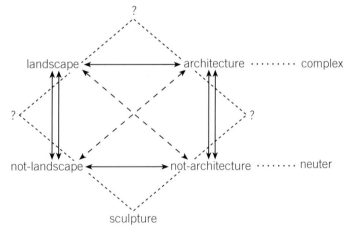

The dimensions of this structure may be analyzed as follows: (1) there are two relationships of pure contradiction which are termed *axes* (and further differentiated into the *complex axis* and the *neuter axis*) and are designated by the solid arrows; (2) there are two relationships of contradiction, expressed as involution, which are called *schemas* and are designated by the double arrows: and (3) there are two relationships of implication which are called *deixes* and are designated by the broken arrows.

Another way of saying this is that even though *sculpture* may be reduced to what is in the Klein group the neuter term of the *not–landscape*

plus the *not-architecture*, there is no reason not to imagine an opposite term—one that would be both *landscape* and *architecture*—which within this schema is called the *complex*. But to think the complex is to admit into the realm of art two terms that had formerly been prohibited from it: *landscape* and *architecture*—terms that could function to define the sculptural (as they had begun to do in modernism) only in their negative or neuter condition. Because it was ideologically prohibited, the complex had remained excluded from what might be called the closure of post-Renaissance art. Our culture had not before been able to think the complex, although other cultures have thought this term with great ease. Labyrinths and mazes are *both* landscape and architecture [**42**]; Japanese gardens are *both* land-landscape and architecture; the ritual playing fields and processionals of ancient civilizations were all in this sense the unquestioned occupants of the complex. Which is *not* to say that they were an early, or a degenerate, or a variant form of sculpture. They were part of a universe or cultural space in which sculpture was simply another part—not somehow, as our historicist minds would have it, the same. Their purpose and pleasure is exactly that they are opposite and different.

The expanded field is thus generated by problematizing the set of oppositions between which the modernist category *sculpture* is sus-

pended. And once this has happened, once one is able to think one's way into this expansion, there are—logically—three other categories that one can envision, all of them a condition of the field itself, and none of them assimilable to *sculpture*. Because as we can see, *sculpture* is no longer the privileged middle term between two things that it isn't. *Sculpture* is rather only one term on the periphery of a field in which there are other, differently structured possibilities. And one has thereby gained the 'permission' to think these other forms. So our diagram is filled in as follows:

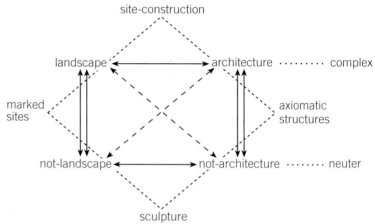

It seems fairly clear that this permission (or pressure) to think the expanded field was felt by a number of artists at about the same time, roughly between the years 1968 and 1970. For, one after another Robert Morris, Robert Smithson, Michael Heizer, Richard Serra [**43**], Walter De Maria, Robert Irwin, Sol LeWitt, Bruce Nauman ... had entered a

49 Richard Long
Untitled, 1969

50 Robert Morris

Untitled (mirrored boxes), 1965

situation the logical conditions of which can no longer be described as modernist. In order to name this historical rupture and the structural transformation of the cultural field that characterizes it, one must have recourse to another term. The one already in use in other areas of criticism is postmodernism. There seems no reason not to use it.

But whatever term one uses, the evidence is already in. By 1970, with the *Partially Buried Woodshed* at Kent State University, in Ohio, Robert Smithson had begun to occupy the complex axis, which for ease of reference I am calling *site construction*. In 1971 with the observatory he built in wood and sod in Holland, Robert Morris had joined him [**44**]. Since that time, many other artists—Robert Irwin, Alice Aycock, John Mason, Michael Heizer, Mary Miss, Charles Simonds—have operated within this new set of possibilities.

Similarly, the possible combination of *landscape* and *not-landscape* began to be explored in the late 1960s. The term *marked sites* is used to identify work like Smithson's *Spiral Jetty* (1970) [**45**] and Heizer's *Double Negative* (1969), as it also describes some of the work in the seventies by Serra, Morris, Carl Andre [**46**], Dennis Oppenheim, Nancy Holt, George Trakis, and many others. But in addition to actual physical manipulations of sites, this term also refers to other forms of marking. These might operate through the application of impermanent marks—Heizer's *Depressions*, Oppenheim's *Time Lines*, or De Maria's *Mile Long Drawing*, for example—or through the use of

photography. Smithson's *Mirror Displacements in the Yucatan* were probably the first widely known instances of this [47, 48], but since then the work of Richard Long [49] and Hamish Fulton has focused on the photographic experience of marking. Christo's *Running Fence* might be said to be an impermanent, photographic, and political instance of marking a site.

The first artists to explore the possibilities of *architecture* plus *not-architecture* were Robert Irwin. Sol LeWitt, Bruce Nauman, Richard Serra, and Christo. In every case of these *axiomatic structures*, there is some kind of intervention into the real space of architecture, sometimes through partial reconstruction, sometimes through drawing, or as in the recent works of Morris, through the use of mirrors [50]. As was true of the category of the *marked site*, photography can be used for this purpose: I am thinking here of the video corridors by Nauman. But whatever the medium employed, the possibility explored in this category is a process of mapping the axiomatic features of the architectural experience—the abstract conditions of openness and closure—onto the reality of a given space.

The expanded field which characterizes this domain of postmodernism possesses two features that are already implicit in the above description. One of these concerns the practice of individual artists; the other has to do with the question of medium. At both these points the bounded conditions of modernism have suffered a logically determined rupture.

With regard to individual practice, it is easy to see that many of the artists in question have found themselves occupying, successively, different places within the expanded field. And though the experience of the field suggests that this continual relocation of one's energies is entirely logical, an art criticism still in the thrall of a modernist ethos has been largely suspicious of such movement, calling it eclectic. This suspicion of a career that moves continually and erratically beyond the domain of sculpture obviously derives from the modernist demand for the purity and separateness of the various mediums (and thus the necessary specialization of a practitioner within a given medium). But what appears as eclectic from one point of view can be seen as rigorously logical from another. For, within the situation of postmodernism, practice is not defined in relation to a given medium—sculpture—but rather in relation to the logical operations on a set of cultural terms, for which any medium—photography, books, lines on walls, mirrors, or sculpture itself—might be used.

Thus the field provides both for an expanded but finite set of related positions for a given artist to occupy and explore, and for an organization of work that is not dictated by the conditions of a particular medium. From the structure laid out above, it is obvious that the logic of the space of postmodernist practice is no longer organized around

51 Joel Shapiro
Untitled (cast iron and plaster houses), 1974–75

the definition of a given medium on the grounds of material, or, for that matter, the perception of material. It is organized instead through the universe of terms that are felt to be in opposition within a cultural situation. (The postmodernist space of painting would obviously involve a similar expansion around a different set of terms from the pair *architecture/landscape*—a set that would probably turn on the opposition *uniqueness/reproducibility*.) It follows, then, that within any one of the positions generated by the given logical space, many different mediums might be employed. It follows as well that any single artist might occupy, successively, any one of the positions. And it also seems the case that within the limited position of sculpture itself the organization and content of much of the strongest work will reflect the condition of the logical space. I am thinking here of the sculpture of Joel Shapiro, which, though it positions itself in the neuter term, is involved in the setting of images of architecture within relatively vast fields (landscapes) of space [**51**]. (These considerations apply, obviously, to other work as well—Charles Simonds, for example, or Ann and Patrick Poirier.)

I have been insisting that the expanded field of postmodernism occurs at a specific moment in the recent history of art. It is a historical event with a determinant structure. It seems to me extremely important to map that structure and that is what I have begun to do here. But clearly, since this is a matter of history, it is also important to explore a deeper set of questions which pertain to something more than mapping and involve instead the problem of explanation. These address the root cause—the conditions of possibility—that brought about the shift

into postmodernism, as they also address the cultural determinants of the opposition through which a given field is structured. This is obviously a different approach to thinking about the history of form from that of historicist criticism's constructions of elaborate genealogical trees. It presupposes the acceptance of definitive ruptures and the possibility of looking at historical process from the point of view of logical structure.

What is an Author?

In proposing this slightly odd question, I am conscious of the need for an explanation. To this day, the 'author' remains an open question both with respect to its general function within discourse and in my own writings; that is, this question permits me to return to certain aspects of my own work which now appear ill-advised and misleading. In this regard, I wish to propose a necessary criticism and reevaluation.

For instance, my objective in *The Order of Things* had been to analyse verbal clusters as discursive layers which fall outside the familiar categories of a book, a work, or an author. But while I considered 'natural history,' the 'analysis of wealth,' and 'political economy' in general terms, I neglected a similar analysis of the author and his works; it is perhaps due to this omission that I employed the names of authors throughout this book in a naive and often crude fashion. I spoke of Buffon, Cuvier, Ricardo, and others as well, but failed to realize that I had allowed their names to function ambiguously. This has proved an embarrassment to me in that my oversight has served to raise two pertinent objections.

It was argued that I had not properly described Buffon or his work and that my handling of Marx was pitifully inadequate in terms of the totality of his thought.[1] Although these objections were obviously justified, they ignored the task I had set myself: I had no intention of describing Buffon or Marx or of reproducing their statements or implicit meanings, but, simply stated, I wanted to locate the rules that formed a certain number of concepts and theoretical relationships in their works.[2] In addition, it was argued that I had created monstrous families by bringing together names as disparate as Buffon and Linnaeus or in placing Cuvier next to Darwin in defiance of the most readily observable family resemblances and natural ties.[3] This objection also seems inappropriate since I had never tried to establish a genealogical table of exceptional individuals, nor was I concerned in forming an intellectual daguerreotype of the scholar or naturalist of the seventeenth and eighteenth century. In fact, I had no intention of forming any family, whether holy or perverse. On the contrary, I wanted to determine—a much more modest task—the functional conditions of specific discursive practices.

Then why did I use the names of authors in *The Order of Things*? Why not avoid their use altogether, or, short of that, why not define the manner in which they were used? These questions appear fully justified and I have tried to gauge their implications and consequences in a book that will appear shortly.[4] These questions have determined my effort to situate comprehensive discursive units, such as 'natural history' or 'political economy,' and to establish the methods and instruments for delimiting, analysing, and describing these unities. Nevertheless, as a privileged moment of individualization in the history of ideas, know-ledge, and literature, or in the history of philosophy and science, the question of the author demands a more direct response. Even now, when we study the history of a concept, a literary genre, or a branch of philosophy, these concerns assume a relatively weak and secondary position in relation to the solid and fundamental role of an author and his works.

For the purposes of this paper, I will set aside a sociohistorical analysis of the author as an individual and the numerous questions that deserve attention in this context: how the author was individualized in a culture such as ours; the status we have given the author, for instance, when we began our research into authenticity and attribution; the systems of valorization in which he was included; or the moment when the stories of heroes gave way to an author's biography; the conditions that fostered the formulation of the fundamental critical category of 'the man and his work.' For the time being, I wish to restrict myself to the singular relationship that holds between an author and a text, the manner in which a text apparently points to this figure who is outside and precedes it.

Beckett supplies a direction: 'What matter who's speaking, some-one said, what matter who's speaking.'[5] In an indifference such as this we must recognize one of the fundamental ethical principles of con-temporary writing. It is not simply 'ethical' because it characterizes our way of speaking and writing, but because it stands as an immanent rule, endlessly adopted and yet never fully applied. As a principle, it domin-ates writing as an ongoing practice and slights our customary attention to the finished product.[6] For the sake of illustration, we need only con-sider two of its major themes. First, the writing of our day has freed it-self from the necessity of 'expression'; it only refers to itself, yet it is not restricted to the confines of interiority. On the contrary, we recognize it in its exterior deployment.[7] This reversal transforms writing into an interplay of signs, regulated less by the content it signifies than by the very nature of the signifier. Moreover, it implies an action that is always testing the limits of its regularity, transgressing and reversing an order that it accepts and manipulates. Writing unfolds like a game that in-evitably moves beyond its own rules and finally leaves them behind. Thus, the essential basis of this writing is not the exalted emotions

related to the act of composition or the insertion of a subject into language. Rather, it is primarily concerned with creating an opening where the writing subject endlessly disappears.[8]

The second theme is even more familiar: it is the kinship between writing and death. This relationship inverts the age-old conception of Greek narrative or epic, which was designed to guarantee the immortality of a hero. The hero accepted an early death because his life, consecrated and magnified by death, passed into immortality; and the narrative redeemed his acceptance of death. In a different sense, Arabic stories, and *The Arabian Nights* in particular, had as their motivation, their theme and pretext, this strategy for defeating death. Storytellers continued their narratives late into the night to forestall death and to delay the inevitable moment when everyone must fall silent. Scheherazade's story is a desperate inversion of murder; it is the effort, throughout all those nights, to exclude death from the circle of existence.[9] This conception of a spoken or written narrative as a protection against death has been transformed by our culture. Writing is now linked to sacrifice and to the sacrifice of life itself; it is a voluntary obliteration of the self that does not require representation in books because it takes place in the everyday existence of the writer. Where a work had the duty of creating immortality, it now attains the right to kill, to become the murderer of its author. Flaubert, Proust, and Kafka are obvious examples of this reversal.[10] In addition, we find the link between writing and death manifested in the total effacement of the individual characteristics of the writer; the quibbling and confrontations that a writer generates between himself and his text cancel out the signs of his particular individuality. If we wish to know the writer in our day, it will be through the singularity of his absence and in his link to death, which has transformed him into a victim of his own writing. While all of this is familiar in philosophy, as in literary criticism, I am not certain that the consequences derived from the disappearance or death of the author have been fully explored or that the importance of this event has been appreciated. To be specific, it seems to me that the themes destined to replace the privileged position accorded the author have merely served to arrest the possibility of genuine change. Of these, I will examine two that seem particularly important.

To begin with, the thesis concerning a work. It has been understood that the task of criticism is not to reestablish the ties between an author and his work or to reconstitute an author's thought and experience through his works and, further, that criticism should concern itself with the structures of a work, its architectonic forms, which are studied for their intrinsic and internal relationships.[11] Yet, what of a context that questions the concept of a work? What, in short, is the strange unit designated by the term, work? What is necessary to its composition, if a work is not something written by a person called an 'author'?

Difficulties arise on all sides if we raise the question in this way. If an individual is not an author, what are we to make of those things he has written or said, left among his papers or communicated to others? Is this not properly a work? What, for instance, were Sade's papers before he was consecrated as an author? Little more, perhaps, than rolls of paper on which he endlessly unravelled his fantasies while in prison.

Assuming that we are dealing with an author, is everything he wrote and said, everything he left behind, to be included in his work? This problem is both theoretical and practical. If we wish to publish the complete works of Nietzsche, for example, where do we draw the line? Certainly, everything must be published, but can we agree on what 'everything' means? We will, of course, include everything that Nietzsche himself published, along with the drafts of his works, his plans for aphorisms, his marginal notations and corrections. But what if, in a notebook filled with aphorisms, we find a reference, a remainder of an appointment, an address, or a laundry bill, should this be included in his works? Why not? These practical considerations are endless once we consider how a work can be extracted from the millions of traces left by an individual after his death. Plainly, we lack a theory to encompass the questions generated by a work and the empirical activity of those who naively undertake the publication of the complete works of an author often suffers from the absence of this framework. Yet more questions arise. Can we say that *The Arabian Nights*, and *Stromates* of Clement of Alexandria, or the *Lives* of Diogenes Laertes constitute works? Such questions only begin to suggest the range of our difficulties, and, if some have found it convenient to bypass the individuality of the writer or his status as an author to concentrate on a work, they have failed to appreciate the equally problematic nature of the word 'work' and the unity it designates.

Another thesis has detained us from taking full measure of the author's disappearance. It avoids confronting the specific event that makes it possible and, in subtle ways, continues to preserve the existence of the author. This is the notion of *écriture*.[12] Strictly speaking, it should allow us not only to circumvent references to an author, but to situate his recent absence. The conception of *écriture*, as currently employed, is concerned with neither the act of writing nor the indications, as symptoms or signs within a text, of an author's meaning; rather, it stands for a remarkably profound attempt to elaborate the conditions of any text, both the conditions of its spatial dispersion and its temporal deployment.

It appears, however, that this concept, as currently employed, has merely transposed the empirical characteristics of an author to a transcendental anonymity. The extremely visible signs of the author's empirical activity are effaced to allow the play, in parallel or opposition, of religious and critical modes of characterization. In granting a

primordial status to writing, do we not, in effect, simply reinscribe in transcendental terms the theological affirmation of its sacred origin or a critical belief in its creative nature? To say that writing, in terms of the particular history it made possible, is subjected to forgetfulness and repression, is this not to reintroduce in transcendental terms the religious principle of hidden meanings (which require interpretation) and the critical assumption of implicit significations, silent purposes, and obscure contents (which give rise to commentary)? Finally, is not the conception of writing as absence a transposition into transcendental terms of the religious belief in a fixed and continuous tradition or the aesthetic principle that proclaims the survival of the work as a kind of enigmatic supplement of the author beyond his own death?[13]

This conception of *écriture* sustains the privileges of the author through the safeguard of the a priori; the play of representations that formed a particular image of the author is extended within a gray neutrality. The disappearance of the author—since Mallarmé, an event of our time—is held in check by the transcendental. Is it not necessary to draw a line between those who believe that we can continue to situate our present discontinuities within the historical and transcendental tradition of the nineteenth century and those who are making a great effort to liberate themselves, once and for all, from this conceptual framework?[14]

It is obviously insufficient to repeat empty slogans: the author has disappeared; God and man died a common death.[15] Rather, we should reexamine the empty space left by the author's disappearance; we should attentively observe, along its gaps and fault lines, its new demarcations, and the reapportionment of this void; we should await the fluid functions released by this disappearance. In this context we can briefly consider the problems that arise in the use of an author's name. What is the name of an author? How does it function? Far from offering a solution, I will attempt to indicate some of the difficulties related to these questions.

The name of an author poses all the problems related to the category of the proper name. (Here, I am referring to the work of John Searle,[16] among others.) Obviously not a pure and simple reference, the proper name (and the author's name as well) has other than indicative functions. It is more than a gesture, a finger pointed at someone; it is, to a certain extent, the equivalent of a description. When we say 'Aristotle,' we are using a word that means one or a series of definite descriptions of the type: 'the author of the *Analytics*,' or 'the founder of ontology,' and so forth.[17] Furthermore, a proper name has other functions than that of signification: when we discover that Rimbaud has not written *La Chasse spirituelle*, we cannot maintain that the meaning of the proper name or this author's name has been altered. The proper

name and the name of an author oscillate between the poles of description and designation, and, granting that they are linked to what they name, they are not totally determined either by their descriptive or designative functions.[18] Yet—and it is here that the specific difficulties attending an author's name appear—the link between a proper name and the individual being named and the link between an author's name and that which it names are not isomorphous and do not function in the same way; and these differences require clarification.

To learn, for example, that Pierre Dupont does not have blue eyes, does not live in Paris, and is not a doctor does not invalidate the fact that the name, Pierre Dupont, continues to refer to the same person; there has been no modification of the designation that links the name to the person. With the name of an author, however, the problems are far more complex. The disclosure that Shakespeare was not born in the house that tourists now visit would not modify the functioning of the author's name, but, if it were proved that he had not written the sonnets that we attribute to him, this would constitute a significant change and affect the manner in which the author's name functions. Moreover, if we establish that Shakespeare wrote Bacon's *Organon* and that the same author was responsible for both the works of Shakespeare and those of Bacon, we would have introduced a third type of alteration which completely modifies the functioning of the author's name. Consequently, the name of an author is not precisely a proper name among others.

Many other factors sustain this paradoxical singularity of the name of an author. It is altogether different to maintain that Pierre Dupont does not exist and that Homer or Hermes Trismegistes have never existed. While the first negation merely implies that there is no one by the name of Pierre Dupont, the second indicates that several individuals have been referred to by one name or that the real author possessed none of the traits traditionally associated with Homer or Hermes. Neither is it the same thing to say that Jacques Durand, not Pierre Dupont, is the real name of *X* and that Stendhal's name was Henri Beyle. We could also examine the function and meaning of such statements as 'Bourbaki is this or that person,' and 'Victor Eremita, Climacus, Anticlimacus, Frater Taciturnus, Constantin Constantius, all of these are Kierkegaard.'

These differences indicate that an author's name is not simply an element of speech (as a subject, a complement, or an element that could be replaced by a pronoun or other parts of speech). Its presence is functional in that it serves as a means of classification. A name can group together a number of texts and thus differentiate them from others. A name also establishes different forms of relationships among texts. Neither Hermes not Hippocrates existed in the sense that we can say Balzac existed, but the fact that a number of texts were attached to a

single name implies that relationships of homogeneity, filiation, reciprocal explanation, authentification, or of common utilization were established among them. Finally, the author's name characterizes a particular manner of existence of discourse. Discourse that possesses an author's name is not to be immediately consumed and forgotten; neither is it accorded the momentary attention given to ordinary, fleeting words. Rather, its status and its manner of reception are regulated by the culture in which it circulates.

We can conclude that, unlike a proper name, which moves from the interior of a discourse to the real person outside who produced it, the name of the author remains at the contours of texts—separating one from the other, defining their form, and characterizing their mode of existence. It points to the existence of certain groups of discourse and refers to the status of this discourse within a society and culture. The author's name is not a function of a man's civil status, nor is it fictional; it is situated in the breach, among the discontinuities, which gives rise to new groups of discourse and their singular mode of existence.[19] Consequently, we can say that in our culture, the name of an author is a variable that accompanies only certain texts to the exclusion of others: a private letter may have a signatory, but it does not have an author; a contract can have an underwriter, but not an author; and, similarly, an anonymous poster attached to a wall may have a writer, but he cannot be an author. In this sense, the function of an author is to characterize the existence, circulation, and operation of certain discourses within a society.

In dealing with the 'author' as a function of discourse, we must consider the characteristics of a discourse that support this use and determine its difference from other discourses. If we limit our remarks to only those books or texts with authors, we can isolate four different features.

First, they are objects of appropriation; the form of property they have become is of a particular type whose legal codification was accomplished some years ago. It is important to notice, as well, that its status as property is historically secondary to the penal code controlling its appropriation. Speeches and books were assigned real authors, other than mythical or important religious figures, only when the author became subject to punishment and to the extent that his discourse was considered transgressive. In our culture—undoubtedly in others as well—discourse was not originally a thing, a product, or a possession, but an action situated in a bipolar field of sacred and profane, lawful and unlawful, religious and blasphemous. It was a gesture charged with risks long before it became a possession caught in a circuit of property values.[20] But it was at the moment when a system of ownership and strict copyright rules were established (toward the end of the eighteenth and beginning of the nineteenth century) that the transgressive

properties always intrinsic to the act of writing became the forceful imperative of literature.[21] It is as if the author, at the moment he was accepted into the social order of property which governs our culture, was compensating for his new status by reviving the older bipolar field of discourse in a systematic practice of transgression and by restoring the danger of writing which, on another side, had been conferred the benefits of property.

Secondly, the 'author-function'[22] is not universal or constant in all discourse. Even within our civilization, the same types of texts have not always required authors; there was a time when those texts which we now call 'literary' (stories, folk tales, epics, and tragedies) were accepted, circulated, and valorized without any question about the identity of their author. Their anonymity was ignored because their real or supposed age was a sufficient guarantee of their authenticity. Texts, however, that we now call 'scientific' (dealing with cosmology and the heavens, medicine or illness, the natural sciences or geography) were only considered truthful during the Middle Ages if the name of the author was indicated. Statements on the order of 'Hippocrates said . . .' or 'Pliny tells us that . . .' were not merely formulas for an argument based on authority; they marked a proven discourse. In the seventeenth and eighteenth centuries, a totally new conception was developed when scientific texts were accepted on their own merits and positioned within an anonymous and coherent conceptual system of established truths and methods of verification. Authentification no longer required reference to the individual who had produced them; the role of the author disappeared as an index of truthfulness and, where it remained as an inventor's name, it was merely to denote a specific theorem or proposition, a strange effect, a property, a body, a group of elements, or pathological syndrome.

At the same time, however, 'literary' discourse was acceptable only if it carried an author's name; every text of poetry or fiction was obliged to state its author and the date, place, and circumstance of its writing. The meaning and value attributed to the text depended on this information. If by accident or design a text was presented anonymously, every effort was made to locate its author. Literary anonymity was of interest only as a puzzle to be solved as, in our day, literary works are totally dominated by the sovereignty of the author. (Undoubtedly, these remarks are far too categorical. Criticism has been concerned for some time now with aspects of a text not fully dependent on the notion of an individual creator; studies of genre or the analysis of recurring textual motifs and their variations from a norm other than the author. Furthermore, where in mathematics the author has become little more than a handy reference for a particular theorem or group of propositions, the reference to an author in biology and medicine, or to the date of his research has a substantially different bearing. This latter refer-

ence, more than simply indicating the source of information, attests to the 'reliability' of the evidence, since it entails an appreciation of the techniques and experimental materials available at a given time and in a particular laboratory.)

The third point concerning this 'author-function' is that it is not formed spontaneously through the simple attribution of a discourse to an individual. It results from a complex operation whose purpose is to construct the rational entity we call an author. Undoubtedly, this construction is assigned a 'realistic' dimension as we speak of an individual's 'profundity' or 'creative' power, his intentions or the original inspiration manifested in writing. Nevertheless, these aspects of an individual, which we designate as an author (or which comprise an individual as an author), are projections, in terms always more or less psychological, of our way of handling texts: in the comparisons we make, the traits we extract as pertinent, the continuities we assign, or the exclusions we practice. In addition, all these operations vary according to the period and the form of discourse concerned. A 'philosopher' and a 'poet' are not constructed in the same manner; and the author of an eighteenth-century novel was formed differently from the modern novelist. There are, nevertheless, transhistorical constants in the rules that govern the construction of an author.

In literary criticism, for example, the traditional methods for defining an author—or, rather, for determining the configuration of the author from existing texts—derive in large part from those used in the Christian tradition to authenticate (or to reject) the particular texts in its possession. Modern criticism, in its desire to 'recover' the author from a work, employs devices strongly reminiscent of Christian exegesis when it wished to prove the value of a text by ascertaining the holiness of its author. In *De Viris Illustribus*, Saint Jerome maintains that homonymy is not proof of the common authorship of several works, since many individuals could have the same name or someone could have perversely appropriated another's name. The name, as an individual mark, is not sufficient as it relates to a textual tradition. How, then, can several texts be attributed to an individual author? What norms, related to the function of the author, will disclose the involvement of several authors? According to Saint Jerome, there are four criteria: the texts that must be eliminated from the list of works attributed to a single author are those inferior to the others (thus, the author is defined as a standard level of quality); those whose ideas conflict with the doctrine expressed in the others (here the author is defined as a certain field of conceptual or theoretical coherence); those written in a different style and containing words and phrases not ordinarily found in the other works (the author is seen as a stylistic uniformity); and those referring to events or historical figures subsequent to the death of the author (the author is thus a definite historical figure

in which a series of events converge). Although modern criticism does not appear to have these same suspicions concerning authentication, its strategies for defining the author present striking similarities. The author explains the presence of certain events within a text, as well as their transformations, distortions, and their various modifications (and this through an author's biography or by reference to his particular point of view, in the analysis of his social preferences and his position within a class or by delineating his fundamental objectives). The author also constitutes a principle of unity in writing where any unevenness of production is ascribed to changes caused by evolution, maturation, or outside influence. In addition, the author serves to neutralize the contradictions that are found in a series of texts. Governing this function is the belief that there must be—at a particular level of an author's thought, of his conscious or unconscious desire—a point where contradictions are resolved, where the incompatible elements can be shown to relate to one another or to cohere around a fundamental and originating contradiction. Finally, the author is a particular source of expression who, in more or less finished forms, is manifested equally well, and with similar validity, in a text, in letters, fragments, drafts, and so forth. Thus, even while Saint Jerome's four principles of authenticity might seem largely inadequate to modern critics, they, nevertheless, define the critical modalities now used to display the function of the author.[23]

However, it would be false to consider the function of the author as a pure and simple reconstruction after the fact of a text given as passive material, since a text always bears a number of signs that refer to the author. Well known to grammarians, these textual signs are personal pronouns, adverbs of time and place, and the conjugation of verbs.[24] But it is important to note that these elements have a different bearing on texts with an author and on those without one. In the latter, these 'shifters' refer to a real speaker and to an actual deictic situation, with certain exceptions such as the case of indirect speech in the first person. When discourse is linked to an author, however, the role of 'shifters' is more complex and variable. It is well known that in a novel narrated in the first person, neither the first person pronoun, the present indicative tense, nor, for that matter, its signs of localization refer directly to the writer, either to the time when he wrote, or to the specific act of writing; rather, they stand for a 'second self'[25] whose similarity to the author is never fixed and undergoes considerable alteration within the course of a single book. It would be as false to seek the author in relation to the actual writer as to the fictional narrator; the 'author-function' arises out of their scission—in the division and distance of the two. One might object that this phenomenon only applies to novels or poetry, to a context of 'quasi-discourse,' but, in fact, all discourse that supports this 'author-function' is characterized by this plurality of egos.

In a mathematical treatise, the ego who indicates the circumstances of composition in the preface is not identical, either in terms of his position or his function, to the 'I' who concludes a demonstration within the body of the text. The former implies a unique individual who, at a given time and place, succeeded in completing a project, whereas the latter indicates an instance and plan of demonstration that anyone could perform provided the same set of axioms, preliminary operations, and an identical set of symbols were used. It is also possible to locate a third ego: one who speaks of the goals of his investigation, the obstacles encountered, its results, and the problems yet to be solved and this 'I' would function in a field of existing or future mathematical discourses. We are not dealing with a system of dependencies where a first and essential use of the 'I' is reduplicated, as a kind of fiction, by the other two. On the contrary, the 'author-function' in such discourses operates so as to effect the simultaneous dispersion of the three egos.[26]

Further elaboration would, of course, disclose other characteristics of the 'author-function,' but I have limited myself to the four that seemed the most obvious and important. They can be summarized in the following manner: the 'author-function' is tied to the legal and institutional systems that circumscribe, determine, and articulate the realm of discourses; it does not operate in a uniform manner in all discourses, at all times, and in any given culture; it is not defined by the spontaneous attribution of a text to its creator, but through a series of precise and complex procedures; it does not refer, purely and simply, to an actual individual insofar as it simultaneously gives rise to a variety of egos and to a series of subjective positions that individuals of any class may come to occupy.

I am aware that until now I have kept my subject within unjustifiable limits; I should also have spoken of the 'author-function' in painting, music, technical fields, and so forth. Admitting that my analysis is restricted to the domain of discourse, it seems that I have given the term 'author' an excessively narrow meaning. I have discussed the author only in the limited sense of a person to whom the production of a text, a book, or a work can be legitimately attributed. However, it is obvious that even within the realm of discourse a person can be the author of much more than a book—of a theory, for instance, of a tradition or a discipline within which new books and authors can proliferate. For convenience, we could say that such authors occupy a 'transdiscursive' position.

Homer, Aristotle, and the Church Fathers played this role, as did the first mathematicians and the originators of the Hippocratic tradition. This type of author is surely as old as our civilization. But I believe that the nineteenth century in Europe produced a singular type of author who should not be confused with 'great' literary authors, or the

authors of canonical religious texts, and the founders of sciences. Somewhat arbitrarily, we might call them 'initiators of discursive practices.'

The distinctive contribution of these authors is that they produced not only their own work, but the possibility and the rules of formation of other texts. In this sense, their role differs entirely from that of a novelist, for example, who is basically never more than the author of his own text. Freud is not simply the author of *The Interpretation of Dreams* or of *Wit and its Relation to the Unconscious* and Marx is not simply the author of the *Communist Manifesto* or *Capital:* they both established the endless possibility of discourse. Obviously, an easy objection can be made. The author of a novel may be responsible for more than his own text; if he acquires some 'importance' in the literary world, his influence can have significant ramifications. To take a very simple example, one could say that Ann Radcliffe did not simply write *The Mysteries of Udolpho* and a few other novels, but also made possible the appearance of Gothic Romances at the beginning of the nineteenth century. To this extent, her function as an author exceeds the limits of her work. However, this objection can be answered by the fact that the possibilities disclosed by the initiators of discursive practices (using the examples of Marx and Freud, whom I believe to be the first and the most important) are significantly different from those suggested by novelists. The novels of Ann Radcliffe put into circulation a certain number of resemblances and analogies patterned on her work—various characteristic signs, figures, relationships, and structures that could be integrated into other books. In short, to say that Ann Radcliffe created the Gothic Romance means that there are certain elements common to her works and to the nineteenth-century Gothic romance: the heroine ruined by her own innocence, the secret fortress that functions as a counter-city, the outlaw-hero who swears revenge on the world that has cursed him, etc. On the other hand, Marx and Freud, as 'initiators of discursive practices,' not only made possible a certain number of analogies that could be adopted by future texts, but, as importantly, they also made possible a certain number of differences. They cleared a space for the introduction of elements other than their own, which, nevertheless, remain within the field of discourse they initiated. In saying that Freud founded psychoanalysis, we do not simply mean that the concept of libido or the techniques of dream analysis reappear in the writings of Karl Abraham or Melanie Klein, but that he made possible a certain number of differences with respect to his books, concepts, and hypotheses, which all arise out of psychoanalytic discourse.

Is this not the case, however, with the founder of any new science or of any author who successfully transforms an existing science? After all, Galileo is indirectly responsible for the texts of those who mechan-

ically applied the laws he formulated, in addition to having paved the way for the production of statements far different from his own. If Cuvier is the founder of biology and Saussure of linguistics, it is not because they were imitated or that an organic concept or a theory of the sign was uncritically integrated into new texts, but because Cuvier, to a certain extent, made possible a theory of evolution diametrically opposed to his own system and because Saussure made possible a generative grammar radically different from his own structural analysis. Superficially, then, the initiation of discursive practices appears similar to the founding of any scientific endeavor, but I believe there is a fundamental difference.

In a scientific program, the founding act is on an equal footing with its future transformations: it is merely one among the many modifications that it makes possible. This interdependence can take several forms. In the future development of a science, the founding act may appear as little more than a single instance of a more general phenomenon that has been discovered. It might be questioned, in retrospect, for being too intuitive or empirical and submitted to the rigors of new theoretical operations in order to situate it in a formal domain. Finally, it might be thought a hasty generalization whose validity should be restricted. In other words, the founding act of a science can always be rechanneled through the machinery of transformations it has instituted.[27]

On the other hand, the initiation of a discursive practice is heterogeneous to its ulterior transformations. To extend psychoanalytic practice, as initiated by Freud, is not to presume a formal generality that was not claimed at the outset; it is to explore a number of possible applications. To limit it is to isolate in the original texts a small set of propositions or statements that are recognized as having an inaugurative value and that mark other Freudian concepts or theories as derivative. Finally, there are no 'false' statements in the work of these initiators; those statements considered inessential or 'prehistoric,' in that they are associated with another discourse, are simply neglected in favor of the more pertinent aspects of the work. The initiation of a discursive practice, unlike the founding of a science, overshadows and is necessarily detached from its later developments and transformations. As a consequence, we define the theoretical validity of a statement with respect to the work of the initiator, whereas in the case of Galileo or Newton, it is based on the structural and intrinsic norms established in cosmology or physics. Stated schematically, the work of these initiators is not situated in relation to a science or in the space it defines; rather, it is science or discursive practice that relate to their works as the primary points of reference.

In keeping with this distinction, we can understand why it is inevitable that practitioners of such discourses must 'return to the origin.'

Here, as well, it is necessary to distinguish a 'return' from scientific 're-discoveries' or 'reactivations.' 'Rediscoveries' are the effects of analogy or isomorphism with current forms of knowledge that allow the perception of forgotten or obscured figures. For instance, Chomsky in his book on Cartesian grammar[28] 'rediscovered' a form of knowledge that had been in use from Cordemoy to Humboldt. It could only be understood from the perspective of generative grammar because this later manifestation held the key to its construction: in effect, a retrospective codification of an historical position. 'Reactivation' refers to something quite different: the insertion of discourse into totally new domains of generalization, practice, and transformations. The history of mathematics abounds in examples of this phenomenon as the work of Michel Serres on mathematical anamnesis shows.[29]

The phrase, 'return to,' designates a movement with its proper specificity, which characterizes the initiation of discursive practices. If we return, it is because of a basic and constructive omission, an omission that is not the result of accident or incomprehension.[30] In effect, the act of initiation is such, in its essence, that it is inevitably subjected to its own distortions; that which displays this act and derives from it is, at the same time, the root of its divergences and travesties. This nonaccidental omission must be regulated by precise operations that can be situated, analysed, and reduced in a return to the act of initiation. The barrier imposed by omission was not added from the outside; it arises from the discursive practice in question, which gives it its law. Both the cause of the barrier and the means for its removal, this omission—also responsible for the obstacles that prevent returning to the act of initiation—can only be resolved by a return. In addition, it is always a return to a text in itself, specifically, to a primary and unadorned text with particular attention to those things registered in the interstices of the text, its gaps and absences. We return to those empty spaces that have been masked by omission or concealed in a false and misleading plenitude. In these rediscoveries of an essential lack, we find the oscillation of two characteristic responses: 'This point was made—you can't help seeing it if you know how to read'; or, inversely, 'No, that point is not made in any of the printed words in the text, but it is expressed through the words, in their relationships and in the distance that separates them.' It follows naturally that this return, which is a part of the discursive mechanism, constantly introduces modifications and that the return to a text is not a historical supplement that would come to fix itself upon the primary discursivity and redouble it in the form of an ornament which, after all, is not essential. Rather, it is an effective and necessary means of transforming discursive practice. A study of Galileo's works could alter our knowledge of the history, but not the science, of mechanics; whereas, a re-examination of the books of Freud or Marx can transform our understanding of psychoanalysis or Marxism.

A last feature of these returns is that they tend to reinforce the enigmatic link between an author and his works. A text has an inaugurative value precisely because it is the work of a particular author, and our returns are conditioned by this knowledge. The rediscovery of an unknown text by Newton or Cantor will not modify classical cosmology or group theory; at most, it will change our appreciation of their historical genesis. Bringing to light, however, *An Outline of Psychoanalysis*, to the extent that we recognize it as a book by Freud, can transform not only our historical knowledge, but the field of psychoanalytic theory—if only through a shift of accent or of the center of gravity. These returns, an important component of discursive practices, form a relationship between 'fundamental' and mediate authors, which is not identical to that which links an ordinary text to its immediate author.

These remarks concerning the initiation of discursive practices have been extremely schematic, especially with regard to the opposition I have tried to trace between this initiation and the founding of sciences. The distinction between the two is not readily discernible; moreover, there is no proof that the two procedures are mutually exclusive. My only purpose in setting up this opposition, however, was to show that the 'author-function,' sufficiently complex at the level of a book or a series of texts that bear a definite signature, has other determining factors when analysed in terms of larger entities—groups of works or entire disciplines.

Unfortunately, there is a decided absence of positive propositions in this essay, as it applies to analytic procedures or directions for future research, but I ought at least to give the reasons why I attach such importance to a continuation of this work. Developing a similar analysis could provide the basis for a typology of discourse. A typology of this sort cannot be adequately understood in relation to the grammatical features, formal structures, and objects of discourse, because there undoubtedly exist specific discursive properties or relationships that are irreducible to the rules of grammar and logic and to the laws that govern objects. These properties require investigation if we hope to distinguish the larger categories of discourse. The different forms of relationships (or nonrelationships) that an author can assume are evidently one of these discursive properties.

This form of investigation might also permit the introduction of an historical analysis of discourse. Perhaps the time has come to study not only the expressive value and formal transformations of discourse, but its mode of existence: the modifications and variations, within any culture, of modes of circulation, valorization, attribution, and appropriation. Partially at the expense of themes and concepts that an author places in his work, the 'author-function' could also reveal the manner in which discourse is articulated on the basis of social relationships.

Is it not possible to reexamine, as a legitimate extension of this kind of analysis, the privileges of the subject? Clearly, in undertaking an internal and architectonic analysis of a work (whether it be a literary text, a philosophical system, or a scientific work) and in delimiting psychological and biographical references, suspicions arise concerning the absolute nature and creative role of the subject. But the subject should not be entirely abandoned. It should be reconsidered, not to restore the theme of an originating subject, but to seize its functions, its intervention in discourse, and its system of dependencies. We should suspend the typical questions: how does a free subject penetrate the density of things and endow them with meaning; how does it accomplish its design by animating the rules of discourse from within? Rather, we should ask: under what conditions and through what forms can an entity like the subject appear in the order of discourse; what position does it occupy; what functions does it exhibit; and what rules does it follow in each type of discourse? In short, the subject (and its substitutes) must be stripped of its creative role and analysed as a complex and variable function of discourse.

The author—or what I have called the 'author-function'—is undoubtedly only one of the possible specifications of the subject and, considering past historical transformations, it appears that the form, the complexity, and even the existence of this function are far from immutable. We can easily imagine a culture where discourse would circulate without any need for an author. Discourses, whatever their status, form, or value, and regardless of our manner of handling them, would unfold in a pervasive anonymity. No longer the tiresome repetitions:

'Who is the real author?'

'Have we proof of his authenticity and originality?'

'What has he revealed of his most profound self in his language?'

New questions will be heard:

'What are the modes of existence of this discourse?'

'Where does it come from; how is it circulated; who controls it?'

'What placements are determined for possible subjects?'

'Who can fulfill these diverse functions of the subject?'

Behind all these questions we would hear little more than the murmur of indifference:

'What matter who's speaking?'

The Allegorical Impulse: Toward a Theory of Postmodernism

> Every image of the past that is not recognized by the present as one of its own concerns threatens to disappear irretrievably.
>
> Walter Benjamin, 'Theses on the Philosophy of History'

I

In a review of Robert Smithson's collected writings, published in this journal in Fall 1979, I proposed that Smithson's 'genius' was an allegorical one, involved in the liquidation of an aesthetic tradition which he perceived as more or less ruined. To impute an allegorical motive to contemporary art is to venture into proscribed territory, for allegory has been condemned for nearly two centuries as aesthetic aberration, the antithesis of art. In *Aesthetic* Croce refers to it as 'science, or art aping science'; Borges once called it an 'aesthetic error.' Although he surely remains one of the most allegorical of contemporary writers, Borges nevertheless regards allegory as an outmoded, exhausted device, a matter of *historical* but certainly not critical interest. Allegories appear in fact to represent for him the distance between the present and an irrecoverable past:

I know that at one time the allegorical art was considered quite charming ... and is now intolerable. We feel that, besides being intolerable, it is stupid and frivolous. Neither Dante, who told the story of his passion in the *Vita nuova*; nor the Roman Boethius, writing his *De consolatione* in the tower of Pavia, in the shadow of his executioner's sword, would have understood our feeling. How can I explain that difference in outlook without simply appealing to the principle of changing tastes?[1]

This statement is doubly paradoxical, for not only does it contradict the allegorical nature of Borges's own fiction, it also denies allegory what is most proper to it: its capacity to rescue from historical oblivion that which threatens to disappear. Allegory first emerged in response to a similar sense of estrangement from tradition; throughout its history it has functioned in the gap between a present and a past which, without allegorical reinterpretation, might have remained foreclosed. A conviction of the remoteness of the past, and a desire to redeem it for the present—these are its two most fundamental impulses. They ac-

52 Troy Brauntuch
Untitled (detail of three-panel work), 1979

count for its role in psychoanalytic inquiry, as well as its significance for Walter Benjamin, the only twentieth-century critic to treat the subject without prejudice, philosophically.[2] Yet they fail to explain why allegory's *aesthetic* potential should appear to have been exhausted long ago; nor do they enable us to locate the historical breach at which allegory itself receded into the depths of history.

Inquiry into the origins of the modern attitude toward allegory might appear as 'stupid and frivolous' as its topic were it not for the fact that an unmistakably allegorical impulse has begun to reassert itself in various aspects of contemporary culture: in the Benjamin revival, for example, or in Harold Bloom's *The Anxiety of Influence*. Allegory is also manifest in the historical revivalism that today characterizes architectural practice, and in the revisionist stance of much recent art-historical discourse: T. J. Clark, for example, treating mid-nineteenth-century painting as political 'allegory.' In what follows, I want to focus this reemergence through its impact on both the practice and the criticism of the visual arts. There are, as always, important precedents to be accounted for: Duchamp identified both the 'instantaneous state of Rest' and the 'extra rapid exposure,' that is, the photographic aspects,[3] of the *Large Glass* as 'allegorical appearance'; *Allegory* is also the title of one of Rauschenberg's most ambitious combine paintings from the fifties. Consideration of such works must be postponed, however, for their importance becomes apparent only after the suppression of allegory by modern theory has been fully acknowledged.

In order to recognize allegory in its contemporary manifestations, we first require a general idea of what it in fact is, or rather what it *represents*, since allegory is an attitude as well as a technique, a perception as well as a procedure. Let us say for the moment that allegory occurs whenever one text is doubled by another; the Old Testament, for example, becomes allegorical when it is read as a prefiguration of

the New. This provisional description—which is not a definition—accounts for both allegory's origin in commentary and exegesis, as well as its continued affinity with them: as Northrop Frye indicates, the allegorical work tends to prescribe the direction of its own commentary. It is this metatextual aspect that is invoked whenever allegory is attacked as interpretation merely appended *post facto* to a work, a rhetorical ornament or flourish. Still, as Frye contends, 'genuine allegory is a structural element in literature; it has to be there, and cannot be added by critical interpretation alone.'[4] In allegorical structure, then, one text is *read through* another, however fragmentary, intermittent, or chaotic their relationship may be; the paradigm for the allegorical work is thus the palimpsest. (It is from here that a reading of Borges's allegorism might be launched, with 'Pierre Menard, Author of the *Quixote*' or several of the *Chronicles of Bustos Domecq*, where the text is posited by its own commentary.)

Conceived in this way, allegory becomes the model of all commentary, all critique, insofar as these are involved in rewriting a primary text in terms of its figural meaning. I am interested, however, in what occurs when this relationship takes place *within* works of art, when it describes their structure. Allegorical imagery is appropriated imagery; the allegorist does not invent images but confiscates them. He lays claim to the culturally significant, poses as its interpreter. And in his hands the image becomes something other (*allos* = other + *agoreuei* = to speak). He does not restore an original meaning that may have been lost or obscured; allegory is not hermeneutics. Rather, he adds another meaning to the image. If he adds, however, he does so only to replace: the allegorical meaning supplants an antecedent one; it is a supplement. This is why allegory is condemned, but it is also the source of its theoretical significance.

The first link between allegory and contemporary art may now be made: with the appropriation of images that occurs in the works of Troy Brauntuch [**52**], Sherrie Levine, Robert Longo …—artists who generate images through the reproduction of other images. The appropriated image may be a film still, a photograph, a drawing; it is often itself already a reproduction. However, the manipulations to which these artists subject such images work to empty them of their resonance, their significance, their authoritative claim to meaning. Through Brauntuch's enlargements, for example, Hitler's drawings, or those of concentration camp victims, exhibited without captions, become resolutely opaque:

Every operation to which Brauntuch subjects these pictures represents the duration of a fascinated, perplexed gaze, whose desire is that they disclose their secrets; but the result is only to make the pictures all the more picturelike, to fix forever in an elegant object our *distance from the history* that produced these images. *That distance is all these pictures signify.*[5]

Brauntuch's is thus that melancholy gaze which Benjamin identified with the allegorical temperament:

If the object becomes allegorical under the gaze of melancholy, if melancholy causes life to flow out of it and it remains behind dead, but eternally secure, then it is exposed to the allegorist, it is unconditionally in his power. That is to say it is now quite incapable of emanating any meaning or significance of its own; such significance as it has, it acquires from the allegorist. He places it within it, and stands behind it; not in a psychological but in an ontological sense.[6]

Brauntuch's images simultaneously proffer and defer a promise of meaning; they both solicit and frustrate our desire that the image be directly transparent to its signification. As a result, they appear strangely incomplete—fragments or runes which must be *deciphered*.

Allegory is consistently attracted to the fragmentary, the imperfect, the incomplete—an affinity which finds its most comprehensive expression in the ruin, which Benjamin identified as the allegorical emblem par excellence. Here the works of man are reabsorbed into the landscape; ruins thus stand for history as an irreversible process of dissolution and decay, a progressive distancing from origin:

In allegory the observer is confronted with the *facies hippocratica* of history as a petrified, primordial landscape. Everything about history that, from the very beginning, had been untimely, sorrowful, unsuccessful, is expressed in a face—or rather in a death's head. And although such a thing lacks all 'symbolic' freedom of expression, all classical proportion, all humanity—nevertheless, this is the form in which man's subjection to nature is most obvious and it significantly gives rise to not only the enigmatic question of the nature of human existence as such, but also of the biographical historicity of the individual. This is the heart of the allegorical way of seeing...[7]

With the allegorical cult of the ruin, a second link between allegory and contemporary art emerges: in site specificity, the work which appears to have merged physically into its setting, to be embedded in the place where we encounter it. The site-specific work often aspires to a prehistoric monumentality; Stonehenge and the Nazca lines are taken as prototypes. Its 'content' is frequently mythical, as that of the *Spiral Jetty*, whose form was derived from a local myth of a whirlpool at the bottom of the Great Salt Lake; in this way Smithson exemplifies the tendency to engage in a *reading* of the site, in terms not only of its topographical specifics but also of its psychological resonances. Work and site thus stand in a dialectical relationship. (When the site-specific work is conceived in terms of land reclamation, and installed in an abandoned mine or quarry, then its 'defensively recuperative' motive becomes self-evident.)

Site-specific works are impermanent, installed in particular loca-

tions for a limited duration, their impermanence providing the measure of their circumstantiality. Yet they are rarely dismantled but simply abandoned to nature; Smithson consistently acknowledged as part of his works the forces which erode and eventually reclaim them for nature. In this, the site-specific work becomes an emblem of transience, the ephemerality of all phenomena; it is the memento mori of the twentieth century. Because of its impermanence, moreover, the work is frequently preserved only in photographs. This fact is crucial, for it suggests the allegorical potential of photography. 'An appreciation of the transience of things, and the concern to rescue them for eternity, is one of the strongest impulses in allegory.'[8] And photography, we might add. As an allegorical art, then, photography would represent our desire to fix the transitory, the ephemeral, in a stable and stabilizing image. In the photographs of Atget and Walker Evans, insofar as they self-consciously preserve that which threatens to disappear, that desire becomes the *subject* of the image. If their photographs are allegorical, however, it is because what they offer is only a fragment, and thus affirms its own arbitrariness and contingency.[9]

We should therefore also be prepared to encounter an allegorical motive in photomontage, for it is the 'common practice' of allegory 'to pile up fragments ceaselessly, without any strict idea of a goal.'[10] This method of construction led Angus Fletcher to liken allegorical structure to obsessional neurosis;[11] and the obsessiveness of the works of Sol LeWitt, say, or Hanne Darboven suggests that they too may fall within the compass of the allegorical. Here we encounter yet a third link between allegory and contemporary art: in strategies of accumulation, the paratactic work composed by the simple placement of 'one thing after another'—Carl Andre's *Lever* or Trisha Brown's *Primary Accumulation*. One paradigm for the allegorical work is the mathematical progression:

If a mathematician sees the numbers 1, 3, 6, 11, 20, he would recognize that the

'meaning' of this progression can be recast into the algebraic language of the formula: X plus 2^x, with certain restrictions on X. What would be a random sequence to an inexperienced person appears to the mathematician a meaningful sequence. Notice that the progression can go on ad infinitum. This parallels the situation in almost all allegories. They have no inherent 'organic' limit of magnitude. Many are unfinished like *The Castle* and *The Trial* of Kafka.[12]

Allegory concerns itself, then, with the projection—either spatial or temporal or both—of structure as sequence; the result, however, is not dynamic, but static, ritualistic, repetitive. It is thus the epitome of counter-narrative, for it arrests narrative in place, substituting a principle of syntagmatic disjunction for one of diegetic combination. In this way allegory superinduces a vertical or paradigmatic reading of correspondences upon a horizontal or syntagmatic chain of events. The work of Andre, Brown, LeWitt, Darboven, and others, involved as it is with the externalization of logical procedure, its projection as a spatiotemporal experience, also solicits treatment in terms of allegory.

This projection of structure as sequence recalls the fact that, in rhetoric, allegory is traditionally defined as a single metaphor introduced in continuous series. If this definition is recast in structuralist terms, then allegory is revealed to be the projection of the metaphoric axis of language onto its metonymic dimension. Roman Jakobson defined this projection of metaphor onto metonymy as the 'poetic function,' and he went on to associate metaphor with poetry and romanticism, and metonymy with prose and realism. Allegory, however, implicates *both* metaphor and metonymy; it therefore tends to 'cut across and subtend all such stylistic categorizations, being equally possible in either verse or prose, and quite capable of transforming the most objective naturalism into the most subjective expressionism, or the most determined realism into the most surrealistically ornamental baroque.'[13] This blatant disregard for aesthetic categories is nowhere more apparent than in the reciprocity which allegory proposes between the visual and the verbal: words are often treated as purely visual phenomena, while visual images are offered as script to be deciphered. It was this aspect of allegory that Schopenhauer criticized when he wrote:

If the desire for fame is firmly and permanently rooted in a man's mind ... and if he now stands before the *Genius of Fame* [by Annibale Caracci] with its laurel crowns, then his whole mind is thus excited, and his powers are called into activity. But the same thing would also happen if he suddenly saw the word 'fame' in large clear letters on the wall.[14]

As much as this may recall the linguistic conceits of conceptual artists Robert Barry and Lawrence Weiner, whose work is in fact conceived as large, clear letters on the wall, what it in fact reveals is the essentially

pictogrammatical nature of the allegorical work. In allegory, the image is a hieroglyph; an allegory is a rebus—writing composed of concrete images.[15] Thus we should also seek allegory in contemporary works which deliberately follow a discursive model: Rauschenberg's *Rebus*, or Twombly's series after the allegorical poet Spenser [**53**].

This confusion of the verbal and the visual is however but one aspect of allegory's hopeless confusion of all aesthetic mediums and stylistic categories (hopeless, that is, according to any partitioning of the aesthetic field on essentialist grounds). The allegorical work is synthetic; it crosses aesthetic boundaries. This confusion of genre, anticipated by Duchamp, reappears today in hybridization, in eclectic works which ostentatiously combine previously distinct art mediums.

Appropriation, site specificity, impermanence, accumulation, discursivity, hybridization—these diverse strategies characterize much of the art of the present and distinguish it from its modernist predecessors. They also form a whole when seen in relation to allegory, suggesting that postmodernist art may in fact be identified by a single, coherent impulse, and that criticism will remain incapable of accounting for that impulse as long as it continues to think of allegory as aesthetic error. We are therefore obliged to return to our initial questions: When was allegory first proscribed, and for what reasons?

The critical suppression of allegory is one legacy of romantic art theory that was inherited uncritically by modernism. Twentieth-century allegories—Kafka's, for example, or Borges's own—are rarely *called* allegories, but parables or fables; by the middle of the nineteenth century, however, Poe—who was not himself immune to allegory—could already accuse Hawthorne of 'allegorizing,' of appending moral tags to otherwise innocent tales. The history of modernist painting is begun with Manet [**54, 55**] and not Courbet, who persisted in painting 'real allegories.' Even the most supportive of Courbet's contemporaries (Prudhon and Champfleury) were perplexed by his allegorical bent; one was either a realist *or* an allegorist, they insisted, meaning that one was either modernist or historicist.

In the visual arts, it was in large measure allegory's association with history painting that prepared for its demise. From the Revolution on, it had been enlisted in the service of historicism to produce image upon image of the present *in terms of* the classical past. This relationship was expressed not only superficially, in details of costume and physiognomy, but also structurally, through a radical condensation of narrative into a single, emblematic instant—significantly, Barthes calls it a hieroglyph[16]—in which the past, present, and future, that is, the *historical* meaning, of the depicted action might be read. This is of course the doctrine of the most pregnant moment, and it dominated artistic practice during the first half of the nineteenth century. Syntagmatic or narrative associations were compressed in order to compel a vertical

reading of (allegorical) correspondences. Events were thus lifted out of a continuum; as a result, history could be recovered only through what Benjamin has called 'a tiger's leap into the past':

Thus to Robespierre ancient Rome was a past charged with the time of the now which he blasted out of the continuum of history. The French Revolution viewed itself as Rome reincarnate. It evoked ancient Rome the way fashion evokes costumes of the past. Fashion has a flair for the topical, no matter where it stirs in the thickets of long ago; it is a tiger's leap into the past.[17]

Although for Baudelaire this allegorical interpenetration of modernity and classical antiquity possessed no small theoretical significance, the attitude of the avant-garde which emerged at mid-century into an atmosphere rife with historicism was succinctly expressed by Prudhon, writing of David's *Leonidas at Thermopyle:*

Shall one say ... that it is neither Leonidas and the Spartans, nor the Greeks and Persians who one should see in this great composition; that it is the enthusiasm of '92 which the painter had in view and Republican France saved

from the Coalition? But why this allegory? What need to pass through Thermopyle and go backward twenty-three centuries to reach the heart of Frenchmen? Had we no heroes, no victories of our own?[18]

So that by the time Courbet attempted to rescue allegory for modernity, the line which separated them had been clearly drawn, and allegory, conceived as antithetical to the modernist credo *Il faut être de son temps*, was condemned, along with history painting, to a marginal, purely historical existence. . . .

II

Near the beginning of 'The Origin of the Work of Art,' Heidegger introduces two terms which define the 'conceptual frame' within which the work of art is conventionally located by aesthetic thought:

The art work is, to be sure, a thing that is made, but it says something other than the mere thing itself is, *allo agoreuei*. The work makes public something other than itself; it manifests something other; it is an allegory. In the work of art something other is brought together with the thing that is made. To bring together is, in Greek, *sumballein*. The work is a symbol.[19]

By imputing an allegorical dimension to every work of art, the philosopher appears to repeat the error, regularly lamented by commentators, of generalizing the term *allegory* to such an extent that it becomes meaningless. Yet in this passage Heidegger is only reciting the litanies of philosophical aesthetics in order to prepare for their dissolution. The point is ironic, and it should be remembered that irony itself is regularly enlisted as a variant of the allegorical; that words can be used to signify their opposites is in itself a fundamentally allegorical perception.

Allegory and symbol—like all conceptual pairs, the two are far from evenly matched. In modern aesthetics, allegory is regularly subordinated to the symbol, which represents the supposedly indissoluble unity of form and substance which characterizes the work of art as pure presence. Although this definition of the art work as informed matter is, we know, as old as aesthetics itself, it was revived with a sense of renewed urgency by romantic art theory, where it provided the basis for the philosophical condemnation of allegory. According to Coleridge, 'The Symbolical cannot, perhaps, be better defined in distinction from the Allegorical, than that it is always itself *a part of* that, of the whole of which it is the representative.'[20] The symbol is a synecdoche, a part representing the whole. This definition is possible, however, if and only if the relationship of the whole to its parts be conceived in a particular manner. This is the theory of expressive causality analyzed by Althusser in *Reading Capital*:

[The Leibnitzian concept of expression] presupposes in principle that the whole in question be reducible to an *inner essence*, of which the elements of the whole are then no more than the phenomenal forms of expression, the inner

principle of the essence being present at each point in the whole, such that at each moment it is possible to write the immediately adequate equation: *such and such an element … = the inner essence of the whole*. [italics added] Here was a model which made it possible to think the effectivity of the whole on each of its elements, but if this category—inner essence/outer phenomenon—was to be applicable everywhere and at every moment to each of the phenomena arising in the totality in question, it presupposed that the whole had a certain nature, precisely the nature of a 'spiritual' whole in which each element was expressive of the entire totality as a 'pars totalis.'[21]

Coleridge's is thus an expressive theory of the symbol, the presentational union of 'inner essence' and outward expression, which are in fact revealed to be identical. For essence is nothing but that element of the whole which has been hypostasized as its essence. The theory of expression thus proceeds in a circle: while designed to explain the effectivity of the whole on its constituent elements, it is nevertheless those elements themselves which react upon the whole, permitting us to conceive the latter in terms of its 'essence.' In Coleridge, then, the symbol is precisely that part of the whole to which it may be reduced. The symbol does not represent essence; it *is* essence.

On the basis of this identification, the symbol becomes the very emblem of artistic *intuition*: 'Of utmost importance to our present subject is this point, that the latter (the allegory) cannot be other than spoken consciously; whereas in the former (the symbol) it is very possible that the general truth represented may be working unconsciously in the writer's mind during the construction of the symbol.'[22] The symbol is thus a motivated sign; in fact, it represents linguistic motivation as such. For this reason de Saussure substituted the term *sign* for *symbol*, for the latter is 'never wholly arbitrary; it is not empty, for there is the rudiment of a natural bond between the signifier and the signified.'[23] If the symbol is a motivated sign, then allegory, conceived as its antithesis, will be identified as the domain of the arbitrary, the conventional, the unmotivated.

This association of the symbol with aesthetic intuition, and allegory with convention, was inherited uncritically by modern aesthetics; thus Croce in *Aesthetic*:

Now if the symbol be conceived as inseparable from the artistic intuition, it is a synonym for the intuition itself, which always has an ideal character. There is no double bottom to art, but one only; in art all is symbolical because all is ideal. But if the symbol be conceived as separable—if the symbol can be on one side, and on the other the thing symbolized, we fall back into the intellectualist error: the so-called symbol is the exposition of an abstract concept, an allegory; it is science, or art aping science. But we must also be just towards the allegorical. Sometimes it is altogether harmless. Given the *Gerusalemme liberata*, the allegory was imagined afterwards; given the *Adone* of Marino, the poet of the lascivious afterwards insinuated that it was written to show how

56 Robert Smithson
Broken Circle, Emmen,
Holland, 1971–72

'immoderate indulgence ends in pain'; given a statue of a beautiful woman, the sculptor can attach a label to the statue saying that it represents *Clemency* or *Goodness*. This allegory that arrives attached to a finished work *post festum* does not change the work of art. What is it then? It is an expression externally added to another expression.[24]

In the name of 'justice,' then, and in order to preserve the intuitive character of every work of art, including the allegorical, allegory is conceived as a *supplement*, 'an expression externally added to another expression.' Here we recognize that permanent strategy of Western art theory which excludes from the work everything which challenges its determination as the unity of 'form' and 'content.'[25] Conceived as something added or superadded to the work after the fact, allegory will consequently be detachable from it. In this way modernism can recuperate allegorical works for itself, on the condition that what makes them allegorical be overlooked or ignored. Allegorical meaning does indeed appear supplementary; we can appreciate Bellini's *Allegory of Fortune*, for example, or read *Pilgrim's Progress* as Coleridge recommended, without regard for their iconographic significance. Rosemond Tuve describes the viewer's 'experience of a genre picture—or so he had thought it—turning into … [an] allegory before his eyes, by something he learns (usually about the history and thence the deeper significance of the image)'.[26] Allegory *is* extravagant, an expenditure of surplus

value; it is always *in excess*. Croce found it 'monstrous' precisely because it encodes two contents within one form.[27] Still, the allegorical supplement is not only an addition, but also a replacement. It takes the place of an earlier meaning, which is thereby either effaced or obscured. Because allegory usurps its object it comports within itself a danger, the possibility of perversion: that what is 'merely appended' to the work of art be mistaken for its 'essence.' Hence the vehemence with which modern aesthetics—formalist aesthetics in particular—rails against the allegorical supplement, for it challenges the security of the foundations upon which aesthetics is erected.

If allegory is identified as a supplement, then it is also aligned with writing, insofar as writing is conceived as supplementary to speech. It is of course within the same philosophic tradition which subordinates writing to speech that allegory is subordinated to the symbol. It might be demonstrated, from another perspective, that the suppression of allegory is identical with the suppression of writing. For allegory, whether visual or verbal, is essentially a form of script—this is the basis for Walter Benjamin's treatment of it in *The Origin of German Tragic Drama*: 'At one stroke the profound vision of allegory transforms things and works into stirring writing.'[28]

Benjamin's theory of allegory, which proceeds from the perception that 'any person, any object, any relationship can mean absolutely anything else,'[29] defies summary. Given its centrality to this essay, however, a few words concerning it are in order. Within Benjamin's œuvre, *The Origin of German Tragic Drama*, composed in 1924–25 and published in 1928, stands as a seminal work; in it are assembled the themes that will preoccupy him throughout his career: progress as the eternal return of the catastrophe; criticism as redemptive intervention into the past; the theoretical value of the concrete, the disparate, the discontinuous; his treatment of phenomena as script to be deciphered. This book thus reads like a prospectus for all of Benjamin's subsequent critical activity. As Anson Rabinbach observes in his introduction to the recent issue of *New German Critique* devoted to Benjamin, 'His writing forces us to think in correspondences, to proceed through allegorical images rather than through expository prose.'[30] The book on baroque tragedy thus throws into relief the essentially allegorical nature of all of Benjamin's work—the 'Paris Arcades' project, for example, where the urban landscape was to be treated as a sedimentation in depth of layers of meaning which would gradually be unearthed. For Benjamin, *inter*pretation is dis*inter*ment.

The Origin of German Tragic Drama is a treatise on critical method; it traces not only the origin of baroque tragedy, but also of the critical disapprobation to which it has been subject. Benjamin examines in detail the romantic theory of the symbol; by exposing its theological origins, he prepares for its supersedure:

The unity of the material and the transcendental object, which constitutes the paradox of the theological symbol, is distorted into a relationship between appearance and essence. The introduction of this distorted conception of the symbol into aesthetics was a romantic and destructive extravagance which preceded the desolation of modern art criticism. As a symbolic construct it is supposed to merge with the divine in an unbroken whole. The idea of the unlimited immanence of the moral world in the world of beauty is derived from the theosophical aesthetics of the romantics. But the foundations of this idea were laid long before.[31]

In its stead, Benjamin places the (graphic) sign, which represents the distance between an object and its significance, the progressive erosion of meaning, the absence of transcendence from within. Through this critical maneuver he is able to penetrate the veil which had obscured the achievement of the baroque, to appreciate fully its theoretical significance. But it also enables him to liberate writing from its traditional dependency on speech. In allegory, then, 'written language and sound confront each other in tense polarity. . . . The division between signifying written language and intoxicating spoken language opens up a gulf in the solid massif of verbal meaning and forces the gaze into the depths of language.'[32]

We encounter an echo of this passage in Robert Smithson's appeal for both an allegorical practice and an allegorical criticism of the visual arts in his text 'A Sedimentation of Mind: Earth Projects' [**56**]:

The names of minerals and the minerals themselves do not differ from each other, because at the bottom of both the material and the print is the beginning of an abysmal number of fissures. Words and rocks contain a language that follows a syntax of splits and ruptures. Look at any *word* long enough and you will see it open up into a series of faults, into a terrain of particles each containing its own void. . . .

Poe's *Narrative of A. Gordon Pym* seems to me excellent art criticism and prototype for rigorous 'non-site' investigations. . . . His descriptions of chasms and holes seem to verge on proposals for 'earthwords.'

Andreas Huyssen 1984

Mapping the Postmodern

[...] In a discussion of Flaubert and the writerly, i.e., modernist, text Barthes writes: 'He [Flaubert] does not stop the play of codes (or stops it only partially), so that (and this is indubitably the proof of writing) *one never knows if he is responsible for what he writes* (if there is a subject *behind* his language); for the very being of writing (the meaning of the labor that constitutes it) is to keep the question *Who is speaking?* from ever being answered.'[1] A similarly prescriptive denial of authorial subjectivity underlies Foucault's discourse analysis. Thus Foucault ends his influential essay 'What Is an Author?' by asking rhetorically 'What matter who's speaking?' Foucault's 'murmur of indifference'[2] affects both the writing and the speaking subject, and the argument assumes its full polemical force with the much broader anti-humanist proposition, inherited from structuralism, of the 'death of the subject.' But none of this is more than a further elaboration of the modernist critique of traditional idealist and romantic notions of authorship and authenticity, originality and intentionality, self-centered subjectivity and personal identity. More importantly, it seems to me that as a postmodern, having gone through the modernist purgatory, I would ask different questions. Isn't the 'death of the subject/author' position tied by mere reversal to the very ideology that invariably glorifies the artist as genius, whether for marketing purposes or out of conviction and habit? Hasn't capitalist modernization itself fragmented and dissolved bourgeois subjectivity and authorship, thus making attacks on such notions somewhat quixotic? And, finally, doesn't poststructuralism, where it simply denies the subject altogether, jettison the chance of challenging the *ideology of the subject* (as male, white, and middle-class) by developing alternative and different notions of subjectivity?

To reject the validity of the question Who is writing? or Who is speaking? is simply no longer a radical position in 1984. It merely duplicates on the level of aesthetics and theory what capitalism as a system of exchange relations produces tendentially in everyday life: the denial of subjectivity in the very process of its construction. Poststructuralism thus attacks the appearance of capitalist culture—individualism writ large—but misses its essence; like modernism, it is always also in sync with rather than opposed to the real processes of

modernization.

The postmoderns have recognized this dilemma. They counter the modernist litany of the death of the subject by working toward new theories and practices of speaking, writing and acting subjects.[3] The question of how codes, texts, images and other cultural artifacts constitute subjectivity is increasingly being raised as an always already historical question. And to raise the question of subjectivity at all no longer carries the stigma of being caught in the trap of bourgeois or petitbourgeois ideology; the discourse of subjectivity has been cut loose from its moorings in bourgeois individualism. It is certainly no accident that questions of subjectivity and authorship have resurfaced with a vengeance in the postmodern text. After all, it *does* matter who is speaking or writing.

Summing up, then, we face the paradox that a body of theories of modernism and modernity, developed in France since the 1960s, has come to be viewed, in the U.S., as the embodiment of the postmodern in theory. In a certain sense, this development is perfectly logical. Poststructuralism's readings of modernism are new and exciting enough to be considered somehow beyond modernism as it has been perceived before; in this way poststructuralist criticism in the U.S. yields to the very real pressures of the postmodern. But against any facile conflation of poststructuralism with the postmodern, we must insist on the fundamental non-identity of the two phenomena. In America, too, poststructuralism offers a theory of modernism, not a theory of the postmodern.

As to the French theorists themselves, they rarely speak of the postmodern. Lyotard's *La Condition Postmoderne*, we must remember, is the exception, not the rule.[4] What the French explicitly analyze and reflect upon is *le texte moderne* and *la modernité*. Where they talk about the postmodern at all, as in the cases of Lyotard and Kristeva,[5] the question seems to have been prompted by American friends, and the discussion almost immediately and invariably turns back to problems of the modernist aesthetic. For Kristeva, the question of postmodernism is the question of how anything can be written in the 20th century and how we can talk about this writing. She goes on to say that postmodernism is 'that literature which writes itself with the more or less conscious intention of expanding the signifiable and thus the human realm.'[6] With the Bataillean formulation of writing-as-experience of limits, she sees the major writing since Mallarmé and Joyce, Artaud and Burroughs as the 'exploration of the typical imaginary relationship, that to the mother, through the most radical and problematic aspect of this relationship, language.'[7] Kristeva's is a fascinating and novel approach to the question of modernist literature, and one that understands itself as a political intervention. But it does not yield much for an exploration of the differences between modernity and postmoder-

nity. Thus it cannot surprise that Kristeva still shares with Barthes and the classical theorists of modernism an aversion to the media whose function, she claims, is to collectivize all systems of signs thus enforcing contemporary society's general tendency toward uniformity.

Lyotard, who like Kristeva and unlike the deconstructionists is a political thinker, defines the postmodern, in his essay 'Answering the Question: What is Postmodernism?,' as a recurring stage within the modern itself. He turns to the Kantian sublime for a theory of the non-representable essential to modern art and literature. Paramount are his interest in rejecting representation, which is linked to terror and totalitarianism, and his demand for radical experimentation in the arts. At first sight, the turn to Kant seems plausible in the sense that Kant's autonomy aesthetic and notion of 'disinterested pleasure' stands at the threshold of a modernist aesthetic, at a crucial juncture of that differentiation of spheres which has been so important in social thought from Weber to Habermas. And yet, the turn to Kant's sublime forgets that the 18th-century fascination with the sublime of the universe, the cosmos, expresses precisely that very desire of totality and representation which Lyotard so abhors and persistently criticizes in Habermas' work.[8] Perhaps Lyotard's text says more here than it means to. If historically the notion of the sublime harbors a secret desire for totality, then perhaps Lyotard's sublime can be read as an attempt to totalize the aesthetic realm by fusing it with all other spheres of life, thus wiping out the differentiations between the aesthetic realm and the life-world on which Kant did after all insist. At any rate, it is no coincidence that the first moderns in Germany, the Jena romantics, built their aesthetic strategies of the fragment precisely on a rejection of the sublime which to them had become a sign of the falseness of bourgeois accommodation to absolutist culture. Even today the sublime has not lost its link to terror which, in Lyotard's reading, it opposes. For what would be more sublime and unrepresentable than the nuclear holocaust, the bomb being the signifier of an ultimate sublime. But apart from the question whether or not the sublime is an adequate aesthetic category to theorize contemporary art and literature, it is clear that in Lyotard's essay the postmodern as aesthetic phenomenon is not seen as distinct from modernism. The crucial historical distinction which Lyotard offers in *La Condition Postmoderne* is that between the *métarécits* of liberation (the French tradition of enlightened modernity) and of totality (the German Hegelian/Marxist tradition) on the one hand, and the modernist experimental discourse of language games on the other. Enlightened modernity and its presumable consequences are pitted against aesthetic modernism. The irony in all of this, as Fred Jameson has remarked,[9] is that Lyotard's commitment to radical experimentation is politically 'very closely related to the conception of the revolutionary nature of high modernism that Habermas

faithfully inherited from the Frankfurt School.'

No doubt, there are historically and intellectually specific reasons for the French resistance to acknowledging the problem of the post-modern as a historical problem of the late 20th century. At the same time, the force of the French rereading of modernism proper is itself shaped by the pressures of the 1960s and 1970s, and it has thus raised many of the key questions pertinent to the culture of our own time. But it still has done very little toward illuminating an emerging post-modern culture, and it has largely remained blind to or uninterested in many of the most promising artistic endeavors today. French theory of the 1960s and 1970s has offered us exhilarating fireworks which illuminate a crucial segment of the trajectory of modernism, but, as appropriate with fireworks, after dusk has fallen. This view is borne out by none less than Michel Foucault who, in the late 1970s, criticized his own earlier fascination with language and epistemology as a limited project of an earlier decade: 'The whole relentless theorization of writing which we saw in the 1960s was doubtless only a swansong.'[10] Swansong of modernism, indeed; but as such already a moment of the postmodern. Foucault's view of the intellectual movement of the 1960s as a swansong, it seems to me, is closer to the truth than its American rewriting, during the 1970s, as the latest avantgarde.

Whither Postmodernism?

The cultural history of the 1970s still has to be written, and the various postmodernisms in art, literature, dance, theater, architecture, film, video, and music will have to be discussed separately and in detail. All I want to do now is to offer a framework for relating some recent cultural and political changes to postmodernism, changes which already lie outside the conceptual network of 'modernism/avantgardism' and have so far rarely been included in the postmodernism debate.[11]

I would argue that the contemporary arts—in the widest possible sense, whether they call themselves postmodernist or reject that label—can no longer be regarded as just another phase in the sequence of modernist and avantgardist movements which began in Paris in the 1850s and 1860s and which maintained an ethos of cultural progress and vanguardism through the 1960s. On this level, postmodernism cannot be regarded simply as a sequel to modernism, as the latest step in the neverending revolt of modernism against itself. The postmodern sensibility of our time is different from both modernism *and* avantgardism precisely in that it raises the question of cultural tradition and conservation in the most fundamental way as an aesthetic and a political issue. It doesn't always do it successfully, and often does it exploitatively. And yet, my main point about contemporary postmodernism is that it operates in a field of tension between tradition and innovation, conservation and renewal, mass culture and high art, in which the sec-

ond terms are no longer automatically privileged over the first; a field of tension which can no longer be grasped in categories such as progress vs. reaction, Left vs. Right, present vs. past, modernism vs. realism, abstraction vs. representation, avantgarde vs. Kitsch. The fact that such dichotomies, which after all are central to the classical accounts of modernism, have broken down is part of the shift I have been trying to describe. I could also state the shift in the following terms: Modernism and the avantgarde were always closely related to social and industrial modernization. They were related to it as an adversary culture, yes, but they drew their energies, not unlike Poe's *Man of the Crowd*, from their proximity to the crises brought about by modernization and progress. Modernization—such was the widely held belief, even when the word was not around—had to be traversed. There was a vision of emerging on the other side. The modern was a world-scale drama played out on the European and American stage, with mythic modern man as its hero and with modern art as a driving force, just as Saint-Simon had envisioned it already in 1825. Such heroic visions of modernity and of art as a force of social change (or, for that matter, resistance to undesired change) are a thing of the past, admirable for sure, but no longer in tune with current sensibilities, except perhaps with an emerging apocalyptic sensibility as the flip side of modernist heroism.

Seen in this light, postmodernism at its deepest level represents not just another crisis within the perpetual cycle of boom and bust, exhaustion and renewal, which has characterized the trajectory of modernist culture. It rather represents a new type of crisis *of* that modernist culture itself. Of course, this claim has been made before, and fascism indeed was a formidable crisis *of* modernist culture. But fascism was never the alternative to modernity it pretended to be, and our situation today is very different from that of the Weimar Republic in its agony. It was only in the 1970s that the historical limits of modernism, modernity and modernization came into sharp focus. The growing sense that we are not bound to *complete* the project of modernity (Habermas' phrase) and still do not necessarily have to lapse into irrationality or into apocalyptic frenzy, the sense that art is not exclusively pursuing some telos of abstraction, non-representation and sublimity—all of this has opened up a host of possibilities for creative endeavors today. And in certain ways it has altered our views of modernism itself. Rather than being bound to a one-way history of modernism which interprets it as a logical unfolding toward some imaginary goal, and which thus is based on a whole series of exclusions, we are beginning to explore its contradictions and contingencies, its tensions and internal resistances to its own 'forward' movement. Postmodernism is far from making modernism obsolete. On the contrary, it casts a new light on it and appropriates many of its aesthetic strategies and techniques inserting them and making them work in new constellations. What has

become obsolete, however, are those codifications of modernism in critical discourse which, however subliminally, are based on a teleological view of progress and modernization. Ironically, these normative and often reductive codifications have actually prepared the ground for that repudiation of modernism which goes by the name of the postmodern. Confronted with the critic who argues that this or that novel is not up to the latest in narrative technique, that it is regressive, behind the times and thus uninteresting, the postmodernist is right in rejecting modernism. But such rejection affects only that trend within modernism which has been codified into a narrow dogma, not modernism as such. In some ways, the story of modernism and postmodernism is like the story of the hedgehog and the hare: the hare could not win because there always was more than just one hedgehog. But the hare was still the better runner ...

The crisis of modernism is more than just a crisis of those trends within it which tie it to the ideology of modernization. In the age of late capitalism, it is also a new crisis of art's relationship to society. At their most emphatic, modernism and avantgardism attributed to art a privileged status in the processes of social change. Even the aestheticist withdrawal from the concern of social change is still bound to it by virtue of its denial of the status quo and the construction of an artificial paradise of exquisite beauty. When social change seemed beyond grasp or took an undesired turn, art was still privileged as the only authentic voice of critique and protest, even when it seemed to withdraw into itself. The classical accounts of high modernism attest to that fact. To admit that these were heroic illusions—perhaps even necessary illusions in art's struggle to survive in dignity in a capitalist society—is not to deny the importance of art in social life.

But modernism's running feud with mass society and mass culture as well as the avantgarde's attack on high art as a support system of cultural hegemony always took place on the pedestal of high art itself. And certainly that is where the avantgarde has been installed after its failure, in the 1920s, to create a more encompassing space for art in social life. To continue to demand today that high art leave the pedestal and relocate elsewhere (wherever that might be) is to pose the problem in obsolete terms. The pedestal of high art and high culture no longer occupies the privileged space it used to, just as the cohesion of the class which erected its monuments on that pedestal is a thing of the past; recent conservative attempts in a number of Western countries to restore the dignity of the classics of Western Civilization, from Plato via Adam Smith to the high modernists, and to send students back to the basics, prove the point. I am not saying here that the pedestal of high art does not exist any more. Of course it does, but it is not what it used to be. Since the 1960s, artistic activities have become much more diffuse and harder to contain in safe categories or stable institutions

such as the academy, the museum or even the established gallery network. To some, this dispersal of cultural and artistic practices and activities will involve a sense of loss and disorientation; others will experience it as a new freedom, a cultural liberation. Neither may be entirely wrong, but we should recognize that it was not only recent theory or criticism that deprived the univalent, exclusive and totalizing accounts of modernism of their hegemonic role. It was the activities of artists, writers, film makers, architects, and performers that have propelled us beyond a narrow vision of modernism and given us a new lease on modernism itself.

In political terms, the erosion of the triple dogma modernism/modernity/avantgardism can be contextually related to the emergence of the problematic of 'otherness,' which has asserted itself in the socio-political sphere as much as in the cultural sphere. I cannot discuss here the various and multiple forms of otherness as they emerge from differences in subjectivity, gender and sexuality, race and class, temporal *Ungleichzeitigkeiten* and spatial geographic locations and dislocations. But I want to mention at least four recent phenomena which, in my mind, are and will remain constitutive of postmodern culture for some time to come.

Despite all its noble aspirations and achievements, we have come to recognize that the culture of enlighened modernity has also always (though by no means exclusively) been a culture of inner and outer imperialism, a reading already offered by Adorno and Horkheimer in the 1940s and an insight not unfamiliar to those of our ancestors involved in the multitude of struggles against rampant modernization. Such imperialism, which works inside and outside, on the micro and macro levels, no longer goes unchallenged either politically, economically or culturally. Whether these challenges will usher in a more habitable, less violent and more democratic world remains to be seen, and it is easy to be skeptical. But enlightened cynicism is as insufficient an answer as blue-eyed enthusiasm for peace and nature.

The women's movement has led to some significant changes in social structure and cultural attitudes which must be sustained even in the face of the recent grotesque revival of American machismo. Directly and indirectly, the women's movement has nourished the emergence of women as a self-confident and creative force in the arts, in literature, film and criticism. The ways in which we now raise questions of gender and sexuality, reading and writing, subjectivity and enunciation, voice and performance are unthinkable without the impact of feminism, even though many of these activities may take place on the margin or even outside the movement proper. Feminist critics have also contributed substantially to revisions of the history of modernism, not just by unearthing forgotten artists, but also by approaching the male modernists in novel ways. This is true also of

the 'new French feminists' and their theorization of the feminine in modernist writing, even though they often insist on maintaining a polemical distance from an American-type feminism.[12]

During the 1970s, questions of ecology and environment have deepened from single-issue politics to a broad critique of modernity and modernization, a trend which is politically and culturally much stronger in West Germany than in the U.S. A new ecological sensibility manifests itself not only in political and regional subcultures, in alternative life-styles and the new social movements in Europe, but it also affects art and literature in a variety of ways: the work of Joseph Beuys, certain land art projects, Christo's California running fence, the new nature poetry, the return to local traditions, dialects, and so on. It was especially due to the growing ecological sensibility that the link between certain forms of modernism and technological modernization has come under critical scrutiny.

There is a growing awareness that other cultures, non-European, non-Western cultures must be met by means other than conquest or domination, as Paul Ricoeur put it more than twenty years ago, and that the erotic and aesthetic fascination with 'the Orient'—so prominent in Western culture, including modernism—is deeply problematic. This awareness will have to translate into a type of intellectual work different from that of the modernist intellectual who typically spoke with the confidence of standing at the cutting edge of time and of being able to speak for others. Foucault's notion of the local and specific intellectual as opposed to the 'universal' intellectual of modernity may provide a way out of the dilemma of being locked into our own culture and traditions while simultaneously recognizing their limitations.

In conclusion, it is easy to see that a postmodernist culture emerging from these political, social and cultural constellations will have to be a postmodernism of resistance, including resistance to that easy postmodernism of the 'anything goes' variety. Resistance will always have to be specific and contingent upon the cultural field within which it operates. It cannot be defined simply in terms of negativity or non-identity à la Adorno, nor will the litanies of a totalizing, collective project suffice. At the same time, the very notion of resistance may itself be problematic in its simple opposition to affirmation. After all, there are affirmative forms of resistance and resisting forms of affirmation. But this may be more a semantic problem than a problem of practice. And it should not keep us from making judgments. How such resistance can be articulated in art works in ways that would satisfy the needs of the political *and* those of the aesthetic, of the producers and of the recipients, cannot be prescribed, and it will remain open to trial, error and debate. But it is time to abandon that dead-end dichotomy of politics and aesthetics which for too long has dominated accounts of modernism, including the aestheticist trend within poststructuralism.

The point is not to eliminate the productive tension between the political and the aesthetic, between history and the text, between engagement and the mission of art. The point is to heighten that tension, even to rediscover it and to bring it back into focus in the arts as well as in criticism. No matter how troubling it may be, the landscape of the postmodern surrounds us. It simultaneously delimits and opens our horizons. It's our problem and our hope.

7

The Gendered Subject

Introduction

Why should anyone concerned with the history of art history and the history of art history's art care about gender? One way to begin answering such a question might be to reflect upon the format and staging of this book itself.

It might seem that there are *two* anthologies or collections here: in the first place, the ('original') texts which make up the 'interior' of these chapters. In the second place, what may be termed a *re*-collection: a series of ongoing (yet at times abruptly disjunctive) observations, comprising the introductions 'exterior' to or framing the collected texts.

You will have noticed that despite its form this book lies somewhere between an anthology and a monograph, between a heterogeneous series of things whose principle of cohesion is imposed from without, and an ongoing thing whose coherence stems from within. The anthology format of course is an echo of the format of the museum collection (see Chapter 9), as well as of the panoply of knowledge-production systems inherited from the Enlightenment, from charts, tables and newspapers to zoos and cities. Which is to say that it partakes of the very *topological dramaturgy* of modernity as such, with its concern with fielding together subjects and objects in predictable and disciplined ways.

What is pertinent to the central issues of this chapter is the *corporeality* and the material *spatiality* of this whole business that is art history. By this I mean that it is in fact a deployment of *bodies* (subjects, to be sure, but also all manner of objects of desire) that are set into disciplined (and at times not so anonymously policed) relations with one another. Moreover, all this doesn't just happen in some virtual reality; it materially *takes place*. It involves the spatialization and theatricalization of knowledge; the submission of things and viewers to complementary yet asymmetrical roles, functions, and places within a landscape.

The texts which stand in the place of an interior of a chapter, with the introductions that stand outside, on the margins, in the *place* of door, window, caption, label, or acousto-guide speaking as you walk through the worlds opened up by each text—all this stagecraft reiter-

ates and reinforces the imaginary one-on-one confrontation between observer and observed, viewer and (art) object, and between a subject and its beloved object of desire, that constitutes the primordial *dream* of art history in which the art historian is both the dreamer and the dreamt. It is also an effect of power.

You may also have concluded that the differentness of my own voice in each introductory place of observation has been designed to fend off the perception of a (continuing, consistent) 'position' on my part with respect to the 'subject-matters' so positioned. This represents no lack of specificity of desire on my part, of course, but is rather a performative enactment of the specificity of any engagement with the presumptions of the texts collected. It is one way of derailing any attempt to construe any position that I (as 'editor') may be taking as an intended value-neutral standard or orthodoxy.

By this I mean not only the stance of a claim to historically privileged knowledge or synoptic truth (that which is formulaically required of an editorial position or *pose* in a book such as this), but also the morality of a self-righteous avant-gardist orthodoxy. I have not chosen these texts as 'illustrations' of some principle which my introductions would highlight and explicate as the texts that bear them unfold. That position—to get closer to the point—is not without its implications for understanding power relations that are gendered. In fact, there is no knowledge that is not partial or perspectival—that is, *gendered*.

All of which is precisely to the point of many of the arguments raised (and contested) overtly or implicitly, in and by the texts in the present chapter, on 'the gendered subject' (and, as we shall see, in the next two sections of the book). So, again: why should anyone concerned with the history of art history and the history of art history's art care about gender?

One might say: because (*a*) there being no bodies that are not gendered, in consequence all artworks are reified, fetishized, or embodied gendered subjects. Or (*b*) there are no positions in which objects of art may be deployed or redeployed that are not already engendered, or always subject to disruptive regenderings and recodings. Or (*c*) because the whole disciplinary technology of artist/artwork/viewer/history/criticism/signification/use/value/(etc.) may actually *read* differently depending on the gender of the looker or maker—and that, logically and properly, there may be as many viable art histories as there are genders, beyond those told by white European heterosexual males or their friends and imitators, of whatever gender or sexual 'orientation'.

To put all of this more generally and more fundamentally: knowledge is a *practice* that does things, and one of the things it does best is to masquerade as a neutral tool or method. Another thing it does well is to mask (or forget) its own genealogy as a product of bodily impulses,[1] along with misrecognizing itself as 'interior' thought. What would be

the implications for art history as a modern(ist) disciplinary mode of knowledge-production of recognizing its productions as the effect of a corporeal drive for power which systematically misrecognized its masculinity as universality?

The readings in this chapter all deal with aspects of this problem, and are arranged here chronologically as a tableau of commentaries from the early 1970s to the present. But this arrangement does not represent any straightforward linear development: it is in fact a kaleidoscopic array of perspectives, arguments, and motivations, many of which overlap and intersect. However, I would like to point out a marked difference in what was at stake for the earliest author (Nochlin) and for the latest (Jones), separated in time by over two decades.

Perhaps the most striking difference between feminist scholarship in art history during the 1970s and the 1990s (and I am referring largely to the English-speaking world)[2] concerns something very funda- mental: the question of whether or not the position of the knower— the author or writer—is itself a subject of scrutiny. From the perspective of feminist scholarship later in this twenty-year period (or early, if one is thinking about France and in particular the writings of Luce Irigaray[3]), work that did *not* submit itself to such scrutiny was as problematic as the (masculinist) knowledge about women (and espe- cially the idealist philosophies, histories, and Freudian psychoanalysis) it sought to replace.

In other words, the recognition that *no* art historical knowledge can be gender-neutral is more characteristic of later work in the field than earlier, as is feminist scholarship which takes as its principal object of study those forms of patriarchal knowledge-production which misrecognize or misrepresent themselves as universal or gender- neutral.

A much-quoted 1971 essay by Linda Nochlin was concerned with what it would mean to *adequately* answer the deceptively straight- forward question, 'Why have there been no great women artists?'[4] For Nochlin this meant addressing the social and institutional factors that perpetuated the circumstances within which women artists could never hope to achieve the kind of 'greatness' commonly ascribed to male artists. The essay by Nanette Salomon of 1991 ('The Art Historical Canon: Sins of Omission') is a historical survey of the na- ture of such 'omissions' of women (and non-heterosexual) artists from standard art historical survey textbooks; it shares many of Nochlin's perspectives and those of another contributor to the earlier art histor- ical debates on the subject, Griselda Pollock.[5]

The reading by Lisa Tickner ('Sexuality in/and Representation: Five British Artists' of 1985) originally appeared in the catalogue to a New York exhibition (*Difference: On Representation and Sexuality*). It

brings into play a different series of critical and theoretical issues, and engages very directly with fundamental questions of sexuality, representation, narrativity, pleasure, and the modernism–postmodernism debates that were dealt with only marginally or indirectly in the first two texts. It also demonstrates very clearly the interactive relations between art practice and contemporary critical theory.

One of the artists whose work figured prominently in Tickner's essay is Mary Kelly, whose extended documentary piece *Post-Partum Document* of 1973–9 explored the ways in which femininity is produced as 'natural' and 'maternal' within the discursive system of social signs constituting mother–child relationships. The work drew extensively on Lacanian psychoanalytic theory, and was engaged with a number of current developments in European critical theory, feminism, and semiology. The text included here, 'No Essential Femininity: A Conversation between Mary Kelly and Paul Smith' appeared in the Canadian art journal *Parachute* in 1982. For Kelly, the production of *Post-Partum Document* was a process of the discovery of no *essential* or pre-given sexuality or femininity: a revelation making it possible to imagine the deconstruction of such hegemonic modes of representation.

The final text ('Postfeminism, Feminist Pleasures, and Embodied Theories of Art') by Amelia Jones appeared in the 1993 anthology *New Feminist Criticism: Art/Identity/Action*,[6] and discusses what has been at stake in recent feminist postmodernist art practice ('postfeminism') with regard to issues of pleasure and the body. It also investigates the antifeminist political movement in the USA in the 1990s, providing a useful overview of the very diverse developments in contemporary feminist art practices and their relationships to theory and politics.

Once again, any bibliography covering a field as extensive and diverse as gender is bound to be idiosyncratic and reflective of the compiler's own most recent interests. What follows is no exception, but is also not a list of masterpieces. It is instead orientational in intent: a few ways into the thicket that today comprises the kaleidoscopic intersections of feminist theory, gender studies, gay and lesbian theories, and the art historical and political dimensions of these—in fact, some of the most interesting writing in art history at present.

The following is a cross-section of writings especially pertinent to the subject of gender in relation to contemporary art historical practices.

Kathleen Adler and Marcia Pointon (eds.), *The Body Imaged: The Human Form and Visual Culture since the Renaissance* (Cambridge, 1993); Seyla Benhabib, *Situating the Self: Gender, Community and Postmodernism in Contemporary Ethics* (New York, 1992); Norma Broude and Mary Garrard (eds.), *Feminism and Art History: Questioning the Litany* (New York, 1982); Broude and Garrard (eds.),

The Expanding Discourse: Feminism and Art History (New York, 1992); Judith Butler, *Gender Trouble: Feminism and the Subversion of Identity* (New York, 1990); id., *Bodies that Matter: On the Discursive Limits of 'Sex'* (New York, 1993); Whitney Chadwick, *Women, Art, and Society* (New York, 1990); Whitney Davis (ed.), *Gay and Lesbian Studies in Art History* (*Journal of Homosexuality*, 27 (1994), nos. 1 and 2); id., 'Gender', in Robert S. Nelson and Richard Shiff (eds.), *Critical Terms for Art History* (Chicago, 1996), 220–33; Teresa de Lauretis, *Technologies of Gender* (Bloomington, Ind., 1987); Kate Linker (ed.), *Difference: On Representation and Sexuality* (New York, 1985); Thalia Gouma-Peterson and Patricia Mathews, 'The Feminist Critique of Art History', *Art Bulletin*, 39.3 (1987), 326–57; Amelia Jones (ed.), *Sexual Politics* (Los Angeles, 1996); Laura Mulvey, *Visual and Other Pleasures* (Bloomington, Ind., 1989); Griselda Pollock, *Vision and Difference: Femininity, Feminism, and Histories of Art* (New York, 1988); Jacqueline Rose, *Sexuality in the Field of Vision* (London, 1986); Lisa Tickner, *The Spectacle of Women* (Chicago, 1988); id., 'Feminism, Art History, and Sexual Difference', *Genders*, 3 (1988).

Nanette Salomon 1991

The Art Historical Canon: Sins of Omission

As canons within academic disciplines go, the art historical canon is among the most virulent, the most virilent, and ultimately the most vulnerable.[1] The simplest analysis of the selection of works included in the history of western European art 'at its best' at once reveals that selection's ideologically motivated constitution. The omission of whole categories of art and artists has resulted in an unrepresentative and distorting notion of who has contributed to 'universal' ideas expressed through creativity and aesthetic effort.

The current official selection of great works of art owes much of its present composition to the ubiquitous standard college text by H.W. Janson, *The History of Art*, first written in 1962 and reprinted at regular intervals ever since.[2] Janson did not invent this list, although his personal selection from a limited number of possibilities is itself a text worthy of analysis. In fundamental ways, the art historical canon, as it appears in Janson (and in others who follow him with unembarrassed exactitude), ultimately and fundamentally is derived from the sixteenth-century book by the Florentine artist and writer Giorgio Vasari, *Le Vite De' più eccellenti Architetti, Pittori et Scultori Italiani*, first published in 1550 and reissued in a much enlarged edition in 1568.[3] This text is generally credited with being no less than the first 'modern' exposition of the history of western European art, a claim that acknowledges its influence and privileges its constitution as the generative source.[4] Vasari introduced a structure or discursive form that, in its incessant repetition, produced and perpetuated the dominance of a particular gender, class, and race as the purveyors of art and culture.

Vasari's book was written at the moment when the accomplishments of the High Renaissance artists Michelangelo and Raphael, under the auspices of papal patronage, were being absorbed as both cultural heritage and Florentine history. Vasari's desire not only to construct that history but also to place Florence at its center motivated both the form and the content of his book.[5] While modern art historians concede that it is structured to place Michelangelo and his art at the very zenith of all artistic creation, above even the revered ancients, few have seen through the more insidious aspects of his project. This is true, no doubt, because the structural aspects of Vasari's book—

ordering biographies chronologically by generations and making value judgments that stress innovation and influence—continue effectively to dominate the way art history is written today.

The most important premise of Vasari's book is his assertion that great art is the expression of individual genius and can be explicated only through biography.[6] The stress on individuals' biographies, announced in the book's title, encapsulates those individuals and presents them as discrete from their social and political environments. The inherent and manipulative limitations imposed by such a biographical system are clear. The most significant limitation is that, *as* a system, it at once ties the work of art to a notion of inaccessible genius and thereby effectively removes it from consideration as a real component in a process of social exchange that involves both production and consumption.[7] This constitution of art history as biography thus occludes an analysis of works of art as material objects and understanding their formulative role in the dynamics of ideological constructs.[8]

Here in Vasari's work we can identify the moment when the myth of the 'artist' as a construct is born—that is to say, invented. This 'artist' is identical to the author whose death is announced by contemporary theorists such as Roland Barthes.[9] Vasari inaugurates the idea that what is worth knowing about a work of art is explained only through knowledge of the artist. As Barthes wrote, 'the Author' (for Barthes's 'Author,' read 'Artist') when believed in, is always conceived as the past of his book:

book and author stand automatically on a single line divided into a *before* and an *after*. The Author is thought to *nourish* the book, which is to say that he exists before it, thinks, suffers, lives it, is in the same relation of antecedence to this work as a father to his child.[10]

The individual whom Vasari describes as an artist is, socially, a free agent, and therefore is clearly gendered, classed, and raced; more specifically, he is a white upper-class male. Only such an individual is empowered by his social position successfully to stake a claim to the personal freedom and creative calling that Vasari's construct requires.

Moreover, we can identify here the moment when Vasari invents/produces the critic, or art historian.[11] He does so by giving individual works particular validity through his assertion of value judgments bearing the weight of his authority.[12] His basic strategies are intricately related. Great works of art are treated as the product of the life of an unfathomable genius. Yet, incomprehensible as they are, they can be retrieved and made accessible by the documentation and explanation of the art historian. In consequence, the art historian has the license and the authority to proclaim what has quality and is valuable. The power inherent in the art historian's position was quickly grasped and immediately made overt in the writings of Vasari's follower, Raffaello

Borghini, in his book *Il Riposo*, published in 1584. What was new about Borghini's theoretical position—and soon to become the norm—is that he wrote from the position of a connoisseur rather than that of a practitioner, since he himself was not an artist. Of even greater significance is that he wrote for a new kind of reader, the art lover, the educated individual who wished to be cultured through the proper appreciation of art.[13] While Vasari implies this wider audience, Borghini emphatically says that he writes his biographies of artists not only for other artists but also for those who, though not artists, wish to be in a position to judge works of art.[14] This is, undoubtedly, the ultimate concern of Janson's *History of Art* as well.

The two most significant developments of Vasari's age that bear a complex relationship to the inception, conditions, and success of his formation of art history were the creation of an art academy and the proliferation of works of art through mechanical reproduction. The former event is directly tied to Vasari himself. His Accademia del Disegno, created in Florence, was fostered by the joint authority of Michelangelo and the State of Florence through the person of Cosimo de' Medici.[15] Just as Vasari's book became the model for histories of male artists for centuries to come, his academy became the model for art academies throughout the European continent up to and including our own century.[16] The art academy became a place where would-be artists could learn to privilege the formal qualities Vasari and his followers had described as great in Michelangelo's art. The academy institutionalized art instruction throughout Europe, and its promise was nothing short of empowering its students with access to divine genius.

As Linda Nochlin has shown, the conditions of the art academy, with its high priority on drawing from the live nude model, excluded women *qua* ladies from the possibility of creating 'great art.'[17] The art academy is at once a historical safeguard against women's entering the canon and a rationale for their exclusion, an exclusion that historically predated the institutionalized academy.

In addition, the mechanical reproduction of unique works of sculpture and painting in prints became popular in Vasari's age. The mass production in engravings of works by Michelangelo, Raphael, and Titian broadened the base of culturally literate consumers and gave a viability (one might say an urgency) to Vasari's programs in both the Academy and the *Lives*.[18] At this time, because the exclusivity and proprietorial possession of ideas expressed through representational images were threatened, Vasari's programs intervened to reassert control and management by determining selections.

Once conditions for value have been established, whole histories may be written in which art is ordered and ranked. Art critics or historians can determine the course of art history by establishing binary rela-

tionships in conformity with systems that in their turn reestablish their prerogative to establish them. Eleanor Dickinson's interview with Janson in 1979 is a case in point. When she questioned the exclusion of women artists from his textbook, Janson blithely replied that no woman artist had been 'important enough to go into a one-volume history of art.'[19] When asked what his terms of inclusion were, he said, 'The works that I have put in the book are representative of achievements of the imagination ... that have one way or another changed the history of art. Now I have yet to hear a convincing case made for the claim that Mary Cassatt has changed the history of art.'[20] A critical reading of Janson's *History of Art* reveals that his notion of changing history is, like Vasari's, constructed on the ideas of innovation and influence. The internal logic that justifies his selection and thus inclusion in the canon is based on a reenactment of father/son relationships on various levels of the teacher/student project.[21] This kind of relationship is apparent in the structuring affinities that art historians create between the ancients and the Italian Renaissance, between Raphael and Poussin, between Manet and Degas, and ultimately between themselves, Vasari and Janson. The play set in motion here is a perpetual one, between submission to established authority and innovation within its preset terms. Artists thereby may 'change the history of art' insofar as they can be located within this father/son logic. It is critical to analyze some of the practices that situate women outside this logic.

It hardly seems necessary to say that a fundamental condition of canonical selection as construed by Vasari and his followers, up to and including Janson, is that only male artists are taken seriously. Women are not simply omitted. Before the twentieth century, there is barely a history of art that completely omits women, and Vasari himself included some in the *Lives*—evidence of what must surely have been their undeniable presence in the art world that Vasari set out to chronicle.[22] These women artists remind us that women's participation in the somewhat rarified world of art, as in society in general, at some point in history was much greater than the accounts of modern historians suggest.[23] In fact, as Joan Kelly demonstrated, it was precisely in the period we call the 'Renaissance' that the systematic diminution of social and personal options for women began.[24] In this context, Vasari's *Lives* may be seen as part of the apparatus that abrogated women's direct and unproblematical participation in cultural life. In discussing the creativity of women, Vasari strategically enhanced their marginalization by using patronizing and demeaning terms to explain their art and its oddity, their exceptional status as women artists. For example, his treatment of the Cremona artist Sofonisba Anguisciola includes all of the by-now-clichéd references to women's creative abilities in childbirth, as well as astonishment at her exceptional abilities as a visual artist. The notion

of the 'exceptional' woman artist may be one of the most insidious means of undermining the likelihood of women's entering the creative arts.

A primary strategy of Vasari/Janson is to establish a narrow focus through the imposition of a standard or norm. This standard is defined by classical art and by the recuperation of the achievement of classical culture as most perfectly realized in the art of Michelangelo.[25] The implications of this standard are complex and require dismantling on a variety of levels. I shall return presently to the inherent meaning of classical imagery and classicism for constructing notions of gender and sexuality. First, however, I discuss the more overt consequences of this standard. It functions to create a hierarchy of insiders and outsiders. The stigma of 'otherness,' as applied to the 'outsider,' can be bestowed equally on some male artists as it has been on female artists. The classical paradigm defines the 'Renaissance' of central Italy as the art with the greatest value and successfully marginalizes all other artistic traditions.[26] Artistic traditions contemporary with the Italian Renaissance, no matter how diverse, are simply lumped together under the heading 'art north of Alps.' The rationale for discussing these complex and varied traditions as a single tradition can only be that their differences from one another are deemed irrelevant and their singular difference from Central Italian classicism crucial. For example, Vasari, discussing northern European artists, indiscriminately uses the term *fiamminghi* (that is, someone from Flanders), even when discussing the German artists Martin Schongauer and Albrecht Dürer.[27] In addition, he relegates his comments on these artists to his book on technical instruction rather than including them in the *Lives* proper, thereby locating them with the practical and manual aspects of art as craft, rather than with the more elevated position of art as an intellectual activity. It is true that some northern artists are discussed at the very end of the *Lives*, but in a section that has no name.[28]

Vasari/Janson's stated preference for classical forms as the basis of an absolute system of aesthetic evaluation enables them to judge all other European traditions according to how close they come to accepting classicism as a paradigm. Thus Janson writes: 'Gifted though they were, Cranach and Altdorfer both evaded the main challenge of the Renaissance so bravely faced—if not always mastered—by Dürer: the image of man.'[29]

The devaluation of 'art north of the Alps,' like the devaluation of the art of the 'pre-Renaissance' Medieval period, can be seen as a strategy with a deeper import for us than might at first be suspected. Women in these cultures were more essential to, and better integrated into, the workings of economic and social life and thus, by extension, were better integrated into the production of works of art than women were in Italy.[30] Michelangelo's reputed comments on Flemish paint-

ing, reported by Francisco de Hollanda in 1538, recognize the import-
ance of women in the constructs of Netherlandish painting: 'Women
will like it, especially very old ones, or very young ones. It will please
likewise friars and nuns, and also some noble persons who have no ear
for true harmony.'[31] As late as 1718–21, Arnold Houbraken's book on
the lives of the great Dutch painters not only includes both men and
women artists but also acknowledges their joint contributions in its
title, *De Groote Schooburgh der Nederlandtsche Konstschilders en
Schilderessen*.[32] The decided prejudice in favor of Italian male artists
and art therefore can be understood not only as a statement asserting
the superiority of men over women but also as a prejudice in favor of
whole systems that supported and made possible that superiority.

Between Vasari's *Lives* and Janson's *History of Art*, many variations
of art history were written. Yet, despite the many versions produced by
art historians of different nationalities at different times, fundamental
constants can be discerned. We can attribute these constants to the un-
challenged influence of Vasari, the orthodox source to whom writers
returned again and again.[33] While Venetian, French, and Dutch art
histories featured their own artists, they all adhered strongly to Vasari's
structural prototype and maintained his classical bias. Vasari's struc-
ture itself took on canonical status. This characteristic structure em-
phasizes individual contributions, fixes the terms of a generational and
stylistic development of the history of art, and provides standards for
aesthetic judgments along classical lines. This structure is repeated in
the art historical writing of Janson and most other contributors to this
genre in the intervening four centuries. The project of the early art
histories served nationalistic motives. Yet, clearly, more was at stake—
that is, maintaining the control of culture for a privileged few. In the
late seventeenth century, Joachim von Sandrart, Filippo Baldinucci,
André Félibien, and Roger de Piles broke away from allegiance prim-
arily to nationalistic motives and included an international array of
artists in their texts.[34] Significantly, despite the tendency of art histor-
ians in the late seventeenth century to amplify their texts by adding
artists of different nationalities, they systematically eroded and finally
erased the presence of women.

In our own historical moment, women have fought for and regained
the privilege and the responsibility of having a say in the ways culture
gets produced and disseminated. Feminists have opened places within
canonical discourse to allow for the inclusion of women as artists and
women as critics. But at this juncture, inclusion alone is not enough.
Feminist practice has produced several strategies for dealing with the
academic field of art history and its canon. Primary among these is
the archeological excavation of women as creators. The second is the
appearance of women as critics and interpreters, receiving and in-

flecting works of art in ways meaningful for them. The implications of the two developments—women recovered as artists and women as critics—are vast, and they are, of course, not mutually exclusive.

Among the most useful consequences of the first strategy, the recovery of women artists, is bringing 'normal' selection under direct scrutiny and thereby denaturalizing and politicizing it. What heretofore had appeared to be an objective account of cultural history, the 'Western European Tradition,' suddenly reappears as a history with a strong bias for white, upper-class male creativity and patronage. It is a history in profound support of exclusively male interests. Feminists' insistence on exposing exclusions reveals the ways in which works within the canon cohere with one another in terms quite different from those traditionally advanced. Rather than appearing as paradigmatic examples of aesthetic value or meaningful expression, or even as representative of major historical movements and events, canonical works support one another as components in a larger system of power relations. Significance and pleasure are defined as projected exclusively through male experiences. The simple corrective gesture of introducing women into the canon to create a more accurate picture of what 'really happened' and to give them a share of the voice that proclaims what is significant and pleasurable does not really rectify the situation. Our understanding of the political implications of what is included and excluded from the repertoire of canonical works and, even more, our understanding of historical writing itself as a political act render this, at best, a tactic with limited effects. The terms of art historical practice themselves, whether formalist or contextualist, are so laden with ideological overtones and value judgments as to what is or is not worthwhile—or, as it was expressed in the past, 'ennobling'—that questions of gender and class are designed to be irrelevant to its discourse. These crucial questions not only seem to be *beside* the point of traditional art historical questions; they are specifically *outside* the point.

Chronologically, in feminist art historical writing, the introduction of 'great women artists' was the first real attempt at bringing women into the iconic system of the art historical canon.[35] A host of probing, but to my mind unanswerable, questions were asked. They remain unanswerable because they are wrought with essentially the same methodological tools that so restrictively govern the traditional art historical enterprise. For example, there is the question deriving from the Morellian tradition of connoisseurship: Can one tell from looking at a work of art that the artist was a woman? And one deriving from Panofskian iconology: Do women interpret themes differently than men? And from the Gombrich model: What are the social conditions that led women to paint and draw the way they did?

The uncritical insertion of women artists into the pre-existing structure of art history as a discipline tends to confirm rather than challenge the prejudicial tropes through which women's creativity is dismissed. Logically, the women artists who were hailed by the feminists of the 1970s were exactly the ones easiest to excavate, because their work most closely approximated that of traditional, mainstream movements as defined by academe. Yet, precisely because those women had achieved some measure of traditional success, they were by definition appropriate for comparison with the textbook male 'genius' whose work their art most resembled. Like a knee-jerk reaction or a Pavlovian response, the device of 'compare and contrast' was proffered to situate these new-yet-not-so-new entries into the canon. This device, the staple of art historical analysis since the days of Wölfflin,[36] continually serves as an instrument for ranking value and establishing a hierarchy of prestige. The device compels its users to put 'versus' between two artists. Thus, Artemisia Gentileschi is inevitably and detrimentally compared to Caravaggio; Judith Leyster, inevitably and detrimentally, to Frans Hals; Mary Cassatt, inevitably and detrimentally, to Degas. When the rules of the game are neither challenged nor changed, the very structure of such binary oppositions insists that one side be master, the other side pupil; one major, the other minor. These comparisons, in a disheartening way, seem to prove once and for all that women have not produced anything either innovative or influential. They were rather on the receiving end of the influence exchange, with all of the attendant anxiety assigned to that undesirable position in modernist discourse.[37] Their only form of retreat and solace comes in the ghettoized subcategory 'women artists.'

Whereas Vasari used the device of biography to individualize and mystify the works of artistic men, the same device has a profoundly different effect when applied to women. The details of a man's biography are conveyed as a measure of the 'universal,' applicable to all mankind; in the male genius they are simply heightened and intensified. In contrast, the details of a woman's biography are used to underscore the idea that she is an exception; they apply only to her and make her an interesting individual case. Her art is reduced to a visual record of her personal and psychological makeup.

No doubt the most egregious example is the seventeenth-century Italian artist Artemisia Gentileschi. Her rape by her 'mentor,' the artist Agostino Tassi, and the litigation brought against Tassi by her father Orazio Gentileschi, enter into every discussion of her art. Not to discuss it is to avoid it. The degree to which Artemisia Gentileschi's sexual history is the most discussed aspect of her persona contrasts sharply with the embarrassment about and denial of the equally documentable sexual histories that are an integral part of great male artists' biographies (the most obvious example being the homosexual-

ity of Michelangelo and Caravaggio).[38]

Artemisia Gentileschi's history is brought to bear on her images of what Mary Garrard calls her 'heroic women,' particularly her paintings of *Judith Beheading Holofernes* and *Susanna and the Elders*.[39] In the end, these paintings are reduced by critics to therapeutic expressions of her repressed fear, anger, and/or desire for revenge. Her creative efforts are thus compromised, in traditional terms, as personal and relative.

The fact that her father waited ten months before bringing charges against Tassi seems strange to modern-day researchers, as does her apparent consent to be Tassi's lover after the rape.[40] While the proceedings of the trial may or may not add to our understanding of Gentileschi's art, they can do so only when seen as part of the highly coded discourse of sexuality and the politics of rape in the seventeenth century. Perhaps more than anything, they emphasize the fact that Artemisia, body and soul, was treated as the site of exchange between men, primarily her father/mentor and her lover/rapist/mentor, but also between Tassi and Cosimo Quorli, orderly of the Pope, who, presumably because of his own jealous desire for her, asked Tassi not to marry her. Tassi complied with his request. The process of exchange began when she was 'given' to Tassi as a pupil, and it continued when he violently 'took' her, when her honor was 'redeemed,' and when she was given and taken again. The homosocial bonding ritual enacted and reenacted among these men render 'Artemisia' a historically elusive construct. If the testimony of the trial reveals anything, it is a person with an obstinate sense of her own social and sexual needs. Her paintings thus look less like 'heroic women' than like the nexus of a series of complicated negotiations between convention and disruption, between 'Artemisia' and Artemisia.

Much writing on Artemisia Gentileschi and her art exemplifies the ways in which the conventional structures of art-historical discourse safeguard their deepest subtexts—those that preserve power for and endow with significance a privileged few. The motives behind this writing need not be seen as willful or even conscious. Their strength lies in their centuries-old history and in the mutually supportive, reciprocal relationship between that history and the ends such motives produce.

Mary Garrard's attempt to 'heroize' Artemisia Gentileschi and the women she depicted reveals her desire to enroll Gentileschi in the canon as presently constructed. She wants for Gentileschi the status afforded to men who make 'heroic' images and whose art, which is an extension of their biography, sets positive examples for others, in this case women. As most recently pointed out by Patricia Rubin, the aim of Renaissance biography in general and of Vasari in particular was to make heroes of exemplary men.[41] Yet we are rudely reminded that what can and has been done for men cannot simply and unproblematically

be done for women. To cite Rubin again, our interest in Renaissance men 'arises from the representative nature of these figures, taken to embody values that match and confirm basic themes which organize and characterize cultural understanding.'[42] The hierarchical relationships established by Vasari are still intact and his preferences profoundly and successfully potent.

It may seem 'natural' that Vasari put his fellow citizens above all others and that, within Italy, his Florentine bias was tolerated. It is less 'natural' (that is, less understandable) that his heroes became the heroes of similar texts written by German, Dutch, French, English, and American authors, up to and including H.W. Janson.[43] The success of Vasari's canon with its classical bias must be accounted for on grounds more complex than its articulation of a proprietary turf for 'men only.' That canon creates a position of dominance for a certain kind of man who can understand and appreciate classical and classicist art as most perfectly embodied in the art of Michelangelo. The ideological value of the classical model in the constitution of power relations through the coding of gender and sexuality can be uncovered only by feminist analysis.

The art of Michelangelo and classical Greek sculpture, his primary source of inspiration, took as their ideal form the male nude youth, whom they viewed as equally the ideal of art and of 'nature,' predicated on a notion of beauty that they defined as specifically male.[44] For the Greeks and for Michelangelo, as in nearly all cases where the object of aesthetic admiration is the human form, the enjoyment of the male body is conjoined with homoerotic desire. For the Greeks this conjunction seemed a natural one, and surely that socially legitimate desire contributed to constituting the male nude as an ideal.[45] The conjunction for Michelangelo was far more problematical, yet not so problematical as to have been prohibitive.[46] Homoerotic desire and the artistic production of the idealized male nude youth clearly have a historical relationship. Yet, as important as that relationship is, it is equally meaningful and informative that there is no mention—in fact, can be no mention—of homosexuality in Vasari/Janson.[47] Their repression of homosexuality is facilitated by another fundamental principle of classicism, that a perfect body contains a beautiful spirit, that physical and moral beauty are inextricably united. This principle framed homosexual desire in a larger moral and aesthetic discourse. Art history, produced in patriarchal yet officially heterosexual Christian times, could use, and indeed embrace, the presumptive moral and aesthetic aspects of the desire that fostered the works of art, but only after severing them from any traces of sexual meaning. The erotic appreciation of artistic nudes was masked by the concept of pure aesthetic pleasure, unpolluted by either the sexual desires of the producers or the threat of corresponding sexual desires in the viewers.[48] The fiction created by this

'purification' of the art object renders it sound currency in a hetero-sexual world that cannot bear to acknowledge homosexuality as anything but deviance.[49]

The form central to the art of Michelangelo and his Greek sources, the one heralded as the most brilliant of Western civilization by Vasari/Janson, is the freestanding sculpture of an idealized male nude youth. This form exhibits features worth considering in this context. It—or he—is characterized by the conflation of an athletic and a military iconography resulting in the 'heroic.' The nude stands unselfconsciously present, in the sense that he neither flaunts nor covers his penis. It is, rather, represented as is any other body part in the classical homoerotic system that sexualizes the youth as a complete and coherent being without fetishizing his genitals.

The male nude youth stands in startling contrast to the female nude youth, the other standard icon of the Vasari/Janson canon—whose portrayal, it must be said, is completely absent from Michelangelo's sculpted work. The fashioning of the female nude as it—or she—appears in ancient art and in the art of the Italian Renaissance (in, for example, the art of Botticelli or Titian) is also produced within the framework of sexual desire. That desire is also repressed in formal art-historical writing, despite recent attempts by some art historians to acknowledge it.

The history of the form raises interesting problems in evaluating the main subjects of the canon. The so-called 'classical' female nude in monumental sculpture was, in fact, not introduced in Greek art until the postclassical period. It was invented by the fourth-century sculptor Praxiteles, whose life-sized sculpture of Aphrodite, entitled the *Cnidian Aphrodite* for the name of its ancient site, is known to us only through Roman copies.[50] This sculpture is the source for a massive number of works representing Aphrodite/Venus in the art of the Western world, not only because it is the first monumental female nude but also and more significantly because it is the first to be fashioned covering her pubis. This gesture is repeatedly interpreted as one of modesty, which the ancients called 'pudica.' Despite its name, the gesture signifies a great deal more than modesty. It is so endemic to our culture that its effect has been 'naturalized'; that is to say, we no longer 'connect' with the pernicious narrative of fear expressed by a woman shown trying to protect her pubis against violent assault. The 'pudica' pose has become for us the epitome of aesthetics or artfulness. Nevertheless, looking at a naturalistically crafted sculpture of a woman who does not want to be seen cannot help but titillate, even if we react subconsciously. The gesture, with all it connotes, is more than an image of fear and rejection. Merely by placing the hand of the woman over her pubis, Praxiteles—and every artist since him who has used this device—creates a sense of desire in the viewer and constructs a

Peeping-Tom response. This voyeuristic response is installed in all types of viewers, male and female, heterosexual or homosexual. However, it is clearly male heterosexuals who are encouraged to translate that desire into socially sanctioned acts. These acts, not to be confused with private acts of sexual behavior, are rather publicly displayed appreciation of the totally sexualized female form. As high culture, this appreciation is synonymous with the appreciation of a work of art signified by a female nude; as low culture, this appreciation is synonymous with lewd remarks made to women on the street by men in groups. In the end, the high and low forms of appreciation conditioned by the 'pudica' pose create special opportunities for publicly shared male sexual experience without overt homosexual overtones. The female nude is the site of, and the public display of heterosexual desire the medium for, a male bonding ritual.[51]

The role of Vasari/Janson in promoting the heroic male nude and the sexualized, vulnerable female nude as paradigms cannot be underestimated. Historically, the two forms were created within the framework of constructing two male desires, one homosexual and the other heterosexual. The disparate erotic treatments of the male and female tell us a great deal about the different ways in which men and women were and are viewed as objects of sexual desire. Yet formal art historical texts like those of Vasari and Janson treat the male and female nudes in ways that prevent conscious consideration of them as dynamic components in establishing power relations that are expressed in sexual terms. Rather, more covert ways of giving the works their significance in structuring gender and sexuality become effective. In modern society, where heterosexual dominance has prevailed at least since the sixteenth century, the artistic fashioning of the male and female nude defines a cosmopolitan and international club of culturally literate heterosexual males whose ardent allegiance is to one another. The love and admiration of men for one another is thus made acceptable through the shared expression of their overt and irrepressible heterosexual drives.

Vasari's invention of the artist, the critic, and the canon is tied to the economic and social conditions of his moment in history. While these conditions have changed, the deeper stratifications of gender, race, and class continue to operate within the culturally expressed power relationships that he articulated. Vasari thus furnished the discursive forms that remain potent in Janson's moment—and ours.

Lisa Tickner 1984

Sexuality and/in Representation: Five British Artists

This exhibition draws together work from both sides of the Atlantic, with shared concerns but different aesthetic, theoretical, and political trajectories. It includes work by women and men on sexual difference that is devoted neither to 'image-scavenging' alone (as the theft and deployment of representational codes), nor to 'sexuality' (as a pre-given entity); but to the theoretical questions of their interrelation: sexuality and/in representation.

These questions have been rehearsed by American critics, largely under the diverse influences of Walter Benjamin, Jean Baudrillard, Guy Debord, and the Frankfurt School. A comparable body of writing in England has drawn more pointedly on the work of Bertolt Brecht, Louis Althusser, Roland Barthes, and tendencies in European Marxism, poststructuralism, feminism, and psychoanalysis.

The crucial European component in the debate has been the theorization of the gendered subject in ideology—a development made possible, first, by Althusser's reworking of base/superstructure definitions of ideology in favor of the ideological as a complex of practices and representations and, second, by the decisive influence of psychoanalysis (chiefly Lacan's rereading of Freud).

It was psychoanalysis that permitted an understanding of the psycho-social construction of sexual difference in the conscious/ unconscious subject. The result was a shift in emphasis from equal rights struggles in the sexual division of labor and a cultural feminism founded on the revaluation of an existing biological or social femininity to a recognition of the processes of sexual *differentiation*, the instability of gender positions, and the hopelessness of excavating a free or original femininity beneath the layers of patriarchal oppression. 'Pure masculinity and femininity,' as Freud remarked, 'remain theoretical constructions of uncertain content.'[1]

My concern here is with the work of the British-based artists and the priming influence of material produced over the past ten years. This work has its own history, but that history is bound up with the development of associated debates on the left and within feminism: debates on the nature of subjectivity, ideology, representation, sexuality, pleasure, and the contribution made by psychoanalysis to the un-

raveling of these mutually implicated concerns. What I want to turn to is a consideration of this relationship—that is, the relationship between these arguments and this work—rather than to a biographical account which treats each artist's authorship as the point of entry into what they make. It is appropriate here to stress the importance of theory—which is always transformed and exceeded in the production of 'art'—as part of the very texture and project of the work itself.

Representation: Ideology, Subjectivity[2]

The house is now filled with all sorts of replicas and copies: genuine imitations, original copies, prints of paintings, prints of prints, copies of copies. . . . Do we feel that all is now becoming completely *framed* by representation and that there is no limit to this framing? Can just about everything today become an image? Are we caught within an endless process of duplication, an incessant flow whereby an image is infinitely repeatable and the real world merely a spectre, a ghost whose presence barely haunts the frame?[3]

We have no unmediated access to the real. It is through representations that we know the world. At the same time we cannot say, in a simple sense, that a representation or an image 'reflects' a reality, 'distorts' a reality, 'stands in the place' of an absent reality, or bears no relation to any reality whatsoever.[4] Relations and events do not 'speak themselves' but are *enabled to mean* through systems of signs organized into discourses on the world. Reality is a matter of representation, as Stephen Heath puts it, and representation is, in turn, a matter of discourse.[5]

There is another reason why we cannot measure representations against a 'real' to which they might be held to refer, and that is because 'this real is itself constituted through the agency of representations.'[6] What the world 'is' for us depends on how it is described. In an example Victor Burgin gives, we cannot evaluate a particular representation of femininity against some true or essential feminine nature because the femininity we adapt to and embody is itself the product of representation.[7] Since they enter into our collective social understandings in this way, constituting our sense of ourselves, the positions we take up in the world, and the possibilities we see for action in it, representations must be understood as having their own level of effect and as comprising a necessary site of contention.

Ideology is a production of representations—although it does not present itself as such, but rather as a complex of common-sense propositions about the world, which are assumed to be self-evident. As an arrangement of social practices and systems of representations, ideology is materially operative through specific institutions. Such 'ideological state apparatuses,' as Althusser calls them, include education, the family, religion, law, culture, and communications.[8] Material circumstances may provide the raw materials on which ideological dis-

courses operate, but these discourses, through the largely unconscious and naturalized assumptions of which they are comprised, effect certain closures and structure certain positions on that raw material.

At the same time, ideology has the further and necessary function of producing ('interpellating') subjects for its representations. We imagine ourselves as outside of, even as originating, the ideological representations into which we are inserted and in which we 'misrecognize' ourselves.

These Althusserian notions of interpellation and misrecognition have been productive, but they have also been contested. They do not adequately account for the unconscious, for the constitution of the subject in language, or for the relations between ideology and language or discourse. Nor do they easily allow for the possibility of refusal and struggle in the ideological arena or for the range of interpellations to which individuals, by virtue of class, race, or sex, may be subject.[9]

The question of meaning relates not only to the social but also to the psychic formation of the author or reader,[10] 'formations existentially simultaneous and coextensive but theorized in separate discourses,'[11] as Burgin has written. We need to account for the deep hold of ideology, for the level on which social structures become an integral part of an identity which is in fact precarious—not fully conscious, rational, or coherent.

The subject, continually in process, is neither a fixed entity nor an autonomous being outside of history and representations. The (gendered) subject is inscribed in the symbolic order through a series of psycho-social processes as 'the product of a channelling of predominantly sexual basic drives within a shifting complex of heterogeneous cultural systems (work, the family, etc.).'[12] The formal devices of representation are effective here too, particularly the perspective and framing systems of Western painting and the camera, which produce both an object and a point of view (i.e., a coherent viewing subject) for that object. This setting-into-place of the subject is simultaneously secured through the harnessing of the sexual drives and their forms of gratification (fetishism, voyeurism, identificatory processes, pleasure in recognition and repetition). The breaking of these circuits, these processes of coherence that help secure the subject to and in ideology, becomes a central task for artists working, in Burgin's distinction, not on the representation of politics, but on the politics of representation.[13]

Art is a practice of representation, and hence of ideology (it is productive of meanings and of subject positions for those meanings). The five artists under discussion here work *in*, but also *on*, ideology: their representations attempt, in differing ways and through particular strategies (such as montage and the manipulation of image with text), to dis-articulate the dominant and naturalized discourses on sexuality, class, subjectivity, and representation itself.

The course and impact of these debates can be understood by look-ing at the trajectory of Victor Burgin's work since the mid-1970s. This work has put into play different concepts of ideology and representa-tion:[14] first a classical or economistic Marxism, then its Althusserian inflection, and subsequently feminism and psychoanalysis, as inter-related in theories of the construction of the subject. 'St. Laurent de-mands a whole new lifestyle,' from *UK 76*, is concerned with economic relations and a concept of ideology as 'false consciousness.' In setting the language of *haute couture* (and consumption) against the image of an immigrant female textile worker (and production), it renders visible the invisible social relations that commodity fetishism disavows. Similarly, it attempts to bring the outside world into the gallery through both the content of the image and its reference to advertising.

Burgin later concluded, however, that the meanings and political/aesthetic effects of this work were too quickly exhausted: 'they could be simply consumed as the speech of any author, there was very little space left for the productivity of the reader.'[15] He began to alter his practice in *US 77*, which is informed by the Althusserian notion of ideological apparatuses and their relation to the construction of subjectivity. In a panel such as *Framed*, image and text offset each other in a more ellip-tical way than in the head-on confrontation of *UK 76*. We are drawn by their interplay into the world of frames (poster, photograph, mirror, the work itself) and of framing (the process of [mis]representation and [mis]recognition in which we find our sexed identity).[16]

Most recently, *Tales from Freud* draws on psychoanalysis not only for its concepts but also for its form, asking us to think about memory, desire, sexuality, masculinity and femininity, drawing us into and across the relations of image and text through the devices of repres-entation, condensation, and displacement that characterize what Freud called the dream-work. This is a very different process—more enveloping and associative, more pleasurable and less conscious—from that of reading off the ironic distance of image from text in the 'St Laurent' panel of *UK 76*. It is produced within the purview of psycho-analysis, rather than at the intersection of psychoanalytic and Marxist theories of ideology; it is centered on a notion of sexual identity as an everyday process of structuring and positioning; and it is concerned now with what might be called the 'deep springs' of ideology in the constitution of subjectivity itself. (Burgin: 'There's going to be no major shift in extant social forms without a shift in the construction of masculinity.')[17]

Sexuality

… there is no such thing as sexuality; what we have experienced … is the fab-rication of a 'sexuality,' the construction of something called 'sexuality' through a set of representations—images, discourses, ways of picturing and

describing—that propose and confirm, that make up this sexuality to which we are then referred and held in our lives …[18]

What we experience as 'sexuality' has both an endogenous and an exogenous history. It is regulated and understood at the 'social' level—the level of investigation of writers such as Michel Foucault, Heath, and Jeffrey Weeks, who are concerned with the history of discourses and cultural practices.[19] But it is also organized in the history of each (sexed) subject. This is the 'psychic' level, to which psychoanalysis addresses itself, positing a sexual energy or libido that is established as 'sexuality' during the course of early life, changing in both its mechanisms and its aims.

The term 'sexuality' is a nineteenth-century one, emerging at a particular conjuncture and within the specific context of medicine, where it was understood in relation to reproduction, abnormality, and disease.[20] As Heath remarks, not until Freud's *Three Essays on the Theory of Sexuality* (1905) do we enter 'a new conception, no longer organs, the sexual act, normal penis, genital finality: sexuality now as complex history and structure and patterning of desire.'[21] Two things follow from this. First, that in psychoanalysis sexuality is not reducible to reproduction and the genital act. It 'arises from various sources, seeks satisfaction in various ways, makes use of diverse objects,'[22] and includes a range of phenomena that are not manifestly sexual but are held to be derived from, or traversed by, the infant and adult sexual drives. Second, that the subject is understood as precipitated by and through sexuality (specifically, around the moment of the Oedipal and castration complexes). Thus in psychoanalysis 'the development of the human subject, its unconscious and its sexuality go hand-in-hand, they are causatively intertwined … a person is formed *through* their sexuality, it could not be added to him or her.'[23]

Both the history of the social ordering of sexuality and its psychic organization oblige us to rethink the relations between sexuality and representation. That is, to remove them from any conception as two distinct domains (representation and sexuality), or as a given, homogeneous, and anterior sexuality (the representation of sexuality), in favor of the recognition of how each is bound up in the processes of the other. On one hand, we cannot speak of a body organized sexually outside of the processes of representation.[24] On the other, we have to recognize the organization of the sexual drive in representation and in the viewing subject. 'The structure of representation is a structure of fetishism,' as Heath puts its, following Barthes—and visual pleasure is bound up with gratifications in looking that are sexually impelled.[25]

Questions of 'sexuality' and 'representation,' then, are complicated beyond a certain point by their mutual entanglement. They are simply not discrete, as mechanisms or as structures. Nevertheless, we can un-

ravel some strands within that relation that are particularly relevant to the work of the artists here.

First, there is the concept of the psychic construction of gender identity through the organization of the bisexuality of the drives (Freud), reworked as an understanding of the formation of subjectivity within language (Lacan). Since these processes are neither final nor secure, there is a struggle at all levels for the definition and redefinition of negotiated categories: 'sexual difference is not an immediately given fact of 'male' and 'female' identity but a whole process of differentiation,' as Heath notes.[26]

Second, this differentiation is produced and reproduced in the representations of a range of discourses (medicine, law, education, art, the mass media). This moves us beyond the question of stereotypes to an understanding of how representations operate discursively, and in relation to subjectivity. It is within this complex of discourses on sexuality that a sexual politics attempts to intervene, to contest the strategies of representations, as well as those of the legal, political, and economic institutions through which they are guaranteed.

Third, there is the implication of sexual difference in the structuring of pleasure. The ordering of libidinal investments in looking is not symmetrical. For the young child, looking and being-looked-at are equally possible and pleasurable activities; in the social world of the adult, there is a division of labor between the two. In Laura Mulvey's account:

The determining male gaze projects its phantasy on to the female figure which is styled accordingly. In their traditional exhibitionist role women are simultaneously looked at and displayed, with their appearance coded for strong visual and erotic impact so that they can be said to connote *to-be-looked-at-ness*.[27]

Finally, the point for these artists of taking up such issues is to interrogate and reorder them as part of a political project. Their work points to the contradictory relations among discourses. It involves a refusal of the fixing of the feminine and femininity (and, increasingly, of the masculine and masculinity). It argues for a form of female fetishism and for a place for the mother's desire. It interrogates the Lacanian identification of women and 'lack.' And it attempts forms of representation that can engage with the primary processes of visual and verbal condensation and displacement to construct new pathways of meaning and pleasure.

Mary Kelly's *Post-Partum Document*, for example, draws on psychoanalysis (and particularly Lacan) in its insistence that 'the development of the human subject, its unconscious and its sexuality go hand-in-hand.' It uses psychoanalysis for its 'secondary revision,' its way of working through difficult experiences; at the same time it attempts a deconstruction of the psychoanalytic discourse on femininity. The

Document stresses the continuous production of difference through systems of representation (there is no essential femininity outside of representational practices); and in Kelly's terms, it argues 'against the self-sufficiency of lived experience and *for* a theoretical elaboration of the social relations in which 'femininity' is formed.'[28]

Conceived as 'an ongoing process of analysis and visualization of the mother-child relationship,'[29] the *Document* was produced in six sections of 135 frames between 1973 and 1979. Through its strategic deployment of found objects, diagrams, diary fragments, and commentaries, the idea of motherhood as a simple biological and emotional category is displaced in favor of the recognition of motherhood as a complex psychological and social process—a double movement of setting-in-place that is masked by the ideology of an instinctive and natural 'mothering.'

The physical and psychic interdependence and the pleasurable 'completeness' of the first post-natal period must gradually give way as the infant takes his/her place in the world through a series of separations or 'weanings.'[30] The six stages of the *Post-Partum Document* trace this process to the point where the child signs his own name, confirmed in language and culture as a sexed individual. But at the same time these stages give a voice to the mother's fantasies, 'her desire, her stake in that project called motherhood.'[31] The structure of recognition-and-denial that characterizes fetishism can be found in the woman's castration fears which center on the loss of her loved objects, especially her children.[32] The fetishizing of the child through his gifts and memorabilia is the mother's disavowal—a fetishization that Mary Kelly *as artist* has tried to displace onto the work, at the same time drawing attention to the fetishistic nature of representation itself.

With hindsight, as she indicates, another story unfolds across the *Document*—'a kind of chronicle of feminist debate within the women's movement in Great Britain during the 1970s.'[33] And, through the empirical data and their reworking in artistic practice, a series of conceptual shifts was also taking place: the *Document* moves from a primary emphasis on sexual division in 1973 to the question of sexual difference in 1976, to a point at which notions of a 'negative entry into the symbolic of patriarchy' were replaced by the development of theories of representation—that is, representation in both the psychoanalytic sense (the 'feminine' as position in language) and the ideological sense (the reproduction of difference within specific discourses and social practices). *Documentation VI* attempts to bring these analyses of sexual division and sexual difference together—it is together that they work and find their effectiveness in describing 'the construction of the agency of the mother/housewife within the institution of the school.'[34]

Masculinity, of course, is implicated here as well. Sexuality is not

just women's problem (or symptoms, or politics), but the consequences *for men* of psychoanalytic and feminist theories of subjectivity are usually ignored.[35] The question 'can men make feminist work?' becomes 'can men make work on masculinity from a feminist position?' Both Ray Barrie and Burgin are concerned with mapping 'the constantly shifting landscape of fantasy and reminiscence that shapes male sexual identity.'[36]

Barrie's '*Master/Pieces*' and *Screen Memories* are conceived from the position of a male author questioning masculinity (men do not speak as men, men speak as authority), and the authorship of the work is raised as an issue and a problem in terms of its sexuality. Both pieces deal with the repressed in the sense of phantasy and desire, but also as that which is lost to collective representation. (How often do we see images of a *domestic* masculinity?) They also deal with masculinity in the naturalizing processes of signification—the phallic investment of the natural and manufactured worlds in the shark and the car ('the hottest shape on the road')—and with the exchange of meanings from and for a masculine position that is common to both the public world of advertising and the private space of toilet graffiti. Advertisements offer meaning and pleasure in the process of consuming the representation as well the product. This kind of graffiti, which is based on a reduced iconography of the sex of women, of sex with women, also offers pleasure in consumption. It reconstructs an active, possessive, phallic sexuality for the male, and through the symbolization of women it enables an exchange of meanings around that sexuality among men.

The title and format of *Screen Memories* connect in two directions: first, to the counterpoint of visual and verbal elements in film (the first-person narrative, taken from John Dos Passos, suggests the difficulty and cost of a masculine position); and second, to psychoanalysis and Freud's concept of the 'screen memory'[37] that effects a compromise between what must be simultaneously remembered and repressed. The apparent insignificance of a sharply recalled childhood memory is an alibi, its survival a trace of that which stands behind it. Like the backdrop to *Screen Memories*—spectral images, formed in dust, of picture frames in a derelict house—it is the seemingly trivial clue to an absent history.

Burgin's work has been concerned with male sexuality primarily through an exploration of the structures of voyeurism and fetishism in phantasy. Although at first sight the picturing of the naked woman in the surveillance panel of *Zoo*, or of Olympia and her stand-in from *Tales from Freud*, seems to enforce dominant relations of specularity, these images are placed within a network of references that begins to open up and challenge this very issue. The alternative and 'positive' image of the woman immigrant worker in *UK 76* gives way to a different project, that of the 'interrogation of the "male voice" as it is

constructed across the specific discourses of photography.'[38] Or, we might say, a series of 'male' voices as they are alluded to in *Olympia*, or a series of positions on female sexuality—each a kind of consumption, each with its nexus of knowledge, pleasure, and power.

There are narrative fragments but there is no linear coherence. We are encouraged to read vertically, through association, across the relations of text to image, along the terms of the primary processes of condensation and displacement. No longer consumers at the margin of a finished work, we are drawn onto the site and onto the process of meaning itself. In this process our sexed subjectivity and its pleasures in representation are also implicated, and indeed become the subject matter of the work.

Narrative

A characteristic of the kind of society in which we live is the mass production of fictions: stories, romances, novels, photo-novels, radio serials, films, television plays and series—fictions everywhere, all-pervasive, with consumption obligatory by virtue of their omnipresence, a veritable requirement of our social existence … This mass-production of fictions is the culture of what might be called the 'novelistic,' the constant narration of the social relations of individuals, the ordering of meanings for the individual in society.[39]

The work of these artists employs and relates to narrative, but it does so in order to deconstruct the 'fictions of coherence' that Stephen Heath describes. It uses fragments of narrative—or the ingredients for a narrative or particular narrative devices—in opposition to a modernist elimination of content in the image. At the same time, it draws on the disruption of anticipated sequence and closure in modernist writing, and on more recent analyses of narrativity in structuralist literary criticism. It refuses the authority of the 'master narrative,' the gratification of an enigma posed and solved, and the resulting coherence and fullness of subject position ('A narrative is a sequence of something *for* somebody').[40]

Behind Heath's 'mass production of fictions' lies the classic realist text[41] in which one discourse—that of narration—is privileged over all others. From a position of dominance it presumes to tell us what really happens. It is both ubiquitous and persuasive, and we have every reason to take pleasure in its devices, its resolutions and its promise of authority and truth because they answer our own needs for coherence and control.[42] Just as the classic realist text conceals the fact that its master discourse is another articulation—one story amongst others—so it also conceals the position of the subject as inside this articulation, offering us instead an imaginary and coherent place external to it from which we may view things 'as they are.'

In contrast, the production of work in which there is narration but

no privileged narrative aims at engaging our storytelling tendencies while refusing us a fixed position of knowledge. Robert Scholes says that the postmodernist anti-narratives:

bring the codes to the foreground of our critical attention, requiring us to see them as codes rather than as aspects of human nature or the world. The function of anti-narrative is to problematize the entire process of narration and interpretation for us.[43]

We should therefore distinguish between 'narrative' as a conventional means for representing and structuring the world, and the employment of certain narrative devices in an art that seeks to interrogate the processes of representation. Such work stresses the contradictions in the 'real,' the incoherence of the ego, and unexpected transformations of meaning across image and text. This disruption of the codes of the classic realist text, this relocation and imbrication of image and script, this interplay of multiple discourses without offer of a fixed position— all this is part of the productivity of the work and common to such otherwise disparate projects as the *Post-Partum Document*, *Tales from Freud*, *The Missing Woman*, *Metaphorical Journey*, and *Screen Memories*.

In Marie Yates' *The Missing Woman* we are teased by a narrative process which is first offered and then withdrawn. Images are paired with fragmentary texts—letters, diaries, newspaper cuttings, official reports—that we designate as documentary, but which we might well subsume under Heath's 'mass production of fictions.' Marie Yates describes her project as:

a play on that [i.e., Lacan's] process of identification exploring our persistence as subjects in language in our belief that somewhere there is a point of certainty, of knowledge and truth.[44]

Through visual and verbal signs, by means of characters and occurrences, we are invited to construct the identity of a woman, 'A,' and encouraged to believe that by following the sequence we will be rewarded at this point of 'certainty, knowledge and truth.' The relations between text and image appear at times straightforward and at others elliptical. We do our best, as we do with novels, to construct the image of a whole character from the evidence we are given: to find 'A's' story, identity, and relationship to the child, for instance, in a still life of domestic paraphernalia.

In pursuing the enigma of 'A' we are tracing the production of sexual difference in fragments of discourse—feminine identities in social relationships, the family, property rights, and legal ceremonies that are not necessarily either whole or wholesome. 'Identity' is a narrativization of life, a story that satisfies us about who we are. But the pull towards narrative is finally refused, so that character and sequence remain elusive (the panels can be hung in any order), and any sense of

closure or equilibrium is undermined by an assertion (attributed to 'B') that calls us into consciousness of what we do:

however much photography is equated with content, and painting with 'thing-in-itself' or 'window-on-the-world,' whenever we look at an image we are its authors through the field of discourse and generally put images to use in providing narratives to our satisfaction.[45]

In seeking to make sense of images, we also work to produce a coherent position for ourselves.

But the question remains: who is *The Missing Woman?* (Lacan: 'Woman as such does not exist'). Is the feminine itself the missing (woman defined as absence or lack)? Or is there—as the discrete references to culture and class in the piece suggest—no one femininity, present or missing? Perhaps we have been distracted and the absence is not 'A's' but that of whoever has ordered these elements for our reworking. Is the artist outside or inside the work ('B,' an artist. 'Y,' a woman who resembles 'B')? Is the narrator the author, a character ('B') among others, or, effectively, ourselves (on what other point does this 'evidence' converge)? Who speaks, in narrative? (Benveniste: in narrative, no one speaks).[46] Is the image a tableau offering the fictional promise of 'a sleek and whole identity' or, as Yates suggests in her writing, a mirror 'which can reveal its operation through mobilizing the discursive in its mode of address'?[47]

Partial narratives—or the invitations to attempt them—are present in Yve Lomax's work too. What suggests a story is not the representational tableau that Barthes likened to a hieroglyph condensing past, present, and future,[48] but something closer to a frame cut from a *film noir:* a moment of anonymity and anomie with no 'before' or 'after' except those that we propose.

The limited identifications offered by the female figures in Lomax's *Open Rings and Partial Lines* quickly come unraveled. They are in all senses flat: the sense of a represented space, a rounded character, or a moment's emotional resonance is undercut by the insistent play between narrative and surface. (Lomax: 'Think about the question of representation falling flat, spreading out and becoming a question of the horizontal assemblage of parts.')[49] Surface marks and blocks of primary color effect this pull-back from narrative and illusion, together with a particular use of montage. Representations of femininity from fashion photography, television, B-movies and advertising, technically degraded through their reproduction, abrade each other. But between the paired segments there lies a gap which challenges the classic, Eisensteinian notion of montage as the production of a third meaning from the juxtaposition of two images. As the artist remarks:

I would say that montage is concerned with bits as bits, not as fragments broken from some original whole ... [and] the politics of montage concerns

the way in which we negotiate heterogeneity and multiplicity ... the way in which we take up with practices (literature, science ... sex) as assemblages, indeed as montages, and not as monolithic wholes.[50]

Pleasure

Laura Mulvey's account of 'Visual Pleasure and Narrative Cinema' assumes that pleasure is bound up in the structuring of sexual difference. Asking how systems of representation (in this case Hollywood cinema) play on unconscious pleasures in looking, she suggests a distinction: between the voyeuristic pleasure of the male-positioned viewer presented with the fetishization of woman as spectacle; and the different pleasure that the viewer takes in identifying with the (male) character who appears to control the narrative and move the plot along.

The pleasures accorded to women (or to the female-positioned subject) in this regime are those of a complementary exhibitionism. Because we are formed by it we are not immune to a narcissistic fascination with images apparently addressed to men—with finding our own satisfactions in the spotlight of that controlling gaze. Alternatively, but with some discomfort and collusion, we may cross-identify with the bearer of the look. But in so far as such forms of gratification are oppressive to us, pleasure becomes a political issue:

The man's relation to the whole problematic differs fundamentally from the woman's: the woman must, by discovery and invention, locate herself-for-herself in representation (where now, predominantly, she takes place only for men); the man, on the other hand, is everywhere in representation in his own interest ...[51]

Within the psychic economy, pleasure cannot be refused. Images *will* gratify scopophilic components in the libido, *will* engage the structures of fantasy and desire, *will* invoke narcissistic identifications by various means. We cannot, in Victor Burgin's terms, 'dispense with the phantasmatic relation to representation.'[52] We can work with it (in Burgin's case, by the direct quotation of voyeuristic imagery in the context of a critique); we might be able to subvert or reconstruct it in less oppressive forms. Or perhaps the drive is sufficiently undifferentiated that there is no one thing that pleasure is: it may follow familiar paths, but cannot ultimately be defined in isolation from the social and discursive formations in which it occurs.

There is also the question of pleasure, not just as it relates to a variety of psychic investments but in relation to knowledge. Something here connects with Barthes' distinction in *The Pleasure of the Text* between 'pleasure' and 'jouissance.' The text of pleasure is the text we know how to read (the representation that supports our identifications and offers us the satisfaction of recognition). The text of 'jouissance' (or ecstasy), on the other hand,

imposes a state of loss, ... discomforts ... unsettles the reader's historical, cultural, psychological assumptions, the consistency of his tastes, values, memories, brings to a crisis his relation with language.[53]

Such disruption of the 'readerly' text is necessary if the social and psychic economy is not simply to be reproduced in its dominant mechanisms and effects. But some return is necessary for this effort: the 'thrill that comes from leaving the past behind,'[54] as Mulvey calls it, or the pleasures of play as a strategy for the work as Lomax intends:

Play ... in all senses of the word: to disquiet; to disturb but also to engage in an amusing and pleasurable activity ... it is also, in a sense, its politics: to no longer separate politics from pleasure.[55]

How willing the spectator is to enter into 'play' may depend on their self-perception and situation. Disruption of this order is threatening, and not only to the security of the already known. Work that denies identity and emphasizes the subject-in-process, in a sense proposes the viewer's undoing. For men, perhaps, a pleasurable reading of this work will be difficult at best. Women, on the other hand, have an investment in the deconstruction of 'femininity' and compensatory pleasures: in answering back (Barbara Kruger: 'Your gaze hits the side of my face'), in hide-and-seek (Cindy Sherman presenting herself as object of the look while refusing, in mobility of self-constructed identities, to be discovered by it), and in evacuating woman's image in favor of a more circuitous route to 'the mother as subject of her own desire.'[56]

Context: Feminism, Modernism, and Postmodernism

The first question to pose is therefore: how can women analyze their exploitation, inscribe their claims, within an order prescribed by the masculine? Is a politics of women possible there?[57]

Since the nineteenth century at least, pro- and anti-feminist positions have been engaged in struggles over the varied propositions that culture is neutral, androgynous, or gender-specific. What these debates generally have not addressed is the problematic of culture itself, in which definitions of femininity are produced and contested and in which cultural practices cannot be derived from or mapped directly onto a biological gender.

The most important contribution of the feminism under consideration here is the recognition of the relations between representation and sexed subjectivity *in process*, and of the need to intervene productively within them. The artists considered here hold the common aim of 'unfixing' the feminine, unmasking the relations of specularity that determine its appearance in representation, and undoing its position as a 'marked term' which ensures the category of the masculine as some-

thing central and secure.

This is a project within feminism that can be seen as distinct from, say, the work of Judy Chicago. The importance of *The Dinner Party*[58] lies in its scale and ambition, its (controversially) collaborative production, and its audience. But its deployment of the fixed signs of femininity produces a reverse discourse,[59] a political/aesthetic strategy founded on the same terms in which 'difference' has already been laid down. What we find in the work in this exhibition is rather an interrogation of an unfixed femininity produced in *specific systems of signification*. In Burgin's words,

meaning is perpetually displaced from the image to the discursive formations which cross and contain it; there can be no question of either 'progressive' contents or forms *in themselves*, nor any ideally 'effective' synthesis of the two.[60]

This work has been claimed for modernism (for a Russian, rather than a Greenbergian formalism) and for postmodernism (via poststructuralist theory rather than new expressionist practice), but we need, finally, to see it in yet another context. Not as the phototextual work of the '70s now eclipsed by the panache of the new, not as one ingredient amongst others guaranteeing the plurality of the new, not even as a 'postmodernism of resistance'[61] (despite the equivocal attractions of the term). Rather as that 'cinematic of the future'[62] Barthes called for, that concern with sexuality in process which Luce Irigaray described as 'woman as the not-yet'[63]—a continued countering of cultural hegemony in its ceaseless and otherwise unquestioned production of meanings and of subject positions for those meanings.

She had acted out for long enough, inside those four corners: frame, home, tableaux or scene. She no longer wanted to be found, where she was expected to be found, as if each time she was found it were all the same. As if it were all a matter of one pattern from which, on and on, the same was cut out, pressed out, and indeed could be put back ... She arose. She straightened herself out. She made ready to go. But as she turned to look at what she was leaving behind, she knocked some metaphors off the table ...[64]

No Essential Femininity

Paul Smith Would you begin by describing your *Post-Partum Document*?
Mary Kelly Speaking quite generally, it's an extended documentation, which I began in 1973, of the mother-child relationship. It took about six years to complete and is divided into six sections including, in all, about 135 pieces. I suppose I should also say that it was conceived as a piece for the conventional gallery space, that is, specific modes of presentation are employed: the plastic frames, for instance, parody the whole iconography of the museum 'display'—not just the art museum but something like the natural history museum as well (which I've always thought of as a vast metaphor for the exploration of the mother's body). I wanted to put this archeology of everyday life into that kind of framed space—an unexpected place—which would set up certain conditions for a critical reading. I felt it was crucial to consider how the work intervened in a particular institutionalised context. So, in a sense, the way it 'looks' in the gallery is an important consideration. On the one hand, it appears to be a record of external events, but on the other, it doesn't function in that space as simply a document: the installation is intended to construct several readings or ways through the text. These are indicated firstly by the objects and the narrative texts which accompany them; secondly, by a series of diagrams which refer elsewhere to a kind of explication of the empirical procedures in the work; and thirdly, by another set of diagrams which refer specifically to the work of Lacan and which suggest another possible reading based on psychoanalysis [57].

So, at one level, the spectator is caught up, as it were, in a first-person narrative which traces the events specifically related to moments in the child's (that is, my son's) relationship, with me: for instance, weaning from the breast, learning to speak, starting school, the first questions about sexuality, and finally, learning to write. Each one of these moments 'develops' in an empirical sense and this might indicate that the piece had a definite beginning and end; but, of course, at another level, the space of the diagrams that refer to the Lacanian readings places much more emphasis, not on a literal document or on a notion of, say, developmental stages, but rather on the construction of the relationship in terms of the mother's fantasies.

57 Mary Kelly
Post-Partum Document, 1971

P.S. I'd like to pick up on a lot of those points, but would you start by talking about the notion of narrative here? As I see it, the story of the mother-child relationship *is* specifically a story, chronological and linear, working on the level of traditional narrative in the sense that there's a problem posed and a resolution reached (which, here, is the final imposition of the social and symbolic upon the child). And also, isn't the spectator obliged to move around the work in the linear way that narrative traditionally entails?

M.K. Certainly I didn't see it as a narrative in the traditional sense. I suppose that the diaries give a place to the mother in terms of the subject 'I'; she speaks in the first person. But that's displaced by the meta-discursive style, which enters by way of the footnotes and which uses the third person as the dominant mode of address. So I'm not really privileging the autobiographical discourse—I'm always attempting to disrupt it.

As to what you say about a sort of development and resolution: I think that movement is thwarted in the work as well. In a traditional narrative one would perhaps expect a central point at which the heroine makes the decisions which cause a certain effect or dictate her fate at the end. That's not the case here. The diaries just prolong and extend the description of events at the same level; so that when you talk about a resolution, I'd reply that it refers in a much more general way to the theoretical implications of the work, which are presented in the footnotes. That's to say, when I describe the mother-child relationship in the post-partum period as a confrontation between the Real and the Imaginary which is always structured within the *primacy* of the

Symbolic, that can be referred to in a certain sense as a resolution. It's not, though, to do with the narrative structure of the work, but rather with the theoretical perspective which always sees the positioning of the subject and the construction of femininity as framed within the limits of language and culture. Some feminists, I know, might not agree. But then you have to ask yourself a question: if you don't subscribe to that notion of the universality of language; if you say that men and women don't enter into the same order of language and culture and that it's *essentially* different for the woman, that she can discover something outside, as it were, in opposition to that order; then doesn't that also effect a kind of closure—perhaps one that's even more dangerous in its implications for feminism? In its most extreme form it would imply that femininity is tied to essential biological differences; or, alternatively, it would place emphasis on the experience of the pre-oedipal moment as privileged for the woman, maintaining that the passage she makes through the Oedipus complex in somehow incomplete, or that she occupies a position 'outside' in relation to representation. This would ultimately suggest that all women are in some sense neurotic as the necessary effect of their psychic positioning within the Symbolic.

P.S. I suppose that, traditionally, one of the most effective ways of imposing a closure through a visual means of representation is to use the biographical or autobiographical image, always given as a wholeness. You've very deliberately left out of the *Post-Partum Document*, your own body, your own image. What's involved in foregoing that temptation, and what kind of image of yourself do you think does finally emerge from the work?

M.K. When I placed emphasis on the fact that the work wasn't a reiteration of child-development but an attempt to give a place to the mother's fantasies, this was also relevant in terms of the modes or forms of representation which I chose for underlining that decision. For me it was very important not to use filmic or photographic means —that is, nothing which would suggest the notion of documentation as a 'slice of life'—not because that's actually the function of film or photography but rather, strategically, it was important to avoid any implication of that sort. The decision was also crucial because I feel that when the image of the woman is used in a work of art, that is, when her body or person is given as signifier, it becomes extremely problematic. Most women artists who have presented themselves in some way, visibly, in the work have been unable to find the kind of distancing devices which would cut across the predominant representations of woman as object of the look, or question the notion of femininity as a pre-given entity. I'm not exactly an iconoclast, but perhaps historically, just at the moment, a method needs to be employed which foregrounds the construction of *femininity as a representation of*

difference within a specific discourse.

In the *Post-Partum Document* I'm concerned to see how femininity, within the discourse of the mother-child relationship, is produced as natural and maternal. Of course, the practices that are implied in that process, like feeding or dressing a child, are as dependent on a system of signs as are writing or speaking. In a sense, I see all social practices as expressions of a general social law (of a symbolic dimension, as Kristeva puts it), which is given in language. This means that the formal emphasis on written and spoken words in my work simply stresses the fact that the production of the subject is primarily a question of positionality in language.

But I'm also aware of another implication: what I've evacuated at the level of the look (or the representational image) has returned in the form of my diary narrative. That acts as a kind of capture of the viewer within that first-person narrative of the diary texts. For me, it's also absolutely crucial that this kind of pleasure in the text, in the objects themselves, should engage the viewer, because there's no point at which it can become a deconstructed critical engagement if the viewer is not first—immediately and affectively—drawn into the work. I also think that narrative can function differently in an art work because it is unexpected and controversial in that space [**58**, **59**].

P.S. Working in this manner, you're cutting across a certain type of women's art-practice which, in the last ten or fifteen years, has been concerned to alter woman's given image by exactly the opposite mode you've chosen. I wonder if there's not something important going on in such work, which treats the woman as the object of the look but where she is redefined in some way.

M.K. I suppose I'd like to generalise the question into a consideration of how the construction of femininity is viewed within differing art practices by women artists. Since the early seventies you could probably point to at least four different categories of work.

Firstly, what we think of as cultural feminism, an attempt to excavate a separate order of language and culture for women. This work usually inscribes itself as either an appropriation of earlier forms of traditional women's crafts, or as a reinvention and exploration of those means in terms of a contemporary practice—say, for instance, the emphasis on pattern painting in New York. Perhaps the most important example of that tendency was the early work of Judy Chicago and the project *Womenhouse*; and more recently its triumphant finale, as it were, with *The Dinner Party*. Chicago suggests that this valorisation of women from the past is taking place precisely because history has tended, as she puts it, 'to devour women.' There, interestingly, you have a kind of inversion of the totem-meal: what's forbidden on the one hand—the devouring of the mother—is permitted on this one ritual occasion where the historical mother-figures are put in the position

of the father, their name and status ingested as in the totem-meal, by the female viewers of this visual feast.

Secondly, you have the work which actually uses the body itself, like Suzanne Santoro's well-known book, *Towards a New Expression*. Here, exploration of the female genitals becomes a means of appropriating a specifically feminine relation to language, which is given in the body. Theoretically, I imagine, the most effective exposition of that position would be in the work of Luce Irigaray: she talks very poetically about the female sex as two lips kissing one another. For her, any kind of intervention in that primal auto-eroticism is seen to be a sort of violence against the woman.

Then there's a more varied third category which revolves around what could be loosely described as feminine experience. These women artists feel that there is, not necessarily a biologically determined femininity, but an essentially feminine experience of the body, or dominated by *representations* of the body. This is the case with most performance work. Hannah Wilke, for instance, refers to the eroticism of the woman's body. She presents herself very typically as the object of the look, and in doing that I suppose she is acting out the feminine position—the position of being the phallus for the other. But there is a contradiction. That image of totalisation, the mirror-image as it were, is always subject to fragmentation, disarray or disavowal. So you have with Gina Pane, for example, the signs of self-mutilation that could be interpreted as the other side of the mirror-image; or Adrian Piper, in her *Guerrilla Theatre*, where she makes herself as despicable as possible—a kind of inversion of what she sees as the stereotype of the desired object.

What I think emerges as a kind of underlying contradiction there is that, while the woman sees her experience in terms of the 'feminine' position as the object of the look, she has to also deal with the fact that she's the subject of desire, or that she is, as artist, in the 'masculine' position as subject of the look. The difficulty she finds in being in those two places at once seems to me to demonstrate through the actual practice something about the insistent bisexuality of the drives. You find this in the practice of most of the women artists right through these categories; you find there's some way in which a fundamental negation of the notion of an essential femininity nonetheless appears. Even in work which is overtly derived from the female body you can find a kind of super-imposition of phallocentric and concentric imagery—Louise Bourgeois' sculpture is an interesting example. And I could go on endlessly citing examples, but the point I'm trying to make in general is that the work of representations of women does, in fact, demonstrate to what extent masculine and feminine positions are never fixed.

The question of sexuality which I feel is emerging (partly as a consequence of that other work) is posed neither in terms of a reduction to

the body, nor to the order of an essential feminine experience, but precisely in the realm of the social construction of masculine or feminine identities. This new tendency is by no means homogeneous. It turns, on the one hand, towards a kind of economic determinism in, say, the work of Martha Rosler; or perhaps, on the other hand, towards a theory of subjectivity—I might use my own work as an example, which in general I would say tries to place an emphasis on the intersection of those two instances, the social and the psychic as they meet in constructing the sexed subject.

P.S. You're talking somewhat in psychoanalytical terms and you've also indirectly brought up the question of Marxism. Maybe this is the place to propose my sense of your work as characteristically European, insofar as one of the firm bases of North American feminism has been exactly a repudiation of Freud, a refusal to accept certain of his ideas and, in some cases, a foreclosure of the very idea of the unconscious. This hasn't been true in Europe, so do you see your work at all in that dialectical opposition to such a tendency in North America?

M.K. Certainly one of the conspicuous differences in the European Women's Movement is that socialist feminism has remained alive and well. In America the development of the Movement seems to have been circumscribed by radical feminism on the one hand and traditional Marxism on the other; only very recently has there been any real attempt to mediate these positions in terms of art practices. Lucy Lippard's organisation of the exhibition *Issue* at the ICA in London last year was the first real initiative of that kind. But one could still sense there in most of the work by American artists that any emphasis on the 'personal' appeared to distract from what they would consider 'wider social issues'.

Now, in the way that much European feminist work has developed, I don't think that's been the case—the social and the psychic haven't been seen as necessarily antagonistic or contradictory. But one would have to add that within the socialist feminist groupings, say in Britain, it's only a smaller tendency that's been involved in work on psychoanalysis. Certainly the debates around psychoanalysis and Marxism in the Movement have been very productive, although the intended marriage of the two never took place. The outcome has been more in the order of discovering that one can only use certain methods of analysis in relation to their specific objects: there's no single theoretical discourse which is going to offer us an explanation for all forms of social relations or for every mode of political practice.

The *Post-Partum Document* found its inspiration, if you can call it that, within the socialist feminist tendency of the Women's Movement in Britain. I identify very much with those who have been doing work in the field of psychoanalysis—initially the History group, then the Lacan reading group, and more recently the journal *m/f*. In 1976 there

(age 3.9) E IS FOR ELEPHANT. He's discovered a system of combining what he calls "a straight one and another, straight one." He usually makes capital E, but by subtracting he gets F and by an excessive addition — E! It's as symptomatic as his 'O' but derived from x rather than O. E IS FOR ALLIGATORS ENTERTAINING ELEPHANTS. E IS FOR EIGHT ELEPHANTS WITH ENORMOUS EARS. GOOD NIGHT LITTLE E. EDWARD ELMER ELEPHANT. GOOD NIGHT LITTLE E.

October 5, 1977: Kelly had his 4yr. old check-up to-day at the nursery (I felt like I was having a check-up myself). The doctor asked me if he dressed himself yet, (I thought, well yes, but I usually haven't got the patience to wait). I said 'yes'. Then she asked if he could use a knife and fork properly. I said 'yes' again, (but in fact although he can, he usually doesn't and I don't insist because I'm so pleased if he's just sitting still and eating). Then he had to identify pictures, count, draw circles and squares and build a bridge with blocks. (I was holding my breath, thinking he might not do it because I was there). I was so pleased when she said he was the only boy, in his class to do all the tests correctly, (I wanted to tell her about his wonderful writing too, but decided it wouldn't be discrete to boast about your own child). Then she said he would be ready to start infants school soon.

3.909E

58 and 59 Mary Kelly

Post-Partum Document VI: Pre-writing Alphabet, Exergue and Diary, 1979.

(age 3.10) Z IS FOR ZEBRA. His combination of straight lines and diagonals has introduced Z and y as well as I on its own. Now there is a marked distinction between these kinds of letters and those he calls "hooks" (f, t) although they're all derived from X. Z IS FOR ZIPPITY ZOUND, ALLIGATORS ALL AROUND. Z IS FOR A ZEBRA PLAYING THE ZITHER. ZORBA ZACHARY ZEBRA. GOOD NIGHT LITTLE Z.

December 6, 1977: Now I'm back to square one because I have to find an infants school for next year. To-day I went to see the two schools nearest us. The first one was old and dilapitated and very crowded (just as they said in the C.P. pamphlet). The head-mistress was lovely but seemed to be desparately trying to erase the schools 'bad' reputation. Most of the children were West Indian or Asian. The atmosphere was casual and friendly, but somehow I felt it was all hopeless. She gave me some material (on the i.t.a. (initial teaching alphabet) as she could see I was suspicious, i.e. ignorant. At the second school, the head-mistress was shouting at some children who were charging into her office and when I stepped in, behind them, she looked rather embarrassed. The school was crowded but orderly. It reminded me of a prison. The teachers looked harassed. They used T.O (traditional orthography) which I felt easier about but didn't like the strict age grouping. I felt confused by then and very depressed. I went home, planning to discuss it with Ray and cried instead.

210102

was an important conference on the topic of patriarchy where the issues of psychoanalysis were raised within a wider context. There were workshops discussing Lacan's re-reading of Freud. It was very controversial but nevertheless it *was debated* within the Movement; that hasn't been the case in North America. My work grows directly out of those debates and is almost concurrent with their every stage. It started out with an emphasis on the psychology, the feminine psychology of the mother being sealed in the division of labour and childcare—a position which one could say is reflected in Mitchell's book *Woman's Estate*, which was then modified and reworked so that by the last section of the *Post-Partum Document* in 1979 I wasn't talking so much about patriarchy in terms of the division of labour, but rather with reference to the construction of sexual difference.

P.S. Implied there, and in those debates, is the necessity of inserting into political considerations a theory of the speaking subject; your work does seem to me to highlight one of the problems that much of this kind of work has had to face, namely that it can be accused of a certain patriarchal bias because of its reliance on Lacan and his definition of woman in relation to the phallus. Also, there is in your work a sort of recourse to rational structures (diagrams, graphs, theoretical discourse, etc.) which I'd characterise here as patriarchal, as male. Do you accept, on the one hand, that there is this recourse to rationality as an authority in your work; and on the other hand do you accept this view of Lacan as being irredeemably patriarchal?

M.K. There are several levels the answer could operate on; but taking it up in relation to the art-practice itself, one would have to see the theoretical work primarily as 'writing' or as a mode of representation rather than as any form of final explication. When I employ something like the Lacanian diagrams, they too are cathected as images of the difficulty of the Symbolic, or perhaps as emblems of a kind of love– hate relationship with the father—which is not exactly a recourse to rationality as authority. At one level you could say the work itself, particularly the reworking of that experience of maternity in the footnotes, expresses a fundamental desire to know and to master. Now, in regard to the actual theoretical examples cited—say the articles by Lacan which I used to analyse the various moments of separation—another level of questioning is raised as to whether I should be using any kind of what some feminists might call 'male discourse' at all—why Freud, why Lacan? I must admit that I did really want to find alternatives in the beginning. I read Mannoni, Dalto, Klein; but Lacan's work, particularly his notion of the two end-points of the mirror-phase, was crucial for my first three works, *Weaning from the Breast*, *Weaning from the Holophrase* and *Weaning from the Dyad*; that material required a rather more complicated analysis of separation and entry into the order of language than could be afforded by either Klein (who pushes the Oedipal moment so

far back that we can't get a clear picture of those early distinctions) or Dalto (who places it too schematically, that is, at two-and-a-half years old). But in sections IV and V (*On Femininity* and *On the Order of Things*) which are centrally concerned with the representation of loss, not only as loss of the child but also as loss of the maternal body, I rely very heavily on Montrelay's reading of Lacan, her definition of the 'feminine' unconscious as the imposition of 'concentricity', an archaic oral-anal schema, upon the phallocentric organisation of the drives. Then in the final section, *On the Insistence of the Letter*, a definite theoretical shift takes place, initiated by the analysis of the child's pre-writing, which raises questions concerning the phonocentric and perhaps logocentric bias of Lacan's position. (By that I mean his dependence on Jakobson's linguistics.)

P.S. For me, though, one of the most interesting parts of the whole work is its double-inscription of fetishism; on the one hand, the mother fetishizing the child as phallus, and on the other, the sense that the work itself, once installed, becomes a further fetish, replacing the dangers of the fetishization of the child. Underneath that, however, is a discomfort arising from the idea that fetishism is always a surrender to the law of the father, to patriarchal order—and Freud, of course, ascribes fetishism specifically to the masculine domain. So what is fetishism for a woman, and how does it work?

M.K. Obviously, as you pointed out, the submission to the law of the father is precisely what Lacan would mean by symbolic castration; but castration is also inscribed at the level of the imaginary, that is, in fantasy, and this is where the fetishistic scenario originates and is continually replayed. The child's recognition of difference between mother and father (which is not quite the same thing as actually seeing it), is above all an admission that the mother does not have the phallus. What's at stake for the child is the question of his or her own sexual identity. This submission to patriarchy is, in other terms, the outcome of the passage through the Oedipus complex which, for the boy, is completed in a sense by the castration complex, and initiated by it for the girl. So conventionally, I suppose, the fetishist postpones that moment of recognition, although certainly he's made the passage—he knows the difference but denies it. This is what we usually associate with the whole iconography of pornographic images where the man is reassured by some phallic substitute, or alternatively, by the form of the woman herself, the complete arrangement of her body. I know this is extremely controversial but I think that the woman, insofar as the outcome of the Oedipal moments has involved at one point a heterosexual object-choice, postpones the recognition of lack in view of the promise of having the child. To that end she will give up the mother, that is, will identify with her and take the father as a love-object. In a sense, having the child she has the phallus. So at the imaginary level, the mother's

loss of the child is the loss of that symbolic plenitude.

In fantasy, castration anxiety for the man is often expressed as the loss of the penis, the arms, the legs or some other substitute. When we talk about this imaginary scenario for the woman, we say that her castration fears take the form of losing her loved-objects, especially her children. The child is going to grow up and leave her, reject her, perhaps die. In order to delay, disavow, that separation she has already, in a sense, acknowledged that the woman tends to fetishize the child in some way: for example, by dressing him up, by continuing to feed him no matter how old he gets, or simply by having another 'little one'. Perhaps, in place of pornography, we could talk about the mother's memorabilia; the way she saves things, like the first shoes, photographs, locks of hair, and so on. My work takes off from that point. In place of the first shoes, we have the stained liners, or the first words set out in actual typeface. When I use something like the plaster imprints of the child's hands, the fragments of his comforter, or the objects like insects or plants that were his gifts, they are intended to be read as transitional objects, but not in Winnicott's sense of surrogates, rather in Lacan's terms as, say, emblems of desire.

So I've displaced the fetishization of the child at one level onto the art work. But I've made it explicit in the work so that I think this also functions at another level which questions the fetishistic nature of representation itself. All the objects are framed and fixed, in a way which defines them as precious objects, things to be seen or sold. Yet they're commonplace or ordinary. What's more, because they're found objects, they're not properly invested with creative subjectivity, in other words, with the kind of authenticating mark, or authorship, which is so essential to the art market.

But the question of fetishism gets us into some difficulties about the work. One of the clinical definitions of fetishism is that it doesn't concern any specific object: it's simply a question of how the original cathexis is displaced from one idea or object or part of the body, to something often totally unrelated. As Freud points out, art is a kind of non-neurotic variation on the theme of fetishism, so there's a sense in which we're not actually talking about the same thing in *Post-Partum Document* because it's something which is sublimated in a socially acceptable form, and therefore generalisable as a discourse and as a practice. But the work is also a case-history—it is *my* experience of those events. It has sometimes been frightening, but I don't think the implications of this are really accessible to me for analysis.

P.S.: I'd like to ask you about writing and language in the work. Because you're overlaying different types of discourse, mapping out various linguistic terrains and adding one voice to others, there seems to me to be implicitly some kind of hierarchy of discourse established at certain points. This perhaps comes out of my sense that the discourse of psychoanalysis is being privileged, but also, on a more local level (as in *Documentation III* [**60, 61**] where you have your voice, your inner speech and the child's original discourse all inscribed over the child's scribblings), there does seem to be some sense of a hierarchy pointing to some position of power and suggesting that someone somewhere could be using the 'right' language: this brings up the question for the whole work as to what kind of language you're aspiring towards.

M.K. Hopefully, the work is a continual displacement rather than a hierarchization of certain forms of language. The way it works through different levels of language is certainly seen to be unravelling the sense in which representation is always a representation of loss. The piece

that illustrates this most clearly is *Documentation IV*, where the imprints of the child's hands disappear and a diagrammatic representation of the relationship appears. Throughout the work, while I'm speaking about it and trying to understand it, I'm also in the process of recognizing that something has already been lost. So in that particular part, where I talk about the pleasure of the child's body and the problem of the incest taboo for the mother, I'm also trying to see what's at stake beyond the representation of the child's body itself. What emerges, I think, is (as usual) the mother's body. By saying that the representation of femininity is constructed as maternal, I mean that in this relationship the woman experiences that closeness to the mother's body which she imagined in those first identifications with her own mother. In that sense, too, when I use the writing on the slates in *Documentation VI*, I'm referring to the child's marks as a kind of anagram of the maternal body. The whole project, not only the visible art work but the process itself, is about the relation of writing to the mother's body. But this has been said often enough. What I've emphasized in that relation is a moment of transgression where separation threatens the woman's representation of herself as essentially and naturally maternal, and creates a kind of chasm which resounds with questions. The woman questions the socially given meanings for the feminine. So I guess the kind of language I'm aspiring to is one which will prolong that rupture.

P.S. In some way, you've just answered the question I'm about to ask. If that transgressional moment of loss does open up a new space, it might nonetheless still be read with a certain pessimism regarding women's condition since, even though it gives the impulse to change and to make different things happen, it can surely be a moment that's repeatable only at certain junctures in your life (and for most women not very often at that). Doesn't it suggest finally that the symbolic realm imposed and re-imposed upon us is constricting and unchangeable?

M.K. On the contrary, I see it as very optimistic because it shows exactly that the symbolic realm is not really fixed and homogeneous, but that it's riddled with contradictions. Precisely because what we call 'ideology' is a complex arrangement of social practices and systems of representations which are always inscribing their difference from one another, we can find a space for change. It's the totalizing view of culture that leads to pessimism. When you say either that we're absolutely constrained by patriarchy or that it's only a matter of false consciousness to be shaken off, *that*, for me, is when you come up with a much more constricting view. I think that what's discovered in working through the *Post-Partum Document* is that there is no pre-existing sexuality, no *essential* femininity; and that to look at the processes of their construction is also to see the possibility of deconstructing the dominant forms of representing difference and justifying subordination in our social order.

Postfeminism, Feminist Pleasures, and Embodied Theories of Art

Dedicated to Hannah Wilke, 1940–1993

We live in a particular moment of highly charged sexual politics. Within the last year, supporters of women's rights have seen a number of disturbing public displays of these politics: the ridicule of a well-educated African-American female lawyer by an all-white, all-male Senate commission for her exposure of sexual harassment by an African-American male candidate for the Supreme Court; the media-fed rise of Camille Paglia, whose self-serving, pseudo-intellectual, and antifeminist pronouncements have established her as the Phyllis Schlafly of gender studies. And we have seen women professionals, both fictional and actual, become targets for reactionary rhetoric about 'family values' and the 'cultural elite,' as men debate the vicissitudes of feminine behavior and attempt to pass legislation on a woman's right to choose. Intimately related to these epochal events in the history of American sexual politics is the development of antifeminist cultural discourses that veil their hostility to feminism through the spuriously historicizing term 'postfeminism.' In the last decade, as Susan Faludi points out in her book on the antifeminist 'backlash,' feminism has become a dirty word.[1]

I will explore here the discursive means by which the death of feminism (its status as 'post') has been promoted through photographic and written texts, examining what is at stake—politically, culturally, and economically—in this promotion. Tracing various constructions of postfeminism, I will analyze it on several different levels, each of which corresponds to a sociocultural configuration of oppression against women that must be excavated in order for an effective understanding of postfeminist politics to take place. I will begin by introducing some examples of how feminism has been reduced to a unitary construct, then discursively and photographically executed (in both senses of the word) as postfeminism in the popular press in the last few years, and will follow this with an examination of some of the ways in which post-feminism has permeated art discourse.

As a coda to this critique I will suggest ways of rethinking the dilemma posed by the mobilization of the term postfeminism by returning to a previous moment of feminist art history, reintegrating into the so-called postfeminist debate the feminist body artists from

the explosive early years of the second wave women's movement, the 1960s and 1970s. Looking again at these artists, who began to produce their work before postfeminism (or feminist postmodernism) began to be defined in art discourse, will be useful in exposing the negative effects of postfeminism. Through this recourse to feminists' articulations of the physical body I hope to suggest a way to revive positive and empowering meanings in relation to feminism in Western culture. The point of looking back to practices that have been for the most part ignored since the 1970s is definitively *not* to reject 1980s feminist art practices and theories in all of their complex and variously enabling effects, but, rather, to think a way out of a critical definition of feminist art that, from the point of view of the 1990s, is beginning to appear dangerously prescriptive. In this essay, then, I will suggest a way of rethinking the relatively limited notions of sexual critique that I believe have accompanied the incorporation of feminism into postmodernism (as postfeminism) in art discourse by theorizing the particular feminist interpretive pleasures that these embodied works evoke as they activate the feminist subjects of art and art history.

Postfeminism in Popular Culture

The enemies of the postfeminist backlash in the popular press are professional women in general, and feminism and its avatars in particular —especially those self-defined feminists who confuse and transgress previously accepted codes of domesticated femininity. The fantasized feminist enemy is a homogeneous figure: visually and textually coded as a professionally powerful and often excessively sexual woman, she is also severely limited in terms of race and class, not to mention sexual orientation. Within the representational politics of popular culture, any identity formation deviating from the upper-class, Anglo, straight imaginary of the American subconscious must be transformed or homogenized to comply with the normative American subject.

The demographically limited yet still highly threatening feminist enemy to the status quo has been epitomized recently by the fictional character Murphy Brown, whose repeated invocation and excoriation by the conservative right has signaled the strength of the threat posed by the figure of the self-sufficient woman. By naming Murphy Brown the enemy of 'family values' because of her independence from men, the namer both denies the existence of those other, actual single mothers who aren't as picturesque for the dominant myths of femininity as Brown, and hopes to negate the dramatic social and political shifts in American culture that undermine the paternalist ideology of the ideal family. The recent resuscitation of this patriarchal fantasy by the right under the guise of 'family values' is a symptom of the massive anxiety of the patriarchal system, signaling a reaction formation against the threatening incursion of women into the work force and,

more recently, the political arena.[2]

As innocuous (and fictional) as she may seem to those of us on the 'radical' feminist edge (and/or from Dan Quayle's 'cultural elite'), Murphy Brown, then, functions as a powerful discursive category for the right, which has explicitly identified her as feminist and so anti-thetical to their antifeminist agendas. In contrast, in the advertise-ments and news magazines I want to discuss here the contemporary female subject is produced as unequivocally postfeminist—still safely subordinate to the commodity system and to the circulation of norm-ative, heterosexual male desires. The photographic images of post-feminist women perform an ideological function. With the cultural authority of Anglo masculinity increasingly thrown into question as gay, feminist, and nonwhite cultures insistently articulate counter-identities to this imaginary norm, it has become all the more urgent for the patriarchally driven commodity system to reinforce predictable stereotypes of femininity. The upper-middle-class, white, post-feminist woman is produced to bolster a masculinist economy of social relations.

Exemplifying the explosion of media interest in the volatile and changing nature of contemporary feminine identities are the five issues of *Time* magazine that have been devoted to the 'woman question' in the last three years.[3] Articles in each issue fabricate models of gender relations based on the kind of statistical information that Susan Faludi's *Backlash* exposes as inaccurate and deceptively applied; they manipulate popular conceptions of feminism through these spurious statistics, defining it as 'post' in advance.

Two advertisements for the Fall 1990 special issue entitled 'Women: The Road Ahead,' for example, set the stage for this issue's overall anti-feminist orientation, juxtaposing cartoon images of women with the texts 'You've Come the Wrong Way, Maybe,' and 'Who says you *can* have it all?' Not surprisingly, the title page of the issue itself labels our current period unequivocally as 'the postfeminist era.' While contain-ing diverse articles, some of which are clearly feminist,[4] the special issue is sprinkled with postfeminist ads for its sponsor Sears; these work blatantly to reinforce profit-driven notions of 'proper' femininity. With photographs of glamorous, predominantly white women ab-sorbed in frivolous, consumerist activities, the advertisements rely on texts to finalize their constructions of contemporary femininity: 'I don't like to go shopping, I like to go buying,' and 'I'm a senior partner in a very successful enterprise, my family' are two examples. The eco-nomic stakes and class implications subtending postfeminist ideo-logies are evident in these advertisements: it is clearly the independently wealthy, stay-at-home postfeminist who makes the better consumer than the working feminist. The advertisements construct unequivocal images of contemporary women as Anglo, rich, nonprofessional,

narcissistic, and profoundly materialist—determining a unified post-feminist subject.

The cover story of *Time* from December 4, 1989 is unabashedly antifeminist in tone and content. In bold yellow letters, the cover text reads, 'Women Face the '90s,' continuing, less favorably: 'In the '80s they tried to have it all. Now they've just plain had it. Is there a future for feminism?'[5] Inside the magazine, the cover article—which is illustrated by a range of images of protesting feminists and feminist symbols on a time line (including a cartoon of a woman, labeled a post-feminist, saying 'I can't believe it. I forgot to have children')—employs the term postfeminist in describing the rejection of feminism by younger generations of women.[6] Attributing this rejection to the 'fact' of their realization that women can't have it all (as if 'having it all' were necessarily the primary goal of the women's movement in the first place), the author, Claudia Wallis, attempts to make younger women's putative disillusionment appear inevitable. She asserts that 'motherhood is back' and feminism is outmoded because, after all, 'hairy legs haunt the feminist movement, as do images of being *strident and lesbian*. Feminine clothing is back; breasts are back … [and] the movement that loudly rejected female stereotypes seems hopelessly dated' (p. 81; my emphasis). While the article appears to ask innocently if there is 'a future for feminism,' it precludes such a future by linking feminism inexorably to the highly charged and implicitly devalued image of 'being strident and lesbian.'

The *Time* article is one among innumerable examples of the popular construction of feminism as a unified attack on the mythologized American family. Calling for a return to the ostensibly simpler family values of yore, this view of feminism in turn legitimates and in fact necessitates its obliteration. The image of the woman's responsibility to the family is most blatantly reinforced in antagonism to feminism in the *Good Housekeeping* 'New Traditionalist' advertisements that have been displayed prominently at bus stops and in upscale magazines such as the *New York Times Magazine* in the last few years. In these ads, bold texts such as 'She started a revolution—with some not-so revolutionary ideals' and 'More and more women have come to realize that having a contemporary lifestyle doesn't mean that you have to abandon the things that make life worthwhile—family, home, community, the timeless, enduring values,' are accompanied by images of beaming, yuppie mothers in sparkling domestic settings with one or two cherubic children.

The politics of postfeminism takes a violent and explicit turn in the recent spate of films exploring the deviance and ultimate expendability of women who are sexually and/or professionally powerful; examples here include the notorious *Fatal Attraction* (1987), as well as *Presumed Innocent* (1990), *The Hand That Rocks the Cradle* (1991), *Poison Ivy*

(1992), *Single White Female* (1992), and the virulently misogynist and homophobic *Basic Instinct* (1992), where the 'strident lesbian' becomes a man-killing bisexual with an ice pick/phallus.[7] These narratives produce the necessity of annihilating the nondomesticated contemporary woman in bloody orgies of human destruction, or at least of reinscribing her into the family structure. With the termination of this woman (who is always, needless to say, pretty and Anglo) comes the termination of feminism and its threatening antipatriarchal goals.

Notable, too, the other side of the postfeminist coin is the emergence of the so-called 'men's movement' in the popular media. Its popularity confirmed by the phenomenal success of Robert Bly's recent book *Iron John*, the men's movement appropriates and perverts the rhetoric of feminism to urge the contemporary American male to 'find a voice of [his] own' as a 'Wild Man.'[8] Bly laments the feminization of the American male at the hands of his female caretakers, and calls for the extirpation of this spineless femininity through primitivist histrionics and rituals of male bonding. The 'Wild Man' immerses himself in mother nature and beats the appropriated drums of his 'primitive' brothers with big sticks to prove to himself that, even as he becomes outnumbered in the job market, his ability to dominate is intact.[9]

These photographic images and their accompanying texts encourage men to reconstruct a primitivistic masculine self through the appropriation of elements from non-Western cultures, a gesture of self-renewal that is hardly innovative, having a long and nefarious tradition within Western practices of cultural and military conquest. Just as discourses of postfeminism attest to the power of feminist and working women in contemporary culture, the fact that masculinity needs to be shored up proves the intensity of the threat that the vast numbers of working women of all sexual, racial, and class identities pose to the patriarchal system (not to mention the threat posed by the increasingly powerful identity politics of the nonheterosexual male).[10]

The Postfeminist Subjects/Objects of Contemporary Art

The popular deployment of the term postfeminism thus involves invidiously redefining femininity, feminism, and even masculinity in relation to racist, class-bound, and patriarchal models of gender and sexual identity. While the use of the term postfeminism in discourses on contemporary art appears, in constant, to involve a significantly different purpose, in my view it has had primarily negative effects for feminism here as well. I want to argue, in fact, that it has tended to be played out in dominant discourses of postmodernism in the 1980s into the 1990s through appropriative techniques that ultimately generalize and defuse the politics of feminism.

While I do not have the space to describe at length the parameters of what I am identifying as dominant discourses of postmodernism in

the visual arts, it is important to give a very general definition to clarify this descriptive, and thus inevitably narrowing, label.[11] The discourses of postmodernism I am calling 'dominant' are those texts, generated primarily within New York City-based institutions in the last ten years or so, that tend to work from models of radicality derived from avant-garde theories of culture to privilege contemporary art practices defined as undermining, deconstructing, or otherwise subverting earlier claims of purity and transcendence made in the name of modernist art (particularly by art critic Clement Greenberg). Within this logic, a specific type of feminist practice (whose effects are determined to be compatible with avant-gardist strategies of subversion) is incorporated into postmodernism and the particular politics of feminism are defused; feminism is generalized as one radical strategy among many available to disrupt modernism's purities and exclusionary ideologies.[12] The label postfeminism, which signals a moment 'beyond' feminism, is symptomatic of the effects of this incorporation.

Postfeminism, however, is by no means always mobilized in a consciously antifeminist way. Artists who speak and work from explicitly feminist perspectives—Mary Kelly and Barbara Kruger, for example—have been labeled postfeminist by feminist art historians and critics in an attempt to distinguish their work from earlier, supposedly essentialist feminist art practices.[13] But, I am arguing, the end result of the application of this term, with all of the historical implications of its 'post' prefix, is to promote antifeminist ends. Although far more subtle and certainly more thoughtful than the popular media's blatant attempts to dismiss feminism *in toto*, discourses of postmodernism tend to address the relationship between feminism and postmodernism through modernist and ultimately masculinist models of interpretation—models that work to empower the postmodern critic through 'aesthetic terrorism,' hierarchizing art practices on the basis of avant-gardist categories of value and excluding work not deemed to be 'radical' or anti-modern enough.[14] The incorporation of one particular kind of feminism into a broadly conceived, even universalizing, project of postmodernist cultural critique tends to entail the suppression of other kinds of feminist practices and theories. It encourages the collapse of the specific claims of feminism into postmodernism, allowing the postmodern theorist to claim postmodernism as an antimasculinist (if not explicitly feminist) alternative to an authoritative and phallocentric modernism. The strategic appropriation of feminism both radicalizes postmodernism and simultaneously facilitates the silencing of the confrontational voices of feminism—the end result being the replacement of feminism by a less threatening, postfeminism of (non)difference.

Ironically, the strategic construction of a radical, antimasculinist postmodernism relies on the very type of oppositional logic constitu-

tive of modernist art discourse that postmodernism is defined as reject-
ing (the logic in the texts of Clement Greenberg, for example, that af-
fords him the power to differentiate 'high' art from 'low,' 'good' art
from 'bad'). In discourses of postmodernism, 'progressive' artistic prac-
tices are privileged through their alignment with a narrow, avant-
gardist feminism, and opposed to 'regressive' artistic practices. Still
working to hierarchize artistic practices and, by extension, to promote
the judgments of the critic as correct and to confirm her or his author-
ity, these discourses serve masculinist critical ends. Thus, even Craig
Owens's sophisticated and important article, 'The Discourse of Others:
Feminists and Postmodernism,' which begins seemingly innocently by
placing feminism and postmodernism in the same space (he describes
'women's insistence on incommensurability' as 'not only compatible
with, but also an instance of postmodern thought'), ends up collapsing
feminism into the 'postmodernist critique of representation': 'th[e]
feminist position is also a postmodern condition.'[15]

As Tania Modleski points out in her new book, *Feminism Without
Women: Culture and Criticism in a 'Postfeminist' Age*, the effects of this
discursive dynamic within postmodern discourses, in which 'feminist
criticism [is] … becoming absorbed into the academy,' are facilitated
by the confusion of feminism with feminization, a confusion that
serves masculinist critics who wish to benefit from the radicalizing
force of the feminist label.[16] Interestingly, then, while the postfemin-
ism of popular culture works to deny the continuing empowerment of
feminist discourse and the sexually and professionally active feminist
subject, the postfeminism of academic criticism works simultaneously
to celebrate and absorb feminism and feminist theory. Postfeminism in
art discourse is precisely this absorptive operation: the incorporation of
feminism into postmodernism as 'post'.

Exemplifying the effects of this incorporation, Dan Cameron em-
ploys postfeminism as the title of a recent article on postmodern art,
using the term broadly to encompass all art by women in the 1980s that,
in his terms, uses 'structuralism to critique social patterns in terms of so-
cial domination.'[17] Under the broad rubric of postfeminism, Cameron
discusses women artists as diverse as Barbara Kruger and Susan
Rothenberg, lumping together an artist well known for her feminist
polemic (Kruger) and one who is not concerned in any direct way with
feminist issues in her approach to object making (Rothenberg). In fact,
Cameron's argument becomes increasingly muddled as the article pro-
gresses. Cameron implies that any female can be (and, perhaps, neces-
sarily is) postfeminist just by virtue of her sex; but he also claims that
'there is by no means a dearth of male artists working from [the] ident-
ical premises' of the female postfeminists (p. 80). According to
Cameron, men are able to appropriate feminist radicality by simply
acknowledging the contingency of art as language; feminism becomes

useful to nonfeminist male artists and critics as postfeminism.

Cameron also discounts the explicitly feminist agendas of artists such as Kruger and Laurie Simmons by placing these artists in a masculinist genealogy of avant-garde critique: 'following on the heels of Pop,' they then become the 'sources' for male artists Jeff Koons, Peter Halley, and Philip Taaffe, whose works, Cameron admits, are 'more vociferously' collected than those of their supposed (maternal?) mentors, the postfeminists (pp. 80, 82). We can hardly be surprised at this last discovery, given the modernist value systems and hierarchies still maintained even in Cameron's own ostensibly pro- but effectively antifeminist argument.

It has become quite common in art criticism to subsume feminist work under a broad framework of postmodernism. Barbara Kruger and Sherrie Levine, for example, are described by *New York Times Magazine* writer Richard Woodward in universalizing terms as simply using 'photography conceptually to ask questions about the source and presentation of images in our culture.'[18] Even the most explicitly feminist projects, such as Cindy Sherman's incisive critiques of the visual construction of the feminine, are submitted to this absorptive strategy. Sherman has posed herself as embodied object, frozen into gendered positions of vulnerability in her *Untitled Film Stills* in the late 1970s and, in work from the 1980s, as monstrously overblown in the very clichéd 'darkness' of her sexual unknown; in recent photographs, she poses and photographs grotesque plastic female sex dolls, aggressively displaying their rigid genitalia, dildos, and artificial limbs. Yet Sherman has been construed by Donald Kuspit as expressing a 'universal' message lamenting the general condition of humanity:

Sherman's work has been interpreted as a feminist deconstruction of the variety of female roles—the lack of fixity of female, or for that matter any, identity, although instability seems to have been forced more on women than men. . . . But this interpretation is a very partial truth. Sherman shows the disintegrative condition of the self as such, the self before it is firmly identified as male or female. This is suggested by the indeterminate gender of many of the faces and figures that appear in these pictures, and the presence of male or would-be male figures in some of them. Female attributes—for example, the woman's clothes in one untitled work—... are just that, dispensable attributes, clothes that can be worn by anyone. The question is what the condition of the self is that will put them on ...[19]

In this article—entitled, with disturbing and certainly unintentional irony, 'Inside Cindy Sherman'—the stakes of postfeminist rhetoric are clear. Being 'inside' Cindy Sherman, Kuspit constructs himself as knowing the artist better than she does herself. (How else could Kuspit 'know' that what certainly do appear to be 'female attributes'—women's clothing, a female authorial name, and even bloody women's

underpants—are really things 'that can be worn by anyone'?) Kuspit's fantasized *penetration* into this interior takes place via a probing set of metaphysical art historical tools such that Sherman's insistence on her otherness, as a 'symptom' of masculinity's uncertainties about itself, is folded back into a narrative of (masculine) universality.

Kuspit concludes with the following argument: 'It is ... her wish to excel with a certain aesthetic purity as well as to represent inventively ... that reveals her wish to heal a more fundamental wound of selfhood than that which is inflicted on her by being a woman' (p. 396). For Kuspit, the 'true' meaning of this art is not feminist but moves into the wide yet phallocentrically organized expanse of the universal, with its 'fundamental wounds' and intrinsic 'aesthetic purity.' Familiarly enough it is masculinity and, in this case, critical and political authority that are at stake in Kuspit's argument: to sustain the privilege of masculinity, a pre- or antifeminist system of gender relations must be maintained, with Sherman's feminism effectively eradicated through its incorporation into the 'universal' concerns of humanism. Crucial to this maintenance is the recuperation of female subjectivity within the pre-/ postfeminist terms of sexual difference whereby, as French feminist Luce Irigaray points out, even while the difference of a unified category 'woman' is established, it is always already incorporated into a masculinist economy of the same.[20] For Kuspit this economy takes place as a 'new subjectivism' (the title of the book that includes the Sherman essay).

The Stakes of Postfeminism

As I have suggested, these incorporative disempowerments of feminism in art discourse require and rely on the maintenance of certain modernist and ultimately authoritative and masculinist models of artistic value. These are models that draw from avant-gardist ideologies to construct oppositional categories of 'progressive' versus 'regressive' postmodern art practices.[21] Underlying this dominant postmodern value system is the stipulation that the progressive art practice must follow avant-gardist strategies of 'distanciation' as developed in the aesthetic theories of Bertolt Brecht—must aim to displace and provoke the spectator, making her/him aware of the process of experiencing the text and precluding her/his identification with the illusionary and ideological functions of representation.

As appropriated by postmodern art theory, Brechtian distanciation requires, above all, a resistance to pleasure—a prohibition of the object's seduction of the spectator as an embodied and desiring subject.[22] In dominant conceptions of postmodernism, which tend to perpetuate Greenbergian modernism's hierarchies of taste disguised under avant-gardist terms of political rather than formal radicality, art that refuses visual pleasure is valued over more overtly seductive, sensual, or

'decorative' work. As feminist art historian Griselda Pollock argues, distanciation is a crucial strategy for feminist artists because of its 'erosion of the dominant structures of cultural consumption which ... are classically fetishistic.... . Brechtian distanciation aims to make the spectator an agent in cultural production and activate him or her as an agent in the world.'[23] This is a feminist strategy for Pollock because the fetishistic, objectifying regime of consumerist capitalism is consummately patriarchal.

The desire to maintain critical and artistic authority, an authority that demands the illusion of control over chaotic pleasures of the flesh, paradoxically has its feminist parallel in Laura Mulvey's feminist call for a destruction of visual pleasure in her ubiquitous and formulative 1975 article, 'Visual Pleasure and Narrative Cinema.' Mulvey states her well-known polemic as follows: 'It is said that analyzing pleasure, or beauty, destroys it. That is the intention of this essay.'[24] According to Mulvey's argument, because the construction of woman as objectified other through visual representation is inevitable, feminists must necessarily work to refuse this objectification. Woman, Mulvey argues, stands 'in patriarchal culture ... as bearer ... not maker of meaning,' becoming an object of scopophilic, fetishizing, and inexorably *male* desire—an object of the 'male gaze'; her disempowerment serves to palliate the male viewer's fear of lack (p. 15).

Mulvey's call to refuse male visual pleasure has been an organizing force in the development of feminist art and theory for the last two decades, particularly those very same art practices from New York now canonically inscribed in much contemporary criticism as feminist postmodernism or postfeminism (from the works of Kruger and Sherman to those of Mary Kelly). The so-called postfeminists have operated consistently within the Freudian terms of Mulvey's paradigm, working explicitly through psychoanalytic models of sexual difference to deconstruct the modernist conception of subjectivity as masculine and empowered through vision (through the 'male gaze'). In working to deconstruct modernism's reliance on the subject/object dichotomy, manipulating photographic imagery of the female body (or, in Kelly's case, scrupulously avoiding it) in order to intervene in its psychically objectifying effects, these artists work polemically within oppositional models of sexual difference to break them apart.

While Mulvey's polemic has provided a space for the development and definition of a feminist postmodernist practice in the last decade, in view of its insistence on the refusal of pleasure (a pleasure that she defines as exclusively male and exclusively visual), it can also be seen to be aligned with a particularly masculinist emphasis in modernist art criticism on bodily control. Mulvey's call to distance the (male) spectator exemplifies the turn to avant-gardist theories of representation in 1980s discourses on contemporary art and the consequent

devaluing of art practices that elicit bodily desires. In view of the pervasiveness of Mulvey's model—and its role in reinforcing what Mulvey herself has recently called the '1970s paranoia about visual pleasure'[25]—it is clear why feminist artists whose works evoke visual and other bodily pleasures have been excluded from histories and theories of contemporary art.

How is the refusal of pleasure a masculinist project? The maintenance of critical authority in art discourse demands the rigorous separation of embodied pleasure from so-called theory; within this cultural policing, the possibility of a work of art that is both sensual and conceptual, both corporeal and theoretical, both eroticized and politically critical is disallowed. As sociologist Pierre Bourdieu has written of the psychic motivations encouraging this refusal of pleasure in discourses of 'high' culture, 'the object which "insists on being enjoyed" ... neutralizes both ethical resistance and aesthetic neutralization; it annihilates the distanciating power of representation, the essentially human power of suspending immediate, animal attachment to the sensible and refusing submission to the pure affect. . . . [Only] pure pleasure—ascetic, empty pleasure which implies the renunciation of pleasure—... is predisposed to become a symbol of moral excellence and the work of art a test of ethical superiority...'.[26]

According to Bourdieu, the aesthete's 'disgust' toward the impure pleasures of the flesh is the means by which he or she ensures 'ethical superiority,' performing his or her distance from the chaos of human corporeality and the stench of fully embodied desire (p. 489). The resistance to pleasure is above all a resistance to corporeal engagement motivated by a desire to control the chaotic and unpredictable pleasure of the erotically engaged body. Only a cerebral pleasure purified of eroticism can elevate the aesthete or critic above the masses (which, as a number of cultural theorists have noted, are inexorably identified with the threat of femininity).[27] Within the eminently masculinist logic of criticism, the critic fears a collapse of the very hierarchizing boundaries of difference that enable the 'male gaze.'

The exclusion of 1960s and 1970s feminist body art from histories of contemporary art is deeply informed by mutually implicated fears of femininity, physical seduction, and the dangerously chaotic pleasures of the flesh. Seduction, sexuality, and corporeality, as male philosophers from Nietzsche to Baudrillard have consistently argued, are intimately connected to the threateningly sexualized feminine body (the seducer's 'domain approaches that of the feminine and sexuality').[28] Because the feminist body artists of the 1960s and 1970s aimed to revalorize these cultural codings of femininity by performing the very bodies so threatening to patriarchal culture, the turn to conceptions of radical practice as necessarily distancing or antipleasurable in effect has enabled the suppression of their works. Explicitly playing out highly

charged scenarios through the performance of female (though not 'essentially' determined) bodies, the feminist body artists break down the masculinist critical prohibition of pleasure. As authors of and objects within their own works, they perform female artistic agency. Encompassing both the sensual and conceptual, they trouble the exclusionary value systems of art history and criticism by refusing the prohibition of pleasure.

As French feminist Luce Irigaray has pointed out, the refusal of pleasure intersects with the denial of female agency and thus has ideological, and explicitly antifeminist, effects. Within the psychoanalytic map of bourgeois Western subjectivity, 'woman has to remain a body without organs. . . . The geography of feminine pleasure is not worth listening to. Women are not worth listening to, especially when they try to speak of their pleasure.'[29] While it is the female body that elicits most directly the 'disgusting' (lower class, but also clearly heterosexual and male) pleasure of which Bourdieu writes, and thus requires objectification as a means of controlling its potential threat, this very same body is conventionally refused to the female viewer as a locus of pleasure. As Emily Apter has written of this dynamic, 'The fetishized feminine Imago, conforming to a commercialized ideal of what seduces the eye, is thus barred to the female spectator.' In the Mulveyan 'feminist anti-fetishism' or 'puritanism of the eye,' where Freud's models of subjectivity prevail and visual seduction is seen to be necessarily complicitous with male fetishism, female pleasure is simply ignored.[30] The negation of female pleasure is potentially complicitous with its denial by patriarchy, the disempowering effects of which are described so vividly by Irigaray. In overlooking the question of female pleasure, critical texts that privilege so-called postfeminist art for its refusal of the desiring 'male gaze' have maintained both modernism's general refusal of pleasure and the Mulveyan focus on male pleasure (and its prohibition) at the expense of accounting for the possibility of desiring female viewers and makers of art.

In the last part of this essay, I want to reinscribe into this debate my particular anti-postfeminist interpretations of several examples of feminist body art, which I read as activating rather than negating relations of pleasure in experiencing the work of art. In offering these readings, arguing that the works articulate multiple feminist identities that transgress the psychoanalytic determination of the woman as objectified other and refuse the oppositional critical logic subtending postfeminism, I am specifically *not* claiming feminist body art as 'inherently' working against the effects of postfeminism. Rather, I argue this while acknowledging the contingency of my claims on my own feminist desires, which I selfconsciously attempt to implicate in the interpretive exchange through which I designate the works as anti-postfeminist. In my view, acknowledging the productive and desiring role of interpreta-

tion itself is a necessary component of strategically challenging the masculinist logic of postmodernist and postfeminist interpretative models, which confirm their own authority by denying the highly motivated nature of their resistance to and fear of pleasure.

My central argument is that at this particular moment the most radical rethinking of feminism can take place through the articulation of re-embodied theories of female artistic subjectivity, feminist agency, and representation in the broadest sense. Ideally, by re-embodying the subjects of feminism—by saturating theory in and with the desiring making, viewing, and interpretive bodies of art theory and practice—the notion of a unified feminist subject (a notion that we saw was integral to this subject's termination in the popular press accounts of postfeminism) can be rejected. And, by acknowledging multiple feminist subjects of infinitely variable identities, we can perform reinvigorated feminist art histories and practices that are radically empowered through the newly recognized diversity of feminisms. […]

8

Deconstruction and the Limits of Interpretation

Introduction

There is a certain structural affinity between two otherwise radically different phenomena: the practice of reading elaborated in the work of the French philosopher Jacques Derrida beginning in the 1960s that became widely known by the name he coined, *deconstruction*, and the situation of the child discovering the fallibility of its parents and remaining committed to loving and caring for them whilst learning to comprehend, to think through and with, their contradictory behaviours.

In both cases these are practices of reckoning in the double sense of the term: coping with a situation in which one is impelled to investigate the contradictions and exclusions that haunt an appearance of unity and homogeneity, and thinking with it, using its own language. Derrida's term was a transformation of a word used by Martin Heidegger (1889–1976), variously rendered as 'destruction' and 'retrieve', and which for Heidegger indicated the nature of a relationship to one's tradition that was simultaneously critical and respectful; both detached and attached at the same time. For Derrida, deconstruction named this complex relationship, and the situation of reading philosophy in which practising it and confounding it were inseparable.

What implications might there be of a 'deconstructive' attention to art history: to art history's *art* and to its *history* of art, as well as to the history of art history as an instituted 'practice of reading'? Could there be such a thing as a 'deconstructivist' art history?

To appreciate the extent of the possible implications of deconstruction for the practice of art history, consider that Derrida's first essays on the visual arts, in *The Truth in Painting* (1978), addressed a subject essential to any understanding of artworks, and one that directly addressed some of the most fundamental concerns of the aesthetic philosophers of the eighteenth century. Put briefly, this was the problem as to whether objects designated as aesthetic in intent, motivation, or effect could be considered as relatively autonomous in a semiological sense. In other words, whether 'the visual arts' might justifiably be considered a *code* comparable to, but distinct from, other practices of social meaning-production (see the discussion in Chapter 5). This was the

question as to the limits or boundaries of works—both individually, or as a class of objects—an issue first raised by Kant in his *Critique of Judgement* (see Chapter 1), in connection with the idea of the *parergon* or the boundaries or limits of a work.

What exactly might constitute the 'inside' of a work, in contrast to its 'outside', is a question of the most fundamental kind, not least because it affects all aspects of the critical and historical discourse about art in modern times. Derrida's perspective on these problems, which he elaborated in the essays making up *The Truth in Painting*, connected such questions to frames, signatures, museums, archives, and commodity marketing, among other things. It was his contention that both visual and verbal practices were fundamentally heterogeneous, never existing in any pure or unmediated form. An 'otherness' always inhabits a work, and no artistic expression can ever be an unmediated manifestation of emotion or thought.

Derrida made it clear that the visual arts were a species of graphic production, which includes writing itself, and that from such a perspective, the social situation or contingency of fixed distinctions between genres or media or semiological codes might be better understood. Fundamental to this was the notion of the *trait* or trace, referring to anything that is drawn (including writing). His work has dealt extensively with the boundaries and distinctions between writing and speech as well as those conventionally articulated in modern Western philosophies between all forms of graphic production (art, architecture, film) and what those practices purport to 're-present'.

In effect, what Derrida sought to show was that the 'inside' of any work is already inhabited by that which might have been bracketed out as its 'outside'—signatures, verbal discourse, frames, institutional stagecraft, and so forth. He began his investigations of the visual arts at their conceptual heart and historical beginnings: with Kant's idea of the parergon; it was the frame or frame-effect that was essential to Enlightenment philosophy's project of delineating an 'aesthetic' realm of cognition as distinct from practical or pure reasoning. As earlier readings and discussions in this volume have suggested, such distinctions formed the basis for the construction of 'art' and its 'history' as a distinct investigative domain.

The aim of this chapter and its selection of readings is to situate these questions at the centre of the reading of three texts which, in Derrida's own words, are gathered together as a 'polylogue' in which all three (one of which is Derrida's own) are both juxtaposed and cumulatively superimposed.

The Melville essay ('The Temptation of New Perspectives' of 1990) is placed here as a kind of prologue to the 'polylogue' that Derrida made of the superimposition of the two earlier texts by Schapiro and Heidegger. It is an astute meditation on art history as a historical

artefact in its own right, and its perspective on Hegel and his fabrication of a (German) nationalist discipline compares with that of Luc Ferry, discussed in Chapter 1.

The second selection (Heidegger's 'The Origin of the Work of Art' of 1935) is followed by a Meyer Schapiro essay ('The Still Life as a Personal Object—A Note on Heidegger and van Gogh') published in a 1968 anthology. The Schapiro essay is a critique of Heidegger's use of van Gogh's painting *Old Shoes* to 'illustrate' a point that, in Schapiro's opinion, could as well apply to a 'real' pair of peasant shoes.

The Derrida text, excerpted from the 'restitutions' section of his 1978 publication *The Truth in Painting*,[1] originated as a short article in the same issue of the journal *Macula* (vol. 3, 1978) in which the Schapiro essay was also reprinted; both were part of a series of articles in that issue on Heidegger's observations on van Gogh's *Shoes*, and Derrida acted out or narrated his text in a seminar at Columbia University in New York in October 1977. Schapiro took part in the ensuing debate. The excerpt made here includes much of the very complex multivoiced quality of Derrida's text, and is an excellent example of Derrida's deconstructive practice of reading that attends to the paradoxes of its own position(s), and to the fundamental ironies of art historical 'reading' as such.

The literature on deconstruction, and on Jacques Derrida, is very extensive, as is the body of Derrida's own writing, extending from 1962 to the present. Among the most useful introductions to deconstruction in general are: Jonathan Culler, *On Deconstruction: Theory and Criticism after Structuralism* (Ithaca, 1982), which situates Derrida's work in its historical and critical contexts, and discusses its implications for theory and criticism; Christopher Norris, *Deconstruction: Theory and Practice* (London, 1982), which relates Derrida's work to various intellectual and social movements in the twentieth century; and Norris's *Derrida* (Cambridge, Mass., 1987), which discusses his place in modern philosophy. The volume edited by Peggy Kamuf, *A Derrida Reader: Between the Blinds* (New York, 1991), contains an excellent introduction to Derrida's writings, perhaps the most diverse and representative selection of his work, and has a complete bibliography of his writings between 1962 and 1990. David Carroll's *Paraesthetics: Foucault, Lyotard, Derrida* (London, 1987) is an excellent comparative examination of the concept of the aesthetic in the writings of these three authors, and Michael Payne's *Reading Theory: An Introduction to Lacan, Derrida, and Kristeva* (Oxford, 1993) investigates the similarities and differences between psychoanalytic and deconstructive practices; it includes a very clear comparative discussion on 'reading paintings' by Foucault, Lacan, and Derrida (Chapter 5).

For two decades there have been very lively debates about 'deconstruction and ... '—the potentially very extensive implications of

deconstruction for art, architecture, literature, linguistics, feminism, or postmodern culture in general. Two volumes which provide an excellent introduction to some of this are: Peter Brunette and David Wills, *Deconstruction and the Visual Arts: Art, Media, Architecture* (Cambridge, 1994), which includes an interview with Derrida on the spatial arts. On relations between architecture and philosophy, the most interesting study is that of Mark Wigley, *The Architecture of Deconstruction: Derrida's Haunt* (Cambridge, Mass., 1993). Both of these texts will also provide a useful introduction to the work of artists and architects who have engaged with Derridean concepts.

Of Derrida's own writings, only several of the earlier and most widely known will be mentioned: *Of Grammatology*, translation by Gayatri Spivak of *De la grammatologie* (Paris, 1967), (Baltimore, 1976); *Dissemination*, translation by Barbara Johnson of *La Dissemination* (Paris, 1972), (Chicago, 1981); *Margins of Philosophy*, translation by Alan Bass of *Marges de la philosophie* (Paris, 1972) (Chicago, 1982). In addition to *The Truth in Painting* of 1978 excerpted here, Derrida's *Memoirs of the Blind: The Self-Portrait and Other Ruins* (Chicago, 1993; translation by Pascale-Anne Brault and Michael Naas of *Mémoires d'aveugle: L'autoportrait et autres ruines* (Paris, 1990)) extends his exploration of art and representation begun in this earlier study. *Mémoires* is a catalogue to an exhibition of which Derrida was curator at the Louvre.

The Temptation of
New Perspectives

Let me begin by offering three rather disparate characterizations of these remarks. They constitute, first, a sort of story about an interest literary theory might take or discover in art history; as such they sketch out if not an actual intellectual and institutional itinerary then something of the underlying logic of one. It is, I think, important here that this is not a story about the portability of theory or method but more a story about the way in which what is sometimes called theory reshapes or rediscovers itself within its new occasion.

My remarks might also be described as a sort of oblique introduction to certain writings by Jacques Derrida. Under this description, it will be a significant feature of my presentation that it falls somewhat short of its goal. Martin Heidegger produced, beginning in 1935, a piece of 'aesthetics' under the title 'The Origin of the Work of Art.' In the late 1960s Meyer Schapiro threw his considerable professional weight behind a sharply administered art-historical correction to Heidegger's treatment of a particular van Gogh, with the clear intent of disposing of the apparent more general interest of Heidegger's speculations. In the mid 70s Derrida took up this argument in a complex 'polylogue' called 'Restitutions of the Truth in Pointing' that seems aimed at least in part at renewing the philosophic interest of Heidegger's essay.[1] One question one might have about this sequence of writings is whether or not it is of any conceivable interest to art history; I want to suggest that it is, and I want to do so by a somewhat circuitous return to the speculative foundations of art history. If I do not now have much to say about the three essays in question, I am nonetheless working toward a certain description or redescription of the place in which the debate among them happens.

Finally, this reflection is an attempt to map, in an admittedly brief and preliminary fashion, something of the relations that may now bind together the notions of 'theory,' 'postmodernity,' and 'art history.' It is an attempt to say something about the kinds of challenge and possibility that may be facing the discipline of art history now.

I have already mentioned Derrida, and it should be clear in advance that my position is at least loosely deconstructionist.

Deconstruction presents itself as, in general, a practice of reading,

a way of picking things up against their own grain, or at their margins, in order to show something about how they are structured by the very things they act to exclude from themselves, and so more or less subtly to displace the structure within which such exclusions seem plausible or necessary. Like an analyst listening to an analysand, deconstruction attends to the other that haunts, organizes and disorganizes, a speech that takes itself to be in control of its meanings and identity. Deconstruction arises as a certain commitment to flux and to fluidity —rather like this essay, it rambles, circles, connects, and disconnects. In his *Blindness and Insight* the late Paul de Man offered a summary of Derrida's reading of Rousseau that still seems a good enough short introduction to deconstruction's typical and most easily standardized textual procedures:

Whenever Rousseau designates the moment of unity that exists at the beginning of things, when desire coincides with enjoyment, the self and the other are united in the maternal warmth of their common origin, and consciousness speaks with the voice of truth, Derrida's interpretation shows, without leaving the text, that what is thus designated as a moment of presence always has to posit another, prior moment and so implicitly loses its status as a point of origin. . . . All attempts to trace writing back to a more original form of vocal utterance lead to the repetition of the disruptive experience that alienated the written word from experience in the first place.

The term *deconstruction* itself was coined by Derrida as, at least in part, an interpretation of a nest of terms in the philosophic writings of Martin Heidegger that had been variously rendered 'destruction' and 'retrieve.' With these terms Heidegger attempted to name a relation to his tradition that was at once radically critical *of* and profoundly attached *to* it; for Heidegger, as for most continental philosophy after Hegel, the distinction frequently made in Anglo-American circles between being an historian of philosophy and actually doing philosophy is essentially senseless: one does philosophy out of its past and in search of what remains in some sense concealed within that past. Derrida's revisionary translation of Heidegger's terms participates in this complex ambition, at once continuing and critiquing the deep lines of the Heideggerean project, and it accelerates the confounding of the reading of philosophy and the doing of it.

Given the weight this places on the act of reading, it is hardly surprising that Derrida's writings should have had a substantial effect on literary criticism. But, of course, crossing from philosophy to criticism and from France to America, deconstruction enters into engagement with different pasts and different conditions, and some of us at least are still concerned to understand the full weight of these differences.

The term 'deconstruction' seems to have entered art talk primarily because of a perceived appropriateness to the effect of work frequently

described as 'postmodern.' It has also gained some more general methodological purchase as a part of broader efforts to bring literary theory to bear upon the consideration of visual objects—as, for example, in the work of Norman Bryson. But there is certainly one other area in which one can imagine it intervening, and that would lie in the reading of the texts of art history itself. In the long run, these three areas are bound to be interconnected, and the surest index of this interconnection lies perhaps in the apparent naturalness with which one will speak, precisely, of 'reading' a painting; deconstruction does not let such remarks pass as somehow 'merely metaphorical.'

To one who comes from literary theory, one of the most striking features of art history is what I might call its 'foundedness.' Literary criticism is, at least in this country, not founded in the way art history is: it took no special argument to invent departments for the study of literature, although it did take the construction of some special methods, more or less captured by the phrase 'close reading.' Literature departments are just that—literature departments; even if their curricula are for the most part organized by period, the essential element in their self-definition seems to be a notion of the rights or necessity of 'literary language' and not, in the first instance, the historicity of their object. It was enough for I. A. Richards and others to find a way to read that could be justified in the face of very strong and particular philosophic pressures—generally associated with the project of logical positivism—for there to be English Departments.[2]

With art history we have a very different situation. There are founding texts, texts engaged in a struggle to define both an object and an account of our access to it. The work of Riegl, Wölfflin, Panofsky, and others is quite different from that of the founders of academic literary criticism; it is more densely engaged with a philosophic past— above all an Hegelian past—that seems at once to offer to it and to deprive it of the very same object; my questions will be about how far art history can be said to have mastered this past in establishing a certain past as its object. It should be noted in advance that the philosophic past at issue here is one the discipline shares to a significant degree with the tradition that eventuates in Derrida's philosophic work of reading and writing.

This is then a sort of report on work in progress in which I have been trying to make some sense of these founding struggles, to read in them the scars and fissures by which they are still marked and which can open again at any moment—and which are indeed perhaps being forcibly opened now under the impress of a new inflection of the modern. The argument I offer here is partial in every sense: tendentious, incomplete in its arguments and evidence, and committed to a certain finitude of appearings.

Whatever interest the works that concern us may have held for

observers throughout the course of what we now call the history of art, that history in its specific visibility becomes possible only at a certain moment within the Western tradition, and this moment is firmly moored to the name of Hegel, whose claim that art has come to an end—has become, that is, merely historical—engenders both an object and a question about our access to it.

Hegel's claim, as I understand it, is not so much that the artistic impulse has exhausted itself as much as it is that an impulse once inchoate and buried in the terms of its world has become now detached and explicit, and that with this achievement it passes over into the still greater explicitness of philosophy. From Hegel's vantage what had been lived variously as ornament, religion, memorial, and so on shows itself to have formed a single history, a story of what is now visible as art. The concept of art is thus bound up with the notion of its end; its achievement is inseparable from its pastness—art comes to presence and explicitness precisely as historical, as already overcome. It is in this sense that one might see or sense in Hegel a certain registration of the museum as the essential site of art (although, to the best of my knowledge, the word 'museum' does not appear in Hegel's writings). One might thus be led to think of what are now called 'institutional theories of art' as coeval with the emergence of art itself.

I want to note a couple of consequences of this view.

A first is the inscription of a permanent worry about context within the project of art history: precisely because the becoming available of art is the story of its detachment from context, there will be a deep tension within the art-historical project between the historicity of its object, the rhythms that organize art as art, and the history in or through which works were lived. This tension seems now most visible in the form of a conflict between the claim to achievement and the claims of context and condition, between the masterpiece and its social history. Institutional theories of art derive such power as they have from their apparent ability to span—or obliterate—some versions of this gap, but they are perhaps better taken as symptoms of it, intimately entangled with the extraordinarily difficult relation of art history and modern art. One mark of the postmodern—I am thinking of the work of someone like Hans Haacke—lies in its impulse to address this entanglement as art and not as a theory of art.

These considerations may point us toward a second consequence of the Hegelian account of art: that the emergence of art as a properly historical object is contemporaneous with the possibility of claiming to make art *as* art. The same history that produces the possibility of art history produces the possibility of modernism in art, and the two possibilities are linked in the thought, which I borrow from Stanley Cavell, that modernism is well defined as the having of the past as a problem. It bears remarking here that these twinned possibilities do

not and in general cannot face one another, falling as they do on opposite slopes of the cusp that is the becoming explicit or objective of art. If art history and modernism in art are tied to one another, they nonetheless do not stand fully in one another's view. One thing the recently entered claims to 'postmodernism' may mean is just that this relation has achieved a certain kind of availability for us: that modernism itself can now appear to us as historical, and that art history can now be seen as in some specifiable sense modernist. A full acknowledgment of the postmodern would then entail not simply the addition of a period to the normal art history curriculum but a reevaluation of the discipline itself.

A third consequence of the Hegelian view can set us toward such a work of revision. For those moved to lay out the terms of art history in Hegel's wake, a certain argumentative course is laid out in advance. A Hegelianizing history of art must give some account of its own coming to be, and this means an account, explicit or not, of the becoming historical of art in the North, in Germany above all. It seems to me important that whatever else Wölfflin and Riegl are doing, they are also offering a story about how art history emerges as a Northern discipline. The failure of this offering—a breaking with Hegelian kinds of narrative—would then be an important feature of what art history has been for us. The full story of this failure is not simply intellectual or argumentative; it is a story of war and immigrations, of translations made and not made, of the construction and fate of Germany, and of the propping of that construction on an imagination of Greece and in the face of another, prior claim to Renaissance. It is a story that knots together a nation, its poets and philosophers, Hölderlin and Hegel, Nietzsche and Burckhardt, in ways I cannot pretend to understand. 'America' too would have its place in this story. What I offer instead is a few thoughts about Riegl and Wölfflin and Panofsky.

The Hegelian task assigned to the German founders of art history is extraordinarily complex. A casual index of this complexity may perhaps be found in the recurrence of the term 'late' in the titles of major works by both Riegl and Wölfflin. It seems important to notice this as a description not only of the periods under central consideration but of an interest in 'lateness' or 'belatedness' inscribed within the founding task. 'Lateness' seems to encode or allegorize beyond chronology interests in being both German and post-Hegelian as well as an uncertainty about when art history comes on the scene in relation to the actual history of art. One might recall here Hegel's assertion that 'philosophy always arrives on the scene too late'—an assertion through which philosophy assumes or is condemned to the burden of modernism. One might also note that these resonances might well cease to be heard in the different philosophical climate of, for example, America.

If under the impress of Hegelian logic and historiography, the ques-

tion of art history is inseparable from the question of the becoming historical of art, the theoretical foundations of the discipline will be laid only through accounts of the history of art. These accounts will have as one major task the avoidance of any overt reliance upon the Hegelian schematizations that end by reducing an apparent history of vision to a real history of philosophic knowledge and self-consciousness on the one hand, or to a transient and historically regional science within a larger logic on the other.

Alois Riegl, for example, seems to play peek-a-boo with the dialectic, giving us what appear to be analyses from significantly different methodological positions of disparate empirical moments within the history of art. And yet something seems to bind just those moments together, thus justifying Riegl's claim that with his study of the later Roman art industry, the story of art attains closure. And indeed Riegl's work does seem to sketch out a certain systematic dialectic within which methodological variation shows itself as a dialectically driven development like that of the consciousness that journeys through Hegel's *Phenomenology of Spirit*—we have an initial moment of the self-unfolding of sheer artistic will and attention in the *Stilfragen*, a later moment of transformation that imposes upon that sheer will an awareness of its being for another, and a final moment in which that other is explicitly posed as a human, and Northern, subject. Across the movement from palmette motifs to late Roman art to the group portrait, the initial brute fact of 'attention'—and its subsidiary terms of 'feeling' and 'will'—becomes the highly complex fact of a Northern audience or witness to the historicality of art. Punning implicitly, perhaps unconsciously, but nonetheless powerfully against Hegel, this narrative is one of the freeing of art from the haptic *grasp* of the Concept to an opticality standing in permanent need of a beholder to guarantee its objectivity. Hegel is thus revised back toward Kant, inscribing a permanent formalism among the constituent elements of the emergent field. This revisionary move remains difficult for art history, at once enabling its objectivity in the face of the threat of its absorption into mere intellectual history and risking the detachment of those objects from the thicker prose of the world in which they gained their initial shape and human purchase.

The tension engendered here can be seen to animate centrally the work of Wölfflin as it struggles to assert the 'two roots of style,' and finds that difference between what might be said to be internal and external to art repeated within what is claimed to be purely internal. As I understand the intention of Wölfflin's argument in his *Principles*, it is in part to justify both classical and Northern baroque, with their linked subpolarities, as distinct and equally legitimate modes of representation. Each yields a valid presentation of things—on the one hand 'as they are' and on the other 'as they appear.' Further, both modes are

defined primarily not by any relation, adequate or otherwise, to things, but by their ability to sustain visual presentation—the painterly giving us things as 'pure seeings,' sheer visual presences, and the linear giving us, with equal claim to the truth of painting, the fact of material surface and planar extent.

When, however, we protest against Wölfflin's formalism and isolation of the visual from the larger world, we are registering an effect of the text that outraces the argument it would embody. To recognize this is to extend the implications of Marshall Brown's deconstructive reading of Wölfflin's *Principles* and his argument about the primacy of the baroque and impossibility of the classical as such, which we can now recognize as itself a version of the question of things-as-they-are/things-as-they-appear.[3] It is the baroque impulse alone that moves toward a purification of vision apart from material conditions or bodily/conceptual graspings. That is, if one takes Wölfflin's *intention* seriously one has to postulate an original and irreducible duplicity to such key terms as 'vision' and 'surface.' But in doing so, one loses the stable and principled object of the disciplined or disciplinary history of vision, so the text works always to displace its major insight to the margins in order to ensure an apparent stability at the center. If Brown is right that the classical becomes actual only and always in the baroque, the cast-out impurity of its proper and impossible image of vision returns as the always deferred or excluded 'second root of style' (so this nondialectic of classical and baroque threatens to betray art history again to Kant). This renegotiation of the distinction between haptic and optic is not without its costs: in particular, one loses the distinction between, and interlacing of, internal and external form that underlay Riegl's understanding of the place of the art historian and that gave his account its dialectical energy. What one gains is something like a method, an analytic vocabulary, propped up on what seems to be the discovery and isolation of the proper object of a history of vision.

One index of the continuing instability of Wölfflin's object appears in the complex bundle of references to language at work in the text *Principles*. On the one hand, his five founding polarities introduce a recognizably linguistic model for art history, surprisingly close to Saussure's. Given the strong diacritical tendency of Wölfflin's polarities, it becomes natural to speak of our 'reading' of one or another feature as 'marked' in one way or another. The language of art would be structured by diacritical contrasts of linear/painterly, open/closed, and so on. At the same time, however, Wölfflin casts each individual term within these oppositions as itself amounting to a language; these two levels of linguistic analogy are run constantly together in his text, thus tangling together problems of translation and representation. Such terms as 'one's own language' or 'mode of representation as such'

introduce a deep complication to notions of medium, genre, and relation within art history. This uncertainty within Wölfflin's text about the level at which a linguistic analogy is to enter the account seems of a piece with the other uncertainties about internal and external roots of style and the classical and the baroque that I have tried, too briefly, to chart here: all of them, I suggest, work both to maintain a constant reference to reading within the field of the history of vision, and to maintain it as at once fleeting and natural, something like a metaphor—but a metaphor without which one cannot quite manage, a catechresis then.

There is a sense in which we may be tempted to think of Riegl certainly, and Wölfflin largely, as ancient history, not yet really art history. With Panofsky we seem to step into an altogether different register, one in which the founding of art history is an achieved fact. But I think this sense is perhaps well understood as the effect of a text of extraordinary power.[4]

Certainly one element in our sense of Panofsky's difference lies in the distance he takes from the 'Northern' problematic that seemed to impose itself on both Riegl and Wölfflin. Whereas in Wölfflin, key terms ('thing in itself,' 'thing as it appears') can, from paragraph to paragraph and often undecidably, be given variously Kantian or Hegelian inflections, in Panofsky, Kant unequivocally presides and the explicit problematic of historicality recedes. The 'Kant' in question here is also quite particular: given the state of Kant's German inheritance in the early part of this century, Panofsky could, in effect, have moved either toward the neo-Kantian tendencies that culminate in the work of Ernst Cassirer or toward the more radical revision of Kant set in motion by Heidegger. And Panofsky's choice was, clearly, for Cassirer. Panofsky thus turns away from the arguably most powerful inheritors of Hegel in his tradition—Nietzsche and Heidegger. This choice is reflected in Panofsky's effort to read the necessarily hermeneutical activity of art history as a constrained passage from the 'natural' to the 'essential,' the circularity of which can be held at bay and is essentially inconsequential.[5] One can say that Schapiro's much later attack on Heidegger in effect replays this early reduction of interpretive implication within one's object to questions of methodology distinct from the historicity of the object.

One consequence of this choice appears to be a return to the valorization of Italian art that now seems to be defining art history in its traditional practice.[6] But we will not have given an adequate account of this until we have described not only how the retreat from Hegelian and Heideggerean considerations of historicity de-emphasizes the question of Northern art, but also how Panofsky finds within Italian art a more compelling articulation of the terms of our access to the past. Both Michael Podro and Michael Holly have convincingly located this

new articulation in the essay 'Perspective as Symbolic Form,' with its explicit dependence on Cassirer. It is, I think, hard to find a succinct formulation for what Panofsky manages here: I suppose I want to say that he finds in the Renaissance a period that delivers us from what might seem the debilitating fact of periodicity by finding in it an optical model that can liberate us from our situations. History lies before us much as we might imagine nature to, available to our view. What I want to stress here is that any critique of the 'privileging' of the Italian Renaissance in art history will be empty and merely resentful insofar as it does not recognize that such privileging is not in any simple sense arbitrary. It is not the case that one could take Panofsky's science and correct its untoward privilegings. Its privileges are continuous with its ability to have an object at all. To put it somewhat differently: what we call access to the past is always redescribable in terms of privilege and appropriation, and to give up one is to give up the other. To step outside of such privilege is to cease to have an object and to fall into the merely empirical or willful.

Panofsky's essay acts, across its manifold difficulties, to forge an art-historical subject whose distance from and responsiveness to his or her objects, is, if not fully natural, at least fully rational. The Renaissance achievement of rational perspective becomes the condition of possibility of the art-historical discipline, and we are compelled to its terms whenever we look to establish another world view that would not, for example, privilege the Renaissance, because we can neither 'look' nor imagine a 'world view' without reinstalling at the heart of our project the terms only the Renaissance can expound for us.

The way to Panofsky's understanding of the objectivity of art history lies through the Renaissance because that Renaissance provides the means to elide questions of the becoming historical of art; his valorization of perspective forges an apparently nonproblematic access of the rationalized space of the past. We are freed then to imagine ourselves henceforth as scientists of a certain kind, and within this imagination the grounds of privilege become invisible and profoundly naturalized. The shift away from Hegel and toward the assumptions and interests of Anglo-American philosophy is an essential part of this reimagining of art history, as is the psychologization of such key inherited terms as 'schema.'[7] With this, Riegl, and Wölfflin, the speculative past of art history itself comes to seem mere prehistory, the proto-science from which art history has elevated itself.

This altogether-too-brief sketch means then to suggest that the achievement of art history can also be thought of—and perhaps must be thought of—as a forgetting of itself and its object. Just as for Heidegger and Derrida philosophy can and must be thought of as a forgetting of itself and its object—which is hardly to say that with them philosophy ends. It is, however, to say that the conditions of its

continuation become radically complex and self-critical, something Derrida tries to make explicit by packing Heidegger's interest in both philosophy and the destruction of philosophy into the commodious portmanteau of 'deconstruction.'

My story has brought the notion of perspective to a position of particular prominence, and I want, in closing, to note some of the ways in which we may now, under the impress of a new inflection of the modern, want to say that the invocation of perspective can and must be thought of as a forgetting of perspective, a forgetting of the fact that we are always situated and presented with a partial view. I will try to bring this back around to some large-scale considerations about the discipline of art history, but it is perhaps worth noting some of the small-scale questions that are here in tow: Why is it natural to us to speak of an introductory survey course as providing 'perspective'? What would it be like to imagine that an introductory course in something in particular could provide 'perspective'—that is, the seeing of something from somewhere, rather than the seeing of everything from nowhere? What if the survey were the achievement and not the precondition? I will shortly be trying to say something about photography and here too there are small questions in tow: What is a slide projector? How simple or complex a tool is it? Is its use a contingent fact about art history, or is it more intimately bound to the structure of the field? I don't have answers for these questions; it is enough for me, at the moment, that they can find a place within an exploration of the intellectual foundations of art history.

Our ordinary uses of the word 'perspective' are oddly divided: we claim it on the one hand as what gives us the world more or less just as it is, and on the other as a name for what divides us one from another. You have your perspective and I have mine—and yet the perspective rendering has as good a claim on public truth as anything we can imagine. Something of this division surely informs the recurrent, often strangely senseless, arguments about whether perspective is 'natural' or 'conventional'—the moral of these arguments may just be that perspective pushes us up against deep incoherences in our normal sense of these words, which would then also be deep incoherences in our understandings of how we stand with or toward one another.

However we come down on these questions, it is clear that our involvements with the notion of perspective cannot be confined to considerations of pictorial practice; the word haunts our images of knowledge from the moment we imagine that the best model for the grasping of sense lies in the seeing of an idea, an *eidos*, to the Nietzschean moment in which we appeal explicitly to something named 'perspectivism' as a way of moving beyond the falsification of the world through a vision of its beyond. 'Perspective' never was a practice art history simply found within its purview, which is why

Panofsky's formulation of it had the power to wrest a discipline from its historical embeddedness and transform it into a science. This would also be why certain reformulations of it may pose a deep challenge to the terms of that science as a whole and provide an impetus to the rereading of texts whose founding power and radical complexity are half-forgotten.

I am thinking here particularly of the ways in which certain discussions of postmodernism turn crucially on the fact of the camera.

The camera is most simply a machine for producing automatic linear perspective renditions of the world. It can of course do other things, including give the lie to this automatism, but it is for the present enough that it can do this one thing. Because it can do this one thing, it is frequently tempting to see it as spelling out an end of art, or of painting, or of a certain kind of painting. But I don't think this is what is finally interesting about the camera. What matters for at least some recent writing on photography and postmodernism is that in fulfilling a certain dream of vision—the dream, more or less, of an eye gazing out upon its world—the camera exerts effects that go beyond and turn against that dream: it gives us that world as profoundly textual, even in its very moment of appearing, or it gives us that world as a *source* as well as an object of vision.[8] It can compel us to return to, reengage with, the early grapplings with the apparent duplicity and self-division of vision; it can return us even to the baroque and seemingly gratuitous complexity of the models and experiments through which the Renaissance found its way to rational perspective.[9] It may be tempting to say here something familiar like 'postmodernism offers us a new perspective on the past,' but what needs to be said is something more like, 'postmodernism compels a rethinking of the way in which we imagine "perspective" to offer us an access to the past.' It is perhaps worth noting that it follows from this that whatever 'postmodernism' is, it is not quite a period term and it is not quite, within the existing terms of art history, an art-historical object; it is more nearly a way in which attention can be drawn to certain 'grammatical'—a term I prefer to 'methodological'—difficulties in our talk of periodization and objectivity. What defines the postmodern within an art history curriculum is a certain slippage between it and the received terms of that curriculum.

I have described the camera as a linear perspective machine and I have seemed to make a certain challenge to art history dependent upon its existence. But this mere machine can no more bear such a weight than the mere facts of brush, pigment, and surface could bear the weight of painting in general. It takes a certain history and a certain art history for this description of the camera to become compelling, to let it impose itself not simply as a description but a challenge. The art-historical story about modernism that I follow says that the camera can

matter in this way only in the wake of painterly claims to the achievement of something like pure opticality. But my interest lies here with the subject of art history and not its object, so I would like to close by locating the camera on the Heideggerean route not taken by Panofsky.

Heidegger's thought about art, like Hegel's, is tied to a thought about modernity, which Heidegger describes as a sort of fall into what one can only call blinding lucidity—a flat availability of objects to our view, our calculation, and our research, as if we were frozen into a permanent midday, the world freed of its burden of shadow. It names this modernity 'the age of the world as picture' and glosses it in terms of the reign of the 'Ge-stell,' usually rendered as the 'frame.' It is a feature of this flat availability of things that among the things available are, hanging 'on the wall, like a rifle or a hat,' works of art. And because these pictures hang there in just this way, they offer us no access to the fact that our world too has come to hang before us like a picture—but it is also the case that if we could come to understand what a picture is we might come again to understand what a world is.[10] We stand poised for Heidegger between a mere aestheticism and some other grasp of the work of art, and what poses us there Heidegger calls 'technology.' I am calling it, for now, within a certain history of art, 'the camera.' Heidegger's counter-appeals are too often palpably and weakly Romantic—he hears the unalienated voice of the peasant in his proximity to the earth; he hopes for a god and an *eschaton*. In his best moments he knows that none of this will do; that there is nothing saving apart from the very danger itself; that, for example, the very thing that materializes the world as picture might also renew for us a sense of why it is that pictures matter, releasing us from the noontide demon's grasp.

And here I will stop. I have come a certain way toward turning a full circle, ending with the Heidegger from whom Derrida actively translates 'deconstruction' and I have tried to show something about how art history and the history of art history might be at issue within that movement. I have tried to stop at a particular place, a site of textual controversy in which both vision and reading are at stake. On the wall hangs a van Gogh, about whose value we know everything and nothing. Before it, arguing, gesturing, and pointing, stand Martin Heidegger and Meyer Schapiro. Watching it and them, reading it and them, writing, there is now Jacques Derrida, as well. His writing scatters into indefinite and unspecifiable voices. What do 'perspective,' 'frame,' and 'vision' mean here? What kind of history is this? Where do 'we' stand? What discipline, what patience, and what violence is called for here?

The Origin of the Work of Art

Origin here means that from and by which something is what it is and as it is. What something is, as it is, we call its essence or nature. The origin of something is the source of its nature. The question concerning the origin of the work of art asks about the source of its nature. On the usual view, the work arises out of and by means of the activity of the artist. But by what and whence is the artist what he is? By the work; for to say that the work does credit to the master means that it is the work that first lets the artist emerge as a master of his art. The artist is the origin of the work. The work is the origin of the artist. Neither is without the other. Nevertheless, neither is the sole support of the other. In themselves and in their interrelations artist and work *are* each of them by virtue of a third thing which is prior to both, namely that which also gives artist and work of art their names—art.

As necessarily as the artist is the origin of the work in a different way than the work is the origin of the artist, so it is equally certain that, in a still different way, art is the origin of both artist and work. But can art be an origin at all? Where and how does art occur? Art—this is nothing more than a word to which nothing real any longer corresponds. It may pass for a collective idea under which we find a place for that which alone is real in art: works and artists. Even if the word art were taken to signify more than a collective notion, what is meant by the word could exist only on the basis of the actuality of works and artists. Or is the converse the case? Do works and artists exist only because art exists as their origin?

Whatever the decision may be, the question of the origin of the work of art becomes a question about the nature of art. Since the question whether and how art in general exists must still remain open, we shall attempt to discover the nature of art in the place where art undoubtedly prevails in a real way. Art is present in the art work. But what and how is a work of art?

What art is should be inferable from the work. What the work of art is we can come to know only from the nature of art. Anyone can easily see that we are moving in a circle. Ordinary understanding demands that this circle be avoided because it violates logic. What art is can be gathered from a comparative examination of actual art works. But how

are we to be certain that we are indeed basing such an examination on art works if we do not know beforehand what art is? And the nature of art can no more be arrived at by a derivation from higher concepts than by a collection of characteristics of actual art works. For such a derivation, too, already has in view the characteristics that must suffice to establish that what we take in advance to be an art work is one in fact. But selecting works from among given objects, and deriving concepts from principles, are equally impossible here, and where these procedures are practiced they are a self-deception.

Thus we are compelled to follow the circle. This is neither a makeshift nor a defect. To enter upon this path is the strength of thought, to continue on it is the feast of thought, assuming that thinking is a craft. Not only is the main step from work to art a circle like the step from art to work, but every separate step that we attempt circles in this circle.

In order to discover the nature of the art that really prevails in the work, let us go to the actual work and ask the work what and how it is.

Works of art are familiar to everyone. Architectural and sculptural works can be seen installed in public places, in churches, and in dwellings. Art works of the most diverse periods and peoples are housed in collections and exhibitions. If we consider the works in their untouched actuality and do not deceive ourselves, the result is that the works are as naturally present as are things. The picture hangs on the wall like a rifle or a hat. A painting, e.g., the one by van Gogh that represents a pair of peasant shoes, travels from one exhibition to another. Works of art are shipped like coal from the Ruhr and logs from the Black Forest. During the First World War Hölderlin's hymns were packed in the soldier's knapsack together with cleaning gear. Beethoven's quartets lie in the storerooms of the publishing house like potatoes in a cellar.

All works have this thingly character. What would they be without it? But perhaps this rather crude and external view of the work is objectionable to us. Shippers or charwomen in museums may operate with such conceptions of the work of art. We, however, have to take works as they are encountered by those who experience and enjoy them. But even the much-vaunted aesthetic experience cannot get around the thingly aspect of the art work. There is something stony in a work of architecture, wooden in a carving, colored in a painting, spoken in a linguistic work, sonorous in a musical composition. The thingly element is so irremovably present in the art work that we are compelled rather to say conversely that the architectural work is in stone, the carving is in wood, the painting in color, the linguistic work in speech, the musical composition in sound. 'Obviously,' it will be replied. No doubt. But what is this self-evident thingly element in the work of art?

Presumably it becomes superfluous and confusing to inquire into this feature, since the art work is something else over and above the

thingly element. This something else in the work constitutes its artistic nature. The art work is, to be sure, a thing that is made, but it says something other than the mere thing itself is, *allo agorenei*. The work makes public something other than itself; it manifests something other; it is an allegory. In the work of art something other is brought together with the thing that is made. To bring together is, in Greek, *sumballein*. The work is a symbol.

Allegory and symbol provide the conceptual frame within whose channel of vision the art work has for a long time been characterized. But this one element in a work that manifests another, this one element that joins with another, is the thingly feature in the art work. It seems almost as though the thingly element in the art work is like the substructure into and upon which the other, authentic element is built. And is it not this thingly feature in the work that the artist really makes by his handicraft?

Our aim is to arrive at the immediate and full reality of the work of art, for only in this way shall we discover real art also within it. Hence we must first bring to view the thingly element of the work. To this end it is necessary that we should know with sufficient clarity what a thing is. Only then can we say whether the art work is a thing, but a thing to which something else adheres; only then can we decide whether the work is at bottom something else and not a thing at all.

Thing and Work

What in truth is the thing, so far as it is a thing? When we inquire in this way, our aim is to come to know the thing-being (thingness) of the thing. The point is to discover the thingly character of the thing. To this end we have to be acquainted with the sphere to which all those entities belong which we have long called by the name of thing.

The stone in the road is a thing, as is the clod in the field. A jug is a thing, as is the well beside the road. But what about the milk in the jug and the water in the well? These too are things if the cloud in the sky and the thistle in the field, the leaf in the autumn breeze and the hawk over the wood, are rightly called by the name of thing. All these must indeed be called things, if the name is applied even to that which does not, like those just enumerated, show itself, i.e., that which does not appear. According to Kant, the whole of the world, for example, and even God himself, is a thing of this sort, a thing that does not itself appear, namely, a 'thing-in-itself.' In the language of philosophy both things-in-themselves and things that appear, all beings that in any way are, are called things.

Airplanes and radio sets are nowadays among the things closest to us, but when we have ultimate things in mind we think of something altogether different. Death and judgment—these are ultimate things. On the whole the word 'thing' here designates whatever is not simply

nothing. In this sense the work of art is also a thing, so far as it is not simply nothing. Yet this concept is of no use to us, at least immediately, in our attempt to delimit entities that have the mode of being of a thing, as against those having the mode of being of a work. And besides, we hesitate to call God a thing. In the same way we hesitate to consider the peasant in the field, the stoker at the boiler, the teacher in the school as things. A man is not a thing. It is true that we speak of a young girl who is faced with a task too difficult for her as being a young thing, still too young for it, but only because we feel that being human is in a certain way missing here and think that instead we have to do here with the factor that constitutes the thingly character of things. We hesitate even to call the deer in the forest clearing, the beetle in the grass, the blade of grass a thing. We would sooner think of a hammer as a thing, or a shoe, or an ax, or a clock. But even these are not mere things. Only a stone, a clod of earth, a piece of wood are for us such mere things. Lifeless beings of nature and objects of use. Natural things and utensils are the things commonly so called.

We thus see ourselves brought back from the widest domain, within which everything is a thing (thing = *res* = *ens* = an entity), including even the highest and last things, to the narrow precinct of mere things. 'Mere' here means, first, the pure thing, which is simply a thing and nothing more; but then, at the same time, it means that which is only a thing, in an almost pejorative sense. It is mere things, excluding even use-objects, that count as things in the strict sense. What does the thingly character of these things, then, consist in? It is in reference to these that the thingness of things must be determinable. This determination enables us to characterize what it is that is thingly as such. Thus prepared, we are able to characterize the almost palpable reality of works, in which something else inheres.

Now it passes for a known fact that as far back as antiquity, no sooner was the question raised as to what entities are in general, than things in their thingness thrust themselves into prominence again and again as the standard type of beings. Consequently we are bound to meet with the definition of the thingness of things already in the traditional interpretations of beings. We thus need only to ascertain explicitly this traditional knowledge of the thing, to be relieved of the tedious labor of making our own search for the thingly character of the thing. The answers to the question 'What is the thing?' are so familiar that we no longer sense anything questionable behind them.

The interpretations of the thingness of the thing which, predominant in the course of Western thought, have long become self-evident and are now in everyday use, may be reduced to three.

This block of granite, for example, is a mere thing. It is hard, heavy, extended, bulky, shapeless, rough, colored, partly dull, partly shiny. We can take note of all these features in the stone. Thus we acknowledge

its characteristics. But still, the traits signify something proper to the stone itself. They are its properties. The thing has them. The thing? What are we thinking of when we now have the thing in mind? Obviously a thing is not merely an aggregate of traits, nor an accumulation of properties by which that aggregate arises. A thing, as everyone thinks he knows, is that around which the properties have assembled. We speak in this connection of the core of things. The Greeks are supposed to have called it *to hupokeimenon*. For them, this core of the thing was something lying at the ground of the thing, something always already there. The characteristics, however, are called *la sumbebekota*, that which has always turned up already along with the given core and occurs along with it.

These designations are no arbitrary names. Something that lies beyond the purview of this essay speaks in them, the basic Greek experience of the Being of beings in the sense of the presence. It is by these determinations, however, that the interpretation of the thingness of the thing is established which henceforth becomes standard, and the Western interpretation of the Being of beings stabilized. The process begins with the appropriation of Greek words by Roman-Latin thought. *Hupokeimenon* becomes *subiectum*; *hupostasis* becomes *substantia*; *sumbebekos* becomes *accidens*. However, this translation of Greek names into Latin is in no way the innocent process it is considered to this day. Beneath the seemingly literal and thus faithful translation there is concealed, rather, a *translation* of Greek experience into a different way of thinking. *Roman thought takes over the Greek words without a corresponding, equally authentic experience of what they say, without the Greek word*. The rootlessness of Western thought begins with this translation.

According to current opinion, this definition of the thingness of the thing as the substance with its accidents seems to correspond to our natural outlook on things. No wonder that the current attitude toward things—our way of addressing ourselves to things and speaking about them—has adapted itself to this common view of the thing. A simple propositional statement consists of the subject, which is the Latin translation, hence already a reinterpretation, of *hupokeimenon* and the predicate, in which the thing's traits are stated of it. Who would have the temerity to assail these simple fundamental relations between thing and statement, between sentence structure and thing-structure? Nevertheless we must ask: Is the structure of a simple propositional statement (the combination of subject and predicate) the mirror image of the structure of the thing (of the union of substance with accidents)? Or could it be that even the structure of the thing as thus envisaged is a projection of the framework of the sentence?

What could be more obvious than that man transposes his propositional way of understanding things into the structure of the thing itself?

Yet this view, seemingly critical yet actually rash and ill-considered, would have to explain first how such a transposition of propositional structure into the thing is supposed to be possible without the thing having already become visible. The question which comes first and functions as the standard, proposition structure of thing-structure remains to this hour undecided. It even remains doubtful whether in this form the question is at all decidable.

Actually, the sentence structure does not provide the standard for the pattern of thing-structure, nor is the latter simply mirrored in the former. Both sentence and thing-structure derive, in their typical form and their possible mutual relationship, from a common and more original source. In any case this first interpretation of the thingness of the thing, the thing as bearer of its characteristic traits, despite its currency, is not as natural as it appears to be. What seems natural to us is probably just something familiar in a long tradition that has forgotten the unfamiliar source from which it arose. And yet this unfamiliar source once struck man as strange and caused him to think and to wonder.

Our reliance on the current interpretation of the thing is only seemingly well founded. But in addition this thing-concept (the thing as bearer of its characteristics) holds not only of the mere thing in its strict sense, but also of any being whatsoever. Hence it cannot be used to set apart thingly beings from non-thingly beings. Yet even before all reflection, attentive dwelling within the sphere of things already tells us that this thing-concept does not hit upon the thingly element of the thing, its independent and self-contained character. Occasionally we still have the feeling that violence has long been done to the thingly element of things and that thought has played a part in this violence, for which reason people disavow thought instead of taking pains to make it more thoughtful. But in defining the nature of the thing, what is the use of a feeling, however certain, if thought alone has the right to speak here? Perhaps however what we call feeling or mood, here and in similar instances, is more reasonable—that is, more intelligently perceptive—because more open to Being than all that reason which, having meanwhile become *ratio*, was misinterpreted as being rational. The hankering after the irrational, as abortive offspring of the unthought rational, therewith performed a curious service. To be sure, the current thing-concept always fits each thing. Nevertheless it does not lay hold of the thing as it is in its own being, but makes an assault upon it.

Can such an assault perhaps be avoided—and how? Only, certainly, by granting the thing, as it were, a free field to display its thingly character directly. Everything that might interpose itself between the thing and us in apprehending and talking about it must first be set aside. Only then do we yield ourselves to the undisguised presence of the thing. But we do not need first to call or arrange for this situation in

which we let things encounter us without mediation. The situation always prevails. In what the senses of sight, hearing, and touch convey, in the sensations of color, sound, roughness, hardness, things move us bodily, in the literal meaning of the word. The thing is the *aistheton*, that which is perceptible by sensations in the senses belonging to sensibility. Hence the concept later becomes a commonplace according to which a thing is nothing but the unity of a manifold of what is given in the senses. Whether this unity is conceived as sum or as totality or as form alters nothing in the standard character of this thing-concept.

Now this interpretation of the thingness of the thing is as correct and demonstrable in every case as the previous one. This already suffices to cast doubt on its truth. If we consider moreover what we are searching for, the thingly character of the thing, then this thing-concept again leaves us at a loss. We never really first perceive a throng of sensations, e.g., tones and noises, in the appearance of things—as this thing-concept alleges; rather we hear the storm whistling in the chimney, we hear the three-motored plane, we hear the Mercedes in immediate distinction from the Volkswagen. Much closer to us than all sensations are the things themselves. We hear the door shut in the house and never hear acoustical sensations or even mere sounds. In order to hear a bare sound we have to listen away from things, divert our ear from them, i.e., listen abstractly.

In the thing-concept just mentioned there is not so much an assault upon the thing as rather an inordinate attempt to bring it into the greatest possible proximity to us. But a thing never reaches that position as long as we assign as its thingly feature what is perceived by the senses. Whereas the first interpretation keeps the thing at arm's length from us, as it were, and sets it too far off, the second makes it press too hard upon us. In both interpretations the thing vanishes. It is therefore necessary to avoid the exaggerations of both. The thing itself must be allowed to remain in its self-containment. It must be accepted in its own constancy. This the third interpretation seems to do, which is just as old as the first two.

That which gives things their constancy and pith but is also at the same time the source of their particular mode of sensuous pressure—colored, resonant, hard, massive—is the matter in things. In this analysis of the thing as matter (*hule*), form (*morphe*) is already coposited. What is constant in a thing, its consistency, lies in the fact that matter stands together with a form. The thing is formed matter. This interpretation appeals to the immediate view with which the thing solicits us by its looks (*eidos*). In this synthesis of matter and form a thing-concept has finally been found which applies equally to things of nature and to use-objects.

This concept puts us in a position to answer the question concerning the thingly element in the work of art. The thingly element is

manifestly the matter of which it consists. Matter is the substrate and field for the artist's formative action. But we could have advanced this obvious and well-known definition of the thingly element at the very outset. Why do we make a detour through other current thing-concepts? Because we also mistrust this concept of the thing, which represents it as formed matter.

But is not precisely this pair of concepts, matter-form, usually employed in the domain in which we are supposed to be moving? To be sure. The distinction of matter and form is *the conceptual schema which is used, in the greatest variety of ways, quite generally for all art theory and aesthetics.* This incontestable fact, however, proves neither that the distinction of matter and form is adequately founded, nor that it belongs originally to the domain of art and the art work. Moreover, the range of application of this pair of concepts has long extended far beyond the field of aesthetics. Form and content are the most hackneyed concepts under which anything and everything may be subsumed. And if form is correlated with the rational and matter with the irrational; if the rational is taken to be the logical and the irrational the alogical; if in addition the subject–object relation is coupled with the conceptual pair form–matter; then representation has at its command a conceptual machinery that nothing is capable of withstanding.

If, however, it is thus with the distinction between matter and form, how then shall we make use of it to lay hold of the particular domain of mere things by contrast with all other entities? But perhaps this characterization in terms of matter and form would recover its defining power if only we reversed the process of expanding and emptying these concepts. Certainly, but this presupposes that we know in what sphere of beings they realize their true defining power. That this is the domain of mere things is so far only an assumption. Reference to the copious use made of this conceptual framework in aesthetics might sooner lead to the idea that matter and form are specifications stemming from the nature of the art work and were in the first place transferred from it back to the thing. Where does the matter-form structure have its origin—in the thingly character of the thing or in the workly character of the art work?

The self-contained block of granite is something material in a definite if unshapely form. Form means here the distribution and arrangement of the material parts in spatial locations, resulting in a particular shape, namely that of a block. But a jug, an ax, a shoe are also matter occurring in a form. Form as shape is not the consequence here of a prior distribution of the matter. The form, on the contrary, determines the arrangement of the matter. Even more, it prescribes in each case the kind and selection of the matter—impermeable for a jug, sufficiently hard for an ax, firm yet flexible for shoes. The interfusion of form and matter prevailing here is, moreover, controlled beforehand by

the purposes served by jug, ax, shoes. Such usefulness is never assigned or added on afterward to a being of the type of a jug, ax, or pair of shoes. But neither is it something that floats somewhere above it as an end.

Usefulness is the basic feature from which this entity regards us, that is, flashes at us and thereby is present and thus is this entity. Both the formative act and the choice of material—a choice given with the act—and therewith the dominance of the conjunction of matter and form, are all grounded in such usefulness. A being that falls under usefulness is always the product of a process of making. It is made as a piece of equipment for something. As determinations of beings, accordingly, matter and form have their proper place in the essential nature of equipment. This name designates what is produced expressly for employment and use. Matter and form are in no case original determinations of the thingness of the mere thing.

A piece of equipment, a pair of shoes for instance, when finished, is also self-contained like the mere thing, but it does not have the character of having taken shape by itself like the granite boulder. On the other hand, equipment displays an affinity with the art work insofar as it is something produced by the human hand. However, by its self-sufficient presence the work of art is similar rather to the mere thing which has taken shape by itself and is self-contained. Nevertheless we do not count such works among mere things. As a rule it is the use-objects around us that are the nearest and authentic things. Thus the piece of equipment is half thing, because characterized by thingliness, and yet it is something more; at the same time it is half art work and yet something less, because lacking the self-sufficiency of the art work. Equipment has a peculiar position intermediate between thing and work, assuming that such a calculated ordering of them is permissible.

The matter-form structure, however, by which the being of a piece of equipment is first determined, readily presents itself as the immediately intelligible constitution of every entity, because here man himself as maker participates in the way in which the piece of equipment comes into being. Because equipment takes an intermediate place between mere thing and work, the suggestion is that nonequipmental beings—things and works and ultimately everything that is—are to be comprehended with the help of the being of equipment (the matter-form structure).

The inclination to treat the matter-form structure as *the* constitution of every entity receives a yet additional impulse from the fact that on the basis of a religious faith, namely, the biblical faith, the totality of all beings is represented in advance as something created, which here means made. The philosophy of this faith can of course assure us that all of God's creative work is to be thought of as different from the action of a craftsman. Nevertheless, if at the same time or even

beforehand, in accordance with a presumed predetermination of Thomistic philosophy for interpreting the Bible, the *ens creatum* is conceived as a unity of *materia* and *forma*, then faith is expounded by way of a philosophy whose truth lies in an unconcealedness of beings which differs in kind from the world believed in by faith.

The idea of creation, grounded in faith, can lose its guiding power of knowledge of beings as a whole. But the theological interpretation of all beings, the view of the world in terms of matter and form borrowed from an alien philosophy, having once been instituted, can still remain a force. This happens in the transition from the Middle Ages to modern times. The metaphysics of the modern period rests on the form-matter structure devised in the medieval period, which itself merely recalls in its words the buried natures of *eidos* and *hule*. Thus the interpretation of 'thing' by means of matter and form, whether it remains medieval or becomes Kantian-transcendental, has become current and self-evident. But for that reason, no less than the other interpretations mentioned of the thingness of the thing, it is an encroachment upon the thing-being of the thing. [...]

We choose as example a common sort of equipment—a pair of peasant shoes. We do not even need to exhibit actual pieces of this sort of useful article in order to describe them. Everyone is acquainted with them. But since it is a matter here of direct description, it may be well to facilitate the visual realization of them. For this purpose a pictorial representation suffices. We shall choose a well-known painting by van Gogh, who painted such shoes several times. But what is there to see here? Everyone knows what shoes consist of. If they are not wooden or bast shoes, there will be leather soles and uppers, joined together by thread and nails. Such gear serves to clothe the feet. Depending on the use to which the shoes are to be put, whether for work in the field or for dancing, matter and form will differ.

Such statements, no doubt correct, only explicate what we already know. The equipmental quality of equipment consists in its usefulness. But what about this usefulness itself? In conceiving it, do we already conceive along with it the equipmental character of equipment? In order to succeed in doing this, must we not look out for useful equipment in its use? The peasant woman wears her shoes in the field. Only here are they what they are. They are all the more genuinely so, the less the peasant woman thinks about the shoes while she is at work, or looks at them at all, or is even aware of them. She stands and walks in them. That is how shoes actually serve. It is in this process of the use of equipment that we must actually encounter the character of equipment.

As long as we only imagine a pair of shoes in general, or simply look at the empty, unused shoes as they merely stand there in the picture, we shall never discover what the equipmental being of the equipment in

truth is. From van Gogh's painting we cannot even tell where these shoes stand. There is nothing surrounding this pair of peasant shoes in or to which they might belong—only an undefined space. There are not even clods of soil from the field or the field-path sticking to them, which would at least hint at their use. A pair of peasant shoes and nothing more. And yet—

From the dark opening of the worn insides of the shoes the toilsome tread of the worker stares forth. In the stiffly rugged heaviness of the shoes there is the accumulated tenacity of her slow trudge through the far-spreading and ever-uniform furrows of the field swept by a raw wind. On the leather lie the dampness and richness of the soil. Under the soles slides the loneliness of the field-path as evening falls. In the shoes vibrates the silent call of the earth, its quiet gift of the ripening grain and its unexplained self-refusal in the fallow desolation of the wintry field. This equipment is pervaded by uncomplaining anxiety as to the certainty of bread, the wordless joy of having once more withstood want, the trembling before the impending childbed and shivering at the surrounding menace of death. This equipment belongs to the *earth*, and it is protected in the *world* of the peasant woman. From out of this protected belonging the equipment itself rises to its resting-within-itself.

But perhaps it is only in the picture that we notice all this about the shoes. The peasant woman, on the other hand, simply wears them. If only this simple wearing were so simple. When she takes off her shoes late in the evening, in deep but healthy fatigue, and reaches out for them again in the still dim dawn, or passes them by on the day of rest, she knows all this without noticing or reflecting. The equipmental quality of the equipment consists indeed in its usefulness. But this usefulness itself rests in the abundance of an essential being of the equipment. We call it reliability. By virtue of this reliability the peasant woman is made privy to the silent call of the earth; by virtue of the reliability of the equipment she is sure of her world. World and earth exist for her, and for those who are with her in her mode of being, only thus—in the equipment. We say 'only' and therewith fall into error; for the reliability of the equipment first gives to the simple world its security and assures to the earth the freedom of its steady thrust.

The equipmental being of equipment, reliability, keeps gathered within itself all things according to their manner and extent. The usefulness of equipment is nevertheless only the essential consequence of reliability. The former vibrates in the latter and would be nothing without it. A single piece of equipment is worn out and used up; but at the same time the use itself also falls into disuse, wears away, and becomes usual. Thus equipmentality wastes away, sinks into mere stuff. In such wasting, reliability vanishes. This dwindling, however, to which use-things owe their boringly obtrusive usualness, is only one

more testimony to the original nature of equipmental being. The worn-out usualness of the equipment then obtrudes itself as the sole mode of being, apparently peculiar to it exclusively. Only blank usefulness now remains visible. It awakens the impression that the origin of equipment lies in a mere fabricating that impresses a form upon some matter. Nevertheless, in its genuinely equipmental being, equipment stems from a more distant source. Matter and form and their distinction have a deeper origin.

The repose of equipment resting within itself consists in its reliability. Only in this reliability do we discern what equipment in truth is. But we still know nothing of what we first sought: the thing's thingly character. And we know nothing at all of what we really and solely seek: the workly character of the work in the sense of the work of art.

Or have we already learned something unwittingly, in passing so to speak, about the work-being of the work?

The equipment quality of equipment was discovered. But how? Not by a description and explanation of a pair of shoes actually present; not by a report about the process of making shoes; and also not by the observation of the actual use of shoes occurring here and there; but only by bringing ourselves before van Gogh's painting. This painting spoke. In the vicinity of the work we were suddenly somewhere else than we usually tend to be.

The art work let us know what shoes are in truth. It would be the worst self-deception to think that our description, as a subjective action, had first depicted everything thus and then projected it into the painting. If anything is questionable here, it is rather that we experienced too little in the neighborhood of the work and that we expressed the experience too crudely and too literally. But above all, the work did not, as it might seem at first, serve merely for a better visualizing of what a piece of equipment is. Rather, the equipmentality of equipment first genuinely arrives at its appearance through the work and only in the work.

What happens here? What is at work in the work? Van Gogh's painting is the disclosure of what the equipment, the pair of peasant shoes, *is* in truth. This entity emerges into the unconcealedness of its being. The Greeks called the unconcealedness of beings *aletheia*. We say 'truth' and think little enough in using this word. If there occurs in the work a disclosure of a particular being, disclosing what and how it is, then there is here an occurring, a happening of truth at work.

In the work of art the truth of an entity has set itself to work. 'To set' means here: to bring to a stand. Some particular entity, a pair of peasant shoes, comes in the work to stand in the light of its being. The being of the being comes into the steadiness of its shining.

The nature of art would then be this: the truth of beings setting itself to work. But until now art presumably has had to do with the

beautiful and beauty, and not with truth. The arts that produce such works are called the beautiful or fine arts, in contrast with the applied or industrial arts that manufacture equipment. In fine art the art itself is not beautiful, but is called so because it produces the beautiful. Truth, in contrast, belongs to logic. Beauty, however, is reserved for aesthetics. [...]

We seek the reality of the art work in order to find there the art prevailing within it. The thingly substructure is what proved to be the most immediate reality in the work. But to comprehend this thingly feature the traditional thing-concepts are not adequate; for they themselves fail to grasp the nature of the thing. The currently predominant thing-concept, thing as formed matter, is not even derived from the nature of the thing but from the nature of equipment. It also turned out that equipmental being generally has long since occupied a peculiar pre-eminence in the interpretation of beings. This pre-eminence of equipmentality, which however did not actually come to mind, suggested that we pose the question of equipment anew while avoiding the current interpretations.

We allowed a work to tell us what equipment is. By this means, almost clandestinely, it came to light what is at work in the work: the disclosure of the particular being in its being, the happening of truth. If, however, the reality of the work can be defined solely by means of what is at work in the work, then what about our intention to seek out the real art work in its reality? As long as we supposed that the reality of the work lay primarily in its thingly substructure we were going astray. We are now confronted by a remarkable result of our considerations—if it still deserves to be called a result at all. Two points become clear:

First: the dominant thing-concepts are inadequate as means of grasping the thingly aspect of the work.

Second: what we tried to treat as the most immediate reality of the work, its thingly substructure, does not belong to the work in that way at all.

As soon as we look for such a thingly substructure in the work, we have unwittingly taken the work as equipment, to which we then also ascribe a superstructure supposed to contain its artistic quality. But the work is not a piece of equipment that is fitted out in addition with an aesthetic value that adheres to it. The work is no more anything of the kind than the bare thing is a piece of equipment that merely lacks the specific equipmental characteristics of usefulness and being made.

Our formulation of the question of the work has been shaken because we asked, not about the work but half about a thing and half about equipment. Still, this formulation of the question was not first developed by us. It is the formulation native to aesthetics. The way in which aesthetics views the art work from the outset is dominated by the traditional interpretation of all beings. But the shaking of this

accustomed formulation is not the essential point. What matters is a first opening of our vision to the fact that what is workly in the work, equipmental in equipment, and thingly in the thing comes closer to us only when we think the Being of beings. To this end it is necessary beforehand that the barriers of our preconceptions fall away and that the current pseudo concepts be set aside. That is why we had to take this detour. But it brings us directly to a road that may lead to a determination of the thingly feature in the work. The thingly feature in the work should not be denied; but if it belongs admittedly to the work-being of the work, it must be conceived by way of the work's workly nature. If this is so, then the road toward the determination of the thingly reality of the work leads not from thing to work but from work to thing.

The art work opens up in its own way the Being of beings. This opening up, i.e., this deconcealing, i.e., the truth of beings, happens in the work. In the art work, the truth of what is has set itself to work. Art is truth setting itself to work. What is truth itself, that it sometimes comes to pass as art? What is this setting-itself-to-work? [...]

The Still Life as a Personal Object—A Note on Heidegger and van Gogh

In his essay on *The Origin of the Work of Art*, Martin Heidegger interprets a painting by van Gogh [**62**] to illustrate the nature of art as a disclosure of truth.[1]

He comes to this picture in the course of distinguishing three modes of being: of useful artifacts, of natural things, and of works of fine art. He proposes to describe first, 'without any philosophical theory … a familiar sort of equipment—a pair of peasant shoes'; and 'to facilitate the visual realization of them' he chooses 'a well-known painting by van Gogh, who painted such shoes several times.' But to grasp 'the equipmental being of equipment,' we must know 'how shoes actually serve.' For the peasant woman they serve without her thinking about them or even looking at them. Standing and walking in the shoes, the peasant woman knows the serviceability in which 'the equipmental being of equipment consists.' But we,

as long as we only imagine a pair of shoes in general, or simply look at the empty, unused shoes as they merely stand there in the picture, we shall never discover what the equipmental being of equipment in truth is. In van Gogh's painting we cannot even tell where these shoes stand. There is nothing surrounding this pair of peasant shoes in or to which they might belong, only an undefined space. There are not even clods from the soil of the field or the path through it sticking to them, which might at least hint at their employment. A pair of peasant shoes and nothing more. And yet.

From the dark opening of the worn insides of the shoes the toilsome tread of the worker stands forth. In the stiffly solid heaviness of the shoes there is the accumulated tenacity of her slow trudge through the far-spreading and ever-uniform furrows of the field, swept by a raw wind. On the leather there lies the dampness and saturation of the soil. Under the soles there slides the loneliness of the field-path as the evening declines. In the shoes there vibrates the silent call of the earth, its quiet gift of the ripening corn and its enigmatic self-refusal in the fallow desolation of the wintry field. This equipment is pervaded by uncomplaining anxiety about the certainty of bread, the wordless joy of having once more withstood want, the trembling before the advent of birth and shivering at the surrounding menace of death. This equipment belongs to the *earth* and it is protected in the *world* of the peasant woman. From out of this protected belonging the equipment itself rises to its resting-in-self.[2]

62 Vincent van Gogh
Old Shoes with Laces, 1886

Professor Heidegger is aware that van Gogh painted such shoes several times, but he does not identify the picture he has in mind, as if the different versions are interchangeable, all presenting the same truth. A reader who wishes to compare this account with the original picture or its photograph will have some difficulty in deciding which one to select. Eight paintings of shoes by van Gogh are recorded by de la Faille in his catalogue of all the canvasses by the artist that had been exhibited at the time Heidegger wrote his essay.[3] Of these only three show the 'dark openings of the worn insides' which speak so distinctly to the philosopher.[4] They are clearly pictures of the artist's own shoes, not the shoes of a peasant. They might be shoes he had worn in Holland, but the pictures were painted during van Gogh's stay in Paris in 1886–87; one of them bears the date: '87'.[5] From the time before 1886 when he painted Dutch peasants are two pictures of shoes—a pair of clean wooden clogs set on a table beside other objects.[6] Later in Arles he represented, as he wrote in a letter of August 1888 to his brother, 'une paire de vieux souliers' which are evidently his own.[7] A second still life of 'vieux souliers de paysan' is mentioned in a letter of September 1888 to the painter Emile Bernard, but it lacks the characteristic worn surface

and dark insides of Heidegger's description.[8]

In reply to my question, Professor Heidegger has kindly written me that the picture to which he referred is one that he saw in a show at Amsterdam in March 1930.[9] This is clearly de la Faille's no. 255; there was also exhibited at the same time a painting with three pairs of shoes,[10] and it is possible that the exposed sole of a shoe in this picture inspired the reference to the sole in the philosopher's account. But from neither of these pictures, nor from any of the others, could one properly say that a painting of shoes by van Gogh expresses the being or essence of a peasant woman's shoes and her relation to nature and work. They are the shoes of the artist, by that time a man of the town and city.

Heidegger has written: 'The art-work told us what shoes are in truth. It would be the worst self-deception if we were to think that our description, as a subjective action, first imagined everything thus and then projected it into the painting. If anything is questionable here, it is rather that we experienced too little in contact with the work and that we expressed the experience too crudely and too literally. But above all, the work does not, as might first appear, serve merely for a better visualization of what a piece of equipment is. Rather, the equipmental being of equipment first arrives at its explicit appearance through and only in the work.

'What happens here? What is at work in the work? Van Gogh's painting is the disclosure of what the equipment, the pair of peasants' shoes, *is* in truth.'[11]

Alas for him, the philosopher has indeed deceived himself. He has retained from his encounter with van Gogh's canvas a moving set of associations with peasants and the soil, which are not sustained by the picture itself but are grounded rather in his own social outlook with its heavy pathos of the primordial and earthy. He has indeed 'imagined everything and projected it into the painting.' He has experienced both too little and too much in his contact with the work.

The error lies not only in his projection which replaces a close and true attention to the work of art. For even if he had seen a picture of a peasant woman's shoes, as he describes them, it would be a mistake to suppose that the truth he uncovered in the painting—the being of the shoes—is something given here once and for all and is unavailable to our perception of shoes outside the painting. I find nothing in Heidegger's fanciful description of the shoes represented by van Gogh that could not have been imagined in looking at a real pair of peasants' shoes. Though he credits to art the power of giving to a represented pair of shoes that explicit appearance in which their being is disclosed—indeed 'the universal essence of things', 'world and earth in their counterplay'—this concept of the metaphysical power of art remains here a theoretical idea.[12] The example on which he elaborates

with strong conviction does not support that idea.

Is Heidegger's mistake simply that he chose a wrong example? Let us imagine a painting of a peasant-woman's shoes by van Gogh. Would it not have made manifest just those qualities and that sphere of being described by Heidegger with such pathos?

Heidegger would still have missed an important aspect of the painting: the artist's presence in the work. In his account of the picture he has overlooked the personal and physiognomic in the shoes which made them so absorbing a subject for the artist (not to speak of the intimate connection with the peculiar tones, forms, and brush-made surface of the picture as a painted work). When van Gogh depicted the peasant's wooden sabots, he gave them a clear, unworn shape and surface like the smooth still life objects he had set beside them on the same table: the bowl, the bottles, etc. In the later picture of a peasant's leather slippers he has turned them with their backs to the viewer.[13] His own shoes he has isolated on the floor and he has rendered them as if facing us, and so individual and wrinkled in appearance that we can speak of them as veridical portraits of aging shoes.

We come closer, I think, to van Gogh's feeling for these shoes in a paragraph written by Knut Hamsun in the 1880s in his novel *Hunger*, describing his own shoes:

'As I had never seen my shoes before, I set myself to study their looks, their characteristics, and when I stir my foot, their shapes and their worn uppers. I discover that their creases and white seams give them expression—impart a physiognomy to them. Something of my own nature had gone over into these shoes; they affected me, like a ghost of my other I—a breathing portion of my very self.'[14]

In comparing van Gogh's painting with Hamsun's text, we are interpreting the painting in a different way from Heidegger's. The philosopher finds in the picture of the shoes a truth about the world as it is lived by the peasant without reflection; Hamsun sees the real shoes as experienced by the self-conscious contemplating wearer who is also the writer. Hamsun's personage, a brooding, self-observant drifter, is closer to van Gogh's situation than to the peasant's. Yet van Gogh is in some ways like the peasant; as an artist he works, he is stubbornly occupied in a persistent task that is for him his inescapable calling, his life. Of course, van Gogh, like Hamsun, has also an exceptional gift of representation; he is able to transpose to the canvas with a singular power the forms and qualities of things; but they are things that have touched him deeply, in this case his own shoes—things inseparable from his body and memorable to his reacting self-awareness. They are not less objectively rendered for being seen as if endowed with his feelings and revery about himself. In isolating his own worn shoes on a canvas, he turns them to the spectator; he makes of them a piece from a self-portrait, that part of the costume with which we tread the earth

and in which we locate the strains of movement, fatigue, pressure, heaviness—the burden of the erect body in its contact with the ground. They mark our inescapable position on the earth. To 'be in someone's shoes' is to be in his predicament or his station in life. For a painter to represent his worn shoes as the main subject of a picture is for him to express a concern with the fatalities of his social being. Not the shoes as an instrument of use, though the landscape painter as a worker in the fields shares something of the peasant's life outdoors, but the shoes as 'a portion of the self' (in Hamsun's words) are van Gogh's revealing theme.

Gauguin, who shared van Gogh's quarters in Arles in 1888, sensed a personal history behind his friend's painting of a pair of shoes. He has told in his reminiscences of van Gogh a deeply affecting story linked with van Gogh's shoes.

'In the studio was a pair of big hob-nailed shoes, all worn and spotted with mud; he made of it a remarkable still life painting. I do not know why I suspected that there was a story behind this old relic, and I ventured one day to ask him if he had some reason for preserving with respect what one ordinarily throws out for the rag-picker's basket.

'"My father," he said, "was a pastor, and at his urging I pursued theological studies in order to prepare for my future vocation. As a young pastor I left for Belgium one fine morning, without telling my family, to preach the gospel in the factories, not as I had been taught but as I understood it myself. These shoes, as you see, have bravely endured the fatigue of that trip."

'Preaching to the miners in the Borinage, Vincent undertook to nurse a victim of a fire in the mine. The man was so badly burned and mutilated that the doctor had no hope for his recovery. Only a miracle, he thought, could save him. Van Gogh tended him forty days with loving care and saved the miner's life.

'Before leaving Belgium I had, in the presence of this man who bore on his brow a series of scars, a vision of the crown of thorns, a vision of the resurrected Christ.'

Gauguin continues: 'And Vincent took up his palette again; silently he worked. Beside him was a white canvas. I began his portrait. I too had the vision of a Jesus preaching kindness and humility.'[15]

It is not clear which of the paintings with a single pair of shoes Gauguin had seen at Arles. He described it as violet in tone in contrast to the yellow walls of the studio. It does not matter. Though written some years later, and with some literary affectations, Gauguin's story confirms the essential fact that for van Gogh the shoes were a piece of his own life.

Restitutions of the Truth in Pointing ['Pointure']

POINTURE (Latin *punctura*), sb. fem. Old synonym of prick. Term in printing, small iron blade with a point, used to fix the page to be printed on to the tympan. The hole which it makes in the paper. Term in shoemaking, glovemaking: number of stitches in a shoe or glove.

Littré

I owe you the truth in painting, and I will tell it to you.

Cézanne

But truth is so dear to me, and so is the *seeking to make true*, that indeed I believe, I believe I would still rather be a cobbler than a musician with colors.

van Gogh

[…]—What interested me, was finally to see explained from a certain angle why I had always found this passage of Heidegger's on van Gogh ridiculous and lamentable. So it really was the naïveté of what Schapiro rightly calls a 'projection.' One is not only disappointed when his academic high seriousness, his severity and rigor of tone give way to this 'illustration' (*bildliche Darstellung*). One is not only disappointed by the consumerlike hurry toward the content of a representation, by the heaviness of the pathos, by the coded triviality of this description, which is both overloaded and impoverished, and one never knows if it's busying itself around a picture, 'real' shoes, or shoes that are imaginary but outside painting, not only disappointed by the crudeness of the framing the arbitrary and barbaric nature of the cutting-out, the massive self-assurance of the identification: 'a pair of peasants' shoes,' just like that! Where did he get that from? Where does he explain himself on this matter? So one is not only disappointed, one sniggers. The fall in tension is too great. One follows step by step the moves of a 'great thinker,' as he returns to the origin of the work of art and of truth, traversing the whole history of the West and then suddenly, at a bend in a corridor, here we are on a guided tour, as schoolchildren or tourists. Someone's gone to fetch the guide from the neighboring farm. Full of goodwill. He loves the earth and a certain type of painting when he can

find himself in it [*quand il s'y retrouve*]. Giving up his usual activity he goes off to get his key while the visitors wait, slowly getting out of the coach. (There is a Japanese tourist among them, who in a moment will ask a few questions of the guide, in a stage whisper.) Then the tour begins. With his local [Swabian] accent, he tries to get the visitors going [he sometimes manages it and each time this happens he also trembles regularly, in time], he piles up the associations and immediate projections. From time to time he points out of the window to the fields and nobody notices that he's no longer talking about painting. All right. And one says to oneself that the scene, the choice of the example, the procedure of the treatment, nothing in all this is fortuitous. This casual guide is the very person who, before and after this incredible tirade, carries on with his discourse on the origin of the work of art and on truth. It's the same discourse, it has never been interrupted by the slightest digression (what all these professorial procedures with regard to the shoes are lacking in, moreover, is the sense of digression: the shoes have to make a pair and walk on the road, forwards or backwards, in a circle if pushed, but with no digressions or sidesteps allowed, now there is a link between the detachability of the step and the possibility of the digressive). I see that you are shocked, in your deference, by the scene which I have, how shall I put it
—projected.
—Then let's get back into the classroom. All that is classical, class-business, the business of pedagogy and classicity, Professor Heidegger, as Professor Schapiro says in homage to Professor Goldstein, projects a transparency. He wants to capture your interest, through this illustration, right from the beginning of his lecture. For *The Origin* was in the beginning, at a very significant date, a series of lectures delivered before a *kunstwissenschaftliche Gesellschaft* and then before a *freie deutsche Hochstift*, and shows it.
—The word 'illustration' has just been uttered. And it had been several times previously. I suggest that that's where we should start, if we must begin and if we must read Schapiro's *Note* against which I intend to defend systematically, at least for the committee exercise, the cause of Heidegger [who, don't forget, also proffers, in this place where it is a question of the thing, an important discourse on the *causa*]. A fair number of difficulties arise from what is translated by *illustration*. In his protocol, Schapiro uses this word which also translates [into French] '*bildliche Darstellung*' ['For this purpose an illustration suffices. We choose for this a famous picture by van Gogh …']. Schapiro opens his text—and *The Origin*—at this point [by what right?] and he writes: 'In his essay on *The Origin of the Work of Art*, Martin Heidegger interprets a painting by van Gogh to illustrate the nature of art as a disclosure of truth.

'He comes to this picture in the course of distinguishing three

modes of being: of useful artifacts [products], of natural things, and of works of fine art. He proposes to describe first, 'without any philosophical theory … a familiar sort of equipment [*Zeug*: product]—a pair of peasant shoes', and 'to facilitate the visual realization [translating *Veranschaulichung*, intuitive sensory presentation] of them' he chooses 'a well-known painting by van Gogh, who painted such shoes several times' [see **62**]. But to grasp the 'equipmental being of equipment,' we must know 'how shoes actually serve.' For the peasant woman they serve without her thinking about them or even looking at them. Standing and walking in the shoes, the peasant woman knows the serviceability [*Dienlichkeit*] in which 'the equipmental being of equipment consists.' But we …' [Schapiro, p. 203]. And Schapiro quotes these two paragraphs which you all find so ridiculous or so imprudent. Let's reread them first, in German, in French, in English.

… …
… …
… …

—It's done.
—Before going any further, I shall pick out from the cutting-out in Schapiro's protocol a certain number of simplifications, not to call them anything worse. They have effects on everything that follows. He simplifies matters by saying that Heidegger interprets a painting to illustrate the nature of art as the unveiling of truth. To prove this, one has no need to refer to what the following page says, i.e., [in translation first]: 'the work in no way served [*diente gar nicht*], as it may have seemed at first, to illustrate more clearly what a product is.' What has here been translated as 'illustrate' is *Veranschaulichung* this time, and not *Darstellung*, which was also translated above as illustration. *Veranschaulichung*, intuitive presentation, as it were, is what had to be facilitated by invoking the example of the picture. But it is also what *was not done,* although it seemed as though that's what was happening. Heidegger makes this quite clear: the work did not serve us to do that, did not do us this service which, all in all, we pretended to expect from it. It did better than illustrating or presenting something to sensory intuition—or worse, depending on the point of view—it showed, it made appear. Heidegger has just recalled that the work did not 'serve' as *Veranschaulichung* or *Darstellung*, and he goes on to specify: 'Much more is it the being-product of the product which arrives, properly [*eigens*] and only through the work, at its appearing.' This appearing of the being-product does not, according to Heidegger, take place in an elsewhere which the work of art could illustrate by referring to it. It takes place properly (and only) in the work. In its very truth. This might seem to aggravate the illusion denounced by Schapiro and to place under the heading of presentation what was marked down only in

the name of representation, as if Heidegger thought he could see still more directly what Schapiro reproaches him for inferring too hastily. But things are not yet so simple and we shall have to return to this.

First of all: it is not as *peasant* shoes, but as *product* [*Zeug*] or as shoes-*as-product* that the being-product manifested itself. The manifestation is that of the being-product of the product and not of this or that species of product, such as shoes. Such was the function of the *Darstellung*. It must be carefully demarcated in this passage and its stages differentiated. Heidegger is not simply, as Schapiro claims, in the process of distinguishing between three modes of being of the thing.

—Then what *is* going on when the so-called illustration intervenes?

—Heidegger has just analyzed the system of the three couples of determinations superimposed on the thing. They are connected, associated in a sort of 'conceptual mechanism' [*Begriffsmechanik*] which nothing resists. Among the effects of this system, the matter/form couple and the concept of thing as informed matter have long dominated every theory of art and every aesthetics. And still do so today. From the moment he is interested here in the work of art, Heidegger insists and makes his question more precise: does this (dominant) form-matter complex have its origin in the being-thing of the thing or else in the being-work of the work and in the being-product [with the participation of man, it is understood, whence the temptation to take this matter-form complex to be the immediate structure of the thing] of the product? In other words, would it not be on the basis of the thing as work or as product that this *general* interpretation (or rather one that is claimed to be general) of the thing as informed matter was secretly constituted? Now reread the chapter: in the course of this questioning about the product as informed matter, the example of the pair of shoes appears at least three times *before and in the absence of the least reference to a work of art,* be it pictorial or otherwise. Twice associated with the example of the ax and the pitcher.

—There's a lot that needs to be said about these examples and about the discourse on the pitcher in Heidegger, with reference to the thing, precisely.

—Yes, in Heidegger and others before him, in his tradition, or after him: Ponge, for example. But let's not let ourselves get sidetracked. Another time. Having been twice associated with the pitcher and the ax, the pair of shoes (the third time it is mentioned but still before there is any question of the picture) detaches itself from the other examples. Suddenly it is alone. No doubt it is responding to a particular need, but Heidegger will never thematize this. Perhaps it is because, unlike the ax and the pitcher, this useful product is also an article of clothing [*Fussbekleidung*] whose mode of attachment to the body of the subject —let's say, more rigorously, to its *Dasein*—involves an element of orig-

inality from which more can be got in this context. But let's leave that. In any case this example manages very well, for many pages, to do without any aesthetic or pictorial reference. And it is during its last occurrence before the allusion to the 'famous picture' that an essential schema is set in place. Without it we would understand nothing of the passage about such-and-such a work by van Gogh, nothing of its differential function, and nothing of its irreducible equivocality either. I called it a schema: basically, and in a barely displaced Kantian sense, it's a hybrid, a mediation or a double belonging or double articulation. The product [*Zeug*] seems to be situated between the thing and the work of art (the work is always a work *of art* in this context: *Werk*). It shares in both, even though the work resembles [*gleicht*] the 'simple thing' more than does the product. The example of the shoes guides the analysis of this schematism when it is first set in place. It is only three pages later, in order to take a further step [*un pas de plus*] in this question of the being-product, that Heidegger will take up the same example again: this time 'inside' a work of art, we shall see why and how this 'inside' turns itself inside out, and is crossed with a single step [*d'un seul pas franchi*]. For the moment, the pair of shoes is a paradigm.

—in its status as paradigm, it has a very noble philosophical genealogy, going back to Plato. So we can hear at this point a sort of quotation, as encrypted as it is conventional, in a long discursive chain.

—it is here a paradigm of the thing as 'product.' It is not yet 'painted' or 'painting' and it occupies, in an exemplary way, that 'intermediate place [*Zwischenstellung*, place of the between, the inter-stela or, as Lacoue-Labarthe might say, the inter-posture: see his 'Typographie,' in *Mimesis*][1] between the mere thing [*blossen Ding*] and the work [*Werk*].' When the 'product' is the subject of a 'work,' when the thing-as-product [shoes] is the 'subject' presented or represented by a thing-as-work (a picture by van Gogh), the thing will be too complicated to be treated as lightly and simply as Schapiro does. For then one will have to deal with a work (which resembles a mere thing more than it does a product, and resembles a mere thing more than a product does), with a work presenting or representing a product the status of which is intermediary between the thing and the work, etc. The intermediate mode is *in the middle* of the other two, which it gathers and divides in itself according to a structure of envelopment which is difficult to spread out. Here, first of all, is the schematism of the product. For example: shoes *in general*. I pick out and emphasize a few words: 'The product [*Zeug*], for example the shoe-product [*Schuhzeug*] rests, as ready [*fertig*, finished] in itself as the thing pure and simple, but it does not have, as does the block of granite, this *Eigenwüchsige* (difficult to translate: not 'spontaneity,' as the French translation has it, but compact self-sufficiency, dense propriety referring only to itself, stubborn). On the other hand the product also shows an affinity [*Verwandtschaft*] *with the*

work of art, inasmuch as it is produced [*hervorgebracht*] by the hand of man. In spite of this, the work of art in its turn, by its self-sufficient presence [*in seinem selbstgenügsamen Anwesen*], resembles [*gleicht*] the thing pure and simple, referring only to itself [*eigenwüchsige*] and constrained to nothing [*zu nichts gedrängten*] [...]. Thus the product is half a thing, because determined by thingliness, and yet more than that, at the same time it is half work of art, and yet less than that

—so a work like the shoe picture *represents* half of itself and yet less than that

—and yet less than that, because it lacks the self-sufficiency of the work of art.

—so a work like the shoe-picture exhibits what something lacks in order to be a work, it exhibits—in shoes—its lack of itself, one could almost say its own lack. And that is how it's supposed to be self-sufficient? Accomplished? Does it complete itself then? Unless it overflows (itself), into inadequation, excess, the supplement?

—Heidegger continues. 'The product thus has its proper intermediate place [*Zwischenstellung*] *between* the thing and the work, always supposing that it is permissible to give in to such an accountant-like classification.'

What, to Heidegger's own eyes, limits the legitimacy of this arithmetical triplicity (the one by which Schapiro boldly sums up the whole context: 'in the course of distinguishing three modes of things ...'), is that if thing 2 (the product) is between thing 1 (naked, pure and simple thing) and thing 3 [the work of art], thus participating in both of them, the fact nonetheless remains that thing 3 is more like thing 1: also, further on, the picture will be presented as a thing and it will be allowed a privilege in the presentation made *in it* (in presence and self-sufficient) of thing 2 (shoes as product). These 'three' 'modes' do not entertain among themselves a relationship of distinction, as Schapiro thinks. (Tight interlacing, but one which can always be *analyzed,* untied up *to a certain point.* Like a lace, each 'thing,' each mode of being of the thing, passes inside then outside the other. From right to left, from left to right. We shall articulate this *strophe* of the lace: in its rewinding passing and repassing through the eyelet of the thing, from outside to inside, from inside to outside, on the external surface and *under* the internal surface (and vice versa when this surface is turned inside out like the top of the left-hand shoe), it remains the 'same' right through, between right and left, shows itself and disappears [*fort/da*] in its regular traversing of the eyelet, it makes the thing sure of its gathering, the underneath tied up on top, the inside bound on the outside, by a law of stricture. Hard and flexible at one and the same time). Thus the work, which is more like the thing pure and simple than a product is (shoes, for example), is *also* a product. The shoe picture is a product (of art) which is like a thing, presenting (and not representing, we shall come

to this) a product (shoes), etc.

The recourse to the 'famous picture' is in the first place justified by a question on the being-product and not on the work of art. The work of art as such will be talked about, it seems, only as if in passing and after the event. At the moment when Heidegger proposes to turn toward the picture, he is thus *not* interested in the work, but only in the being-product of which some shoes—any shoes—provide an example. If what matters to him and what he describes at this point are not shoes in painting, one cannot legitimately expect from him a description of the picture *for itself,* nor, in consequence, criticize its appositeness. So what is he up to and why does he insist so much on the being-product? He, too, has a suspicion, and a hypothesis: has not the thing pure and simple, thing 1, been secretly determined on the basis of thing 2, of the product *as* informed matter? Must we not try to think the being-product 'before,' 'outside,' 'under' this supervening determination? 'Thus it is that the interpretation of the thing in terms of matter and form, whether it remains medieval or becomes transcendental in the Kantian sense, has become current and self-evident. But this does not make it any less a superimposition fallen upon [*Überfall*] the being-thing of the thing, than the other interpretations. This situation reveals itself already in the fact of naming things properly speaking [*eigentlichen Dinge*] things pure and simple [*blosse Dinge*, naked things]. This 'naked' [*Das 'bloss'*] does however mean the stripping [*Entblössung*, the denuding which strips of -] away of the character of usefulness [*Dienlichkeit*] and of being made
—If I understand rightly: not the denuding of the foot, for example, but the denuding of the shoes that have become naked things again, without usefulness, stripped of their use-value? Presenting the shoes as things (1 or 3, without 2) would involve exhibiting a certain nudity, or even an obscenity
—obscenity, that's already laying it on a bit thick [*en remettre*], let's say nudity, yes. Heidegger goes on: 'and of being made. The naked thing [*blosse Ding*] is a sort of product [*Zeug*] but a product divested [*entkleidete*] of its being-as-product. Being-thing then consists in what still remains [*was noch übrigbleibt*]. But this remainder [*Rest*] is not properly [*eigens*] determined in itself. . . .'
—The remainder: these naked shoes, these things of uncertain use, returned to their abandonment as things for doing nothing.
—Perhaps saying that still involves thinking of them too much in terms of their use-value. In order to think this 'remainder' and 'properly' [*eigens*] otherwise, Heidegger then takes another step. He wants to interpret the being-product *without* or before the matter-form couple, convinced that this remainder will not be reached by subtraction of the 'product' but by opening up *another* road toward what is properly product in the product, toward the 'Zeughaften des Zeuges.'

The reference to van Gogh is inscribed in this movement, in whatever makes it very strictly singular. That said, *inside* this movement, Heidegger's gesture, with all the craftsmanlike subtlety of a cobbler with a short awl, going quickly from inside to outside, speaks *now of the picture, in it, now of something quite different, outside it.* In a first movement and most importantly, the question which provokes the reference to the picture in no way concerns a work of art. In a manner of speaking the primary motivation of the passage does not concern painting. And yet, through this lacing movement we were talking about (from inside to outside, from outside to inside, his iron point passing through the surface of the leather or the canvas in both directions, pricking and pointing [*par piqûre et pointure*]), the trajectory of the reference is divided and multiplied. In a way which is doubtless both wily and naïve, but following a necessity which Schapiro's lawsuit seems to me to overlook.

—is it a matter of rendering justice to Heidegger, of restituting what is his due, his truth, the possibility of his own gait and progress?

—This question comes a little too early. I'm only starting. […]

—I always get the impression that in commenting on Heidegger, in restituting him in an apparently very strict way, one makes him say something quite other, all the accents are changed, his language is no longer recognizable. The commentary becomes obscene and thinking otherwise becomes thinking otherwise than he, who wants to think the remainder 'properly.' Here, 'otherwise' would be otherwise than properly. But then what would be proper to this other?

—Let us rather return to the 'famous picture.' A product-thing, some shoes, is there as if represented (Heidegger will, moreover, say that it is not represented, re-produced, but let's leave these questions for the moment, we shall pick them up again). This 'product' has at least the following singular characteristics that we can point out immediately: It belongs to the genus 'clothing' (and is in this sense parergonal), and this is not the case with all products. It hints at a movement of return to the thing that is said, by metaphor or transference, to be 'naked': insofar as it is a useless product, not in current use, abandoned, unlaced, offered, as thing (1 and 3) and as product (thing 2) in a sort of idleness [*désoeuvrement*]. And yet, insofar as it is a usable product, and especially insofar as it is a product of the genus clothing, it is invested, inhabited, informed

—haunted

—by the 'form' of another naked thing from which it is (partially and provisionally?) detached

—'the *parergon* is detached …'

—and to which it seems to be waiting (seems to make us wait for it) to be reattached, reappropriated. It seems to be made to be retied. But the line of detachment (and thus of the out-of-use and the idleness alike) is

not only the one which goes around the shoes and thus gives them form, cuts them out. This first line is already a tracing of coming and going between the outside and the inside, notably when it follows the movement of the lace. It is therefore not simple, it has an internal border and an external border which is incessantly turned back in. But there is another line, another system of detaching *traits*: this is the work *qua* picture in its frame. The frame makes a work of supplementary *désoeuvrement*. It cuts out but also sews back together. By an invisible lace which pierces the canvas (as the *pointure* 'pierces the paper'), passes into it then out of it in order to sew it back onto its milieu, onto its internal and external worlds. From then on, if these shoes are no longer useful, it is of course because they are detached from naked feet and from their subject of reattachment (their owner, usual holder, the one who wears them and whom they bear). It is also because they are painted: within the limits of a picture, but limits that have to be thought in laces. Hors-d'oeuvre in the *oeuvre*, hors-d'oeuvre as *oeuvre:* the laces go through the eyelets (which also go in pairs) and pass on to the invisible side. And when they come back from it, do they emerge from the other side of the leather or the other side of the canvas? The prick of their iron point, through the metal-edged eyelets, pierces the leather and the canvas simultaneously. How can we distinguish the two textures of invisibility from each other? Piercing them with a single *pointure*

—So there'd be a *pointure* of the laces, in this other sense—

—piercing them with a single *pointure*

—does the *pointure* belong to the picture? I'm thinking of the points that nail the canvas onto the stretcher. When nails are painted (as they are by Klee in his *Constructif-impressionnant* of 1927), as figure on a ground, what is their place? To what system do they belong?

—the nails do not form part of the 'principal' figure, as the laces do. The functioning of their *pointure* requires another analysis—

—piercing them with a single *pointure*, the figure of the laces will have sewn the leather onto the canvas. If the two textures are traversed by a single doubled blow, then they are henceforth indiscernible. Everything is painted on leather, the canvas is both *shod* [*chaussée*] and unshod, etc. That is how it appears, at least, in this play of appearance/disappearance. [...]

—I'll sharpen up the question: to a peasant or a peasant woman? It's the limen of this debate, let's remain there a little longer: why does Heidegger sometimes say 'a pair of peasants' shoes [*ein Paar Bauernschuhe*] and nothing else [*und nichts weiter*],' without determination of sex or allowing the masculine to gain a footing thanks to this neutrality, and sometimes—more often, in fact—'the peasant woman' [*die Bäuerin*], when designating the 'subject'? He never explains himself on this point, and Schapiro, for his part, never pays the

slightest attention to it. To which sex are these shoes due? This is not exactly the same question as that posed earlier, when we were wondering whether or not there was a symbolic equivalence between the supposed 'symbol' 'shoe' and such-and-such a genital organ, or whether only a differential and idiomatic syntax could arrest bisexuality, confer on it some particular leading or dominant value, etc. Here it is not the same question and yet the attribution of shoes (in painting) to a subject-wearer (bearer)

—of shoes and of a sex

—a masculine or feminine sex, this attribution is not without its resonance with the first question. Let us not forget that *The Origin* deals with the essence of truth, the truth of essence and the abyss [*Abgrund*] which plays itself out there like the 'veiled' destiny [*fatum*] which transfixes being.

Graft of sex onto the shoes. This graft is not arrested by *The Origin*: sometimes the indeterminacy slips by force of language toward the masculine, sometimes the feminine wins out. There is *some* peasant (*liness*) and the peasant woman, but never a peasant man. For Schapiro, it comes down without any possible argument on the side of the masculine ('a man of the town and city'), Vincent van Gogh's sex being in no doubt for the signatory of the 'Still Life ...'

—It is true that neither Heidegger nor Schapiro seems to give thematic attention to the sex of reattachment. The one reattaches, prior to any examination of the question, to peasantry, but passes without warning from peasantry to the peasant woman. The other, having examined the question, reattaches to some city-dwelling painter, but never asks himself why they should be men's shoes nor why the other, not content with saying 'peasantry,' sometimes adds 'the peasant woman.' Sometimes, and even most often.

—But what is thematic attention? And does what it seems to exclude (the implicit? the foreclosed? the denied? the unthought? the encrypted? the 'incorporated'?—so many different functions) allow itself to be excluded from the field?

—From what field? Fenced by whom? By what? By peasantry or peasant-womanry? [...]

—All this aggravates Heidegger's referentialist, monoreferential naïveté. This must be emphasized with respect to a discourse on *The Origin of the Work of Art*. It can't not have some relationship with the whole undertaking. And yet:

a. Heidegger 'is well aware,' and Schapiro knows that he is well aware: 'Van Gogh painted such shoes more than once' [*solches Schuhzeug mehrmals gemalt hat*]. Why did he not take this into account? Is his error more serious or less serious for this? Has he arrived by induction at a sort of 'general picture,' retaining, by abstraction or subtraction, the common or supposedly common traits of a whole series? This hypo-

thesis—the least favorable—is ruled out by everything of Heidegger's one can read. He was always very severe on this conceptualism, which would here be doubled by an empiricist barbarity. So?

Heidegger's defence, mitigating circumstances: his 'intention' was not that of concentrating on a given painting of describing and interrogating its singularity as an art critic would do. So let's read once more the opening of this passage. It is indeed a question of 'simply describing' [*einfach beschreiben*] not a picture but 'a product,' 'without philosophical theory.' 'We choose as an example a common sort of product: a pair of peasants' shoes.' *Not yet a picture, not a work of art, but a product.* Let's go on. 'In order to describe them, we do not need to have in front of us real samples of useful objects of this type. Everyone is familiar with them. But since it is a matter here of an immediate description, it may be as well to facilitate intuitive presentation [*Veranschaulichung*]. By way of an accessory aid [*Für diese Nachhilfe*, omitted in the French (and English) translation], a pictorial representation [*bildliche Darstellung*] suffices. For this purpose we choose a famous picture by van Gogh who painted such shoes more than once.'

—It's clear, the picture is, *for the moment,* as a hypothesis, an intuitive accessory. One can reproach Heidegger for this illustrative procedure, but that would be a different matter from behaving as though he were trying to describe the picture for itself, and then, in this hypothesis which for the moment is not his, reproaching him for mistakes in the reading. *For the moment,* the object to be described, to be interpreted, is not the picture or even the object insofar as it is painted ([re]presented), but a familiar product well known to everyone. None of what follows concerns, or pretends to delimit, the pictorial specificity of the shoes or even their specificity insofar as they may be different from other shoes. With a picture in front of you to keep up attention and facilitate intuition, a picture of a pair of shoes, whatever pair it may be, peasants' shoes or not, painted or not, you could bring out the same features: the being-product, the usefulness, the belonging to the world and to the earth, in the very definite sense that Heidegger accords to these two words which do not interest Schapiro and to which we shall have to return. But in that case, you'll say, why choose a painting? Why explicate so heavily what stems from the problematical identification of these shoes as peasants' shoes? At the stage where we are at the moment, and Heidegger says so, some real shoes (peasants' or not) or shoes drawn vaguely in chalk on the blackboard would have rendered the same service. The blackboard would have sufficed.

—That's what Schapiro reproaches Heidegger with.

—But Heidegger says it ('But what more is there to see there? Everybody knows what belongs to shoes'), and you can only reproach him for it by assuming that he was *primarily* interested in a picture, that he was trying to analyze it as such, which is not the case. For the use to

which he wanted to put it at first, the various canvases were indeed interchangeable, with no harm done. If his attribution of the thing to peasantry is indeed (and we shall still have to examine to what point it is) imprudent and precipitate, we do at least know that he could have produced, for what mattered to the analysis of the being-product, the same discourse on town shoes: the relationship of the wearer to this strange product (very close to, and yet detachable from, his body), the relationship with walking, with work, with the ground, the earth, and the world. Everything that comes down to the 'peasant' world is in this respect an accessory variable even if it does come massively under 'projection' and answers to Heidegger's pathetic-fantasmatic-ideological-political investments.

b. The 'same truth,' that 'presented' by the picture, is not for Heidegger 'peasant' truth, a truth the essential content of which would depend on the attribution (however imprudent) of the shoes to peasantry. The 'peasant' characteristic remains secondary here. The 'same truth' could be 'presented' by any shoe painting, or even by any experience of shoes and even of any 'product' in general: the truth being that of a being-product coming back from 'further away' than the matter-form couple, further away even than a 'distinction between the two.' This truth is due to a 'more distant origin.' It is not the truth of a *relationship* (of adequation or attribution) between such-and-such a product and such-and-such an owner, user, holder, bearer/wearer-borne. The belonging of the product 'shoes' does not relate to a given *subjectum,* or even to a given world. What is said of belonging to the world and the earth is valid for the town and for the fields. Not indifferently, but equally.

Thus Schapiro is mistaken about the primary function of the pictorial reference. He also gets wrong a Heideggerian argument which should ruin in advance his own restitution of the shoes to van Gogh: art as 'putting to work of truth' is neither an 'imitation,' nor a 'description' copying the 'real,' nor a 'reproduction,' whether it represents a singular thing or a general essence. For the whole of Schapiro's case, on the other hand, calls on real shoes: the picture is supposed to imitate them, represent them, reproduce them. Their belonging has then to be determined as a belonging to a real or supposedly real subject, to an individual whose extremities, outside the picture, should not remain bare [*déchaussées*; also, 'loose' (of teeth)] for long.

—loose like old teeth. But he won't be able to avoid the bridge. He doesn't know that the shoe already forms a prosthesis. And perhaps the foot does too. It can always be someone else's. So many sayings pass through here to speak of the dislocation of the inadequate, like when one is '*à côté de ses pompes*' (literally, 'beside one's shoes (with fatigue)'), or the usurper's abuse: 'to be in someone's shoes.'[2] Thrown into the abyss, the sphynx, from the moment the turgidity

—Schapiro tightens the picture's laces around 'real' feet. I underline: *'They are clearly* pictures of the artist's *own* shoes, not the shoes of a peasant. . . . Later in Arles he *represented,* as he wrote in a letter of August 1888 to his brother, 'une paire de vieux souliers,' which are *evidently his own. . . .' They are*: the lace passes here, in the copula, it couples the painted shoes and the painter's feet. It is drawn out of the picture, which presupposes a hole in the canvas.

—And besides, did we have to wait for Heidegger before being on our guard? Before we could avoid considering a painted object as a copy? Worse, before we could avoid attributing it an adequate model (real shoes) and what's more attributing to this model an adequate subject (van Gogh), which makes two capitalized attributions? Then there is the word *evidently,* the word *clearly* which comes in again later, when a picture is identified in a catalog, the words *his own* which several times so calmly declare property, propositions of the type 'this is that' in which the copula ties a 'real' predicate to a 'painted' object. One is surprised that an expert should use all this dogmatic and precritical language. It all looks as though the hammering of the notions of self-evidence, clarity, and property was meant to resound very loudly to prevent us from hearing that nothing here is clear, or self-evident, or proper to anyone or anything whatsoever. And doubtless Schapiro knows this or says it to himself more or less clearly. But it is only at this price that he can have the shoes, acquire them with a view to a restitution, snatch them from the one to give them to the other. That other to whom he believes he is no stranger. To slip them on, then. On his own feet and on the other's feet. Like a garment or an object that one puts on [*qu'on se passe*]. The *se passer* of this thrust [*cette passe*] is also what the shoes in *restance* are doing. That's what's happening here.[3]

—I would distinguish three dogmas in Schapiro's credo, when he speculates in this way on the occasion of these old shoes. Three dogmas with structures that are distinct from one another but analogous in their functional finality. 1. Painted shoes can belong really and really be restituted to a real, identifiable, and nameable subject. This illusion is facilitated by the closest identification between the alleged holder of the shoes and the so-called signatory of the picture. 2. Shoes are shoes, be they painted or 'real,' solely and simply shoes which are what they are, adequate to themselves and in the first place fittable onto feet. Shoes belong properly. In their structure as replaceable product, in the standard nature of their size, in the detachability of this clothing-type instrument, they do not have what it would take to make all *strict* belonging and propriety drift. 3. Feet (painted, ghostly, or real) belong to a body proper. They are not detachable from it. These three assurances can't stand up to the slightest question. They are in any case immediately dismantled by what *happens* [*se passe*] by what *there is* in this painting.

—Although they bear on three distinct articulations, these three assurances tend to efface them in the interests of one and the same continuum. To reattach the detachables according to an absolute stricture.

—No more laces, what, no longer even a knot to be seen, or holes or eyelets, but full shoes, absolutely adherent to the foot.

—Like in Magritte's *Le Modèle rouge* [**63**]. But there, too, one must take into account an effect of series and citationality. Magritte painted several of them. There, not counting *La Philosophie dans le boudoir* (1947) [**64**], or *Le Puits de vérité* (1963) [**65**], there is incontestably a pair, you can see the disposition of the toes which form one and the same body with the boots. They form both the pair and the join.

—*Le Modèle rouge* also mimics this lure and mocks it. It also cuts off the shoe-foot at the ankle, at the neck, indicating by this trait or stroke, added to the horizontal and regular lines of the wooden background, then added to the lines of the frame, that this pair of rising-sided (rising toward what?) shoes, now out of use, with empty unlaced neck

64 René Magritte

Philosophy in the Boudoir,
(La Philosophie dans le
boudoir), 1947

(unlaced differently from one model to another), then summoning van Gogh's witnesses to appear, are still deferring their supplement of property, the revenue on their usury [*usure:* also 'wear']. Their silence makes the expert speak, and he will not take long to say, like Heidegger speaking of van Gogh's picture: 'it has spoken.' Two psychoanalysts—from London, of course, that sort of thing would never get across the English Channel—said to Magritte: '*The Red Model* is a case of castration.' The painter then sent them 'a real psycho-analytical drawing' which inspired the same discourse from them.

—But why so cutting in this verdict against Schapiro? If he were so credulous in the identification of this picture

—I haven't demonstrated that yet, I've stuck to the general premises. Later, with respect to this picture

—All right, let's say credulous in the attribution, in general, of painted

shoes to a determinable subject and, which is indeed more serious, to one that is determinable *in reality:* isn't Heidegger's naïveté still more massive! He also attributes the painted shoes, without the slightest examination, to peasantry, or even to the peasant woman. This attribution appears to be incompatible with what he says further on against imitation, copy, representative reproduction, etc., against the notion of adequation or *homoiosis.* For example: 'Or else would the proposition according to which art is the putting-itself-to-work of truth give new life to a fortunately outdated opinion according to which art is an imitation or a descriptive copy of the real? The replica of the given doubtless demands conformity with being, a regulated measuring against it; *adaequatio,* say the Middle Ages, ὁμοíωσιϛ said Aristotle already. For a long time, conformity with being has been considered to be equivalent to the essence of truth. But do we really believe that this picture by van Gogh copies [*male ab,* depicta] a given [present, *vorhandenes*] pair of peasants' shoes, and that it is a work because it has succeeded in doing so? Do we wish to say that the picture has taken a copy of the real and that it has transformed the real into a product [*Produkt*] of artistic production? Nowise.' This reply ['Nowise'] also holds, in the next paragraph, for the reproduction of a general essence which some tried to substitute for the singular given, keeping the same schema. Now I understand well enough how that hits Schapiro's preoccupations and disqualifies his assurances (Schapiro who seems to believe in the reproduction of 'given' shoes, those of van Gogh and even of a 'given' van Gogh, in a given time and place, 'by that time a man of the town and city'!), and I also understand well enough how the proof itself is in this case *a priori* irrelevant. But what I do not understand is why Heidegger should escape from the same suspicion, from his own suspicion basically, from the moment he says, without proof this time, without even looking for a proof: they are peasants' shoes. He does not even say *they are* in order to reply to a possible question, he names

65 René Magritte

The Well of Truth,
(Le Puits de vérité), 1963

them, '*Ein Paar Bauernschuhe*,' without even imagining the first murmur of a question.

—That's the whole dissymmetry, the innocent outbidding of this correspondence. One claim is more naïve, more excessive, if one can say that, than the other. One attribution exceeds the other. Imagine an auctioneer who is both an expert and a buyer, pushing up the bidding in the empty room. Bidding for second-hand, more or less unmatched shoes on a framed canvas. On the one hand, Schapiro's attribution remains in the aesthetics of representation, and even of the most empiricist kind: either short of (precritical), or going beyond (excessive), the movement carried out by *The Origin* in the passage just translated. But on his side, by saying '*Bauernschuhe*' without asking himself any questions about this, Heidegger falls short of his discourse on the truth in painting, and is even more naïve than Schapiro. Excessive to the extent of talking about peasants' shoes even before any question of 'representation,' and already in the order of a 'presentative' truth. The fact is that the step backwards from a truth of adequation to a truth of unveiling, whatever its necessity and its 'critical' force, can also leave one practically disarmed in the face of the ingenuous, the precritical, the dogmatic, in the face of any 'preinvestment' (be it 'fantasmatic,' 'ideological,' etc., or whatever name you call it). There's a law here. This is perhaps one of the secrets of this correspondence, of its dissymmetry or its excessive symmetry: in the contract of truth ('I owe you the truth in painting'), between truth as adequation (of a representation, here an attributive one, on Schapiro's side) and the truth of unveiled presence (Heidegger's side). For the moment let us leave this truth contract, between the two truths. (What is *doing* the *contracting* there has to do with *a trait* [*Riss*] and an attraction [*attrait*] [*Zug*] of the work, with a *Gezüge*, which will draw us much further into Heidegger's text.) The truth of the shoes as things due (the object of the subject) constrains this correspondence and we ought (supposing one ever has to ought) to reexamine its terms later. One of the innumerable difficulties in reading *The Origin* and especially this passage, is that of grasping the furtive moment when a certain line is crossed, and of grasping too the step with which it is crossed.

—In the sense of *über die Linie* [*trans lineam* or *de linear*] and of the topology of being in *Zur Seinsfragel*

—No. Well, yes. But this connection passes through detours we don't have time for here. Or space. I was simply designating, close at hand here, the crossing of certain lines, of certain *traits* in the picture (the outline of the 'product,' for example the line of the collar or the line of the lace). And above all, first of all, the crossing of the lines of framing, the *traits* which detach the picture from the real milieu. Where, at what moment, in what direction [*sens*] does this transgression take place? And is this crossing a transgression? Transgression of what law?

Which comes down to wondering notably whether and within what limits Heidegger intended to speak of the 'famous picture.'

—Which one?

—We don't know yet. We have verified that at the precise moment when in this chapter he takes the example of a pair of peasants' shoes, no picture has yet been necessary. None has even been invoked. And it's been going on like that for several pages. Now even at the moment when the 'famous picture' provides what is basically an example of an example, its status leaves us in a definitive uncertainty. We can always say, challenging proof to be produced, that Heidegger does not intend to speak of the picture, does not describe it *as such*, and passes regularly from an example of a product (peasants' shoes) to the example of the example (some particular shoes in some particular picture), in both directions, then from exemplarity to the being-product, picking out the predicates of the being-product and letting the others drop

—like old shoes

9

The Other: Art History and/ as Museology

Introduction

Trying to leave a museum behind when one walks out of the door may be like trying to exit a labyrinth similar to the one described by Derrida as including in itself its own exits.[1]

The existence of museums has been essential to the fabrication and maintenance of the modern world. This is a point complementary to that made by Timothy Mitchell in his essay (below), 'Orientalism and the Exhibitionary Order', which, in its discussion of nineteenth-century Parisian expositions and the astonished reactions to them by Egyptians and other non-European visitors, highlights the specificities of the modern European penchant for transforming the world into a representation: an *exhibition*. European modernity—in Heidegger's phrase the 'age of the world picture' (i.e. the world-as-exhibition)[2]—is also a labyrinth of the kind just mentioned, where the exits to an exposition, fair, theme park, theatre, or museum seem to lead immediately into more of the same.

This obsession with 'the organization of the view' (*intizam al-manzar*) as the visitors characterized European behaviour both at home and as tourists everywhere in the world, entailed understanding the world as a system of objects whose very organization evoked some larger meaning or reality (Empire, Progress, the Spirit of a People, and so on). Such a world demanded to be understood in terms of palpable distinctions between objects 'in themselves' and their 'meanings'— representation in terms of what Heidegger called *dis-position*[3]—and was compatible with an ethical view of the individual as itself represented *in and as* his or her works.

To inhabit such a world would be to live one's life as a tourist or anthropologist, in a dualistic universe characterised by distinctions between objects and meanings, 'representations' and the (ever elusive) 'realities' they portray.

Which brings us back both to Hegel and his History of Art as the account of the unfolding of Spirit whose trace is legible in art objects, and to the museological or exhibitionary order which is the subject of the provocative readings making up this chapter. The central point of Mitchell's essay is that 'orientalism' was (or is) not just a nineteenth-

century instance of a general problem of how one culture (Europe) portrays another (the cultures of Arabic- or Turkish-speaking Muslims from Morocco to Saudia Arabia), nor is it merely an aspect of colonial domination.

He argues that orientalism is more than the (presumably alterable) *content* of a policy, but is rather a central and essential part of the *cognitive methods of order and truth* constituting European modernity itself. Orientalism in Mitchell's view would thus be part and parcel of a more fundamental cognitive organization of the modern European and eurocentric world *as* an 'exhibitionary order'. Such a world is driven by a desire to possess 'realities' behind their 'representations': a desire that is forever unsatisfied.

Mitchell's arguments resonate to some extent with those of Derrida in a famous critique of Saussurian linguistic semiology, summarized in an interview with Julia Kristeva in 1968.[4] Derrida argued that Saussure's maintenance, despite their inseparability, of a rigorous distinction between signifier and signified, allowed for the construal of signifieds as concepts which were somehow autonomous, and with an independent existence, apart from the signifiers or forms used to 'express' them.

The following essay, by Carol Duncan ('The Art Museum as Ritual') stresses the performative and ceremonial aspects of museum architecture, spatial organization, display, and the roles performed by viewers and users in these civic rituals. She articulates the spiritual dimension underlying museological practices, and provides a compelling account of the ways in which these practices are centrally invested in fabricating and sustaining dominant social ideologies. Duncan argues that the invention of aesthetics represented a transference of spiritual values from the sacred to the secular realm. The invention of the modern museum is an institutional corollary of this philosophical transference in which art objects were invested with transformative spiritual, ethical, and emotional power.

The last two texts, by Annie Coombes and Néstor García Canclini, address problems inherent in questioning and disrupting the perceived boundaries of the West and its Other(s) in museology and art history. Coombes's essay ('Inventing the "Postcolonial": Hybridity and Constituency in Contemporary Curating') argues that, under a banner of 'multiculturalism', the replacement of traditional European fine-art objects by hybrid objects often achieves little or no effectively substantive disruption of hegemonic museological practices, and often glosses over the specificity of experience informing such objects.

Focusing upon recent exhibitions in which culturally 'hybrid' or 'transcultural' objects play central roles in representing a new 'postcolonial' awareness, she concludes that the most successful exhibits have been those which turn an ironic and self-critical eye on the view-

ing subject, as well as on the museological processes of othering. The concept of aesthetic hybridity, however, has been a double-edged sword. While it has suggested an effective strategy in the contemporary political project of decolonization, it has also had a long negative history within art history and anthropology, having been in the late nineteenth century a key component of xenophobic racialist theories, particularly in supporting hypotheses of cultural and racial 'degeneration' due to miscegenation.

Coombes raises points that reflect back on the discussions and readings in our previous chapters. She notes that the uncritical celebration of hybridity in contemporary museum culture may be having an effect opposite to what might have been intended by curators and art historians, in that it 'threatens to collapse the heterogeneous experience of racism into a scopic feast where the goods on display are laid out for easy consumption in ever more enticing configurations'. These, she argues, fail to challenge or expose the ways in which 'such difference is constituted and operates as a mechanism of oppression'.

In examining several recent exhibitions which attempted to redress the primitivist or miscegenist ideologies of earlier museum practices, she reminds us of a very important aspect of museum history which in fact has seriously complicated much of the contemporary debate on postcolonial practices and the critiques of racism. This is the paradoxical situation which arose during the nineteenth century whereby the extensive new public visibility in European art and ethnographic museums of cultural artefacts from many societies provided *at the same time* material for the disinterested systematic comparative investigation of culture, *and* fodder for palpable 'evidence' of racial superiorities and inferiorities (and thereby a justification for colonialism), *and* the reduction of alien artefacts to objects of exotic aesthetic pleasure, divorced from the specificities of their historical and social purposes, functions, and meanings.

The importance of this cannot be overestimated, for it goes to the heart of many of the historical practices of art history and museology examined above. Not least of these was the universalist impulse in making visible the objects of all cultures and races in what was taken to be neutral discursive or architectural spaces founded upon the rhetoric of equal access and scientific objectivity. This impulse was clearly present in the public educational 'museum movement' in the second half of the nineteenth century, when the institution was heralded as a common, democratic territory neutral enough to offer equal access to all classes, thereby serving as an objective or scientific instrument transcending ethnic and national boundaries.

As we have seen (and see also my essay below), this double-edged universalism had very deep roots in the Enlightenment project of commensurability. For Coombes, what is most deeply at stake today is

whether the contemporary appraisal of non-Western material culture can effectively expose those power relations built into the institutions of exhibition and display that have hitherto not been critically engaged in debates on multiculturalism. As she astutely suggests, art historical and museological issues cannot effectively be addressed in isolation from the histories of consumerism, tourism, and the modern heritage industries.

Néstor García Canclini's 'Remaking Passports: Visual Thought in the Debate on Multiculturalism' addresses issues that resonate with those raised by Coombes. He deals with the pretension of constructing national cultures and 'representing' them by specific iconographies, arguing that these have been substantially challenged in recent times by an ongoing process of economic and symbolic transnationalization. Canclini's essay makes clear the degree to which the discipline of art history was historically tied to the identity politics of nation, race, class, and ethnicity.

Such disciplinary links or groundings problematize attempts to articulate transnational, hybrid, and multicultural practices using conventional disciplinary methods and theories. But it is not only the future of a professional discipline that is at stake in the contemporary discussions, debates, and negotiations about 'art' and its 'histories' represented in this chapter. Nor is it only the future viability of the institutional artefact, the art of art history, that is at stake. Rather, it may be nothing less than the shape of the future of the subject itself.

Orientalism and the Exhibitionary Order

It is no longer unusual to suggest that the construction of the colonial order is related to the elaboration of modern forms of representation and knowledge. The relationship has been most closely examined in the critique of Orientalism. The Western artistic and scholarly portrayal of the non-West, in Edward Said's analysis, is not merely an ideological distortion convenient to an emergent global political order but a densely imbricated arrangement of imagery and expertise that organizes and produces the Orient as a political reality.[1] Three features define this Orientalist reality: it is understood as the product of unchanging racial or cultural essences; these essential characteristics are in each case the polar opposite of the West (passive rather than active, static rather than mobile, emotional rather than rational, chaotic rather than ordered); and the Oriental opposite or Other is, therefore, marked by a series of fundamental absences (of movement, reason, order, meaning, and so on). In terms of these three features—essentialism, otherness, and absence—the colonial world can be mastered, and colonial mastery will, in turn, reinscribe and reinforce these defining features.

Orientalism, however, has always been part of something larger. The nineteenth-century image of the Orient was constructed not just in Oriental studies, romantic novels, and colonial administrations, but in all the new procedures with which Europeans began to organize the representation of the world, from museums and world exhibitions to architecture, schooling, tourism, the fashion industry, and the commodification of everyday life. In 1889, to give an indication of the scale of these processes, 32 million people visited the Exposition Universelle, built that year in Paris to commemorate the centenary of the Revolution and to demonstrate French commercial and imperial power.[2] The consolidation of the global hegemony of the West, economically and politically, can be connected not just to the imagery of Orientalism but to all the new machinery for rendering up and laying out the meaning of the world, so characteristic of the imperial age.

The new apparatus of representation, particularly the world exhibitions, gave a central place to the representation of the non-Western world, and several studies have pointed out the importance of this

construction of otherness to the manufacture of national identity and imperial purpose.[3] But is there, perhaps, some more integral relationship between representation, as a modern technique of meaning and order, and the construction of otherness so important to the colonial project? One perspective from which to explore this question is provided by the accounts of non-Western visitors to nineteenth-century Europe. An Egyptian delegation to the Eighth International Congress of Orientalists, for example, held in Stockholm in the summer of 1889, traveled to Sweden via Paris and paused there to visit the Exposition Universelle, leaving us a detailed description of their encounter with the representation of their own otherness. Beginning with this and other accounts written by visitors from the Middle East, I examine the distinctiveness of the modern representational order exemplified by the world exhibition. What Arab writers found in the West, I will argue, were not just exhibitions and representations of the world, but the world itself being ordered up as an endless exhibition. This world-as-exhibition was a place where the artificial, the model, and the plan were employed to generate an unprecedented effect of order and certainty. It is not the artificiality of the exhibitionary order that matters, however, so much as the contrasting effect of an external reality that the artificial and the model create—a reality characterized, like Orientalism's Orient, by essentialism, otherness, and absence. In the second half of the article, I examine this connection between the world-as-exhibition and Orientalism, through a rereading of European travel accounts of the nineteenth-century Middle East. The features of the kind of Orient these writings construct—above all its characteristic absences—are not merely motifs convenient to colonial mastery, I argue, but necessary elements of the order of representation itself.

La rue du Caire

The four members of the Egyptian delegation to the Stockholm Orientalist conference spent several days in Paris, climbing twice the height (as they were told) of the Great Pyramid in Alexandre Eiffel's new tower, and exploring the city and exhibition laid out beneath. Only one thing disturbed them. The Egyptian exhibit had been built by the French to represent a street in medieval Cairo, made of houses with overhanging upper stories and a mosque like that of Qaitbay. 'It was intended,' one of the Egyptians wrote, 'to resemble the old aspect of Cairo.' So carefully was this done, he noted, that 'even the paint on the buildings was made dirty.'[4] The exhibit had also been made carefully chaotic. In contrast to the geometric layout of the rest of the exhibition, the imitation street was arranged in the haphazard manner of the bazaar. The way was crowded with shops and stalls, where Frenchmen, dressed as Orientals, sold perfumes, pastries, and

tarbushes. To complete the effect of the Orient, the French organizers had imported from Cairo fifty Egyptian donkeys, together with their drivers and the requisite number of grooms, farriers, and saddlers. The donkeys gave rides (for the price of one franc) up and down the street, resulting in a clamor and confusion so lifelike, the director of the exhibition was obliged to issue an order restricting the donkeys to a certain number at each hour of the day. The Egyptian visitors were disgusted by all this and stayed away. Their final embarrassment had been to enter the door of the mosque and discover that, like the rest of the street, it had been erected as what the Europeans called a facade. 'Its external form was all that there was of the mosque. As for the interior, it had been set up as a coffee house, where Egyptian girls performed dances with young males, and dervishes whirled.'5

After eighteen days in Paris, the Egyptian delegation traveled on to Stockholm to attend the Congress of Orientalists. Together with other non-European delegates, the Egyptians were received with hospitality —and a great curiosity. As though they were still in Paris, they found themselves something of an exhibit. 'Bona fide Orientals,' wrote a European participant in the Congress, 'were stared at as in a Barnum's all-world show: the good Scandinavian people seemed to think that it was a collection of Orientals, not of Orientalists.'6 Some of the Orientalists themselves seemed to delight in the role of showmen. At an earlier congress, in Berlin, we are told that 'the grotesque idea was started of producing natives of Oriental countries as illustrations of a paper: thus the Boden Professor of Sanskrit at Oxford produced a real live Indian Pandit, and made him go through the ritual of Brahmanical prayer and worship before a hilarious assembly. . . . Professor Max Müller of Oxford produced two rival Japanese priests, who exhibited their gifts; it had the appearance of two showmen exhibiting their monkeys.'7 At the Stockholm Congress, the Egyptians were invited to participate as scholars, but when they used their own language to do so they again found themselves treated as exhibits. 'I have heard nothing so unworthy of a sensible man,' complained an Oxford scholar, 'as … the whistling howls emitted by an Arabic student of El-Azhar of Cairo. Such exhibitions at Congresses are mischievous and degrading.'8

The exhibition and the congress were not the only examples of this European mischief. As Europe consolidated its colonial power, non-European visitors found themselves continually being placed on exhibit or made the careful object of European curiosity. The degradation they were made to suffer seemed as necessary to these spectacles as the scaffolded facades or the curious crowds of onlookers. The facades, the onlookers, and the degradation seemed all to belong to the organizing of an exhibit, to a particularly European concern with rendering the world up to be viewed. Of what, exactly, did this exhibitionary process consist?

An Object-World

To begin with, Middle Eastern visitors found Europeans a curious people, with an uncontainable eagerness to stand and stare. 'One of the characteristics of the French is to stare and get excited at everything new,' wrote an Egyptian scholar who spent five years in Paris in the 1820s, in the first description of nineteenth-century Europe to be published in Arabic.[9] The 'curiosity' of the European is encountered in almost every subsequent Middle Eastern account. Toward the end of the nineteenth century, when one or two Egyptian writers adopted the realistic style of the novel and made the journey to Europe their first topic, their stories would often evoke the peculiar experience of the West by describing an individual surrounded and stared at, like an object on exhibit. 'Whenever he paused outside a shop or showroom,' the protagonist in one such story found on his first day in Paris, 'a large number of people would surround him, both men and women, staring at his dress and appearance.'[10]

In the second place, this curious attitude that is described in Arabic accounts was connected with what one might call a corresponding *objectness*. The curiosity of the observing subject was something demanded by a diversity of mechanisms for rendering things up as its object—beginning with the Middle Eastern visitor himself. The members of an Egyptian student mission sent to Paris in the 1820s were confined to the college where they lived and allowed out only to visit museums and the theater—where they found themselves parodied in vaudeville as objects of entertainment for the French public.[11] 'They construct the stage as the play demands,' explained one of the students. 'For example, if they want to imitate a sultan and the things that happen to him, they set up the stage in the form of a palace and portray him in person. If for instance they want to play the Shah of Persia, they dress someone in the clothes of the Persian monarch and then put him there and sit him on a throne.'[12] Even Middle Eastern monarchs who came in person to Europe were liable to be incorporated into its theatrical machinery. When the Khedive of Egypt visited Paris to attend the Exposition Universelle of 1867, he found that the Egyptian exhibit had been built to simulate medieval Cairo in the form of a royal palace. The Khedive stayed in the imitation palace during his visit and became a part of the exhibition, receiving visitors with medieval hospitality.[13]

Visitors to Europe found not only themselves rendered up as objects to be viewed. The Arabic account of the student mission to Paris devoted several pages to the Parisian phenomenon of '*le spectacle*,' a word for which its author knew of no Arabic equivalent. Besides the Opéra and the Opéra-Comique, among the different kinds of spectacle he described were 'places in which they represent for the person the view of a town or a country or the like,' such as 'the Panorama, the

Cosmorama, the Diorama, the Europorama and the Uranorama.' In a panorama of Cairo, he explained in illustration, 'it is as though you were looking from on top of the minaret of Sultan Hasan, for example, with al-Rumaila and the rest of the city beneath you.'[14]

The effect of such spectacles was to set the world up as a picture. They ordered it up as an object on display to be investigated and experienced by the dominating European gaze. An Orientalist of the same period, the great French scholar Sylvestre de Sacy, wanted the scholarly picturing of the Orient to make available to European inspection a similar kind of object-world. He had planned to establish a museum, which was to be

> a vast depot of objects of all kinds, of drawings, of original books, maps, accounts of voyages, all offered to those who wish to give themselves to the study of [the Orient]; in such a way that each of these students would be able to feel himself transported as if by enchantment into the midst of, say, a Mongolian tribe or of the Chinese race, whichever he might have made the object of his studies.[15]

As part of a more ambitious plan in England for 'the education of the people,' a proposal was made to set up 'an ethnological institution, with very extensive grounds' where 'within the same enclosure' were to be kept 'specimens in pairs of the various races.' The natives on exhibit, it was said,

> should construct their own dwellings according to the architectural ideas of their several countries; their ... mode of life should be their own. The forms of industry prevalent in their nation or tribe they should be required to practise; and their ideas, opinions, habits, and superstitions should be permitted to perpetuate themselves.... To go from one division of this establishment to another would be like travelling into a new country.[16]

The world exhibitions of the second half of the century offered the visitor exactly this educational encounter, with natives and their artifacts arranged to provide the direct experience of a colonized object-world. In planning the layout of the 1889 Paris Exhibition, it was decided that the visitor 'before entering the temple of modern life' should pass through an exhibit of all human history, 'as a gateway to the exposition and a noble preface.' Entitled 'Histoire du Travail,' or, more fully, 'Exposition retrospective du travail et des sciences anthropologiques,' the display would demonstrate the history of human labor by means of 'objects and things themselves.' It would have 'nothing vague about it,' it was said, 'because it will consist of an *object lesson*.'[17]

Arabic accounts of the modern West became accounts of these curious object-worlds. By the last decade of the nineteenth century, more than half the descriptions of journeys to Europe published in Cairo were written to describe visits to a world exhibition or an international

congress of Orientalists.[18] Such accounts devote hundreds of pages to describing the peculiar order and technique of these events—the curious crowds of spectators, the organization of panoramas and perspectives, the arrangement of natives in mock colonial villages, the display of new inventions and commodities, the architecture of iron and glass, the systems of classification, the calculations of statistics, the lectures, the plans, and the guide books—in short, the entire method of organization that we think of as representation.

The World-as-Exhibition

In the third place, then, the effect of objectness was a matter not just of visual arrangement around a curious spectator, but of representation. What reduced the world to a system of objects was the way their careful organization enabled them to evoke some larger meaning, such as History or Empire or Progress. This machinery of representation was not confined to the exhibition and the congress. Almost everywhere that Middle Eastern visitors went they seemed to encounter the arrangement of things to stand for something larger. They visited the new museums, and saw the cultures of the world portrayed in the form of objects arranged under glass, in the order of their evolution. They were taken to the theater, a place where Europeans represented to themselves their history, as several Egyptian writers explained. They spent afternoons in the public gardens, carefully organized 'to bring together the trees and plants of every part of the world,' as another Arab writer put it. And, inevitably, they took trips to the zoo, a product of nineteenth-century colonial penetration of the Orient, as Theodor Adorno wrote, that 'paid symbolic tribute in the form of animals.'[19]

The Europe one reads about in Arabic accounts was a place of spectacle and visual arrangement, of the organization of everything and everything organized to represent, to recall, like the exhibition, a larger meaning. Characteristic of the way Europeans seemed to live was their preoccupation with what an Egyptian author described as '*intizam al-manzar*,' the organization of the view.[20] Beyond the exhibition and the congress, beyond the museum and the zoo, everywhere that non-European visitors went—the streets of the modern city with their meaningful facades, the countryside encountered typically in the form of a model farm exhibiting new machinery and cultivation methods, even the Alps once the funicular was built—they found the technique and sensation to be the same.[21] Everything seemed to be set up before one as though it were the model or the picture of something. Everything was arranged before an observing subject into a system of signification, declaring itself to be a mere object, a mere 'signifier of' something further.

The exhibition, therefore, could be read in such accounts as epitomizing the strange character of the West, a place where one was

continually pressed into service as a spectator by a world ordered so as to represent. In exhibitions, the traveler from the Middle East could describe the curious way of addressing the world increasingly encountered in modern Europe, a particular relationship between the individual and a world of 'objects' that Europeans seemed to take as the experience of the real. This reality effect was a world increasingly rendered up to the individual according to the way in which, and to the extent to which, it could be made to stand before him or her as an exhibit. Non-Europeans encountered in Europe what one might call, echoing a phrase from Heidegger, the age of the world exhibition, or rather, the age of the world-as-exhibition.[22] The world-as-exhibition means not an exhibition of the world but the world organized and grasped as though it were an exhibition.

The Certainty of Representation

'England is at present the greatest Oriental Empire which the world has ever known,' proclaimed the president of the 1892 Orientalist Congress at its opening session. His words reflected the political certainty of the imperial age. 'She knows not only how to conquer, but how to rule.'[23] The endless spectacles of the world-as-exhibition were not just reflections of this certainty but the means of its production, by their technique of rendering imperial truth and cultural difference in 'objective' form.

Three aspects of this kind of certainty can be illustrated from the accounts of the world exhibition. First there was the apparent realism of the representation. The model or display always seemed to stand in perfect correspondence to the external world, a correspondence that was frequently noted in Middle Eastern accounts. As the Egyptian visitor had remarked, 'Even the paint on the buildings was made dirty.' One of the most impressive exhibits at the 1889 exhibition in Paris was a panorama of the city. As described by an Arab visitor, this consisted of a viewing platform on which one stood, encircled by images of the city. The images were mounted and illuminated in such a way that the observer felt himself standing at the center of the city itself, which seemed to materialize around him as a single, solid object 'not differing from reality in any way.'[24]

In the second place, the model, however realistic, always remained distinguishable from the reality it claimed to represent. Even though the paint was made dirty and the donkeys were brought from Cairo, the medieval Egyptian street at the Paris exhibition remained only a Parisian copy of the Oriental original. The certainty of representation depended on this deliberate difference in time and displacement in space that separated the representation from the real thing. It also depended on the position of the visitor—the tourist in the imitation street or the figure on the viewing platform. The representation of

reality was always an exhibit set up for an observer in its midst, an observing European gaze surrounded by and yet excluded from the exhibition's careful order. The more the exhibit drew in and encircled the visitor, the more the gaze was set apart from it, as the mind (in our Cartesian imagery) is said to be set apart from the material world it observes. The separation is suggested in a description of the Egyptian exhibit at the Paris Exhibition of 1867.

A museum inside a pharaonic temple represented Antiquity, a palace richly decorated in the Arab style represented the Middle Ages, a caravanserai of merchants and performers portrayed in real life the customs of today. Weapons from the Sudan, the skins of wild monsters, perfumes, poisons and medicinal plants transport us directly to the tropics. Pottery from Assiut and Aswan, filigree and cloth of silk and gold invite us to touch with our fingers a strange civilization. All the races subject to the Vice-Roy were personified by individuals selected with care. We rubbed shoulders with the fellah, we made way before the Bedouin of the Libyan desert on their beautiful white dromedaries. This sumptuous display spoke to the mind as to the eyes; it expressed a political idea.[25]

The remarkable realism of such displays made the Orient into an object the visitor could almost touch. Yet to the observing eye, surrounded by the display but excluded from it by the status of visitor, it remained a mere representation, the picture of some further reality. Thus, two parallel pairs of distinctions were maintained, between the visitor and the exhibit and between the exhibit and what it expressed. The representation seemed set apart from the political reality it claimed to portray as the observing mind seems set apart from what it observes.

Third, the distinction between the system of exhibits or representations and the exterior meaning they portrayed was imitated, within the exhibition, by distinguishing between the exhibits themselves and the plan of the exhibition. The visitor would encounter, set apart from the objects on display, an abundance of catalogs, plans, sign posts, programs, guidebooks, instructions, educational talks, and compilations of statistics. The Egyptian exhibit at the 1867 exhibition, for example, was accompanied by a guidebook containing an outline of the country's history—divided, like the exhibit to which it referred, into the ancient, medieval, and modern—together with a 'notice statistique sur le territoire, la population, les forces productives, le commerce, l'effective militaire et naval, l'organisation financière, l'instruction publique, etc. de l'Egypte' compiled by the Commission Impériale in Paris.[26] To provide such outlines, guides, tables, and plans, which were essential to the educational aspect of the exhibition, involved processes of representation that are no different from those at work in the construction of the exhibits themselves. But the practical distinction that was main-

tained between the exhibit and the plan, between the objects and their catalog, reinforced the effect of two distinct orders of being—the order of things and the order of their meaning, of representation and reality.

Despite the careful ways in which it was constructed, however, there was something paradoxical about this distinction between the simulated and the real, and about the certainty that depends on it. In Paris, it was not always easy to tell where the exhibition ended and the world itself began. The boundaries of the exhibition were clearly marked, of course, with high perimeter walls and monumental gates. But, as Middle Eastern visitors had continually discovered, there was much about the organization of the 'real world' outside, with its museums and department stores, its street facades and Alpine scenes, that resembled the world exhibition. Despite the determined efforts to isolate the exhibition as merely an artificial representation of a reality outside, the real world beyond the gates turned out to be more and more like an extension of the exhibition. Yet this extended exhibition continued to present itself as a series of mere representations, representing a reality beyond. We should think of it, therefore, not so much as an exhibition but as a kind of labyrinth, the labyrinth that, as Derrida says, includes in itself its own exits.[27] But then, maybe the exhibitions whose exits led only to further exhibitions were becoming at once so realistic and so extensive that no one ever realized that the real world they promised was not there.

The Labyrinth without Exits

To see the uncertainty of what seemed, at first, the clear distinction between the simulated and the real, one can begin again inside the world exhibition, back at the Egyptian bazaar. Part of the shock of the Egyptians came from just how real the street claimed to be: not simply that the paint was made dirty, that the donkeys were from Cairo, and that the Egyptian pastries on sale were said to taste like the real thing, but that one paid for them with what we call '*real* money.' The commercialism of the donkey rides, the bazaar stalls, and the dancing girls seemed no different from the commercialism of the world outside. With so disorienting an experience as entering the facade of a mosque to find oneself inside an Oriental cafe that served real customers what seemed to be real coffee, where, exactly, lay the line between the artificial and the real, the representation and the reality?

Exhibitions were coming to resemble the commercial machinery of the rest of the city. This machinery, in turn, was rapidly changing in places such as London and Paris, to imitate the architecture and technique of the exhibition. Small, individually owned shops, often based on local crafts, were giving way to the larger apparatus of shopping arcades and department stores. According to the *Illustrated Guide to Paris* (a book supplying, like an exhibition program, the plan and

meaning of the place), each of these new establishments formed 'a city, indeed a world in miniature.'[28] The Egyptian accounts of Europe contain several descriptions of these commercial worlds-in-miniature, where the real world, as at the exhibition, was something organized by the representation of its commodities. The department stores were described as 'large and well organized,' with their merchandise 'arranged in perfect order, set in rows on shelves with everything symmetrical and precisely positioned.' Non-European visitors would remark especially on the panes of glass, inside the stores and along the gas-lit arcades. 'The merchandise is all arranged behind sheets of clear glass, in the most remarkable order. . . . Its dazzling appearance draws thousands of onlookers.'[29] The glass panels inserted themselves between the visitors and the goods on display, setting up the former as mere onlookers and endowing the goods with the distance that is the source, one might say, of their objectness. Just as exhibitions had become commercialized, the machinery of commerce was becoming a further means of engineering the real, indistinguishable from that of the exhibition.

Something of the experience of the strangely ordered world of modern commerce and consumers is indicated in the first fictional account of Europe to be published in Arabic. Appearing in 1882, it tells the story of two Egyptians who travel to France and England in the company of an English Orientalist. On their first day in Paris, the two Egyptians wander accidentally into the vast, gas-lit premises of a wholesale supplier. Inside the building they find long corridors, each leading into another. They walk from one corridor to the next, and after a while begin to search for the way out. Turning a corner they see what looks like an exit, with people approaching from the other side. But it turns out to be a mirror, which covers the entire width and height of the wall, and the people approaching are merely their own reflections. They turn down another passage and then another, but each one ends only in a mirror. As they make their way through the corridors of the building, they pass groups of people at work. 'The people were busy setting out merchandise, sorting it and putting it into boxes and cases. They stared at the two of them in silence as they passed, standing quite still, not leaving their places or interrupting their work.' After wandering silently for some time through the building, the two Egyptians realize they have lost their way completely and begin going from room to room looking for an exit. 'But no one interfered with them,' we are told, 'or came up to them to ask if they were lost.' Eventually they are rescued by the manager of the store, who proceeds to explain to them how it is organized, pointing out that, in the objects being sorted and packed, the produce of every country in the world is represented.[30] The West, it appears, is a place organized as a system of commodities, values, meanings, and representations, forming signs that reflect one another in a labyrinth without exits.

The Effect of the Real

The conventional critique of this world of representation and commodification stresses its artificiality. We imagine ourselves caught up in a hall of mirrors from which we cannot find a way out. We cannot find the door that leads back to the real world outside; we have lost touch with reality. This kind of critique remains complicitous with the world-as-exhibition, which is built to persuade us that such a simple door exists. The exhibition does not cut us off from reality. It persuades us that the world is divided neatly into two realms, the exhibition and the real world, thereby creating the effect of a reality from which we now feel cut off. It is not the artificiality of the world-as-exhibition that should concern us, but the contrasting effect of a lost reality to which such supposed artificiality gives rise. This reality, which we take to be something obvious and natural, is in fact something novel and unusual. It appears as a place completely external to the exhibition: that is, a pristine realm existing prior to all representation, which means prior to all intervention by the self, to all construction, mixing, or intermediation, to all the forms of imitation, displacement, and difference that give rise to meaning.

This external reality, it can be noted, bears a peculiar relationship to the Orientalist portrayal of the Orient. Like the Orient, it appears that it simply 'is.' It is a place of mere being, where essences are untouched by history, by intervention, by difference. Such an essentialized world lacks, by definition, what the exhibition supplies—the dimension of meaning. It lacks the plan or program that supplies reality with its historical and cultural order. The techniques of the world exhibition build into an exterior world this supposed lack, this original meaninglessness and disorder, just as colonialism introduces it to the Orient. The Orient, it could be said, is the pure form of the novel kind of external reality to which the world-as-exhibition gives rise.

Before further examining this connection between the features of Orientalism and the kind of external reality produced by the world-as-exhibition, it is worth recalling that world exhibitions and the new large-scale commercial life of European cities were aspects of a political and economic transformation that was not limited to Europe itself. The new department stores were the first establishments to keep large quantities of merchandise in stock, in the form of standardized textiles and clothing. The stockpiling, together with the introduction of advertising (the word was coined at the time of the great exhibitions, Walter Benjamin reminds us) and the new European industry of 'fashion' (on which several Middle Eastern writers commented) were all connected with the boom in textile production.[31] The textile boom was an aspect of other changes, such as new ways of harvesting and treating cotton, new machinery for the manufacture of textiles, the resulting increase in profits, and the reinvestment of profit abroad in

further cotton production. At the other end from the exhibition and the department store, these wider changes extended to include places such as the southern United States, India, and the Nile valley.

Since the latter part of the eighteenth century, the Nile valley had been undergoing a transformation associated principally with the European textile industry.[32] From a country that formed one of the hubs in the commerce of the Ottoman world and beyond and that produced and exported its own food and its own textiles, Egypt was turning into a country whose economy was dominated by the production of a single commodity, raw cotton, for the global textile industry of Europe.[33] The changes associated with this growth and concentration in exports included an enormous growth in imports, principally of textile products and food, the extension throughout the country of a network of roads, telegraphs, police stations, railways, ports, and permanent irrigation canals, a new relationship to the land (which became a privately owned commodity concentrated in the hands of a small, powerful, and increasingly wealthy social class), the influx of Europeans (seeking to make fortunes, transform agricultural production or make the country a model of colonial order), the building and rebuilding of towns and cities as centers of the new European-dominated commercial life, and the migration to these urban centers of tens of thousands of the increasingly impoverished rural poor. In the nineteenth century, no other place in the world was transformed on a greater scale to serve the production of a single commodity.

Elsewhere I have examined in detail how the modern means of colonizing a country that this transformation required—new military methods, the reordering of agricultural production, systems of organized schooling, the rebuilding of cities, new forms of communication, the transformation of writing, and so on—all represented the techniques of ordering up an object-world to create the novel effect of a world divided in two: on the one hand a material dimension of things themselves, and on the other a seemingly separate dimension of their order or meaning.[34] Thus it can be shown, I think, that the strange, binary order of the world-as-exhibition was already being extended through a variety of techniques to places like the Middle East. If, as I have been suggesting, this binary division was, in fact, uncertain and it was hard to tell on close inspection where the exhibition ended and reality began, then this uncertainty extended well beyond the supposed limits of the West. Yet at the same time as these paradoxical but enormously powerful methods of the exhibition were spreading across the southern and eastern shores of the Mediterranean, the world exhibitions began to portray, outside the world-as-exhibition and lacking by definition the meaning and order that exhibitions supply, an essentialized and exotic Orient.

There are three features of this binary world that I have tried to

outline in the preceding pages. First, there is its remarkable claim to certainty or truth: the apparent certainty with which everything seems ordered and represented, calculated and rendered unambiguous—ultimately, what seems its political decidedness. Second, there is the paradoxical nature of this decidedness: the certainty exists as the seemingly determined correspondence between mere representations and reality; yet the real world, like the world outside the exhibition, despite everything the exhibition promises, turns out to consist only of further representations of this 'reality.' Third, there is its colonial nature: the age of the exhibition was necessarily the colonial age, the age of world economy and global power in which we live, since what was to be made available as exhibit was reality, the world itself.

To draw out the colonial nature of these methods of order and truth and thus their relationship to Orientalism, I am now going to move on to the Middle East. The Orient, as I have suggested, was the great 'external reality' of modern Europe—the most common object of its exhibitions, the great signified. By the 1860s, Thomas Cook, who had launched the modern tourist industry by organizing excursion trains (with the Midland Railway Company) to visit the first of the great exhibitions, at the Crystal Palace in 1851, was offering excursions to visit not exhibits of the East, but the 'East itself.' If Europe was becoming the world-as-exhibition, what happened to Europeans who went abroad—to visit places whose images invariably they had already encountered in books, spectacles, and exhibitions? How did they experience the so-called real world such images had depicted, when the reality was a place whose life was not lived, or at least not yet, as if the world were an exhibition?

The East Itself

'So here we are in Egypt,' wrote Gustave Flaubert, in a letter from Cairo in January, 1850.

What can I say about it all? What can I write you? As yet I am scarcely over the initial bedazzlement … each detail reaches out to grip you; it pinches you; and the more you concentrate on it the less you grasp the whole. Then gradually all this becomes harmonious and the pieces fall into place of themselves, in accordance with the laws of perspective. But the first days, by God, it is such a bewildering chaos of colours…[35]

Flaubert experiences Cairo as a visual turmoil. What can he write about the place? That it is a chaos of color and detail that refuses to compose itself as a picture. The disorienting experience of a Cairo street, in other words, with its arguments in unknown languages, strangers who brush past in strange clothes, unusual colors, and unfamiliar sounds and smells, is expressed as an absence of pictorial order. There is no distance, this means, between oneself and the view, and the

eyes are reduced to organs of touch: 'Each detail reaches out to grip you.' Without a separation of the self from a picture, moreover, what becomes impossible is to grasp 'the whole.' The experience of the world as a picture set up before a subject is linked to the unusual conception of the world as an enframed totality, something that forms a structure or system. Subsequently, coming to terms with this disorientation and recovering one's self-possession is expressed again in pictorial terms. The world arranges itself into a picture and achieves a visual order, 'in accordance with the laws of perspective.'

Flaubert's experience suggests a paradoxical answer to my question concerning what happened to Europeans who 'left' the exhibition. Although they thought of themselves as moving from the pictures or exhibits to the real thing, they went on trying—like Flaubert—to grasp the real thing as a picture. How could they do otherwise, since they took reality itself to be picturelike? The real is that which is grasped in terms of a distinction between a picture and what it represents, so nothing else would have been, quite literally, thinkable.

Among European writers who traveled to the Middle East in the middle and latter part of the nineteenth century, one very frequently finds the experience of its strangeness expressed in terms of the problem of forming a picture. It was as though to make sense of it meant to stand back and make a drawing or take a photograph of it; which for many of them actually it did. 'Every year that passes,' an Egyptian wrote, 'you see thousands of Europeans traveling all over the world, and everything they come across they make a picture of.'[36] Flaubert traveled in Egypt on a photographic mission with Maxime du Camp, the results of which were expected to be 'quite special in character' it was remarked at the Institut de France, 'thanks to the aid of this modern traveling companion, efficient, rapid, and always scrupulously exact.'[37] The chemically etched correspondence between photographic image and reality would provide a new, almost mechanical kind of certainty.

Like the photographer, the writer wanted to reproduce a picture of things 'exactly as they are,' of 'the East itself in its vital actual reality.'[38] Flaubert was preceded in Egypt by Edward Lane, whose innovative *Account of the Manners and Customs of the Modern Egyptians*, published in 1835, was a product of the same search for a pictorial certainty of representation. The book's 'singular power of description and minute accuracy' made it, in the words of his nephew, Orientalist Stanley Poole, 'the most perfect picture of a people's life that has ever been written.'[39] 'Very few men,' added his grandnephew, the Orientalist Stanley Lane-Poole, 'have possessed in equal degree the power of minutely describing a scene or a monument, so that the pencil might almost restore it without a fault after the lapse of years. . . . The objects stand before you as you read, and this not by the use of imaginative language, but by the

plain simple description.'[40]

Lane, in fact, did not begin as a writer but as a professional artist and engraver, and had first traveled to Egypt in 1825 with a new apparatus called the camera lucida, a drawing device with a prism that projected an exact image of the object on to paper. He had planned to publish the drawings he made and the accompanying descriptions in an eight-volume work entitled 'An Exhaustive Description of Egypt,' but had been unable to find a publisher whose printing techniques could reproduce the minute and mechanical accuracy of the illustrations. Subsequently he published the part dealing with contemporary Egypt, rewritten as the famous ethnographic description of the modern Egyptians.[41]

The problem for the photographer or writer visiting the Middle East, however, was not just to make an accurate picture of the East but to set up the East as a picture. One can copy or represent only what appears already to exist representationally—as a picture. The problem, in other words, was to create a distance between oneself and the world and thus constitute it as something picturelike—as an object on exhibit. This required what was now called a 'point of view,' a position set apart and outside. While in Cairo, Edward Lane lived near one of the city's gates, outside which there was a large hill with a tower and military telegraph on top. This elevated position commanded 'a most magnificent view of the city and suburbs and the citadel,' Lane wrote. 'Soon after my arrival I made a very elaborate drawing of the scene, with the camera lucida. From no other spot can so good a view of the metropolis … be obtained.'[42]

These spots were difficult to find in a world where, unlike the West, such 'objectivity' was not yet built in. Besides the military observation tower used by Lane, visitors to the Middle East would appropriate whatever buildings and monuments were available in order to obtain the necessary viewpoint. The Great Pyramid at Giza had now become a viewing platform. Teams of Bedouin were organized to heave and push the writer or tourist—guidebook in hand—to the top, where two more Bedouin would carry the European on their shoulders to all four corners, to observe the view. At the end of the century, an Egyptian novel satirized the westernizing pretensions among members of the Egyptian upper middle class, by having one such character spend a day climbing the pyramids at Giza to see the view.[43] The minaret presented itself similarly to even the most respectable European as a viewing tower, from which to sneak a panoptic gaze over a Muslim town. 'The mobbing I got at *Shoomlo*,' complained Jeremy Bentham on his visit to the Middle East, 'only for taking a peep at the town from a thing they call a *minaret* … has canceled any claims they might have had upon me for the dinner they gave me at the *divan*, had it been better than it was.'[44]

Bentham can remind us of one more similarity between writer and camera, and of what it meant, therefore, to grasp the world as though it were a picture or exhibition. The point of view was not just a place set apart, outside the world or above it. Ideally, it was a position from where, like the authorities in Bentham's panopticon, one could see and yet not be seen. The photographer, invisible beneath his black cloth as he eyed the world through his camera's gaze, in this respect typified the kind of presence desired by the European in the Middle East, whether as tourist, writer, or, indeed, colonial power.[45] The ordinary European tourist, dressed (according to the advice in *Murray's Handbook for Travellers in Lower and Upper Egypt*, already in its seventh edition by 1888) in either 'a common felt helmet or wide-awake, with a turban of white muslin wound around it' or alternatively a pith helmet, together with a blue or green veil and 'coloured-glass spectacles with gauze sides,' possessed the same invisible gaze.[46] The ability to see without being seen confirmed one's separation from the world, and constituted at the same time a position of power.

The writer, too, wished to see without being seen. The representation of the Orient, in its attempt to be detached and objective, would seek to eliminate from the picture the presence of the European observer. Indeed, to represent something as Oriental, as Edward Said has argued, one sought to excise the European presence altogether.[47] 'Many thanks for the local details you sent me,' wrote Théophile Gautier to Gérard de Nerval in Cairo, who was supplying him with firsthand material for his Oriental scenarios at the Paris Opéra. 'But how the devil was I to have included among the walk-ons of the Opéra these Englishmen dressed in raincoats, with their quilted cotton hats and their green veils to protect themselves against ophthalmia?' Representation was not to represent the voyeur, the seeing eye that made representation possible.[48] To establish the objectness of the Orient, as a picture-reality containing no sign of the increasingly pervasive European presence, required that the presence itself, ideally, become invisible.

Participant Observation

Yet this was where the paradox began. At the same time as the European wished to elide himself in order to constitute the world as something not-himself, something other and objectlike, he also wanted to experience it as though it were the real thing. Like visitors to an exhibition or scholars in Sacy's Orientalist museum, travelers wanted to feel themselves 'transported … into the very midst' of their Oriental object-world, and to 'touch with their fingers a strange civilization.' In his journal, Edward Lane wrote of wanting 'to throw myself entirely among strangers, … to adopt their language, their customs, and their dress.'[49] This kind of immersion was to make possible

the profusion of ethnographic detail in writers such as Lane, and pro-
duce in their work the effect of a direct and immediate experience of
the Orient. In Lane, and even more so in writers such as Flaubert and
Nerval, the desire for this immediacy of the real became a desire for
direct and physical contact with the exotic, the bizarre, and the erotic.

There was a contradiction, therefore, between the need to separate
oneself from the world and render it up as an object of representation,
and the desire to lose oneself within this object-world and experience it
directly; a contradiction that world exhibitions, with their profusion of
exotic detail and yet their clear distinction between visitor and exhibit,
were built to accommodate and overcome. In fact, 'experience,' in this
sense, depends upon the structure of the exhibition. The problem in a
place such as Cairo, which had not been built to provide the experience
of an exhibition, was to fulfill such a double desire. On his first day in
Cairo, Gérard de Nerval met a French 'painter' equipped with a
daguerreotype, who 'suggested that I come with him to choose a point
of view.' Agreeing to accompany him, Nerval decided 'to have myself
taken to the most labyrinthine point of the city, abandon the painter to
his tasks, and then wander off haphazardly, without interpreter or
companion.' But within the labyrinth of the city, where Nerval hoped
to immerse himself in the exotic and finally experience 'without inter-
preter' the real Orient, they were unable to find any point from which
to take the picture. They followed one crowded, twisting street after
another, looking without success for a suitable viewpoint, until eventu-
ally the profusion of noises and people subsided and the streets became
'more silent, more dusty, more deserted, the mosques fallen in decay
and here and there a building in collapse.' In the end they found them-
selves outside the city, 'somewhere in the suburbs, on the other side of
the canal from the main sections of the town.' Here at last, amid the
silence and the ruins, the photographer was able to set up his device
and portray the Oriental city.[50] [...]

In claiming that the 'East itself' is not a place, I am not saying
simply that Western representations created a distorted image of the
real Orient; nor am I saying that the 'real Orient' does not exist, and
that there are no realities but only images and representations. Either
statement would take for granted the strange way the West had come
to live, as though the world were divided in this way into two: into a
realm of 'mere' representations opposed to an essentialized realm of
'the real'; into exhibitions opposed to an external reality; into an order
of models, descriptions, texts, and meanings opposed to an order of
originals, of things in themselves.[51] What we already suspected in the
streets of Paris, concerning this division, is confirmed by the journey to
the Orient: what seems excluded from the exhibition as the real or the
outside turns out to be only that which can be represented, that which
occurs in exhibitionlike form—in other words, a further extension of

that labyrinth that we call an exhibition. What matters about this labyrinth is not that we never reach the real, never find the promised exit, but that such a notion of the real, such a system of truth, continues to convince us.

The case of Orientalism shows us, moreover, how this supposed distinction between a realm of representation and an external reality corresponds to another apparent division of the world, into the West and the non-West. In the binary terms of the world-as-exhibition, reality is the effect of an external realm of pure existence, untouched by the self and by the processes that construct meaning and order. The Orient is a similar effect. It appears as an essentialized realm originally outside and untouched by the West, lacking the meaning and order that only colonialism can bring. Orientalism, it follows, is not just a nineteenth-century instance of some general historical problem of how one culture portrays another, nor just an aspect of colonial domination, but part of a method of order and truth essential to the peculiar nature of the modern world.

Carol Duncan 1995

The Art Museum As Ritual

[...] Art museums have always been compared to older ceremonial monuments such as palaces or temples. Indeed, from the eighteenth through the mid-twentieth centuries, they were deliberately designed to resemble them. One might object that this borrowing from the architectural past can have only metaphoric meaning and should not be taken for more, since ours is a secular society and museums are secular inventions. If museum facades have imitated temples or palaces, is it not simply that modern taste has tried to emulate the formal balance and dignity of those structures, or that it has wished to associate the power of bygone faiths with the present cult of art? Whatever the motives of their builders (so the objection goes), in the context of our society, the Greek temples and Renaissance palaces that house public art collections can signify only secular values, not religious beliefs. Their portals can lead to only rational pastimes, not sacred rites. We are, after all, a post-Enlightenment culture, one in which the secular and the religious are opposing categories.

It is certainly the case that our culture classifies religious buildings such as churches, temples, and mosques as different in kind from secular sites such as museums, court houses, or state capitals. Each kind of site is associated with an opposite kind of truth and assigned to one or the other side of the religious/secular dichotomy. That dichotomy, which structures so much of the modern public world and now seems so natural, has its own history. It provided the ideological foundation for the Enlightenment's project of breaking the power and influence of the church. By the late eighteenth century, that undertaking had successfully undermined the authority of religious doctrine—at least in western political and philosophical theory if not always in practice. Eventually, the separation of church and state would become law. Everyone knows the outcome: secular truth became authoritative truth; religion, although guaranteed as a matter of personal freedom and choice, kept its authority only for voluntary believers. It is secular truth—truth that is rational and verifiable—that has the status of 'objective' knowledge. It is this truest of truths that helps bind a community into a civic body by providing it a universal base of knowledge and validating its highest values and most cherished memories. Art

66

The Glyptothek, Munich

museums belong decisively to this realm of secular knowledge, not only because of the scientific and humanistic disciplines practiced in them—conservation, art history, archaeology—but also because of their status as preservers of the community's official cultural memory.

Again, in the secular/religious terms of our culture, 'ritual' and 'museums' are antithetical. Ritual is associated with religious practices —with the realm of belief, magic, real or symbolic sacrifices, miraculous transformations, or overpowering changes of consciousness. Such goings-on bear little resemblance to the contemplation and learning that art museums are supposed to foster. But in fact, in traditional societies, rituals may be quite unspectacular and informal-looking moments of contemplation or recognition. At the same time, as anthropologists argue, our supposedly secular, even anti-ritual, culture is full of ritual situations and events—very few of which (as Mary Douglas has noted) take place in religious contexts.[1] That is, like other cultures, we, too, build sites that publicly represent beliefs about the order of the world, its past and present, and the individual's place within it.[2] Museums of all kinds are excellent examples of such microcosms; art museums in particular—the most prestigious and costly of these sites[3]—are especially rich in this kind of symbolism and, almost always, even equip visitors with maps to guide them through the universe they construct. Once we question our Enlightenment assumptions about the sharp separation between religious and secular experience—that the one is rooted in belief while the other is based in lucid and objective rationality—we may begin to glimpse the hidden —perhaps the better word is disguised—ritual content of secular ceremonies.

We can also appreciate the ideological force of a cultural experience that claims for its truths the status of objective knowledge. To control a

museum means precisely to control the representation of a community and its highest values and truths. It is also the power to define the relative standing of individuals within that community. Those who are best prepared to perform its ritual—those who are most able to respond to its various cues—are also those whose identities (social, sexual, racial, etc.) the museum ritual most fully confirms. It is precisely for this reason that museums and museum practices can become objects of fierce struggle and impassioned debate. What we see and do not see in art museums—and on what terms and by whose authority we do or do not see it—is closely linked to larger questions about who constitutes the community and who defines its identity.

I have already referred to the long-standing practice of museums borrowing architectural forms from monumental ceremonial structures of the past. Certainly when Munich, Berlin, London, Washington, and other western capitals built museums whose facades looked like Greek or Roman temples, no one mistook them for their ancient prototypes [**66, 67**]. On the contrary, temple facades—for 200 years the most popular source for public art museums[4]—were completely assimilated to a secular discourse about architectural beauty, decorum, and rational form. Moreover, as coded reminders of a pre-Christian civic realm, classical porticos, rotundas, and other features of Greco-Roman architecture could signal a firm adherence to Enlightenment values. These same monumental forms, however, also brought with them the spaces of public rituals—corridors scaled for processions, halls implying large, communal gatherings, and interior sanctuaries designed for awesome and potent effigies.

Museums resemble older ritual sites not so much because of their specific architectural references but because they, too, are settings for rituals. (I make no argument here for historical continuity, only for the existence of comparable ritual functions.) Like most ritual space,

67
The National Gallery of
New South Wales, Sydney

IN THE MUSEUM...
PLEASE... MUSE, CONVERSE, SMOKE,
STUDY, STROLL, TOUCH, ENJOY, LITTER,
RELAX, EAT, LOOK, LEARN; TAKE
NOTES WITH PEN, PENCIL...

museum space is carefully marked off and culturally designated as reserved for a special quality of attention—in this case, for contemplation and learning. One is also expected to behave with a certain decorum. In the Hirshhorn Museum, a sign spells out rather fully the dos and don'ts of ritual activity and comportment [**68**]. Museums are normally set apart from other structures by their monumental architecture and clearly defined precincts. They are approached by impressive flights of stairs, guarded by pairs of monumental marble lions, entered through grand doorways. They are frequently set back from the street and occupy parkland, ground consecrated to public use. (Modern museums are equally imposing architecturally and similarly set apart by sculptural markers. In the United States, Rodin's *Balzac* is one of the more popular signifiers of museum precincts, its priapic character making it especially appropriate for modern collections.)[5]

By the nineteenth century, such features were seen as necessary prologues to the space of the art museum itself:

Do you not think that in a splendid gallery ... all the adjacent and circumjacent parts of that building should ... have a regard for the arts, ... with fountains, statues, and other objects of interest calculated to prepare [visitors'] minds before entering the building, and lead them the better to appreciate the works of art which they would afterwards see?

The nineteenth-century British politician asking this question[6] clearly understood the ceremonial nature of museum space and the need to differentiate it (and the time one spends in it) from day-to-day time and space outside. Again, such framing is common in ritual practices everywhere. Mary Douglas writes:

A ritual provides a frame. The marked off time or place alerts a special kind of expectancy, just as the oft-repeated 'Once upon a time' creates a mood receptive to fantastic tales.[7]

'Liminality,' a term associated with ritual, can also be applied to the kind of attention we bring to art museums. Used by the Belgian folklorist Arnold van Gennep,[8] the term was taken up and developed in the anthropological writings of Victor Turner to indicate a mode of consciousness outside of or 'betwixt-and-between the normal, day-to-day cultural and social states and processes of getting and spending.'[9] As Turner himself realized, his category of liminal experience had strong affinities to modern western notions of the aesthetic experience—that mode of receptivity thought to be most appropriate before works of art. Turner recognized aspects of liminality in such modern activities as attending the theatre, seeing a film, or visiting an art exhibition. Like folk rituals that temporarily suspend the constraining rules of normal social behavior (in that sense, they 'turn the world upside-down'), so these cultural situations, Turner argued, could open a space in which individuals can step back from the practical concerns and social relations of everyday life and look at themselves and their world—or at some aspect of it—with different thoughts and feelings. Turner's idea of liminality, developed as it is out of anthropological categories and based on data gathered mostly in non-western cultures, probably cannot be neatly superimposed onto western concepts of art experience. Nevertheless, his work remains useful in that it offers a sophisticated general concept of ritual that enables us to think about art museums and what is supposed to happen in them from a fresh perspective.[10]

It should also be said, however, that Turner's insight about art museums is not singular. Without benefit of the term, observers have long recognized the liminality of their space. The Louvre curator Germain Bazin, for example, wrote that an art museum is 'a temple where Time seems suspended'; the visitor enters it in the hope of finding one of 'those momentary cultural epiphanies' that give him 'the illusion of knowing intuitively his essence and his strengths.'[11] Likewise, the Swedish writer Goran Schildt has noted that museums are settings in which we seek a state of 'detached, timeless and exalted' contemplation that 'grants us a kind of release from life's struggle and … captivity in our own ego.' Referring to nineteenth-century attitudes to art, Schildt observes 'a religious element, a substitute for religion.'[12] As we shall see, others, too, have described art museums as sites which enable individuals to achieve liminal experience—to move beyond the psychic constraints of mundane existence, step out of time, and attain new, larger perspectives.

Thus far, I have argued the ritual character of the museum experience in terms of the kind of attention one brings to it and the special quality of its time and space. Ritual also involves an element of performance. A ritual site of any kind is a place programmed for the enactment of something. It is a place designed for some kind of performance. It has this structure whether or not visitors can read its cues.

In traditional rituals, participants often perform or witness a drama—enacting a real or symbolic sacrifice. But a ritual performance need not be a formal spectacle. It may be something an individual enacts alone by following a prescribed route, by repeating a prayer, by recalling a narrative, or by engaging in some other *structured* experience that relates to the history or meaning of the site (or to some object or objects on the site). Some individuals may use a ritual site more knowledgeably than others—they may be more educationally prepared to respond to its symbolic cues. The term 'ritual' can also mean habitual or routinized behavior that lacks meaningful subjective context. This sense of ritual as an 'empty' routine or performance is not the sense in which I use the term.

In art museums, it is the visitors who enact the ritual.[13] The museum's sequenced spaces and arrangements of objects, its lighting and architectural details provide both the stage set and the script—although not all museums do this with equal effectiveness. The situation resembles in some respects certain medieval cathedrals where pilgrims followed a structured narrative route through the interior, stopping at prescribed points for prayer or contemplation. An ambulatory adorned with representations of the life of Christ could thus prompt pilgrims to imaginatively re-live the sacred story. Similarly, museums offer well-developed ritual scenarios, most often in the form of art-historical narratives that unfold through a sequence of spaces. Even when visitors enter museums to see only selected works, the museum's larger narrative structure stands as a frame and gives meaning to individual works.

Like the concept of liminality, this notion of the art museum as a performance field has also been discovered independently by museum professionals. Philip Rhys Adams, for example, once director of the Cincinnati Art Museum, compared art museums to theatre sets (although in his formulation, objects rather than people are the main performers):

The museum is really an impresario, or more strictly a *régisseur*, neither actor nor audience, but the controlling intermediary who sets the scene, induces a receptive mood in the spectator, then bids the actors take the stage and be their best artistic selves. And the art objects do have their exits and their entrances; motion—the movement of the visitor as he enters a museum and as he goes or is led from object to object—is a present element in any installation.[14]

The museum setting is not only itself a structure; it also constructs its *dramatis personae*. These are, ideally, individuals who are perfectly predisposed socially, psychologically, and culturally to enact the museum ritual. Of course, no real visitor ever perfectly corresponds to these ideals. In reality, people continually 'misread' or scramble or resist the museum's cues to some extent; or they actively invent, consciously or

unconsciously, their own programs according to all the historical and psychological accidents of who they are. But then, the same is true of any situation in which a cultural product is performed or interpreted.[15]

Finally, a ritual experience is thought to have a purpose, an end. It is seen as transformative: it confers or renews identity or purifies or restores order in the self or to the world through sacrifice, ordeal, or enlightenment. The beneficial outcome that museum rituals are supposed to produce can sound very like claims made for traditional, religious rituals. According to their advocates, museum visitors come away with a sense of enlightenment, or a feeling of having been spiritually nourished or restored. In the words of one well-known expert,

The only reason for bringing together works of art in a public place is that … they produce in us a kind of exalted happiness. For a moment there is a clearing in the jungle: we pass on refreshed, with our capacity for life increased and with some memory of the sky.[16]

One cannot ask for a more ritual-like description of the museum experience. Nor can one ask it from a more renowned authority. The author of this statement is the British art historian Sir Kenneth Clark, a distinguished scholar and famous as the host of a popular BBC television series of the 1970s, 'Civilization.' Clark's concept of the art museum as a place for spiritual transformation and restoration is hardly unique. Although by no means uncontested, it is widely shared by art historians, curators, and critics everywhere. Nor, as we shall see below, is it uniquely modern.

We come, at last, to the question of art museum objects. Today, it is a commonplace to regard museums as the most appropriate places in which to view and keep works of art. The existence of such objects— things that are most properly used when contemplated as art—is taken as a given that is both prior to and the cause of art museums. These commonplaces, however, rest on relatively new ideas and practices. The European practice of placing objects in settings designed for contemplation emerged as part of a new and, historically speaking, relatively modern way of thinking. In the course of the eighteenth century, critics and philosophers, increasingly interested in visual experience, began to attribute to works of art the power to transform their viewers spiritually, morally, and emotionally. This newly discovered aspect of visual experience was extensively explored in a developing body of art criticism and philosophy. These investigations were not always directly concerned with the experience of art as such, but the importance they gave to questions of taste, the perception of beauty, and the cognitive roles of the senses and imagination helped open new philosophical ground on which art criticism would flourish. Significantly, the same era in which aesthetic theory burgeoned also saw a growing interest in galleries and public art museums. Indeed, the rise of the art museum is

a corollary to the philosophical invention of the aesthetic and moral powers of art objects: if art objects are most properly used when contemplated as art, then the museum is the most proper setting for them, since it makes them useless for any other purpose.

In philosophy, Immanuel Kant's *Critique of Judgement* is one of the most monumental expressions of this new preoccupation with aesthetics. In it, Kant definitively isolated and defined the human capacity for aesthetic judgement and distinguished it from other faculties of the mind (practical reason and scientific understanding).[17] But before Kant, other European writers, for example, Hume, Burke, and Rousseau, also struggled to define taste as a special kind of psychological encounter with distinctive moral and philosophical import.[18] The eighteenth century's designation of art and aesthetic experience as major topics for critical and philosophical inquiry is itself part of a broad and general tendency to furnish the secular with new value. In this sense, the invention of aesthetics can be understood as a transference of spiritual values from the sacred realm into secular time and space. Put in other terms, aestheticians gave philosophical formulations to the condition of liminality, recognizing it as a state of withdrawal from the day-to-day world, a passage into a time or space in which the normal business of life is suspended. In philosophy, liminality became specified as the aesthetic experience, a moment of moral and rational disengagement that leads to or produces some kind of revelation or transformation. Meanwhile, the appearance of art galleries and museums gave the aesthetic cult its own ritual precinct.

Goethe was one of the earliest witnesses of this development. Like others who visited the newly created art museums of the eighteenth century, he was highly responsive to museum space and to the sacral feelings it aroused. In 1768, after his first visit to the Dresden Gallery, which housed a magnificent royal art collection,[19] he wrote about his impressions, emphasizing the powerful ritual effect of the total environment:

The impatiently awaited hour of opening arrived and my admiration exceeded all my expectations. That *salon* turning in on itself, magnificent and so well-kept, the freshly gilded frames, the well-waxed parquetry, the profound silence that reigned, created a solemn and unique impression, akin to the emotion experienced upon entering a House of God, and it deepened as one looked at the ornaments on exhibition which, as much as the temple that housed them, were objects of adoration in that place consecrated to the holy ends of art.[20]

The historian of museums Niels von Holst has collected similar testimony from the writings of other eighteenth-century museum-goers. Wilhelm Wackenroder, for example, visiting an art gallery in 1797, declared that gazing at art removed one from the 'vulgar flux of life' and

produced an effect that was comparable to, but better than, religious ecstasy.[21] And here, in 1816, still within the age when art museums were novelties, is the English critic William Hazlitt, aglow over the Louvre:

Art lifted up her head and was seated on her throne, and said, All eyes shall see me, and all knees shall bow to me. . . . There she had gathered together all her pomp, there was her shrine, and there her votaries came and worshipped as in a temple.[22]

A few years later, in 1824, Hazlitt visited the newly opened National Gallery in London, then installed in a house in Pall Mall. His description of his experience there and its ritual nature—his insistence on the difference between the quality of time and space in the gallery and the bustling world outside, and on the power of that place to feed the soul, to fulfill its highest purpose, to reveal, to uplift, to transform and to cure—all of this is stated with exceptional vividness. A visit to this 'sanctuary,' this 'holy of holies,' he wrote, 'is like going on a pilgrimage —it is an act of devotion performed at the shrine of Art!'

It is a cure (for the time at least) for low-thoughted cares and uneasy passions. We are abstracted to another sphere: we breathe empyrean air; we enter into the minds of Raphael, of Titian, of Poussin, of the Caracci, and look at nature with their eyes; we live in time past, and seem identified with the permanent forms of things. The business of the world at large, and even its pleasures, appear like a vanity and an impertinence. What signify the hubbub, the shifting scenery, the fantoccini figures, the folly, the idle fashions without, when compared with the solitude, the silence, the speaking looks, the unfading forms within? Here is the mind's true home. The contemplation of truth and beauty is the proper object for which we were created, which calls forth the most intense desires of the soul, and of which it never tires.[23]

This is not to suggest that the eighteenth century was unanimous about art museums. Right from the start, some observers were already concerned that the museum ambience could change the meanings of the objects it held, redefining them as works of art and narrowing their import simply by removing them from their original settings and obscuring their former uses. Although some, like Hazlitt and the artist Philip Otto Runge, welcomed this as a triumph of human genius, others were—or became—less sure. Goethe, for example, thirty years after his enthusiastic description of the art gallery at Dresden, was disturbed by Napoleon's systematic gathering of art treasures from other countries and their display in the Louvre as trophies of conquest. Goethe saw that the creation of this huge museum collection depended on the destruction of something else, and that it forcibly altered the conditions under which, until then, art had been made and understood. Along with others, he realized that the very capacity of the museum to frame objects as art and claim them for a new kind of

ritual attention could entail the negation or obscuring of other, older meanings.[24]

In the late eighteenth and early nineteenth centuries, those who were most interested in art museums, whether they were for or against them, were but a minority of the educated—mostly poets and artists. In the course of the nineteenth century, the serious museum audience grew enormously; it also adopted an almost unconditional faith in the value of art museums. By the late nineteenth century, the idea of art galleries as sites of wondrous and transforming experience became commonplace among those with any pretensions to 'culture' in both Europe and America.

Through most of the nineteenth century, an international museum culture remained firmly committed to the idea that the first responsibility of a public art museum is to enlighten and improve its visitors morally, socially, and politically. In the twentieth century, the principal rival to this ideal, the aesthetic museum, would come to dominate. In the United States, this new ideal was advocated most forcefully in the opening years of the century. Its main proponents, all wealthy, educated gentlemen, were connected to the Boston Museum of Fine Arts and would make the doctrine of the aesthetic museum the official creed of their institution.[25] The fullest and most influential statement of this doctrine is Benjamin Ives Gilman's *Museum Ideals of Purpose and Method*, published by the museum in 1918 but drawing on ideas developed in previous years. According to Gilman, works of art, once they are put in museums, exist for one purpose only: to be looked at as things of beauty. The first obligation of an art museum is to present works of art as just that, as objects of aesthetic contemplation and not as illustrative of historical or archaeological information. As he expounded it (sounding much like Hazlitt almost a century earlier), aesthetic contemplation is a profoundly transforming experience, an imaginative act of identification between viewer and artist. To achieve it, the viewer 'must make himself over in the image of the artist, penetrate his intention, think with his thoughts, feel with his feelings.'[26] The end result of this is an intense and joyous emotion, an overwhelming and 'absolutely serious' pleasure that contains a profound spiritual revelation. Gilman compares it to the 'sacred conversations' depicted in Italian Renaissance altarpieces—images in which saints who lived in different centuries miraculously gather in a single imaginary space and together contemplate the Madonna. With this metaphor, Gilman casts the modern aesthete as a devotee who achieves a kind of secular grace through communion with artistic geniuses of the past—spirits that offer a life-redeeming sustenance. 'Art is the Gracious Message pure and simple,' he wrote, 'integral to the perfect life,' its contemplation 'one of the ends of existence.'[27]

The museum ideal that so fascinated Gilman would have a com-

pelling appeal to the twentieth century. Most of today's art museums
are designed to induce in viewers precisely the kind of intense absorp-
tion that he saw as the museum's mission, and art museums of all kinds,
both modern and historical, continue to affirm the goal of communion
with immortal spirits of the past. Indeed, the longing for contact with
an idealized past, or with things imbued by immortal spirits, is prob-
ably pervasive as a sustaining impetus not only of art museums but
many other kinds of rituals as well. The anthropologist Edmund
Leach noticed that every culture mounts some symbolic effort to con-
tradict the irreversibility of time and its end result of death. He argued
that themes of rebirth, rejuvenation, and the spiritual recycling or

70

Modern Art in the Tate Gallery, London

perpetuation of the past deny the fact of death by substituting for it symbolic structures in which past time returns.[28] As ritual sites in which visitors seek to re-live spiritually significant moments of the past, art museums make splendid examples of the kind of symbolic strategy Leach described.[29]

Nowhere does the triumph of the aesthetic museum reveal itself more dramatically than in the history of art gallery design. Although fashions in wall colors, ceiling heights, lighting, and other details have over the years varied with changing museological trends, installation design has consistently and increasingly sought to isolate objects for the concentrated gaze of the aesthetic adept and to suppress as irrelevant other meanings the objects might have. The wish for ever closer encounters with art have gradually made galleries more intimate, increased the amount of empty wall space between works, brought works nearer to eye level, and caused each work to be lit individually.[30] Most art museums today keep their galleries uncluttered and, as much as possible, dispense educational information in anterooms or special kiosks at a tasteful remove from the art itself. Clearly, the more 'aesthetic' the installations—the fewer the objects and the emptier the surrounding walls—the more sacralized the museum space. The sparse installations of the National Gallery in Washington, DC, take the aesthetic ideal to an extreme [**69**], as do installations of modern art in many institutions [**70**]. As the sociologist César Graña once suggested, modern installation practices have brought the museum-as-temple

metaphor close to the fact. Even in art museums that attempt education, the practice of isolating important originals in 'aesthetic chapels' or niches—but never hanging them to make an historical point—undercuts any educational effort.[31]

The isolation of objects for visual contemplation, something that Gilman and his colleagues in Boston ardently preached, has remained one of the outstanding features of the aesthetic museum and continues to inspire eloquent advocates. Here, for example, is the art historian Svetlana Alpers in 1988:

Romanesque capitals or Renaissance altarpieces are appropriately looked at in museums (*pace* Malraux) even if not made for them. When objects like these are severed from the ritual site, the invitation to look attentively remains and in certain respects may even be enhanced.[32]

Of course, in Alpers' statement, only the original site has ritual meaning. In my terms, the attentive gazing she describes belongs to another, if different, ritual field, one which requires from the performer intense, undistracted visual contemplation.

In *The Museum Age*, Germain Bazin described with penetrating insight how modern installations help structure the museum as a ritual site. In his analysis, the isolation and illumination of objects induces visitors to fix their attention onto things that exist seemingly in some other realm. The installations thus take visitors on a kind of mental journey, a stepping out of the present into a universe of timeless values:

Statues must be isolated in space, paintings hung far apart, a glittering jewel placed against a field of black velvet and spot-lighted; in principle, only one object at a time should appear in the field of vision. Iconographic meaning, overall harmony, aspects that attracted the nineteenth-century amateur, no longer interest the contemporary museum goer, who is obsessed with form and workmanship; the eye must be able to scan slowly the entire surface of a painting. The act of looking becomes a sort of trance uniting spectator and masterpiece.[33]

One could take the argument even farther: in the liminal space of the museum, everything—and sometimes anything—may become art, including fire-extinguishers, thermostats, and humidity gauges, which, when isolated on a wall and looked at through the aesthetizing lens of museum space, can appear, if only for a mistaken moment, every bit as interesting as some of the intended-as-art works on display, which, in any case, do not always look very different. [...]

Annie E. Coombes 1992

Inventing the 'Postcolonial': Hybridity and Constituency in Contemporary Curating

[A] willingness to descend into that alien territory … may reveal that the the-
oretical recognition of the split-space of enunciation may open the way to
conceptualizing an international culture, based not on the exoticism or multi-
culturalism of the diversity of cultures, but on the inscription and articulation
of culture's hybridity.[1]

> hybridity, impurity, intermingling, the transformation that
> comes of new and unexpected combinations of human beings,
> cultures, ideas, politics, movies, songs.[2]

I

The past few years have seen the flowering of a new phenomenon in
cultural institutions at the heart of the western metropolitan centre: a
series of exhibitions which claimed to disrupt radically the boundaries
of that dyad the 'West' and its 'Other', the relationship of centre to
periphery.[3] In fact, each went even further and declared itself the
harbinger, if not the representative of a new 'post-colonial' conscious-
ness.[4] In curatorial terms, a shared feature of all these exhibitions was
the prioritizing of transculturated objects, both as the ultimate sign of a
productive culture contact between the western centres and those
groups on the so-called periphery, and as the visible referent of the self-
determination of those nations once subjugated under colonial dom-
ination.

More specifically, the cultural object was to be the primary signifier
of a cultural, national and ethnic identity which proclaimed and celeb-
rated its integrity and 'difference' from the centres of western capital-
ism. But it was also to be the sign of a mutually productive culture
contact—an exchange. To accomplish this the curators deliberately
selected cultural production which straddled a number of different
taxonomies, objects designated at various moments as the domains of
ethnography, science, popular culture and fine art.

This article explores some of the difficulties arising from the use of
this particular curatorial strategy and the extent to which it actually

offers a productive challenge to the Eurocentrism of the western art establishment or simply a more complex revision of the primitivist fantasies of early modernism. I would like to add that my analysis is underwritten by a tacit recognition of hybridity as an important cultural strategy for the political project of decolonization.[5] For me the problem is not to question the validity of hybridity, either as a strategy of oppositional identity ('roots revivalism') or as an instance of creative transactional transculturation. I take both as contingent and conditional. As Stuart Hall, Benita Parry and Gayatri Chakravorty Spivak have done elsewhere, I would argue for a strategic essentialism.[6] The focus of this paper is rather to interrogate the ways in which 'hybridity' is transformed and to what effect, in the narratives of the western art and ethnographic museum and to ask what relations of power and transgression it can still articulate there.[7]

One of the difficulties of appropriating 'hybridity' as a sign of postcolonial self-determination is that as a cultural concept and as a descriptive term for the cultural object itself, it already has a particular pedigree in the discourse of both art history and anthropology as Surrealist, Pop, Folk art, or popular versions of historical cultural practices, redefined for a commercial market. The meanings and values of each category shift of course, according to complex historical and social relations. Yet more often than not, such exhibitions demonstrate a curious resistance to addressing the implications of such potentially contradictory categories. Even the more obvious dialogical relation imposed by the distinct institutional contexts, the ethnographic museum on the one hand and the museum of fine art on the other, are not often seriously considered.[8] This is all the more remarkable in a curatorial project dedicated to a strategic reassessment of the relationship of the West and its 'Other', since both sites are subject to different institutional and disciplinary histories directly implicated in both world capitalism and colonialism.

Successfully relocating the cultural object as a sign of processes of cultural assimilation, appropriation and transformation requires, perhaps, a more self-conscious acknowledgement of the ways in which this object, and more specifically, cultural objects assigned to an 'Other' (whether in terms of nationality, ethnicity, class or gender), are already circumscribed at any given moment. Not only in terms of the weight of meanings attributed to them through ethnography or anthropology, or the predominantly modernist paradigm of conventional art history, but also in terms of the competing definitions established by their presence in a variety of institutional and educational practices in the public sphere.

In Britain, for example, during the stringent economic cutbacks characteristic of the 1980s, the local and national museum has ironically come into its own. Through transformations in marketing and

policy, the museum has become both a vital component in the reclaiming and defining of a concept of collective memory on the local level and, on the national level, an opportune site for the reconstituting of certain cultural icons as part of a common 'heritage'—a 'heritage' often produced as a spectacle of essentialist national identity with the museum frequently serving as the site of the nostalgic manufacture of a consensual past in the lived reality of a deeply divided present.[9]

Simultaneously, as the central argument against the restitution of cultural property, western museums proclaim the internationalism of museum culture as irrefutable 'proof' of their neutrality and objectivity and as justification for their self-appointed role as cultural custodians. Finally, multicultural educational initiatives from within the western metropolitan centres have heralded a new and possibly more self-reflexive conception for the ethnographic museum, despite debate on the relative merits of an initiative which may well be multicultural without necessarily being anti-racist.[10] Resultant questions about constituency have been taken on by some anthropologists and ethnographers. These have revived a concern with the political implications of anthropological practice and the way anthropological knowledge is used that has been dormant since Kathleen Gough's and others' searing critiques of their own discipline at the height of American intervention in Vietnam.[11]

Any cultural object is, of course, recuperable to some degree. But, in particular, such ambiguity has always been intrinsic to western consumption of material culture from erstwhile colonies. Paradoxically, however, this same material culture is simultaneously awarded the status of visible referent—the ultimate sign—of cultural and social value, replete with immanent meaning. Further complications follow once such objects are assigned an aesthetic value apparently commensurate with western standards, while at the same time they are declared as embodying an other and different, but equally valid, criterion for determining cultural value. An ambitious project! Most recently these complexities have been neatly resolved by the liberal white curatorial establishment in terms of a recognition, celebration and reassertion of 'difference' through an apparently magnanimous acceptance of plurality and cultural diversity.

One of the difficulties with any exhibition which foregrounds hybridity is that while it may recognize and celebrate the polysemic nature of the objects on display, it often disavows the complexity of the ways in which this is articulated across a series of relations at the level of the social, not only in the culture of origin but also in the dominant culture of the host institution. I would argue that while the celebration of cultural diversity may well produce worthwhile reassessments of certain racial and cultural stereotypes, the use of 'difference' and 'diversity' as analytical devices for the dissipation of grand narratives

can ultimately produce a homogenizing and levelling effect that has serious consequences.[12] As a curatorial strategy its fluidity actively undermines the potential of such exhibitions to explore and explode the means by which differentiation reproduces the experience of multiple but specific forms of social and political disempowerment.[13] More importantly, what this also means is that the ways in which the host institution and its ideal constituency is implicated in such discriminatory practices remain shrouded in mystery.

The celebration of 'difference' is a strategy which is particularly pernicious when mobilized in the sphere of visual culture precisely because of the way in which the site of its public consumption—the art or ethnographic museum—is predicated on a 'visibility' which reaffirms and naturalizes the apparent transparency of meaning invested in the object. What might by now seem to be a commonplace observation—that the cultural object can never be an empty vessel waiting to be filled with meaning, but rather is a repository replete with meanings that are never immanent but always contingent—is evidently not to be taken for granted.

The ways in which such 'visibility' is mediated by an aesthetic consideration is especially significant in the 'post-colonial' context. Of course the West's advocation of aesthetic criteria for evaluating material culture from the colonies or from independent nation-states with a history of colonial subjugation is not, and never has been, an unqualifiedly progressive move.[14] While it has sometimes had the potential to disrupt and fracture certain assumptions of racial and cultural inferiority, it has always been fraught with more or less productive contradictions. When public ethnographic collections were established in Britain, for example, at the end of the nineteenth century, their effectivity operated on a number of competing levels. Indeed, their very existence depended precisely on promoting the material in the collection simultaneously as fodder for the purportedly disinterested scientific and comparative study of culture, as visible 'evidence' of racial inferiority (and therefore as justification of colonial intervention), but also in their capacity as objects of aesthetic pleasure, exotic delectation, and spectacle.[15]

II

The present historical conjuncture finds us at the crossroads of postmodern critiques of the alienating effects of commodity culture on the one hand, and on the other, the celebration of the liberating possibilities opened up by the subsequent demise of certain historical models now dismissed as hopelessly teleological. Perhaps this might be a good moment to reassess some of the more complex ways in which 'difference' is articulated across race, class and gender relation in highly specific ways. This is especially important if we are to avoid the uncrit-

ical celebration in museum culture of a hybridity which threatens to collapse the heterogeneous experience of racism into a scopic feast where the goods on display are laid out for easy consumption in ever more enticing configurations, none of which actually challenges or exposes the ways in which such difference is constituted and operates as a mechanism of oppression.

At various moments in the history of western imperialism, different colonial powers have used the 'visibility' of the museum to set up initiatives which were as dependent then on the rhetoric of equal access that we hear so much about now. In Britain in the 1850s, and again in the Edwardian era, for example, this was invoked in no uncertain terms. The museum was heralded as '… the most democratic and socialistic possession of the people. All have equal access to them, peer and peasant receive the same privileges and treatment.'[16] Museums occupied a territory apparently 'neutral' enough to provide what was seen as a 'common' meeting ground for children from 'different class backgrounds'—the basis in fact of an objective education. Again in 1903 the ethnographic museums' potential as a 'scientific' and therefore 'objective' educational tool which cut across ethnic and national boundaries as well as those of class, was affirmed through an initiative which aimed to bring children in different parts of the Empire in contact with one another and 'get them acquainted' with each other's lifestyles. Today, of course, in England and elsewhere, multiculturalism has other implications contingent on the different experiences of diverse social groups living in a white patriarchy. I would argue, however, that it is precisely under the banner of a form of multiculturalism that those exhibitions, uncritically celebrating cultural 'diversity' through the primary strategy of displaying culturally hybrid objects from once colonized nations, can claim immunity from addressing the specificity of this experience. They ultimately invoke as misleading a rhetoric of equality as those earlier manifestations, laying claim to an impossible relativism that declares objectivity at the expense of a recognition of the multiple political interests at stake in such an initiative.

Evidently the preoccupation with originary unity and the emphasis on racial purity, which characterized much of the aesthetic discourse around material culture from the colonies in the early part of this century, have been challenged by the current celebration of hybridity.[17] To suggest a tidy continuum between the ideologies that marked the formation of anthropology as a discipline in the early twentieth century, and the present 'post-colonial' context, would be overdetermined. But what sort of shifts in significance are possible for cultural objects with such a legacy once visual displays do acknowledge transculturation?

Again, certain aspects of the professionalization of anthropology, particularly in France and Britain, warrant elaboration. As a means of validating the expansion of ethnographic collections, the rhetoric most

frequently employed was (and still is) the necessity of conserving and preserving the material culture in the museum's custody, in the face of what was taken to be the inevitable extinction of the producers themselves.[18] Paradoxically, of course, anthropology's desire for state recognition as an academic discipline, and its need for public funding, necessitated its aiding and abetting this extinction by proposing itself as an active agent in colonial subjugation. While speeding the inevitability of such destruction, anthropologists boosted the already multiple values assigned to the discipline's objects of study, thus enhancing the status of anthropological knowledge, while simultaneously ensuring that the producers maintained their position at the lower end of the evolutionary scale.

What we might then call the 'disappearing world' phenomenon is alive and well today and living in New York, London and Paris (or, as below, in the cutting room of Britain's Granada TV). Of course, now as then, any analysis of the effects of this ideology is complicated by its adoption for ostensibly different ends in the discourses of both Right and Left, with organizations like Survival International working in tandem and often on the initiative of indigenous rights organizations. In the words of one critic of the Granada TV series which has done so much to popularize the concept: 'The structural need which Disappearing World has for a fragile exoticism (a world as yet unrepresented) demands … difference and … disappearance is the only way of maintaining that distance.'[19] Paradoxically, while the programmes are premised on the inevitability of this destruction usually as a result of contact with western capitalism (if not with the paraphernalia of filmmaking itself), it is precisely those moments where the inevitability implied by such 'documentary' veracity is rumbled, that are edited out of the script permitted to the subjects of the Granada series.[20]

Crucially, critiques of the absences implicit in the 'disappearing world' syndrome have come from those whose experience is silenced through such representation. The example which immediately comes to mind is the protest made against the Museum of Mankind's 'Hidden Peoples of the Amazon' exhibition in 1985. Notwithstanding the use of the intractable interior of Burlington Gardens as an unlikely substitute for the Amazon Jungle, the exhibition itself provided a spectacle which represented the various Indian populations of the Amazon basin as productive, active and evidently in possession of an encyclopaedic knowledge of the complex ecology of their environment. The meta-narrative of the exhibition, however, if not already evident simply through both the actual and metaphorical 'containment' of diverse strata of Amerindian societies in three rooms of the Museum, is made explicit in the accompanying guide: after cataloguing the threats to the very environment represented in the display, the writer continues, 'In the light of this, reservations such as the large Xingu

que faut-il sauver du présent ?

71

Exhibits from 'Temps Perdu, Temps Retrouvé', at the Musée d'Ethnographie, Neuchâtel, 1985/86.

'What's worth preserving of the present?'

Indian park set up in Brazil in 1959, must be seen as the most acceptable of alternatives for the protection of Indian interests in the welter of modern economic development.'[21] The tone of resignation and inevitability here is continuing proof of the way in which those discourses used to justify ethnographic practice during its historical formation as an 'officially' accredited 'profession' are continually invoked today [**71**].

However, on 8 August 1985, the Museum was picketed by representatives from Survival International and two Indian representatives from different Indian rights organizations. What interests me here are the particular terms of their critique of the exhibition and the way it highlights some of the difficulties of addressing the issue of culture contact through the display of culturally 'hybrid' objects. The demonstration concerned not the absence of the evidence of culture contact, assimilation and adaptation in the display, but rather the absence of an acknowledgement of the dialectical and dynamic relationship of diverse Amerindian populations to such contact—not simply at the level of the hybridization of material culture, but at a much more fundamental social level. It concerned, in fact, the absence of any evidence of the ongoing struggle between the Indians and the Brazilian government; the absence of any signs of selective and strategic resistance; in short, the absence of any self-determination by those Indians represented in the exhibition. The Museum's concession to the contemporary situation was to put up a story-board advertising western aid

campaigns against the decimation of the Amazonian rain forests and two photographs supposed to demonstrate a flourishing hybrid culture—a ceremonial house made out of recycled cans and a Panare Indian in 'traditional' clothing riding a yellow Yamaha bike on a cleared highway. The statement made by Evaristo Nugkuag, one of the leaders of an Indian rights organization, neatly sums up the problem: 'It was as though we could have the white's machine without losing our land and our way of life.'[22]

Four years later, the Calgary exhibition 'The Spirit Sings: Artistic Traditions of Canada's First Peoples' put on to coincide with the Winter Olympics in January 1988, became the centre of another controversy. The Lubicon Lake Cree organized a demonstration and boycott of the Olympic Games in order to draw attention to their forty-year-old land claim. The exhibition itself gradually became the focus of the boycott since its very existence was only assured as the result of a substantial grant from Shell Oil Canada Ltd—who also happened to be drilling in precisely the area of the land claim. In the words of Bernard Ominayak, Chief of the Lubicon: 'The irony of using a display of North American Indian artefacts to attract people to the Winter Olympics being organized by interests who are still actively seeking to destroy Indian people, seems obvious.'[23] The curator's response was to play the old 'objectivity' card—'Museums, like universities, are expected by their constitutions, to remain non-partisan.'[24] In answer to the Lubicon's retort that Glenbow Museum had already made a political stand by accepting Shell sponsorship, the astounding response was that there was no 'evidence that the public confuses corporate support for corporate policy'.[25]

Clearly, those who apparently 'cannot represent themselves' are more than able to do just that. In both the Tukano and the Lubicon Cree cases, their intervention exposed not only the hidden agendas of corporate sponsorship and 'objective' museum scholarship, but also the inextricability of discourses of cultural continuity and/or cultural transformation as a result of contact with western capitalism, with other more problematic discourses around the concept of 'tradition'. The 'disappearing world' syndrome—the West's search for the authentic encounter with originary unity, that is both constantly threatened and passively awaited by those whose visibility rests on the magnanimity of 'objective' scholarship—was well and truly rumbled.[26]

Most importantly, both Amazon and Lubicon Indian rights groups have made it clear that there are complex interests at stake in the representation of culture contact in western museums. The 'context' which needs to be made explicit in such displays is no longer solely the old functionalist call for 'mythic' and 'ritual' significance, or a reassessment of the validity of such practices for the canons of the western art establishment, but the ways in which such cultural activities are often

72

Exhibits from 'Temps Perdu, Temps Retrouvé', at the Musée d'Ethnographie, Neuchâtel, 1985/86

Ethnographic objects as souvenirs including a mask from Gabon and a South American poncho which belonged respectively to Dr Albert Schweitzer and Jean-Jacques de Tschudi.

framed within a specific engagement with global politics, and certainly with local demands. The meanings attributed and attributable to such practices are, in fact, politically contingent, unstable and often strategic.

The historical conditions for culture appropriation by the West, and the critique of western modernism as posing some form of impossible universal internationalism, makes it untenable to speak of shifting the binary oppositions, for so long the structural principle in so much western appraisal of non-European culture, by simply including in the display objects showing signs of culture contact. Even if this does go some way towards disrupting the continuity of the search for authenticity it does little to disintegrate the problems implicit in the continued suggestion of the inevitability of the cycle of corruption, change and modernity. After a discussion of the multiple meanings produced by the evidence of such contact in the visual narratives of western ethnographic museums and art galleries, not to mention other media, this suggestion either has the ring of a native voluntarism about it or takes on a more pernicious aspect [**72**].[27]

Clearly, we should recognize the positive way in which the 'disappearing world' phenomenon and the question of culture contact is today inflected with other knowledges and a recognition in some instances of a 'post-colonial' context. The axes which operate now may be more productive: 'traditional' versus tourist or airport art; popular versus high culture; local versus global.[28] But is there, in fact, any evidence of other types of display policy that would shift the implicit value judgements of even these binaries, that would indeed provide the west-

ern viewer with the basis for acknowledging other, more complex, structural affinities and exchanges?[29]

III

'*Les Magiciens de la Terre*' at the Beaubourg in Paris was one of the more notorious exhibitions to foreground hybridity as a condition of 'post-coloniality'. It highlighted some of the problems in the kinds of binaries which are often reinforced despite the disavowal of any comparisons on the grounds of a spurious, but supposedly self-evident 'similarity' between exhibitors from the western metropolitan centres and those from nation-states with a more recent history of colonial subjugation. The irony here was, of course, that the one thing that most critics of the show picked up on was the major structuring device of racial and cultural 'difference'—a 'difference' which is transformed here into a 'cultural diversity', a contented global village. A highly selective 'difference' which includes African, Australian and Chilean artists, but has no room for the huge North African diaspora, the residents of the Beaubourg's neighbouring arrondissements.

This is where it might be valuable to consider the historical formation of the public museum as the transformation from private courtly collection to public collection, a moment represented in its starkest form by the foundation of the Louvre after the Revolution.[30] The subsequent invitation to participate in a supposedly shared culture—the address to the citizen—underwrites all public museums. In such spaces the viewer is necessarily interpolated as both citizen and individual, and the relationship between public and subjective identities, and the values and exclusions implicit in both, is crucial. In the context of '*Les Magiciens*', for example, the confusion invoked by such an address, and the contradictions between this and the actual address and conditions of access to cultural capital, might account for why the huge North African diaspora in Paris is a regular user of the videotech and library at the Beaubourg, but rarely, if ever, uses the exhibition space downstairs.[31] And this despite the fact that the Beaubourg is predicated on an almost monstrous visibility which declares through its 'transparent' functionalist architectural idiom a condition of permanent and open accessibility.[32]

If, as Paul Gilroy has suggested, 'diaspora' enables a way out of a binary constituted across 'essentialism' versus 'difference', we need to recognize the significance of the fact that 'hybridity' and 'difference' in most of these exhibitions are articulated as a symptom of what is identified as 'post-colonial' (itself a rather dubious category) as opposed to 'diasporic' formations.[33] It is a coincidence which effectively marginalizes diaspora—the 'Other' within—a concept which is far more politically disquieting to western bourgeois hegemonic culture. Perhaps this also accounts for the disruptive and transgressive

power (for all their failings) of exhibitions like Rasheed Araeen's 'The Other Story' at the Hayward Gallery and the earlier exhibition 'From Other Worlds' in London's Whitechapel Gallery.[34] In both these exhibitions, the primary constituency was precisely these 'new communities' (the result of migration, dispersal, and settlement) that have transformed for good the face of British society. Attentiveness to audience and constituency is all: who is doing the looking, or more precisely, who is being addressed, is a central issue. And, perhaps for this very reason, those exhibitions in the western metropolis which have turned an ironic and self-critical eye on the viewing subject and on the museological process of 'othering' have been most successful in pointing a way forward. In this respect the Museum of Ethnography at Neuchâtel under the direction of Jacques Hainard has been one of the most innovative precursors.[35]

In exhibitions such as '*Les Magiciens de la Terre*' the comparisons which serve to reinstate the binary divide are not between the signs of cultural assimilation or appropriation—the signifiers of 'difference'—in and between the work of Nancy Spero, Alfredo Jaar or Rasheed Araeen. The problematic and most striking comparison is between these self-consciously modernist and postmodernist artists and those like Cheri Samba or Sunday Jack Akpan, whose work grew out of a concern with, and certainly use of, the visual language associated with existing cultural practices which initially they transformed to create a new relevance, often for a popular local audience.

One of the questions this raises is whether or not the postmodern strategy of 'bricolage' (the organizing principle for '*Les Magiciens*') does in fact constitute a kind of counterpractice.[36] Maybe one of the distinctions between modernist collage and postmodernist 'bricolage' lies precisely in the ability of the former to articulate the dialectical tensions which the latter tends to reproduce as a free-flowing confusion and flux, what becomes, in fact, in-differentiation. Paradoxically, it may be the ethnographic museum (traditionally the site of 'visibility' of colonial appropriation and territorial expansion) where this dialectical relation is most likely, precisely because its 'visibility' was never the neutral in-difference of modernist universality—the claim to subjective individualism that is historically the project of the modern art museum.

In the same way that bricolage superficially reproduces the qualities of collage but smoothes over the fracture that collage retains, 'difference' as an analytical tool can simply revert to the pitfalls of the older cultural relativist model, concealing the distances between cultures while affirming that all are equal. The chasm is too great between the actual experience of economic, social and political disempowerment, and the philosophical relativism of postmodernism's celebration of flux and indeterminacy as the product of the mobility of global capital. We

need an account of difference which acknowledges the inequality of access to economic and political power, a recognition which would carry with it an analysis of class and gender relations within subaltern *and* dominant groups, and would articulate the ways in which such differences are constituted, not only in relation to the western metropolitan centres. Maybe this would allow us to explore hybridity as a condition occurring within and across different groups interacting in the same society. Néstor García Canclini has usefully discussed the shortcomings of the cultural relativist model as a means of explaining the 'hybridity' of Latin American culture as one of conflictual groups with common or convergent histories which may no longer exist separately.[37] Lisa Lowe points to the divisions and identities within the Asian-American community.[38] And finally, Homi Bhabha has spoken about the hybridity of all cultures—a suggestion which should encourage us to explore the specific conditions of this hybridity; the *how* and the *who* of it—which might then dispel (despite postmodernist pretensions) the monolithic repetition of hybridity as an encounter between the West and its Other and the ultimate reassertion of a Manichean model.[39]

For culture contact to be an effective strategy in countering the implicit racism of primitivist discourses in museums, then, it would require at least demonstrating a selective and self-conscious engagement with western consumerism. The knowing recognition of new markets, but also the vitality of a hybrid product that, crucially, speaks as directly to a thriving local market as it appeals now to a western tourist market. It would require a recognition of the cultural, economic and political infrastructure that already supports such activity on a local level and that existed long before the museum 'discovered' it. Such work is already inscribed within a complex critical discourse and does not depend on the western art establishment for its 'visibility'. In a sense, of course, the dialectical relationship that needs to be articulated in the cultural sphere—between the global and the local, the national and the truly international—is thwarted by the scarcity of exhibitions which raise any of these issues and the fact that each one that does is made to bear the entire burden of responsibility for redressing the balance. Nevertheless, one thing we should have learnt by now is that it is not enough to imagine the voluntarist disposal of the complex ideological frameworks, which have existed for so long in western cultural and scientific institutions, for the appraisal of non-western material culture, if the power relations which have facilitated such easy categories remain intact and unexposed. [...]

Remaking Passports: Visual Thought in the Debate on Multiculturalism

How do we interpret the changes in contemporary visual thought? One of the greatest difficulties rests in the fact that tendencies do not develop from one paradigm to the next. We are not displacing ourselves from one type of rationality and visuality to another as in the Renaissance or in the transition from classicism to romanticism, nor as in the substitution that happened amongst the avant-gardes throughout the 20th century. A real reorganisation has emerged from the intersection of multiple, simultaneous processes. Rather than changing, art appears to be vacillating. I am going to linger over one of those fluctuations which I consider to be crucial in the debate on identities: I am referring to the oscillation between a national visuality and the deterritorialised and transcultural forms of art and communication. Concerning the basis of this analysis, we might ask ourselves what type of visual thinking can speak today significantly in the discordant dialogue between fundamentalism and globalisation.

How are Artists Thinking?

This is difficult to answer if we consider that the polemic at the core of the modern aesthetic, that opposition between romanticism and classicism, persists even into postmodernity. For the romantics, art is a production of the intuitive and solitary genius; in the same way, reception is defined as an act of unconditional contemplation, the empathy of an individual sensitive disposition which allows itself to be penetrated by the mysterious eloquence of the work. Classical thought, by contrast, always works to subordinate sensibility and intuition to the order of reason: artistic production should be a way of presenting multiple meanings and expand the world in relation to its forms; we the spectators see those images in diverse ways—from the different codes imprinted in us by our social and educational structures—, searching for the geometry of the real or expressionistically lamenting its loss.

The history of modern art, written as the history of avant-gardes, has contributed to the maintenance of this disjunction: on one hand Surrealism Pop Art and 'Bad Painting', for example; and on the other, constructivism, the Bauhaus, geometricism and all the self-reflexive artists from Marcel Duchamp to the conceptualists, for whom art is a

mental activity. The disillusioned farewell to the avant-gardes did not end this dichotomy; some postmoderns nostalgically pursue the order of Hellenic or Renaissance symmetry (even if it is under the sceptical-ironic form of the ruin), others place their irrationalist vocation in the enigmatic exuberance of rituals and tribal objects. In the former case, the artist as archaeologist or restorer of classical harmony; in the second, as a 'magician of the earth'. Such work, part of the hypothesis of contemporary epistemology, at least since Gaston Bachelard and Claude Lévi-Strauss, argues that the theory of art stems from the dilemma between rationalism and irrationalism. I agree with Michel Serres when he said that Bachelard is the last romantic (his cultural psychoanalysis adopted a non-positivist polysemy of meaning) and the first neo-classicist (because he reunited 'the clarity of form for freedom and the density of content for understanding').[1] His new scientific spirit coincides, up to a point, with that of Lévi-Strauss when he demonstrated that the difference between science and magic, or between science and art, is not the distance between the rational and the pre-rational, but between two types of thought, one expressed in concepts and the other submerged in images. Magic and art are not weak or babbling forms of science, but—together with it—strategic and distinct levels in which nature and society allow themselves to be attacked by questions of knowledge.[2]

The second hypothesis is that a theory of art capable of transcending the antagonism between thought and intuition could contribute to a re-elaboration of the dilemmas of the end of the century, when all the socio-cultural structures are destabilised and we ask ourselves if it is possible to construct imaginaries that do not empty into irrational arguments. We need to discover if the actual organisation of the aesthetic field (producers, museums, galleries, historians, critics and the public) contributes, and in what way, to the elaboration of shared imaginaries. It is not only the wit of a picture or the will of the artist that is inserted in or isolated from social history; it is also the inter-action between the diverse members of the field (as both cultural system and market) which situates the significance of art in the vacil-lating meaning of the world.[3] In posing the problem in this way it is possible to include in the question something about how art thinks today, even its innovative gestures: what capacity to think about a world orphaned of paradigms do transgressive or deconstructive works possess that are submitted to the order of the museums and the market?

Our third hypothesis is that this contribution of art is enabled by tendencies which are not only dedicated to thinking about the national but also to multiculturalism and globalisation. It seems unattractive to elaborate this theme from the perspective of Latin American art, because many artists are moving in that direction; but the strategies of

the market, of international exhibitions and of the critics almost always banish it to the margins as the magic realism of local colour. Even when our people migrate extensively and a large part of our art work and literature is dedicated to *thinking* about the multicultural, Latin America continues to be interesting only as a continent of a violent nature, of an archaicism irreducible to modern nationality, an earth fertilised by an art conceived as tribal or national dreaming and not as thinking about the global and the complex.

How is the Nation Thinking, How is the Market Thinking?
Are the artists thinking the nation or thinking for it? When one observes, for example, the stylistic uniformity of French Baroque, Mexican muralism or American pop, one might ask if the artists of those currents thought the nation in their work or if they left the pre-existing cultural structure to shape the configuration. Individual differences in creative gestures are undeniable, but in the larger trajectory of these movements there has prevailed the enunciation of an 'ideology of images', a national community, that has proclaimed the heroism of the citizen, from David and Duplessis in pre-Revolutionary France,[4] across the reiterations of Diego Rivera, Siqueiros and their innumerable followers in Mexican legends, and through the work of Jasper Johns, Claes Oldenburg, Rauschenberg and others in the imaginary of the American consumer.

It is not possible to enter here into a debate on how far the possessions or patrimony of a nation condition fine art discourses and to what degree personal innovations evade such conditioning.[5] Rather, I am interested in emphasising that the modern history of art has been practised and written, to a great extent, as a history of the art of nations. This way of suppressing the object of study was mostly a fiction, but it possessed a verisimilitude over several centuries because the nations appeared to be the 'logical' mode of organisation of culture and the arts. Even the vanguards that meant to distance themselves from the sociocultural codes are identified with certain countries, as if these national profiles would help to define their renovative projects: thus, one talks about Italian futurism, Russian Constructivism and the Mexican Muralist School.

A large amount of actual artistic production is made as an expression of national iconographic traditions and circulates only in its own country. In this way fine art remains one of the nuclei of the national imaginary, scenarios of the dedication and communication of signs of regional identities. But a sector, increasingly more extensive in the creation, the diffusion and the reception of art, is happening today in a deterritorialised manner. Many painters whom critical favour and cultural diplomacy promote as the 'big national artists', for example Tamayo and Botero, manifest a sense of the cosmopolitan in their

73 Luis Felipe Noé

Algun dia de estos
(One of These Days), 1963

work, which partly contributes to their international resonance. Even those chosen as the voices of more narrowly defined countries—Tepito or the Bronx, the myths of the Zapotecos or the Chicano Frontier—become significant in the market and in the exhibitions of American art insofar as their work is a 'transcultural quotation'.[6]

It is not strange that time and again international exhibitions subsume the particularities of each country under conceptual transnational networks. The shows in the Georges Pompidou Centre, 'Paris-Berlin' and 'Paris-New York', for example, purported to look at the history of contemporary art not suppressing national patrimonies but distinguishing axes that run through frontiers. But it is above all the art market that declassifies national artists, or at least subordinates the local connotations of the work, converting them into secondary folkloric references of an international, homogenised discourse. The internal differences of the world market point less to national characteristics than to the aesthetic currents monopolised by the leading galleries, whose headquarters in New York, London, Paris, Milan and Tokyo circulate work in a deterritorialised form and encourage the artists to adapt to different 'global' publics. The art fairs and the biennials also contribute to this multicultural game, as one could see in the last Venice Biennale, where the majority of the 56 countries represented did not have their own pavilion: most of the Latin Americans (Bolivia, Chile, Colombia, Costa Rica, Cuba, Ecuador, El Salvador, Mexico, Panama, Paraguay and Peru) exhibited in the Italian section, but that mattered little in a show dedicated, under the title 'Puntos cardinales del arte/Cardinal Points of Art', to exhibiting what today is

constituted as 'cultural nomadism'.[7]

As these international events and the art magazines, the museums and the metropolitan critics manage aesthetic criteria homologous to the criteria of the market, so the artists who insist on national particularity rarely get recognition. The incorporation for short periods of some territorial movements into the mainstream, as happened with Land Art, or recently, with marginal positions, such as the Chicanos and Neomexicanists, does not negate the above analysis. The short-term speculations of the art market and their 'innovative and perpetual turbulence'[8] is as harmful in the long run to national cultures as to the personal and lengthy productions of artists; only a few can be adopted for a while to renovate the attraction of the proposition. It is in this sense that thinking today for much visual art means to be thought by the market.

From Cosmopolitanism to Globalisation

References to foreign art accompany the whole history of Latin American art. Appropriating the aesthetic innovations of the metropolises was a means for much art to rethink its own cultural heritage: from Diego Rivera to Antonio Berni, innumerable painters fed on Cubism, Surrealism and other Parisian vanguards to elaborate national discourses. Anita Malfatti found in New York expressionism and Berlin Fauvism the tools to reconceptualise Brazilian identity, analogous to the way Oswald de Andrade utilised the Futurist Manifesto to re-establish links between tradition and modernity in São Paulo.

This cosmopolitanism of Latin American artists resulted, in most cases, in the affirmation of the self. A national consciousness has existed, torn by doubts about our capacity to be moderns, but capable of integrating into the construction of repertoires of images the journeys, the itinerant glances, which would differentiate each people. The foreign 'influences' were translated and relocated in national matrices, in projects which united the liberal, rationalist aspiration for modernity with a nationalism stamped with the romantic, by which the identity of each people could be one, distinctive and homogeneous.

The pretension of constructing national cultures and representing them by specific iconographies is challenged in our time by the processes of an economic and symbolic transnationalisation. Arjun Appadurai groups these processes into five tendencies: a. the population movements of emigrants, tourists, refugees, exiles and foreign workers; b. the flows produced by technologies and transnational corporations; c. the exchanges of multinational financiers; d. the repertoires of images and information distributed throughout the planet by newspapers, magazines and television channels; e. the ideological models representative of what one might call western modernity: concepts of democracy, liberty, wellbeing and human rights, which

74 Guillermo Kuitca

Installation, IVAM Centre del Carme, Valencia, Spain, 1993

transcend the definitions of particular identities.[9]

Taking into account the magnitude of this change, the deterritorialisation of art appears only partly the product of the market. Strictly speaking, a part is formed by a greater process of globalisation of the economy, communications and cultures. Identities are constituted now not only in relation to unique territories, but in the multicultural intersection of objects, messages and people coming from diverse directions.

Many Latin American artists are participating in the elaboration of a new visual thought which corresponds to this situation. There is no single pathway for this search. One is amazed that the preoccupation with decentring the artistic discourse from national niches crosses as much through the expressionistic romantics as those who cultivate rationalism in conceptual practices and installations.

I agree with Luis Felipe Noé and his defence of an aesthetic that 'doesn't need a passport'. We cannot, he says, interrogate identity as a simple reaction against cultural dependency: to pose it in that way is like proposing 'to reply to a policemen who requires documents of identity or like a functionary who asks for a birth certificate'. For this reason, he affirms that the question whether there exists a Latin American art is one that is 'absurdly totalitarian'.[10]

Rather than devote ourselves to the nostalgic 'search for a non-existent tradition', he proposes we take on the diverse Baroque nature of our history, reproduced in many contemporary painters by 'an

incapacity to make a synthesis faced with the excess of objects'. He pleads for an expressionistic painting, like that of his own work: trying to feel oneself primitive in the face of the world, but transcended not so much by nature as by the multiplicity and dispersion of cultures. In this way, his paintings escape from the frame, reach from ceiling to floor, in tempestuous lands that 'rediscover' the Amazons, historical battles, the glance of the first conquistador [**73**].[11]

In another way, of a conceptual character, Alfredo Jaar realises an analogical search. He invented a Chilean passport, in which only the covers replicated the official document. Inside, each double page opened to show the barbed wire of a concentration camp which receded towards an infinity uninterrupted by the mountains. The scene could be in his native Chile or in Hong Kong—where he made a documentary for the Vietnamese exiles—, or in any of those countries where people speak seven languages and which repeat the phrase 'opening new doors', written in the sky of this closed horizontal: English, Cantonese, French, Italian, Spanish, German and Japanese. They correspond to certain nations with harder migration problems and with a more restrictive politics of migration. As the document of identification, at the same time national and individual, the passport is made to locate the origin of the traveller. It enables the passage from one country to another, but also stamps people by their place of birth and at time impedes them from change. The passport, as a synthesis of access entrapment, serves as a metaphor to men and women of a multi-cultural age, and amongst them to artists for whom 'their place is not within any particular culture, but in the interstices between them, in transit'.[12]

How can we study this delocalised art? By contrast to those explanations referring to a geographic milieu or a social unity, many actual artistic works need to be seen 'as something transported'. Guy Brett used this formula for the 'airmail' paintings of Eugenio Dittborn, those 'fold-up and compartmented rafts' that one receives in order to return: they are for 'seeing between two journeys'.[13] They are supported by a poetic of the transitory, in which their own peripheric nation—in this case Chile, the same as Jaar—can be the point of departure, but not the destination. Neither is any metropolis, as believed by some cosmo-politan Latin Americans, because the 'airmail' paintings, said Roberto Merino, also change metropolises into places of transit. Without centre, without hierarchical trajectories, these works, like those of Felipe Ehrenberg, Leon Ferrari, and many others who make postal art, speak about Chile, Mexico or Argentina but overflow their own territories, because the works' journeys make its external resonance a component of the message.

Dittborn used to include little houses in his paintings. The same tension between the journey and the period of residence is encountered

in the maps and beds of Guillermo Kuitca [**74**]. His images name at the same time the relation between particular territories and deterritorialisation. On one hand, street maps like that of Bogotá, whose streets are not drawn in lines but in syringes, or the maps of apartments made with bones, reflectors which illuminate uninhabited beds, the recording machines and the microphones without personages which allude to the terror in Argentina. 'During the time of the Malvinas I started to paint little beds... it was a period of depression and what I wanted to transmit in the work was that I was staying quiet with the paintbrush in my hand, and, to produce the painting, what was moving was the bed.'[14]

The quietude of the brush while the context was transformed, while people travel. In painting over the mattress maps of Latin America and Europe, Kuitca reconfigures the tensions of many exiles: from Europe to America, from one America to another, from America again to Europe. Is it for this reason that the 'beds are without homes'?[15] To organise the world, Kuitca poses it at the same time as travel and rest: the maps of cities on the mattresses seem intended to disrupt rest. He wants to reconcile the romantic sense, uncertain or simply a painful journey with the organised space of a regular mattress, or conversely, exasperate the rigorous geometry of the maps, superimposing them over the territory of dreams. The map as a ghost, or the bed as a root: bedmaps, in this way migrates the person who looks for roots.

Who Gives Passports?

These works do not allow us to interrogate them for social identities and the identity of art. But they attempt to be an art that recognises the exhaustion of ethnic or national mono-identities, which thinks to represent very little but talks about local and non-temporal essences. The materials that create their icons are not uniquely persistent objects, the monuments and rituals that gave stability and distinction to the culture are also related to passports, the beds with maps, the vibrant images of the media. Like today's identities, their works are polyglot and migrant, they can function in diverse and multiple contexts and permit divergent readings from their hybrid constitution.

But these multicultural reformulations of visual thinking are in conflict with at least three tendencies in the artistic camp/context. In the first place, in front of the inertia of the artist, intermediaries and public that continue to demand from art that it is representative of a pre-nationalised globalised identity. In the second place, the artist who relativises national traditions has difficulty being accommodated by state promotion which expects work from its creators that has the capacity to show to the metropolis the splendour of many centuries of national history.

Finally, the Latin American artists who work with globalisation

and multiculturalism interact with the strategy of museums, galleries and critics of the metropolis who prefer to keep them as representatives of exotic cultures, of ethnic alterity and Latin otherness, that is, in the margins. In the US, George Yúdice observes, the multicultural politic of the museums and universities has been useful more to the recognition of difference than as an interlocutor in a dialogue of equality, to situate them as a subaltern corner of the *American way of life*. 'If before, they asked Latin Americans to illustrate pure surrealism, as in the case of Alejo Carpentier, with his "marvellous realism" or his *santería*, now today they are asking that Latin Americans become something like "Chicano" or "Latino".'[16] Also, in Europe, the mechanisms of determination of artistic value hope that Latin Americans act and illustrate their difference: in a recent multicultural exhibition that took place in Holland, *Het Klimaat* (The Climate), the catalogue maintained that 'for the non-western artist or intellectual it is above all essential to create and recreate the historical and ideological conditions that more or less provide the possibility to exist'. The Argentinean artist Sebastián López challenged this 'condescending point of view' which relegates foreign artists to exhibiting their work in the alternative circuits: 'While the European artist is allowed to investigate other cultures and enrich their own work and perspective, it is expected that the artist from another culture only works in the background and with the artistic traditions connected to his or her place of origin (even though many Dutch managers of cultural politics, curators, and dealers were ignorant of these traditions and their contemporary manifestations). If the foreign artist does not conform to this separation, he is considered inauthentic, westernised, and an imitator copyist of 'what we do'. The universal is 'ours, the local is yours'.'[17]

Thinking today is, as always, thinking difference. In this time of globalisation this means that visual thinking transcends as much the romantic conceit of nationalism as the geometric orders of a homogenous transnationalism. We need images of transits, of crossings and interchanges, not only visual discourses but also open, flexible reflections, which find a way between these two intense activities: the nationalist fundamentalism which seeks to conjure magically the uncertainties of multiculturalism, and on the other, the globalising abstractions of the market and the mega exhibitions, where one loses the will and desire for re-formulating the manner in which we are thought.

The Art of Art History

> Is there not in the word *vrai* a sort of supernatural rectitude? Is there not in the terse sound it demands a vague image of chaste nudity, of the simplicity of the true in everything? ... Does not every word tell the same story? All are stamped with a living power which they derive from the soul and which they pay back to it by the mysteries of action and the marvellous reaction that exists between speech and thought—like, as it were, a lover drawing from the lips of his mistress as much love as he presses into them
>
> Honoré de Balzac, *Louis Lambert*

The modern practices of museology—no less than those of the museum's auxiliary discursive practice, art history (let us call this here *museography*)—are firmly rooted in an ideology of representational adequacy, wherein exhibition is presumed to 'represent' more or less faithfully some set of extra-museological affairs; some 'real' history which, it is imagined, pre-exists its portrayal; its *re*-presentation, in exhibitionary space.

However fragmentary, temporary, or terse the collection or exhibition, it exists today within the parameters of expectation established by two centuries and more of museums, galleries, salons, fairs, expositions, displays, and visual and optical demonstrations and experiments of many familiar kinds. Every exhibition is commonly understood as a fragment, or a selection out of, some absent and fuller whole. Every item in museological space is a *specimen*—a member of a class of like objects.

Each mode of modern exposition is in its own way the successor to, or a modern version of, one or more older 'arts', 'books', or 'houses' of memory, some of which are of very great antiquity in the West.[1] It may be useful to consider all such modes of exposition and display as comprising facets of an interrelated and mutually defining network of social practices or epistemological technologies which together make up the vast enterprise of modernity. Just as the set of practices which came to be orchestrated together as the modern museum may have had separate and distinct antecedents,[2] so too may it be useful to understand the museum as itself one of a *set* of techniques whose co-ordination and

interrelation came about in connection with the evolution of the modern nation-state.

This essay is a meditation or reflection (the use of such words is inescapably part of that long tradition) upon the broad architectonic parameters, distinctive features, or systemic structures underlying the historical formation of art history and museology. In particular, it is an attempt to articulate what characterizes the *storied space* of museology in a manner which may help shed light on what may have been at stake in the origins of art history, itself a facet of a broader discursive field that might possibly be termed 'museography'.

This I will characterize loosely for the moment as a peculiarly modernist orchestration and *linking together of subjects and objects in a variety of stages or venues that became key operating components of the efficient functioning of the modern nation-state.* These would include not only the familiar features of professional art historical practice such as slide, photo, and electronic archives and teaching facilities, but also aspects of the tourist, fashion, and heritage industries. Museums and other modernist artefacts such as novels would be examples of such museographic practices. More on these distinctions below.

One motivation for what follows here is the pressing need to think art history *otherwise*: to consider it apart from two kinds of inertias: first, the obstinacies of millennialist scenarios of traditional disciplinary historiographies, which continue to articulate the 'histories' of art historical practices in a social and epistemological vacuum (thus recapitulating and simulating the 'art history' of art history); second, the recent satisfactions of recanonization and the formulaic assimilation of various 'new art histories' that have largely expanded the ground of existing canons and orthodoxies rather than offering substantive alternatives to the *status quo*.[3] The format of what follows, then, reflects an attempt to stand apart from the discipline at an oblique and raking angle; to read it obliquely or *anamorphically*, as it were.

The evolution of the modern nation-state was enabled by the cumulative formation of a series of cultural institutions which pragmatically allowed national mythologies, and the very myth of the nation-state as such, to be vividly imagined and effectively embodied. As an imaginary entity, the modern nation-state depended for its existence and maintenance on an apparatus of powerful (and, beginning in the eighteenth century, increasingly ubiquitous) cultural fictions, principal amongst which were the *novel* and the *museum*. The origins of the professional discipline of art history, it will be argued here, cannot be understood outside of the orbit of these complementary developments.

The new institution of the museum in effect established an imaginary space-time and a storied space: a historically inflected or *funeous*[4]

site. It thereby served as a *disciplinary* mode of knowledge-production in its own right, defining, formatting, modelling, and 're-presenting' many forms of social behaviour by means of their products or relics. Material of all sorts was recomposed and transformed into component parts of the stage-machinery of display and spectacle. These worked to establish by example, demonstration, or explicit exhortation, various parameters for acceptable relations between subjects and objects, among subjects, and between subjects and their personal histories, that would be consonant with the needs of the nation-state. To be seen in the storied spaces of the museum were not only objects, but other subjects viewing objects, and viewing each other viewing. And the smile of the Mona Lisa appearing not to smile for thee.

Museums, in short, established exemplary models for 'reading' objects as traces, representations, reflections, or surrogates of individuals, groups, nations, and races and of their 'histories'. They were civic spaces designed for European ceremonial engagement with (and thus the evocation, fabrication, and preservation of) its own history and social memory.[5] As such, museums made the visible *legible*, thereby establishing what was worthy to be seen, whilst teaching museum users how to read what is to be seen: how to activate social memories. Art history becomes one of the voices—one might even say a major popular historical novel—*in and of* museological space.[6] In a complementary fashion, art history established itself as a window onto a vast imaginary universal museum, encyclopaedia, or archive of all possible specimens of all possible arts,[7] in relation to which any possible physical exhibit, collection, or museum would be itself a fragment or part.

Since its invention in late eighteenth-century Europe as one of the premier epistemological technologies of the Enlightenment, and of the social, political, and ethical education of the populations of modernizing nation-states, the modern museum has most commonly been constructed as an evidentiary and documentary artefact. At the same time, it has been an instrument of historiographic practice; a civic instrument for *practising* history. It constitutes in this regard a particular mode of fiction: one of the most remarkable genres of imaginative fiction, and one which has become an indispensable component of statehood and of national and ethnic identity and heritage in every corner of the world. In no small measure, *modernity itself is the museum's collective product and artefact; the supreme museographic fiction.*

What can it mean, then, to be a 'subject' in a world of 'objects' where some are legible or construed as *representative* of others because of their physical siting in the world, or the manner in which they are staged or framed? What constitutes such 'representation'? What exactly makes this possible or believable? The possibilities of representation in the modern world are grounded in much more ancient philosophical and

religious traditions of thought regarding the nature of the relations be-tween character and appearance. Nevertheless, as we shall see, there are aspects of civic and secular forms of representational adequacy and responsibility that are specific to the syntheses of modernity, being closely tied to what is made possible by the system of cultural techno-logies in service to, and simultaneously enabling, the nation-state.

We live in a world in which virtually anything can be staged or deployed *in* a museum, and in which virtually anything can be desig-nated or serve *as* a museum. Although in the last two decades of the twentieth century there has appeared an immense and useful literature on museums and museology,[8] it has also become clear that significant progress in understanding the remarkable properties, mechanisms, and effects of museological practice remains elusive. In fact it is clear that nothing less is demanded than a major rethinking of not a few historical and theoretical assumptions, and modes of interpretation and explanation. The position taken here is that the Enlightenment invention of the modern museum was an event as profound and as far-reaching in its implications as the articulation of central-point per-spective several centuries earlier (and for not dissimilar reasons).[9]

That this was truly a revolutionary social invention is increasingly clear. It was achieved abruptly in some places, and more gradually in others, as was the case with the European social revolutions that the new institution was designed to serve. The museum crystallized and transformed a variety of older practices of knowledge-production, formatting, storage, and display into a new synthesis that was com-mensurate with the eighteenth-century development of other modern forms of observation and discipline in hospitals, prisons, and schools.[10] In this regard, the museum will most usefully be understood as a prim-ary site for the manufacture of that larger synthesis constituting modernity itself; it simultaneously stands as one of its most powerful *epitomes.*

The following three sections consist of, first (Part 1) a series of observa-tions and informal propositions expanding on some of the ideas just outlined. Although much of this appears assertive and declarative, it is in fact written on a translucent surface beneath which you may be able to catch glimpses of descending layers of questions. Each proposition, then, may be taken as an anamorphic perspective on the entire set of observations; or as a provocation intended to move the discourse of museology out of its current muddy tracks. This is followed, in Part 2, by an expansion on the propositions and observations just set forth, which consists primarily of an examination of certain properties of the art of art history, particularly in its relationship to fetishism. The final section (Part 3) is an attempt to delineate in a systematic fashion the properties and features of the storied spaces of museology and museo-

graphy, and is written as a response to the question: what was most deeply at stake in the foundation of the discipline of art history two centuries ago?[11]

1. Museology and Museography

> I identify myself in language, but only by losing myself in it like an object.
>
> Jacques Lacan[12]

1. Museums do not simply or passively reveal or 'refer' to the past; rather they perform the basic historical gesture of *separating out of the present* a certain specific 'past' so as to collect and recompose (to *re*-member) its displaced and dismembered relics as elements in a *genealogy* of and for the present. The function of this museological past sited within the space of the present is to signal alterity or otherness; to distinguish from the present an Other which can be reformatted so as to be legible in some plausible fashion as generating or *producing* the present. What is superimposed within the space of the present is imaginatively juxtaposed to it as its prologue.[13]

This museological 'past' is thus an *instrument* for the imaginative production and sustenance of the present; of modernity as such. This ritual performance of commemoration is realized through disciplined individual and collective use of the museum, which, at the most basic and generic level, constitutes a choreographic or spatiokinetic complement or analogue to the labour of reading a novel or newspaper, or attending a theatre or show.

2. The elements of museography, including art history, are highly coded rhetorical tropes or linguistic devices that actively 'read', compose, and allegorize the past. In this regard, our fascination with the institution of the museum—our being drawn to it and being held in thrall to it—is akin to our fascination with the novel, and in particular the 'mystery' novel or story. Both museums and mysteries teach us how to solve things; how to think; and how to put two and two together. Both teach us that things are not always as they seem at first glance. They demonstrate that the world needs to be coherently pieced together (literally, re-membered) in a fashion that may be perceived as rational and orderly: a manner that, in reviewing its steps, seems by hindsight to be natural or inevitable. In this respect, the present of the museum (within the parameters of which is also positioned our identity) may be staged as the inevitable and logical outcome of a particular past (that is our heritage and origins), thereby extending identity and cultural patrimony back into a historical or mythical past, which is thereby recuperated and preserved, without appearing to lose its mystery.

In essence, both novel and museum evoke and enact a desire for

panoptic or panoramic points of view from which it may be seen that all things may indeed fit together in a true, natural, real, or proper order. Both modes of magic realism labour at convincing us that each of us could 'really' occupy privileged synoptic positions, despite all the evidence to the contrary in daily life, and in the face of domination and power.

Exhibition and art historical practice (both of which are subspecies of museography) are thus genres of imaginative fiction. Their practices of composition and narration constitute the 'realities' of history chiefly through the use of prefabricated materials and vocabularies—tropes, syntactic formulas, methodologies of demonstration and proof, and techniques of stagecraft and dramaturgy.[14] Such fictional devices are shared with other genres of ideological practice such as organized religion and the entertainment—that is, the containment—industries.

3. The museum is also the site for the imaginary exploration of link-ages between subjects and objects; for their superimposition by means of juxtaposition. The art museum *object* may be imagined as function-ing in a manner similar to an *ego*: an object that cannot exactly coincide with the subject, that is neither interior nor exterior to the subject, but is rather a permanently unstable *site* where the distinction between inside and outside, subject and object, is continually and unendingly negotiated.[15] The museum in this regard is a stage for socialization; for playing out the similarities and differences between an *I* (or eye) confronting the *world* as object, and an *I* (or eye) confronting *itself* as an object among objects in that world—an adequation, however, that is never quite complete. See also (8) below.

4. In modernity, to speak of things is to speak of persons. The *art* of art history and aesthetic philosophy is surely one of the most brilliant of modern European inventions, and an instrument for retroactively rewriting the history of all the world's peoples. It was, and remains, an organizing concept which has made certain Western notions of the subject more vividly palpable (its unity, uniqueness, self-sameness, spirit, non-reproducibility, and so on); in this regard it recapitulates some of the effects of the earlier invention of central-point perspective.

At the same time, the art of art history came to be the paradigm of all production: its ideal horizon, and a standard against which to meas-ure all products. In a complementary fashion, the producer or artist became the paragon of all agency in the modern world. As ethical artists of our own subject identities, we are exhorted to compose our lives as works of art, and to live *exemplary* lives: lives whose works and deeds may be legible as representative artefacts in their own right.

Museography in this regard forms an intersection and bridge between religion, ethics, and the ideologies of Enlightenment govern-ance, wherein delegation and exemplarity constitute political repres-entation.

5. Art is both an *object* and an *instrument*. It is thus the name of what is to be *seen*, read, and studied, and the (often occluded) name of the *language* of study itself; of the artifice of studying. As with the term 'history', denoting ambivalently a disciplined practice of writing and the referential field of that scriptural practice, *art* is the metalanguage of the history fabricated by the museum and its museographies. This instrumental facet of the term is largely submerged in modern discourse in favour of the 'objecthood' of art.[16] What would an art historical or museological practice consist of which was attentive to this ambivalence?

As an organizing concept, as a method of organizing a whole field of activity with a new centre that makes palpable certain notions of the subject, art renarrativizes and recentres history as well. As a component of the Enlightenment project of commensurability, art became the universal standard or measure against which the products (and by extension the people) of all times and places might be envisioned together on the same hierarchical scale or table of aesthetic progress and ethical and cognitive advancement. To each people and place its own true art, and to each true art its proper position on a ladder of evolution leading towards the modernity and presentness of Europe. Europe becomes not only a collection of artworks, but the organizing *principle of collecting*: a set of objects in the museum, and the museum's vitrines themselves.[17]

As Sir John Summerson astutely observed in 1960:

New art is observed as history the very moment it is seen to possess the quality of uniqueness (look at the bibliographies on Picasso or Henry Moore) and this gives the impression that art is constantly receding from modern life—is never possessed by it. It is receding, it seems, into a gigantic landscape—the landscape of ART—which we watch as if from the observation car of a train … in a few years [something new] is simply a grotesque or charming incident in the whole—that whole which we see through the window of the observation car, which is so like the *vitrine* of a museum. Art is behind glass—the history glass.[18]

Art, in short, came to be fielded as central to the very machinery of historicism and essentialism; the very *esperanto* of European hegemony. It may be readily seen how the culture of spectacle and display comprising museology and museography became indispensable to the Europeanization of the world: for every people and ethnicity, for every class and gender, for every individual no less than for every race, there may be projected a legitimate 'art' with its own unique spirit and soul; its own history and prehistory; its own future potential; its own respectability; and its own style of representational adequacy. The brilliance of this colonization is quite breathtaking: there is no 'artistic tradition' anywhere in the world which today is not fabricated through

the historicisms and essentialisms of European museology and museography, and (of course) in the very hands of the colonized themselves.

In point of fact, art history makes colonial subjects of us all.

In other words, the Enlightenment invention of the 'aesthetic' was an attempt to come to terms with, and classify on a common ground or within the grid of a common table or spreadsheet, a variety of forms of subject–object relationships observable (or imagined) across many different societies. As object and instrument, this art is simultaneously a kind of thing, and a term indicating a certain relativization of things. *It represents one end in a hierarchized spectrum from the aesthetic to the fetishistic*: an evolutionary ladder on whose apex is the aesthetic art of Europe, and on whose nadir is the fetish-charm of primitive peoples.

6. Taking up a position from within the museum makes it natural to construe it as the very summa of optical instruments, of which the great proliferation of tools, toys, and optical games and architectural and urban experiments of the eighteenth and nineteenth centuries might then be understood as secondary servo-mechanisms and anecdotal emblems. The institution places its users in anamorphic positions from which it may be seen that a certain historical dramaturgy unfolds with seamless naturalism; where a specific teleology may be divined or read in geomantic fashion as the hidden figure of the truth of a collection of forms; and where all kinds of genealogical filiations may come to seem reasonable, inevitable, and demonstrable. Modernity itself as the most overarching form of identity politics.

It is the most extraordinary of 'optical illusions' that museological space appears baldly Euclidean in this anamorphic dramaturgy. The museum appears to masquerade (but then there's no masquerade, for it's all masquerade) as a heterotopic lumber-yard or department store of alternative models of agency that might be taken up and consumed, meditated upon, imagined, and projected upon oneself or others. What one is distracted from is of course the larger picture and the *determinations* of these storied spaces: the overall social effects of these ritual performances, which (*a*) instantiate an ideology of the nation as but an individual subject writ large, and (*b*) reduce all differences and disjunctions between individuals and cultures to variations on the same; to different but commensurate versions of the same substance and identity. In such a regime, we are all relatives in this Family-of-Man-and/as-Its-Works.

7. Within the museum, each object is a trap for the gaze.[19] As long as our purview remains fixed in place at the level of the individual specimen, we may find it comfortable or pleasing to believe in an individual 'intentionality' at play in the production and appearance of things, as its significant and determinate, and even final, cause. Intentionality becomes the vanishing point, or explanatory horizon, of

causality. It is a catalyst of the ubiquitous museological exhortation, 'let the work of art speak directly to you with a minimum of interference or distraction.'[20]

8. The museum may also be understood as an instrument for the production of *gendered* subjects. The topologies of imaginary gender positions are among the institution's effects: the position of the museum user or operator (the 'viewer') is an unmarked analogue to that of an unmarked (usually, but not necessarily, male) heterosocial pose or position. But as an object of desire, the staged and storied museum artefact is simultaneously a simulacrum of an agental being or subject (usually, but not necessarily female) with whom the viewing subject will bond, or by whom he/she will be repelled.

In short, the superimposition of subjects and objects within the storied space of the museum creates the conditions for a blurring or complexifying of male–female gender distinctions: the museum object, in other words, is gender-ambiguous. Such an ambiguity creates the need for more distinct gender-framing. What becomes clear in the process is that all art is drag, and that *both* hegemonic and marginalized sexualities are themselves continual and repeated imitations and re-iterations of their own idealizations. Just as the viewer's position in exhibitionary space is always already prefabricated and bespoken, so too is all gender (a) drag.[21]

Museology and museography are instrumental ways of distributing the space of memory. Both operate together on the relationships between the past and present, subjects and objects, and collective history and individual memory. These operations are in aid of transforming the recognized past *in* the present into a storied space wherein the past and present are imaginatively *juxta*posed, where their virtual relationships cannot *not* be construed as succession and progression; cause and effect. Where, in other words, the illusion that the past exists in and of itself, immune from the projections and desires of the present, may be sustained.

Progress in understanding the museographical project, as well as the museology which is one of its facets, would entail taking very seriously indeed the paradoxical nature of that *virtual* object (what I elsewhere called the *eucharistic* object)[22] that constitutes and fills that space. The art of art history and its museology became an instrument for thinking representationally and historically; for imagining a certain kind of historicity commensurate with the (now universally exported) nationalist teleologies of European modernity.

2. Art History and Fetishism
To appreciate the extraordinary power and success of this enterprise, we would have to articulate in fine detail what was most deeply at stake

two centuries ago in the invention of the modern nation-state. What came to be the canonical art of art history was indeed a magical and paradoxical object, perfectly suited to being an explanatory instrument in the enterprise of fabricating and sustaining the modern nation-state and its (statuesque) epitome, the citizen.[23] It becomes the product of the aestheticization of social life, and the embodiment of social desires.

Art was the complementary (civilized) foil to its implicit and imaginary obverse, that enigma of the Enlightenment, the (uncivilized) fetish: that 'safely displaced synecdoche of the Enlightenment's Other', in the words of William Pietz.[24] It was a powerful instrument for legitimizing the belief that what you see in what you make is what in some deep, essential way you truly *are*. The form of your work is the *physiognomy* of your truth. At the same time, it provided a powerful instrument for making palpable the proposition that Europe was the brain of the earth's body, and that all outside the edifice of Europe was its prologue. Of course that external anterior, that Other, was the necessary support and defining instance of what constituted the presence, the modernity, of Europe.[25]

The term fetish ultimately derives from the Latin adjective *factitius* (used by Pliny to refer to that which is the result of art or artifice), through the Portuguese (*feiticaria*, a term applied to West African 'witchcraft' and idol-worship), the word *fetisso* referring to small objects or charms used in trade between West Africans and Europeans. Its early modern meaning may have more to do with a late Latin sense of the term as something imitative of natural properties (like sound, as in onomatopoeia).

At any rate, it came to be constituted as the uncivilized (read 'black') anterior to the imaginary 'disinterestedness' of European aestheticism. These two terms imply one another and cannot be understood in isolation from each other. Their dyadic *complementarity* has served as the skeletal support of all that art history has been for the past two centuries.

There are some processual parallels. If sexuality came to be privileged by European society as of the essence of the self—the innermost truth of one's personality—then art might come to be its civilized and complementary obverse, the very mark of civilized interaction between subjects and objects. In modernity, moreover, art and sex are *commensurate*: like sex, art became a secret *truth* to be uncovered about all peoples everywhere; an omnipresent, universal phenomenon linking the caves of Lascaux with the lofts of lower Manhattan—a fictitious unity, to be sure, yet an immensely powerful and durable one.

Historically, art and fetish came to occupy opposite poles in what was none the less a spectrum of continuities from disinterestedness to idolatry, from the civilized to the primitive. Neither one, in short, can be understood in isolation from the other.

Art did not precede art history like some phenomenon of nature discovered and then explained by science. Both are ideological formations designed to function within specifiable parameters. Art history, aesthetic philosophy, museology, and art-making itself were historically co-constructed social practices whose fundamental, conjoint mission was the production of subjects and objects commensurate with each other, and possessive of a decorum suitable for the orderly and predictable functioning of the emergent nation-states of Europe.

At the same time, this enterprise afforded the naturalization of an entire domain of dyadic and graded concepts that could be employed as ancillary instruments for scripting (and then speaking about) the histories of all peoples through the systematic and disciplined investigation of their cultural productions.[26] Museography and its museologies were grounded upon the metaphoric, metonymic, and anaphoric associations that might be mapped amongst their archived specimens. They demonstrated, in effect, that all things could be understood as specimens, and that specimenization could be an effective prerequisite to the production of useful knowledge about any thing.

This archive, in other words, was itself no passive storehouse or data bank; it was rather a critical instrument in its own right; a dynamic device for calibrating, grading, and accounting for variations in continuity and continuities in variation and difference. The epistemological technology of the museographical archive was and remains indispensable to the social and political formation of the nation and to its various legitimizing paradigms of ethnic autochthony, cultural uniqueness, and social, technological, or ethical progress (or decline) relative to real or imagined Others.

It works, in part, this way. The enterprises of mythic nationalism required a belief that the products of an individual, studio, nation, ethnic group, class, race, or even gender would share demonstrably common, consistent, and unique properties of form, decorum, or spirit. Correlative to this was a paradigm of temporal isomorphism: the thesis that an art historical period or epoch would be marked by comparable similarities of style, thematic preoccupation or focus, or techniques of manufacture.[27]

All of this makes sense only if time is framed not simply as linear or cyclic but rather as *progressively unfolding*, as framing some epic or novel-like adventure of an individual, people, nation, or race. Only then would the notion of the period be pertinent, as standing for a plateau or stage in the graded development of some story. (It would have to be graded; or delineated into chronological parts or episodes, so as to be vividly perceptible to an audience.) The period would mark gradual changes in things—as the gradual change or transformation of that Thing (or Spirit) underlying things.

Museology and museography fabricated object-histories as surrog-

ates for or simulacra of the developmental histories of persons, mentalities, and peoples. These consisted of narrative stagings—historical novels or novellas—that served to demonstrate and delineate significant aspects of the character, level of civilization or of skill, or the degree of social, cognitive, or ethical advancement or decline of an individual, race, nation.[28]

Art historical objects have thus always been *object-lessons* of documentary import in so far as they might be deployed or staged as cogent 'evidence' of the past's causal relationship to the present, enabling us thereby to articulate certain kinds of desirable (and undesirable) relations between ourselves and others. Rarely discussed in art historical discourse in this regard is the silent contrast between European 'progress' in the arts in contradistinction to the coincident 'decline' of Europe's principal Other in early modern times, the (comparably multinational and multi-ethnic) world of Islam.[29]

It is in this connection that we may understand the enterprises of museography and museology as having served, in their heyday (which is still now) as a very powerful and effective modern(ist) *concordance* of politics, religion, ethics, and aesthetics. It still remains virtually impossible, at the end of the twentieth century, *not* to see direct, causal, and essential connections between an artefact and the (co-implicative) moral character and cognitive capacity of its producer(s). Such idealist, essentialist, racist, and historicist assumptions as were so explicitly articulated in museology and art history in their historical origins still commonly comprise the subtext of contemporary practices, underlying many otherwise distinct or opposed theoretical and methodological perspectives.

The nation as the *ark* of a people: a finite and bounded artefact with a trajectory in time; a storied space. Museology and art history as cybernetic or navigational instruments; optical devices allowing each passenger (who is also always permitted to play the role of 'captain' of his or her own fate) both to see behind the ship, the direction whence it came (its unique and singular past), and to steer and guide it forward along the route implied by its prior history: the reflection back from the vanishing-point in the past to the ideal point of fulfilment in the future.

Its substance is 'art', that extraordinary *artifice* (or anti-fetishist fetish) which is the art of art history; the Enlightenment invention designed/destined to become a universal *language of truth* (revelatory along a sliding scale from primitive fetish to art). It is the common frame within which all human manufacture could be set, classified, fixed in its proper places, and set into motion in the historical novel of the nation.

The art of art history is the Latin of modernity: a universal medium of (formerly religious, latterly scientific) truth. At the same time it is a

golden standard, mean, or ideal canon, relative to which all forms of (manu)facture are anticipatory; relative to whose ideal orotundities each utterance is an approximation, as each botanical entity is a realization of certain ideal internal formal relationships.[30]

This was nothing less than a brilliant gesture and a massively devastating hegemonic act, this transformation of the world into not simply a 'picture' but an image of what would be visible from the specific central-point perspective of Europe masquerading *as* a snapshot, or archive, or museum, of the world, exported and assimilated around the world as the natural and 'modern' order of things. This making of Europe into the *brain of the earth's body* and a vitrine for the collection and containment of all the things and peoples of the world: the most thoroughgoing and effective imperialist gesture imaginable. Eurocentrism was more than any of the myriad ethnocentrisms ubiquitous elsewhere, but was a co-option of all possible centres.[31]

Modernity, the nation-state, as an effect of the *aestheticization* of social relations; as a *factitius*-object which is simultaneously a space and a time. What would have been needed to effect this transformation? How might it have worked? Just what is this 'space'?

What follows is a preliminary sketch or blueprint of this technology.

3. Art History in Space and Time
I

First, a small *frontispiece*.[32]

The Paris Exposition of 1900 was organized spatially in such a manner that the 'palaces' built to house the products of the two major French colonies of Algeria and Tunisia were situated between the Trocadero Palace on the right bank of the Seine and the Eiffel Tower on the left bank. Looking north from the elevated eye of the Tower towards the Trocadero across the river, you would see these colonial buildings embraced by the two arms of the Trocadero's 'Neo-Islamic' style façade. France's North African colonies—indeed all of them— would appear to occupy a place within the nurturing and protective arms of the French nation, whose own identity would appear to be figured as assimilative, and thus supportive of, the peoples[33] and products that were contained and exhibited in and by these colonial edifices.

Taking up the view from the opposite direction, looking south from the Trocadero towards the Exposition ground across the river, there is a markedly different morphology. The entire fairground is dominated by the Eiffel Tower, that gigantic technological feat of modern French engineering. Dwarfing all the colonial edifices like a colossus (or a colossal figure of the sublime),[34] its four great piers are grounded amongst the massed buildings of the colonial possessions. Appearing to have been built up on top of these buildings, the Tower, one might

say, puts things (back) in a proper perspective.[35]

This extraordinary image—a veritable two-way mirror—is a clear and poignant emblem both of the imaginary logic of nationalism (and its imperialist correlates), and of the rhetorical carpentry and museological stagecraft of art historical practice. Consider the following.

From a eurocentric point of view, art history is constru(ct)ed as a universal empirical science, systematically discovering, classifying, analysing, and interpreting specimens of what is thereby instantiated as a universal human phenomenon. This is the ('natural') artisanry or 'art' of all peoples, samples of which are all arranged relative to each other both in museum space and in the more extensive, encyclopaedic, and totalizing space-time of museography, a distillation and refraction of Universal Exposition. All specimens in this vast archive sit as delegates or 'representatives'—that is, as representations—in a congress of imaginary equals, as the myriad of manifestations making up a Universal World History of Art. To each is allotted a plot and display space, a platform or a vitrine.

And yet, if you shift your stance just a bit—say by taking up a position amongst the objects and histories of non-European (or, in recent disciplinary jargon, 'non-Western') art, it becomes apparent that this virtual museum *has* a narrative structure, direction, and point. All its imaginary spaces lead to the modernity of a European present, which constitutes the apex or observation-point; the vitrine within which all else is visible. Europe, in short, *is* the museum space within which non-European specimens *become* specimens, and where their (reformatted) visibility is rendered legible.

European aesthetic principles—in the guise of a reinvented generic modern or neo-classicism (or 'universal principles of good design'[36])— constitute the self-designated unmarked centre or Cartesian zero-point around which the entire virtual museographic edifice circulates, on the wings of which all things may be plotted, ranked, and organized in their differential particularities. There is no 'outside' to this: all different objects are ranked as primitive, exotic, charming, or fascinating distortions of a central classical (European) canon or standard—the *un*marked (and seemingly unclassed, ungendered, and so on) point or site towards which all others may be imagined as aspiring. A veritable Eiffel Tower, if you will.

What would be pragmatically afforded by this archive was the systematic assembly or re-collection of artefacts now destined to be constru(ct)ed as material *evidence* for the elaboration of a universalist language of description and classification: the vocabulary of art history. Even the most radically disjunctive differences could be reduced to differential and time-factored qualitative manifestations of some pan-human capacity; some collective human essence or soul. In other words, differences could be reduced to the single dimension of differ-

ent (but ultimately commensurate) '*approaches* to artistic form' (*the* Inuit, *the* French, *the* Greek, *the* Chinese, and so on). Each work could be seen as approximating, as attempting to get close to, the ideal, canon, or standard. (The theoretical and ideological justification for 'art criticism' is thus born in an instant, occluding whilst still instantiating the magic realisms of exchange value.)[37]

In short, the hypothesis of art as a universal human phenomenon was clearly essential to this entire enterprise of commensurability, intertranslatability, and hegemony. Artisanry in the broadest and fullest sense of 'design' is positioned—and here of course archaeology and palaeontology have their say—as one of the defining characteristics of humanness. The most *skilled* works of art shall be the *widest* windows onto the human soul, affording the *deepest* insights into the mentality of the maker, and thus the clearest refracted insights into humanness as such.

The art of art history is thus simultaneously the instrument of a universalist Enlightenment vision *and* a means for fabricating qualitative distinctions between individuals, peoples, and societies. How could this be?

Consider again that essential to the articulation and justification of art history as a systematic and universal human science in the nineteenth century was the construction of an indefinitely extendable *archive*,[38] potentially coterminous (as it has since in practice become) with the 'material (or "visual") culture' of all human groups. Within this vast imaginary museographical artefact or edifice (every slide or photo library as an *ars memorativa*)—of which all museums are fragments or part-objects—every possible object of attention might then find its fixed and proper place and address relative to all the rest. Every item might thereby be sited (and cited) as referencing or indexing another or others on multiple horizons (metonymic, metaphoric, or anaphoric) of useful association. The set of objects displayed in any exhibition (as with the system of classification of slide collections) is sustained by the willed fiction[39] that they somehow constitute a coherent 'representational' universe, as signs or surrogates of their (individual, national, racial, gendered) authors.

The pragmatic and immediately beneficial use or function of art history in its origins was *the fabrication of a past that could be effectively placed under systematic observation for use in staging and politically transforming the present*.[40] Common to the practices of museography and museology was a concern with spectacle, stagecraft, and dramaturgy; with the locating of what could be framed as distinctive and exemplary objects such that their relations amongst themselves and to their original circumstances of production and reception could be vividly imagined and materially envisioned in a cogent and useful manner. This is useful above all to the production of certain modes of civic subjectivity

and responsibility. The problem of historical causality, evidence, demonstration, and proof constituted the rhetorical scaffolding of this matrix or network of social and epistemological technologies.

Needless to say, much of this was made feasible by the invention of photography—indeed, art history is in a very real sense the child of photography, which has been equally enabling of the discipline's fraternal nineteenth-century siblings, anthropology and ethnography.[41] It was photography which made it possible not only for professional art historians but for whole populations to *think art historically* in a sustained and systematic fashion—to put Winckelmann, Kant, and Hegel into high academic gear, as it were, thereby setting in motion the stage machinery of an orderly and systematic university discipline.

It also, and most crucially, made it possible to envision objects of art as *signs*. The impact of photography on determining the future course of art historical theory and practice was as fundamental as Marconi's invention of the wireless radio six decades later in envisioning the concept of arbitrariness in language—which, as linguists of the 1890s very rapidly saw, paved the way for a new synthesis of the key concepts of modern linguistics.

As we have seen, a clear and primary motivation for this massive archival labour was the assembly of material evidence justifying the construction of historical novels of social, cultural, national, racial, or ethnic origins, identity, and development. The professional art historian was a key instrument for scripting and giving voice to that archive, providing its potential users, both lay and professional, with safe and well-illuminated access routes into and through it. Museology itself became a key art of this museography, this House of Historicist Memory, evolving as it did as a paradigmatic instrument for the *instituting* of archivable events.

Once again: What kind of *space* is here delineated?

II

Not a conclusion, but a proposition:
The space of museography, the edifice of art history, is a virtual space in three dimensions, each of which affords and confers a specific mode of legibility upon objects in their relationship to subjects. This social and epistemological space may be imagined as having been constructed, historically, through a *triple superimposition* beginning in the second half of the eighteenth century.

(*A*) The *First Superimposition* (this might be called the dimension or axis of Winckelmann) entailed the superimposition of objects and subjects wherein the object is seen by a subject as through a screen of the erotic fetishization of another subject:[42] the object, in short, is invested with erotic agency.

[The object is deployed as an object of sublimated erotic desire]

(*B*) The *Second Superimposition* (this might be called the dimension or axis of Kant) affords a linkage of erotics and ethics, or the hierarchized markedness of eroticized objects: their ethical aestheticization. This hierarchization constitutes a spectrum or continuum from the fetish to the work of fine art. Aesthetics is thereby entailed with a superior ethics, fetishism with an inferior one: but both were commensurate *as* ethical.[43]

[The ethically eroticized object of desire is rescued from cultural and ethical relativism]

(*C*) The *Third Superimposition* (this might be called the dimension or axis of Hegel) affords the *historicization of ethically eroticized objects*, a hierarchization of time in terms of teleology. This museographical space in which ethically eroticized objects are rendered legible is thus a *storied* site, within which objects become protagonists or surrogate agents in historical novels (one version of which is the modern museum) with a common underlying theme: the search for identity, origins, and destinies.

[Ethically superior objects of desire are teleologically marked, their time-factored truth positioned in contradistinction to objects exterior (and thus always already anterior) to time's leading edge, which is the European present; the point of seeing and of speaking; the vitrine in which is re-collected the rest of what has thus become a *remaindered* world][44]

The result of these superimpositions is the spatiotemporal economy of modernity, the storied space and museographic artefact of an unending process. These superimposed coordinates are realized on a variety of fronts, which include but are not exhausted by the museum and art history. As a key component of the operating engines of the modern nation-state, museography worked toward the systematic historicization of ethically eroticized objects of value as *partners* in the enterprises of the social collective.[45]

At the same time, the framed and storied artefacts or monuments were invested with a *decorum*, wherein objects would be legible in a disciplined manner, construable as emblems, simulacra, or object-lessons; as 'illustrating' (or 'representing') desirable and undesirable social relations in the (perpetually) modernizing nation (whose faults, it may be added, would seem to lie not in its nature, but in the relative abilities of its citizens to realize the national potential).

In addition, artworks, monuments, archives, and histories are the *sites* where the hidden truth of the citizen, the modern individual, is to be rediscovered and read. (Of course there is never a final monument.)[46] The art historical object is the *elsewhere* of the subject, the place where it is imagined that unsaid or unsayable truths are already

written down. Museography might have been a 'science', then, both of the idea of the nation, and of the discovery of the truth of individuals (nations, ethnicities, races, genders) in their objects and products.

Such a science, however, did not exist as a single professional field, but rather as the generic protocol of modern disciplinarity as such; as 'method' itself. It existed perhaps at such a scale as to be invisible in the ordinary-light spectrum of individual perceptions. It could be known and recoverable today through an examination of traces and effects dimly legible in its later twin progeny (separated at their disciplinary birth), namely, history and psychoanalysis,[47] or through a critical historiography of a discursive practice—art history—that was always a superimposition of the two before their modern schism, and that in its oscillatory and paradoxical *modus vivendi*, continues to bridge, albeit at times in the dark, what has since become their difference. Its oscillations *are* that bridge.

Traces of this superimposition are palpable in that ambivalent and paradoxical object that has constituted the *art* of art history since the Enlightenment, with its perpetual oscillation between the ineffable and the documentary, the eucharistic and the semiotic.[48] The art of art history circulates in a virtual space whose own dimensions are the result of the triple superimpositions described above.

Modernity is thus the paradoxical *status quo* of nationalism. It exists as a virtual site constituting the edge between the material residues and relics of the past and the adjacent empty space of the future. That which is perpetually in between two fictions: its origins in an immemorial past and the destiny of its fulfilled future. The fundamental labour of the nation and its parts, this cyborg entity conjoining the organic with the artefactual, was to use the image of the latter fulfilment as a rear-view mirror oriented back towards the former, so as to reconstitute its origins, identity, and history as the reflected source and truth of that projective fulfilled destiny. A hall of mirrors, in fact.

You might *picture* it this way:

You're standing in the middle of a small room. The wall ahead of you is all mirror. That behind you is also mirrored. When you stand in such a place, watching your image reflected *ad infinitum*, you can usually see, after a dozen or so repeated reflections, that your images recede in a gradually accelerating curve, in one direction or another—up or down, or to one or another side. After a while you notice that the reflections are not infinite at all, but rather *disappear* behind one of the room's structural boundaries, or behind your own image. And you can't see the spot where the vanishing-point actually vanished: you are occluded by your own image or by its frame.

Of course, at a quick glance you *do* seem to go on for ever, your finitude safely invisible.

Or, you might phrase it this way:

I identify myself in language, but only by losing myself in it like an object. What is realized in my history is not the past definite of what was, since it is no more, or even the present perfect of what has been in what I am, but the future anterior of what I shall have been for what I am in the process of becoming.[49]

Comprehending art history's past is a prerequisite to coping with its present, and productively imagining its futures, should it have any. So much would seem obvious. But to do so effectively would mean at the very least abandoning certain comfortable academic habits of viewing art history's history as a straightforward practice—as simply a history of ideas about art, or as genealogies of individuals who had ideas about art and its 'life' and its 'history', or as an episode in the evolutionary adventure of the history of ideas—as increasingly refined protocols of interpreting objects and their histories and their makers: all those 'theories and methods' from Marxism to feminism, or from formalism and historicism to semiology and deconstruction; and all those disciplinary object-domains from fine art to world art to visual culture, which by hindsight seem so very much cut from the same cloth.

Art history was a complex and internally unstable enterprise throughout its two-century history. Since its beginnings, it has been deeply invested in the fabrication and maintenance of a modernity that linked Europe to *an ethically superior aesthetics grounded in eroticized object-relations*, thereby allaying the anxieties of cultural relativism, wherein Europe (and Christendom) were, in their expanding encounter with alien cultures, but one reality amongst many.[50]

It has been argued here that art history was always a facet of a broader set of practices that I have termed museography, and that to isolate art history and its history from the circumstances and motivations that conferred viability and substance upon it would be to perpetuate the obstinacies of disciplinarity itself. Effectively remembering what the millennialist discipline with the innocuous name of 'the history of art' *did* may, in its own ironic way, and at the same time, require *forgetting* art history: thinking it *otherwise*, so as to recollect it more completely.

Afterword

At the beginning of this anthology I alluded to my position as an anthologizer who is himself part of the debates. You will have noticed that the introductory discussions in each chapter sought to avoid giving the impression of an impossible position: that of a neutral frame that is not part of what it frames. I hope to have made clear throughout this book that any such 'positionless position' was part of a hegemonic dream—a desire to impose itself not as 'interpretation' but as reason itself.

Any notion of an institution or discipline as a neutral arena or stage for fielding investigation and analysis is itself an interpretation and part of the very conflict it purports to oversee. This is no less true of the history of art history, which, as this volume has demonstrated, is marked by irreducible ambivalences and by constant oscillations between the articulation of aesthetic autonomy and specificity, and aesthetic contingency: the object as unique and irreducible, a bounded essence, and as expression, medium, representation, or the effect of something more basic, real, or true (Spirit, political economy, ethnicity, gender, and so on). The artwork as monument and as document.

'Art history' has been the name given to the institutionalization of these unresolvable contradictions for two centuries. They may only be resolved by fundamentally changing the terms of the debate: a possibility which may very well transform beyond recognition what has been 'art history'. Not a few glimmerings of such unrecognizable histories of art have been seen above, and by no means only at the recent end of art history's history.

Art history has been no exception to the rule that all institutional structures and academic curricula tend to perpetuate a dissimulation of the conflicts that have produced them. Some more than others carry such dissimulations into a mythical consensus on the model of the seemingly neutral level of the university itself,[1] whether articulated as a liberal mall or 'marketplace of ideas' (in which the presumably strong and well funded survive) or as some other less ruthless eclectic 'pluralism'.

We have seen many articulations, transformations, and metamorphoses of these positions in this collection. My aim has been to juxta-

pose and superimpose examples of some especially useful and thought-provoking resources for readers to construct critical histories of the discipline of art history—both of art history's art, and of art history as an art (the two, it will have become quite clear in this volume, are inextricable)—and at the same time to imagine its possible futures. Along the way it may have been possible to imagine some of the possible alternative futures it might have had at times in the past.

I will leave you with a quotation which succinctly (if unintentionally) summarizes what has been at stake in the 200-year-old history of debates and dreams sometimes given the name 'art history'. It is by a Parisian interior decorator hired by the Getty Museum to introduce colour to the stark white Late Modernist gallery interiors of its new modern art museum being built on a Los Angeles mountain top. Asked by the *Los Angeles Times* about his plans, the interior designer said: 'Architecture is meant to be experienced and not talked about.'[2] In that assertion, which necessarily entails and evokes its devalued contrary (and which could just as well be reversed to be pertinent here), is summarized both the history of art history's art, and the history of art history *as* an art: an *art of history* both designed and destined to be as eloquent in its silences as in its speech.

Notes

Donald Preziosi: Making the Visible Legible
1. The following books may provide useful overviews of the historical development of the modern discipline; many of these are discussed in the chapters of the text below: Oskar Baetschmann, *Einfuehrung in die Kunstgeschichtliche Hermeneutik* (Darmstadt, 1984); Moshe Barasch, *Modern Theories of Art, 1: From Winckelmann to Baudelaire* (New York, 1990); Michael Baxandall, *Patterns of Intention: On the Historical Explanation of Pictures* (New Haven, 1985); Hans Belting, *The End of the History of Art?* (Chicago, 1987); Heinrich Dilly, *Kunstgeschichte als Institution: Studien zur Geschichte einer Disziplin* (Frankfurt, 1979); Paul Duro and Michael Greenhalgh, *Essential Art History* (London, 1992); Eric Fernie (ed.), *Art History and Its Methods* (London, 1995); Ernst Gombrich, *Reflections on the History of Art: Views and Reviews* (Princeton, 1987); Arnold Hauser, *The Philosophy of Art History* (New York, 1959); A. L. Lees and F. Borzello, (eds.), *The New Art History* (Atlantic Highlands, NJ, 1988); W. E. K. Kleinbauer, *Modern Perspectives in Western Art History* (New York, 1971); Vernon Minor, *Art History's History* (New York, 1994); Erwin Panofsky, *Meaning in the Visual Arts: Papers in and on Art History* (New York, 1955); Michael Podro, *The Critical Historians of Art* (New Haven, 1982); Marcia Pointon (ed.), *Art Apart: Art Institutions and Ideology Across England and North America* (Manchester, 1994); Alex Potts, *Flesh and the Ideal: Winckelmann and the Origins of Art History* (New Haven and London, 1994); Donald Preziosi, *Rethinking Art History: Meditations on a Coy Science* (New Haven and London, 1989); Mark Roskill, *What is Art History?* (2nd edn., Amherst, 1989); Hans Sedlmayr, *Kunst und Wahrheit: Zur Theorie und Methode der Kunstgeschichte* (Hamburg, 1978); Herbert Spencer (ed.), *Readings in Art History*, vols. i and ii (New York, 1969, 1972, 1983).
2. These issues are discussed in some detail in

D. Preziosi, 'The Question of Art History', *Critical Inquiry*, 18 (Winter 1992), 363–86.
3. On the Vasari legacy in Art History, see the discussion in Ch. 1.
4. A fuller examination of these approaches to explanation, demonstation, and proof may be found in Preziosi, *Rethinking Art History*.

Chapter 1
1. G. Vasari, *Le vite de' piu eccellenti architteti, pittori, et scultori italiani da Cimabue insino a tempi nostri* (Florence, 1550; 2nd edn., 1568). English trans. A. B. Hinds, ed. William Gaunt, Giorgio Vasari, *The Lives of the Painters, Sculptors and Architects* (rev. edn., London, 1963), vol. i, preface, p. 18.
2. J. J. Winckelmann, *Geschichte des Kunst des Alterthums* (Dresden, 1764). The only complete English translation is that of G. H. Lodge: Johann Joachim Winckelmann, *The History of Ancient Art* (Boston, 1880), in 4 vols.
3. Vasari, *Le vite*, 17.
4. See Licio Collobi, *Il libro del disegno del Vasari* (Florence, 1974).
5. See Marjorie Garber, *Vice-Versa: Bisexuality and the Eroticism of Everyday Life* (New York, 1995), for an elaboration of this theme.
6. An excellent contemporary translation by Elfriede Heyer and Roger C. Norton, pub. 1987 (La Salle, Ill.), includes the complete German text. The selections reprinted here are taken from this edition.
7. Michel de Certeau, *The Writing of History* (New York, 1988), trans. by Tom Conley of *L'Ecriture de l'histoire* (Paris, 1975), esp. part I, pp. 17–112.

Johann Winckelmann: Reflections on the Imitation of Greek Works
Winckelmann's own notes have been included, exactly as they appear in the original German edition; they are placed within parentheses and are preceded, for purposes of identification, by '*W*':

1. (*W*: Plato in Timaeo, edit. Francof. p. 1004.) Plato wrote in *Timaios* that the goddess Athena (Minerva) founded the Athenian state in the Grecian landscape because 'the happy combination of seasons there was best suited for the breeding of wise people.'

2. A reference to paintings from the collection of Rudolph II, which were taken from Prague to Dresden by the conquering Swedes in 1648.

3. 'The great August' is the Electoral Prince August I of Saxony, who also ruled Poland under the title of August II (August the Strong). His son and successor was Friedrich August, to whom Winckelmann dedicates this work. Winckelmann flatters him here by comparing him with the Roman emperor Titus Flavius Vespasianus, who was known as a particularly beneficent ruler.

4. A famous marble group representing Laocoon and his two sons in the coils of two snakes (see n. 14).

5. Dido was the legendary founder of Carthage and a figure in Virgil's *Aeneid* and Homer's *Odyssey*.

6. Polyclitus was a Greek sculptor of the 5th c. BC, who was the first to develop universally valid laws of proportion, with the help of which he wanted to create the ideal form of the human body.

7. The Medicean Venus was a copy of an Aphrodite (Venus) statue, made during the time of the Roman Imperium, later in possession of the Medici family.

8. A mythical hero of the Trojan War.

9. (*W*: Proclus in Timaeum Platonis.)

10. Hercules was the son of Zeus and Alcmene, Iphicles, the son of Amphitryon and Alcmene. According to Hesiod's account they were born as twins.

11. A person dedicated to luxurious living, an epicure. The name is derived from the inhabitants of Sybaris in southern Italy.

12. An area on the west coast of the Peloponnesian peninsula. The most famous games of antiquity took place there in the valley of Olympia.

13. Diagoras was the hero of an ode by Pindar. (*W*: v. Pindar. Olymp. Od. VII. Arg. & Schol.)

14. Laocoon: this marble group, which represents Laocoon, priest of Apollo at Troy, and his two sons in the coils of two snakes, was created apparently in the 1st c. BC by Agesander, Polydorus, and Athenodorus of Rhodes. It was rediscovered in Rome in 1506 and transferred to the Vatican. Since Virgil in his Aeneid describes the death throes of Laocoon in similar fashion (Aeneid II, 213–24) it is assumed that he knew this sculpture. In

Virgil, to be sure, Laocoon's 'terrible screaming' during the struggle is described, and Lessing's disagreement with Winckelmann's interpretation of the statue and what it depicted provided the initial impulse for Lessing's critical work, *Laokoon oder über die Grenzen der Malerei und Poesie* (*Laocoon or the Limits of Painting and Poetry*).

15. Jacopo Sadoleto dedicated his Latin poem 'De Laocoontis statua' to this marble group, which had just been rediscovered.

16. Philoctetes, who inherited the bow and arrows of his friend Hercules, was bitten by a snake during the journey of the Greeks against Troy and had to be left on the island of Lemmos because of the unbearable odour of his wound. He lived there in needy circumstances until Ulysses and Diomedes (in Sophocles: Neoptolemus) brought him to Troy where his skill with the bow was needed and where he killed Paris with one of his poisoned arrows. Sophocles' tragedy *Philoctetes* was discussed in detail by Lessing in his *Laocoon*.

17. Metrodorus of Athens, painter and Epicurean philosopher, went to Rome in 168 BC in order to tutor the children of L. Aemilius Paulus and to produce paintings glorifying the military triumphs of Paulus.

18. Parenthyrsos was originally a term used in rhetoric, signifying exaggerated, out-of-place pathos.

19. An Italian term for 'openness', 'sincerity', 'frankness'.

20. Italian for 'contrast'. In sculpture it signifies an assymetrical pose involving a strong contrast between the position of the leg carrying the body weight and the other leg.

21. Ajax was the strongest and wildest Greek hero of the Trojan War, a rival of Ulysses, who in his madness killed a herd of sheep and then himself. Capaneus was a figure in the cycle of legends concerning Thebes, known for his arrogance. He was one of the 'Seven against Thebes'; as he was storming the wall during the siege of the city, he boasted that not even Zeus could keep him out, and the angry Zeus struck him down with a lightning bolt.

22. Hyperbole: poetical or rhetorical exaggeration.

23. 'So that everyone thinks he can do it too; yet, however hard he sweats and strives, his attempt is in vain' Horace, *Ars poetica*, 240–3.

24. Raphael portrays the legendary encounter between the king of the Huns and Pope Leo I, who is referred to here in his capacity as Bishop of Rome. When Attila and his army attacked Italy in the year 452, the Pope is said

to have succeeded in persuading him to spare Rome.

25. 'When they see then a man so worthy and venerable, they all keep silence and listen attentively' Virgil, *Aeneid* i, 151 f.

26. (*W*: v. Wright's Travels.)

27. A reference to Joseph Addison (1672–1719), whose poem 'The Campaign' (1704) eulogizes the Duke of Marlborough (1650–1722), under whose leadership an English army conquered the French in the battle of Blenheim.

28. This 'Sistine Madonna' had been brought to Dresden in 1753.

29. An ancient city in Central Greece.

30. Winckelmann includes in his notes an eleven-line quotation in Italian ascribed to 'Vasari, Vite de' Pittori, Scult. & Archit. edit. 1568, Part. III, p. 776', which we shall omit here. The Reclam edition of *Gedanken . . .* comments thus on W.'s description of Vasari's report: 'Winckelmann's hypothesis that Michelangelo established the contours of sculptural models with the aid of a water container, could only be based on a reference in Giorgio Vasari's *Vite de' Pittori*, in which the delineation of sculptural lines by means of a water surface appears only as a figurative comparison. The procedure which Winckelmann describes in such detail is therefore probably a pure invention of Winckelmann or of his friend Adam Friedrich Oeser, as Carl Justi has conjectured' (Carl Justi: *Winckelmann und seine Zeitgenossen*, 5. Aufl. Bd 1, Köln 1956, S. 474–481). (Reclam quotation is from Ludwig Uhlig's edition of Winckelmann's *Gedanken . . .*, Universal-Bibliothek #8338 (2), 1977, p. 131, as translated by us.)

31. (*W*: Turnbull's Treatise on Ancient Painting, 1740. fol.)

32. A fresco of the 1st c. AD, rediscovered in Rome in 1606.

33. The legendary Attic national hero, Theseus, killed the monster Minotaur which every year, at the behest of the Cretan king, Minos, had received seven Athenian boys and girls to devour.

Whitney Davis: Winckelmann Divided

1. This paper began as a presentation to the session 'Art History Within and Without' at the Annual Meeting of the Association of Art Historians, London, England, Apr. 1990, and was delivered in forms resembling the present one at the Midwest Art History Society meetings, Columbus, Ohio, Apr. 1991, and the International Congress of the History of Art, Berlin, July 1992. Some parallel reflections have been published as 'Founding the Closet: Sexuality and the Invention of Art History', *Art Documentation*, 11 (1992), 171–5.

2. For Winckelmann's *History*, the only complete English translation, by G. H. Lodge (4 vols., Boston, 1880) is unsatisfactory in several respects; a new rendition is long overdue. The French translation (by M. Huber, but not credited in the publication) is worth consulting for its more subtle representation of Winckelmann's nuanced prose (*Histoire de l'art chez les anciens, par Winckelmann, avec des notes historiques et critiques de differens auteurs* (Paris, 1802–3). For Winckelmann's publications of gems and other antiquities, see his *Description des pierres gravées du feu Baron de Stosch* (Florence, 1760) and *Monumenti inediti antichi*, 2 vols. (Rome, 1767). For his treatise on allegory, see *Versuch einer Allegorie, besonders für die Kunst* (Dresden, 1766). A convenient but very partial English selection of Winckelmann's writings can be found in *Winckelmann: Writings on Art*, ed. David Irwin (London, 1972). The standard, complete German edition is *Johann Winckelmanns sämtliche Werke*, ed. Joseph Eiselein, 12 vols. (Donaueschingen, 1825–9); see also *Kleine Schriften, Vorreden, Entwürfe*, ed. Walther Rehm (Berlin, 1968), an edition of Winckelmann's briefer works with excellent annotations.

3. Two judicious views can be found in Heinrich Dilly, *Kunstgeschichte als Institution: Studien zur Geschichte einer Disciplin* (Frankfurt, 1979), and Wolf Lepenies, 'Der andere Fanatiker: Historisierung und Verwissenschaftlichung der Kunstauffassung bei Winckelmann', in *Ideal und Wirklichkeit der bildenden Kunst im späten 18. Jahrhundert*, ed. Herbert Beck, Peter C. Bol, and Eva Maek-Gerard (Berlin, 1984), 19–29.

4. See esp. Peter D. Fenves, *A Peculiar Fate: Metaphysics and World History in Kant* (Ithaca, NY, 1991).

5. See Alex Potts, 'Political Attitudes and the Rise of Historicism in Art Theory', *Art History*, 1 (1978), 191–213; id., 'Winckelmann's Construction of History', *Art History*, 5 (1982), 377–407; id., 'Beautiful Bodies and Dying Heroes: Images of Ideal Manhood in the French Revolution', *History Workshop Journal*, 30 (1990), 1–21. Potts's studies are the foundation for any further work on Winckelmann; for other studies on Winckelmann's French and German reception, see Henry Hatfield, *Aesthetic Paganism in German Literature from*

Winckelmann to the Death of Goethe
(Cambridge, Mass., 1948); Ludwig Uhlig,
*Griechenland als Ideal: Winckelmann und seine
Rezeption in Deutschland* (Frankfurt, 1988);
Edouard Pommier, 'Winckelmann et la vision
de l'antiquité classique dans la France des
lumières et de la Révolution', *Revue de l'art*, 83
(1989), 9–21; Michael Embach,
'Kunstgeschichte und Literatur: Zur
Winckelmann-Rezeption des deutschen
Idealismus', in *Arts et Ecclesia: Festschrift für
Franz J. Ronig zum 60. Geburtstag*, ed. Hans-
Walter Stork (Trier, 1989), 97–113.

6. See Sigmund Freud, 'Splitting of the Ego
in the Process of Defence' (1938), *Standard
Edition of the Complete Psychological Works of
Sigmund Freud*, ed. and trans. James Strachey
(London, 1952–74), vol. 23: 275–78.

7. See Potts, 'Winckelmann's Construction of
History'.

8. It will not quite do to say that what we now
describe as Greek 'Archaic' art was unknown
to Winckelmann. Although he did not know
the range of *kouroi* from the late 7th, 6th, and
early 5th centuries, he understood, for
example, that Greek sculpture sprang from
'crude stone' beginnings and that it could be
taken—although he disagreed with the idea—
to be related conceptually and formally to
Egyptian art. Moreover, he knew preclassical
Greek art in the form of small metal figures
and vase paintings.

9. See esp. Sigmund Freud, 'The Dynamics of
Transference' (1912), *Standard Edition*, 12:
99–113.

10. Only a handful of studies have attempted
to integrate Winckelmann's aesthetic and art-
historical writing with an account of his
sexuality. The most successful, although still
problematic in one way or another, are
Leopold D. Ettlinger, 'Winckelmann, or
Marble Boys are Better', in Moshe Barasch
and Lucy Freeman Sandler (eds.), *Art the Ape
of Nature: Studies in Honor of H. W. Janson*
(Englewood Cliffs, NJ, 1981), 505–11; Hans
Mayer, 'Winckelmann's Death and the
Discovery of a Double Life', in *Outsiders: A
Study in Life and Letters*, trans. Denis M.
Sweet (Cambridge, Mass., 1982) 167–74; Denis
M. Sweet, 'The Personal, the Political, and the
Aesthetic: Johann Joachim Winckelmann's
German Enlightenment Life', in Kent Gerard
and Gert Hekma (eds.), *The Pursuit of Sodomy:
Male Homosexuality in Renaissance and
Enlightenment Europe* (Binghamton, NY,
1988: *Journal of Homosexuality*, 16, nos. 1/2
(1988), 147–61); Seymour Howard,
'Winckelmann's Daemon: The Scholar as

Critic, Chronicler, and Historian', in
*Antiquity Restored: Essays on the Afterlife of the
Antique* (Vienna, 1990), 162–74, 278–83; Kevin
Parker, 'Winckelmann and the Problem of the
Boy', *Eighteenth Century Studies*, 25 (1992),
523–40. For Winckelmann's life, see the
unsurpassed biography by Carl Justi,
Winckelmann und seine Zeitgenossen, 3 vols., 5th
edn., ed. Walther Rehm (Cologne, 1956); his
fascinating letters, an essential source for
understanding his personal erotics, are
collected in *Briefe*, ed. Walther Rehm, 4 vols.
(Berlin, 1952–5), with excellent annotations.
Winckelmann's *Nachlass*, a large proportion of
which are now in the Bibliothèque Nationale,
Paris, give a sense of his wide reading (they
contain many excerpts).

11. In addition to Gerard and Hekma (eds.),
The Pursuit of Sodomy, valuable information
has been compiled by several authors in R.
Maccubbin (ed.), *Unauthorized Sexual
Behavior in the Enlightenment* (= *Eighteenth
Century Life*, 9 (1985)), and G. S. Rousseau
and Roy Porter (eds.), *Sexual Underworlds of
the Enlightenment* (Chapel Hill, NC, 1988).

12. See *Monumenti inediti antichi*, vol. 1: 73,
vol. ii: no. 59; the head is now in the
Glyptothek, Munich (no. A618). It was
originally a post-Polykleitan athlete's head,
reworked, at a later point, into a faun's head.

13. For a recent edition of Goethe's famous
essay, see J. W. von Goethe, H. Holtzauer
(ed.), *Winckelmann und sein Jahrhundert in
Briefen und Aufsätzen* (Leipzig, 1969).

14. See Sweet, 'The Personal, the Political,
and the Aesthetic', and Wolfgang von
Wangenheim, 'Casanova trifft Winckelmann
oder die Kunst des Begehrens', *Merkur:
Deutsche Zeitschrift für Europäisches Denken*, 39
(1985), 106–20.

15. See James D. Steakley, 'Sodomy in
Enlightenment Prussia: From Execution to
Suicide', in Gerard and Hekma (eds.), *The
Pursuit of Sodomy* 163–74.

16. See G. S. Rousseau, 'The Pursuit of
Homosexuality in the Eighteenth Century:
'Utterly Confused Category' and/or Rich
Repository?' in Maccubbin (ed.),
Unauthorized Sexual Behavior, 155, and id.,
'The Sorrows of Priapus: Anticlericalism,
Homosocial Desire, and Richard Payne
Knight,' in Rousseau and Porter (eds.), *Sexual
Underworlds of the Enlightenment*, 101–53. It
should be said, however, that documenting the
homosocial practices of the residents of Papal
Rome at the end of the 18th c.—and the
homoerotic interpretation of Rome by 18th-c.
European society in general—is still very

incomplete.

17. A good English translation can be found in *Reflections on the Imitation of Greek Works in Painting and Sculpture*, trans. Elfriede Heyer and Roger C. Norton (La Salle, Ill., 1987).

18. See esp. Ettlinger, 'Marble Boys are Better', Parker, 'Winckelmann and the Problem of the Boy', and Barbara Maria Stafford, 'Beauty of the Invisible: Winckelmann and the Aesthetics of Imperceptibility', *Zeitschrift für Kunstgeschichte*, 43 (1980), 65–78.

19. In an insightful study of the problematic temporality of the modern 'imitation' of ancient art as recommended by Winckelmann, Michael Fried approaches the issue I raise here from a different vantage point; see his 'Antiquity Now: Reading Winckelmann on Imitation', *October*, 37 (1986), 87–97.

20. *The Absolute Bourgeois*, rev. edn. (Princeton, 1980), preface.

21. For the relation of 'conviction' and 'transference' in art-historical interpretation, and their connection with a 'homosexual' subjectivity, see further Whitney Davis, 'Sigmund Freud's Drawing of the Dream of the Wolves', *Oxford Art Journal*, 15 (1992), 70–87.

22. Versions of these debates and contrasts can be found e.g. in Donald Preziosi, *Rethinking Art History: Mediations on a Coy Science* (New Haven, 1989); David Carrier, *Principles of Art History Writing* (University Park, Pa., 1991); Selim Kemal and Ivon Gaskell (eds), *The Language of Art History* (Cambridge, 1991); Norman Bryson, Michael Ann Holly, and Keith Moxey (eds.), *Visual Theory: Painting and Interpretation* (New York, 1991).

23. See Sigmund Freud, 'Mourning and Melancholia' (1917), *Standard Edition*, xiv. 239–52; Christopher Bollas, *The Shadow of the Object: Psychoanalysis of the Unthought Known* (New York, 1987).

24. Freud, 'Mourning and Melancholia', 245.

Chapter 2

1. Alexander Gottlieb Baumgarten, *Aesthetica*, 1750; enlarged edn, 1758 (Hildesheim, 1961). Baumgarten collaborated in his work on aesthetics with a former student, Georg Friedrich Meier (1718–77), whose *Foundations of All Fine Sciences* appeared in 1754 (Meier, *Anfangsgruende aller schoenen Wissenschaften*; Hildesheim and New York, 1976).

2. Immanuel Kant, *Kritik der Urteilskraft*

(Berlin and Libau, 1790). The best recent English translation is Werner S. Pluhar, Immanuel Kant, *Critique of Judgment* (Indianapolis, 1987), with a foreword by Mary J. Gregor. The translator's preface and introduction (pp. xix–cix) are especially valuable both in outlining the argument of this (Third) *Critique* and in elucidating its relationship to the other two *Critiques*, the First (*of Pure Reason*, pub. 1781) and the Second (*of Practical Reason*, pub. 1788).

3. *Observations on the Feeling of the Beautiful and Sublime*, 1764.

4. In the words of Luc Ferry, *Homo Aestheticus: The Invention of Taste in the Democratic Age*, trans. Robert de Loaiza (Chicago, 1993), 97.

5. G. W. F. Hegel, *Vorlesungen ueber die Aesthetik* (Berlin, 1835–8), in 3 vols. The English translation used here is that of T. M. Knox, *Aesthetics: Lectures on Fine Art* (Oxford, 1975).

Immanuel Kant: What is Enlightenment?
1. 'Dare to be wise!' (Horace, *Ars poetica*).

Immanuel Kant: The Critique of Judgement
1. Where one has reason to suppose that a relation subsists between concepts, that are used as empirical principles, and the faculty of pure cognition *a priori*, it is worthwhile attempting, in consideration of this connexion, to give them a transcendental definition—a definition, that is, by pure categories, so far as these by themselves adequately indicate the distinction of the concept in question from others. This course follows that of the mathematician, who leaves the empirical data of his problem indeterminate, and only brings their relation in pure synthesis under the concepts of pure arithmetic, and thus generalizes his solution.—I have been taken to task for adopting a similar procedure (*Critique of Practical Reason*, Preface, p. 16) and fault has been found with my definition of the faculty of desire, as *a faculty which by means of its representations is the cause of the actuality of the objects of those representations*: for mere *wishes* would still be desires, and yet in their case every one is ready to abandon all claim to being able by means of them alone to call their Object into existence.—But this proves no more than the presence of desires in man by which he is in contradiction with himself. For in such a case he seeks the production of the Object by means of his representation alone, without any hope of its being effectual, since

he is conscious that his mechanical powers (if I may so call those which are not psychological), which would have to be determined by that representation, are either unequal to the task of realizing the Object (by the intervention of means, therefore) or else are addressed to what is quite impossible, as, for example, to undo the past (*O mihi praeteritos*, &c.) or, to be able to annihilate the interval that, with intolerable delay, divides us from the wished-for moment.—Now, conscious as we are in such fantastic desires of the inefficiency of our representations, (or even of their futility,) as *causes* of their objects, there is still involved in every *wish* a reference of the same as cause, and therefore the representation of its *causality*, and this is especially discernible where the wish, as *longing*, is an affection. For such affections, since they dilate the heart and render it inert and thus exhaust its powers, show that a strain is kept on being exerted and re-exerted on these powers by the representations, but that the mind is allowed continually to relapse and get languid upon recognition of the impossibility before it. Even prayers for the aversion of great, and, so far as we can see, inevitable evils, and many superstitious means for attaining ends impossible of attainment by natural means, prove the causal reference of representations to their Objects—a causality which not even the consciousness of inefficiency for producing the effect can deter from straining towards it.— But why our nature should be furnished with a propensity to consciously vain desires is a teleological problem of anthropology. It would seem that were we not to be determined to the exertion of our power before we had assured ourselves of the efficiency of our faculty for producing an Object, our power would remain to a large extent unused. For as a rule we only first learn to know our powers by making trial of them. This deceit of vain desires is therefore only the result of a beneficent disposition in our nature.

2. The definition of taste here relied upon is that it is the faculty of estimating the beautiful. But the discovery of what is required for calling an object beautiful must be reserved for the analysis of judgements of taste. In my search for the moments to which attention is paid by this judgement in its reflection, I have followed the guidance of the logical functions of judging (for a judgement of taste always involves a reference to understanding). I have brought the moment of quality first under review, because this is what the aesthetic judgement on the beautiful looks to in the first instance.

3. A judgement upon an object of our delight may be wholly *disinterested* but withal very *interesting*, i.e. it relies on no interest, but it produces one. Of this kind are all pure moral judgements. But, of themselves, judgements of taste do not even set up any interest whatsoever. Only in society is it *interesting* to have taste—a point which will be explained in the sequel.

4. An obligation to enjoyment is a patent absurdity. And the same, then, must also be said of a supposed obligation to actions that have merely enjoyment for their aim, no matter how spiritually this enjoyment may be refined in thought (or embellished), and even if it be a mystical, so-called heavenly, enjoyment.

5. Models of taste with respect to the arts of speech must be composed in a dead and learned language; the first, to prevent their having to suffer the changes that inevitably overtake living ones, making dignified expressions become degraded, common ones antiquated, and ones newly coined after a short currency obsolete; the second to ensure its having a grammar that is not subject to the caprices of fashion, but has fixed rules of its own.

6. It will be found that a perfectly regular face—one that a painter might fix his eye on for a model—ordinarily conveys nothing. This is because it is devoid of anything characteristic, and so the idea of the race is expressed in it rather than the specific qualities of a person. The exaggeration of what is characteristic in this way, i.e. exaggeration violating the normal idea (the finality of the race), is called *caricature*. Also experience shows that these quite regular faces indicate as a rule internally only a mediocre type of man; presumably—if one may assume that nature in its external form expresses the proportions of the internal—because, where none of the mental qualities exceed the proportion requisite to constitute a man free from faults, nothing can be expected in the way of what is called *genius*, in which nature seems to make a departure from its wonted relations of the mental powers in favour of some special one.

7. As telling against this explanation, the instance may be adduced, that there are things in which we see a form suggesting adaptation to an end, without any end being cognized in them—as, for example, the stone implements frequently obtained from sepulchral tumuli and supplied with a hole, as if for [inserting] a handle; and although these by their shape

manifestly indicate a finality, the end of which is unknown, they are not on that account described as beautiful. But the very fact of their being regarded as art-products involves an immediate recognition that their shape is attributed to some purpose or other and to a definite end. For this reason there is no immediate delight whatever in their contemplation. A flower, on the other hand, such as a tulip, is regarded as beautiful, because we meet with a certain finality in its perception, which, in our estimate of it, is not referred to any end whatever.

Chapter 3

1. Plato's Theory of Forms is developed in two of his dialogues, the *Republic* and the *Phaedo*, and his ideas about the illusory nature of art appear in Book 10 of the former. Among countless commentaries on these views, a useful recent summary of them as they apply both to archaeology and art history is James Whitley, 'Art history, Archaeology and Idealism: The German Tradition', in Ian Hodder (ed.), *Archaeology as Long-Term History* (Cambridge, 1987), 11–15.
2. On which, see S. Runciman, *Byzantine Style and Civilisation* (Harmondsworth, 1975), 81–9; and T. Ware, *The Orthodox Church* (Harmondsworth, 1964), 38–42.
3. Heinrich Wölfflin, *Principles of Art History*, translated by M. D. Hottinger (7th edn., New York, 1932) from the original *Kunstgeschichtliche Grundbegriffe: Das Problem der Stilentwicklung in der neueren Kunst* (1915).
4. Henri Focillon, *Vie des Formes* (Paris, 1934).
5. George Kubler, *The Shape of Time: Remarks on the History of Things* (New Haven, 1962).

Heinrich Wölfflin: Principles of Art History
1. In the German, *das Lineare* and *das Malerische*. The term *malerisch*, here translated as 'painterly', has no exact English equivalent.
2. In the German, *Fläche* and *Tiefe*.
3. *Klassisch*. The word 'classic' throughout this extract refers to the art of the High Renaissance. It implies, however, not only a historical phase of art, but a special mode of creation of which that art is an instance.
4. In the German, *Geschlossene Form* and *Offene Form*—what Wölfflin defined elsewhere in his book as *tektonisch* and *atektonisch*.
5. In the German, *Vielheit* and *Einheit*; later in his book, Wölfflin defines these terms as *vielheitliche Einheit* and *einheitliche Einheit*.
6. In the German, *Klarheit* and *Unklarheit*; in a later chapter of Wölfflin's book, these terms

are further defined as *Unbedingte* and *bedingte Klarheit*.
7. In the German, *geistigen Sphären*.
8. Wilhelm von Bode, in *Königliche Museen zu Berlin, Die Gemäldegalerie des Kaiser-Friedrich-Museums*, ed. Hans Posse, 2 vols. (Berlin, 1909–11), I:v.

David Summers: 'Form', Nineteenth-Century Physics, and the Problem of Art Historical Description
1. Michael Podro, *The Critical Historians of Art* (New Haven, 1982), 61.
2. Heinrich Wölfflin, *Principles of Art History: The Problem of the Development of Style in Later Art*, trans. M. D. Hottinger (New York, n.d.), 1; hereafter abbreviated *P*.
3. Podro, *The Critical Historians of Art*, 62. See also Leo Steinberg, 'Other Criteria', *Other Criteria: Confrontations with Twentieth-Century Art* (New York, 1972), 64–6. Steinberg provides a brief but insightful history of formalist criticism beginning with Baudelaire.
4. Wilhelm Worringer, *Abstraction and Empathy: A Contribution to the Psychology of Style*, trans. Michael Bullock (Cleveland and New York, 1967), 77.
5. Rosalind E. Krauss, 'Poststructuralism and the Paraliterary', *The Originality of the Avant-Garde and Other Modernist Myths* (Cambridge, Mass., 1985), 293; my emphasis.
6. See Erwin Panofsky, *Renaissance and Renascences in Western Art* (New York and Evanston, Ill., 1969), 188–200.
7. E. H. Gombrich, '*Icones Symbolicae*: Philosophies of Symbolism and their Bearing on Art', *Symbolic Images: Studies in the Art of the Renaissance, II* (London, 1972), 123–91.
8. David Summers, '*Difficultà*', Michelangelo and the Language of Art* (Princeton, 1981), 177–85.
9. See Gombrich, 'Raphael's *Madonna della Sedia*', *Norm and Form: Studies in the Art of the Renaissance, I* (London, 1966), 64–80; hereafter abbreviated *M*.
10. See Gombrich, 'On Physiognomic Perception', *Meditations on a Hobby Horse and Other Essays on the Theory of Art* (London and New York, 1963), 45–55.
11. Gombrich, *Art and Illusion: A Study in the Psychology of Pictorial Representation, The A. W Mellon Lectures in the Fine Arts, 1956*, Bollingen Series XXXV (Princeton, 1969), 28.
12. Summers, 'Intentions in the History of Art', *New Literary History*, 17 (Winter 1986), 306–7.
13. Gombrich, 'On Physiognomic Perception', 51; my emphasis.

14. Gombrich, 'André Malraux and the Crisis of Expressionism', *Meditations on a Hobby Horse*, 82.

15. See Walter Benjamin, 'Theses on the Philosophy of History', *Illuminations*, ed. Hannah Arendt, trans. Harry Zohn (New York, 1969), 253–64.

16. Ibid. 262.

17. Meyer Schapiro, 'Style', in Morris Philipson, *Aesthetics Today* (Cleveland and New York, 1961), 97.

Ernst Gombrich: Style

1. René Wellek and Austin Warren, *Theory of Literature* (New York, 1949; 3rd edn., 1965), ch. 11.

2. Stephen Ullmann, *Style in the French Novel* (Cambridge, 1957), 6.

3. Anton Daniel Leeman, *Orationis Ratio: The Stylistic Theories and Practice of the Roman Orators, Historians and Philosophers*, 2 vols. (Amsterdam, 1963).

4. E. H. Gombrich, 'The Debate on Primitivism in Ancient Rhetoric', *Journal of the Warburg and Courtauld Institutes*, 29 (1966), 24–38.

5. Ernst Robert Curtius, *European Literature and the Latin Middle Ages* (New York, 1963), 249.

6. Jan Bialostocki, 'Das Modusproblem in den bildenden Kunsten', *Zeitschrift für Kunstgeschichte*, 24 (1961), 128–41.

7. E. H. Gombrich, *Norm and Form: Studies in the Art of the Renaissance* (London, 1966), 83–6.

8. Paul Frankl, *The Gothic: Literary Sources and Interpretations through Eight Centuries* (Princeton, 1960).

9. O. Kurz, 'Barocco: Storia di una parola', *Lettere italiane*, 12:4 (1960).

10. S. Fiske Kimball, *The Creation of the Rococo* (New York, 1964).

11. Gombrich, *Norm and Form*, 99–106.

12. Erwin Panofsky, *Renaissance and Renascences in Western Art* (Stockholm, 1960).

13. George Boas, 'Il faut être de son temps', in id., *Wingless Pegasus: A Handbook of Art Criticism* (Baltimore, 1950).

14. Franz Boas, *Primitive Art* (New York, 1955).

15. Paul O. Kristeller, 'The Modern System of the Arts: A Study in the History of Aesthetics, *Journal of the History of Ideas*, 12 (1951), 496–527, and 13 (1952), 17–46.

16. Nikolaus Pevsner, *Pioneers of Modern Design from William Morris to Walter Gropius* (1936; revised edn., New York, 1958).

17. E. H. Gombrich, *Art and Illusion: A Study in the Psychology of Pictorial Representation* (1960; 2nd edn., London and New York, 1961).

18. Gombrich, *Norm and Form*.

19. Thomas Munro, *Evolution in the Arts and Other Theories of Culture History* (Cleveland, 1963).

20. Johan Huizinga, *The Waning of the Middle Ages: A Study in the Forms of Life, Thought and Art in France and the Netherlands in the 14th and 15th Centuries* (London, 1924).

21. Heinrich Wölfflin, *Renaissance and Baroque* (London, 1964).

22. James S. Ackerman and Rhys Carpenter, *Art and Archaeology* (Englewood Cliffs, NJ, 1963).

23. Georg Wilhelm Friedrich Hegel, *The Philosophy of History* (New York, 1956), 53.

24. Wölfflin, *Renaissance and Baroque*. For a detailed discussion, see Meyer Schapiro, 'Style', in Morris Philipson (ed.), *Aesthetics Today* (Cleveland, 1961), 81–113.

25. Heinrich Kulka (ed.), *Adolf Loos: Das Werk des Architekten* (Vienna, 1931).

26. T. H. Pear, *Personality, Appearance, and Speech* (London, 1957).

27. E. H. Gombrich, *Meditations on a Hobby Horse, and Other Essays on the Theory of Art* (London, 1963).

28. Morse Peckham, *Man's Rage for Chaos: Biology, Behavior and the Arts* (Philadelphia, 1965).

29. Francis Haskell, *Patrons and Painters: A Study in the Relations between Italian Art and Society in the Age of the Baroque* (London and New York, 1963).

30. Geraldine Pelles, *Art, Artists and Society: Origins of a Modern Dilemma; Painting in England and France, 1750–1850* (Englewood Cliffs, NJ, and London, 1963).

31. Renato Poggioli, *Teoria dell'arte d'avanguardia* (Bologna, 1962), 'Il Mulino'.

32. Joel E. Cohen, 'Information Theory and Music', *Behavioral Science*, 7 (1962), 137–63.

33. Alvan Ellegård, *A Statistical Method for Determining Authorship: The Junius Letters, 1769–1772*, Gothenburg Studies in English, 13 (Goteborg, 1962). Helmuth Kreuzer and R. Gunzenhäuser, *Mathematik und Dichtung: Versuche zur frage einer exakten Literaturwissenschaft* (Munich, 1965).

34. Friedrich von Hayer, 'Rules, Perception, and Intelligibility', *Proceedings of the British Academy*, 48 (1963), 321–44. Gombrich, *Norm and Form*, 127.

35. O. Kurz, *Fakes: A Handbook for Collectors and Students* (London, 1948).

Chapter 4

1. On disciplinary stagings as erudite

machines, see Preziosi, 'The Question of Art History', 363–86 in reference to the establishment of Harvard's original Fogg Museum (1895), as the first building anywhere specifically designed to house the entire disciplinary apparatus. See also Mary Carruthers, *The Book of Memory: A Study of Memory in Mediaeval Culture* (Cambridge, 1990) for a historical perspective on the arts of memory since antiquity.

2. See Preziosi, *Rethinking Art History*, 89 ff. Taine's *De l'idéal dans l'art* (Paris, 1867) was one of the most influential late 19th-c. studies on the visual arts, and set forth his concatenation of 'race-milieu-moment' as the determining factors in the appearance of an object. By 1909, Taine's *De l'idéal* had reached its 13th edition. His *Philosophie de l'art* (Paris, 1865), lectures delivered at the École des Beaux-Arts, had gone through twenty editions by 1926.

3. Alois Riegl, *Stilfragen: Grundlegungen zu einer Geschichte der Ornamentik* (Berlin, 1893).

4. *Die Spätroemische Kunst-Industrie, nach dem Funden in Oesterreich-Ungarn dargestellt* (Vienna, 1901–23); translated as *Late Roman Art Industry* by Rolf Winckes (Rome, 1985).

5. See Ch. 6, no. 20 (R. Krauss, 'Sculpture in the Expanded Field') for a reappearance of this same systemic logic, expressed in the language of structuralist semiology.

6. Friedrich Nietzsche's *The Birth of Tragedy* (1872) articulated a radical rethinking of Greek culture as a creative tension between warring forces—the calm 'Apollonian' spirit and the emotionally vibrant and chaotic 'Dionysian'.

7. The library was moved to London in 1933, four years after Warburg's death, by the art historian Fritz Saxl; it became the nucleus of the Warburg Institute, and in 1944 was incorporated into the University of London. The Warburg Library has recently been recreated in Hamburg. On the history of the Library, see F. Saxl in E. Gombrich, *Aby Warburg: An Intellectual Biography, with a Memoir on the History of the Library by F. Saxl* (Chicago, 1986).

8. Aby Warburg, *Gesammelte Schriften hrsg. von der Bibliothek Warburg unter Mitarbeit von Fritz Rougemont hrsg. von Gertrud Bing*, 2 vols. (Leipzig, 1932). Only two of Warburg's essays have so far been translated into English: the 'Pueblo Indian' essay reprinted here, and 'Italian Art and International Astrology in the Palazzo Schifanoia in Ferrara', in Gert Schiff, (ed.), *German Essays on Art History* (New York, 1988), 234–54.

Alois Riegl: Leading Characteristics of the late Roman *Kunstwollen*

1. In view of the skepticism which has hithero met the investigation of such kind, it seems to be timely to emphasize right away that Augustine does not limit himself like modern philosophers of aesthetics to the postulation of general abstract doctrines, but—even though not very frequent, still often enough—talks about individual works of art or certain details of the creation of the individual objects. Hence, comes a comforting certainty that Plotinus was very well aware in which manner the general doctrines forwarded by him were expressed in the individual work of art in a clear and certain manner.

2. Augustine is thus one of the first who recognized the relativeness between beauty and ugliness; how he opposed in that respect earlier antiquity will be demonstrated below. Ugliness as such he still defines in an entirely ancient spirit in that he determines this as shapeless (deformed), that is, not belonging to a completed individual shape. [. . .]

3. The naturalistic and idealistic side which any work of art without exception combines in itself, could not be defined more conclusively than it is done in this definition. However, to reclaim the 'naturalism' for particular styles can just lead to misunderstandings. The ancient Egyptian, who tried to represent the objects in their strictly 'objective' appearance, meant this to be as 'naturalistic' as one could imagine. The Greek, however, felt his own to be especially 'naturalistic' when he compared his with them. And could the master of the portraits of Constantine with its lively expression of the eyes not have felt he was a greater 'naturalist' than, for example, the master of the portrait of Pericles? Yet all three would have, in the most modern sense, taken 'naturalism' for something purely unnatural. Indeed, each style of art strives for a true representation of nature and nothing else and each has indeed its own perception of nature in that he views a very particular phenomenon of it (tactile or optical, *Nahsicht*, *Normalsicht*, or *Fernsicht*). Entirely unscholarly (even though commonly done) to base 'naturalism' on the character of the motive. This reveals, it seems, the indestructable confusion between the history of art and iconography, even though the creative art is not concerned with 'what' but with 'how' and lets 'what' be presented, particularly through poetry and religion. Iconography reveals thus to us not so much the history of the *Wollen* in the visual arts but rather the poetic and religious *Wollen*. That

there exists a bridge between the two was already emphasized in as much as the meaning, to which belongs to a deeper knowledge of the connection, has been pointed out emphatically; yet, in order to create this connection usefully it is necessary to separate that first one sharply. In the creation of a clear separation between iconography and history of art I see the precondition of any progress of art historical research for the near future.

4. ... omnis pulchritudinis forma unitas ... (Epist. XVIII: Augustinus Coelestino. t. II col. 85).

5. Thus a tree constitutes a unit with its completed individual shape (de Orandin lib. II. c. XVIII, c. I, cl. 1017) and no less with its individual *anima vegetativa*, to whom it owes its development and movement (growth). In the eyes of modern mankind the tree is, however, a collective being consisting of thousands of independent organisms; and in its action it follows also not one underlying force, but thousands, which influence it in a thousand manners. While the ancient artist meant to produce unity as nature and beauty of each individual object, the modern artist fulfills exactly the same purpose in that he means to express with one-sided emphasis the collective character of the natural objects in the work of art.

6. (*De vera religione*, c. XXX). Another dialogue about the same subject with artifacts at exactly the same place, c. XXXII, col. 148. It is characterisitic that in either case the artist hesitates to respond to the question posed by Augustine: i.e. the beauty the artist is looking for in his works. Augustine wanted thus to indicate that an artist of his time generally was embarrassed by such questions. This is very understandable at a time when artistic creation is restricted by firm typical lines: at a time of the modern hyper-individualism each individual artist thinks he should write a book about his own *Kunstwollen* based on a very understandable fear that his *Kunstabsicht* would not be understood by the public with his works alone.

7. et (ratio) terram coelumque collustrans, sensit nihil aliud quam pulchritudine sibi placere, et in pulchritudine figuras, in figuris dimensiones, in dimensionibus numeros (*De Ordine*, lib. II, c. XV, col. 1014). With 'figurae' are meant individual shapes, with 'dimensiones' the ones which are effective on the plane (height and width). About the identity of the words numeros and rhythm: *de Ordine*, lib. II. c. XIC. col. 1014, t. I.

8. *De vera religione*, c. XXX, t. III., col. 146 and 147.

9. The beginning of this process goes far back before the time of Constantine. Very characteristic for the ancient perception is a remark by Cicero (*De oratore*, lib. III, c. 48) about rhythm 'quem in cadentibus guttis quae intevallis distinguuntur, notare possumus, in amni praecipante non possumus'. Compare in opposition to this the modern *Kunstwollen* which seeks its satisfaction especially in the falling creek.

10. A number of those are quoted in Berthaud, pp. 44 ff.

11. About the relativity between beauty and ugliness and between light and shadow compare *de musica*, lib. VI, c. 13, c. I, col. 118–1184. Bright light and impenetrable shadows are disliked by men, but are the more liked by other beings.

12. *De civitate dei*, lib. XI, cap. 23 (Migne, *Patrologie der lateinischen Väter*, XLI, 336).

13. Now one also understands the analogue utterances as in *de civitate dei*, XI, 18; Contrariorum oppositione saeculi pulchritudo componitur or in the case, where ordo is defined as pulcherrimum carmen ex quibusdam quasi antithetis. Or, also: *Epistola, Nebridio Augustinus*, t. II, col. 65: Quid est corporis pulchritudo? Congruentia partium (Rhythm of the line) cum quadam coloris suavitate (of light and dark coloring). The postulate for *Fernsicht* can be concluded from the sentence: quod horremus in parte si cum toto consideramus plurimum placet, which he demonstrates immediately by using an example from architecture: nec in aedificio iudicando unum tantum angulum considerare debemus (*De vera religione*, c. XL). The latter would have been perhaps possible in the Greek columnar hall, where each column for itself constitutes a completed shape, but not in the early Christian basilica.

14. Alchemy which was as much magic as it was chemistry constitutes certainly a direct connection between the late Roman perception of magic and the modern perception of the chemical connection between objects. Yet also the modern perception about continuous forces which are not dependent on the individuality of objects (for example, electricity) as well as the theory about the cells and the tissue is based on the post-antique dissolution of the individual shape into mass composition and on the perception that an object can be influenced through thousands and many thousands of other objects which are partly more distant

while existing at the same moment.

15. Plan and character of this work do not permit to establish a parallel between the visual arts and the *Weltanschauung* of antiquity in all forms of expression. Just one point may be raised here, because one finds for it numerous connections particularly in my deliberations in the chapter on 'sculpture'. Particularly obvious is the imagined parallel in the simultaneous rise of a explicit dualism in Greek thinking and a consideration of the psychological effects in Greek figurative art. This contradicts the ancient Near Eastern and Greek archaic period with its materialistic monism (the soul seen as a fine material) and its objective representation of the material individual shape. We just seem to see during the concluding phase of antiquity the elements of the primitive step—monism and artistic objectivity—returned: in reality they are extremes. Monism is now spiritualistic (the body as a cruder shape of the soul) and objectivity is directed towards the appearance of the psychological element (one-sided emphasis of the eye as mirror of the soul, turning of the figures in the direction of the beholder); yet, as far as the bodily appearance as such goes objectivity now searches three-dimensional appearance which needs for the perception of deep space a stronger inclusion of the mental consciousness—replacing the two-dimensional appearance towards which the Egyptian search for objectivity was directed. What was common to the first and the third step was the irresistible search for an absolute legal norm excluding as much as possible all subjective elements; hence, the art of the first and third step was objective and anonymous and very closely connected with the cults, its contemporary *Weltanschauung* was strictly religious or more precisely appropriate for a cult. In the classical phase (which exists in between the two) we find alone subjectivity and personality present in the *Weltanschauung* among the visual arts, philosophy, and sciences (which are both subjective and personal)—the closest parallel we find for the indicated process of development for the first two steps in a survey of the history of the visual arts since Charlemagne: during the middle ages the strife exists towards isolation of the objects (now in space rather than on the ancient plane) and towards an objective norm of its (three-dimensional) appearance and also towards a close connection with the cult (which is nothing else than an objective common legal norm which produces the subjective need of

the individual for religion). In more recent times, however, we find the search for a connection of the objects (in space, this can be done with the line as it was done during the sixteenth century or it can be done with light as it was done during the seventeenth century or it can be done with individual coloring as done in modern art) and for a representation of its subjective appearance as well as for a disconnection with the cult which is then replaced by philosophy and the sciences (serving as disciplines which announce the natural connection of the objects).

Aby Warburg: Images from the Region of the Pueblo Indians of North America
1. E. Schmidt, *Vorgeschichte Nordamerikas im Gebiet der Vereinigten Staaten*, 1894.
2. Jesse Walter Fewkes, 'Archeological Expedition to Arizona in 1895', in *Seventeenth Annual Report of the Bureau of American Ethnology*, 1895–6 (Washington, DC, 1898), 2:519–74.
3. Pótnia Qhrẅn see Jane E. Harrison, *Prolegomena to the Study of Greek Religion* (Cambridge, 1922), 264.
4. [Note from the 1988 German edition—M.P.S.] In the first draft of this passage, Warburg explained the symbolic power of the serpent image in the following way: Through which qualities does the serpent appear in literature and art as a usurping imposter [ein verdrängender Vergleicher]? 1. It experiences through the course of a year the full life cycle from deepest, deathlike sleep to the utmost vitality. 2. It changes its slough and remains the same. 3. It is not capable of walking on feet and remains capable nonetheless of propelling itself with great speed, armed with the absolutely deadly weapon of its poisonous tooth. 4. It is minimally visible to the eye, especially when its colors act according to the desert's laws of mimicry, or when it shoots out from its secret holes in the earth. 5. Phallus. These are qualities which render the serpent unforgettable as a threatening symbol of the ambivalent in nature: death and life, visible and invisible, without prior warning and deadly on sight.
5. Lactantius, *Divinae institutiones* 4.28.

Edgar Wind: Warburg's Concept of *Kulturwissenschaft*
1. Warburg called his library 'Die kulturwissenschaftliche Bibliothek Warburg', and Wind's lecture was intended as an introduction to Warburg's theory of imagery. Wind is here attempting to put into systematic

order the basic ideas he had learnt from Warburg in long conversations. On the meaning of 'Kulturwissenschaft' and the difficulty of rendering it in English, see Wind's introduction to the English edition of *A Bibliography on the Survival of the Classics*, 1 (1934), pp. v f. The background to Warburg's concern with *Kulturwissenschaft* is to be found in late 19th-c. writings by Windelband, Rickert, and Dilthey on the relationship between history and the natural sciences, cf. Wind's German introduction to the Bibliography, 1 (1934), pp. vii-xi, for his 'Kritik der Geistesgeschichte', not included in the English version. Warburg's particular contribution to historical method was to conceive of the humanities not only in their specificity and their totality, but primarily in their inter-relation.

2. *Psychologie des mimischen und hantierenden Ausdrucks:* Warburg's elliptic use of 'hantierend' for 'functional' or 'artefactual' expression derives from Carlyle's definition of man as a 'Tool-using Animal (*Handthierendes Thier*)'. Cf. *Sartor Resartus*, 1, v:

3. For Wölfflin's earliest definition of these 'optischen Schichten', or visual layers of style, see the final chapter of *Die klassische Kunst* (1899), which anticipates the principles as defined in *Kunstgeschichtliche Grundbegriffe. Das Problem der Stilentwicklung in der neueren Kunst* (1915). See also Wind, 'Zur Systematik der künstlerischen Probleme', *Zeitschrift für Ästhetik und allgemeine Kunstwissenschaft*, 18 (1925), 438 ff.; *Art and Anarchy* (1969), 21 ff. and 126 ff.

4. *Kunstgeschichtliche Grundbegriffe*, 12.

5. Cf. *A Bibliography on the Survival of the Classics*, pp. vi ff.

6. On the origins of Riegl's method and the term 'Kunstwollen' or, as rendered by Wind, 'autonomous formal impulse', see E. Heidrich, *Beiträge zur Geschichte und Methode der Kunstgeschichte*, 19 (1920), 321–9; also Wind *Zeitschrift für Ästhetik*, 442 ff., and *Art and Anarchy*, 128 ff. and 170 ff. On the difference between 'Kunstwollen' and 'Kunstwillen', see O. Pächt, 'Alois Riegl', *Burlington Magazine*, 105 (1963), 488–93.

7. Of course, this conceptual scheme is quite different from Wölfflin's. There is no simple division of form and content, but a complex relationship of dynamic interaction between a conscious and autonomous 'formal impulse' and the 'coefficients of friction' of function, raw material, and technique. However, on closer inspection the dynamic element suddenly disappears from Riegl's method of procedure. For, in order to show that within a given period the most diverse forms of artistic phenomena are informed by the same autonomous 'formal impulse', Riegl can only resort to formalization. In the study of the history of ornament he explicitly bids us to abandon analysing the ornamental motif for its content and to concenetrate instead on the 'treatment it has received in terms of form and colour in plane and space'. And in the study of the history of pictorial art in the wider sense, he similarly demands that we disregard all considerations of subject-matter which place the picture in a cultural-historical context, and concentrate instead on the common formal problems which link the picture with all other forms of visual art. 'The iconographic content', he writes, 'is quite different from the artistic; the function of the former, which is to awaken particular ideas in the beholder, is an external one, similar to the function of architectural works or to that of the decorative arts, while the function of art is solely to present objects in outline and colour, in plane or space, in such a way that they arouse liberating delight in the beholder.' (A. Riegl, *Die spätrömische Kunstindustrie im Zusammenhange mit der Gesamtentwicklung der bildenden Künste bei den Mittelmeervölkern*, 1, 1901, 119 f.) In this antithesis of utilitarian and artistic functions only what is literally 'optical' is allocated to the artistic, while the utilitarian is held to include not only material requirements, but also the ideas that are awakened by the work of art and are supposed to play a part in any contemplation of it. With this we come full circle to Wölfflin's point of view.

8. Wölfflin, 'Prolegomena zu einer Psychologie der Architektur', in *Kleine Schriften 1886–1933*, ed. J. Gantner (1946), 44 f.; cf. *Art and Anarchy*, 21 and 127.

9. On their relationship see *Jacob Burckhardt und Heinrich Wölfflin. Briefwechsel und andere Dokumente ihrer Begegnung 1882–1897*, ed. J. Gantner (1948); also Wölfflin's obituary notice of Burckhardt, *Repertorium für Kunstwissenschaft*, 20 (1897), 341 ff., reprinted in *Kleine Schriften*, 186 ff.

10. *Bildniskunst und Florentinisches Bürgertum. Domenico Ghirlandajo in Santa Trinità: Die Bildnisse des Lorenzo de' Medici und seiner Angehörigen* (1902), Vorbemerkung, p. 5, reprinted in *Die Erneuerung der Heidnischen Antike. Kulturwissenschaftliche Beiträge zur Geschichte der Europäischen Renaissance*, ed. G. Bing in collaboration with F. Rougemont, *Gesammelte Schriften*, i (1932),

93.

11. Idem.

12. *Kunstgeschichtliche Grundbegriffe*, 13.

13. *Die spätrömische Kunstindustrie*, i. 212 n.

14. Warburg himself habitually arranged and rearranged on portable screens the photographs of material he was studying; and such photographic demonstrations remained for some years a characteristic feature of the Warburg Institute's public exhibitions.

15. 'Italienische Kunst und internationale Astrologie im Palazzo Schifanoja zu Ferrara', in *L'Italia e l'arte straniera, Atti del X congresso internazionale di storia dell'arte*, Rome, 1912 (1922), 179–93 (*Gesammelte Schriften*, ii. 459 ff., see esp p. 464).

Margaret Iversen: Retrieving Warburg's Tradition

1. Book-length re-evaluations of the tradition include Michael Ann Holly, *Panofsky and the Foundations of Art History*, (Ithaca, NY, 1984); Margaret Iversen, *Alois Riegl: Art History and Theory* (Cambridge, Mass. and London, 1993); Margaret Olin, *Forms of Representation in Alois Riegl's Art Theory* (Penn State, 1992); Michael Podro, *The Critical Historians of Art* (New Haven and London, 1972); Donald Preziosi, *Rethinking Art History: Meditations on a Coy Science* (New Haven and London, 1989).

2. Svetlana Alpers, 'Art History and its Exclusions: The Example of Dutch Art', in N. Broude and M. Garrard (eds.), *Feminism and Art History: Questioning the Litany* (New York, 1982).

3. See particularly Griselda Pollock, 'Modernity and the Spaces of Femininity' in *Vision and Difference: Femininity, Feminism and Histories of Art* (London, 1988).

4. This term has become current among feminists influenced by Derrida. It unites his sense of 'logocentrism', the Western prejudice which prioritizes speech over writing in order to secure the possibility of a kind of unmediated signification which transcends the historical accidents that befall texts, with 'phallocentrism', a term which indicates that masculinist discourse is organized around unequal pairs of binary oppositions that ultimately relate back to the pair 'phallus/lack of phallus'.

5. F. Nietzsche, *The Birth of Tragedy*, trans. Walter Kaufmann. 1967. There is no need to speculate about this connection because Warburg's copy of the essay in the Institute is much underlined and annotated.

6. Where possible I will make reference to a cheap and readily available selection of essays by Warburg and critical essays about his work: Dieter Wuttke (ed.), *Aby Warburg Ausgewälte Schriften and Würdigungen* (Baden-Baden. 1980). 125. The Collection contains an extensive bibliography. See also the recently published collection of essays in H. Bredekamp, M. Diers, and C. Schoell-Glass (eds.), *Aby Warburg Akten des internationalen Symposiums*, Hamburg, 1990. (Weinheim, 1991), which contains an embryonic version of this paper. Also of interest is Silvia Ferretti, *Cassirer, Panofsky, Warburg: Symbol, Art and History*, trans. Richard Pierce, (New Haven and London, 1989). My interest in Warburg was first stimulated by reading the reprint of Edgar Wind's splenetic review of Gombrich's biography in Jaynie Anderson (ed.), *Edgar Wind. The Eloquence of Symbols* (Oxford, 1983). 106–113.

7. Erwin Panofsky, 'Albrecht Dürer and Classical Antiquity', *Meaning in the Visual Arts* (Harmondsworth, 1970), 277–89.

8. Ibid. 311.

9. Ibid. 312.

10. Ibid.

11. Ibid.

12. Aby Warburg, 'A Lecture on Serpent Ritual', *Journal of the Warburg Institute*, 2 (1939). English translation of a lecture delivered at Kreuzlinger, 21 April 1923, p. 288. Sadly, this is one of only two works by Warburg available in English. The other is 'Italian Art and International Astrology in the Palazzo Schifanoia in Ferrara', in Gert Schiff (ed.), *German Essays on Art History* (New York, 1988), 234–54.

13. E. H. Gombrich, *Aby Warburg: An Intellectual Biography* (Chicago, 1986), p. viii. First published by the Warburg Institute, University of London (1970).

14. Ibid. 13.

15. See particularly 'Ninfa Fiorentia', unpublished notes and fragments dating from 1900 in Warburg Archive. Cited by Gombrich, *Aby Warburg*, 105–27.

16. A useful volume of essays on the subject is Sandra Harding and Merrill B. Hintikka (eds.), *Discovering Reality: Feminist Perspectives on Epistemology, Metaphysics, Methodology, and Philosophy of Science* (Boston and London, 1983). See also Sandra Harding, *The Science Question in Feminism* (Milton Keynes, 1986); Ludmilla Jordanova, *Sexual Visions: Images of Gender in Science and Medicine between the Eighteenth and Twentieth Centuries* (London, 1989); Luce Irigaray, 'Is the Subject of Science Sexed?', *Cultural Critique*, 1 (1985), 73–88; Donna Haraway,

'Situated Knowledges: The Science Question in Feminism and the Privilege of Partial Perspectives', *Simains, Cyborgs and Women: the Re-invention of Nature* (London, 1991), 183–202. For an incisive critique of essentialist feminist objections to patriarchal thought see Toril Moi, 'Patriarchal Thought and the Drive for Knowledge', in Teresa Brennan, *Between Feminism and Psychoanalysis* (London and New York, 1989). I have found particularly helpful those critiques of modern science and philosophy grounded in the branch of psychoanalysis called 'object relations' theory: Evelyn Fox Keller, *Reflections on Gender and Science* (New Haven and London, 1985); Jane Flax, *Thinking Fragments: Psychoanalysis, Feminism and Postmodernism in the Contemporary West* (Berkeley, 1990), and Jessica Benjamin, *The Bonds of Love: Psychoanalysis, Feminism and the Problem of Domination*. Julia Kristeva's work has been crucial in the formation of my thoughts on these matters.

17. My references are to the Penguin edition, Peter Fairclough (ed.), *Three Gothic Novels*, 296. Recently there have been many feminist appropriations of *Frankenstein*. See e.g. Sandra M. Gilbert and Susan Gubar, *The Madwoman in the Attic: The Woman Writer and the Nineteenth-Century Imagination* (New Haven and London, 1979), 213–47.

18. Ibid. 330.

19. Ibid. 307.

20. See particularly Keller and Jordanova.

21. Shelley, *Three Gothic Novels*, Peter Fairclough (ed.), 316.

22. Julia Kristeva, 'Woman's Time', in Toril Moi (ed.), *The Kristeva Reader* (New York, 1986), 198.

23. J. Kristeva, 'The System and the Speaking Subject', reprinted in *The Kristeva Reader*, 28.

24. S. Freud, 'Some Psychical Consequences of the Anatomical Distinction between the Sexes' (1925), in *On Sexuality*, The Pelican Freud Library, vii. 342 or in the *Standard Edition*, vol. xix. 241–58.

25. A useful anthology is Elaine Marks and Isabelle de Courtivron (eds.), *New French Feminisms: An Anthology* (Brighton, 1980). See also Luce Irigaray, *This Sex which is not One* (Ithaca, NY, 1985), and *Speculum of the Other Woman*, (Ithaca, NY, 1985).

26. A. Warburg, 'Notes on Serpent Ritual', note cited in E. H. Gombrich, *Aby Warburg*, 220.

27. Gombrich, *Aby Warburg*, 223 n.6.

28. Ibid. 237. Citation from unpublished notes in Warburg archive.

29. E. Panofsky, 'Der Begriff des Kunstwollens' (1920), *Aufsätze zu Grundfragen der Kunstwissenschaft* (Berlin, 1964, translated loosely 'The Concept of Artistic Volition', trans. Kenneth J. Northcott and Joel Snyder, *Critical Inquiry*, 8 (Autumn 1981), 17–33.

30. E. Panofsky, 'Die Entwicklung der Proportionslehre als Abbild der Stilentwicklung' (1921), in *Monatshefte für Kunstwissenschaft*, 14. 188–219, translated as 'The History of the Theory of Human Proportions as a Reflection of the History of Style', *Meaning in the Visual Arts*.

31. I discuss this more fully in the final chapter of my book on Riegl: Margaret Iversen, *Alois Riegl: Art History and Theory*.

32. E. Panofsky, 'Art History as a Humanistic Discipline', *Meaning in the Visual Arts*, 48.

33. Also reprinted in Panofsky, *Meaning in the Visual Arts*, 225.

34. Ibid. 277.

35. Reprinted in Stephan Füssel (ed.), *Mnemosyne* (Göttingen, 1979), 33.

36. Unpublished manuscript; cited in Gombrich, *Aby Warburg*, 289.

37. F. Nietzsche, *The Birth of Tragedy*, trans. Walter Kaufmann (1967), 50. Warburg's notes on grisaille (1929) are in the archive. Charlotte Schoel-Glass has commented on them in H. Bredekamp et al. (eds.), *Aby Warburg Akten*; see n. 6.

38. A. Warburg, 'A Lecture on Serpent Ritual', 289.

39. I refer particularly to Warburg, 'Francesco Sassettis letzwillige Verfügung' (1907), reprinted in Wuttke, *Aby Warburg Ausgewälte Schriften*, 137–64.

40. Warburg, *Gesammelte Schriften*, vol. ii, (Leipzig and Berlin, 1932), 479.

41. Gombrich, *Aby Warburg*, 322. Letter to Mesnil, 18 August 1927. Warburg's interdisciplinarity is stressed by W. Heckscher, 'The Genesis of Iconology', *Stil und Uberlieferung in der Kunst des Abendslandes*, Akten des 21. Internationalen Kongresses für Kunstgeschichte in Bonn 1964. Band II, Berlin 1967, 239–62.

42. Ibid. 282.

43. *Mnemosyne*, also called *Bilderatlas* (1928–9), consists of photographs of screens. The *Grundbegriffe* I and II (1929) is the introduction to the *Bilderatlas*. Both are in the Warburg Archive. See Werner Hofmann, Georg Syamken and Martin Warnke, *Die Menschenrechte des Auges: Uber Aby Warburg* (Frankfurt am Main, 1980), 92–3, 159. See also the commentary on the Bilderatlas project by Dorothée Bauerle, *Gespenstergeschichten für*

Ganz Erwachsene: ein Kommentar zu Aby Warburgs Bilderatlas, Mnemosyne (Münster, 1988).

44. Gombrich, *Aby Warburg*, 282.

45. E. Panofsky, *Dürers Kunsttheorie, vornehmlich in ihrem Verhältnis zur Kunsttheorie der Italiener* (Berlin, 1915), 199.

46. E. Panofsky, 'Die Perspektive als "symbolische Form"' (1927) reprinted in *Aufsätze zu Grundfragen der Kunstwissenschaft*, translated as *Perspective as Symbolic Form*, trans. Christopher Wood (Cambridge, 1991).

47. Ibid. 101.

48. E. Cassirer, *The Philosophy of Symbolic Forms: Mythical Thought*, vol. ii. trans. R. Manheim (New Haven (1955), 1972), 83 ff.

49. Panofsky, 'Perspektive', 101.

50. Ibid. 123.

51. Ibid.

52. Introduction to *Mnemosyne*, unpublished manuscript.

53. Martin Jay, 'Scopic Regimes of Modernity', in Hal Foster (ed.). *Vision and Visuality*, DIA Art Foundation, Discussion in Contemporary Culture (1988), No. 2, Seattle, p. 7.

54. Ibid. 8.

55. A. Warburg, 'A Lecture on Serpent Ritual', 289.

56. See Wolfgang Kemp, 'Walter Benjamin und die Kunstgeschichte: Part 2', *Kritische Berichte*, 1: 4.

57. 'He never accepted the wireless because of its threatening obliteration of distance', Gombrich, *Aby Warburg*, 224.

58. Warburg, 'A Lecture on Serpent Ritual', 289.

59. Ibid. 292.

60. Theodor Adorno and Max Horkheimer. *Dialectic of Enlightenment*, trans. John Cumming (London. 1979), 9.

61. Warburg, 'A Lecture on Serpent Ritual', 292.

Chapter 5

1. See the excellent summary of these developments in the recent study by John Roberts (ed.), *Art Has No History! The Making and Unmaking of Modern Art* (London, 1994).

2. A discussion of art historical social history may be found in Preziosi, *Rethinking Art History*, ch. 6.

3. On this see the interesting essay by Thomas Y. Levin, 'Walter Benjamin and the Theory of Art History. An Introduction to [Benjamin's] "Rigorous Study of Art"', *October*, 47 (1988), 77–83. Benjamin's 'Rigorous Study of Art', translated by Levin, with its attack on

Wölfflin's formalism, follows on pp. 84–90.

4. On which see the discussion by John Roberts in the introduction to John Roberts (ed.), *Art Has No History!*, 1–36.

5. The bibliography of works in and on semiology is enormous. A few of those relevant to visual culture studies include the following. The best compendium of information about all aspects of semiotics is Winfried Noeth, *Handbook of Semiotics* (Bloomington, Ind., 1990), in which all aspects of visual semiotics are discussed on pp. 421–80, and where an extensive bibliography on the subject may be found (pp. 481–550). The most complete survey of visual semiotics is Goeran Harry Sonesson, *Pictorial Concepts: Inquiries into the Semiotic Heritage and its Relevance for the Analysis of the Visual World* in the series *Ars Nova* published by the Institute of Art History, University of Lund (Lund, 1989). Other useful texts include the survey by Fernande Saint-Martin, *Semiotics of Visual Language* (Bloomington, Ind., 1990); Meyer Schapiro, 'On Some Problems in the Semiotics of Visual Art: Field and Vehicle in Image-Signs', *Semiotica*, i (1969), 223–42; id., *Words and Pictures: On the Literal and the Symbolic in the Illustration of a Text* (The Hague and Paris; 1973). A good general overview of the philosophical interest in systems of signification from the 17th c. to the beginning of the 20th is Hans Arsleff, *From Locke to Saussure: Essays on the Study of Language and Intellectual History* (Minneapolis, 1982), in which two essays are especially important: 'Taine and Saussure', pp. 356–71, illustrates the ways in which certain key notions of Ferdinand de Saussure, the Swiss linguist credited with being the progenitor of modern semiology, were derived from Hippolyte Taine's lectures on art in Paris when Saussure was a student (summarized in D. Preziosi, *Rethinking Art History*, ch. 4, pp. 80–121), and 'Condillac's Speechless Statue', pp. 210–24.

6. Hubert Damisch, 'Semiotics and Iconography', in Thomas A. Sebeok (ed.), *The Tell-Tale Sign: A Survey of Semiotics* (Lisse, 1975), 27–36. The anthology in which it appeared contains important surveys of semiotic research in a number of fields.

7. Mieke Bal and Norman Bryson, 'Semiotics and Art History', *Art Bulletin*, 73: 2 (1991), 174–208.

8. Norman Bryson begins his introduction to the anthology *Calligram: Essays in New Art History from France* (Cambridge, 1988) with the statement 'There can be little doubt: the discipline of art history, having for so long

lagged behind, having been among the humanities perhaps the slowest to develop and the last to hear of changes as these took place among even its closest neighbors, is now unmistakably beginning to alter' (p. xiii).

9. It does not, however, mention the work of Jan Mukarovsky (1891–1975), the eminent Czech aesthetician and a semiotician of art and architecture, who was a key member of the Prague School group of the 1930s. Several of his essays became more widely known in Western Europe and America only after World War II; one of the most important of his texts (*Aesthetic Function, Norm and Value as Social Facts* (1936)) was republished in English in 1979 by the University of Michigan Press; his 1934 essay 'Art as Semiological Fact' was republished in L. Matejka and I. R. Titunik (eds.), *The Semiotics of Art* (Cambridge, Mass., 1976).

10. Erwin Panofsky, *Studies in Iconology: Humanistic Themes in the Art of the Renaissance* (Oxford, 1939), 3–17.

11. Erwin Panofsky, 'Zum Problem der Beschreibung und Inhaltsdeutung von Werken der bildenden Kunst', *Logos*, 21 (1932), 103–19.

12. Among many writings on the subjects, the most useful is: Christine Hasenmueller, 'Panofsky, Iconography, and Semiotics', *Journal of Aesthetics and Art Criticism*, 36 (1978), 289–301. Related book-length studies include Michael A. Holly, *Panofsky and the Foundations of Art History* (Ithaca, NY, 1984), and W. J. T. Mitchell, *Iconology: Image, Text, Ideology* (Chicago, 1986); the former was an admirably ambitious but largely unsuccessful attempt to frame Panofsky as a proto-semiotician, while the latter was a general overview of ideas about visual-verbal relations from the perspective of traditional literary criticism.

13. Erwin Panofsky, '*Et in Arcadia Ego*: On the Conception of Transience in Poussin and Watteau', in R. Klibansky and H. J. Patton, (eds.), *Philosophy and History: Essays Presented to Ernst Cassirer* (Oxford, 1936) 223–54.

14. Louis Marin, 'Toward a Theory of Reading in the Visual Arts: Poussin's *The Arcadian Shepherds*', in Susan Suleiman and Inge Crossman (eds.), *The Reader in the Text: Essays on Audience and Interpretation* (Princeton, 1980).

Hubert Damisch: Semiotics and Iconography

1. 'On some Problems in the Semiotics of Visual Art: Field and Vehicle in Image Signs', *Semiotica*, 1/3, 1969.

Mieke Bal and Norman Bryson: Semiotics and Art History

1. We would like to thank Michael Ann Holly for her very pertinent comments on this paper.

2. See C. Hasenmueller, 'Panofsky, Iconography, and Semiotics', *Journal of Aesthetics and Art Criticism*, 36, (1978), 289–301; M. Iversen, 'Style as Structure: Alois Riegl's Historiography', *Art History*, 2(1979), 66–7; and M. A. Holly, *Panofsky and the Foundations of Art History* (Ithaca, NY, 1984), 42–5. The semiotic nature of an apparently 'natural' device like linear perspective is masterfully demonstrated in Hubert Damisch's seminal study, *L'Origine de la perspective*, (Paris, 1988).

3. See e.g. M. Schapiro, 'On Some Problems in the Semiotics of Visual Art: Field and Vehicle in Image-Signs', *Semiotica*, 1, (1969), 223–42.

4. The clearest and most convincing overview of epistemological currents in the 19th and 20th centuries is Habermas's *Erkenntnis und Interesse* of 1968 (*Knowledge and Human Interests*, trans. J. Shapiro, (London, 1972). Habermas's work has been challenged by psychoanalysts who believe that his idealized view of psychoanalytic practice as a constraint-free communication misunderstands their discipline. See e.g. J. Rose, *Sexuality in the Field of Vision*, (London, 1986). Habermas's œuvre is also under pressure from the side of postmodern philosophy, most pertinently by J.-F. Lyotard, in e.g. *The Postmodern Condition*, (New York, 1980). These challenges do not, however, address Habermas's argument against positive knowledge, but his hope for a rational society. If anything, the authors are more skeptical than Habermas.

5. For the 'linguistic' or, rather, rhetorical turn in history, see H. White, *Metahistory: The Historical Imagination in Nineteenth-Century Europe* (Baltimore, 1973), and especially, for a brief and convincing account of the fundamental rhetorical and semiotic nature of historiography, id., 'Interpretation in History', in *Tropics of Discourse* (Baltimore, 1978). The most detailed and incisive analysis of the rhetoric of historiography remains S. Bann's remarkable *The Clothing of Clio*, (Cambridge and New York, 1984).

6. See e.g. the Rembrandt Research Project, in J. Bruyn, B. Haak, S. H. Levie *et al.*, *A Corpus of Rembrandt Paintings*, (The Hague, Boston, London, 1982, 1987, 1989), review by L. J. Slatkes in the *Art Bulletin*, 71 (1989), 139–44.

7. Culler, xiv.

8. Similar arguments within the social history of art, explicitly articulating art history with semiotics, have been put forward in a number of places by Keith Moxey. See 'Interpreting Pieter Aertsen: The Problem of Hidden Symbolism', *Nederlands Kunsthistorisch Jaarboek*, (1989), 42 ff.; 'Pieter Bruegel and Popular Culture', *The Complete Prints of Pieter Bruegel the Elder*, ed. D. Freedberg, (Tokyo, 1989), 42 ff.; 'Semiotics and the Social History of Art', *Acts of the 27th International Congress of the History of Art*, (Strasbourg, 1990).

9. Culler, xiv.

10. F. Saint-Martin, *Semiotics of Visual Language* (Bloomington, Ind., 1990).

11. See the important article by T. G. Peterson and P. Mathews, 'The Feminist Critique of Art History', *Art Bulletin*, 69 (1987), 326 ff.

12. For the distinction between discrete and dense sign-systems, see N. Goodman, *Languages of Art: An Approach to a Theory of Symbols* (Indianapolis, 1976). This theory is much indebted to Wittgenstein. See A. Thiher, *Words in Reflection: Modern Language Theory and Postmodern Fiction*, (Chicago, 1984).

13. The intimate connection between semiotics and linguistics is a problem in Saussurean semiotics, which developed out of linguistics rather than the other way around, and not so much in Peircean semiotics, which came out of logic.

14. Examples of analyses of word and image interaction or comparison can be found in W. Steiner, *The Colors of Rhetoric: Problems in the Relation between Modern Literature and Art* (Chicago, 1982), and *Pictures of Romance: Form against Context in Painting and Literature*, (Chicago, 1988). See also the special issues of *Poetics Today*, 10, 1 and 2 (1989), edited by Steiner. Also A. Kibédi Varga, 'Stories Told by Pictures', in *Style*, 22 (1980), 194–208, and 'Criteria for Describing Word and Image Relations', in *Poetics Today*, 10 (1989), 31 ff. For a critical examination of the hierarchies implied in many of these attempts, see W. J. T. Mitchell, *Iconology: Image, Text, Ideology* (Chicago, 1985), and M. Bal, 'On Reading and Looking', in *Semiotica*, 76 (1989), 283–320.

15. The quotation marks around 'context' ('text,' 'artwork,' etc.) are meant to designate that at this place in our essay the word appears as an object of methodological reflection.

16. The points in this section are worked out in more detail in N. Bryson, 'Art in Context', in *Studies in Historical Change*, ed. R. Cohen (Charlottesville, Va., forthcoming).

17. J. Derrida, *Dissemination*, trans. with introd. and additional notes by B. Johnson (Chicago, 1982). For a discussion of Derrida's theory of signification, see S. Melville, *Philosophy beside Itself: On Deconstruction and Modernism* (Minneapolis, 1986). Umberto Eco, an important semiotician who draws upon Peirce but is also well versed in the Saussurean tradition, warns against a confusion between theoretical polysemy and actual interpretation, where limits are obviously in place. See his *Role of the Reader: Explorations in the Semiotics of Texts* (1979); *Semiotics and the Philosophy of Language* (1984); and, more directly confronting deconstruction, *The Limits of Interpretation*, 1990 (all three Bloomington, Ind.). But the point is that these limits are socially and politically motivated, putting a practical stop to a theoretical polysemy. Thus the very thesis of polysemy provides clearer insight into the limits of interpretation and their motivations.

18. Culler, 139–52.

19. J. L. Austin, *How To Do Things with Words* (Cambridge, 1975), 148 (emphasis in the original). See also J. Searle, 'Reiterating the Differences', *Glyph*, 1, (1977), 198–208; and Derrida, *passim*.

20. J. Derrida, 'Living On: Border Lines', in H. Bloom *et al.*, *Deconstruction and Criticism*, (New York, 1979), 81.

21. 'The fragment of the outside world of which we become conscious comes after the effect that has been produced on us and is projected *a posteriori* as its "cause." In the phenomenalism of the "inner world" we invert the chronology of cause and effect. The basic fact of "inner experience" is that the cause gets imagined after the effect has occurred.' F. Nietzsche, *Werke*, ed. K. Schlechta (Munich, 1986), iii. 804; cited by J. Culler, *On Deconstruction: Theory and Criticism after Structuralism* (London, 1983), 86.

22. Ibid. 86.

23. On synecdoche in historiography, see White, *Tropics of Discourse*, on synecdoche as it functions within the rhetoric of art history, see Roskill, *The Interpretation of Pictures* (Amherst, 1989), 3–35. See also D. Carrier's pertinent study of the rhetoric of art history and art criticism, *Artwriting* (Amherst), 1987.

24. M. A. Holly, 'Past Looking', *Critical Inquiry*, 16 (1990), 373. Holly's essay examines the general problem of 'chronological reversal' in relation to the historiography of Burckhardt.

25. The stroke is what Derrida critically describes as 'the *sans* of the pure cut', a cutting of the field that will be so sharp as to leave no

traces of its own incision; a conceptual blade so acute that when the two sides of the cleavage are brought together the edges will perfectly rejoin; J. Derrida, *The Truth in Painting*, trans. G. Bennington and I. McLeod, (Chicago, 1987), 83–118.

26. On 'iteration', see Derrida, 'Signature Event Context', in *Limited Inc.*, 1–23.

27. See P. de Man, *Blindness and Insight*, 2nd edn., ed. W. Godzich (Minneapolis, 1983).

28. Though the term 'author' has some advantages over the term 'artist' in this discussion, 'author' has its own baggage of connotations. In some kinds of literary criticism, 'author' is no less hagiographic than is 'artist' in some kinds of art history; but we hope that the change of context here, from literary criticism to art history, will enable this range of meanings to be discarded. 'Author' has the further disadvantage that, as a term brought into art-historical discussion from literary theory, it carries with it a connotation of 'linguistic imperialism'—a name for the *verbal* artist being used for the *visual* artist. We are aware of this coloration, and we wish to state expressly that in our discussion the term 'author' is meant to designate a function, or set of functions, not particularized by medium.

29. For this influential concept, see L. Dällenbach, *Le Récit spéculaire. Essai sur la mise en abyme* (Paris, 1977) (*The Mirror in the Text*, trans. J. Whiteley and E. Hughes, (Chicago, 1989)).

30. M. Foucault, 'What Is an Author?', in D. F. Bouchard (ed.), *Language, Counter-Memory, Practice: Selected Essays and Interviews* (Ithaca, NY. 1977), 113–38.

31. In fact, what they say in Britain is likelier to be 'Joe Bloggs'; for us, though, Bloggs can be a woman.

32. Our description of attribution is not, of course, meant to be exhaustive.

33. On the relation between detectives and art historians (and psychoanalysts), see C. Ginzburg, 'Morelli, Freud and Sherlock Holmes: Clues and Scientific Method', *History Workshop*, 9(1980), 5–36.

34. On 'emplotment', see White, *Tropics of Discourse*, 66–7; and Roskill, 7–10.

35. See Culler, xiv.

36. R. Barthes, 'The Death of the Author', in *Image—Music—Text*, ed. and trans. S. Heath (New York, 1977), 145–6.

37. Preziosi, *Rethinking Art History*, 31.

38. G. Pollock, *Vision and Difference: Femininity, Feminism and Histories of Art* (London, 1988), 2.

E. Panofsky: *Et in Arcadia Ego*

1. The connection between Poussin's earlier *Et in Arcadia* composition, viz., the painting owned by the Duke of Devonshire, and the New York Midas picture, was recognized and completely analyzed by A. Blunt, 'Poussin's Et in Arcadia ego', *Art Bulletin*, 20 (1938), 96 ff. Blunt dates the Duke of Devonshire version about 1630, with which I am now inclined to agree.

2. The importance of this habit is, in my opinion, somewhat overestimated in J. Klein, 'An Analysis of Poussin's "Et in Arcadia ego"', *Art Bulletin*, 99 (1937), 314 ff.

3. See e.g., H. Jouin, *Conférences de l'Académie Royale de Peinture et de Sculpture*, (Paris, 1883), 94.

4. Sannazaro, *Arcadia*, ed., Scherillo, p. 306, lines 257–67. Further tombs occur in Sannazaro's poem on p. 70, lines 49 ff., and p. 145, lines 246 ff. (a literal translation of Virgil, *Eclogues*, X, 31 ff.).

5. See the discussion between W. Weisbach, 'Et in Arcadia ego', *Gazette des Beaux-Arts*, ser. 6, 18, (1937), 287 ff., and this writer, ' "Et in Arcadia ego" et le tombeau parlant', ibid., ser. 6, 19 (1938), 305 f. For Michelangelo's three epitaphs in which the tomb itself addresses the beholder ('La sepoltura parla a chi legge questi versi'), see K. Frey, *Die Dichtungen des Michelagniolo Buonaroti* (Berlin, 1897), 77: 34, 38, 40.

6. G. P. Bellori, Le Vite dei pittori, scultori et architetti moderni (Rome, 1672).

7. A. Félibien, *Entretiens sur les vies et les ouvrages des peintres* (Paris, 1666–85; in the edition of 1705, iv. p. 71); cf. also the inscription of Bernard Picart's engraving after Poussin's Louvre picture as quoted by Andresen, ibid., no. 417.

8. Abbé du Bos, *Réflexions critiques sur la poésie et sur la peinture* (first published in 1719), I, section VI; in the Dresden edition of 1760, pp. 48 ff.

9. Diderot, 'De la poésie dramatique', *Oeuvres complètes*, ed. J. Assézat (Paris, 1875–77), vii. 353. Diderot's description of the painting itself is significantly inaccurate: 'Il y a un paysage de Poussin où l'on voit de jeunes bergères qui dansent au son du chalumeau [!]; et à l'écart, un tombeau avec cette inscription "*Je vivais aussi dans la délicieuse Arcadie.*" Le prestige de style dont il s'agit, tient quelquefois à un mot qui detourne ma vue du sujet principal, et qui me montre de côté, comme dans le paysage du Poussin, l'espace, le temps, la vie, la mort ou quelque autre idée grande et mélancolique jetée toute au travers des images de la gaieté'

(cf. also another reference to the Poussin picture in Diderot's 'Salon de 1767,' *Œuvres*, xi, 161; later on the misplaced *aussi* became as much a matter of course in French literature as the misplaced *Auch* in Germany, as illustrated by Delille's *Et moi aussi, je fus pasteur dans l'Arcadie*). The picture described by Diderot seemed to bear out his well-known theory of the *contrastes dramatiques*, because he imagined that it showed the shepherds dancing to the sound of a flute. This error is due either to a confusion with other pictures by Poussin, such, for example, as the *Bacchanal* in the London National Gallery or the *Feast of Pan* in the Cook Collection at Richmond, or to the impression of some later picture dealing with the same subject. Angelica Kauffmann, for instance, in 1766 exhibited a picture described as follows: 'a shepherd and shepherdess of Arcadia moralizing at the side of a sepulchre, while others are dancing at a distance' (cf. Lady Victoria Manners and Dr. W. C. Williamson, *Angelica Kauffmann* (London, 1924), 239; also Leslie and Taylor, *Life and Times of Sir Joshua Reynolds* (London, 1865), i. 260).

10. The motto superscribed on Mrs Felicia Hemans's poem appears to confuse Poussin's Louvre picture with one or more of its later variations: 'A celebrated picture of Poussin represents a band of shepherd youths and maidens suddenly checked in their wanderings and affected with various emotions by the sight of a tomb which bears the inscription "Et in Arcadia ego." ' In the poem itself Mrs Hemans follows in the footsteps of Sannazaro and Diderot in assuming that the occupant of the tomb is a young girl:

Was some gentle kindred maid
In that grave with dirges laid?
Some fair creature, with the tone
Of whose voice a joy is gone?

11. Gustave Flaubert, 'Par les champs et par les grèves'. *Œuvres complètes* (Paris, 1910), 70; the passage was kindly brought to my attention by Georg Swarzenski.

12. See Büchmann, loc. cit.

13. Cf. also Goethe's *Faust*, iii, 3:

Gelockt, auf sel'gem Grund zu wohnen,
Du flüchtetest ins heiterste Geschick!
Zur Laube wandeln sich die Thronen,
Arcadisch frei sei unser Glück!

In later German literature this purely hedonistic interpretation of Arcadian happiness was to degenerate into the trivial conception of 'having a good time'. In the German translation of Offenbach's *Orphée aux Enfers* the hero therefore sings 'Als ich noch Prinz war von *Arkadien*' instead of 'Quand j'étais prince de *Béotie*'.

Louis Marin: Toward a Theory of Reading in the Visual Arts

1. Cf. S. Freud, 'Negation' (*Die Verneinung*, 1925), in *Standard Edition of the Complete Psychological Works*, ed. and trans. James Strachey *et al.*, 24 vols. (London, 1953–74), xiv. 236 f.

2. L. B. Alberti, *Della pittura*, trans. J. R. Spencer (New Haven, 1956), 78.

3. J. Lacan, *Le Séminaire* (*livre XI*) *Les quatre concepts fondamentaux de la psychanalyse* (Paris, 1973), 65–109.

4. A. Manetti, *Vita di Ser Brunelleschi*, quoted in *A Documentary History of Art*, i. *The Middle Ages and the Renaissance*, ed. E. Gilmore Holt (New York, 1957), 170–3.

5. E. Panofsky, 'Die Perspektive als "Symbolische Form" ', *Vortrage der Bibliothek Warburg* (Leipzig and Berlin, 1924–5), 258–330.

6. R. Jakobson, 'Linguistics and Poetics', in T. Sebeok (ed.), *Style in Language* (Cambridge, Mass., 1960), 353.

7. *The Arcadian Shepherds*. 101 x 82 cm. The Chatsworth Settlement, Chatsworth, Derbyshire, before 1631. Cf. A. Blunt, *Paintings of Nicolas Poussin*, p. 80, no. 119.

8. See E. Panofsky, '*Et in Arcadia ego*: Poussin and the Elegiac Tradition', in *Meaning in the Visual Arts* (Garden City, NY, 1955). See also W. Weisbach, '*Et in Arcadia ego*: Ein Beitrag zur Interpretation antiker Vorstellungen in der Kunst des 17. Jahrhunderts', *Die Antike*, 6 (1930); J. Klein, 'An Analysis of Poussin's *Et in Arcadia ego*', *Art Bulletin*, 19 (1937), 314 ff.; A. Blunt, 'Poussin's "Et in Arcadia ego"', *Art Bulletin*, 20 (1938), 96 ff.; W. Weisbach, 'Et in Arcadia ego', *Gazette des Beaux-Arts*, 2 (1938), 287 ff.; M. Alpatov, 'Poussin's "Tancred and Erminia" in the Hermitage: An Interpretation', *Art Bulletin*, 25 (1943), 134.

9. J. Klein, 'An Analysis', 315–16.

10. *Meaning in the Visual Arts*, 306.

11. See n. 8 above, as well as G. Bellori, *Le Vite dei pittori, scultori et architetti moderni* (Rome, 1672), 447 ff.; and Félibien, *Entretiens*, 71.

12. *Meaning in the Visual Arts*, 306.

13. *Problèmes* 1: 151 ff.

14. Cf. E. Galletier, *Etude sur la poésie funéraire romaine* (Paris, 1922); and John Sparrow, *Visible Words* (Cambridge, 1969).

15. See Bellori, *Le Vite dei pittori*, 447 ff., and Panofsky, *Meaning in the Visual Arts*, 305 n.29. See A. Blunt, *Paintings of Nicolas Poussin*, 81, no. 123 for *Time Saving Truth from Envy and Discord*, original lost; in the Palazzo

Rospigliosi till about 1800.

16. N. Poussin, *Correspondance*, ed. Jouanny, de Nobele, Archives de la Société de l'Art français (Paris, 1968), 463.

17. P. Fréart de Chantelou, 'Voyage du cavalier Bernin en France', in *Actes du colloque international Poussin* (Paris, 1960), 2: 127.

Chapter 6

1. Rosalind Krauss, *The Originality of the Avant-Garde and Other Modernist Myths* (Cambridge, Mass., 1985). Other early discussions of the application of structuralist and/or semiological principles to art historical analysis include Annette Michelson, 'Art and the Structuralist Perspective', in the anthology *On the Future of Art*, introduction by Edward Fry (New York, 1970), 37–59; Sheldon Nodelman, 'Structural Analysis in Art and Anthropology, *Yale French Studies*, 36/7 (1966), 89–103.

2. See also Krauss' more recent *The Optical Unconscious* (Cambridge, Mass., 1993).

3. For a critique of which see D. Preziosi, 'La Vi(ll)e en Rose: Reading Jameson Mapping Space', in *Strategies: Journal of Theory, Culture and Politics*, I (1988), 82–99.

Rosalind Krauss: Sculpture in the Expanded Field

1. For a discussion of the Klein group, see Marc Barbut, 'On the Meaning of the Word "Structure" in Mathematics', in Michael Lane (ed.), *Introduction to Structuralism* (New York, 1970); for an application of the Piaget group, see A.-J. Greimas and F. Rastier, 'The Interaction of Semiotic Constraints', *Yale French Studies*, 41 (1968), 86–105.

Michel Foucault: What is an Author?

1. See 'Entretiens sur Michel Foucault' (directed by J. Proust), *La Pensée*, 137 (1968), 6–7 and 11; and also Sylvie le Bon, 'Un Positivisme désesperée', *Esprit*, 5 (1967), 1317–19.

2. Foucault's purpose, concerned with determining the 'codes' of discourse, is explicitly stated in the preface to *The Order of Things*, p. xx. These objections—see 'Entretiens sur Michel Foucault'—are obviously those of specialists who fault Foucault for his apparent failure to appreciate the facts and complexities of their theoretical field.

3. For an appreciation of Foucault's technique, see Jonathan Culler, 'The Linguistic Basis of Structuralism', David Robey (ed.), *Structuralism: An Introduction* (Oxford, 1973),

27–8.

4. *The Archaeology of Knowledge*, trans. A. M. Sheridan Smith (London, 1972) was published in France in 1969; for discussion of the author, see esp. pp. 92–6, 122.

5. Samuel Beckett, *Texts for Nothing*, trans. Beckett, (London, 1974), 16.

6. Cf. Edward Said, 'The Ethics of Language', *Diacritics*, 4 (1974), 32.

7. On 'expression' and writing as self-referential, see Jean-Marie Benoist, 'The End of Structuralism', *Twentieth Century Studies*, 3 (1970), 39; and Roland Barthes, *Critique et vérité* (Paris, 1966). As the following sentence implies, the 'exterior deployment' of writing relates to Ferdinand de Saussure's emphasis of the acoustic quality of the signifier, an external phenomena of speech which, nevertheless, responds to its own internal and differential articulation.

8. On 'transgression', see above, 'A Preface to Transgression', p. 42; and 'Language to Infinity,' p. 56. Cf. Blanchot, *L'Espace littéraire* (Paris, 1955), 58; and David P. Funt, 'Newer Criticism and Revolution', *Hudson Review*, 22 (1969), 87–96.

9. See above, 'Language to Infinity', p. 58.

10. The recent stories of John Barth, collected in *Lost in the Funhouse* and *Chimera*, supply interesting examples of Foucault's thesis. The latter work includes, in fact, a novelistic reworking of *Arabian Nights*.

11. Plainly a prescription for criticism as diverse as G. Wilson Knight's *The Wheel of Fire* (London, 1930) and Roland Barthes' *On Racine*, trans. Richard Howard (New York, 1964).

12. We have kept the French, *écriture*, with its double reference to the act of writing and to the primordial (and metaphysical) nature of writing as an entity in itself, since it is the term that best identifies the program of Jacques Derrida. Like the theme of a self-referential writing, it too builds on a theory of the sign and denotes writing as the interplay of presence and absence in that 'signs represent the present in its absence' ('Differance', in *Speech and Phenomena*, trans. David B. Allison, (Evanston, Ill., 1973), 138). See J. Derrida, *De la grammatologie* (Paris, 1967).

13. On 'supplement', see *Speech and Phenomena*, 88–104.

14. This statement is perhaps the polemical ground of Foucault's dissociation from phenomenology (and its evolution through Sartre into a Marxist discipline) on one side and structuralism on the other. It also marks his concern that his work be judged on its own

merits and not on its reputed relationship to other movements. This insistence informs his appreciation of Nietzsche in 'Nietzsche, Genealogy, History' as well as his sense of his own position in the Conclusion of *The Archaeology of Knowledge*.

15. Nietzsche, *The Gay Science*, iii. 108.

16. John Searle, *Speech Acts: An Essay in the Philosophy of Language* (Cambridge, 1969), 162–74.

17. Ibid. 169.

18. Ibid. 172.

19. This is a particularly important point and brings together a great many of Foucault's insights concerning the relationship of an author (subject) to discourse. It reflects his understanding of the traditional and often unexamined unities of discourse whose actual discontinuities are resolved in either of two ways: by reference to an originating subject or to a language, conceived as plenitude, which supports the activities of commentary or interpretation. But since Foucault rejects the belief in the presumed fullness of language that underlies discourse, the author is subjected to the same fragmentation which characterizes discourse and he is delineated as a discontinuous series; for example, see *L'Ordre du discours*, 54–5 and 61–2.

20. In a seminar entitled 'L'Épreuve et l'enquête', which Foucault conducted at the University of Montreal in the spring of 1974, he centerd the debate around the following question: is the general conviction that truth derives from and is sustained by knowledge not simply a recent phenomenon, a limited case of the ancient and widespread belief that truth is a function of events? In an older time and in other cultures, the search for truth was hazardous in the extreme and truth resided in a danger zone, but if this was so and if truth could only be approached after a long preparation or through the details of a ritualized procedure, it was because it represented power. Discourse, for these cultures, was an active appropriation of power and to the extent that it was successful, it contained the power of truth itself, charged with all its risks and benefits.

21. Cf. *The Order of Things*, p. 300; and above, 'A Preface to Transgression', 30–33.

22. Foucault's phrasing of the 'author-function' has been retained. This concept should not be confused (as it was by Goldmann in the discussion that followed Foucault's presentation) with the celebrated theme of the 'death of man' in *The Order of Things* (342 and 386). On the contrary,

Foucault's purpose is to revitalize the debate surrounding the subject by situating the subject, as a fluid function, within the space cleared by archaeology.

23. See Evaristo Arns, *La Technique du livre d'après Saint Jerome* (Paris, 1953).

24. On personal pronouns ('shifters'), see R. Jakobson, *Selected Writings* (Paris, 1971), ii. 130–2; and *Essais de linguistique générale* (Paris, 1966), 252. For its general implications, see Eugenio Donato, 'Of Structuralism and Literature', *MLN* 82 (1967), 556–8. On adverbs of time and place, see Emile Benveniste, *Problèmes de la linguistique générale* (Paris, 1966), 237–50.

25. Cf. Wayne C. Booth, *The Rhetoric of Fiction* (Chicago, 1961), 67–77.

26. This conclusion relates to Foucault's concern in developing a 'philosophy of events' as described in *L'Ordre du discours*, 60–1: 'I trust that we can agree that I do not refer to a succession of moments in time, nor to a diverse plurality of thinking subjects; I refer to a caesura which fragments the moment and disperses the subject into a plurality of possible positions and functions.'

27. Cf. the discussion of disciplines in *L'Ordre du discours*, 31–8.

28. Noam Chomsky, *Cartesian Linguistics* (New York; 1966).

29. *La Communication: Hermès I* (Paris, 1968), 78–112.

30. For a discussion of the recent reorientation of the sign, see Foucault's 'Nietzsche, Freud, Marx'. On the role of repetition, Foucault writes in *L'Ordre du discours:* 'The new is not found in what is said, but in the event of its return' (p. 28).

Craig Owens: The Allegorical Impulse

1. Jorge Luis Borges, 'From Allegories to Novels', *Other Inquisitions* (New York, 1964), 155–6.

2. On allegory and psychoanalysis, see Joel Fineman, 'The Structure of Allegorical Desire', *October*, 12 (Spring 1980). Benjamin's observations on allegory are to be found in the concluding chapter of *The Origin of German Tragic Drama* (trans. John Osborne, London, NLB, 1977, henceforth referred to as GTD).

3. See Rosalind Krauss, 'Notes on the Index: Seventies Art in America', *October*, 3 (Spring 1977), 68–81.

4. Northrop Frye, *Anatomy of Criticism*, (New York, 1969), 54.

5. Douglas Crimp. 'Pictures', *October*, 8 (Spring 1979), 85, italics added.

6. Benjamin, GTD, 183–4.

7. Ibid., 666.

8. Ibid., 223.

9. 'Neither Evans nor Atget presumes to put us in touch with a pure reality, a thing in itself; their cropping always affirms its own arbitrariness and contingency. And the world they characteristically picture is a world *already made over into a meaning* that precedes the photograph; a meaning inscribed by work, by use, as inhabitation, as artifact. Their pictures are *signs representing signs*, integers in implicit chains of signification that come to rest only in major systems of social meaning: codes of households, streets, public places.' Alan Trachtenberg, 'Walker Evans's *Message from the Interior*: A Reading', *October*, 11 (Winter 1979), 12, italics added.

10. Benjamin, GTD. 178.

11. Angus Fletcher, *Allegory: The Theory of a Symbolic Mode* (Ithaca, NY, 1964), 279–303.

12. Ibid. 174.

13. Fineman, 51. 'Thus there are allegories that are primarily perpendicular, concerned more with structure than with temporal extension On the other hand, there is allegory that is primarily horizontal. . . . Finally, of course, there are allegories that blend both axes together in relatively equal proportions. . . . Whatever the prevailing orientation of any particular allegory, however—up and down through the declensions of structure, or laterally developed through narrative time—it will be successful as allegory only to the extent that it can suggest the authenticity with which the two coordinating poles bespeak each other, with structure plausibly unfolded in time, and narrative persuasively upholding the distinctions and equivalences described by structure.' (p. 50).

14. Arthur Schopenhauer, *The World as Will and Representation*. I. 50. Quoted in Benjamin, GTD, p. 162.

15. This aspect of allegory may be traced to the efforts of humanist scholars to decipher hieroglyphs: 'In their attempts they adopted the method of a pseudo-epigraphical *corpus* written at the end of the second, or possibly even the fourth century A.D., the *Hieroglyphica* of Horapollon. Their subject . . . consists entirely of the so-called symbolic or enigmatic hieroglyphs, mere pictorial signs, such as were presented to the hierogrammatist, aside from the ordinary phonetic signs, in the context of religious instruction, as the ultimate stage in a mystical philosophy of nature. The obelisks were approached with memories of this reading in mind, and a misunderstanding thus became

the basis of the rich and infinitely widespread form of expression. For the scholars proceeded from the allegorical exegesis of Egyptian hieroglyphs, in which historical and cultic data were replaced by natural, philosophical, moral, and mystical commonplaces, to the extension of this new kind of writing. The books of iconology were produced, which not only developed the phrases of this writing, and translated whole sentences "word for word by special pictorial signs", but frequently took the form of lexica. "Under the leadership of the artist-scholar, Albertus, the humanists thus began to write with concrete images (*rebus*) instead of letters; the word 'rebus' thus originated on the basis of the enigmatic hieroglyphs, and medallions, columns, triumphal arches, and all the conceivable artistic objects produced by the Renaissance, were covered with such enigmatic devices."' Benjamin, GTD, pp. 168–69. (Benjamin's quotations are drawn from Karl Giehlow's monumental study *Die Hieroglyphenkunde des Humanismus in der Allegorie der Renaissance*.)

16. Roland Barthes, 'Diderot, Brecht, Eisenstein', *Image-Music-Text*, trans. Stephen Heath, (New York, 1977), 73.

17. Walter Benjamin, 'Theses on the Philosophy of History', *Illuminations*, trans. Harry Zohn (New York, 1969), 255.

18. Quoted in George Boas, 'Courbet and His Critics', *Courbet in Perspective*, ed. Petra ten-Doesschate Chu (Englewood Cliffs, NJ, 1977), 48.

19. Martin Heidegger, 'The Origin of the Work of Art', *Poetry, Language, Thought*, trans. Albert Hofstadter (New York, 1971), 19–20.

20. *Coleridge's Miscellaneous Criticism*, ed. Thomas Middelton Raysor (Cambridge, Mass., 1936), 99.

21. Louis Althusser and Etienne Balibar, *Reading Capital*, trans. Ben Brewster (London, 1970), 186–7.

22. Coleridge, p. 99. This passage should be compared with Goethe's famous condemnation of allegory: 'It makes a great difference whether the poet starts with a universal idea and then looks for suitable particulars, or beholds the universal *in the particular*. The former method produces allegory, where the particular has status merely as an instance, an example of the universal. The latter, by contrast, is what reveals poetry in its true nature: it speaks forth a particular without independently thinking of or referring to a universal, but in grasping the particular in its living character *it implicitly apprehends the*

universal along with it.' Quoted in Philip Wheelwright, *The Burning Fountain*, Bloomington, Ind., 1968), 54, italics added. This recalls Borges's view of allegory: 'The allegory is a fable of abstractions, as the novel is a fable of individuals. The abstractions are personified; therefore in every allegory there is something of the novel. The individuals proposed by novelists aspire to be generic (Dupin is Reason, Don Segundo Sombra is the Gaucho); an allegorical element inheres in novels.' (p. 157).

23. Ferdinand de Saussure, *Course in General Linguistics*, trans. Wade Baskin (New York, 1966), 68.

24. Benedetto Croce, *Aesthetic*, trans. Douglas Ainslie (New York, 1966), 34–5.

25. This is what sanctioned Kant's exclusion, in the *Critique of Judgment*, of color, drapery, framing ... as ornament merely appended to the work of art and not intrinsic parts of it. See Jacques Derrida, 'The Parergon', *October*, 9 (Summer 1979), 3–40, as well as my afterword, 'Detachment/from the *parergon*', 42–9.

26. Rosemond Tuve, *Allegorical Imagery* (Princeton, 1966), 26.

27. Cited in Borges. p. 155.

28. Benjamin, GTD, p. 176.

29. Ibid. 175.

30. Anson Rabinbach, 'Critique and Commentary/Alchemy and Chemistry', *New German Critique*, 17 (Spring 1979), 3.

31. Benjamin, GTD, p. 160.

32. Ibid. 201.

Andreas Huyssen: Mapping the Postmodern

1. Roland Barthes, *S/Z* (New York, 1974), 140.

2. Michel Foucault, 'What is an Author?' in *Language, Counter-Memory, Practice* (Ithaca, NY, 1977), 188.

3. This shift in interest back to questions of subjectivity is actually also present in some of the later poststructuralist writings, for instance in Kristeva's work on the symbolic and the semiotic and in Foucault's work on sexuality. On Foucault see Biddy Martin, 'Feminism, Criticism, and Foucault', *NGC*, 27 (Fall 1982), 3–30. On the relevance of Kristeva's work for the American context see Alice Jardine, 'Theories of the Feminine', *Enclitic*, 4: 2 (Fall 1980), 5–15; and 'Pre-Texts for the Transatlantic Feminist', *Yale French Studies*, 62 (1981), 220–36. Cf. also Teresa de Lauretis, *Alice Doesn't: Feminism, Semiotics, Cinema* (Bloomington, Ind., 1984), especially ch. 6, 'Semiotics and Experience'.

4. Jean François Lyotard, *La Condition postmoderne* (Paris, 1979). English translation *The Postmodern Condition* (Minneapolis, 1984).

5. The English translation of *La Condition postmoderne* includes the essay, important for the aesthetic debate, 'Answering the Question: What is Postmodernism?' For Kristeva's statement on the postmodern see 'Postmodernism?', *Bucknell Review*, 25: 11 (1980), 136–41.

6. Kristeva, 'Postmodernism?', 137.

7. Ibid. 139 f.

8. In fact, *The Postmodern Condition* is a sustained attack on the intellectual and political traditions of the Enlightenment embodied for Lyotard in the work of Jürgen Habermas.

9. Fredric Jameson, 'Foreword' to Lyotard, *The Postmodern Condition*, p. xvi.

10. Michel Foucault, 'Truth and Power', in *Power/Knowledge* (New York, 1980), 127.

11. The major exception is Craig Owens, 'The Discourse of Others', in Hal Foster (ed.), *The Anti-Aesthetic*, 65–98.

12. Cf. Elaine Marks and Isabelle de Courtivron (eds.), *New French Feminisms* (Amherst, Mass., 1980). For a critical view of French theories of the feminine cf. the work by Alice Jardine cited in n. 3 and her essay 'Gynesis', *Diacritics*, 12: 2 (Summer 1982), 54–65.

Chapter 7

1. One of the more interesting discussions of these issues in recent years is that of Elizabeth Grosz, *Space, Time, and Perversion: Essays on the Politics of Bodies* (New York and London, 1995), esp. pp. 25–43. Grosz argues that the Nietzschean 'will to power' that constitutes knowledge assumes a corporeality of knowledge that is essentially masculine.

2. Distinctions between that world and feminist writing in France during the early period are quite marked, and have been discussed at length. I am thinking of the extraordinary work of Luce Irigaray and Julia Kristeva.

3. Notably, Luce Irigaray, *Speculum of the Other Woman*, trans. Gillian Gill (Ithaca, NY, 1985); and *This Sex Which is Not One*, trans. Catherine Porter (Ithaca, NY, 1985). An excellent discussion of Irigaray's work may be found in Elizabeth Grosz, *Space, Time and Perversion*, 40 ff.

4. Linda Nochlin, 'Why Have There Been No Great Women Artists?' in Nochlin, *Women, Art and Power and Other Essays* (New York, 1988), 145–78

5. See Rozsika Parker and Griselda Parker,

Old Mistresses: Women, Art and Ideology (New York, 1981).

6. Joanna Frueh, C. Langer, and Arlene Raven (eds.), *New Feminist Criticism: Art/Identity/Action* (New York, 1993). Jones is the editor and contributor to the important 1996 *Sexual Politics* volume (reference in text), a comprehensive critical overview of feminist art and art history.

Nanette Salomon: The Art Historical Canon

1. I wish to thank Griselda Pollock, Keith Moxey, Flavia Rando, Ellen Davis, and the editors, Joan E. Hartman and Ellen Messer-Davidow, for reading earlier drafts of this essay.

2. Several articles have critically examined H. W. Janson, *The History of Art* (New York, 1962): Eleanor Dickinson, 'Sexist Texts Boycotted', *Women Artists News* 5, no. 4 (Sept.–Oct. 1979), 12; Eleanor Tufts, 'Beyond Gardner, Gombrich, and Janson: Towards a Total History of Art', *Arts Magazine*, 55, no. 8 (Apr. 1981): 150–4; and Bradford R. Collins, 'Book Reviews of H. W. Janson and E. H. Gombrich', *Art Journal* 48, no. 1 (Spring 1989), 90–5.

3. Editions of Vasari's book translated in all languages have appeared with regularity. The edition most often cited is Giorgio Vasari, *Le vite de' più eccellenti pittori, scultori ed architettori italiani*, ed. Gaetano Milanesi, 9 vols. (Florence, 1865–79). See also the bibliography in T. S. R. Boase, *Giorgio Vasari: The Man and the Book* (Princeton, 1971), 341.

4. Vasari's *Lives* is 'traditionally identified as the first art history' (W. Eugene Kleinbauer and Thomas P. Slavens, *Research Guide to the History of Western Art* (Chicago, 1982), 19, 88). While it clearly has been the most influential compilation of artists and art history, it was by no means the first. For the most complete history of the history of art, see Julius Schlosser, *Die Kunstliteratur* (Vienna, 1924). Vasari himself relied on a mixture of classical sources such as Plutarch and Pliny the Elder (Patricia Rubin, 'What Men Saw: Vasari's Life of Leonardo da Vinci and the Image of the Renaissance Artist', *Art History* 13, no. 1 (Mar. 1990), 34).

5. Vasari's desire to relocate much of the credit for the achievements of the Renaissance to Florence under the Medicis is discussed by Anthony Blunt, *Artistic Theory in Italy, 1450–1600* (Oxford, 1940), 86–102, and T. S. R. Boase, *Vasari*, ch. 1.

6. See Griselda Pollock, 'Artists Mythologies and Media Genius, Madness and Art History', *Screen*, 21, no. 3 (Spring 1980), 57–95, for a full discussion of how biography mystifies art in traditional art historical writing. For an early explanation of the myth of the artist and biography in psychological terms, see Ernst Kris and Otto Kurz, *Legend, Myth, and Magic in the Image of the Artist: A Historical Experiment* (New Haven, 1979).

7. Griselda Pollock, *Vision and Difference: Femininity, Feminism, and the Histories of Art* (London, 1988), esp. ch. 1.

8. Griselda Pollock, 'Women, Art and Ideology: Questions for Feminist Art Historians', *Woman's Art Journal*, 4, no. 1 (Spring–Summer 1983), 39–48.

9. Roland Barthes, 'The Death of the Author', *Image-Music-Text*, ed. and trans. Stephen Heath (London, 1977), 142–7. The most recent application of Barthes's important essay to art history is Griselda Pollock, 'Critical Reflections', *Artforum* 27, no. 6 (Feb. 1990), 126–7.

10. Barthes, 'Death of the Author', 145.

11. For the relationship of Vasari's *Lives* to the late 16th century as 'the age of criticism', see Peter Burke, *The Renaissance* (London, 1987), 54–5.

12. E. H. Gombrich, *Meditations on a Hobby Horse* (London, 1965), 109.

13. Moshe Barasch, *Theories of Art: From Plato to Winckelmann* (New York, 1985), 206–9.

14. Blunt, *Artistic Theory*, 101.

15. For a history of the Art Academy and the seminal position of Vasari, see Nikolaus Pevsner, *Academies of Art, Past and Present* (Cambridge, 1940).

16. Ibid.

17. Linda Nochlin, 'Why Have There Been No Great Women Artists?', rptd. in Nochlin, *Art, Women and Power and Other Essays* (New York, 1988), 145–75.

18. Walter Benjamin, 'The Work of Art in the Age of Mechanical Reproduction', rptd. in *Illuminations*, trans. Harry Zohn (New York, 1969), 217–52.

19. Dickinson, 'Sexist Texts', 12.

20. Ibid.

21. I am grateful for discussions with Griselda Pollock that clarified the ideas in this section.

22. Vasari's treatment of women has not, to my knowledge, been analysed. There is a brief discussion of women artists in Netherlandish texts by Margarita Russell, 'The Women Painters in Houbraken's *Groote Schouburgh*', *Woman's Art Journal*, 2, no. 1 (Spring–Summer 1981), 5–12.

23. Rozsika Parker and Griselda Pollock, *Old Mistresses: Women, Art and Ideology* (New York,

1981), ch. 1.

24. Joan Kelly, 'Did Women Have a Renaissance?', rptd. in *Women, History, and Theory: The Essays of Joan Kelly* (Chicago, 1984), 19–50.

25. Hans Belting, 'Vasari and His Legacy: The History of Art as Process?', in Belting, *The End of the History of Art?* (Chicago, 1987), 73.

26. The reception of North Italian art was somewhat mixed, and it was approved only with qualifications. See e.g. Vasari's treatment of Titian (Boase, *Vasari*, 277–9).

27. The case of Albrecht Dürer is particularly interesting, since much of his artistic project involved reconciling an Italianate mode with an essentially Northern iconography. His Italianate manner makes him a favorite non-Italian entry in the canon. Thus, in 1987, Hans Belting still could categorize the 'other': 'For the artist *north of the Alps* the journey to Italy became a voyage of discovery into the homeland of art. Albrecht Dürer . . . was among *the earliest of these pilgrims*' (emphasis added; Belting, 'Vasari and His Legacy', 81). Certainly Dürer was not among the earliest artists 'north of the Alps' to come to Italy, just among the first to attempt to paint in an Italian style.

28. Boase, *Vasari*, 197, n. 1.

29. Quoted by Collins, 'Book Reviews', 92.

30. For the position of women in Germany, see Merry E. Wiesner, *Working Women in Renaissance Germany* (New Brunswick, NJ, 1986); in Germany and the Netherlands, Martha C. Howell, *Women, Production, and Patriarchy in Later Medieval Cities* (Chicago, 1986). For the position of women in Italy, see Christiane Klapisch-Zuber, *Women, Family, and Ritual in Renaissance Italy* (Chicago, 1985). See also Martha C. Howell's review essay, 'Marriage, Property, and Patriarchy: Recent Contributions to a Literature', *Feminist Studies*, 13, no. 1 (Spring 1987), 203–24, esp. 209.

31. Charles Holroyd, *Michael Angelo Buonarroti* (London, 1903), 279. Svetlana Alpers attributes a slightly different significance to Michelangelo's remarks in 'Art History and Its Exclusions', in Norma Broude and Mary D. Garrard (eds.), *Feminism and Art History: Questioning the Litany* (New York, 1982), 194–5.

32. Arnold Houbraken, *De Groote Schouburgh der nederlantsche konstchilders en schilderessen* (*The Great Theatre of Netherlandish Painters and Paintresses*) (1753; rptd. Amsterdam, 1976).

33. Schlosser, *Kunstliteratur*; Lionello Venturi, *History of Art Criticism* (New York, 1964), 118.

34. Giulio Mancini and Carel van Mander, by considering artists on an international scale, may be considered precursors. Nevertheless, Mancini dealt only with artists active in Rome, and van Mander separated ancient, Italian, and Northern art by putting them in different books.

35. The list of books on women artists is by now quite long; see the bibliography in Whitney Chadwick, *Women, Art, and Society* (London, 1990).

36. Heinrich Wölfflin, *Principles of Art History*, trans. M. D. Hottinger (1932; rptd. New York, 1950).

37. Harold Bloom, *The Anxiety of Influence: A Theory of Poetry* (London, 1973).

38. Michelangelo's homosexuality is discussed in James Saslow, *Ganymede in the Renaissance: Homosexuality in Art and Society* (New Haven, 1986). For Caravaggio, see Donald Posner, 'Caravaggio's Homo-erotic Early Works', *Art Quarterly*, 34, no. 3 (Autumn 1971): 301–24.

39. Mary D. Garrard, *Artemisia Gentileschi: The Image of the Female Hero in Italian Baroque Art* (Princeton, 1989).

40. Ibid.; Richard Spear, 'Images of Heroic Women' (review of Garrard), *Times Literary Supplement* no. 4496 (2–8 June 1989), 603.

41. Rubin, 'What Men Saw', 34–5.

42. Ibid. 34; 44, n. 1.

43. Venturi, *History of Art Criticism*, chs. 5–7; Kleinbauer and Slavens, *Research Guide*, 89.

44. John Boswell, 'Revolutions, Universals and Sexual Categories', *Salmagundi*, 58–9 (Fall 1982–Winter 1983), 106–9.

45. For the history of homosexuality in ancient Greece, see K. J. Dover, *Greek Homosexuality*, 1978 (rptd. New York, 1980), and, more recently, Michel Foucault, *The Use of Pleasure: The History of Sexuality*, trans. Robert Hurley, vol. ii (New York, 1985).

46. Michelangelo's homosexuality was first discussed by John Addington Symonds in *The Life of Michelangelo Buonarroti*, 2 vols. (London, 1899), and most recently in Saslow, *Ganymede*, 17–63.

47. Saslow, discussing what he takes to be Vasari's lack of interest in sexuality, writes: 'Vasari . . . is generally not much interested in his subjects' private lives' (Saslow, *Ganymede*, 14). This claim is difficult to sustain, looking at any two pages of Vasari's *Lives*.

48. The degree to which homophobia still distorts art history can be observed by the absence of 'homosexuality' in David Freedberg's index to *The Power of Images:*

Studies in the History and Theory of Response (Chicago, 1989), despite chapters entitled 'Arousal by Image' and 'Senses and Censorship'. Freedberg acknowledges only heterosexual responses to works of art, as if they are the only ones that exist.

49. Monique Wittig, 'The Straight Mind', *Feminist Issues*, 1, no. 1 (Summer 1980), 103–11.

50. Praxiteles' sculpture is fully discussed in Chr. Blinkenberg, *Knidia: Beiträge zur kenntnis der Praxitelischen Aphrodite* (Copenhagen, 1933).

51. Eve Kosofsky Sedgwick investigates homosocial bonding in English literature in *Between Men: English Literature and Male Homosocial Desire* (New York, 1985). Her ideas have stimulated my reading of the 'pudica' pose. See also Susan Winnett, 'Coming Unstrung: Women, Men, Narrative, and Principles of Pleasure', *PMLA* 105, no. 3 (May 1990), 505–18, esp. 507.

Lisa Tickner: Sexuality and/in Representation

1. Sigmund Freud, *The Standard Edition of the Complete Psychological Works of Sigmund Freud*, trans. James Strachey (London, 1953), xix. *Some Psychical Consequences of the Anatomical Distinction Between the Sexes* (1925), 241–58.

2. I have kept the term 'representation' although it has been contested. Paul Q. Hirst's critique 'Althusser and the Theory of Ideology', *Economy and Society*, 4: 5 (November 1976), 385–412 insists on *signification* and *signifying practices* as concepts that avoid, in his view, the suggestion that representation has a fixed correspondence to a 'real'.

3. Yve Lomax, 'When Roses are No Longer Given a Meaning in Terms of Human Future', *Camerawork*, 26 (April 1983), 10–11.

4. Cf. Jean Baudrillard, 'The Precession of Simulacra', in *Simulations* (New York, Semiotext(e), 1983). (Repr. in Brian Wallis (ed.), *Art After Modernism: Rethinking Representation* (New York, Boston, 1984), 251–81).

5. Stephen Heath, 'Narrative Space', *Screen*, 17: 3 (August 1976), 73.

6. Ibid.

7. Victor Burgin (ed.), *Thinking Photography* (London and Basingstoke, 1982), 8–9.

8. Louis Althusser, 'Ideology and Ideological State Apparatuses (Notes Towards an Investigation)', in *Lenin and Philosophy and Other Essays*, trans. Ben Brewster (London, 1971), 121–73. This essay gave rise to extensive and detailed discussion which is not possible to outline here, but see Burgin, *Thinking Photography*, particularly ch. 3, 'Photographic Practice and Art Theory'; and Rosalind Coward and John Ellis, 'Marxism, Language, and Ideology', *Language and Materialism: Developments in Semiology and the Theory* (London, 1977), 61–92.

9. Cf. Burgin, *Thinking Photography*, 7.

10. For a useful outline see Rosalind Coward, 'Sexual Politics and Psychoanalysis: Some Notes on their Relation', in Rosalind Brunt and Caroline Rowan (eds.), *Feminism, Culture and Politics* (London, 1982), 171–87.

11. Burgin, *Thinking Photography*, 144–5.

12. Ibid. 145.

13. Tony Godfrey, 'Sex, Text, Politics: An Interview with Victor Burgin', *Block*, 7 (1982), 2–26; also Yve Lomax, 'The Politics of Montage', *Camerawork*, 24 (March 1982), 8–9.

14. Burgin outlines this himself in the interview with Tony Godfrey cited above, and adds that he used three 'voices' in *US 77*: a didactic voice, a narrative voice (as in 'framed'), and a paradoxical voice.

15. Godfrey, 'Sex, Text, Politics', 16.

16. Psychoanalytic concepts were present in *US 77* (see esp. *Graffitification*) but were taken further in *Zoo*; for example in the bringing together of Foucault and Freud with the image of the peep show model, proposing 'the oppressive surveillance of woman in our society as the most visible, socially sanctioned form of the more covert surveillance of society-in-general by the agencies of the state' (Burgin in Godfrey, 'Sex, Text, and Politics', 20).

17. Burgin, in conversation with Lisa Tickner.

18. Stephen Heath, *The Sexual Fix* (New York, 1982), 3.

19. Michel Foucault, *The History of Sexuality*, i. *An Introduction*, trans. Robert Hurley (New York, 1978); Heath, *The Sexual Fix*; Jeffrey Weeks, *Sex, Politics, and Society: The Regulation of Sexuality Since 1800* (New York, 1981).

20. Heath, *The Sexual Fix*, esp. p. 7 where he notes that in relation to 'sexuality' the *Oxford English Dictionary* cites James Matthews Duncan, *Clinical Lectures on the Diseases of Women* (1889).

21. Heath, *The Sexual Fix*, 44.

22. Juliet Mitchell, 'Introduction-1', in Juliet Mitchell and Jacqueline Rose (eds.), *Feminine Sexuality: Jacques Lacan and the école freudienne* (New York, 1983), 2. See also the entry on 'Sexuality' in Jean Laplanche and Jean-Baptiste Pontalis, *The Language of Psychoanalysis* (London, 1980), 417ff.

23. Mitchell, 'Introduction-1', 2.

24. Cf. Parveen Adama, 'Representation and Sexuality', *m/f* 1 (1978), 78.

25. Stephen Heath, 'Lessons from Brecht', *Screen*, 15: 2 (Summer 1974), 106. Also Laura Mulvey, 'Visual Pleasure and Narrative Cinema', *Screen*, 16: 3 (Autumn 1975), 6–18. (Repr. in Wallis (ed.), *Art After Modernism*, 361–73); and Burgin, *Thinking Photography*, 190.

26. Heath, *The Sexual Fix*, 144.

27. Mulvey, 'Visual Pleasure', 11. It has to be said that this question is complicated by the bisexuality of the drives, and by possible disjunctions between the (predominantly) 'male' or 'female' sexuality of author or reader, and the gendered positioning inscribed by the text. Victor Burgin (*Block*, 7: 24) refers to an unconscious, pre-Oedipal 'tourist' of a subject 'which can take up positions more or less freely on either side of the divide of gender, or even on both sides simultaneously'. Laura Mulvey herself, in an article on *Duel in the Sun* (*Framework*, 15/16/17 (Summer 1981): 12–15) provides some 'afterthoughts on "Visual Pleasure and Narrative Cinema" ' in which she attempts to account for the position of the female spectator, her pleasure and identifications, and the use of a female protagonist in Hollywood melodrama.

28. Mary Kelly, 'Notes on Reading the Post-Partum Document', *Control*, 10 (November 1977), 10.

29. Mary Kelly, *Post-Partum Document* (London, 1983), p. xv. Ultimately the *division* of labor in childcare is insufficient to account for the structuring of *difference* which is in part determined by the place of the child in the mother's fantasies.

30. The six sections of the *Document* are headed 'Weaning from the Breast'; 'Weaning from the Holophrase'; 'Weaning from the Dyad'; 'On Femininity'; 'On the Order of Things'; and 'On the Insistence of the Letter.' Across these, as Mary Kelly puts it, 'a problem is continually posed but no resolution is reached. There is only a replay of moments of separation and loss, perhaps because desire has no end, resists normalization, ignores biology, disperses the body' (*Post-Partum Document*, p. xvii).

31. Kelly, *Post-Partum Document*, p. xvii.

32. See Mary Kelly, 'On Femininity,' *Control*, 11 (November 1979), 14–15.

33. Kelly, *Post-Partum Document*, p. xix.

34. Kelly, 'The Post-Partum Document', *m/f* 5–6 (1981), 127.

35. Ray Barrie quoted in Mary Kelly, 'Beyond the Purloined Image', *Block*, 9 (1984).

36. Kelly, 'Beyond the Purloined Image'.

37. For Freud on 'Screen Memories', (1899) see *Standard Edition*, iii. 307, 315–16, 321–2 and ch. 4 of *The Psychopathology of Everyday Life*. Laplanche and Pontalis provide a useful summary (pp. 410–11).

38. Godfrey, 'Sex, Text, Politics', 15.

39. Heath, *The Sexual Fix*, 85.

40. Robert Scholes, 'Language, Narrative, and Anti-Narrative', *Critical Inquiry*, 7: 1 (Autumn 1980), 209.

41. I am drawing on Colin McCabe's account in 'Realism and the Cinema: Notes on Some Brechtian Theses', *Screen*, 15: 2 (Summer 1974), 7–27.

42. See Heath, 'Lessons from Brecht', 121.

43. Scholes, 'Language, Narrative, and Anti-Narrative', 211.

44. Marie Yates in a statement accompanying the exhibition of *The Missing Woman* in *Beyond the Purloined Image*, Riverside Studios, 1983. The *dramatis personae* are outlined for us: A a woman known to B by sight; B the narrator, an artist; C a man who lives with A; D a child; Y a woman who resembles B. Nowhere are we offered an adequate image of the woman or the narrator: 'A' is spoken by the others and, by the 'evidence' (i.e., the signs) that surround her— and hence by us.

45. 'From a statement by "B" Aug. 1982' partially reinserts this within the fiction; but because 'B' has been identified as both artist and narrator, and because the statement offers itself as a meta-comment on the rest of the piece, its status as inside and outside the work remains equivocal.

46. Benveniste quoted in Roland Barthes, 'Introduction to the Structural Analyses of Narratives', *Image–Music–Text*, ed. and trans. Stephen Heath (New York, 1977), 112.

47. Marie Yates in a statement accompanying the exhibition of *The Missing Woman*. For her views on representation, narrative, and subjectivity, see also Lucy Lippard, *Issue: Social Strategies by Women Artists* (exhibition catalogue) (London, 1980), n.p.

48. Roland Barthes, 'Diderot, Brecht, Eisenstein', *Screen*, 15: 2 (Summer 1974), 36.

49. Yve Lomax from *Sense and Sensibility in Feminist Art Practice* (exhibition catalogue) (Nottingham, 1982), n.p.

50. Lomax, 'The Politics of Montage', 9; Heath, 'Lessons from Brecht', 112; and Gilles Deleuze and Felix Guattari, *Anti-Oedipus: Capitalism and Schizophrenia* (New York, 1977). A *note on image and text*.

The 'polysemy' of the image may be 'anchored' or 'relayed' in particular ways: by montage, by

text, by context (i.e., in the space of intertextuality, and by the sense-making proclivities of the viewer, which are themselves the product of what Barthes called the déjà vu, the already-read, already-seen). See *S/Z* (New York, 1974), 10: 'This "I" which approaches the text is already itself a plurality of other texts, of codes which are infinite, or, more precisely, lost (whose origin is lost).'

Narrative, which 'smooths reading into the forward flow of its progress' may be threaded through image and text, stringing them into a single sequence of meaning in which each is reconciled to the other. On the other hand, it may be the intention of a particular (and political) representational practice to disrupt this easy flow: by setting image against text (as in Burgin's *UK 76*); by opening up a gap between image and text (as in *The Missing Woman*, where we take what clues we can in our effort to stitch them together again); by entailing us in the process of pulling together fragments of discourses that already cut across image and text and whose signification emerges from this interplay (*Post-Partum Document, Screen Memories*); by exploiting in the construction of the work the transferability of word and image in the primary processes of the unconscious and in 'inner speech'.

51. Godfrey, 'Sex, Text, Politics', 25.
52. Burgin, in conversation with Lisa Tickner, and see also Godfrey, p. 26. The possibility for change, in Burgin's account lies 'precisely in the fact of the *shared* pre-Oedipal sexuality of men and women; the recognition of sexuality as a construct, subject to social and historical change; and the recognition of the body as not simply given, as essence, in nature, but as constantly reproduced, "revised" in discourse.'
53. Barthes, *The Pleasure of the Text*, trans. Richard Miller (New York, 1975), 14.
54. Mulvey, 'Visual Pleasure', 8.
55. Yve Lomax from her unpublished notes to *Double-Edged Scenes*; see also Marie Yates's article in *Camerawork*, no. 26 (April 1983), 16; 'for some years my work has not been about consumption but about play'.
56. Mary Kelly, *Sense and Sensibility*, and cf. Luce Irigaray as discussed in Mary Jacobus, 'The Question of Language: Men of Maxima and *The Mill on the Floss*', *Critical Inquiry* 8: 2 (Winter 1981), 210.
57. Irigaray, quoted by Jacobus in 'The Question of Language', 207.
58. See Judy Chicago, *The Dinner Party: A Symbol of Our Heritage* (New York, 1979) and Judy Chicago and Susan Hill, *Embroidering Our Heritage: The Dinner Party Needlework*

(New York, 1980).
59. Foucault, *The History of Sexuality*, i. 101.
60. Burgin, *Thinking Photography*, 215–16.
61. Hal Foster, (ed.), *The Anti-Aesthetic: Essays on Post-modern Culture* (Port Townsend, Wash., 1983).
62. Barthes, *Image–Music–Text*, 66, and Victor Burgin in conversation with Lisa Tickner.
63. Quoted in Meaghan Morris, 'A-Mazing Grace: Notes on Mary Daly's Poetics', *Lip*, 7 (1982/3), 39.
64. Yve Lomax, from *Metaphorical Journey*, exhibited in *Light Reading*. B2 Gallery, London, March 1982.

Amelia Jones: Postfeminism, Feminist Pleasures, and Embodied Theories of Art

1. Susan Faludi, *Backlash: The Undeclared War Against Women* (New York, 1991).
2. See Ruth Rosen's 'Column left/"Family Values" Is a GOP Code for Meanness', *Los Angeles Times*, 21 April 1992, B7.
3. This includes the following issues of *Time* magazine: 'Women: The Road Ahead', *Time* special issue, Fall 1990; '"Women Face the '90s". In the '80s they tried to have it all. Now they've just plain had it. Is there a future for feminism?', *Time*, 4 December 1989; 'Why Are Men and Women Different? If it isn't just upbringing. New studies show they are born that way', *Time*, 20 January 1992; 'Why Roe v. Wade Is Already Moot', *Time*, 4 May 1992. For a slightly more profeminist note, see 'Fighting the Backlash Against Feminism: Susan Faludi and Gloria Steinem Sound the Call to Arms', *Time*, 9 March 1992. See also Sally Quinn's strikingly antifeminist editorial, 'Feminists Have Killed Feminism', *Los Angeles Times*, 23 January 1992, B7.
4. The issue includes a critical examination of 1980s antifeminist by Barbara Ehrenreich. 'Sorry, Sisters. This Is Not the Revolution', *Time*. 'Women: The Road Ahead', special issue, (Fall 1990), 15.
5. The cover image, which features a crudely carved wooden sculpture of a woman in a business suit clutching a baby and a briefcase, was created for *Time* by the feminist artist Marisol. Purchasing the skills of an artist whose work is usually identified as exemplary of 1960s and early 1970s feminist art, the magazine recontextualizes her piece into an icon of postfeminism.
6. Claudia Wallis, 'Onward, Women', *Time*, 4 December 1989, 80–2, 85–6, 89.
7. I discuss the remasculinizing operations of recent Hollywood films in my article ' "She

Was Bad News": Male Paranoia and the Contemporary New Woman', *Camera Obscura*, 25–6 (January–May 1991), 297–320.

8. Robert Bly, *Iron John: A Book About Men* (Reading, Mass., 1990). These phrases come from the titles of popular-press essays on the 'postfeminist male'; see the issue 'Drums, Sweat and Tears: What Do Men Really Want? Now They Have a Movement of Their Own', *Newsweek*, 24 June 1991, including the article 'Heeding the Call of the Drums: All over America, the ancient, primal art of drumming is helping men find a voice of their own' (52–3); and the special issue of *Esquire* entitled 'Wild Men and Wimps', October 1991.

9. See Janice Castro, 'Get Set: Here They Come! The 21st century work force is taking shape now. And guess what? White, U.S.-born men are a minority', *Time*, 'Women: The Road Ahead', special issue (Fall 1990), 50–1.

10. As Russell Ferguson has argued, the 'need to enforce values which are at the same time alleged to be "natural" demonstrates the insecurity of a center which could at one time take its own power much more for granted'; in 'Introduction: Invisible Center', Russell Ferguson *et al.* (eds.), *Out There: Marginalization and Contemporary Cultures* (New York, Cambridge, Mass., and London, 1990), 10.

11. I discuss this hegemonic postmodernism and its attendant modes of exclusionism at length in my book, *Postmodernism and the En-Gendering of Marcel Duchamp* (Cambridge, 1994).

12. Thus Fredric Jameson conflates feminism with minority civil rights movements and other specific protests as merely a 'jargon' or pose taken up as a means of empowerment. For Jameson, feminism is an example of the 'stupendous proliferation of social codes today into professional and disciplinary jargons, but also into the badges of ethnic, race, religious, and class-refraction adhesion.' In 'Postmodernism or the Cultural Logic of Late Capitalism', *New Left Review*, 46 (July–August 1984), 65.

13. As in Laura Mulvey's article, 'Dialogue with Spectatorship: Barbara Kruger and Victor Burgin' (1983), in her book *Visual and Other Pleasures* (Bloomington and Indianapolis, Ind., 1989); see 134.

14. Mira Schor introduces this notion of 'aesthetic terrorism' in 'Figure/Ground', *M/E/A/N/I/N/G*, 6 (1989); 18.

15. Craig Owens, 'The Discourse of Others: Feminists and Postmodernism', in Hal Foster

(ed.), *The Anti-Aesthetic: Essays on Postmodern Culture* (Port Townsend, Wash., 1983), 62, 59, 64. There are many feminist cultural theorists who have examined the feminism/postmodernism intersection in ways that are more sensitive to the specificities of feminist theory. See e.g. Janet Lee, 'Care to Join Me in an Upwardly Mobile Tango? Postmodernism and the "New Woman"' and Shelagh Young. 'Feminism and the Politics of Power: Whose Gaze Is It Anyway', in Lorraine Gamman and Margaret Marshment (eds.), *The Female Gaze: Women as Viewers of Popular Culture* (Seattle, 1989), 166–72, 173–88; Susan Suleiman, 'Feminism and Postmodernism: In Lieu of an Ending', *Subversive Intent: Gender, Politics, and the Avant-Garde* (Cambridge, Mass., 1990), 181–205; and the essays collected in Linda Nicholson (ed.), *Feminism/Postmodernism* (New York, 1990).

16. Tania Modleski, *Feminism without Women: Culture and Criticism in a 'Postfeminist' Age* (New York and London, 1991), 3. This confusion, as I have argued in my book *Postmodernism and the En-Gendering of Marcel Duchamp* (see 21–8), takes place in discourses of postmodernism through the appropriation of the notion of the disruptive feminine developed by French feminists such as Julia Kristeva and Hélène Cixous. Conflating the disruptive feminine with femin*ism*, postmodern theorists then radicalize particular art practices as undermining the phallocentric subject perceived as central to modernist ideologies of artistic genius; by extension, they also radicalize themselves, confirming their critical authority.

17. Dan Cameron, 'Post-feminism', *Flashart*, 132 (February/March 1987), 80–3.

18. Richard Woodward, 'It's Art, but Is It Photography?' *New York Times Magazine*, 9 October 1988, 31.

19. Donald Kuspit, 'Inside Cindy Sherman', *The New Subjectivism: Art in the 1980s* (Ann Arbor, 1988), 395.

20. Luce Irigaray, 'The Blind Spot of an Old Dream of Symmetry', *Speculum of the Other Woman*, trans. Gillian C. Gill (Ithaca, NY, 1985), 21, 22.

21. As in Hal Foster's argument opposing 'neoconservative' postmodernism to a radically avant-garde 'poststructuralist' postmodernism; Hal Foster, '(Post)Modern Polemics', *Recodings: Art, Spectacle, Cultural Politics* (Seattle, 1985), 121–38.

22. Isaac Julien, a filmmaker best known for his experimental films on black identities and homosexual pleasure, discusses the politics of

the prohibition of pleasure in avant-gardist theory: 'On the left of avant-gardism is pleasure, which the avant-garde itself denies, clinging to the purism of its constructed ethics, measuring itself against a refusal to indulge in narrative or emotions and, indeed, in some cases, refusing representation itself, because all these systems of signs are fixed, entrenched in the "sin or evil" of representation. The high moral tone of this discourse is based on a kind of masochistic self-censorship.' Isaac Julien quoted in Manthia Diawara, 'Black Studies, Cultural Studies: Performative Acts'. *Afterimage*, 20: 3 (October 1992), 6. See also Roland Barthes's discussion of the effects of this disdain of pleasure by the left, in *The Pleasure of the Text* (1973), trans. Richard Miller (New York, 1975), 22–3.

23. Griselda Pollock, 'Screening the Seventies: Sexuality and Representation in Feminist Practice—a Brechtian Perspective', *Vision and Difference: Femininity, Feminism and the Histories of Art* (London and New York, 1988), 163.

24. Laura Mulvey, 'Visual Pleasure and Narrative Cinema', in *Visual and Other Pleasures*, 16.

25. Laura Mulvey, 'Impending Time: Mary Kelly's *Corpus*', in *Visual and Other Pleasures*, 149.

26. Pierre Bourdieu, *Distinction: A Social Critique of the Judgement of Taste*, trans. Richard Nice (Cambridge, Mass., 1984), 489, 490, 491.

27. See e.g. Klaus Theweleit's brilliant study of the texts of male fascist writers, in which, he argues, women are conflated with the masses as threatening to masculinity: *Male Fantasies*, 2 vols., trans. Stephen Conway, Erica Carter, Chris Turner (Minneapolis, 1987, 1989).

28. Jean Baudrillard, *Seduction*, trans. Brian Singer (New York, 1990), 180. Andreas Huyssen discusses at length this link between mass culture and femininity in modern Western culture, citing several examples from Nietzsche's work, in 'Mass Culture as Woman: Modernism's Other', *After the Great Divide: Modernism, Mass Culture, Postmodernism* (Bloomington, 1986), 44–62.

29. Luce Irigaray, 'Così Fan Tutte', *This Sex Which is Not One*, trans. Catherine Porter with Carolyn Burke (Ithaca, NY, 1985), 90. See also Johanna Drucker's article 'Visual Pleasure: A Feminist Perspective', *M/E/A/N/I/N/G*, 11 (May 1992), 3–11.

30. Emily Apter, 'Fetishism and Visual Seduction in Mary Kelly's *Interim*', *October*, 58 (Fall 1991), 97, 101.

Chapter 8

1. Jacques Derrida, *La Vérité en peinture* (Paris, 1978), trans. by Geoff Bennington and Ian McLeod as *The Truth in Painting* (Chicago, 1987). An earlier English translation by Craig Owens of a short excerpt from Part 1, 'Parergon', was published in *October* 9 (1979), 3–40.

Stephen Melville: The Temptation of New Perspectives

1. Heidegger's essay is available in the essay collection *Poetry, Language, Thought*, trans. Albert Hofstadter (New York, 1971). The Schapiro essay is in the Kurt Godstein Festschrift, *The Reach of Mind: Essays in Memory of Kurt Godstein* (New York 1968); and Derrida's 'Restitutions of the Truth in Pointing' is included in his *The Truth in Painting*, trans. Geoff Bennington and Ian McLeod (Chicago, 1987).

2. Michael Baxandall's *Patterns of Intention* (New Haven, 1985) is particularly interesting here; to a high degree it seems to reinvent the terms of New Criticism within a project that is historical in a way quite alien to the New Critics.

3. 'The explanation of this historiographical muddle—which points to the core of Wölfflin's achievement—is both unmistakably implicit and, at one key point, inescapably explicit. Classic art is absent, silent, static, or even dead; baroque art is present, vocal, and alive. The difference between classic and baroque that rationalizes Wölfflin's system and that establishes at once their radical opposition and their total identity is quite simply this: that *the classic does not exist*. It never existed and can never have existed, for when the classic comes into existence or manifests itself, it does so in the form of existence, which is the baroque. The classic is the baroque. This is not a speculative judgment about Wölfflin. It is precisely what he says.' Marshall Brown, 'The Classic Is the Baroque: On the Principle of Wölfflin's Art History', *Critical Inquiry*, 9: 2 (December 1982), 397.

4. I seem to recall Michael Podro speaking aptly in this respect of Panofsky's 'deft dreamwork'.

5. In terms of present discussion within literary theory, Panofsky ends up holding a position much like that of E. D. Hirsch rather than that of Hans Georg Gadamer or other still more radical receivers of Heidegger.

6. That this is indeed a 'return' points toward a nest of questions about the 'prehistory' of academic art history—questions that will remain unposed and unaddressed here but which would certainly belong to any fuller and more formal treatment of the issues. Addressing these further questions will, it seems to me, not affect the analysis offered here as much as it will complicate one's understanding of the critical terms in play and render more difficult the idea of any simple escape from the norms of traditional art history.

7. One does well to note here the radically different direction in which Heidegger extends the notion of the schematism in his writings on Kant.

8. I am here abstracting and drawing implications from some of the recent writings of Rosalind Krauss, writings which in their turn rely heavily on the work of Jacques Lacan and Georges Bataille.

9. I think particularly of the recent work of Hubert Damisch.

10. See Martin Heidegger, *The Question Concerning Technology*, esp. 'The Age of the World Picture', trans. William Lovitt (New York, 1977).

Meyer Schapiro: The Still Life as a Personal Object

1. M. Heidegger, 'Der Ursprung des Kunstwerkes', in *Holzwege* (Frankfurt, 1950; repr. as a book, with introd. by H.-G. Gadamer, Stuttgart, 1962); trans. by A. Hofstadter as 'The Origin of the Work of Art', in A. Hofstadter and R. Kuhns, *Philosophies of Art and Beauty* (New York, 1964), 649–710. It was Kurt Goldstein who first called my attention to this essay, presented originally as a lecture in 1935 and 1936.

2. Ibid. 662–3. Heidegger refers again to van Gogh's picture in a revised lecture of 1935, trans. and repr. in his *An Introduction to Metaphysics* (New York, 1961). Speaking of *Dasein* (being-there, or 'essent') he points to a painting by van Gogh. 'A pair of rough peasant shoes, nothing else. Actually the painting represents nothing. But as to what is in that picture, you are immediately alone with it as though you yourself were making your way wearily homeward with your hoe on an evening in late fall after the last potato fires have died down. What is here? The canvas/ The brush strokes? The spots of color?' (p. 29).

3. J. B. de la Faille, *Vincent van Gogh* (Paris, 1939). no. 54, fig. 60; no. 63, fig. 64; no. 255, fig. 248; no. 331, fig. 249; no. 332, fig. 250; no. 333,

fig. 251; no. 461, fig. 488; no. 607, fig. 597.

4. Ibid. nos. 255, 332, 333.

5. Ibid. no. 333. It is signed 'Vincent 87'.

6. Ibid. nos. 54 and 63.

7. Ibid. no. 461. Vincent van Gogh, *Verzamelde brieven van Vincent van Gogh*, 4 vols. (Amsterdam, 1952–4), iii. 291, Letter no. 529.

8. De la Faille, *Vincent van Gogh*, no. 607; van Gogh, *Verzamelde brieven*, iv. 227.

9. Personal communication, letter of 6 May 1965.

10. De la Faille, *Vincent van Gogh*, no. 250.

11. Heidegger, 'The Origin of the Work of Art', 664.

12. Ibid. 665. 'Truth happens in van Gogh's painting. This does not mean that something is rightly portrayed, but rather that in the revelation of the equipmental being of the shoes that which *is* as a whole—world and earth in their counterplay—attains to unconcealment. . . . The more simply and essentially the shoes appear in their essence . . . the more directly and fascinatingly does all that *is* attain to a greater degree of being along with them' (p. 680).

13. De la Faille, *Vincent van Gogh*, no. 607, fig. 597.

14. K. Hamsun, *Hunger*, trans. G. Egerton (New York, 1941), 27.

15. J. de Rotonchamp, *Paul Gauguin 1848–1903* (2nd edn., Paris, 1925), 53. There is an earlier version of the story in P. Gauguin, 'Natures Mortes', in id., *Essais d'art libre* (1894), 273–5. These two texts were kindly brought to my attention by Prof. Mark Roskill.

Jacques Derrida: Restitutions of the Truth in Pointing [*Pointure*]

1. See *Mimesis des articulations*, collective work (Paris, 1975), 165–270.

2. In English in original.

3. *Voilà de qui se passe ici*: this plays on the three senses of *se passer*: to happen, to put on (a garment), to do without (something).

Chapter 9

1. Jacques Derrida, *Speech and Phenomena and Other Essays on Husserl's Theory of Signs* (Evanston, Ill., 1973), 104.

2. Martin Heidegger, 'The Age of the World Picture', in id., *The Question Concerning Technology and Other Essays* (New York, 1977).

3. On which see Herman Rapoport, 'Deconstruction's Other: Trinh T. Minh-Ha and Jacques Derrida', *Diacritics*, 25: 2 (1995), 98–113.

4. Jacques Derrida, 'Semiology and

Grammatology', in id., *Positions* (Chicago, 1981), 17–36; originally published in *Information sur les sciences sociales*, 7 (June 1968). The interview in *Positions* was a summary of certain key aspects of his *Of Grammatology*, published the previous year. See the discussion of this in D. Preziosi, *Rethinking Art History*, 109–10.

Timothy Mitchell: Orientalism and the Exhibitionary Order

1. Edward Said, *Orientalism* (New York, 1978).
2. Tony Bennett, 'The Exhibitionary Complex', *New Formations*, 4 (Spring, 1988), 96. Unfortunately, this insightful article came to my attention only as I was completing the revisions to this article.
3. See esp. Robert W. Rydell, *All the World's a Fair: Visions of Empire at American International Expositions, 1876–1916* (Chicago, 1984); see also Bennett, 'Exhibitionary Complex'.
4. Muhammad Amin Fikri, *Irshad al-alibbà ila mahasin Urubba* (Cairo, 1892), 128.
5. Fikri, *Irshad*, 128–9, 136.
6. R. N. Crust, 'The International Congresses of Orientalists', *Hellas*, 6 (1897), 359.
7. Ibid. 351.
8. Ibid. 359.
9. Rifa'a al-Tahtawi, *al-A'mal al-kamila* (Beirut: al-Mu'assasa al-Arabiyya li-l-Dirasat wa-l-Nashr, 1973), 2: 76.
10. Ali Mubarak, *Alam al-din* (Alexandria, 1882), 816. The 'curiosity' of the European is something of a theme for Orientalist writers, who contrast it with the 'general lack of curiosity' of non-Europeans. Such curiosity is assumed to be the natural, unfettered relation of a person to the world, emerging in Europe once the loosening of 'theological bonds' had brought about 'the freeing of human minds' (Bernard Lewis, *The Muslim Discovery of Europe* (London, 1982), 299). See Mitchell, *Colonising Egypt*, 4–5, for a critique of this sort of argument and its own 'theological' assumptions.
11. Alain Silvera, 'The First Egyptian Student Mission to France under Muhammad Ali', in Elie Kedourie and Sylvia G. Haim (eds.), *Modern Egypt: Studies in Politics and Society* (London, 1980), 13.
12. Tahtawi, *al-A'mal*, 2: 177, 199–20.
13. Georges Douin, *Histoire du règne du Khédive Ismail* (Rome, 1934), 2: 4–5.
14. Tahtawi, *al-A'mal*, 2: 121.
15. Quoted in Said, *Orientalism*, 165.

16. James Augustus St John, *The Education of the People* (London, 1858), 82–3.
17. 'Les origines et le plan de l'exposition', in *L'Exposition de Paris de 1889*, 3 (15 December 1889), 18.
18. On Egyptian writing about Europe in the 19th c. see Ibrahim Abu-Lughod, *Arab Rediscovery of Europe* (Princeton, 1963); Anouar Louca, *Voyageurs et écrivains égyptiens en France au XIXe siècle* (Paris, 1970); Mitchell, *Colonising Egypt*, 7–13, 180 n. 14.
19. Theodor Adorno, *Minima Moralia: Reflections from a Damaged Life* (London, 1978), 116: on the theater, see e.g. Muhammad al-Muwaylihi, *Hadith Isa ibn Hisham, aw fatra min al-zaman*, 2d edn. (Cairo, 1911), 434, and Tahtawi, *al-A'mal*, 2: 119–20; on the public garden and the zoo, Muhammad al-Sanusi al-Tunisi, *al-Istitla at al-barisiya fi ma rad sanat 1889* (Tunis, 1891), 37.
20. Mubarak, *Alam al-din*, 817.
21. The model farm outside Paris is described in Mubarak, *Alam al-din*, 1008–42; the visual effect of the street in Mubarak, *Alam al-din*, 964, and Idwar Ilyas, *Mashahid Uruba wa-Amirka* (Cairo, 1900), 268; the new funicular at Lucerne and the European passion for panoramas in Fikri, *Irshad*, 98.
22. Martin Heidegger, 'The Age of the World Picture', in *The Question Concerning Technology and Other Essays* (New York, 1977).
23. International Congress of Orientalists, *Transactions of the Ninth Congress*, 1892 (London, 1893), 1: 35.
24. Al-Sanusi, *al-Istitla'at*, 242.
25. Edmond About, *Le Fellah: souvenirs d'Egypte* (Paris, 1869), 47–8.
26. Charles Edmond, *L'Egypte à l'exposition universelle de 1867* (Paris, 1867).
27. Jacques Derrida, *Speech and Phenomena and Other Essays on Husserl's Theory of Signs* (Evanston, Ill., 1973), 104. All of his subsequent writings, Derrida once remarked, 'are only a commentary on the sentence about a labyrinth' ('Implications: Interview with Henri Ronse', in *Positions* (Chicago, 1981), 5). My article, too, should be read as a commentary on that sentence.
28. Quoted in Walter Benjamin, 'Paris, Capital of the Nineteenth Century', in *Reflections: Essays, Aphorisms, Autobiographical Writings* (New York, 1978), 146–7.
29. Mubarak, *Alam al-din*, 818; Ilyas, *Mashahid Uruba*, 268.
30. Mubarak, *Alam al-din*, 829–30.
31. Benjamin, 'Paris', 146, 152; Tahtawi, *al-A'mal*, 2: 76.
32. See André Raymond, *Artisans et*

commerçants au Caire au XVIIIe siècle
(Damascus, 1973), 1: 173–202; Roger Owen,
*The Middle East in the World Economy
1800–1914* (London, 1981).

33. By the eve of World War I, cotton
accounted for more than 92 per cent of the
total value of Egypt's exports (Roger Owen,
Cotton and the Egyptian Economy (Oxford,
1969), 307).

34. See Mitchell, *Colonising Egypt*.

35. Gustave Flaubert, *Flaubert in Egypt: A
Sensibility on Tour*, trans. Francis Steegmuller
(London, 1983), 79.

36. Mubarak, *Alam al-din*, 308.

37. Flaubert, *Flaubert in Egypt*, 23.

38. Eliot Warburton, author of *The Crescent
and the Cross: or Romance and Realities of
Eastern Travel* (1845), describing Alexander
Kinglake's *Eothen, or Traces of Travel Brought
Home from the East* (London, 1844; reprint
edn., 1908); cited in *The Oxford Companion to
English Literature*, 5th edn. (Oxford, 1985), s.v.
'Kinglake'.

39. Edward Lane, *An Account of the Manners
and Customs of the Modern Egyptians*, reprint
edn. (London, 1908), pp. vii, xvii.

40. Stanley Lane-Poole, 'Memoir', in
Edward Lane, *An Arabic–English Lexicon*,
reprint edn. (Beirut, 1980), vol. V. p. xii.

41. Leila Ahmed, *Edward W. Lane: A Study of
His Life and Work* (London, 1978); John D.
Wortham, *The Genesis of British Egyptology,
1549–1906* (Norman, Okla., 1971), 65.

42. Quoted in Ahmed, *Edward Lane*, 26.

43. Muwaylihi, *Isa ibn Hisham*, 405–17.

44. Jeremy Bentham, *The Complete Works*, ed.
John Bowring (Edinburgh, 1838–43), 4: 65–6.

45. Cf. Malek Alloula, *The Colonial Harem*
(Minneapolis, 1986).

46. *Murray's Handbook for Travellers in Lower
and Upper Egypt* (London, 1888).

47. Said, *Orientalism*, 160–1, 168, 239. My
subsequent analysis is much indebted to Said's
work.

48. J. M. Carré, *Voyageurs et écrivains français
en Egypte*, 2nd edn. (Cairo, 1956), 2: 191.

49. Quoted in Lane, *Arabic–English Lexicon*,
5: vii.

50. Gérard de Nerval, *Oeuvres*, ed. Albert
Béguin and Jean Richer, i: *Voyage en Orient*
(1851), ed. Michel Jeanneret (Paris, 1952),
172–4.

51. Cf. Jacques Derrida, 'The Double Session',
in *Dissemination* (Chicago, 1981), 191–2, *Speech
and Phenomena*, and 'Implications'.

Carol Duncan: The Art Museum as Ritual

1. Mary Douglas, *Purity and Danger*
(London, Boston, and Henley, 1966), 68. On
the subject of ritual in modern life, see Abner
Cohen, *Two-Dimensional Man: An Essay on
the Anthropology of Power and Symbolism in
Complex Society* (Berkeley, 1974); Steven
Lukes, 'Political Ritual and Social
Integration', in *Essays in Social Theory* (New
York and London, 1977), 52–73; Sally F. Moore
and Barbara Myerhoff, 'Secular Ritual: Forms
and Meanings', in Moore and Myerhoff
(eds.), *Secular Ritual* (Assen and Amsterdam,
1977), 3–24; Victor Turner, 'Frame, Flow, and
Reflection: Ritual and Drama as Public
Liminality', in Michel Benamou and Charles
Caramello (eds.), *Performance in Postmodern
Culture* (Milwaukee, Wisc. 1977), 33–55; and
Turner, 'Variations on a Theme of Liminality',
in Moore and Myerhoff, 'Secular Ritual',
36–52. See also Masao Yamaguchi, 'The
Poetics of Exhibition in Japanese Culture', in
I. Karp and S. Levine (eds.), *Exhibiting
Cultures: The Poetics and Politics of Museum
Display* (Washington and London, 1991),
57–67. Yamaguchi discusses secular rituals and
ritual sites in both Japanese and western
culture, including modern exhibition space.
The reference to our culture being anti-ritual
comes from Mary Douglas, *Natural Symbols*
(1973) (New York, 1982), 1–4, in a discussion of
modern negative views of ritualism as the
performance of empty gestures.

2. This is not to imply the kind of culturally or
ideologically unified society that, according to
many anthropological accounts, gives rituals a
socially integrative function. This integrative
function is much disputed, especially in
modern society (see e.g. works cited in the
preceding notes by Cohen, Lukes, and Moore
and Myerhoff, and Edmund Leach, 'Ritual',
in David Sills (ed.), *International Encyclopedia
of the Social Sciences*, xiii (1968) 521–6.

3. As Mary Douglas and Baron Isherwood
have written, 'the more costly the ritual
trappings, the stronger we can assume the
intention to fix the meanings to be' (*The World
of Goods: Towards an Anthropology of
Consumption* (1979) (New York and London,
1982), 65).

4. See Nikolaus Pevsner, *A History of Building
Types* (Princeton, NJ, 1976), 118 ff.; Niels von
Holst, *Creators, Collectors and Connoisseurs*,
trans. B. Battershaw (New York, 1967), 228 ff.;
Germain Bazin, *The Museum Age*, trans. J. van
Nuis Cahill (New York, 1967), 197–202; and
William L. MacDonald, *The Parthenon:
Design, Meaning, and Progeny* (Cambridge,
Mass., 1976). 125–32.

5. The phallic form of the *Balzac* often stands

at or near the entrances to American museums, e.g. the Los Angeles County Museum of Art or the Norton Simon Museum; or it presides over museum sculpture gardens, e.g. the Museum of Modern Art in New York or the Hirshhorn Museum in Washington, DC.

6. William Ewart, MP, in *Report from the Select Committee on the National Gallery*, in House of Commons, *Reports*, vol. xxxv (1853). 505.

7. Douglas, *Purity and Danger*, 63.

8. Arnold van Gennep. *The Rites of Passage* (1908), trans. M. B. Vizedom and G. L. Caffee (Chicago, 1960).

9. Turner, 'Frame, Flow, and Reflection', 33. See also Turner's *Dramas, Fields, and Metaphors: Symbolic Action in Human Society* (Ithaca NY and London, 1974), esp. 13–15 and 231–2.

10. See Mary Jo Deegan, *American Ritual Dramas: Social Rules and Cultural Meanings* (New York, Westport, Conn., and London, 1988). 7–12, for a thoughtful discussion of Turner's ideas and the limits of their applicability to modern art. For an opposing view of rituals and of the difference between traditional rituals and the modern experience of art, see Margaret Mead, 'Art and Reality From the Standpoint of Cultural Anthropology', *College Art Journal* 2: 4, (1943), 119–21. Mead argues that modern visitors in an art gallery can never achieve what primitive rituals provide, 'the symbolic expression of the meaning of life'.

11. Bazin, *The Museum Age*, 7.

12. Goran Schildt, 'The Idea of the Museum', in L. Aagaard-Mogensen (ed.), *The Idea of the Museum: Philosophical, Artistic, and Political Questions*, Problems in Contemporary Philosophy, vol. vi (Lewiston, NY, and Quenstron, Ontario, 1988), 89.

13. I would argue that this is the case even when they watch 'performance artists' at work.

14. Philip Rhys Adams, 'Towards a Strategy of Presentation', *Museum* 7: 1 (1954), 4.

15. For an unusual attempt to understand what museum visitors make of their experience, see Mary Beard, 'Souvenirs of Culture: Deciphering (in) the Museum', *Art History* 15 (1992), 505–32. Beard examines the purchase and use of postcards as evidence of how visitors interpret the museum ritual.

16. Kenneth Clark, 'The Ideal Museum', *ArtNews* 52 (January 1954), 29.

17. Kant, *Critique of Judgment* (1790), trans. J. H. Bernard (New York, 1951).

18. Two classics in this area are: M. H. Abrams. *The Mirror and the Lamp* (New York, 1958), and Walter Jackson Bate, *From Classic to Romantic: Premises of Taste in Eighteenth-Century England* (New York, 1946). For a substantive summary of these developments, see Monroe C. Beardsley, *Aesthetics from Classical Greece to the Present: A Short History*, University, Ala. 1975), chs. 8 and 9.

19. For the Dresden Gallery, see von Holst, *Creators, Collectors and Corroisseurs*, 121–3.

20. From Goethe's *Dichtung und Wahrheit*, quoted in Bazin, *The Museum Age*, 160.

21. Von Holst, *Creators, Collectors and Connoisseurs*, 216.

22. William Hazlitt, 'The Elgin Marbles' (1816), in P. P. Howe (ed.), *The Complete Works* (New York, 1967), xviii. 101. Thanks to Andrew Hemingway for the reference.

23. William Hazlitt, *Sketches of the Principal Picture-Galleries in England* (London, 1824), 2–6.

24. See Goethe, cited in Elizabeth Gilmore Holt, *The Triumph of Art for the Public*, (Garden City, NY, 1979), 76. The Frenchman Quatremère de Quincy also saw art museums as destroyers of the historical meanings that gave value to art. See Daniel Sherman, 'Quatremère/Benjamin/Marx: Museums, Aura, and Commodity Fetishism', in D. Sherman and I. Rogoff (eds.), *Museum Culture: Histories, Discourses, Spectacles*, Media and Society, (Minneapolis and London, 1994), vi. 123–43. Thanks to the author for an advance copy of his paper.

25. See especially Paul Dimaggio, 'Cultural Entrepreneurship in Nineteenth-Century Boston: The Creation of an Organized Base for High Culture in America', *Media, Culture and Society* 4 (1982), 33–50 and 303–22; and Walter Muir Whitehill, *Museum of Fine Arts, Boston: A Centennial History*, 2 vols., (Cambridge, Mass., 1970).

In this chapter, I have quoted more from advocates of the aesthetic than the educational museum, because, by and large, they have valued and articulated more the liminal quality of museum space, while advocates of the educational museum tend to be suspicious of that quality and associate it with social elitism (see, for example, Dimaggio, 'Cultural Entrepreneurship'.). But, the educational museum is no less a ceremonial structure than the aesthetic museum.

26. Benjamin Ives Gilman, *Museum Ideals of Purpose and Method* (Cambridge, Mass., 1918), 56.

27. Ibid. 108.

28. Leach, 'Two Essays Concerning the

Symbolic Representation of Time', in *Rethinking Anthropology* (London and New York, 1961), 124–36. Thanks to Michael Ames for the reference.

29. Recently, the art critic Donald Kuspit suggested that a quest for immortality is central to the meaning of art museums. The sacralized space of the art museum, he argues, by promoting an intense and intimate identification of visitor and artist, imparts to the visitor a feeling of contact with something immortal and, consequently, a sense of renewal. For Kuspit, the success of this transaction depends on whether or not the viewer's narcissistic needs are addressed by the art she or he is viewing ('The Magic Kingdom of the Museum', *Artforum* (April 1992), 58–63). Werner Muensterberger, in *Collecting: An Unruly Passion: Psychological Perspectives* (Princeton, 1994), brings to the subject of collecting the experience of a practicing psychoanalyst and explores in depth a variety of narcissistic motives for collecting, including a longing for immortality.

30. See, e.g. Charles G. Loring, a Gilman follower, noting a current trend for 'small rooms where the attention may be focused on two or three masterpieces' (in 'A Trend in Museum Design', *Architectural Forum* (December 1927), vol. 47, p. 579).

31. César Graña, 'The Private Lives of Public Museums', *Trans-Action*, 4: 5 (1967), 20–5.

32. Alpers, 'The Museum as a Way of Seeing', in Karp and Levine, *Exhibiting Cultures*, 27.

33. Bazin, *The Museum Age*, 265.

Annie E. Coombes: Inventing the Postcolonial

1. Homi Bhaba, 'The Commitment to Theory', *New Formations*, 5, (Summer 1988), 22.

2. Salman Rushdie, *In Good Faith*, (London, 1990).

3. I have deliberately restricted my attention to large international institutions in western metropolitan centres, rather than smaller local institutions, since these museums still unfortunately maintain a hegemonic position in relation to the representation of other cultures. For an interesting set of observations about the comparative function of what he calls 'majority' and 'tribal' museums, see James Clifford, 'Four Northwest Coast Museums: Travel Reflections', in Ivan Karp and Steven Levine (eds.), *Exhibitin Cultures* (Washington DC, 1991), 212–54.

4. Museum of Mankind, *Lost Magic Kingdoms and Six Paper Moons from Nahuatl*,

(London, 1986); Museum voor Volkenkunde, *Kunst uit een Andere Wereld* (Rotterdam, 1988); Beaubourg, '*Les Magiciens de la Terre*' (Paris, 1989); Center for African Art and New Museum for Contemporary Art, *Africa Explores* (New York, 1991).

5. Although my own article is framed as a critique of the kind of position on 'hybridity' articulated by Peter Wollen, 'Tourism, Language and Art', *New Formations*, 12 (Winter 1990), 43–59, he usefully traces the adoption of hybridizing strategies as models of resistance or nationalism in particular moments of Mexican, Irish and Jewish history.

6. Stuart Hall, 'Cultural Identity as Diaspora', in J. Rutherford (ed.), *Identity: Community, Culture, Difference*, (London, 1990), 223. Benita Parry, 'Resistance Theory/Theorising Resistance' in Fran Barker *et al.* (eds), *Colonial Discourse: Post-Colonial Theory*, (Manchester, forthcoming); see David Lloyd, 'Ethnic Cultures, Minority Discourse and the State', ibid.

7. See also Cornel West, 'Black Culture and Postmodernism' in Barbara Kruger and Phil Mariani (eds.), *Remaking History*, (Seattle, 1989), 91, where he writes: The issue here is not simply some sophomoric, moral test that surveys the racial bases of the interlocutors in a debate. Rather the point is to engage in structural and institutional analysis to see where the debate is taking place, why at this historical moment and how this debate enables or disenables oppressed peoples to exercise their opposition to the hierarchies of power.

8. e.g. '*Les Magiciens de la Terre*' at the Beaubourg, Paris, 1989; and *Lost Magic Kingdoms and Six Paper Moons from Nahuatl*, at the Museum of Mankind, London 1986. For a critique of the latter see Annie E. Coombes and Jill Lloyd, '"Lost and Found" at the Museum of Mankind', *Art History*, (December 1986), 540–5.

9. It is important to realize that the Heritage boom is fraught with ambivalence. In Britain, for example, there is a cruel irony in the tendency to set up museums of working life in once thriving industrial areas where unemployment has now decimated the workforce and shut down the very industries that are represented as 'living' displays in the heritage museums. On the other hand, even the worst of these cannot avoid some reference to class and labour relations even of the most banal kind, and have often provided an opportunity for local history groups to rediscover aspects of their collective pasts. For

useful discussions on the implications of the heritage industry, see: Patrick Wright, *On Living in an Old Country* (London, 1985); Robert Hewison. *The Heritage Industry*, (London, 1987); Robert Lumely (ed.), *The Museum Time Machine* (London, 1988); John Corner and Sylvia Harvey (eds.), *Enterprise and Heritage, Crosscurrents of National Culture* (London, 1991).

10. See e.g. Ethnic Minority Rights Group, *Education for All: the Report of the Committee of Inquiry into the Education of Children from Ethnic Minority Groups*, (London, 1985); A Sivanandan, 'Challenging Racial Strategies for the 1980s', *Race and* (XXV (Autumn 198 Sneja Gunew, 'Australia 1984: A Moment in the Archaeology of Multiculturalism' Francis Barker *et al* (eds), *Europe and its Others*, vol. 1, (Colchester, 1985).

11. K. Gough. 'New Proposals for Anthropologists', *Current Anthropology*, 9 (1968), 403–7: P. Bandyopadhyay, 'One Sociology or Many—Some Issues in Radical Sociology', *Sociological Review*, 19 (1971), 5–29; J. Clifford and George E. Marcus (eds.), *Writing Culture*, (Berkeley, 1986); Edward W. Said, 'Representing the Colonised: Anthropology's Interlocutors', *Critical Inquiry*, 15 (1989), 205–25.

12. For a development of this argument see Avtar Brah, 'Difference, Diversity, Differentiation', in James Donald and Ali Kattansi (eds.), *Race, Culture and Identity*, (London, 1992); Trin T. Minha, *Women, Native, Other: Writing Post-Coloniality and Feminism* (Bloomington, Ind., 1989): John Corner and Sylvia Harvey, *Enterprise and Heritage*, 18.

13. Cornel West, 'The New Cultural Politics of Difference', in Russell Ferguson *et al.* (eds.), *Out There, Marginalization and Contemporary Cultures*, (New York and Cambridge, Mass., 1990), 19–36, charts some of the pitfalls and difficulties with the concept of difference, but also its progressive potential.

14. Here I would urge caution in relation to James Clifford's positive espousal of the category of fine art as 'one of the most effective ways to give cross-cultural value (moral and commercial) to a cultural production', in Clifford, 'Four Northwest Coast Museums', 241.

15. For a development of these ideas see Annie E. Coombes, *Reinventing Africa: Museums, Material Culture, and Popular Imagination in late Victorian and Edwardian England* (New Haven and London, 1994).

16. *Museums Journal*, 2 (Sept. 1902), 75.

17. See *Art in America*, (July 1989), where Martha Rosler and James Clifford take up opposing positions on this issue.

18. For a contemporary example, see the current exhibition at the British Museum, 'Collecting the Twentieth Century', where the panel introducing the ethnographic department's collection states explicitly that this is the primary work of the department. The booklet which accompanies the exhibition, however, actually critiques this suggestion.

19. Chris Pinney, 'Appearing Worlds', *Anthropology Today*, 5 (June 1989). 27.

20. L. Woodhead, *A Box Full of Spirits: Adventures of a Film-maker in Africa*, (London, 1987).

21. Museum of Mankind, *The Hidden Peoples of the Amazon*, (London, 1985), 11.

22. *Observer*, 11 August 1985.

23. Quoted in J.D. Harrison, ' "The Spirit Sings" and the Future of Anthropology', *Anthropology Today*, 4 (December 1988), 6. See also Jean Fisher, 'The Health of the People is the Highest Law', *Third Text*, 2 (Winter 1987), 63–75.

24. J.D. Harrison, ' "The Spirit Sings" ', 8.

25. Ibid.

26. It is as a result of such acutely aimed and orchestrated protests from often disempowered indigenous peoples that the liberal white establishment is now being forced to take on board criticism that has become politically embarrassing. One such instance is the recent series on Channel 4 TV, 'The Savage Strikes Back'. Instead of focusing solely on the 'inevitability' of extinction this series, produced in direct consultation with local rights groups, highlighted the organized political struggles of a number of indigenous peoples to regain control over their lands and their lives. It is also interesting that the Chicago Field Museum have felt obliged to shut down their display of Hopi artifacts after protests by Hopi representatives. I am grateful to Luke Holland, Lisa Tickner and Sandy Nairne for information on these points.

27. See e.g. the interview with Jean-Hubert Martin by Benjamin Buchloch, 'The Whole Earth Show', *Art in America* (May 1989).

28. See e.g. G. Brett, *Through Our Own Eyes* (London, 1986); B. Jules-Rosette, *The Messages of Tourist Art* (New York, 1984).

29. For an informed and critical view which analyzes this issue in terms of the Australian context and the recent celebration of Aboriginal cultural production, see Anne-Marie Willis and Tony Fry, 'Art as Ethnocide:

The Case of Australia', *Third Text* (Winter 1988–9), 3–21.

30. See Carol Duncan and Alan Wallach, 'The Universal Survey Museum', *Art History*, 3, (December 1980).

31. I am indebted to Michel Melot for this information.

32. For one of the most interesting critical assessments of the Beaubourg, see Cultural Affairs Committee of the *Parti Socialiste Unifié*, 'Beaubourg: The Containing of Culture in France', *Studio International*, 1 (1978), 27–36.

33. Paul Gilroy, '"Cheer the Weary Traveller"': W.E.B. Dubois and the Politics of Displacement', in Francis Barker *et al.* (ed.), *Colonial Discourse*.

34. Whitechapel Art Gallery, 'From Two Worlds', 1986; Hayward Gallery, 'The Other Story', 1990. See also, 'The Decade Show', New York, 1990.

35. See e.g. Jacques Hainard and Roland Kaehr (eds.), *Temps Perdu, Temps Retrouvé: Voir des Choses du Passé au Présent* (Neuchâtel, 1985); and Jacques Hainard and Roland Kaehr (eds), *Les Ancêtres Sont Parmi Nous* (Neuchâtel, 1989), 70.

36. Hal Foster, 'The "Primitive" Unconscious of Modern Art, or White Skin Black Masks', in *Recodings: Art*, *Spectacle*, *Cultural Politics* (Seattle, 1985), 202.

37. Néstor García Canclini, 'Culture and Power: the State of Research', *Media, Culture and Society*, no. 10 (1988), 467–97. Thanks to John Kraniauskas for bringing Canclini's work to my attention.

38. Lisa Lowe, 'Heterogeneity, Hybridity, Multiplicity: Marking Asian American Differences', *Diaspora* (Spring 1991), 24–44. Thanks to David Lloyd for bringing Lisa Lowe's work to my attention.

39. Bhabha, 'The Commitment to New Theory'.

Néstor García Canclini: Remaking Passports

1. Michel Serres, 'Analisis simbolico y metodo estructural', in Andrea Bonomi *et al.*, *Estructuralismo y filosofia* (Buenos Aires, 1969), 32.

2. Claude Lévi-Strauss. *El pensamiento salvate* (Mexico, 1964), 30–3.

3. For this form of enquiry we should not forget the founding work of Rudolf Arnheim, *El pensamiento visual* (Buenos Aires, 1971), which connects well with the contributions of Howard S. Becker, Pierre Bourdieu and Fredric Jameson, whose possible complement I discussed in *Culturas hibridas. Estrategias*

para entrar y salir de la modernidad. (Mexico, 1990), chs. 1 and 2.

4. As expressed by Nicos Hadjinicolau (*Historia del arte y lucha de clases*, 5th ed., Mexico, 1976, ch. 5), but this author relates 'ideology in the image' to social class and dismisses the nationalist differences that also have an effect on styles. Although I do not have space here to develop this critique, I want to at least say that a non-reductionist sociological reading, besides social class, ought to take into account other groups that organise social relations: nation, ethnicity, generation, etc.

5. I analysed this theme in 'Memory and Innovation in the Theory of Art', *South Atlantic Quarterly*, 92: 3 (1993).

6. See *Art from Latin America: The Transcultural Meeting*, exhibition catalogue; exhibition curated by Nellie Richard, the Museum of Contemporary Art, Sydney, 10 March–13 June, 1993.

7. The formula belongs to the curator of the Biennale, Achille Bonito Oliva, quoted by Lilia Driben, 'La XLV Bienal de Venecia, los puntos cardinales del arte nómada de 56 paises', *La Jornada*, 23 August 1993, p. 23.

8. See the illuminating chapter on this theme, 'Le marché et le musée', in Raymonde Moulin, *L'Artiste, l'institution et le marché* (Paris, 1992).

9. Arjun Appadurai, 'Disjuncture and Difference in the Global Cultural Economy', in Mike Featherstone (ed.), *Global Culture, Nationalism, Globalization and Modernity*, (London and New Delhi, 1990).

10. Luis Felipe Noé, 'Does Art from Latin America Need a Passport?' in Rachel Weiss and Alan West (eds.), *Being America*: *Essays on Art, Literature and Identity from Latin America*, (New York, 1991).

11. Luis Felipe Noé, 'La nostalgia de la historia en el proceso de imaginación plástica de América Latina', in *Encuentro artes visuales e identidad en América Latina* (Mexico, 1982), 46–51.

12. Adriana Valdés, 'Alfredo Jaar: imágenes entre culturas', *Arte en Colombia Internacional*, 42 (December 1989), 47.

13. Guy Brett and Sean Cubitt, *Camino Way*. *Las pinturas aeropostales de Eugenio Dittborn* (Santiago de Chile, 1991).

14. Martin Rejtman, 'Guillermo Kuitca. Mirada interior', *Claudia* (Buenos Aires, November 1992), no. 3, p. 68. Reproduced by Marcelo B. Pacheco in 'Guillermo Kuitca: inventario de un pintor', *Un libro sobre Guillermo Kuitca* (Valencia, 1993), 123.

15. The phrase is from Jerry Saltz, 'El toque humano de Guillermo Kuitca', in *Un libro sobre Guillermo Kuitca*.

16. George Yúdice, 'Globalización y nuevas formas de intermediación cultural', paper presented at the conference 'Identidades, políticas e integración regional', Montevideo, 22–3 July, 1993.

17. Sebastián López, 'Identity: Reality or Fiction', *Third Text*, 18 (1992), 32–4, cited by Yúdice, *Globalización*. See also the issue of *Les Cahiers du Musée National d'Art Moderne* dedicated to the exhibition 'Les Magiciens de la terre', no. 28, 1989, esp. the articles by James Clifford and Lucy Lippard.

Donald Preziosi: The Art of Art History

1. See Mary Carruthers, *The Book of Memory: A Study of Memory in Mediaeval Culture* (Cambridge, 1990), and Frances Yates, *The Art of Memory* (Chicago, 1966) for introductions to the subject. On 19th-c. optical games and displays, see Jonathan Crary, *Techniques of the Observer: On Vision and Modernity in the Nineteenth Century* (Cambridge, Mass., 1990). On the subject of museums and memory, see D. Preziosi, *Brain of the Earth's Body: Museums and the Fabrication of Modernity*, forthcoming.

2. On this subject, see D. Preziosi, *Rethinking Art History: Meditations on a Coy Science* (New Haven and London, 1989), especially ch. 3, 'The Panoptic Gaze and the Anamorphic Archive', pp. 54–79. See also the references in n. 8 below.

3. A poignant example being the discussions about 'visual culture' studies, formatted as a questionnaire circulated amongst friends of the editors of the New York art world journal *October*, 77 (Summer 1996), 25–70.

4. The term is derived from the title of a Borges story 'Funes the Memorious', about an individual who remembered everything he had ever experienced; a *funeous* object or place incorporates traces of its entire history or ontogeny in its very structure. On the notion of funicity as employed in materials science, see Preziosi, *Rethinking Art History*, 188 n. 10.

5. See in this regard Timothy Mitchell, *Colonising Egypt* (Cairo, 1988), and Zeynip Celik, *Displaying the Orient: The Architecture of Islam at Nineteenth-Century World's Fairs* (Berkeley and Los Angeles, 1992) for interesting analyses of the modern European culture of spectacle and display as seen by non-Europeans.

6. Other 'reading devices' or explanatory instruments would be anthropology, ethnography, history, the sciences, etc.; in short, any formal discursive formation. Modern tourism, for example, might be usefully understood as a 'scripting' of the world and its past in a manner complementary or parallel to professional art historical practice. In this regard, it might be recalled that, in England at least, companies that were to become by the end of the 19th century the major overseas tourist establishments (e.g. Cook's) began as companies organizing groups of urban and provincial visitors to London museums and expositions (beginning with the Crystal Palace exposition in the mid-19th c.).

7. On which, see D. Preziosi, 'The Question of Art History', in J. Chandler, A. Davidson, and H. Harootunian (eds.), *Questions of Evidence: Proof, Practice, and Persuasion across the Disciplines* (Chicago, 1994), which examines the origins of Harvard University's Fogg Museum as the first institution specifically designed to house the entire ensemble of what then constituted art historical practices.

8. More has appeared on the subject during this time than during the entire two preceding centuries. While any list of recommendations will be largely idiosyncratic, the following represents a useful introductory cross-section of recent, easily available work: on the historical origins of modern museological practices, see O. Impey and A. MacGregor (eds.), *The Origins of Museums: the Cabinet of Curiosities in Sixteenth- and Seventeenth-Century Europe* (Oxford, 1985); A. Lugli, *Naturalia et Mirabilia: Il collezionismo enciclopedico nelle Wunderkammern d'Europa* (Milan, 1983); J-L. Deotte, *Le Musée: L'Origine de l'esthetique* (Paris, 1993); A. McClellan, *Inventing the Louvre* (Cambridge, 1994). See also E. Hooper-Greenhill, *Museums and the Shaping of Knowledge* (London, 1992); S. M. Pearce, *Museums, Objects, and Collections* (Washington, 1992); K. Walsh, *The Representation of the Past* (London, 1992); and the anthologies D. J. Sherman and I. Rogoff (eds.), *Museum Culture: Histories, Discourses, Spectacles* (Minneapolis, 1994); M. Pointon (ed.), *Art Apart* (Manchester, 1995). Other useful introductions include: F. Dagognet, *Le Musée sans Fin* (Paris, 1993); Tony Bennett, *The Birth of the Museum* (London, 1995); Carol Duncan, *Civilizing Rituals: Inside Public Art Museums* (London, 1994); and S. Stewart, *On Longing: Narratives of the Miniature, the Gigantic, the Souvenir, the Collection* (Durham, NC, 1993). See also D. Preziosi, *Brain of the Earth's Body*. Major multi-volume series of studies on all aspects of

museums and museology are currently being published by the Leicester University Press in the UK, and, on a smaller scale, by the Smithsonian Institution in the USA. The recent *Journal of the History of Collections* publishes important research on museum history and theory.

9. On the subject of perspective, see two important new studies: H. Damisch, *The Origin of Perspective* (Cambridge, 1994), and J. Elkins, *The Poetics of Perspective* (Ithaca, NY, 1994). An extensive evaluation of both volumes, and of the role of vision and the gaze in modern art historical practice, may be found in a recently completed UCLA dissertation by Lyle Massey, forthcoming.

10. The classic studies are: M. Foucault, *The Order of Things: An Archaeology of the Human Sciences* (New York, 1970), and id., *The Archaeology of Knowledge* (New York, 1972); and see also T. J. Reiss, *The Discourse of Modernism* (Ithaca, NY, 1982). On the relationship of European Freemasonry to these developments, particularly as regards the origins of the modern museum (most of whose founders, in England, France, and America were Masons), see Preziosi, *Brain of the Earth's Body*.

11. A preliminary version of part of the next section was published under the same title in *The Art Bulletin*, 77: 1 (March 1995), 13–15.

12. J. Lacan, 'Function and Field of Speech and Language in Psychoanalysis', *Ecrits: A Selection*, trans. A. Sheridan (New York, 1977), 86.

13. See in relation to this Michel de Certeau, 'Psychoanalysis and its History', in M. de Certeau, *Heterologies: Discourse on the Other*, trans. Brian Massumi (Minneapolis, 1986), 3–16; and id., *The Writing of History*, trans. Tom Conley (New York, 1988). Aspects of this question of historical juxtaposition and superimposition may also be found in Ronald Schleifer, Robert Con Davis, and Nancy Mergler, *Culture and Cognition: The Boundaries of Literary and Scientific Inquiry* (Ithaca, NY, 1992), esp. 1–63

14. See Hayden White, 'The Fictions of Factual Representation', in H. White, *Tropics of Discourse: Essays in Cultural Criticism* (Baltimore, 1978), 121–34.

15. On the question of distinctions between ego and subject, see J. Butler, *Bodies that Matter* (New York, 1993), esp. ch. 2, 'The Lesbian Phallus and the Morphological Imaginary', 57–91. See also Elizabeth Grosz, *Space, Time, and Perversion* (New York, 1995) for an excellent discussion of the work of

Jacques Lacan in relationship to the subject of ego-formation, as well as an insightful and thought-provoking critique of Butler.

16. Two explications of which within the parameters of traditional art history and aesthetic philosophy are Michael Fried, 'Art and Objecthood' (1967) and Arthur Danto, 'Artworks and Real Things' (1973), both of which are reprinted in the anthology *Aesthetics Today* (revised edn.), ed. Morris Philipson and Paul Gudel (New York, 1980), 214–39 and 322–36.

17. See Part 2 below.

18. Sir John Summerson, 'What is a Professor of Fine Art?', a lecture on the occasion of his inauguration as the first Ferens Professor of Fine Art in the University of Hull (Hull, 1961), 17.

19. See Jacques Lacan, *The Four Fundamental Concepts of Psychoanalysis* (London, 1977), particularly the chapter 'The Line and Light', 91–104.

20. The exhortation on the first page of the very widely circulated book by David Finn, *How to Visit a Museum* (New York, 1985). For an important critique of this and related 'communicational models', see J. Derrida, *Signeponge/Signsponge*, trans. R. Rand (New York, 1984), 52–4; and Grosz, *Space, Time, and Perversion*, ch. 1, 'Sexual Signatures', 9–24. See also a discussion of the Finn volume and related issues in D. Preziosi, 'Brain of the Earth's Body', in P. Duro (ed.), *The Rhetoric of the Frame* (Cambridge; in press 1996), and id., 'Museums/Collecting', in Robert Nelson and Richard Schiff (eds.), *Critical Terms for Art History* (Chicago, in press 1996).

21. See Butler, *Bodies That Matter*, and Grosz, *Space, Time, and Perversion*, for a general overview of the arguments here.

22. See Preziosi, *Rethinking Art History*, ch. 4, 'The Coy Science', 80–121.

23. On this subject as it pertains to the subject of modern national identity, see Karen Lang, *The German Monument, 1790–1914: Subjectivity, Memory, and National Identity*, UCLA doctoral dissertation, 1996, a portion of which is in *The Art Bulletin*, 79 (June 1997).

24. Essential to the bourgeoning contemporary discourse on fetishism and modern culture is the work of William Pietz; see esp. his 'Fetishism', in Nelson and Shiff, eds, *Critical Terms for Art History*; 'The Problem of the Fetish', part 1, *Res*, 9 (Spring 1985), 12–13; Part 2, *Res*, 13 (Spring 1987), 23–45; and Part 3, *Res*, 16 (Autumn, 1988), 105–23. See also his 'Fetishism and Materialism: The Limits of Theory in Marx', in Emily Apter

and William Pietz, (eds.), *Fetishism as Cultural Discourse* (Ithaca, NY, 1993), 119–51. That anthology has a number of especially useful discussions of the subject as it pertains to research in various fields, including art history, such as A. Solomon-Godeau, 'The Legs of the Countess', 266–306, and K. Mercer, 'Reading Radical Fetishism: The Photographs of Robert Mapplethorpe', pp. 307–29. The observations by anthology co-editor E. Apter regarding the 'Eurocentric voyeurism of "other-collecting"' (p. 3) resonate with the perspectives being developed here. Other important recent sources on the subject include Jean Baudrillard, *For a Critique of the Political Economy of the Sign* (St Louis, 1981); Louis Althusser, 'Ideology and Ideological State Apparatuses', in his *Lenin and Philosophy, and Other Essays*, trans. B. Brewster (New York, 1971), 162; and Jacques Derrida, *Glas*, trans. J.P. Leavey and R. Rand (Lincoln, Nebr., 1986), 226–7. See also the important essay by Vivian Sobchack, 'The Active Eye: A Phenomenology of Cinemativc Vision', *Quarterly Review of Film and Video*, 12: 3 (1990), 21–36. On fetishism for Kant, see I. Kant, *Religion within the Limits of Reason Alone*, trans. T. M. Greene and H. H. Hudson (New York, 1960), 165–8; Hegel discusses fetish worship in his *Philosophy of Mind*, trans. A. V. Miller (Oxford, 1971), 42, and in his *Aesthetics: Lectures on Fine Arts*, trans. T. M. Knox, vol. i (Oxford, 1975), 315–16.

25. On which, see above, n. 5., and Claire Farago, '"Vision Itself has its History": "Race," Nation, and Renaissance Art History', in C. Farago (ed.), *Reframing the Renaissance: Visual Culture in Europe and Latin America* 1450–1650 (New Haven and London, 1995), 67–88.

26. See in this connection V. Y. Mudimbe, *The Invention of Africa: Gnosis, Philosophy, and the Order of Knowledge* (Bloomington, Ind., 1988), 10 ff; Homi K. Bhabha, *The Location of Culture* (London, 1994), and Benedict Anderson, *Imagined Communities* (revised and expanded edn., London, 1991).

27. A discussion of this may be found in D. Preziosi, 'The Wickerwork of Time', in *Rethinking Art History*, 40–4. On historicism, see ibid. 14 ff. See M. Foucault, *The Archaeology of Knowledge*, esp. Part II, 'The Discursive Regularities', 21–76.

28. Most prominent of the earliest such evolutionary histories was Giorgio Vasari's *The Lives of the Most Eminent Italian Architects, Painters, and Sculptors from Cimabue to Our Times* of 1550, which led up to the work of Vasari's own mentors and presumed audience,

Michelangelo and Raphael.

29. See above, n. 5, and the following section.

30. This issue is taken up in some detail in Preziosi, *Brain of the Earth's Body* in connection with an examination of Sir John Soane's Museum in London, the Pitt Rivers Museum in Oxford, and the Egyptian, Coptic, Islamic, and Graeco-Roman Museums in Cairo and Alexandria.

31. On the subject of Eurocentrism, see the important study by Vassilis Lambropoulos, *The Rise of Eurocentrism: Anatomy of Interpretation* (Princeton, NJ, 1993), which discusses the perennial antitheses of Hebraic and Hellenic ethnocentrisms in the history of Europe, in connection with what he terms 'aesthetic faith'.

32. I owe this image to a fine paper by Zeynip Celik, '"Islamic" Architecture in French Colonial Discourse', presented at the 1996 UCLA Levi Della Vida Conference, Los Angeles, 11 May 1996.

33. On individuals as/on exhibit, see T. Mitchell, *Colonising Egypt* (Cairo, 1988), and Meg Armstrong, '"A Jumble of Foreignness": The Sublime Musayums of Nineteenth-Century Fairs and Expositions', *Cultural Critique*, 23 (Winter 1992–3), 199–250. In the latter is a fascinating discussion of the exhibition of a living Turk (pp. 222–3).

34. On which see J. Derrida, 'The Colossal', Part IV of 'Parergon' in his *The Truth in Painting*, trans. Geoff Bennington and Ian McLeod (Chicago, 1987), 119–47

35. See Timothy Brennan, 'The National Longing for Form', in T. Brennan, *Salman Rushdie and the Third World* (New York, 1989), 44–70.

36. Which can be discovered or unearthed in the 'best' of, say, the carvings of the Inuit peoples, or in aboriginal bark paintings, and which can thereby be marketed as such; as 'classic' examples of a (native) genre. The marketing itself constitutes a mode of canonizing and classicizing of the 'typical', which characteristically feeds back on the contemporary production of 'marketable' 'typical', i.e. 'classical', 'examples' of a (reified) genre. See in this connection the discussion on the organization of the original Fogg Museum curriculum in art history as beginning with a compulsory indoctrination into good design practice as a prerequisite for studying art history, in Preziosi, 'The Question of Art History' (above, n. 7). The role of Freemasonry in this is discussed in Preziosi, *Brain of the Earth's Body*, forthcoming.

37. See the essays by Thomas Keenan, 'The

Point is to (Ex)Change It: Reading *Capital*, Rhetorically', in Apter and Pietz (eds.), *Fetishism as Cultural Discourse*, 152–85, and by William Pietz, 'Fetishism and Materialism: The Limits of Theory in Marx', 119–51.

38. On the question of the archive, see M. Foucault, *The Archaeology of Knowledge*, esp. Part III, 'The Statement and the Archive', 79–131; J. Derrida, 'Archive Fever: A Freudian Impression', *Diacritics*, 25:2 (Summer 1995), 9–63.

39. On which see Eugenio Donato, 'Flaubert and the Quest for Fiction', in Donato, *The Script of Decadence* (New York, 1993), 64. See also Henry Sussman, 'Death and the Critics: Eugenio Donato's Script of Decadence', *Diacritics*, 25:3 (Fall 1995), 74–87.

40. This is quite explicit in the writings of early museum founders in the late 18th c.; see e.g. Alexandre Lenoir, who spelled out the nature of the political and pedagogical motivations and justifications for new museums in Paris in his *Musée des monuments* (Paris, 1806), 36; see also F. Dagognet, *Le Musée sans fin* (Paris, 1993) 103–23.

41. See Alain Schnapp, *The Conquest of the Past*, forthcoming.

42. See the interesting hypotheses developed by Whitney Davis in his essay 'Winckelmann Divided: Mourning the Death of Art History' (*Journal of Homosexuality*, 27: 1/2 (1994), 141–59, and reprinted here in this collection) regarding this mode of erotic conflation. If Davis is correct, then Winckelmann's move resonates quite clearly with certain strains of the very ancient European arts of memory, in particular the work of *lectio* as propounded by Hugh of St Victor, who defines such 'tropological' interactions with textual entities as that of transforming a text onto and into one's self: see Carruthers, *The Book of Memory* ch. 5, 'Memory and the Ethics of Reading', 156–88, and app. A, 261–6

43. On fetishism in Kant, see above, n. 24.

44. A key 19th-c. exemplar being the Pitt Rivers Museum in Oxford: see Preziosi, *Brain of the Earth's Body*, ch. 2.

45. It may be asked if certain theoretical positions within the modern academic discipline of art history correspond to different emphases upon one or another dimension of this social and epistemological enterprise.

46. In one sense, these are all solutions to the problem of designing a memory, whether one's own or a machine's. In which case, they represent recent metamorphoses of a very ancient and rich European tradition; see Carruthers, *The Book of Memory*, 16–45 and ch. 156–88.

47. On which, see Michel de Certeau, 'Psychoanalysis and its History', in id., *Heterologies*, (Minneapolis, 1986), 3–16.

48. On the semiotic status of the disciplinary object as *irreducibly ambivalent*, see Preziosi, 'Brain of the Earth's Body', in Duro (ed.), *The Rhetoric of the Frame* (Cambridge, 1996), 96–110; and 'Collecting/Museums', in Nelson and Schiff (eds.), *Critical Terms for Art History* (Chicago, 1996), 281–91.

49. Jacques Lacan, *Écrits*, 86.

50. On relativism vs. relativity, see Preziosi, *Brain of the Earth's Body*, ch. 1, on Sir John Soane's Museum (preserved in its final state at Soane's death in 1837) as the first fully realized art historical instance of the latter.

Afterword

1. On which see Jacques Derrida, 'The Principle of Reason: The University in the Eyes of Its Pupils', *Diacritics*, 13:3 (1983), 3–20; and Peggy Kamuf, 'The Division of Literature', *Diacritics*, 25:3 (1995), 53–72, to whose very fine articulation of these issues my remarks are heavily indebted.

2. 'Fleshing Out the Getty', by Karrie Jacobs, *Los Angeles Times/Calendar Section*, 25 Aug. 1996, p. 86.

List of Texts

The publisher would like to thank the following individuals and publishers who have kindly give permission to reproduce the texts listed below.

Mieke Bal and **Norman Bryson**, 'Semiotics and Art History' from *Art Bulletin*, 73, no. 2 (June 1991) Reprinted by permission of College Art Association of America, New York.

Michael Baxandall, *Patterns of Intention: On the Historical Explanation of Pictures* (Yale University Press, New Haven, 1985), 1–11. Reprinted by permission of Yale Representation Ltd.

Annie Coombes, 'Inventing the "Postcolonial": Hybridity and Constituency in Contemporary Curating', from *Hybridity* 18 (Winter, 1992), 39–52. Reproduced by kind permission of the author.

Hubert Damisch, 'Semiotics and Iconography', from *The Tell-Tale Sign: A Survey of Semiotics*, T. Sebeok (ed.), (1975) 27–36. Reprinted by permission of Pieter de Ridder Press, Lisse.

Whitney Davis, 'Winckelmann Divided: Mourning the Death of Art History' from *Journal of Homosexuality*, 27, nos 1/2 (1994), 141–59. © The Haworth Press Inc.

Jacques Derrida, 'Restitutions of the Truth in Pointing [*Pointure*]', from *The Truth in Painting*, trans. G. Bennington and I. McLeod (1978, 1987), 293–329. Reprinted by permission of the University of Chicago Press.

Carol Duncan, 'The Museum as Ritual', from *Civilising Rituals: Inside Public Art Museums* (Routledge, 1995). Reprinted by permission of Routledge.

Michel Foucault, 'What is an Author?' from *Bulletin de la Société Française de Philosophie* 63, no. 3 (1969). © Society of College de France.

Néstor García-Canclini, 'Remaking Passports: Visual Thought in the Debate on Multiculturalism', from *Third Text*, Quesada, trans., (1994), 139–46. Reprinted by permission of Kala Press, London.

Ernst Gombrich, 'Style' from *International Encyclopaedia of the Social Sciences* 15 (Macmillan, New York 1968). © 1968 reprinted by permission of Prentice-Hall Inc, Upper Saddle River, New Jersey.

Georg Wilhelm Friedrich Hegel, 'Philosophy of Fine Art', from *Art and Its Significance: An Anthology of Aesthetic Theory*, Stephen David Ross(ed.), 2nd edn, (1987). Reprinted by permission of State University of New York Press, Albany.

Martin Heidegger, 'The Origin of the Work of Art', from *Poetry, Language, Thought*, Albert Hofstadter, trans., (Harper & Row, 1971). © 1971 by Martin Heidegger, reprinted by permission of HarperCollins Publishers, Inc., New York.

Andreas Huyssen, 'Mapping the Postmodern' from *New German Critique* 33 (Fall 1984), 47–52. Reprinted by permission of Telos Press.

Margaret Iversen, 'Retrieving Warburg's Tradition', from *Art History* 16 (4 December 1993), 541–51. 1993 © Association of Art Historians. Reprinted by permission of Blackwell Publishers.

Amelia Jones, 'Postfeminism, Feminist Pleasures, and Embodied Theories of Art' from *New Feminist Criticism: Art/Identity/Action* Fruch, Langer and Raven (eds), (1993). Reprinted by permission of HarperCollins Publishers, Inc, New York.

Immanuel Kant, 'What is Enlightenment?' from *Kant Selections*, Beck and Lewis White (eds), Macmillan Inc, New York © 1988, reprinted by permission of Prentice-Hall, Inc., Upper Saddle River, New Jersey.

Immanuel Kant, *The Critique of Judgement* trans. James Creed Meredith, trans., (new edn, 1978). Reprinted by permission of Oxford University Press.

Mary Kelly and **Paul Smith**, 'No Essential Femininity: A Conversation with Mary Kelly

and Paul Smith', from *Parachute*, 37, no. 26 (Spring 1982), 29–35. © Artdata, Montreal.

Rosalind Krauss, 'Sculpture in the Expanded Field', from *October*, 8 (Spring, 1979), 31–44 © 1979 by the Massachusetts Institute of Technology and the Institute for Architecture and Urban Studies.

Louis Marin, 'Towards a Theory of Reading in the Visual Arts: Poussin's *The Arcadian Shepherds*', from *The Reader in the Text: Essays on Audience and Interpretation*, S. Leiman and I. Crossman (eds), (1980). © 1980 reprinted by permission of Princeton University Press.

Stephen Melville, 'The Temptation of New Perspectives', from *October*, 52 (Spring, 1990), 3–15 © 1990 by October Magazine, Ltd. and the Massachusetts Institute of Technology.

Timothy Mitchell, 'Orientalism and the Exhibitionary Order' from *Comparative Studies in Society and History 9 (CSSH)* 31 (Cambridge University Press, 1989).

Craig Owens, 'The Allegorical Impulse: Toward a Theory of Postmodernism', from *October*, 12 (1980), 67–86. © The Craig Owens Estate, James B. Owens, Administrator.

Erwin Panofsky, Et In Arcadia Ego: *Poussin and the Elegiac Tradition* (Clarendon Press, 1936). Reprinted by permission of Oxford University Press.

Alois Riegl, 'Leading Characteristics of the Late Roman *Kunstwollen*' from *Late Roman Art Industry*, R. Winckes (trans.), (1985). Reprinted by permission of G. Bretschneider, Rome.

Nanette Salomon, 'The Art Historical Canon: Sins of Omission', from *(En)gendering Knowledge: Feminists in Academe*, Joan E. Hartman and Ellen Messer-Davidow (eds). Reprinted by permission of the University of Tennessee Press. Copyright © 1991 by the University of Tennessee Press.

Meyer Schapiro, 'Style' from *Anthropology Today*, Kroeber (ed.), (1953), 137–44. Reprinted by permission of the University of Chicago Press.

Meyer Schapiro, 'The Still Life as Personal Object—A Note on Heidegger and van Gogh', from *The Reach of Mind: Essays in Memory of Kurt Goldstein*, Marianne L. Simmel (ed.), (Springer Publishing Company, Inc., New York, 1968). Used by permission of Springer Publishing Company, Inc., New York 10012.

David Summers, ' "Form", Nineteenth-Century Metaphysics, and the Problem of Art Historical Description' from *Critical Inquiry* 15 (Winter 1989), 372–93. Reprinted by permission of the University of Chicago Press.

Lisa Tickner, *Sexuality and/in Representation: Five British Artists* (The New Museum of Contemporary Art, 1984). Reprinted by permission of the author.

Aby Warburg, 'Images from the Region of the Pueblo Indians of North America' from *Images from the Region of the Pueblo Indians of North America* , Michael P. Steinberg (trans.), (Cornell University Press, 1995). Reprinted by courtesy of The Warburg Institute, London.

Johann Joachim Winckelmann, *Reflections on the Imitation of Greek Works in Painting and Sculpture* (Carus Publishing, 1987). Reprinted by permission of Open Court Trade & Academic Books, a division of Carus Publishing Company, Peru, Illinois.

Edgar Wind, 'Warburg's Concept of *Kunstwissenschaft* and its Meaning for Aesthetics' from *The Eloquence of Symbols: Studies in Hamisi Art* (1983). Reprinted by permission of Oxford University Press.

Heinrich Wölfflin, 'Principles of Art History' from *Principles in Art History* Hottinger (ed.), (1932). Reprinted by permission of Henry Holt, New York.

The publisher and author apologize for any errors or omissions in the above list. If contacted they will be pleased to rectify these at the earliest opportunity.

List of Illustrations

The publisher would like to thank the following individuals and institutions who have kindly given permission to reproduce the illustrations listed below.

28. Ascelpius. Museo Capitolino, Rome/ photo Alinari, Florence.

29. Ascelpius with serpent. Serpentarius, star constellation. Bibliotheek der Rijksuniversiteit (Cod. Voss. Q79.f.10b), Leiden.

30. Guilio Romano: *Vendor of Antidote against Snake Bites*. Fresco. Palazzo del Te, Mantua/ photo Alinari, Florence.

31. Serpent and Crucifixion, 14th century. Fragment of a *Biblia Pauperum*, Flanders or Germany. British Library (Add.31303, f.2), London.

32. Hopi schoolboy's drawing. Photograph, 1895–96, Aby Warburg. The Warburg Institute, University of London.

33. 'Children stand before a cave.' Photograph, 1895–96, Aby Warburg. The Warburg Institute, University of London.

34. 'Uncle Sam.' Photograph, 1895–96, Aby Warburg. The Warburg Institute, University of London.

35. Parte Prima, Dissegno, 16th century?

36. Nicolas Poussin: *The Arcadian Shepherds*, *c.*1640. Oil on canvas. 85 × 121 cm. Musée du Louvre, Paris/photo Giraudon.

37. Mary Miss: *Perimeter/Pavilions/Decoys*, 1977–78, Nassau County Museum, Roslyn Harbor, Long Island, NY, view above ground. Wood. Tallest tower, H. 548.6 cm; pit opening, 487.7 × 487.7 cm. Photo courtesy the artist.

38. Mary Miss: *Perimeter/Pavilions/Decoys*, 1977–78, Nassau County Museum, Roslyn Harbor, Long Island, NY, view from within pit. Wood. Tallest tower, H. 548.6 cm; pit opening, 487.7 × 487.7 cm. Photo courtesy the artist.

39. Auguste Rodin: Monument to Balzac, 1897. Bronze. 270 × 120.5 × 128 cm. Musée Rodin, Paris/photo Jérôme Manoukian.

40. Constantin Brancusi: *Beginning of the World*, 1924. Musée National d'art Moderne, Paris © ADAGP, Paris, and DACS, London 1998.

41. Robert Morris: Green Gallery Installation, 1964. Painted plywood. Each 243.8 × 243.8 × 60.9 cm. Leo Castelli Gallery, New York/© ARS, New York, and DACS, London 1998.

42. Alice Aycock: *Maze*, 1972. Wood. H. 1.82 m; diameter, 9.75 m. Gibney Farm, New Kingston, PA. John Weber Gallery, New York.

43. Richard Serra: *5.30*, 1969. Lead antimony. Four plates, each 122 × 122 cm; pole 152.4 cm (overall 132 × 152 × 152 cm). Courtesy the artist/Gagosian Gallery, New York/photo Peter Moore.

44. Robert Morris: *Observatory*, 1971.

Permanent installation, Oostelijk, The Netherlands. Robert Morris Archive, Solomon R. Guggenheim Museum, New York/photo Peter Boersma/© ARS, New York, and DACS, London 1998.

45. Robert Smithson: *Spiral Jetty*, 1969–70. Mud, salt crystals, rocks. Spiral, L. 427.2 m, W. 4.57 m. Estate of Robert Smithson/John Weber Gallery, New York/photo Gianfranco Gorgoni/Sygma.

46. Carl Andre: *8 Cuts*, 1967. Concrete block capstones. 1472-unit rectangle with eight 30-unit rectangular voids, 5 × 680 × 1300 cm overall. Raussmüller Collection, Switzerland/Paula Cooper Gallery, New York/© DACS, London/VAGA, New York 1998.

47. Robert Smithson: *First Mirror Displacement*, Yucatan, Mexico, 1969. Estate of Robert Smithson/John Weber Gallery, New York.

48. Robert Smithson: *Seventh Mirror Displacement*, Yucatan, Mexico, 1969. Estate of Robert Smithson/John Weber Gallery, New York.

49. Richard Long: Untitled, Museum Haus Lange, Krefeld, 1969. Earth and grass. H. 25 cm; diameter 1350 cm. Courtesy the artist/ photo Kaiser Wilhelm Museum, Krefeld.

50. Robert Morris: Untitled (Mirrored Boxes), 1965. Glass mirrors on wood. Each 53.3 × 53.3 × 53.3 cm. Leo Castelli Gallery, New York/© ARS, New York, and DACS, London 1998.

51. Joel Shapiro: Untitled, 1974–75. Plaster, iron, graphite, and wood. Courtesy the artist/photo Heini Scheebeli, London.

52. Troy Brauntuch: Untitled (detail of three-panel work), 1979. Photo courtesy the artist.

53. Cy Twombly: *Epthalamion* I and II, 1976. Watercolour, pen, charcoal, postcard, wax paper. I: 162.6 × 109.2 cm; II: 76.2 × 57 cm. Gagosian Gallery, New York/Heiner Bastian Fine Art, Berlin.

54. Edouard Manet: *The Dead Toreador*, 1864. Oil on canvas. 759 × 1533 cm. Widener Collection, Board of Trustees, National Gallery of Art, Washington/Bridgeman Art Library, London.

55. Edouard Manet: *Civil War*, 1871. Lithograph. Yale University Art Gallery, New Haven, CT/photo Courtauld Institute, University of London.

56. Robert Smithson: *Broken Circle*, Emmen, Holland, 1971–72. Estate of Robert Smithson/John Weber Gallery, New York.

57. Mary Kelly: *Post-Partum Document*, 1971. Installation. Courtesy the artist/photo Bob

Bean.

58. Mary Kelly: *Post-Partum Document, Document VI: Pre-writing Alphabet, Exergue and Diary*, 1979. Slate and resin, detail. Sixteen units. 35 × 27 cm. Courtesy the artist.

59. Mary Kelly: *Post-Partum Document, Document VI: Pre-writing Alphabet, Exergue and Diary*, 1979. Slate and resin, detail. Sixteen units. 35 × 27 cm. Courtesy the artist.

60. Mary Kelly: *Post-Partum Document, Documentation III: Analysed Markings and Diary Perspective Schema*, 1975. Mixed media on paper, detail. Eleven units; 27 × 35 cm. Courtesy the artist.

61. Mary Kelly: *Post-Partum Document, Documentation III: Analysed Markings and Diary Perspective Schema*, 1975. Mixed media on paper, detail. Eleven units; 27 x 35 cm. Courtesy the artist.

62. Vincent van Gogh: *Old Shoes with Laces*, 1886. Oil on canvas. 37.5 × 45 cm. Van Gogh Museum, Amsterdam (Vincent van Gogh Foundation). © ADAGP, Paris, and DACS, London 1998.

63. René Magritte: *The Red Model*, 1935. Oil on canvas. 60 × 45 cm. Musée National d'Art Moderne, Centre Georges Pompidou, Paris. © ADAGP, Paris, and DACS, London 1998.

64. René Magritte: *Philosophy in the Boudoir*, 1947. Oil on canvas. © 1990 Sotheby's Inc., New York/© ADAGP, Paris, and DACS, London 1998.

65. René Magritte: *The Well of Truth*, 1963. Oil on canvas. 81 × 60 cm. The Museum of Modern Art, Toyama. © ADAGP, Paris, and DACS, London 1998.

66. The Glyptothek, Munich. Bildarchiv Foto Marburg.

67. The National Gallery of New South Wales, Sydney. Photo Carol Duncan.

68. Instructions to visitors to the Hirshhorn Museum, Washington, DC. Photo Carol Duncan.

69. National Gallery, Washington DC: gallery with a work by Leonardo da Vinci. Photo Carol Duncan.

70. Modern art in the Tate Gallery, London. Photo Carol Duncan.

71. Exhibits from 'Temps Perdu. Temps Retrouvé', at the Musée d'Ethnographie Neuchâtel, 1985/86: 'What's worth preserving of the present?'. © Musée d'Ethnographie Neuchâtel/photo Alain Germond.

72. Exhibits from 'Temps Perdu. Temps Retrouvé', at the Musée d'Ethnographie Neuchâtel, 1985/86: Ethnographic objects as souvenirs including a mask from Gabon, and a South American poncho which 'belonged' respectively to Dr Albert Schweizer and Jean-Jacques de Tschudi. © Musée d'Ethnographie Neuchâtel/photo Alain Germond.

73. Luis Felipe Noé: *One of these Days*, 1963. Mixed media. 180 × 300 cm. Museo de Arte Contemporaneo, Buenos Aires.

74. Guillermo Kuitca: Installation at the IVAM Centre del Carme, Valencia, 1993. Photo IVAM Centre Julio González, Valencia.

The publisher and author apologize for any errors or omissions in the above list. If contacted they will be pleased to rectify these

Biographical Notes

Mieke Bal is Director of the Amsterdam School for Cultural Analysis. Her books include *Reading Rembrandt: Beyond the Word Image Opposition* (1994), *Point of Theory: Practices of Cultural Analysis* (1994, with Inge Boer), and *Double Exposures: Subject of Cultural Analysis* (1996).

Michael Baxandall is Professor of History of the Classical Tradition at the Warburg Institute, University of London. His publications include *Painting and Experience in Fifteenth Century Italy* (1972), *Giotto and the Orators* (1971), *Limewood Sculptors of Renaissance Germany* (1980), and *Patterns of Intention*.

Norman Bryson is Professor of Fine Arts at Harvard University. Among his books are *Vision and Painting: The Logic of Gaze* (1983), *Word and Image: French Painting of the Ancien Régime* (1983), *Calligram: Essays in New Art History from France* (1988), and *Looking at the Overlooked: Four Essays on Still Life Painting* (1990).

Annie E. Coombes teaches in the History of Art Department, Birkbeck College, University of London. Her most recent book is *Reinventing Africa: Museums, Material Culture and Popular Imagination in Late Victorian and Edwardian England* (1994).

Hubert Damisch was Director of the Centre for the History and Theory of Art at the École des Hautes Études en Sciences Sociales, Paris. Among his many books are *Le Jugement de Paris* (1992) and *The Origin of Perspective* (1994, trans. J. Goodman).

Whitney Davis teaches art history at Northwestern University in Chicago and is the author of *Masking the Blow* (1992), a study of representation in Egyptian art.

Jacques Derrida is one of the foremost philosophers of the twentieth century, and professor at the École des Hautes Études en Sciences Sociales, Paris. His books include *The Post Card* (1987), *Writing and Difference* (1978), *Spurs: Nietzsche's Styles* (1976), *Positions* (1981), *Dissemination* (1981) and *Margins of Philosophy* (1982), *Of Grammatology* (1976), and *The Truth in Painting* (1987, trans. G. Bennington and I. McLeod).

Carol Duncan teaches at Ramapo College in New Jersey, and is the author of two books on art history and museums, *Aesthetics of Power: Essays in the Critical History of Art* (1993), and *Civilizing Rituals: Inside Public Art Museums* (1995).

Michel Foucault (1926–84) was a major philosopher and critical historian, whose work had a profound effect upon many disciplines. Among his many publications are *Madness and Civilization* (1961), *Discipline and Punish* (1975), and *The History of Sexuality* (1976).

Néstor García Canclini writes extensively on colonial and postcolonial issues; his most recent book is *Hybrid Cultures: Strategies for Entering and Leaving Modernity* (1995).

Ernst Gombrich is one of the leading art historians of the twentieth century. He was Director and Professor of History of the Classical Tradition at the Warburg Institute, University of London, 1959–76, and Slade Professor at both Oxford and Cambridge. His many publications include *The Story of Art* (1950), and *Art and Illusion* (1960).

Georg Wilhelm Friedrich Hegel (1770–1831) was a German philosopher and teacher whose published writings were profoundly influential on modern ideas on art, philosophy, history, and the state. His *Aesthetics: Lectures on the Fine Arts* were delivered at the University of Berlin between 1820 and 1830 (1975, trans. T. M. Knox).

Martin Heidegger (1889–1976) was an academic and philosopher whose most important work, *Being and Time*, was published in 1927.

Andreas Huyssen is a professor at Columbia University. His recent books include *After the Great Divide* (1988) and *Twilight Memories: Marking Time in a Culture of Amnesia* (1994).

Margaret Iversen teaches art history at the University of Essex. Her most recent books include *Alois Riegl: Art History and Theory*

(1993) and *Psychoanalysis in Art History* (1994).

Amelia Jones is Professor of Art History at the University of California, Riverside. Her publications include *Postmodernism and the En-gendering of Marcel Duchamp* (1995) and she is the editor of *Sexual Politics: Judy Chicago's Dinner Party in Feminist Art History* (1996).

Immanuel Kant (1724–1804) is arguably the most influential modern philosopher. His greatest achievement—the *Critique of Pure Reason*—was also his first major publication, appearing in 1781. This was followed by *Critique of Practical Reason* (1788), and the *Critique of Judgement* (1790).

Mary Kelly is one of the most influential artists and critics in the contemporary world, whose works have included *Post-Partum Document* (1973–9), *Interim* (1984–9), and *Gloria Patri* (1992). She is Chair of the Art Department at UCLA, and her most recent publication is *Imaging Desire* (1997).

Rosalind Krauss teaches art history at Columbia University. Co-editor of the New York art journal *October*, her publications include *Passages in Modern Sculpture* (1981), and *Optical Unconscious* (1993).

Louis Marin (1931–92) was Director of Studies at the École des Hautes Études en Sciences Sociales, Paris. His books include *Utopiques: Jeux des Espaces* (1973), *Portraits of the King* (1988), and *To Destroy Painting* (1995, trans. Mette Hjort).

Stephen Melville is Professor of Art History at Ohio State University. His books include *Vision and Textuality* (1995, ed. with Bill Readings) and *Seams: Art as a Philosophical Context: Critical Voices in Art, Theory and Culture* (1996, with Jeremy Gilbert-Rolfe).

Timothy Mitchell teaches at New York University and is the author of *Colonizing Egypt* (1988).

Craig Owens (1950–90) was a prominent New York art critic among whose many publications were *Beyond Recognition: Representation, Power and Culture* (1992).

Erwin Panofsky (1892–1968) was one of the associates of Aby Warburg, and taught in Hamburg before coming to New York in 1934; his most influential books were *Idea: A Concept in Art Theory* (1924, trans. J. J. S. Peake); *Studies in Iconology* (1939; 1962); *Early Netherlandish Painting*, 2 vols. (1953); and *Renaissance and Renascences in Western Art* (1960).

Alois Riegl (1858–1905) was a key figure in the establishment of the modern principles of art historical practice; he was the author of *Late Roman Art Industry* (1985, trans. R. Winkes).

Nanette Salomon teaches art history at the College of Staten Island in New York, and has published work on seventeenth-century Dutch and Spanish painting and nineteenth-century French painting.

Meyer Schapiro (1904–95) was Professor Emeritus of Fine Arts, Columbia University, New York. His publications include books on van Gogh, Paul Cézanne, and papers on Romanesque art, modern art, and late antique, early Christian and medieval art.

Paul Smith is a postdoctoral fellow in the English Department at Dalhousie University in Halifax, Nova Scotia.

David Summers is William R. Kenan Jr Professor of the History of Art at the University of Virginia. He is the author of *Michelangelo and the Language of Art* (1981) and *The Judgement of Sense: Renaissance Naturalism and the Rise of Aesthetics* (1987).

Lisa Tickner has written many widely influential texts on feminism and art, including *Spectacle of Women: Imagery of the Suffrage Campaign 1907–14* (1988). She is Professor of Art History at Middlesex University.

Aby Warburg (1866–1929) was a German interdisciplinary cultural historian whose own scholarship (on the survival and transformation of the classical tradition) and whose library (first in Hamburg and later in London) were crucial factors influencing the work of twentieth-century scholars such as Ernst Cassirer and Erwin Panofsky. The Warburg Library and Institute was moved to London in 1933 by Warburg's associate, Fritz Saxl; it was incorporated into the University of London in 1944.

Johann Joachim Winckelmann (1717–68) was the founder of the discipline of art history. He published his *History of Ancient Art* in Dresden, 1764, and this is often taken to be the first true 'history of art'.

Edgar Wind, (1900–71) was the author of many books on modern and early modern art history, including *Art and Anarchy* (1985), *Hume and the Heroic Portrait: Studies in Eighteenth-Century Imagery* (1986), and *Eloquence of Symbols: Studies in Humanist Art* (ed. 1993, with Jaynie Anderson).

Heinrich Wölfflin (1864–1945) was one of the most influential and popular teachers of art history in Switzerland and Germany. His most important book was *Kunstgeschichtliche Grundbegriffe; das Problem der Stilentwicklung in der neueren Kunst*, 'Fundamental Concepts of Art History', published in 1915. Its seventh edition was translated by M. D. Hottinger in 1932 as *Principles of Art History*.

Glossary

The most complete contemporary glossary of art historical terms is the encyclopaedic 'A–Z section' of Paul Duro and Michael Greenhalgh's *Essential Art History* (London, 1993), 25–311. A shorter glossary of more general terms and issues may be found in the anthology *Art History and its Methods*, edited by Eric Fernie (London, 1995), 323–68. Most of the technical terms used in this volume are discussed and explained in the text, either in the chapter introductions or in the readings. The following is a brief summary of the more important terms found in the text.

Aesthetic(s): systematic philosophical speculation on the nature of concepts of beauty and taste began during the mid-eighteenth century. The term *aesthetic* was proposed by Baumgarten (see Ch. 2) as the complement to rational or logical thinking; it was also one pole of an Enlightenment (q.v.) opposition with *fetishism* (see below and essay no. 36). The term was adapted from the ancient Greek *aisthetikos*, referring to feeling or sense-perception. In the twentieth century, the term has become a synonym for the 'fine arts' (q.v.) in contrast to the 'decorative' or 'applied' arts.

Anamorphosis: 'without shape' (Gk: ana-morphic). The picture on the cover of this book is of the painting by Hans Holbein (*The Ambassadors*, 1533; London: National Gallery) in which the lower central portion is a grotesquely distorted image, anamorphic. It will only resemble a three-dimensional form (here a skull) by placing the eye close to one side of the picture-plane.

Anthropology: the disciplinary name for a network of investigations of the past and present of the human species, ranging from the 'physical' (concerned with relations of humans to the remainder of the planetary biosphere) to the 'cultural' (q.v.) and 'symbolic' (q.v.) (referring to the social and artefactual

aspects of human behaviour). The concerns of art history and anthropology have overlapped since their professional beginnings in the nineteenth century. By the latter half of the twentieth century art historians became more explicitly engaged with understanding artefacts through their social and cultural uses and functions, whilst anthropologists have increasingly concerned themselves with aspects of artefacts traditionally studied by art historians, such as style, aesthetics, and questions of value and taste.

Antiquity, Antiquarian(ism): antiquarian interests in the past, whether of Greek or Roman antiquity or of the cultural artefacts of non-European peoples and cultures, have been concerned since early modern times with the acquisition and collection of data, particularly the material remains of objects of specific kinds or belonging to certain groups. In the twentieth century the term accrued negative connotations, referring to an a-historical interest in cultural artefacts, or a lack of interest in the social life and functions of things.

Archaeology: in contrast to antiquarianism, archaeological interest in the material evidence of past societies is commonly linked to attempts to reconstruct the social and historical contexts in which cultural artefacts were used and acquired significance. In this respect, archaeology—one of whose modern 'founders' (also a 'founder' of art history) was Winckelmann (see Ch. 1)—complements the concerns of anthropology, whilst differing from it (and from modern art history) in its direct concern with excavation and with the technical investigation of aspects of unearthed material. At the same time, archaeology distinguished its domain from history in its greater emphasis on material culture in contrast to textual records. Traditionally, archaeologists have been less concerned than

art historians with such issues as aesthetics, quality, and taste.

Art history: the principal concern of art history has been the construction of historically grounded explanations for why cultural artefacts—works of art—appear as they do (see essay no. 1). Definitions of art have varied widely over the centuries. The acknowledged object-domain of the academic discipline has varied from a select assemblage of materials considered to be of the highest quality (art or 'fine' art (q.v.); see 'canon' below) produced in the past or the present, to the entire range of objects of human manufacture ('visual culture') playing roles in individual and social life. While art historians traditionally concerned themselves primarily with the 'aesthetic' dimensions of cultural artefacts, leaving other aspects of the lives and functions of objects to historians, anthropologists, archaeologists, philosophers, and psychologists, in the latter half of the twentieth century they increasingly attended to a wider range of evidence deemed necessary to the basic task of explaining why objects appear as they do. The last quarter of the twentieth century was characterized by intense disputes over the primacy or necessity of one or another approach to disciplinary knowledge-production, and the beginnings of an acknowledgement of an inevitable and possibly inescapable diversity of disciplinary subject-matters, theories (q.v.) and methodologies (q.v.). Whether in the twenty-first century what is now called art history comes to resemble a diffuse, heterogeneous field such as present-day anthropology, or diversifies into several institutionally distinct areas of interest and expertise, is unclear.

Canon: traditionally, a body of (art) work regarded by an influential group of professionals as of the highest quality of its type (see 'fine art'; 'classicism'). More currently, the term has come to apply to any body of materials of the greatest significance or pertinence to the interests of a particular (national, social, political, racial, class, or gender) group. Because of the core interest of the discipline of art history in questions of quality, taste, and social and historical significance, the systemic institutional role of 'canonization' has remained intact, even if the justifications and admissable materials have differed markedly. Many of the debates over art historical 'theory' and 'methodology' during the last quarter of the twentieth

century also concerned the valorization or canonization of specific subject-matters worthy of professional or public attention. In this regard, one group's 'masterpieces' and another's 'politically correct' or 'socially relevant' artworks perform equivalent disciplinary roles in maintaining hierarchical distinctions amongst cultural objects—that is, in maintaining a belief that certain kinds and styles of artefacts provide more typical or deeper insights into the mentality or character of an individual or group.

Classicism: originally derived from Roman maritime vocabulary, denoting the most seaworthy ships in a fleet (*classis*), 'classical' has come to refer generally to works considered by a dominant group to be the best of their kind, as well as those whose qualities are most enduring. In art history, the term has had multiple, and often superimposed roles. By extension it has referred to the most typical or characteristic works or products of a person, group, society, or nation. Both time-bound and a-historical, 'classic' has referred, on the one hand, to absolute, even transhistorically superior quality. On the other hand, it has been a relational term, part of the pervasive organic metaphor projected upon the history of artworks, the period after the 'archaic' or early (childhood) phases of development, representing the 'adult' or fully mature phase of a style, before its decline into (baroque) senescence. By the late twentieth century, virtually any social or cultural phenomenon could be designated as having a 'classic' quality—from soft drinks to medical syndromes. Less common today is the (early nineteenth-century) usage of the term as the (earlier) polar (rational, lucid) opposite of the (later irrational, emotional) 'romanticism' in art, music, literature, and philosophy.

Collection: the assembly of objects of singular or diverse types according to particular criteria justifying their association in a particular place. Collecting is an extremely ancient practice in many parts of the world, from Europe to East Asia. Both the Greeks and (on a much more massive scale) the Romans formed collections of art and precious objects, both as (semi-)public treasury-offerings in temples and sanctuaries, and on a private scale. By the late twentieth century, collecting became a pastime pursued by large segments of modern populations, for whom distinctions between the consumption of commodities and the collection of all kinds of objects and

phenomena have often been a matter of degree rather than of kind, both activities subsumed into the practice of constructing identity and forging social allegiances. See 'museum', 'exhibition'.

Connoisseurship: the term *connoisseur* referred generally to a person with expert knowledge; connoisseurship in matters of art has a long history in Europe. In the Renaissance, the connoisseurship of artworks (often practised by those with professional medical skills) concerned the diagnostic evaluation of evidence (or, in semiotic terms, the 'signs') that an object might provide for skill in artistry and/or authentic (and, typically, ancient) origins or provenance. The most famous connoisseurs in European art history were Vasari (sixteenth century), Winckelmann (eighteenth century), Morelli (nineteenth century), and Berenson (early twentieth century). Connoisseurship today commonly entails an ability to discern original or authentic works (or collections of works) from copies or forgeries, on the assumption that the former exhibit finer skill or aesthetic integrity than the latter.

Criticism: closely allied to aspects of connoisseurship, art criticism normally entailed an ability to discern quality and skill in works, as defined by particular standards or canons of taste common to a time or place. As a modern professional public practice, art criticism came to be increasingly allied in the nineteenth and twentieth centuries with commodity market forces and their connection to the monitoring of (and fabrication of) changing trends in taste and fashion.

Culture: in the widest sense, the entire set of means, materials, and methods through which a society or social group fabricates and maintains its realities. In a more narrow modern sense, the term is commonly used to denote a certain range of practices and materials (e.g. 'material culture'; 'visual culture') considered by one or another dominant or subordinate social group to refer to practices and products typical or characteristic of themselves individually or collectively. Such phenomena often overlap with notions of a 'canon' (q.v.) or tradition in practice, values, taste, or attitude. The term culture has also been employed relationally, in a bipolar opposition with 'nature', as referring to all those productions stemming from

human social agency—as opposed to those which might be traced to biologically or genetically inherited abilities. Art was traditionally characterized as a mode of cultural production: as reflecting a pan-human (and hence genetically based) tendency towards making, building, representing, or narrating, which takes culturally specific forms or manifestations.

Deconstruction: in certain respects, deconstruction (which is not a 'method' as such; on this term, coined by Jacques Derrida, see Ch. 8) entails an approach to the 'reading' of texts (or artefacts) of any kind 'against the grain' of their ostensible agendas— 'anamorphically', so to speak—and in such a way as to foreground their internal self-contradictions (or 'otherness'), and the gaps between intention and effect. No less dependent upon diagnostic or semiotic skills than connoisseurship, while constituting a critique of certain key idealist aspects of structuralist (q.v.) semiotics, deconstructive approaches towards the visual environment, whether in the production or interpretation of art and architecture, were widely influential in many humanities and social-science disciplines during the last quarter of the twentieth century, as part of the 'poststructuralist' (q.v.) facets of critical and theoretical writing and practice.

Enlightenment: the liberal, pro-scientific, rationalist philosophical movement (see essay no. 5, Ch. 2) beginning in France in the eighteenth century, and entailing the celebration of the modern nation-state and its representative community groups and institutions (from universal education to art museums) as the most effective and socially responsible medium for the improvement of all aspects of human life.

Exhibition: generally, the public display of artworks in modern times, most likely originating historically in Europe in the practice of making objects for sale or dissemination (as souvenirs or mementos) at religious fairs or festivals. With the rise of artistic academies (and the rise of the social status of artists) during the Renaissance (see Ch. 1), modern exhibitionary practice came to be standardized as a necessary facet of artistic production, whereby the latest works by an individual or workshop were assembled for view (and/or sale) to the public. Closely tied to this was the rise of galleries and auction houses

in seventeenth- and eighteenth-century Europe, along with the rise of connoisseurship and art criticism as professional practices.

Feminism: feminist art practice and feminist art history became important stages for the political and ideological critique of patriarchy and patriarchal institutions, beginning in the 1960s in Europe and America (see Ch. 7). In art history, feminist theory and criticism focused upon a wide variety of issues, from the incorporation into the disciplinary canon of female artists whose work or even identity had been either marginalized, trivialized, or rendered invisible, to challenges of a foundational nature to art historical and critical practices—to an entire system of knowledge-production—which was held to be gender-biased. Feminist practice and theory in art and art history has entailed questioning many essential (and largely unquestioned) assumptions regarding everything from the nature of the art 'object' to gendered perception and the very structure of social and cultural institutions.

Fetish(ism): in its common modern usage, the term (derived ultimately, via the Portuguese *fetisso*, from the late Latin term *factitius*, an adjective meaning that which relates to things made) refers to an obsessive concern with, and/or an attribution of 'magical' agency to human or non-human objects. Early definitions of 'art' and of the 'aesthetic' during the Enlightenment (see Ch. 1 and Ch. 9, the final essay) entailed the articulation of ways to situate the latter with respect to the former, commonly as defining an opposition between a 'civilized' and 'disinterested' interaction with objects and things (read 'European') and a 'primitive' attachment to things (read 'African' or 'pagan'). See also 'sublime', below.

Fine art(s): the term had its origins in distinctions made during the Renaissance between artefacts serving predominantly functional or decorative ends (the 'applied' arts or 'practical' crafts) and those serving higher intellectual and liberal (i.e. liberating) ends. Painting, sculpture, and architecture came to be framed (potentially) as forms of intellectual work, on a par or complementary to that of writing. The distinction is equally grounded in differences in the social and class status of producers, and in the professional circumstances of their training (in academies for 'fine' artists, in guilds for craftspersons), as discussed by Vasari and other artists and architects such as Leonardo da Vinci and Alberti.

Formalism: commonly refers to an approach to the appreciation and analysis of artefacts privileging their formal or morphological qualities over (or without respect to) other aspects of a work's production, reception, subject-matter, or thematic significance. The term has had a variety of inflections during the history of art history, forming for example a primary organizing paradigm for Wölfflin's 1915 *Principles of Art History* (see Ch. 3) or for broadly based attempts to articulate a universally applicable framework for the analysis of all products of human manufacture at all times and places (see Ch. 4 and 5). In the mid-twentieth century, the term came to have positive connotations in modernist art criticism, privileging non-figurative art over nineteenth-century narrative or realist art. Panofsky's 'iconographic' methodology (q.v.) was a reaction to Wölfflin's extreme formalism, which was also opposed by 'social' historians (q.v.) of art, for whom content (as the other pole in a 'form–content' opposition) came to be privileged.

Historicism: generally, the belief that an adequate understanding of any phenomenon and its value can best be gained by considering it in terms of its place within a process of development or evolution. Art history, or history in general, were modern forms of knowledge-production originating during the European Enlightenment as ways of formatting the relationships between past and present in a narrative or causal fashion, as a linear, largely progressive, development. Historicism may be understood as an extreme version of such a paradigm, often allied to metaphysical, spiritualist, or teleological construals of human experience (see the section on Hegel, Ch. 2, and Ch. 9, the final essay).

Historiography: commonly used to refer to the specific historical development of an institution or discipline. In recent years it has also come to imply a critical perspective upon the transitoriness and mutability of particular views on history, art, and their interrelationships, and a concern with delineating the development of different theoretical and methodological approaches to art and its histories. See 'psychoanalysis' below.

Iconography, Iconology although the term 'iconology' was used during the Renaissance to suggest a systematic accounting for the appearance and variety of imagery, it was appropriated in the twentieth century by Erwin Panofsky (see Ch. 5) in a systemic relationship with what he termed in complementary fashion 'iconography', referring to the study of subject-matter in art. Panofsky's 'iconology' referred to the study of the deeper meanings of artworks. An iconographic interest in works implied a broad knowledge of a work's referential subject-matter as a particular variation upon or development out of a common stock of images and themes.

Kunstwollen: the 'force' or 'will' behind the production of and motivation for art, primarily understood on a broad communal, national, ethnic, or racial scale (see Ch. 4 on Riegl)

Marxist art history: one branch of the 'social history' of art (q.v.) achieving prominence during the third quarter of the twentieth century mostly amongst historians of modern realist painting. 'Marxist' art history was devoted to articulating ways in which the thesis of Karl Marx (1818–83) that the modes of economic production in material life bore a determinate relationship to the character of social, political, and spiritual life might provide a useful methodological paradigm for understanding the place and role of art in society and culture. Essentially a variant of Hegel's historicist-idealist argument (see Ch. 2) that human history was a reflection or representation of the progress of a divine or world Spirit towards self-realization, Marx's historical 'materialism' was structurally and theoretically identical to its Hegelian complement. Marxist art historians sought to articulate possible ways in which an economic social 'base' and its artistic or cultural 'superstructure' could be related in a causal manner, whether in fine detail or more broadly.

Meaning: generally, the significance or referential content of an art work; the values or issues, themes, or subject-matter which it may be said to 'contain' or point to.

Medium: the term has had a variety of meanings, referring to the actual matter or material vehicle of a work, as well as to the general idea that any artwork is a 'medium' standing between the artist and his or her intentions, and the viewer or user of a work. In this sense the object would be understood as a means by which the former (intention) is conveyed to the latter. Generally speaking, the term parallels similar understandings of speech and language, wherein a spoken utterance's auditory 'medium' is taken to be the vehicle for transferring the intentions (or 'meanings') of a speaker to a listener.

Methodology: a particular way of approaching the analysis of an artwork, comprising sets of principles referring to the kinds of evidence that are to be admissible as adequate or sufficient in explaining why an object appears as it does. Commonly paired with 'theory' in contemporary art historical pedagogy, and referring to the historical study of the development of different ways of analysing and conceiving of art historical objects of study.

Modernity: a relational term, in contrast to 'antiquity', which as such has been employed within much of European history since the early Renaissance as a synonym for the present artwork (mostly anti-naturalist) produced in the nineteenth and/or twentieth centuries. Discourse on 'postmodernism (q.v.), begun in the 1960s, had the effect of framing modernity and artistic modernism within fixed historical parameters, although views have been divided as to precisely what those parameters might be. In the arts and in social and cultural history, modernity may be broadly construed as referring to the period beginning with the European Enlightenment in the eighteenth century, and the rise of the 'modern' nation-state, its colonial and imperial extensions, along with an entire scientific system of knowledge-production, extending into the 1960s. The (ideally monocultural) nation-state of modernity is seen by some as being transcended by the (multicultural) contemporary world.

Museum: derived from the Greek *mouseion* or home of the Muses, the personifications of various arts and sciences. (See 'Wunder-kammer' below.) Museums as public collections of objects (in most cases formerly in private hands) became an important feature of the new nation-states of Europe beginning in the late eighteenth century; by the mid-nineteenth century, and paralleling the rise of national expositions, fairs, and exhibitions, museums became a necessary component of cities large and small throughout Europe and

its extensions as the venues for the promotion of public scientific and cultural knowledge, as well as for articulating the history and evolution of particular national and ethnic groups by means of historically organized displays of objects and art works.

Orientalism: during the eighteenth and nineteenth centuries, the term referred to the European romantic interest in the 'Orient', construed widely as encompassing both the Middle and Far East. It was used most commonly to refer to artists and writers who travelled amongst and depicted the (largely Muslim) peoples and places of the Eastern Mediterranean and North Africa. In the last quarter of the twentieth century, the term acquired a distinctly critical edge since the publication by Palestinian-American scholar Edward Said's book *Orientalism*, which sparked the extensive investigation of the historical and ideological circumstances surrounding the fabrication of the semitic Near East as the antirationalist, antimodern, anti-humanist, and semi-barbaric antithesis to European modernity: Europe's other and anterior.

Postmodernism: see 'modernity' above. 'Postmodernity' has been defined both as a historical period beginning in the 1960s and contesting modernity (as modernity itself contested traditional knowledge during the eighteenth century), and as one of modernity's antitheses, coexisting with it since the Enlightenment (See essay no. 36). Associated by some with a multicultural contemporary world, it is often contrasted with the (monocultural) ideals of the (modernist) nation-state; in that sense modernity and its so-called posterior(s) are, and have been, coexistent.

Poststructuralism: see 'structuralism', below.

Psychoanalysis: generally, the systematic investigation into the causes and motivations for invidual and collective behaviour, seen to be situated in those 'un'conscious aspects of the individual subject knowable only indirectly or by their traces or effects. It consequently comprises an explanatory model for social and cultural phenomena, including artistic production, which links them to concurrent rather than historical forces. Psychoanalytic explanation thus deals with the superimposition and intertwining of cause and effect, in contrast to the distinct and juxtaposed (past and present) facets of historical explanation or 'historiography' (q.v.).

Representation: perhaps the most enduring concept in art history, representation referred generally to a view of artworks as *re*-presenting, reflecting, or standing in for, the aims and intentions of an artist or maker, and, by extension, those of a time, place, or people. Theories of representation are grounded in traditional Western philosophical and religious notions of the 'sign' (see below and final essay), and are also closely tied to concepts of imitation and naturalism, in which art is understood as a practice of rendering perceptions of things within the parameters of time- and space-specific conventions. To view an artwork as a 'representation' was to adhere to a very particular concept of explanation, concerned with accounting for what might be characterized as congruities and incongruities between the object (copy, surrogate, representation, signifier) and what it is thought to represent. The object thus becomes a trace, sign, symbol, or index of some absent and/or prior event, force, spirit, intention, will, ethnicity, and so on. (The term was also used in the twentieth century in the sense of realism, in contrast to 'abstract' or non-figurative art.)

Semiology, *semiotics*: the systematic investigation of how signs generate meaning; the term is an ancient Greek one, originally associated with medical diagnosis and the inferring of certain invisible diseases from their physical signs or symptoms. See Ch. 5.

Sign: in semiotics, the basic unit of meaning, with a double facet—both that which is 'signified', and (usually a form of some kind) that which signifies, the 'signifier'. The key concept of modern linguistics, itself seen as a branch of semiology by the Swiss linguist Ferdinand de Saussure in the first decades of the twentieth century.

Social history of art: generally, the phrase came to refer during the latter third of the twentieth century to theories (of which Marxism was one; see 'Marxist art history' above, and 'historicism') for explaining the history of artworks and artistic practice by means of the social, political, and economic contexts within which works were conceived, produced, perceived, and used. A very wide variety of 'contextualist' explanatory models were

developed to account for the historical appearance and significance of works, from political environments to the nature of art and craft professionalization to hypotheses about the influence of gender, class, and ethnicity on artistic subject-matter, technique, materials, and stagecraft.

Structuralism: in the most general sense, the systematic investigation of the underlying organizational models held to be determinative or productive of cultural practice. Grounded in principles of binary organization discovered as constituting the 'semiotic' (q.v.) sign structure of spoken language, structuralist principles came to be applied to the investigation of the visual arts, architecture, and culture early in the twentieth century, absorbing and merging with art historical concerns with iconography during the last third of the century (see Ch. 5). Structuralism problematized the autonomy of the individual human subject, the transparency, and fixity of meaning, and the originality and uniqueness of works, by highlighting the social and historical constructedness of all these concepts. 'Poststructuralism' took this critique further, beginning in the 1960s by foregrounding the metaphysical and theological underpinnings of traditional humanist modernism, as well as the hierarchical presuppositions and ahistoricism of certain structuralist ideas. See also 'deconstruction' and 'psychoanalysis' above.

Style: see Ch. 3. The concept (or 'theory'; see below) of 'style' makes it possible to group artworks into related and affiliated groups on the basis of shared and/or contrastive distinctive (stylistic) features; in this manner objects (and their makers, societies, cultures, or nations) can be situated as close to or distant from each other in varying ways. Essentially a form of semiotic analysis, stylistic analysis became a means for fabricating relations of filiation, kinship, descent, or difference amongst objects (as surrogates or 'representations' (q.v.) of connections or differences between their makers) and societies. Along with representation, the term is one of the central concepts of the modern discipline of art history, and both presupposes and promotes the hypothesis of a shared stylistic or family resemblance amongst the artefacts of a group, studio, region, nation, ethnicity, or race. The entire possibility of art history as a discipline rests upon the stylistic hypothesis, and it is a key support for ideas about the ideal homogeneity of the (modernist; see above) nation-state, and the constant selfsameness or identity of its citizen subjects and what is proper to (and the property of) them.

Sublime: a term gaining philosophical and aesthetic currency during the Enlightenment, and referring generally to that which exceeded (rational) understanding either because of awesome or extraordinary qualities, or a massiveness of scale, beyond human comprehension. The contrast with rational understanding links (but hierarchically discriminates) the sublime with another eighteenth-century rational antithesis or excess, the concept of fetishism (q.v.)

Symbol: of many general and discipline-specific uses of 'symbol', the most common in art history has been the notion that an art object may have a double meaning—one that is more literal, and one that is more conventional or allusory: the use of a certain colour, for example, referring both to an actual material property of something represented, as well as to a certain religious or political belief. Because the latter connection is conventional or time- and place-specific, symbolism is a primary concern of various forms of semiotic (q.v.) analyses such as iconography (q.v.). In semiotics, there have been many different uses of the term symbol; most commonly it is used to refer to one kind of association (a conventional one) between a signifier and a signified.

Teleology: the notion that the sequential development of forms or ideas is in some manner driven by a force, impulse, or anticipation of a particular outcome. Thus, Hegel's theory of the history of art as a representation (q.v.) of the developmental evolution or unfolding of a world Spirit is a teleological system (see 'historicism', above). The early attractiveness of teleological explanatory paradigms in art history was related to the pragmatic social functions of a network of early modern historical and interpretative disciplines that provided support for narrative histories of the origins and differential progress toward modernization of various peoples, races, and nations (see essay no. 36; introductions to Ch. 2 and 3).

Theory: (see 'methodology' above). From Greek words referring to sight or seeing, the 'theory' of anything may be understood to be a particular view that unifies in some fundamental sense a wide variety of disparate phenomena. In the last quarter of the twentieth century an interest in 'theory' (or 'critical theory') came to mean an engagement with one or another 'poststructuralist' (or 'postmodernist') perspectives on art, history, culture, and politics (psychoanalytic theory, deconstruction, semiotics, feminism, social history, and so on).

Wunderkammer: a German term often rendered in English as 'cabinet of curiosities', and used to refer to a collection of objects, artefactual and/or natural, unusual in variety, origins, or form; literally, a chamber of wondrous things. See 'museum' and 'collection' above.

Zeitgeist: the (dominant) spirit of an age, period, or time.

Index

Schapiro on 112, 113, 141, 143–9, 570
stylistic physiognomics 159–60
Warburg on 167, 210–11
Wölfflin on 207–10
see also formalism; representation *and under*
 Gombrich
subject/subjectivity:
 clarity 117
 division of (Hegel) 97–106
 and ideology 357–8
 postfemininist 387–91
 split 218–21, 224
 of taste 79, 81, 87, 94–6
 universality of delight as 86–9
 see also sexuality
sublime 65, 331, **582**
Summers, D. 575
 on form, nineteenth century metaphysics
 and problem of art historical description
 112, 113, 127–42, 534–5, 570
Summerson, Sir J. 513
superimposition, triple 522–4
supplement, allegory as 326–7
Surrealism 148
symbol/symbolism **582**
 and allegory 323–5, 328
 Hegel on 66–7, 68, 102–3
 and intuition 325–6
 Kant on 66
 religious *see* Pueblo Indians
 see also semiology
symmetry 172
synchronic 142
syntax 146, 270–4

taboos 162
Taine, H. 166
Tamayo, R. 500–1
Tassi, A. 351, 352
taste 31, 64
 see also delight; moments
technology and fashion 153–6
teleology **582**
temptation of new perspectives (Melville)
 398–9, 401–12, 557–8, 570
text *see* authorship; description; founding texts;
 reading; semiology
textile industry 465–6
theatricality *see* exhibition; performance
theodicy of Hegel 66–7, 110–12
theory 401, **583**
thing *see* object; work and thing
thought/cognition:
 about pictures, descriptions as 52, 54–6
 theoretical 77
 see also judgement; knowledge;
 multiculturalism
Tickner, L. 343, 575
 see also representation *under* sexuality

time 517
 shape of 15
 and space 477, 480–1, 519–25
 see also past
Titian 123
tonality 125
topological dramaturgy 339
tourism 467–72
trajectory of development *see* evolution
Trakis, G. 295
transdiscursive position of authors 309–10
transience 318–19
truth 518, 523
 in pointing, restitutions of (Derrida) 399,
 401, 432–49, 558, 569
Turner, V. 477
Tuve, R. 326
Twombly, C. 321
 Epithalamion I and II 319

ugliness and evil 173–4
unity:
 Baroque 121–6
 and beauty 172–3
 and multiplicity 117, 119–21
 with nature *see* Pueblo Indians
 organic 134
universality 18, 64, 135, 140, 520–1
 of delight, Kant on 84–9
 see also multiculturalism
Uspenskij, B. A. 239–40

van Gogh, V. *see Old Shoes with Laces*
Vasari, G.: biographies of artists 14, 21–2, 23–5,
 59, 67, 152, 166, 221
 and gendered subject 344–9, 351, 352–3, 354,
 355
Vellert, D. 126
verbal and visual confused 320–1
Virgil 35, 37, 273, 529
virtual (eucharistic) object 515
vision/visibility:
 legible 13–18
 mediation and hybridity 489–90
 panoptic 278, 469–71, 514
 pure 209–10
 visual thought *see under* multiculturalism
 visual and verbal confused 320–1
Volterra, D. da 120

Wackenrode, W. 480–1
Wallis, B. 280
Wallis, C. 386
Warburg, A. 215, 228, 536, 575
 Kulturwissenschaft concept, Wind on 168,
 207–14, 538–9, 570
 library 213–14, 216, 222
 on Pueblo Indians of North America 167–8,
 177–206, 219, 538, 570

Oxford History of Art

Titles in the Oxford History of Art series are up-to-date, fully illustrated introductions to a wide variety of subjects written by leading experts in their field. They will appear regularly, building into an interlocking and comprehensive series. In the list below, published titles appear in bold.

The Oxford History of Art is an important new series of books that explore art within its social and cultural context using the most up-to-date scholarship. They are superbly illustrated and written by leading art historians in their field.

'Oxford University Press has succeeded in reinventing the survey ... I think they'll be wonderful for students and they'll also appeal greatly to members of the public ... these authors are extremely sensitive to works of art. The books are very very lavishly illustrated, and the illustrations are terribly carefully juxtaposed.'
Professor Marcia Pointon, Manchester University speaking on *Kaleidoscope*, BBC Radio 4.

'Fully and often surprisingly illustrated, carefully annotated and captioned, each combines a historical overview with a nicely opinionated individual approach.'
Independent on Sunday

'[A] highly collectable series ... beautifully illustrated ... written by the best new generation of authors, whose lively texts offer clear syntheses of current knowledge and new thinking.'
Christies International Magazine

'The new series of art histories launched by the Oxford University Press ... tries to balance innovatory intellectual pizzazz with solid informativeness and lucidity of presentation. On the latter points all five introductory volumes score extremely well. The design is beautifully clear, the text jargon-free, and never less than readable.'
The Guardian

'These five books succeed admirably in combining academic strength with wider popular appeal. Very well designed, with an attractive, clear layout and carefully-chosen illustrations, the books are accessible, informative and authoritative.'
The Good Book Guide

'A welcome introduction to art history for the twenty-first century. The series promises to offer the best of the past and the future, mixing older and younger authors, and balancing traditional and innovative topics.'
Professor Robert Rosenblum, New York University

Art in Renaissance Italy 1350–1500

Evelyn Welch

Evelyn Welch presents a fresh picture of Italian art enriched by new scholarship. In this book, she explains artistic techniques and workshop practices, and discusses contextual issues such as artist—patron relationships, political and religious uses of art, and the ways in which visual imagery related to contemporary sexual and social behaviour. Above all this book recreates the dramatic experiences of contemporary Italians—the patrons who commissioned the works (oil paintings, frescos, tapestries, sculptures, manuscript illuminations), the members of the public who viewed them, and the artists who produced them.

'Evelyn Welch is exemplary; with good sense and clarity, Welch maintains a judicious balance between narrative and detail.'
Times Literary Supplement

'brilliantly fulfils the promoter's promises … With elegance and discretion Welch allows us to imagine that we can feel back into a vanished world. This is essay-writing at its rare best."
Sister Wendy Becket, *The Observer*

'an extraordinarily wide-ranging book within its brief compass, full of insights and information of a kind not readily met with … notably well and clearly written.'
Apollo Magazine

The Photograph

Graham Clarke

How do we *read* a photograph?

In a series of brilliant discussions of major themes and genres, Graham Clarke gives a clear and incisive account of the photograph's historical development and elucidates the insights of the most interesting critics on the subject. At the heart of the book is his innovative examination of the main subject areas — landscape, the city, portraiture, the body, and documentary reportage — and his detailed analysis of exemplary images in terms of the cultural and ideological contexts.

'Graham Clarke's survey, *The Photograph*, argues elegantly while it informs.'
The Guardian

'entrancing . . . There was hardly an image new to me, hardly an image he did not make new to me, reading its complicity . . . with the most sensitive and perceptive eye.'
Sister Wendy Becket, *The Observer*

'Carefully selected images work with the text to illustrate the theme: how the photograph is 'read'. Read this book and you will never look at a photograph in the same way again.'
House & Garden

Oxford
History of
Art

Art in China
Craig Clunas

China can boast a history of art lasting over 5,000 years and embracing a huge diversity of forms, but this rich tradition has not, until recently, been fully appreciated in the West where scholars have focused their attention on the European-style high arts (such as sculpture and painting), traditionally downplaying arts more highly prized by the Chinese themselves.

Art in China marks a breakthrough in the study of the subject. Drawing on recent innovative scholarship — and on newly accessible studies in China itself — Craig Clunas surveys the full spectrum of the visual arts in China. He examines art in a variety of contexts — as it has been designed for tombs, commissioned by rulers, displayed in temples, created by the men and women of the educated élite, and bought and sold in the marketplace.

'This reader was too lost in admiration . . . A triumphant success.'
Sister Wendy Becket, *The Observer*

'Since Thames & Hudson have just re-issued Mary Tregear's *World of Art* volume on *Chinese Art*, we can compare it head to head with Craig Clunas's *Art in China* for OUP. Clunas, I think, wins on nearly every count.'
The Independent

'a serious challenge to the conventional practice of art history . . . written with . . . lucidity, grace, and wit'
Professor Cao Yi Qiang, The National Academy of Art, China

Twentieth-Century Design

Jonathan M. Woodham

The most famous designs of the twentieth century are not those in museums, but in the marketplace. The Coca-Cola bottle and the McDonald's logo are known all over the world, and these tell us more about our culture than a narrowly-defined canon of classics.

Professor Woodham takes a fresh look at the wider issues of design and industrial culture throughout Europe, Scandinavia, North America, and the Far East. In the history which emerges design is clearly seen for what it is: the powerful and complex expression of aesthetic, social, economic, political, and technological forces.

'a showcase for the virtues of the new series . . . deftly organized, extremely cool-headed account . . . his range of reference and eye for detail are superb'
The Guardian

'[F]or a good general introduction to the subject you could not go very far wrong Yet another example of the impressive new Oxford History of Art series.'
The Bookseller

Oxford
History of
Art

Art in Europe 1700–1830
Matthew Craske

In a period of unprecedented change — rapid urbanization, economic growth, political revolution — artists were in the business of finding new ways of making art, new ways of selling art, and new ways of talking about art.

Matthew Craske creates a totally new and vivid picture of eighteenth- and early nineteenth-century art in Europe. He engages with crucial thematic issues such as changes in 'taste' and 'manner' and the impact of enlightenment notions of progress. The result is a refreshingly holistic survey which sets the art of the period firmly in its social history.

'excellent introduction … His capacity to deal with a mass of material genuinely European in scope is outstanding overall. His admirably thought-out bibliography is a model.'
Apollo Magazine

'Craske's text is illuminating and informative, the images a cross-section of the well known and the intriguing … good value.'
Royal Academy Magazine

'The refreshing good sense of this, combined with Craske's conceptual fluency and amazingly broad reach … establishes this volume at the head of its field immediately.'
The Guardian